THE SCULPTURE OF DONATELLO

THE SCULPTURE OF
DONATELLO

BY H. W. JANSON

INCORPORATING THE NOTES AND PHOTOGRAPHS OF
THE LATE JENÖ LÁNYI

PRINCETON · NEW JERSEY

PRINCETON UNIVERSITY PRESS

Foreword

The original two-volume edition of this book, with its 512 collotype plates, was of necessity published at a price that placed it beyond the financial range of many individual purchasers. It has been out of print for several years. The present edition is intended to make the work available to a wider public, offering the complete text of the first edition but a less lavish pictorial apparatus. While the number of plates has been reduced to 128, these contain 316 illustrations—approximately one-half the original number—and the reader will, I trust, find them an adequate accompaniment to the text. In order to keep the price of the new edition as low as possible, the text has been reproduced photographically, except for necessary adjustments in references to page and plate numbers and a few very minor corrections. The significant scholarly literature on Donatello since 1957 is listed in an Appendix (p. 250). The present edition also incorporates two recent discoveries: Plate 50, reproduced with the kind permission of Dr. Georg Kauffmann, shows the upper cornice of the Cantoria reconstructed in accordance with his findings; and text figure 8 (p. 218) illustrates the inscription on the South Pulpit in S. Lorenzo, first observed by Giovanni Previtali.

In the Foreword of the original edition, I thanked the many individuals and institutions whose generosity made possible the preparation and publication of those volumes. It is my pleasant duty to acknowledge once more the great debt of gratitude I owe to them all.

H. W. J.

ACKNOWLEDGMENTS FOR
PHOTOGRAPHS

Unless otherwise specified, the numeral includes all the figures on the plate.

Alinari, Florence: 10c, 17c, 37a, 41a, 47a, 49, 50 (modified by
 Georg Kauffmann), 51a, d, 56a, 69, 99, 123a
Alinari-Anderson, Florence: 32a, 41b, 43, 68, 74-77, 83c-e
Alinari-Brogi, Florence: 1-7, 10a, b, 11, 12b, 13, 14b, 15-17b, 18,
 21a-c, 23c-31b, 31d, e, 32b, 33-35, 37b-38, 44-46, 47c-48, 51b, c,
 e-h, 52, 53, 56b-57, 59, 61, 66, 67, 70-73, 78-83b, 84-98, 100,
 102-120, 122, 124, 125, 127a, c, d; text fig. 8 (p. 218)
Clarence Kennedy, Northampton, Mass.: 8, 9
Escoute, Lille: 54b-55
Gabinetto fotografico, Soprintendenza alle gallerie, Florence:
 12a, c, 14a, 19a, c, 20, 47b, 58, 60, 62-65, 121, 123b, c, 128
Giraudon, Paris: 54a
Museum of Fine Arts, Boston: 36
Piaget, St. Louis, Mo.: 22
Sansaini, Rome: 42
Staatliche Museen, Berlin: 19b, 31c, 126a, 127b
Victoria and Albert Museum, London: 39, 40, 101, 126b
Wildenstein, New York: 21d, 23a, b

Table of Contents

CRITICAL CATALOGUE

Contents
REJECTED ATTRIBUTIONS

PLATES 1-128

List of Illustrations

TEXT FIGURES

PLATES, CRITICAL CATALOGUE

MARBLE DAVID, MUSEO NAZIONALE, FLORENCE

1a. Side view	1c. Back view	2b. Head, front view
1b. Front view	2a. Head, profile	2c. Head of Goliath

3. CRUCIFIX, S. CROCE, FLORENCE

ST. JOHN THE EVANGELIST, MUSEO DELL'OPERA DEL DUOMO, FLORENCE

4a. Front view	5a. Head, profile	5c. Right hand
4b. Side view	5b. Head, front view	5d. Head, front view, eyes retouched

ST. MARK, OR SAN MICHELE, FLORENCE

6. Side view 7. Head and torso, front view

DAVID, WIDENER COLLECTION, NATIONAL GALLERY OF ART, WASHINGTON, D.C.

8a. Front view	9a. Head, front view	9c. Right hand
8b. Back view	9b. Head, profile	9d. Right shoulder

SCULPTURE OF THE ST. GEORGE TABERNACLE, OR SAN MICHELE, FLORENCE

10a. St. George Tabernacle, c. 1890	11a. Head of statue	12a. Statue, back view
10b. Head and torso of statue, front view	11b. Gable relief of tabernacle	12b. Statue, front view
10c. Relief on base of tabernacle	11c. Relief on base of tabernacle, detail	12c. Statue, side view

STATUES FROM THE CAMPANILE, MUSEO DELL'OPERA DEL DUOMO, FLORENCE

13a. Beardless Prophet	15a. Bearded Prophet, head	17a. "Jeremiah," head, front view
13b. Bearded Prophet	15b. Beardless Prophet, head	17b. "Jeremiah," head, profile
13c. Abraham and Isaac	15c. Abraham, head	17c. Niches on west side of Campanile
14a. Niches on east side of Campanile	15d. "Zuccone," head	124e. "Zuccone," signature
14b. Abraham and Isaac, detail	16a. "Zuccone"	124f. "Jeremiah," signature
	16b. "Jeremiah"	

"MARZOCCO," MUSEO NAZIONALE, FLORENCE

18a. Front view 18b. Profile

19a, c. PROPHET AND SIBYL, PORTA DELLA MANDORLA, FLORENCE CATHEDRAL

19b. THE PAZZI MADONNA, STAATLICHE MUSEEN, BERLIN-DAHLEM

SCULPTURE OF THE ST. LOUIS TABERNACLE, OR SAN MICHELE, FLORENCE

20. The statue temporarily installed in the tabernacle	21c. St. Louis, head, profile
21a. St. Louis, head	21d. St. Louis, detail
21b. The mitre	22a. St. Louis, back view (St. Louis, Mo., 1949)

List of Illustrations

Introduction

This book owes its origin to a tragic accident. Soon after the outbreak of the second World War Dr. Jenö Lányi, en route from England to this country, died at sea as the result of enemy action. His luggage included several suitcases full of written material and photographs relating to the work of Donatello. These somehow escaped destruction and were subsequently turned over to me by Mrs. Lányi-Mann with the request that I publish them in whatever form I might deem suitable.

Donatello had been the central interest of Lányi's career. He had devoted many years to the study of the master, and much of his research, embodied in a series of learned papers that appeared during the 1930's, had been of fundamental importance. His ultimate intention was to produce a monograph on Donatello. With this aim in view, he had supervised the taking of many hundreds of new photographs, for he realized only too well the inadequacy of the existing pictorial record of the great sculptor's *œuvre*. However, his scholarly estate, which Ulrich Middeldorf and Clarence Kennedy were kind enough to examine with me, did not bear out our expectations: apparently Lányi had not yet begun to write the monograph. What we found were, for the most part, notes relating to his previous publications, bibliographical files, and excerpts from scholarly literature; there was also the text of a lecture on Donatello that he had delivered in London shortly before his death, some sketches for new papers he had been working on, and scattered observations or memoranda on individual monuments. All these, however, were far too tentative and fragmentary for publication. Even the magnificent legacy of new photographs posed a dilemma. Lányi's campaign had covered, on a most lavish scale, most of the Florentine works of Donatello—those in the Cathedral and the Museo dell'Opera del Duomo, the Baptistery, the Museo Nazionale, Or San Michele, S. Croce, and the bronze pulpits of S. Lorenzo (there were over 200 details of the bronze pulpits alone); it also included the pieces in Siena and Pisa. Yet the project remained incomplete without the sculptures of the Old Sacristy and the monuments in Padua, Venice, Rome, Naples, or in collections outside Italy. Nevertheless, since the visual documentation of the *œuvre* as planned by Lányi was more than half finished, it did not seem unrealistic to hope that a way might be found to close the most important gaps and to issue a well-balanced selection of these photographs as a pictorial corpus elaborate enough to provide a satisfactory record of every facet of Donatello's achievement. This, then, became my primary goal. I believe I have come reasonably close to it in the original two-volume edition of this book. Of the 660 photographs reproduced there, the Lányi legacy accounts for slightly more than one half, or 55 per cent; another 25 per cent were taken under my supervision; and the remainder were chosen from previously available, older stock.

This body of photographic material, whatever its shortcomings, could claim to be by far the most exhaustive record of an individual sculptor's work ever made available in published form. The full exploitation of so rich a harvest of visual data seemed to me a task clearly beyond my powers. All I could hope to accomplish, I decided, was to lay the foundation for future research by means of a thorough critical apparatus designed to establish as firmly as possible the "original text" of Donatello's *œuvre*. The simplest and most useful framework for such an apparatus I believed to be the *catalogue raisonné*, even though I anticipated that some of the entries were likely to grow to the length of "chapters." Apart from its time-tested virtues of conciseness and systematic order, this form also offered a further advantage: it would permit me to report the unpublished findings of Lányi—always, needless to say, clearly identi-

fied as such—in their appropriate context and at whatever length might be required. The sifting of the Lányi papers for this purpose presented certain difficulties, since a good many of the notes had the character of "thoughts of the moment," jotted down on a trial-and-error basis, rather than of considered opinions; these I have felt justified in excluding from my reports whenever it seemed to me that Lányi himself, upon further reflection, would probably have changed his mind.

Readers familiar with Lányi's views will have gathered from the Table of Contents that the conception of the Donatellian *œuvre* underlying this book is significantly different from his in a number of ways. Certain pieces which he emphatically rejected appear among the authentic works, while some others, of whose legitimacy he had no doubt, have been placed in the rejected category. The responsibility for these decisions is entirely mine. The reasons for them are stated at length in the entries concerned. A word of explanation may be necessary, however, in order to account for the obvious incompleteness of the catalogue of rejected attributions. The number of works that have been claimed for Donatello at one time or another is so vast that the total has never been determined—by a rough estimate there must be well over a thousand. To collect and discuss every one of these attributions, however irresponsible, seemed to me as futile as to argue against an insult. Most of them had, in fact, been quietly eliminated by the increasingly critical attitude of Donatello scholars since the 1920's. I resolved, therefore, to confine my comments to the survivors of this earlier sifting process, i.e. the "pending cases" in the court of scholarly opinion during the past two decades, of which I had encountered slightly less than a hundred. Yet in the end I had to abandon even this limited goal as impracticable. For I thought it imperative to provide the same critical apparatus, and a comparable amount of visual documentation, for the entries in the rejected category as for the authentic works; but to deal with all the "pending cases" in this way would have required an additional 200 plates and about 150 pages of text—a prohibitive increase in the size and cost of the planned publication. Nor did I feel that all the objects in question were important enough to warrant so thorough a treatment. Under these circumstances, I had to be content with the bare essentials: the pieces erroneously claimed for Donatello on the basis of documents or sources (ten of the fourteen rejected attributions discussed are of this kind) and a few others whose elimination from the authentic *œuvre* I regarded as particularly significant. That large and ill-defined class of objects commonly labeled "School of Donatello"—a term suggesting that they in some way reflect, or derive from, the master's style, even though they have no overt connection with any of his known works—has been omitted for the same reasons. A vast amount of detailed research is waiting to be done on these "Donatellesque" items (including a host of Madonnas), many of which deserve better than to remain in their present limbo. But their historic position, I am convinced, cannot be adequately stated in terms of the exact degree to which they fall under the great master's penumbra. (The Catalogue contains a number of incidental references to such works; they may be located by consulting the Index, which lists them according to place and ownership.)

Problems of attribution, of course, also arise among the entries devoted to the authentic *œuvre*, especially in the case of large-scale commissions, executed with the aid of collaborators or assistants. These monuments are apt to include elements alien to Donatello not only in execution but sometimes in design as well. I have discussed such elements in the context of the ensembles to which they belong, since to place them under separate headings, for the sake of a strict division of hands, would have been quite impracticable. The same rule has been followed in arranging the sequence of the plates, so that all the illustrations relating to a given monument are grouped together, regardless of the degree of *Eigenhändigkeit* of the component parts.

The sequence of the monuments is chronological. Here too, however, a measure of flexibility has seemed advisable. Thus all the pieces executed for the same location, such as the Prophets for the Campanile of Florence Cathedral or the various bronzes for the Siena Font, are placed together in a single entry, whether or not they were actually commissioned and carried out as a unit. The decisive factor in these cases has been the interdependence of the documents. In a few other instances, slight departures from the strictly chronological order have been suggested by technical or artistic considerations. The dates given at the head of each entry are based on documents if without parenthesis; those in parentheses are derived from indirect evidence.

The internal organization of the entries follows, in the main, a well-established pattern and is thus largely self-explanatory. Some comment may be useful, however, concerning the treatment of the factual data. The most elementary of these, i.e. the physical dimensions of the monuments, have never before been collected in systematic fashion; the measurements provided here are taken directly from the originals, unless otherwise noted, so that they do not always agree with those given in earlier publications. Their degree of accuracy varies with the size, shape, and location of the objects, although the margin of error, generally speaking, is less than one per cent. Figures preceded by *circa* (c.) imply the possibility of a larger error, up to five per cent.

With regard to the documents, I found myself in something of a quandary. Ideally, I should have reproduced them verbatim, after checking the published transcriptions against the original records for accuracy and completeness; and such had indeed been my intention at the start. However, the sheer weight of the material compelled me to abandon this plan for economic reasons, since it would have entailed not only a prolonged campaign of archival studies but also a considerable increase in the cost of the planned publication. A literal rendering of the documents into English likewise struck me as impractical. Most documents, unhappily, have the defects of their virtues: they are "unguarded" statements, hence reliable, but for this very reason their meaning often admits of more than one interpretation. Thus a direct translation would have taken up a great deal of space (many of the texts, especially the contracts, are encumbered by lengthy legal formulas and other kinds of verbal "excess baggage" of little interest for our purpose) and yet the significance of many passages would have been far from clear without elaborate critical notes on the vagaries of local usage and similar problems. I preferred to give the factual content of each document in digest form, citing the verbatim text only for the ambiguous passages. This method of "interpretive condensation" will, I hope, prove acceptable to the scholarly reader.

The sources, on the other hand, seemed to me to demand translation in full. For here, in contrast to the documents, the language itself is usually clear and explicit, while the reliability of the statements is subject to doubt. Moreover, sources belong to the realm of literature, and thus have a quality of style, an individual flavor that is well worth preserving. Since practically all the sources referring to Donatello were composed long after the artist's death, the factual information they contain is of limited value. If we credit them with any degree of authority, we do so on the assumption that they are likely to reflect authentic memories or local traditions, however distorted by the passage of time. This thread leading back to the years before 1466 had already become fairly tenuous when Vasari collected the material for his *Lives*; by the end of the sixteenth century it was about to disappear altogether. I thought it unnecessary, therefore, to go beyond the year 1600 in my compilation of sources, although in a few special cases I have cited later authors as well. But the information to be extracted from the sources is not confined to the factual plane. Of equal interest is what they tell us about the posthumous

reputation of Donatello, the growth of the "Donatello legend," and the changing interpretation of individual works. From this point of view, even the most casual literary references can be illuminating, and I have cited as many as I was able to find prior to the Seicento, omitting only those obviously dependent on Vasari's narrative.

There are, I suspect, three features that some readers will be disappointed not to find in this book: a "Life" of Donatello, a section on the lost and on the nonsculptural works, and a bibliography. Each of these might indeed have been singled out for separate treatment; but to do so would have meant, in substance, a duplication of material already contained in the Catalogue. So far as the omission of a general bibliography is concerned, I submit that an indiscriminate listing of titles, alphabetically or chronologically, has little practical value. The more exhaustive the compilation, the more will the chaff tend to outweigh the wheat. Only a selective, classified, and critically annotated bibliography strikes me as really useful, and the literature cited and summarized in the entries of the Catalogue provides a close equivalent of that. The List of Abbreviations in Volume II, p. vii, offers a brief checklist of basic titles. Those wishing to consult more elaborate lists are referred to the entry in Thieme-Becker's *Lexikon* (ix, 1913, by Max Semrau) and to the Donatello monographs of Colasanti (c. 1927), Rezio Buscaroli (1943) and Planiscig (1947).

The lost works for which Donatello's authorship is attested by contemporary records are surprisingly few. They may be divided into three categories: completed pieces whose fate remains uncertain (and which might, therefore, still be in existence, waiting to be rediscovered); completed pieces certainly or probably destroyed; and commissions abandoned before completion. The first of these is represented by only two examples, the small marble prophet for the Porta della Mandorla ordered by the Florence Cathedral workshop in 1406 and paid for in 1408, and, perhaps, the bronze "Goliath" for Siena that was ready to be cast in the fall of 1457. The second group includes the huge terracotta Joshua of 1410, which stood on one of the buttresses of Florence Cathedral until the seventeenth century, when it had to be removed because of its badly decayed condition; the limestone figure of Dovizia (Wealth) on top of a column in the Mercato Vecchio, a work of the 1420's or 1430's, which was replaced by a Baroque statue after it had been severely damaged by wind and weather; the bronze *sportello* for the Siena Font, of c. 1430, which was rejected and returned to the artist (who presumably had it melted down or sold it for the value of the material alone); and five limestone panels—four "figures" and a God the Father—that were discarded, together with the architectural framework, when the Padua High Altar was "modernized" about 1590. The two bronze heads that once were part of the Cantoria may also belong to this category. The abandoned commissions form the most problematic of our three groups, since we cannot determine at what stage they were abandoned (in some cases we do not even know whether Donatello ever made an effective start on them). They include a second marble prophet for the Porta della Mandorla, commissioned at the same time as the first but apparently never delivered or paid for; a marble David to which we have a single reference among the records of the Florence Cathedral workshop in 1412; the bronze doors for the two sacristies of Florence Cathedral, commissioned in 1437; the Arca di S. Anselmo and various other projects in Mantua, Modena, and Ferrara with which the artist was concerned in 1450-1453; and the work of his Sienese years, 1457-1461 (the bronze doors for the Cathedral and a marble statue of St. Bernard for the Loggia di S. Paolo).[1] All the "authentic lost works" enumerated above are discussed

[1] There is yet another group, which, however, can hardly be counted among the lost works, since it consists of commissions for small-scale models and trial pieces. I am listing them here for the sake of completeness: in 1415, Donatello and Brunelleschi were to make a small marble figure covered with gilt lead, "as a guide for the large figures that will be made for the buttresses of the Cathedral" (cf. Poggi, *Duomo*, pp. 77f, docs. *423, 424*);

at some length in the Catalogue. The references to them can easily be located by consulting the Index. A second, and far longer, list of lost works could be compiled on the basis of sixteenth and seventeenth century sources, but their standing is dubious, to say the least. We certainly cannot afford to accept them on faith, since the same sources also claim a number of extant pieces for Donatello which, on stylistic and sometimes even documentary evidence, are clearly the work of other artists. One is tempted to assume, in fact, that the accuracy score of the sources is particularly low for these "lost works." Is it not likely that many of them are lost only in the sense that we can no longer identify them, because of their utterly un-Donatellesque character? However that may be, we can form an opinion of them only by rediscovering them and then judging them on their individual merits. The relatively few instances where such identification has been proposed (e.g. the Shaw Madonna in the Boston Museum) are included in the Catalogue; the rest I have disregarded as irrelevant to the purpose of this book.

Concerning Donatello's activities outside the field of sculpture (and of the decorative architectural settings associated with it) there is little to be said. So far as we know, he never undertook any architectural work on a monumental scale or apart from his sculptural commissions. Nor do we have any documentary evidence that he ever did goldsmith's work or painting, although he may have been capable of both.[2] While he enjoyed considerable posthumous fame as a draughtsman, not a single drawing has come to light that can be claimed for him with any degree of conviction, so that we know nothing at all about his drawing style (see also below, p. 217). The only work which might permit some conclusions—however indirect—in this respect, and the one documented instance of Donatello's work as a pictorial designer, is the stained-glass window of the Coronation of the Virgin for Florence Cathedral. The *operai* had requested both Donatello and Ghiberti to submit designs of this subject, destined for the round window on the east side of the drum of the dome; in April 1434 they chose Donatello's and entrusted the execution to Domenico di Piero of Pisa and Angelo Lippi, who completed it in four years.[3] This window, unfortunately, has never been adequately photographed. During the Second World War it was removed for safekeeping and until recently has remained inaccessible while in process of being restored. Its omission from this book was thus imposed upon me by *force majeure*. A thorough study of the work is certainly desirable, although one wonders how much of Donatello's style it will be possible to discern in it. Donatello, after all, had nothing to do with its execution, so that Domenico di Piero and Angelo Lippi were free to transform his design however they pleased in adapting it to the technical demands of their craft. Moreover, he apparently availed himself of the help of Paolo Uccello and of Bernardo di Francesco, a stained-glass specialist, for this commission, an indication that the task was unfamiliar to him (or that he took little interest in it). In any event, the design itself may well have borne the imprint of all three masters, rather than of Donatello alone.[4]

in 1434, Donatello and Luca della Robbia were jointly commissioned to do a clay model of a head, to be reproduced in stone for installation on the Cathedral dome (Cesare Guasti, *La Cupola di Santa Maria del Fiore*, Florence, 1857, doc. 252); and in 1439 Donatello had produced a wax model for an altar for the Chapel of St. Paul in Florence Cathedral, which was to be executed by Luca della Robbia (apparently he had made this model in connection with a commission he had received from the *operai* a few weeks earlier for two marble altars; this commission, it seems, was then transferred to Luca, along with the model; cf. Poggi, *Duomo*, pp. 216f, docs. *1078-1080*). The curious incident of the model for an altar "for a certain confraternity in Venice" which a

Florentine rag dealer had ordered from Donatello in 1447, apparently on speculation, is discussed elsewhere (see below, pp. 187f).

[2] Cf. Colasanti, *D.*, pp. 10f, and Kauffmann, *D.*, pp. 19f, 201, nn. 48-51.

[3] Poggi, *Duomo*, pp. 137ff, docs. *719-740*; Donatello received 18 florins for his drawing, Ghiberti 15—rather small amounts in relation to the cost of the window itself, computed at the rate of 16 florins per square braccio.

[4] According to Semper (*D.* '75, p. 283), Donatello was credited on October 4, 1434, with 18 florins for the design of an "occhio alla cappella di S. Zenobio"; he was to share this fee with Bernardo and with Paolo Uccello. The status of this document, however, is somewhat uncertain,

My decision not to attempt a "Life" of Donatello acknowledges, I believe, the manifold difficulties that argue against such an undertaking. There is, to be sure, no dearth of biographical data about the outward, factual aspects of the master's career: from 1404-1407, when we encounter his name among the members of Ghiberti's workshop,[5] to 1461 we have documentary notices for almost every year—a more detailed and continuous record than that of any other artist of the time (the occasional lacunae, of two or three years each, can usually be filled in from other evidence). These data are the structural skeleton for the chronology of his *œuvre*, and have therefore been fully reported and analyzed in the Catalogue. Only about his youth, and the last few years of his old age, do we lack reliable information. Who was his first master? According to Pomponio Gaurico's *De sculptura*, he "is said to have been the pupil of Cione," i.e. either Ghiberti or his stepfather, the goldsmith Bartolo di Michele, called Bartoluccio[6]—a more likely claim than the unsupported assertions of subsequent authors linking him with Lorenzo di Bicci or Dello Delli.[7] His early works certainly betray an important artistic indebtedness to Ghiberti (see below, pp. 7, 11, 29ff).[8] But where and when did he acquire

since it does not occur in Poggi's *Duomo*. Did Poggi overlook it, or did Semper make a mistake? (The date of October 4, 1434, is not attached to any of the notices concerning stained-glass windows published by Poggi.) Wilhelm Boeck (*Paolo Uccello*, Berlin, 1939, p. 98), mistakenly assumes (on the basis of Vasari-Milanesi, II, p. 211n) that the window of 1434 in whose design Uccello had a share was intended for the Chapel of St. Zanobius; evidently he was not familiar with the text of the document as given in Semper, which makes it clear that the window here concerned is the *occhio* [in the drum of the dome] next to the St. Zenobius Chapel, i.e. above the arch leading into the central *tribuna*. Thus, if Semper's transcription is correct, there can be no doubt that the document of October 4, 1434, refers to the Coronation of the Virgin. The poor state of preservation of the window (on which see Paatz, *Kirchen*, III, pp. 514f, n. 290, and the literature cited there) is clearly visible in the two color plates published by Giuseppe Marchini (*Le vetrate italiane*, Milan, 1956, p. 5 and fig. 52), which show the work after its recent cleaning. Of the two main figures, little more is left than the bare outlines. Only the Virgin's gown reveals traces of vigorous modeling, although they are hardly sufficient to bear out the claim of Marchini (*op.cit.*, p. 40) that Donatello himself must have painted these forms. Marchini is certainly right, however, in observing that the design of the window as a whole, with its over-sized figures and large areas of uniform color, meets the ornamental demands of stained glass to a conspicuously lesser degree than do the other windows of the dome. Donatello's boldest departure in this respect is the frame, treated as a coffered marble vault, which disappears behind the throne of Christ and the Virgin instead of forming a flat decorative border around the entire scene. The cherubs' heads filling the coffers, which had been almost invisible before the cleaning, are the only part of the design that can be directly related to Donatello's sculpture; they resemble the cherubs' heads of the spandrels above the door frames in the Old Sacristy of S. Lorenzo (see Pl. 57).

[5] Not 1403, as stated by Kauffmann (*D.*, p. 19), and earlier authors. The document in question, excerpted by Carlo Strozzi from the (lost) records of the Calimala (State Archives, Florence, *Carte Strozziane, seconda serie*, LI, 1, fol. 79v) lists Ghiberti's *lavoranti* "during the period of the first contract," i.e. from early 1404 through May 1407; see Richard Krautheimer and Trude Krautheimer-Hess, *Lorenzo Ghiberti*, Princeton, 1956, pp. 103ff and 369, doc. 28. The text permits no conjectures as to

when Donatello entered Ghiberti's shop, how long he remained in it, or what his rate of pay was. Another Strozzi excerpt informs us that after June 1, 1407, Donatello was again—or still?—employed in Ghiberti's workshop for the North Doors, at an annual wage of 75 florins, indicating that he was no longer an apprentice (see Krautheimer, *op.cit.*, p. 369, doc. 31). His stay this time seems to have been a brief one, however, since his total remuneration is listed as 8.4.0 florins.

[6] Gaurico may have been told that Donatello was "the pupil of Ghiberti's father," in which case he probably mistook Cione di ser Buonaccorso Ghiberti, Lorenzo's true father (of whose profession we know nothing but who was later described as "a thoroughly useless person") for the worthy goldsmith Bartoluccio, the common-law husband of Lorenzo's mother before the death of Cione in 1406 and subsequently the stepfather of Lorenzo, who figures as Lorenzo's partner in the first contract for the North Doors. On the East Doors, Ghiberti gave his name as Lorenzo di Cione, while in earlier years he had called himself Lorenzo di Bartolo. The reasons for this change, and the tangle of confusion surrounding Lorenzo's paternity, are clarified in exemplary fashion by Krautheimer (*op.cit.*, pp. 3f).

[7] Cf. Colasanti, *D.*, pp. 9f, and Kauffmann, *D.*, pp. 19, 201, nn. 48, 49.

[8] Ghiberti himself could hardly have been Donatello's first teacher, since he was only five or six years older. The most plausible assumption would seem to be that Donatello entered the workshop of Bartoluccio as an apprentice in the late 1390's, when Ghiberti was on the point of reaching journeyman status. That he did indeed receive goldsmith's training is attested by the fact that he was enrolled in the painters' guild in 1412 as a "goldsmith and stonecarver" (cf. Semper, *D.* '75, p. 260), and by subsequent references to him in similar terms (cf. Kauffmann, *D.*, p. 201, n. 51). The date of Donatello's birth is not known exactly. The year 1386, generally accepted today, seems the most likely, since it is based on his *Catasto* Declarations of 1427 and 1433. According to his last *Catasto* statement, of 1457, he was born in 1382, and Vasari asserts that he was born in 1383. Yet another alternative is provided by the *Annales* of Bartolomeo Fontio, where we read that Donatello died on December 10, 1466, at the age of 76. There can be little question that he must have been born not later than 1386—after all, by 1406 he could receive independent commissions, and it is difficult to believe that he was less than twenty at the time—but a slightly earlier date might be argued

the technical knowledge of stonecarving that brought him the commission for two prophets for the Porta della Mandorla in 1406? It is tempting to assume that he gained it under one of the older masters involved in the completion of the Porta—Antonio di Banco or Niccolò di Piero—but since the one Prophet which he is known to have completed is lost (see below, pp. 219f) we have no way of verifying such a hypothesis. He might just as well have learned his craft with any one of several other sculptors who were working for the *Opera del Duomo* from the 1390's on.[9]

The problem of Donatello's artistic origins, needless to say, is not without parallels at that time. The early years of Ghiberti and Brunelleschi are equally obscure, and their later development at a number of points offers greater difficulties than does his. Yet these two men project themselves onto the historian's imagination as well-defined, psychologically plausible personalities (the earliest, it seems to me, in the entire history of art): we know something of their character structure, their individual ways of thinking and feeling, so that they exist in our minds as people, rather than as mere abstract names attached to certain important artistic achievements. The same, unhappily, is not true of Donatello, much as we may insist that it ought to be. In his case, we have nothing even remotely equivalent to the *Commentaries* of Ghiberti, the poems of Brunelleschi, or the "Manetti" biography of the latter; not a single line of correspondence, however trivial, has come down to us (his only known "writings" are his *Catasto* Declarations), and only one personal utterance as recorded by a contemporary.[10] Nor do we find any self-portraits, assured or putative, among his work.[11] Comments on his character by those who had direct contact with him are as few as they are contradictory—he could be described at one time as a man of simple tastes whose demands are easily satisfied, at another as difficult and stubborn.[12] (The latter estimate, I am afraid, is by far the more trustworthy of the two.) We know that he moved in humanistic circles, yet the sources of his own time reflect nothing of the quality of his human relationships, except for his friendship with Brunelleschi, and even this only in tendentiously distorted form.[13] Some ribald anecdotes recorded a dozen years after his death are the most revealing testimony we have in this respect.[14] Little wonder, then, that his personal *Leben und Meinungen* remain almost wholly unknown to us. There is always Vasari, of course; but did he not perhaps face the same problem we do, and with fewer scruples? His account of Donatello the man may well contain elements of truth, although his reliability here is apt to be a good deal less than when he speaks of the master's work. If he found himself short of "human-interest material" commensurate with Donatello's importance as an artist, is he not likely to have embroidered rather freely upon what little he had, just as he did with the story of the two Crucifixes?[15] How are we to penetrate to the truth beneath this screen of pious fiction? How to differentiate between

from his status in Ghiberti's workshop after mid-1407, which suggests that he must have been an artist of some experience then. For the date of his death, the precise testimony of Fontio may be accepted as reliable. It is confirmed by Vasari, who gives it as December 13, 1466 (perhaps the day of the funeral), and informs us that Donatello's tomb is in S. Lorenzo, "near that of Cosimo." Its precise location, however, is unknown (cf. Semper, *D.* '75, p. 320 and Kauffmann, *D.*, p. 192).

[9] Kauffmann, *D.*, pp. 20, 201, n. 53, rightly protests against the overemphasis, among some older scholars, on Donatello's connection with Niccolò di Piero.

[10] See below, p. 189.

[11] The only traditional record of his features occurs in the *Portrait of Five Florentines*, supposedly by Paolo Uccello, in the Louvre. According to the acute analysis

of Lányi (*Burlington Magazine*, LXXXIV, 1944, pp. 87ff) this picture is a partial copy after certain portrait heads in the lost Sagra frescoes of Masaccio. While this hypothesis seems plausible enough for the first, fourth, and fifth heads (i.e. "Giotto," or rather Masaccio, if Lányi is right; "Antonio Manetti"; and "Filippo Brunelleschi"), the second and third ("Uccello" and "Donatello") may be extraneous additions, since their conception is clearly different from the rest. Under these circumstances, and considering the poor state of preservation of the panel, one wonders how authentic a portrait this "Donatello" can claim to be.

[12] See below, pp. 110, 205.

[13] See below, pp. 10f, 19, 138ff.

[14] See below, pp. 85f.

[15] See below, pp. 8ff.

the typical and the individual traits? The task is not a hopeless one, I believe, but it cannot be accomplished for the Donatello *Vita* in isolation; we should have to know very much more than we do at present about the whole web of legendary material that began to cluster around the personalities of famous artists since the time of Giotto, and of which Vasari's *Lives* are the great depository. Only then would we have a basis for distinguishing genuine biographical details from aesthetic-didactic *exempla* masquerading as such, in any given instance. This general critique of Trecento and Quattrocento sources is obviously beyond the scope of any monograph, even though I have tried wherever possible to illuminate the background of Vasari's narrative.

Donatello thus presents a curious paradox: how does it happen, we wonder, that we know so little about the personality of the man whose impact on the art of the Early Renaissance was second only to that of Brunelleschi? The fact itself, while hardly due to chance, admits a variety of interpretations, according to one's view of the relationship between the expressive content of the work of art and the character structure of the man who created it. The salient qualities of Donatello's sculpture—its revolutionary boldness, its tremendous range of style, its dramatic force and psychological depth—will surely be evident to anyone thumbing the plates of this book. The dictum of Vincenzo Borghini, approvingly cited by Vasari, that our master was a "pre-incarnation" of Michelangelo, seems to me true in a much more direct sense than its author intended. But these qualities, let us not forget, belong to the work; they do not permit us to endow Donatello the man with a "Michelangelesque" personality (or any other, for that matter) except on an intuitive basis. And intuition, here as elsewhere, has its pitfalls if followed without caution. Even the documents become curiously ambiguous if we try to use them for purposes of character interpretation. They inform us, for instance, that Donatello's relations with his patrons were often strained, that he failed to keep his promises or to live up to the terms of contracts.[16] We might take this as evidence of the peculiar intractability of a genius of the "Michelangelo-type," or we might attribute the friction to quite impersonal causes, i.e. the inevitable conflict between the new individualism of Early Renaissance art and a patronage system still largely mediaeval. There is much to be said in favor of either view, I believe, although it may prove difficult to decide which of them is the more applicable in any given case. For the time being, then, it seems wisest to distrust all broad generalizations about what manner of man Donatello was. Only one thing is certain—that his personality was far too complex to fit any convenient formula. The traditional image of him, first adumbrated by Vasari and still accepted by Colasanti, as the simple "devotee of nature" who lived only for his art, untouched by the political, social, and intellectual struggles of the age, is now well on the way to oblivion. Kauffmann, whose ambitious monograph of twenty years ago gave it the *coup de grâce*, tried to substitute another image, that of a Donatello filled with secret yearning for the monumental art of the Middle Ages who preferred to create great symbolic cycles rather than individual works. This conception takes account, for the first time, of the wealth of symbolic meaning to be found in the master's work; as a milestone of Donatello research, Kauffmann's book ranks second only to the pioneer study by Hans Semper, published sixty years before. But Kauffmann was able to sustain his view only by a highly selective treatment of the evidence. He has disregarded all sorts of inconvenient facts, and placed a strained interpretation on others. Moreover, he has acted like a builder who rebuilds a collapsed edifice according to a new design but neglects to sift the original materials before using them again, so that some of the weaknesses of the older structure are apt to show up once more: his argument is fatally endangered at a number of key points by a reliance on

[16] See especially below, pp. 15, 110f, 183f, 205.

dubious or outmoded attributions. Nor did it strike him as anomalous that the work of a man as fundamentally out of sympathy with his own era as *Donatello Kauffmannensis* should have evoked such a tremendous response among his contemporaries. Lányi, in contrast, though equally well aware of the need for a new approach to Donatello, believed that the primary task was to redefine the master's *œuvre* on the basis of the most rigorous critical standards; he insisted, as it were, on a minute examination of every single brick to determine its fitness for the new and more enduring structure he expected to build. The present book is dedicated to the same proposition. The material it contains will, I hope, ultimately yield another integrated Donatello image—an image less rigid and more subtly shaded than those of the past.

ABBREVIATIONS
of literature frequently cited

Albertini	Francesco Albertini, *Memoriale di molte statue . . . di Florentia . . .*, Florence, 1510, cited from the reprint, Letchworth, 1909
Balcarres, *D.*	Lord Balcarres (David Alexander Edward Lindsay, Earl of Crawford), *Donatello*, London, 1903
Bertaux, *D.*	Emile Bertaux, *Donatello* (*Les maîtres d'art*), Paris, 1910
Billi	*Il libro di Antonio Billi*, ed. Carl Frey, Berlin, 1892
Bocchi	Francesco Bocchi, *Le bellezze della città di Fiorenza*, Florence, 1591
Borghini, *Riposo*	Raffaello Borghini, *Il Riposo*, Florence, 1584
Cinelli	Francesco Bocchi, *Le bellezze di Firenze . . .*, *ampliate da Giovanni Cinelli*, Florence, 1677
Cod. Magl.	*Il codice magliabechiano . . .*, ed. Carl Frey, Berlin, 1893
Colasanti	Arduino Colasanti, *Donatello*, Rome, n.d. [1927]
Cruttwell, *D.*	Maud Cruttwell, *Donatello*, London, 1911
Gelli	Giovanni Battista Gelli, *Vite d'artisti*, ed. Girolamo Mancini, in: *Archivio storico italiano*, 5. serie, xvii, 1896, pp. 32ff
Kauffmann, *D.*	Hans Kauffmann, *Donatello*, Berlin, 1935
Lányi, *Pragm.*	Jenö Lányi, "Zur Pragmatik der Florentiner Quattrocentoplastik (Donatello)," in: *Kritische Berichte zur kunstgeschichtlichen Litteratur*, 1932-1933, Leipzig, 1936, pp. 126ff (the article is dated Florence, May 1935)
Lányi, *Probl.*	Jenö Lányi, "Problemi della critica Donatelliana," in: *La critica. d'arte*, fasc. xix, January-March, 1939, pp. 9ff
Lányi, *Ril.*	Jenö Lányi, "Tre rilievi inediti di Donatello," in: *L'Arte*, xxxviii, 1935, pp. 284ff
Lányi, *Statue*	Jenö Lányi, "Le statue quattrocentesche dei Profeti nel Campanile e nell'antica facciata di Santa Maria del Fiore," in: *Rivista d'arte*, xvii, 1935, pp. 121ff
Middeldorf, *AB*	Ulrich Middeldorf, review of Kauffmann, *D.*, in: *Art Bulletin*, xviii, 1936, pp. 570ff
Milanesi, *Cat.*	Gaetano Milanesi, *Catalogo delle opere di Donatello*, Florence, 1887
Paatz, *Kirchen*	Walter and Elisabeth Paatz, *Die Kirchen von Florenz*, Frankfurt, 1940-1954
Pastor, *D.*	Willy Pastor, *Donatello*, Giessen, 1892
Planiscig, *D.*	Leo Planiscig, *Donatello*, Florence, 1947
Poggi, *Duomo*	Giovanni Poggi, *Il Duomo di Firenze* (*Italienische Forschungen, Kunsthistorisches Institut Florenz*, ii), Berlin, 1909
Reymond, *Sc.Fl.*	Marcel Reymond, *La sculpture Florentine*, Florence, 1897f
Schmarsow, *D.*	August Schmarsow, *Donatello*, Breslau, 1886
Schottmüller, *D.*	Frida Schottmüller, *Donatello*, Munich, 1904
Schubring, *HB*	Paul Schubring, *Die Italienische Plastik des Quattrocento* (*Handbuch der Kunstwissenschaft*), Wildpark-Potsdam, 1924
Schubring, *KdK*	Paul Schubring, *Donatello* (*Klassiker der Kunst*), Stuttgart-Leipzig, 1907
Semper, *D.* '75	Hans Semper, *Donatello, seine Zeit und Schule* (*Quellenschriften . . .*, ed. R. Eitelberger v. Edelberg, ix), Vienna, 1875
Semper, *D.* '87	Hans Semper, *Donatellos Leben und Werke*, Innsbruck, 1887
Semrau, *D.*	Max Semrau, *Donatellos Kanzeln in S. Lorenzo* (*Italienische Forschungen . . .*, ed. August Schmarsow, ii), Breslau, 1891
Tschudi, *D.*	Hugo von Tschudi, "Donatello e la critica moderna," in: *Rivista storica italiana*, iv, fasc. 2, 1887 (separately printed)

Vasari-Ricci* Giorgio Vasari, *Le Vite* . . . , 1st ed., Florence, 1550, cited from the reprint, ed. Corrado Ricci, Milan-Rome, n.d.

Vasari-Milanesi* Giorgio Vasari, *Le Vite* . . . , 2nd ed., Florence, 1568, cited from the critical edition of Gaetano Milanesi, Florence, 1878ff

Venturi, *Storia* Adolfo Venturi, *Storia dell'arte italiana*, VI: *La scultura del quattrocento*, Milan, 1908

* Unless otherwise noted, all passages cited are from the *Vita* of Donatello.

CRITICAL CATALOGUE

DOCUMENTS

A series of entries in the records of deliberations and disbursements by the officials (*operai*) of the Florence Cathedral workshop, in the archives of the Opera del Duomo. These were, in part, known to Milanesi (*Vasari*, II, p. 427), Semper (*D.* '75, pp. 104, 273ff), and other scholars of the later nineteenth century (see Paatz, *Kirchen*, III, p. 580, n. 532). They are printed most completely and systematically in Poggi (*Duomo*, pp. 75ff) under the following numbers:

1408, February 20 (*406*): Donatello is to do a figure of the prophet David, in the manner, under the conditions, and at the rate of pay (*salario*) previously stipulated in a contract with Nanni di Banco, who had undertaken to do the figure of another prophet; these are to be placed on the buttresses of the *tribuna* that is now finished [i.e. the north transept].

1408, June 21 (*407*): Donatello is advanced 10 florins for a marble figure he is carving.

1408, September 11 (*408*): Donatello is to receive 15 florins.

1408, December 15 (*409*): Donatello is to receive 24 florins.

1409, March 27 (*410*): Donatello is to receive 15 florins.

1409, June 13 (*411*): The price of Donatello's prophet is to be 100 florins, and the artist is to receive the 36 florins still due him of this total.

1409, June 14 (*412*): Christoforo Bernardi and his companions are to be paid 20 soldi apiece for appraising the prophet of Donatello.

1416, July 6 (*425*): The *operai* have received an urgent request, dated July 2, from the Signoria for the transfer of "a certain marble David" from the Cathedral workshop to the Palazzo Vecchio, at the expense of the *operai* and without the slightest delay; they agree to send the statue to the Palace.

1416, August 27 (*426*): Donatello receives 5 florins for several days' work, together with his assistants, in "adapting" and "finishing" the David.

1416, September 18 (*427*): A list of miscellaneous expenses connected with the transfer of the David. On August 4, two porters have been paid for carrying two marble consoles to the Palazzo; on August 17 a carter has been paid for the transfer of the statue; on the same day a Master Nanni di Fruosino, called Testa, has been paid for his labor, for gold leaf and for other materials used in "adorning" the inlaid pedestal and consoles as well as the statue itself; and on August 20 the painter Giovanni di Guccio has been paid for painting lilies on a blue ground on the wall behind the statue.

SOURCES

1510 Albertini, p. 17: "In the Palazzo Vecchio . . . in the room with the rich paneling . . . [is] the marble David of Donatello."

1550 Vasari-Ricci, p. 51: "In the hall containing the clock of Lorenzo della Volpaia, there is still, on the left, a marble David [Milanesi, p. 406, has ". . . a most beautiful marble David"]; he holds between his legs, under his feet, the dead head of Goliath, and he has in his hand the sling with which he has hit it." (The same description, slightly abbreviated, in Borghini, *Riposo*, p. 319.)

1591 Bocchi, p. 41: "And in the hall of the clock . . . there is another David [besides the one by Verrocchio], of marble and by Donatello. It is universally admired and held in the highest esteem."

3

1592 Laurentius Schrader, *Monumentorum Italiae . . . libri quattuor*, Helmstedt, 1592, fol. 78v (*s.v.* "Palazzo Vecchio"): ". . . and the marble statue of David with the sling in his hand, which is inscribed, PRO PATRIA FORTITER DIMICANTIBUS ETIAM ADVERSUS TERRIBILISSIMOS HOSTES DII PRAESTANT AUXILIUM." (To those who bravely fight for the fatherland the gods will lend aid even against the most terrible foes.)

The terms alluded to in the document of February 20, 1408, are spelled out in a slightly earlier document (January 24, 1408; Poggi, doc. *405*) that records the commissioning of Nanni di Banco's prophet. It was to be an Isaiah, of marble, 3¼ braccia high, and its price was to be set at the discretion of the *operai*. The statue was finished before the end of the same year; Poggi (*409*) records a lump-sum payment of 85 florins for it. Donatello received 15 florins more, apparently because his statue included the severed head of Goliath. Nanni's Isaiah was regarded as lost until Lányi made a strong case for identifying it with the so-called "Daniel" inside the Cathedral (*Rivista d'arte*, XVIII, 1936, pp. 137-178). This statue had been claimed for Donatello by several earlier scholars (Semper, *D.*, '75, pp. 129ff; Reymond, *Sc. Fl.*, II, p. 90; Cruttwell, *D.*, p. 24), since a marble Daniel by Donatello on the Cathedral façade is mentioned in Billi, p. 38, the Cod. Magl., p. 75, and Vasari-Milanesi, p. 400. (Paatz, *op.cit.*, p. 500, n. 258, gives a detailed survey of scholarly opinion on the "Daniel.") Both the "Daniel"-Isaiah and the marble David very closely approximate the stipulated height of 3¼ braccia (189.8 cm), as pointed out by Lányi, *op.cit.*, p. 143.

On July 3, 1409, the *operai* decided to take down the statue of a prophet that had been placed "near the dome" (Poggi, doc. *413*). In other words, one of the two statues had actually been installed on the buttress for which it was made. Kauffmann (*D.*, p. 208, n. 109) was the first to argue that this must have been the Isaiah, since Donatello's David had been finished only three weeks before. Lányi (*op.cit.*, pp. 150ff) arrived at the same conclusion. He also drew attention to the fact that the base of the "Daniel"-Isaiah shows indentations for the metal clamps which presumably held the figure in place on the buttress, while there are no such marks on the base of the David. The marble prophet was removed, in all likelihood, because it was too small to be effective when viewed from street level (Lányi, *op.cit.*, p. 140), and not because of its material (as suggested by Poggi, *op.cit.*, p. lxxv, and Paatz, *op.cit.*, p. 582, n. 534). In 1410, its place was taken by a very much larger statue, a Joshua of terracotta by Donatello.

The marble David, then, never left the Cathedral workshop until its sudden transfer to the Palazzo Vecchio in August 1416. There it remained until sometime in the eighteenth century, when it entered the Uffizi (Colasanti, *D.*, p. 14). It has been in the Museo Nazionale since the 1870's.[1]

Do the 5 florins Donatello received for "adapting" and "finishing" the David—one third of what he had been paid as a "bonus" for the head of Goliath—indicate that the changes he made were important enough to affect the appearance of the statue as a whole? The amount is certainly too large to be classed as negligible. Colasanti (*D.*, p. 39), Schottmüller (*Zeitschrift für Kunstgeschichte*, I, 1932/33, p. 336), and Planiscig (*D.*, p. 19), suggest that in some respects, not precisely defined, the figure represents Donatello's style as of 1416, rather than of 1408-1409. On the other hand, Kauffmann (*D.*, p. 197, n. 21) is convinced that the 5 florins represent no more than the cost of reinstallation and of a new pedestal. But these labors could not very well be described as "adapting" and "finishing" the statue; moreover, the accounting of September 18, 1416, indicates that they were, for the most part, entrusted to lesser artisans.

It remained for Lányi (*op.cit.*, pp. 146f) to point out a specific instance of "adaptation." He observed that the piece of material extending downward from the fourth and fifth fingers of David's left hand must originally have been a scroll, the standard attribute of prophets, which Donatello subsequently tried to convert into an ordinary piece of drapery. Lányi is certainly right in assuming that the purpose of this change was to accentuate the heroic, patriotic aspect of David at the expense of the prophetic—a shift of emphasis most appropriate to the new setting of the statue; yet, for a number of reasons, his explanation does not entirely fit the case. First of all, the camouflaging of the scroll seems too small an amount of work for 5 florins, even if we grant that it entailed some recarving of the drapery area between the hands, as suggested by Lányi, *loc.cit.* Secondly, one cannot help wondering why Donatello did not cut away the scroll altogether; technically as well as artistically, this could have been done without any difficulty and would have been far more satisfactory. Finally, shouldn't we expect to see the scroll in the right hand of the figure, rather than the left? After all, as Lányi has pointed out, the David is, compositionally, the mirror image of the "Daniel"-

[1] According to Filippo Rossi, *Il Museo del Bargello*, Florence, 1952, p. xvii, the transfer of all the mediaeval and Renaissance sculpture from the Uffizi took place in 1874; Pastor, *D.*, p. 24, and Colasanti, *loc.cit.*, give the date as 1879; Kauffmann, *D.*, p. 197, n. 21, as 1873; and Planiscig, *D.*, p. 135, as 1876!

Isaiah, and the latter carries the scroll in the left hand. Also, David's right hand seems far better adapted to holding a scroll than the left, which is fully occupied with the drapery of the cloak; the way the end of the scroll is tucked under the tips of two bent fingers seems far too casual for so important an attribute. One is almost forced to reverse Lányi's conclusion: what we see is not a scroll turned into drapery but a piece of drapery reshaped, however awkwardly, into something resembling a scroll. That this is indeed the correct view is proved by the fact that the smooth area between the right hand and the right knee of the figure shows two faint parallel lines running downward in a smooth curve—clearly the "ghost" of a scroll that has been cut away (see Pl. 1b). Did Donatello, then, shift the scroll from David's right hand to the left? He might have done so had there been some compelling reason for preserving the scroll as an attribute, but the very opposite seems to have been the case. If, moreover, the Lányi "scroll" was meant to be a scroll, why does it look so much like the surrounding drapery? (Kauffmann, *D.*, p. 197, n. 26, observes that "the scroll in the left hand can hardly be noticed" and criticizes the lack of coherence in the drapery of the surrounding area.)

There is only one plausible answer to all these questions: the notion of a left-hand scroll must be discarded altogether. The peculiar shape of the piece of drapery under discussion, with its incidental resemblance to a scroll, has to be explained in other ways, although there can be little doubt that it resulted from the "adaptation" of 1416. The original design of the statue could hardly have included so ambiguous a feature. But how, and why, did the "scroll" come about? Let us recall here that both Vasari and Schrader describe the David as having a sling in his hand. The loop of the sling, charged with a stone, can still be seen resting on Goliath's head; its ends are perforated to permit the attachment of a band or strap—presumably of bronze, or perhaps a silken cord—that was held by David's right hand. There is a small drillhole, between the second and third finger, for anchoring the strap.[2] Now it seems most improbable that Donatello, in 1408-1409, should have placed both the scroll and the sling in David's right hand. Since the sling at that time was of secondary importance, and also for reasons of design, I think it far more likely that the strap of the sling originally ran straight upward and disappeared among the bunched drapery held in place by the left hand. This strap would have

been of marble, and attached to a piece of drapery hanging down from the left hip and hiding the left leg to a much greater extent than is the case today. When, in 1416, Donatello had to remove the scroll, he decided to let the right hand hold the sling (which now had gained a new significance) instead; and this made it necessary for him to cut away the original strap and most of the drapery behind it, thus uncovering the left leg and, incidentally, producing the scroll-like remnant that was to attract Lányi's and Kauffmann's attention. Our assumption that the statue in its original state included a considerable amount of drapery descending from the left hip towards the head of Goliath, gains further plausibility if we study the side view of the figure (see Pl. 1a). This shows the continuity of the outline broken by a sudden gap exactly in the area where we might expect it—between the loop of the sling and the left hand. In a statue designed to stand on top of a buttress, where it could presumably be seen not only from in front but laterally as well, such an outline would appear strange indeed. But since in the Palazzo Vecchio our David was placed flat against a wall (it even seems to have been anchored to the wall, by means of the dowel hole in its back, visible in Pl. 1c), Donatello could afford to concentrate his attention on the front view, disregarding the somewhat awkward effect we have noted in the side view.

This hypothetical sequence of events may seem unnecessarily complicated at first glance, but it is the only one, so far as I can see, that fits the visual evidence. If accepted, it permits us to draw one conclusion of some importance for the early development of Donatello's style, i.e. that the exposing of the left leg, which greatly strengthens the stance of the figure, dates from 1416, the time of the St. George (see below, pp. 26f). The latter statue—assuming that Donatello conceived it before August 1416—might even have influenced his decision to uncover the left leg of the David. However that may be, our reconstruction of the 5 florins' worth of work Donatello did on the figure in 1416 does not detract from his stature. Only a man of genius could have turned such an "adaptation," imposed upon him by circumstances beyond his control, into an artistic advance.

The fact that our figure was "adapted," and especially the removal of the scroll, sets at rest any possible doubt that the prophet David carved in 1408-1409 is identical with the statue transferred to the Palazzo Vecchio in 1416.[3]

[2] The seventeenth century pen sketch after the statue adduced by Kauffmann (*D.*, p. 197, n. 21 and pl. 3) in corroboration of this feature, shows nothing of the sort; the loop on top of Goliath's head has been omitted entirely, and the right hand holds a piece of drapery.

[3] Milanesi (*Cat.*, pp. 6, 8) had connected the commission of

1408 with the Zuccone; Cornel von Fabriczy (*L'Arte*, vi, 1903, pp. 373ff) had connected it with the giant Joshua. The latter view was shared by Schottmüller (*D.*, p. 58) and Cruttwell (*D.*, p. 37) while Reymond (*loc.cit.*) had suggested the "Daniel" in this connection. Strangely enough, as Lányi points out (*op.cit.*, p. 148, n. 1), the records of the Cathedral work-

The symbolic meaning of the marble David in its new setting is made clear by the inscription (first noted by Heinrich Brockhaus, *Michelangelo und die Medicikapelle*, Leipzig, 1909, p. 18). Could it be that these militant words date back to the summer of 1416? If so, they would help us to understand why the scroll in David's right hand had to be replaced by the sling immediately after the transfer of the statue, and also perhaps why the Signoria insisted that the *operai* carry out its request with the greatest possible dispatch. Could the Signoria have wanted the figure, and the inscription, in place for the purpose of impressing some eminent visitor whose arrival was expected soon? So far as I can judge, the annals of the city do not, at this particular time, record any single occasion of this sort weighty enough to suggest such elaborate advance planning. Still, we need not dismiss our hypothesis altogether if we recall the turbulent political events of those years (Florence was championing the cause of John XXIII, who had been deposed and imprisoned at the Council of Constance in 1415, while Martin V was not elected until 1417). On the other hand, the phrasing of the inscription, with its appeal to "gods," has a classical, pagan ring that suggests a later time, when Donatello's Judith (see below, pp. 198f) and Michelangelo's David were "secularized" in much the same manner.

The iconographic type of the victorious David as an isolated figure appears to have been coined in Florence during the early Trecento, to judge from the one example that antedates our statue. This is the fresco by Taddeo Gaddi, of c. 1330-1335, in the Baroncelli Chapel of S. Croce. It was surely known to Donatello and may well have been the direct iconographic source of the marble David, as suggested by Bertaux, *D.*, p. 20, and Lányi, *loc.cit.*[4] In detail, Taddeo Gaddi's David offers few analogies with Donatello's; he is standing on the prostrate body of his enemy, with a sword in his right hand and holding the head of Goliath by the hair with his left. Only the sling is similar in shape to that of our statue; moreover, it is suspended from David's belt, a feature that tends to fortify our con-

jecture about the original placement of the sling in the marble David. But in view of their different contexts, we could hardly expect to find a close resemblance between the two monuments (in the Baroncelli Chapel, David appears as an ancestor of the Virgin Mary). The iconographic novelty of our statue consists in showing David the Prophet as the youthful victor over Goliath rather than in the customary form of a bearded king with harp or psaltery, and there is reason to believe that this daring idea was conceived by Donatello, rather than by the *operai*. The latter, to judge from the terms of the commission, thought of the David statue as strictly analogous to Nanni di Banco's Isaiah, and expected to pay the same amount for both figures. Since they later found it necessary to have the David specially appraised in order to arrive at a fair (and higher) price for it, we may conclude that the role in which the artist had cast his prophet was something of a surprise to them. The reason for Donatello's departure from tradition is not altogether clear; perhaps he simply wanted to match the youthfulness of Nanni's Isaiah. In any event, he treated the head of Goliath as little more than an identifying attribute.[5] Only in 1416, when the prophet had to be turned into a military hero, did the triumphant aspect of the figure come to the fore. The process of "adaptation," as we have tried to show above, involved an attempt to create a more direct relationship between David and the emblem of his victory by transferring the sling to his right hand. It might be said that this effort was not wholly successful—the shepherd here still seems curiously unaware of the trophy at his feet.

David's head is wreathed in amaranth, a purplish flower symbolic of the enduring fame of the brave. (I owe this identification to the botanical prowess of Dr. Maurice L. Shapiro.) Its name, in Greek, means "non-fading," and it thus came to represent the undying memory of Heroes, especially of Achilles, in classical antiquity. This was the connotation of the amaranth in the emblematic literature of the Renaissance (cf. Andrea Alciati, *Emblemata*, cxxxvi: "Strenuorum

shop also refer to a marble David of Donatello on August 12, 1412 (Poggi *199*), when the master received 50 florins [in part payment] "for a St. John Evangelist and a [marble] David." To all appearances, the latter statue was not the David made and fully paid for in 1408-1409. On the other hand it might, in theory at least, have been the one ceded to the Signoria, but only if we are willing to assume, against all probability, that this second marble David, too, was a scroll-bearing prophet like the first. Since the David of 1412 is not mentioned further in the records, one might conclude that the figure was abandoned in an unfinished state. Could it be identical with the David Martelli? (See below, pp. 21ff.)

[4] Kauffmann (*D.*, p. 197, n. 24) cites as an additional precedent a drawing, from a cycle illustrating a world chronicle, "after [the Eremitani frescoes of] Giusto da Padova" in the Galleria Nazionale delle stampe, Rome, published by Adolfo

Venturi in *Le Gallerie Nazionali Italiane*, IV, 1899, pp. 345ff. This specimen, however, is irrelevant on two counts: not only does it show David as a mature man, crowned and in full classical armor, but the drawing has nothing to do with any Trecento source and is clearly a work of the mid-fifteenth century, as pointed out at some length by Julius Schlosser, *Jahrbuch d. Kunstsammlgn. d. Ah. Kaiserh.*, XXIII, 1903, p. 331. Cf. also the catalogue of the Mostra di quattro maestri del primo rinascimento, Florence, 1954, pp. 72f.

[5] According to Kauffmann, *D.*, p. 5, the conspicuous knot of the mantle, which recurs in Donatello's St. George, denotes heroic strength, since we find it in Giotto's Fortitudo and similar figures. Such knotted mantles, however, also appear quite regularly among the soldiers on Ghiberti's North Doors, so that their symbolic meaning seems more than doubtful.

immortale nomen"—Thetis covering the grave of Achilles with the ever-fresh amaranthus). The "amaranthine crown" also entered the New Testament; in I Peter 5:4, it is held out to the faithful as their ultimate reward. But since the Vulgate renders this Greek term as "immarcessibile . . . corona," the Middle Ages could not have linked it with the flower Amarantho described by Pliny (xxi. 8) as "verius quam flos aliquis . . . mirumque in eo, gaudere decerpi et laetius renasci." It is thus doubly fitting that Donatello's David, standing on the very threshold of the Renaissance, should be adorned with the "renascent" flower. Here we have proof that our artist was in touch with the representatives of the New Learning even at this early stage of his career. For who but a humanist could have suggested so *recherché* a detail, unprecedented in traditional iconography and therefore understandable only to the small circle of the initiated? Was it perhaps Niccolò Niccoli, whose friendship with the artists of his day, including Donatello, is well attested? (See Vespasiano da Bisticci, *Vite di uomini illustri, s.v.* "Niccoli," vii; ed. Angelo Mai, Florence, 1859, pp. 478f.) Or Poggio Braccciolini, who in 1430 sought the expert judgment of Donatello on a piece of ancient sculpture (see below, p. 101).? However that may be, the amaranthine crown helps to explain how it was possible

for the marble David to assume the role of a civic-patriotic monument with such ease. The same humanistic circle that thought up the "renascent" flower might well have inspired the transfer of the statue to the Palazzo Vecchio. That all this happened as early as 1408-1416 makes the marble David one of the true *primordia* of Renaissance iconography. Its symptomatic importance can be appraised only in the context of the general pattern of "cross-breeding" between theology and philosophy, between literature and the fine arts, that molded the intellectual and artistic climate of the new age.[6]

If, iconographically, the statue hovers between the past and the future, the same may be said of its formal and expressive qualities, delicately poised on the borderline of International Gothic and true Early Renaissance. This strange ambivalence is especially pronounced in the head, which made Bertaux (*loc.cit.*) think of the features of one of the artist's studio companions while Venturi (*Storia,* vi, p. 240) saw it as the echo of an ancient Bacchus (he mistook the wreath for ivy). The face does indeed contain hints of both individuality and the conscious pursuit of ideal beauty *all'antica*; in the main, however, its classicality is still of a traditional kind, derived from Ghiberti and rooted in the Tuscan Trecento.

[6] For the recurrence of the amaranthine crown in Nanni di Banco's relief on the Porta della Mandorla, see below, p. 221. A still earlier instance of the influence of humanism on Florentine art has been pointed out by Richard Krautheimer and Trude Krautheimer-Hess (*Lorenzo Ghiberti*, Princeton, 1956, p. 280), who connect the Hercules reliefs on the jambs of the Porta della Mandorla, carved shortly before 1400, with Coluccio Salutati's treatise, *De laboribus Herculis.* See also the section, "Artists and Humanists," *ibid.,* pp. 294ff.

CRUCIFIX, S. CROCE, FLORENCE

PLATE 3 Wood, polychrome; H. c. 168 cm; W. c. 173 cm *(c. 1412)*

D O C U M E N T S : none

S O U R C E S

1510 Albertini, p. 16: "[In the Church of S. Croce] the wooden crucifix of Donatello . . ."

(Before 1530) Billi, *s.v.* "Brunelleschi," p. 32 (Cod. Strozz): "In S. Maria Novella one sees an incomparable crucifix in relief, [which he] made in competition with Donatello, who had made another one that is now in S. Croce." (The same passage, slightly shortened, in Cod. Petrei.)
 s.v. "Donatello," pp. 40f: "A crucifix in the middle of the Church of S. Croce."

1537-1542 Cod. Magl., *s.v.* "Brunelleschi," pp. 65f: "And by his hand, still to be seen today, the incomparable crucifix in relief in S. Maria Novella, which he made in competition with Donatello, who had made another one that is now in the Church of S. Croce. Some parts of it were reproved by Filippo, to which Donatello replied that something besides words was necessary [here], that he had hoped to see him do [better] and [only] then to criticize."
 s.v. "Donatello," p. 70: "And also in said church [S. Croce], about the middle, near the side entrance to the cemetery, there is a crucifix, life-size and in relief, by his hand."

(c. 1550) Gelli, *s.v.* "Brunelleschi," p. 51: "[Brunelleschi] made a life-size crucifix which is now in S.

Maria Novella between the chapels of the Strozzi and the Bardi, and he did it because he had criticized the crucifix of Donatello in S. Croce, which he thought a bit too muscular and too highly finished so that it resembled the body of a peasant. Whereupon Donatello had told him to do [better] and then to criticize."

s.v. "Donatello," p. 60: "[Donatello] also made the crucifix that is in the middle of [S. Croce], as we have related above."

1550 Vasari-Ricci, *Vita* of Taddeo Gaddi, ɪ, p. 178 (Milanesi, ɪ, pp. 573f): "And below the screen that divides the church, to the left above the crucifix of Donatello, he painted in fresco a miracle of St. Francis. . . ."

Vita of Brunelleschi, ɪɪ, pp. 8f (Milanesi, pp. 333f, slightly rephrased but otherwise unchanged): "In those days Donatello had finished a wooden crucifix, which was placed in S. Croce below the scene of St. Francis reviving the child, painted by Taddeo Gaddi; when Donatello asked Filippo [Brunelleschi's] opinion of this work, the latter said that he had put a peasant on the cross. This is the source of the saying, "Take some wood and make one yourself," as recounted at length in the Life of Donatello. Filippo, whose ire could never be provoked by anything people said to him, remained quiet for many months until he had carved a wooden crucifix of the same size. It was of such quality, so well designed and made with such skill and care, that Donatello, whom Filippo had sent to his house ahead of him (and who did not know that Filippo had carved such a piece), dropped an apronful of eggs and other things he had brought for their dinner. He stared at the crucifix as if he were beside himself, marveling at the skilled and artful style shown by Filippo in the legs, the body, and the arms of the figure, which was so finely and harmoniously composed that Donatello not only declared himself beaten but called the work a miracle. It is now in S. Maria Novella, between the Chapels of the Strozzi and of the Bardi of Vernia, where it is still greatly admired to this day for the same qualities."

Vita of Donatello, pp. 47f (Milanesi, pp. 398f, slightly shortened): "In the same church [S. Croce] beneath the screen alongside the scene painted by Taddeo Gaddi, [Donatello] did a wooden crucifix, with great care; it seemed an unusually fine piece to him, so he immediately wanted Filippo Brunelleschi, his close friend, to come and see it. On the way to his house, Donatello began to explain how difficult it is to achieve a thing worthy of praise, and how many there are who shun the necessary travail. When they had entered, and Filippo had looked at Donatello's work, he remained silent and smiled a bit, since he had been led to expect something much better [than what he actually saw]. Donatello perceived this and begged him, for friendship's sake, to speak his mind as frankly as possible. So Filippo, who was of a generous nature and without envy, said that he thought Donatello had put a peasant on the cross, rather than the body of Christ, which was most delicate in every member and of noble aspect throughout. This sharp criticism deeply hurt Donatello, who had anticipated the contrary. "If it were as easy to do things as to judge them," he replied, "my Christ would look like Christ to you and not like a peasant; but take some wood and make one yourself." Without another word, Filippo went home and set to work on a wooden Christ of the same size as Donatello's. He spent many months on it, without anybody's knowledge, in an effort to surpass Donatello, so that his judgment might be vindicated. When he was finished, Filippo went to Donatello and casually invited him to dine with him, since the two friends often ate together. As they were passing the Mercato Vecchio, Filippo bought cheese, eggs, and fruit; then he gave Donatello his key and asked him to take these things home by himself, pretending that he had to wait for the bread at the baker's. Thus Donatello reached Filippo's house alone. As he entered the ground floor, he beheld the crucifix, which had been placed in a good light. It was so perfect, and finished so miraculously, that he stopped in his tracks as if struck by

terror; overcome by the delicate beauty of the work, he opened his hands and dropped the fruit, eggs, and cheese he was holding in his apron, spilling everything on the floor. When Filippo, who had arrived meanwhile, found him standing thus, he thought to himself, if the wonder of my art has made Donatello open his hands, it has opened his heart and mind, too. So he laughingly said, "What have you done, upsetting our entire meal?" Donatello replied, "For my part I've had enough this morning; go ahead and gather up your share. For I realize and confess that to you it is given to make Christs, and to me peasants."

The same anecdote, considerably shortened, is repeated in Borghini, pp. 316f; a brief summary, to illustrate the importance of suitable expression for sacred figures in art, in Lodovico Dolce, *Aretino, dialogo della pittura*, Venice, 1557, ed. and trans. Cajetan Cerri, *Quellenschriften . . . ,* II, Vienna, 1888, p. 40.

1571 Vasari, letter to Matteo Benvenuti, head of the *Opera di S. Croce*, December 29, 1571, in the Archives of S. Croce (from F. Moisè, *Santa Croce di Firenze*, Florence, 1845, p. 184): ". . . I have urged Pier Antonio da Vernia to finish the carved and gilt wooden tabernacle (*ornamento di legniame*) for the crucifix of Donatello, which has been placed in the Chapel of the Bardi; but without changing or spoiling my design [for it] . . ."

1591 Bocchi, p. 165: "In the Chapel of the Bardi, Lords of Vernio, at the head of the cross (i.e. the eastern end of the church), there is the wooden crucifix by Donatello, famous for its beauty and expert workmanship. It has been said that this crucifix was criticized by the master of the Dome (i.e. Brunelleschi) as having a clumsy body and vulgar limbs, but it is nevertheless very beautiful in every way and is still treasured by all as a matchless work. This figure was made for Bernardo or Niccolò del Barbigia; it is as highly prized and admired today as it was in the past."

The oldest known, although not necessarily the original, position of the crucifix in S. Croce is that defined by the Anonimo Magliabechiano and Vasari: against the wall in the fourth bay of the North transept, above the altar of the chapel of the Barbigia family. Bocchi states that it had been ordered by Bernardo or Niccolò Barbigia. (See Kauffmann, *D.*, p. 200, n. 44, and Paatz, *Kirchen*, I, p. 669, n. 425.) About 1570 the crucifix was moved to its present place, the St. Louis Chapel belonging to the Bardi family (the second edition of Vasari's *Vite* agrees with the first in giving the older location). The elaborate gilt tabernacle designed at that time by Vasari was still in existence in 1845 (see Moisè, *loc.cit.*); it has since disappeared. The loincloth shows the original paint surface, but the rest of the figure has been refinished in a dull brown tone, as noted by Kauffmann, *loc.cit.* Careful cleaning might uncover remnants of the old flesh color underneath this layer.

Willi Kurth, *Die Darstellung des nackten Menschen im Quattrocento in Florenz*, Berlin, 1912, pp. 40ff, has claimed that the arms are modeled differently from the rest, and Kauffmann, *loc.cit.*, who apparently shares this impression, suggests that they may be a later restoration. To me, they seem to match the style of the figure so well that there is no reason to doubt their authenticity. The fact that they are hinged to the shoulders, a peculiarity to which Kauffmann, *loc.cit.*,

was the first to draw attention, also argues against their being of a later date. So far as I know, this feature and its history have never been properly investigated; its purpose, no doubt, was to permit the figure to be taken down and placed on a bier or in the tomb as part of a popular religious Easter ceremony. (In Greece, a very similar practice survives to this day: on the night of Good Friday, the *Epitaphios*, the bier of Christ, is carried through the streets of the parish. It consists of a decorated cubicle containing a painted image of Christ that has been ceremoniously removed from the cross inside the church.) Our crucifix, then, could hardly have been made for the semi-privacy of a family altar or chapel. The Barbigia, in all probability, did not commission it but acquired it from the original owner (or owners) sometime before 1500. Once the crucifix was installed above the Barbigia Altar, and certainly after its transfer to the ornate tabernacle of Vasari in the St. Louis Chapel, it could not very well have continued to play the role of a ceremonial puppet, so that the hinging of the arms became superfluous. Assuming that the arms were renewed in the sixteenth century or later, it is difficult to understand why the restorer failed to do away with the hinges, which presumably were quite useless by now. Thus, if the present arms are not the original ones, they must have been replaced during the pre-Barbigia days of the crucifix, i.e. within less

than a century after its creation, which does not seem very likely. The arms were indeed immobilized at an early date by means of heavy nails driven through the armpits; two of them, beneath the right arm, are clearly visible in the side view. The side view also reveals that the front part of the head is carved from a separate piece of wood (Kauffmann, *loc.cit.*). A narrow vertical crack has opened along the line of juncture.

Scholars have shown little unanimity concerning the probable date of the crucifix. Venturi (*Storia*, VI, p. 239) placed it earlier than any other work of Donatello; Schmarsow (*D.*, p. 6), Tschudi (*D.*, p. 10), Cruttwell (*D.*, p. 25) and Colasanti (*D.*, p. 41) pronounced it a youthful work of c. 1410-1415; Kauffmann (*D.*, p. 200, n. 47) proposed "c. 1415"; Bode (in Burckhardt's *Cicerone*, 5th ed., 1884, p. 356), Schottmüller (*D.*, p. 121), and Bertaux (*D.*, p. 29) suggested "1415-1420," Max Semrau (Thieme-Becker, *Lexikon*, IX, 1913, p. 421) and Schubring (*KdK*, p. 20) "c. 1420." Frey (*Cod. Magl.*, p. 306) and Planiscig (*D.*, pp. 27, 139) have argued for a date in the late 1420's, while Reymond (*Sc. Fl.*, II, p. 125) insisted on placing it in the 1430's. This uncertainty must be blamed, in considerable measure, on Vasari's anecdote about the "peasant on the cross." No one, to be sure, has taken the story at face value, and several of the scholars named above have emphasized its Cinquecento character (Frey, Schottmüller, Bertaux, Colasanti; cf. also Cornel von Fabriczy, *Jahrbuch Preuss. Kunstslgn.*, XXX, *Beiheft*, 1909, p. 32f). Yet even the most skeptical among them have usually conceded the "symbolic truth" of the tale to the extent of basing their own discussion of the S. Croce crucifix on a comparison with the one in S. Maria Novella, as if this step were inevitable. Such, however, is far from the case; the two works are so different in style that without the Vasari anecdote nobody would have thought of assuming any kind of connection between them. The S. Maria Novella crucifix is one of the most disputed pieces of its kind; whether or not we accept the authorship of Brunelleschi (vouched for by his late fifteenth century biographer, who may have been Antonio Manetti), its date cannot be established with any degree of assurance. Under the circumstances, the comparison of the two crucifixes was bound to

remain fruitless. Worse than that, it has actually tended to transfer to Donatello's work some of the mysterious character of Brunelleschi's, thus making it appear more problematic than it need be. Lányi's attribution of the S. Croce figure to Nanni di Banco (*Pragm.*, p. 128, without supporting arguments) may be viewed as a desperate attempt to cut the Gordian knot.[1] While deservedly forgotten, it has left a further residue of uncertainty (cf. Planiscig, *loc.cit.*).

The tale of the contest between Brunelleschi and Donatello can be fully understood only in the context of a systematic general study of the anecdote about artists and works of art, and its meaning in Renaissance thought. Here a great deal remains to be done. Ernst Kris and Otto Kurz, the pioneer authors in this neglected field, have already pointed out the basic pattern to which our story conforms—a pattern derived from the legendary contests of Zeuxis and Parrhasios, and of Homer and Hesiod, in Ancient times (*Die Legende vom Künstler*, Vienna, 1934, pp. 118f). The gradual formation of our anecdote emerges clearly enough from the sources: there is every reason to believe that it did not yet exist in the Quattrocento, otherwise we should find it in the Brunelleschi biography of "Antonio Manetti," whose eulogistic intent it would have served to perfection.[2] Billi, the earliest source for our story, simply says that Brunelleschi made his crucifix "in competition" with Donatello; the Anonimo Magliabechiano adds that Brunelleschi had criticized Donatello, whereupon the latter had challenged him to do better; and Vasari embroiders freely upon this rather sparse pattern. But how did the notion of a contest between Donatello and Brunelleschi get started at all? It is, I think, the product of a tendency, clearly discernible from the later fifteenth century on, to "build up" Brunelleschi at the expense of his contemporaries. Characteristically enough, the great architect was accorded the honor of a *Vita* at that time, much earlier than any other artist. This biography, written towards 1475, includes a highly tendentious account of the competition for the North Doors of the Baptistery, designed to explain away Brunelleschi's defeat: his trial relief, we are told, was really better than Ghiberti's, but the latter, through skillful "lobbying," attracted so much support that the judges decided to declare both masters winners and to give them the

[1] Lányi probably based his claim on a comparison with the small Man of Sorrows relief from the Porta della Mandorla in the Museo dell'Opera del Duomo, executed between 1404 and 1409, which he believed to be the work of Nanni di Banco (as does Planiscig, *Nanni di Banco*, Florence, 1946, pp. 16f, plate 8). The Man of Sorrows does indeed show a certain resemblance to the S. Croce Crucifix, but the similarity is one of type, it seems to me, rather than of personal style. It indicates no more than a fairly close chronological relationship between the two pieces. The body of the S. Croce Christ is both more Gothic and more naturalistic than that of the Man of Sorrows, which

betrays a notable classical influence (evidently through contact with the "Hercules Master," whom Giulia Brunetti, *Belle Arti*, 1951, pp. 3ff, has sought to identify with Jacopo della Quercia; see also Richard Krautheimer and Trude Krautheimer-Hess, *Lorenzo Ghiberti*, Princeton, 1956, pp. 52f).

[2] See below, p. 132, for his story of the conflict between the two artists over the door frames in the Old Sacristy, told with evident relish. Kauffmann, *D.*, p. 200, n. 44, and Planiscig, *D.*, p. 139, erroneously state that the Brunelleschi biography includes an account of our contest as well.

commission jointly. Only when Brunelleschi declined to enter into such an arrangement did the contract go to Ghiberti alone. (In his autobiography, Ghiberti states that the victory went to him by unanimous decision of the thirty-four judges, and we have no reason to distrust his word, since he was writing at a time when the true facts were still likely to be remembered.) To contemporary readers, the Brunelleschi biographer's biased version must have had a good deal of plausibility; after all, the fact that Brunelleschi's trial relief was the only one to be preserved besides that of Ghiberti, seemed to indicate that the two had been of equal standing in the competition. Still, the story could hardly be construed as a clear-cut victory for Brunelleschi. This need, we may assume, was filled by a somewhat later Brunelleschi eulogist who seized upon the two crucifixes in S. Croce and S. Maria Novella and, by analogy with the two trial reliefs, interpreted them as tangible evidence of another competition—a private one, unhampered by inconvenient facts, in which Brunelleschi could best an opponent of even greater renown than Ghiberti, and best him completely. Considering its purpose, our story is indeed *ben trovato*, although far from *vero*.

Whatever the reasons behind it, the desire to establish Brunelleschi as a sculptor of unique genius became so strong, from the time of the "Manetti" biography, that every one of the master's few known works in that field was apt to be viewed as proof of his ability to surpass his rivals, especially if these had produced comparable pieces. Thus Billi (*s.v.* "Brunelleschi," p. 32, Cod. Strozz.) in mentioning Brunelleschi's lost wooden statue of Mary Magdalene, cannot refrain from pointing out how much better it was than Donatello's statue of the same subject in the Baptistery; yet he could hardly have known the figure from his own experience, since it perished in the fire that gutted S. Spirito in 1471. That the Brunelleschi statue was no longer available for direct comparison with its "competitor," probably explains why Billi's praise of its superior merit was not taken over by the Anonimo Magliabechiano or by Vasari. Otherwise, this brief reference might well have been elaborated into an anecdote similar to that about the two wooden crucifixes, even though the two Magdalenes could have had little in common.[3] Their difference in style was, in all

likelihood, no greater than that between the two crucifixes—and no more disturbing to Billi and his successors.[4]

But to return to the story of the two wooden crucifixes. Under the circumstances, it seems clear that the phrase about the "peasant on the cross" is of purely Cinquecento coinage, and that its meaning, therefore, must be interpreted in mid-sixteenth century terms (cf. the illuminating passage in Gelli, as well as Dolce's *trattato*, *loc.cit.*) rather than in those of the early fifteenth. Any attempt to view it as an echo of the conflict between Gothic and Renaissance seems little short of absurd, regardless of whether the progressive role be assigned to Donatello (as in Semper, *D.*, '75, p. 145—"realism vs. idealism"; this has become the standard interpretation) or to Brunelleschi (Kauffmann, *D.*, p. 18—"rustic," "peasantlike" as synonyms for "Gothic").

Clearly, then, we shall have to determine the place of the S. Croce crucifix in the evolution of Florentine Early Renaissance sculpture without reference to the "peasant on the cross." The tradition of Donatello's authorship, attested by Albertini, is not only independent of the contest story but probably a good deal older as well. While it cannot be relied upon absolutely, there is nothing to contradict it in the style of the figure. The almost universal preoccupation of critics with the realism, the lack of spirituality of the "peasant Christ," has tended to obscure the conventional aspects of the work. Kauffmann alone drew attention to its Gothic qualities (*D.*, pp. 18f), although without defining the specific tradition from which it stems. This tradition, obviously, is to be found in the so-called International Style that dominated the early years of the fifteenth century. If we survey the Florentine crucifixes of that period in search of antecedents for our figure, we shall find that one of them fits this role far better than the rest: the crucifix on the North Doors of the Baptistery. The relationship is so striking, in fact, that Ghiberti's Christ must rank as a direct ancestor (although not necessarily the specific source) of Donatello's. Schottmüller (*D.*, p. 81), the only scholar to comment upon the resemblance between the two, assumed that the Ghiberti crucifix reflects the "new type" created by Donatello, but this is surely a reversal of the true state of affairs. Ghiberti's figure

[3] Brunelleschi's was carved before 1420, according to a document published by Botto (*Rivista d'arte*, XIII, 1931, p. 432), while Donatello's must be dated some thirty-five years later; see below, pp. 190f.

[4] The derivation of the mythical Donatello-Brunelleschi contest from the Ghiberti-Brunelleschi contest for the North Doors as given in the "Manetti" biography, becomes even more plausible in view of the fact that much the same thing happened a second time: Billi, the Anonimo Magliabechiano, and Vasari claim that the statue of St. Mark on the south façade of Or San Michele was originally a joint commission of Donatello and

Brunelleschi but that Donatello carried it out alone, with the consent of his friend. In this instance, the available documents prove that Brunelleschi had nothing whatever to do with the statue (see below, p. 17), and Albertini refers only to Donatello. Here, then, we have another attempt to let Brunelleschi share the fame radiating from a famous sculptural masterpiece, just as in the "Manetti" account of the two trial reliefs; the parallel is quite unmistakable, since in both cases Brunelleschi magnanimously relinquishes his right as co-recipient of the commission.

represents anything but a novel type, and its older relatives can be found easily enough in the art of Lorenzo Monaco and other Florentine masters around 1400.

The exact date of Ghiberti's crucifixion relief is difficult to fix; Planiscig (*Lorenzo Ghiberti*, Florence, 1949, p. 28) places it among the very first panels of the North Doors, about 1405, because of its Trecentesque character, while Richard Krautheimer ("Ghibertiana," *Burl. Mag.*, LXXI, 1937, pp. 68ff and *Lorenzo Ghiberti*, Princeton, 1956, pp. 105ff) includes it among the earlier members of a "middle group" executed between 1407 and 1415. Neither dating would interfere with our assumption that Donatello took a Ghiberti crucifix—if not this one, then another very much like it—as his point of departure for the S. Croce figure. The correspondences, both in the general outlines and in detail, are indeed remarkable: the way the feet overlap, the emphasis on the projecting kneecap and shinbone of the right leg, the long, clinging loincloth reaching below the left knee, the long and slender waist, even the curly mustache. More remarkable still, however, is the totally different effect Donatello has achieved within the Ghibertian framework. It is due only in part to his far greater interest in correct anatomical detail (analyzed at length in Kurth, *op.cit.*); the compositional changes, although minor when considered separately, are equally important. The arms have been straightened to increase the tension, the head is tilted more strongly sideways than forward, and the hair has been kept shorter, so as to give greater prominence to shoulders and chest; the left leg and hip have been pushed outward, emphasizing the curvature of the entire body and thus conveying a stronger sense of strain; the loincloth has become skin-tight, and the loose end hanging down from the left hip has been tucked away. In the aggregate, these changes mean that Donatello has superimposed a down-to-earth physical reality on the grace and lyricism of his model, sacrificing a good deal of the latter qualities in the process. Had Ghiberti been asked his opinion of the S. Croce crucifix, he—and he alone!—would have been justified in calling it a "peasant."

If we now try, on the basis of everything that has been said before, to fit the S. Croce crucifix into the *œuvre* of Donatello, there can be no doubt that it must be an early work: the artist is vigorously attacking the "International Style" from within but has not yet broken with its major premises. Exactly this phase of his development is represented by the seated St. John the Evangelist, especially its lower half. The St. Mark at Or San Michele already strikes out in a new and bolder direction. We would thus arrive at a tentative date of 1410-1411. However, it seems advisable to make allowance for certain external factors that may have influenced the appearance of the figure. In carving a crucifix for a popular entombment spectacle (the commission might have come from some religious confraternity), Donatello was probably constrained to use a well-established, traditional type regardless of his personal preferences. The skin-tight loincloth, too, may have been dictated by functional considerations; any protruding edges were apt to be knocked off in the process of making the figure "perform." In this instance, the practical purpose of the work appears to to have induced a distinctly progressive feature. On balance, it is perhaps best to assume that the crucifix ought to be dated a bit later than its style suggests. Our proposed date of c. 1412 is to be understood in this sense, with the further proviso that a shift of one to two years in either direction should not be ruled out.

ST. JOHN THE EVANGELIST
MUSEO DELL'OPERA DEL DUOMO, FLORENCE

PLATES 4-5　　　　　Marble; H. 210 cm; W. (at the base) 88 cm;　　*1408-1415 (c. 1409-1411)*
D. (at the base) 54 cm

DOCUMENTS

A series of entries in the records of deliberations and disbursements by the *operai* of the Florence Cathedral workshop, in the archives of the Opera del Duomo. These were, in part, known to Milanesi (*Vasari*, II, pp. 400f, 427), Semper (*D.* '75, pp. 274f), and other late nineteenth century scholars (see Paatz, *Kirchen*, III, p. 545, n. 427). They are printed most completely and systematically in Poggi, *Duomo*, pp. 29ff, under the following numbers:

1408, December 19 (*172*): Niccolò di Pietro Lamberti, Donatello, and Nanni Banco are each to do one marble evangelist; their pay will be determined later, and the master whose statue turns out

best will be asked to do the fourth evangelist. [The last promise was not kept, since on May 29, 1410, Bernardo Ciuffagni received the commission (for a St. Matthew; Poggi, doc. *183*). The blocks for the four statues had been cut at Carrara in 1405 (Poggi, doc. *162*—June 3) under the supervision of Niccolò di Pietro Lamberti and Lorenzo di Giovanni d'Ambrogio. They arrived two years later, delayed by the war with the Duke of Milan (Poggi, doc. *164*), and were weighed, measured, and cut down to a height of 4 braccia (Poggi, docs. *167, 169, 170, 171*).]

1410, July 17 (*186*): The chapels where the four evangelists are being carved are to be closed off from public view.

1412, August 12 (*199*): Donatello is to receive 50 florins for two marble figures, a St. John the Evangelist and a David. [For the latter see above, pp. 5f, and below, pp. 21ff.]

1413, April 18 (*206*): Donatello is to receive 30 florins in part payment for the marble figure of St. John the Evangelist.

1415, January 24 (*210*): Payment for a key to lock the chapel where Donatello is working.

1415, February 21 (*211*): Donatello is to receive 15 florins for the marble figure of St. John the Evangelist.

1415, April 16 (*215*): Donatello must finish the marble figure of St. John the Evangelist by the end of May, otherwise he will incur a penalty of 25 florins.

1415, May 10 (*216*): Donatello is to receive 20 florins for the marble figure of St. John the Evangelist.

1415, June 3 (*218*): Donatello is to receive 35 florins for the marble figure of St. John the Evangelist.

1415, October 8 (*220*): The St. John has been installed on the Cathedral façade and appraised at 160 florins; Donatello is to be paid 60 florins, the remainder still due him of this total.

SOURCES

1510 Albertini, p. 9: "On the façade [of the Cathedral] there is an Evangelist, seated, . . . by the hand of Donatello."

(Before 1530) Billi, p. 38 (repeated in Cod. Magl., p. 75): "Also by his [Donatello's] hand is a St. John the Evangelist on the façade of S. Maria del Fiore, a figure truly perfect in every part, which is in a niche beside the center portal."

(c. 1550) Gelli, p. 58: "[Donatello] did the figure of the seated St. John the Evangelist beside the center portal on the façade of [S. Maria del Fiore]."

1550 Vasari-Ricci, II, p. 49 (Milanesi, p. 400, slightly rephrased): "In his youth [Donatello] made on the façade of S. Maria del Fiore . . . a statue of St. John the Evangelist four braccia tall, seated and clad in simple raiment, which is much praised." (The same description, abbreviated, in Borghini, *Riposo*, p. 318.)

The statues of the four evangelists, in two pairs of niches flanking the main portal, can be seen in a miniature showing the consecration of the Cathedral by Eugene IV in 1436 (Bibl. Laurentiana, cod. Ed. 151; reprod. Raymond van Marle, *The Development of the Italian Schools of Painting*, XI, The Hague, 1929, p. 618); in the fresco by Bernardo Poccetti in the first cloister of S. Marco, representing the entry of St. Antoninus into Florence Cathedral (Poggi, *op.cit.*, fig. 2, p. xxii); and in the well-known large pen drawing of the Cathedral façade in the Museo dell'Opera del Duomo (Poggi, *loc.cit.*, fig. 3). On February 1, 1589, after the destruction of the façade in 1587, the four statues were placed in the chapels of the East *tribuna* (see the *Diario* of Agostino Lapini, ed. G. O. Corazzini, Florence, 1900, p. 281, excerpted in Poggi, *op.cit.*, p. xxxviii, n. 1). They remained there until 1904, when they were shifted to the aisles so as to give them better light (Poggi, *loc.cit.*). Removed for safekeeping in 1940, they were transferred to their present location after the end of the war.

Since the four statues have neither individual at-

tributes nor signatures, they had to be sorted out purely on the basis of style. Cinelli (p. 54) in reporting the relocation of the figures, claimed all four of them for Donatello, as did Ferdinando Leopoldo del Migliore (*Firenze città nobilissima illustrata*, Florence, 1684, pp. 15, 26) and Giuseppe Richa (*Notizie istoriche delle chiese Fiorentine . . .*, VI, 1757, p. 165). Follini-Rastrelli (*Firenze antica e moderna illustrata*, II, Florence, 1790, p. 233) mistook the St. Luke of Nanni di Banco for Donatello's St. John, an error that persisted in the Donatello literature until Wilhelm Bode, in the fifth edition of Burckhardt's *Cicerone*, 1884, p. 346, finally pointed out the correct figure. His identification, enthusiastically endorsed by Semper (*D.* '87, pp. 14f), has never been challenged and seems indeed incontestable. Which of the four niches on the old façade of the Cathedral was occupied by the St. John, cannot be determined with certainty from the pictorial representations of the façade mentioned above; it appears to have been the one next to the south jamb of the portal. A detailed survey of the problem of identification for all four statues is given in Paatz, *loc.cit.* and pp. 503f, n. 262; 505, n. 264; 543f, n. 425; and 572, n. 493.

The lapse of seven years between the dates of commission and completion, at a time of crucial significance for the growth of Donatello's individual style and for the genesis of Florentine Early Renaissance art as a whole, makes it important to place the actual execution of the statue as precisely as possible within the time span bracketed by the documents. Older scholars (Schmarsow, *D.*, p. 7; Tschudi, *D.*, p. 5; Semper, *loc.cit.*) tended to assume that the St. John was done, in the main, during the first few years of the period 1408-1415, because of the conspicuous Gothic elements in its design. Only the head, they thought, must be dated close to 1415, because of its kinship with that of the St. George. Poggi, on the other hand (*op.cit.*, p. xxxvii), pointed out that the earliest payment for the statue is recorded for August 1412 (doc. *199*), and Colasanti (*D.*, pp. 14f) accepted this as proof that Donatello did not begin to carry out the commission until 1412. Kauffmann (*D.*, p. 199, n. 39) went even further; he claimed that the master started working on the St. John only after the completion of the St. Mark for Or San Michele late in 1412, and thus assigned the statue to the years 1413-1415 (similarly Planiscig, *D.*, pp. 23ff, 136).

In arriving at this conclusion, Kauffmann disregarded altogether the document of August 12, 1412. He considered only those advance payments earmarked exclusively for the St. John, beginning with the entry for April 18, 1413 (Poggi, doc. *206*) and ending with that of June 3, 1415 (Poggi, doc. *218*), and found that they add up to 100 florins, the amount

listed in the final accounting of the cost of the statue (Poggi, doc. *220*) as having been received by Donatello previously. Still, the fact remains that in August 1412 the master did receive 50 florins intended, in part at least, for the St. John. Apparently the entire sum was later regarded by the *operai* as applying only to the cost of the other statue, the mysterious "marble David of 1412," so that it had to be omitted in the final accounting for the St. John; but this does not make it any less important. Indeed, the document of August 12, 1412, seems rather more significant to us than the later notices relied upon by Kauffmann, simply because it represents the earliest documented payment explicitly defined as referring—in part—to the St. John. Even this circumstance, however, does not force us to infer that here we have the first payment actually made for our statue, or (assuming it was the first payment) that the artist had done little or no work on the figure up to that time. The authorization to disburse 50 florins to Donatello "for the statue of St. John the Evangelist and [the] David" is followed by an unusual clause which suggests the very opposite: "Ita tamen quod propter stantiamentum predictum non intellegatur quod paga fienda magisterii et marmi albi dicte opere in aliquo deficiat." It may be read to mean that "said authorization must not be made the basis of any claim that the payment to be made . . . is deficient in any way." Unless we choose to regard it as an empty legalism, this phrase would seem to indicate that the *operai* had been dilatory in authorizing payments for the two statues and wanted to discourage Donatello from insisting on a larger installment than the sum they had decided upon. The same document discloses that the *operai* had fallen behind in settling another claim of Donatello; they finally decided, two years after the completion of the statue, that he would get a total of 128 florins for his giant Joshua, although there is no reference to the disbursing of any part of this amount. (This part of the deliberations of August 12, 1412, is printed separately in Poggi, under doc. *420*.) We have only one record of payment specifically connected with the Joshua: the 50 florins authorized on July 27, 1412 (Poggi, doc. *419*). In this instance, fortunately, we are saved from jumping at the wrong conclusion by another record (Poggi, doc. *414*) which proves that the statue was finished not later than the summer of 1410, rather than in August 1412. We still do not know, of course, when Donatello received the balance of the price of the Joshua (amounting to 78 florins), since it is unaccounted for in the documents. May we not assume that he got at least part of it while he was actually at work on the statue? The documents show that Donatello was paid 70 florins, in three installments, during the latter part of 1409 for statues not

mentioned by name. Some of this money may very well have been intended for the Joshua. After all, the five entries recording payments for the marble David (see above, p. 3) do not refer by name to that statue either; the final accounting refers to "a prophet," the others to "a figure" or "a marble figure." Only the circumstances surrounding the commission, and the fact that all the amounts tally so perfectly, permit us to be sure that these disbursements relate to the marble David. The purpose of the three payments in the second half of 1409, and of the numerous "nonspecific" sums paid to Donatello during the ensuing years, is much less certain; the commissions multiply and overlap, and the various amounts advanced to the artist rarely add up to the exact figures of the final prices of the statues. On the face of it, the payment of 20 florins on July 27, 1409 (Poggi, doc. *175*)—the first one on record after the final accounting for the marble David—could easily apply to the Joshua, since the record mentions only "a figure which [Donatello] is making." The second payment, however (Poggi, doc. *177*; 30 florins, November 13) refers to work on "several marble figures," and so, by implication, does the third (Poggi, doc. *178*; 20 florins, November 18; the purpose is defined as "ut supra," obviously meaning the entry of November 13). These 50 florins, then, were intended for marble commissions. Inasmuch as the only such commission we know of for this period is the St. John, we are hardly going too far afield if we weigh the possibility that some share of those 50 florins was meant for our statue.

This seems the more likely since the masters who were carving the other three Evangelists began to get paid for them as early as 1409-1410, even though in their cases, too, the final accounting did not take place until 1414 or 1415. Niccolò Lamberti received the first installment on his St. Mark on November 13, 1409 (Poggi, doc. *177*), the same day that Donatello was granted 30 florins for "several marble figures"; the final payment on the statue was authorized on March 18, 1415 (Poggi, doc. *214*). For the St. Luke of Nanni di Banco, the corresponding dates are June 12, 1410 (Poggi, doc. *184*) and February 16, 1414 (Poggi, doc. *205*); for Ciuffagni's St. Matthew December 10, 1410 (Poggi, doc. *190*; six months after the commission) and October 8, 1415 (Poggi, doc. *220*; together with the final accounting for the St. John). However, the documents also record various nonspecific payments to these masters, along with those explicitly naming the Evangelists. Under the circumstances, the fact that Donatello's St. John is not referred to by name until August 1412 appears far less significant than the striking parallelism in the "pattern of payments" for all four statues.

According to Kauffmann, *loc.cit.*, another reason for dating the St. John late is the fact that the statue was not yet finished in mid-April 1415 (Poggi, doc. *215*). Here again caution seems indicated. Perhaps one method of estimating the amount of work that still had to be done on the figure at that time is to consider the size of the penalty with which the *operai* were threatening Donatello; it seems plausible to assume a relationship between the two. Since the penalty represented about one sixth of what the artist could expect to receive for the completed statue, we may conclude, without too grave risk, that no more than one sixth—and probably less—of the St. John remained unfinished in the spring of 1415. This portion could, of course, have included the features that were most important artistically, such as the face, but from what we know of Donatello's temperament and working habits it does not appear probable. Unlike Ghiberti, Donatello had little regard for the ideal of perfect craftsmanship. Impatient of anything resembling routine work, he tended to lose interest in his commissions before they reached the final stage, leaving the surface finish and the elaboration of details to his assistants. As a result, he was apt to exceed the time limits imposed upon him, or to deliver his pieces in a condition which his patrons, especially those with traditional standards of craftsmanship, would consider technically deficient or unfinished. The main instances of this "modern" intractability, it is true, date from the artist's later years (e.g., his difficulties in Padua, for which see below, p. 189), but he may well have shown tendencies in the same direction almost from the start. Thus there is a somewhat better than even chance that the finishing of the St. John in May 1415 did not involve any labors demanding great creative effort.

The available documents, then, are insufficient to establish the late date of the St. John; they favor, if anything, an early date, although they fail to provide decisive support for either view. All we can state with assurance is that the statue was produced between January 1409 and June 1415. Any attempt to arrive at a more exact dating must be based entirely on the style of the figure. Once this is granted, the problem is simply to decide whether to place the St. John between the David of 1408-1409 and the St. Mark of 1411-1412, or between the latter statue and the St. George of c. 1416. Since the St. Mark, too, is a niche figure representing a bearded apostle, it should not prove too difficult to arrive at a clear-cut answer to our question. Surely the two heads, so similar in type, are as precisely comparable as one could wish. Yet none of the advocates of a late date for the St. John have faced this task. Those who followed Schmarsow and Semper in regarding the head as several years later than the rest of the statue, emphasized its kinship with the head of the St. George and its *terribilità*,

which was to influence Michelangelo's Moses. The features of the St. John are indeed majestic, but the impression of fierceness is rather deceptive. It depends to a large extent on the eyes (Cruttwell, *D.*, p. 28, voices a typical response in saying that they "seem to fulminate fire"), and these have been tampered with, falsifying their original expression. The fiery glance of the St. John is produced by nothing more than two casual nicks on the surface of the eyeballs, nicks of uneven size and so poorly placed as to give the figure a distinctly walleyed appearance. In contrast, both the St. Mark and the St. George show pupils in the shape of regularly carved and precisely placed concave disks, ringed by a concentric engraved circle to represent the iris. Had Donatello intended to give the eyes of the St. John a focused glance, he undoubtedly would have treated them the same way. When and by whom the "missing" pupils were added in such crude fashion we cannot determine—perhaps it was a misguided Michelangelo-enthusiast of the later sixteenth century who wanted to direct the gaze of the statue towards the main portal of the Cathedral. In any event, Donatello had left the eyeballs uncarved, as in the marble David. Strangely enough, this tiny but crucial detail has never been pointed out before, so far as I know; Kauffmann, in fact, goes out of his way to stress that the statue is perfectly preserved except for the tip of the nose. As soon as the eyes are restored to their pristine condition (this has been done by retouching in our Pl. 5d) the expression of the face becomes calmer and more pensive—psychologically "neutral," as it were. We also begin to notice other aspects that strike us as less fully developed than in the St. Mark. Except for the treatment of the eyebrow region, the St. John displays no physical marks of old age: the skin is smooth and tightly stretched, with hardly a trace of wrinkles, no bags under the eyes, and no hint of advancing baldness. This is essentially a youthful head on which a beard and mustache have been superimposed. The hair, too, suggests a cap or wig—it seems curiously "detachable." Structurally, the face still bears strong traces of the idealizing, classically oriented style of the head of the marble David, while the features of the St. Mark, in comparison, are decidedly more realistic and better integrated as well. The same difference appears in the plastic rendering of hair and beard. In the St. Mark, the individual strands or locks are sharply distinguished from one another; in the St. John, on the other hand, they tend to be a unified mass differentiated by shallow engraved lines on the surface, much as in the head of Goliath at David's feet. Equally telling is the traditional treatment of the upper torso and shoulders of the St. John. They form an abstract, rounded block, to which the Ghibertesque drapery clings like an elastic skin, with little regard for the organic shape of the body beneath. The hands approach those of the St. Mark more closely, although the joints, sinews, and veins are less incisively defined; their slender, tapering shape still recalls the right hand of the marble David. In the drapery, a marked change can be noticed from the waist down. The ornamental system of the International Style, with its soft loops and hairpin curves, remains the basic pattern, but disturbed, as it were, by an effort to adapt it to a functional relationship of body and drapery. The next stage in the evolution of Donatello's drapery style is reached in the St. Mark, where the Gothic rhythm has been abandoned altogether and the softness of the International Style survives only in details.

To summarize our observations, the St. John appears in every respect less advanced than the St. Mark, although the lower part of the statue is closer to the St. Mark than to the marble David. This leads us to conclude that the head, shoulders, and chest were probably done as early as 1409-1410, while the hands and the entire lower portion suggest a date of c. 1411, with possible modifications in May 1415.

ST. MARK

OR SAN MICHELE, FLORENCE

PLATES 6-7 Marble; H. 236 cm (including the cushion and plinth); W. (at the base) 74 cm *1411-1413*

DOCUMENTS

Several entries in an account book of the linen drapers' guild, in the Communal Archives of the City of Florence. Already known to Baldinucci (*Notizie*, I, p. 406), they were published in *Memorie originali italiane risguardanti le belle arti*, ed. Michelangelo Gualandi, series IV, Bologna, 1843, No. 138, pp. 104-107, and reprinted in Luigi Passerini, *Curiosità storico-artistiche fiorentine*, series I, Florence, 1866, pp. 161f. Pietro Franceschini, *L'Oratorio di San Michele in Orto*, Florence, 1892, p. 81, added a further entry that had been overlooked by previous authors.

1409, February 15: Niccolò di Pietro Lamberti is commissioned to procure at Carrara and to bring back to Florence, at his peril and expense, a piece of marble for the statue of St. Mark that is to be made for the tabernacle assigned to the linen drapers at Or San Michele. The block must be sufficient for a figure 3¾ braccia tall; his compensation is fixed at 28 florins.

1411, February 16: The guild authorizes five representatives to examine, and accept delivery of, the marble block secured by Niccolò for the St. Mark; to assign it to a sculptor for carving; to have the figure installed in the niche; and to make all the necessary disbursements.

1411, April 3: Donatello is commissioned by the five representatives of the guild to carve the St. Mark from the above-mentioned block of marble. [Here, as in the preceding documents, the block is referred to as *la statua di marmo*, while the statue to be carved from it is called *figura*.] The figure is to be 4 braccia tall, standing on a marble base; it must be completely finished, including the gilding and other suitable ornamentation, and installed by November 1, 1412. The price will then be determined by the five guild members in charge of the project, who will deduct the 28 florins already spent for the block. Donatello agrees in advance to accept their appraisal. His word is vouched for by two guarantors, one of them the sculptor Niccolò di Pietro [Lamberti].

1411, April 24: The stonecarvers Perfetto di Giovanni and Albizzo di Pietro are commissioned to do the tabernacle for the St. Mark. It must be finished within 18 months. The inside should be like that of the tabernacle of St. Stephen; the paneling, of black marble with inlaid white roses and rosettes, and the other details must conform to the drawing submitted by the two masters, who will receive 200 florins for their work.

1413, April 29 (Franceschini, *loc.cit.*): The guild members in charge of the project receive authority to see to it that the figure and tabernacle of St. Mark, which is to stand at Or San Michele, be finished to the extent necessary (*di quanto vi mancha*).

SOURCES

(Before 1472) *XIV uomini singhularj in Firenze dal 1400 innanzi* (ed. Gaetano Milanesi, *Opere istoriche edite ed inedite di Antonio Manetti*, Florence, 1887, p. 164): "In the tabernacles on the exterior of Or San Michele [Donatello made] the St. George, the St. Peter, and the St. Mark, admirable works. . . ."

1510 Albertini, p. 15: "In Or San Michele . . . St. Peter and Mark and George are by the hand of Donatello."

(Before 1530) Billi, *s.v.* "Brunelleschi," p. 32 (repeated in Cod. Magl., p. 66): "He and Donatello together were commissioned to do two marble figures which are in the pilasters of Or San Michele: St. Mark and St. Peter, praiseworthy works indeed."

s.v. "Donatello," p. 38: "[He did] the figures of St. Mark and St. Peter for the pilasters [of Or San Michele], although he received the commission for them jointly with Brunelleschi."

1537-1542 Cod. Magl., *s.v.* "Donatello," p. 75: "Also by his hand is the marble figure of St. Mark in one of the pilasters of said church [Or San Michele], and likewise the marble figure of St. Peter. And it is said that these two figures were commissioned of him jointly with Brunelleschi."

(c. 1550) Gelli, p. 59: "[Donatello] did the figure of St. Mark in one of the pilasters of [Or San Michele]; it has so graceful a stance, and so venerable an air, that Michelangelo used to say he had never seen anyone who had the bearing of an honest man to a greater degree than this figure, and if Saint Mark resembled this statue his words certainly inspired belief." (The same anecdote, slightly rephrased and expanded, in Vasari's Michelangelo *Vita* [Ricci, IV, p. 432; Milanesi, VII, p. 278] and in Bocchi, p. 30.)

1550 Vasari-Ricci, II, *Vita* of Brunelleschi, p. 9 (Milanesi, p. 334): "When the ability of these truly excellent masters had thus become evident [through the two wooden crucifixes they had carved], they were commissioned by the butchers' guild and the linen drapers' guild to make two marble figures for their niches at Or San Michele. These Brunelleschi left for Donatello to carry out alone, since he himself was occupied with other things, and Donatello brought them to [successful] completion."

Vita of Donatello, pp. 49f (Milanesi, pp. 402f, slightly expanded; the significant additions are placed in brackets below): "At Or San Michele in that city he made the marble statue of St. Peter for the butchers' guild, a very graceful and admirable figure; and for the linen drapers' guild he made St. Mark the Evangelist, which he had undertaken to do together with Brunelleschi but which Brunelleschi then allowed him to finish alone. This figure he executed with such judgment and love that when it stood on the ground [its merit was not recognized by those unqualified to judge, and] the consuls of the guild were not disposed to accept it. But Donatello asked them to let him set it up, since he wanted to demonstrate that after some retouching the figure would appear entirely different. This was done, Donatello screened the statue from view for fifteen days and then, without having touched it otherwise, he uncovered it, whereupon everybody was filled with admiration and praised the figure as an outstanding achievement."

1677 Cinelli, p. 11: "Donatello took great care not to give his works too high a finish, so as not to lose the natural vividness and grace he had achieved in the first cast or in the free and truly masterful strokes of his chisel. He thus enhanced their effectiveness from a distance, even though they became somewhat less striking when viewed at close range. And in order to avoid this comparison, he insisted on showing his works only after they had been installed in their proper places, as happened in the case of the marble St. Mark for Or San Michele."

The history of the commission emerges clearly enough from the documents, but the peculiar wording has given rise to some misconceptions concerning the role of Niccolò di Pietro Lamberti. Passerini (*loc.cit.*) assumed that the commission had originally been given to Niccolò and then, in midstream as it were, transferred to Donatello, who finished the statue. This view, already protested by Franceschini (*op.cit.*, p. 79), is contradicted both by the appearance of the figure, which gives no hint of such collaboration, and by the documents themselves. Niccolò was engaged for the sole purpose of procuring a suitable block; his fee, fixed in advance at 28 florins including the cost of the marble, could have covered no more than this purely technical assignment (for a statue 3¾ braccia tall, a master at that time received between 100 and 150 florins as the price of the carving alone). Niccolò's services to the drapers' guild, then, were those of a marble expert, not of a sculptor. He must have been accustomed to this, for in previous years he had performed the same task for the Cathedral workshop, which had sent him and Lorenzo di Giovanni d'Ambrogio to Carrara to supervise the cutting of the blocks for the statues of the four evangelists (see above, p. 13). When the guild representatives, between February 16 and April 3, 1411, accepted delivery of the marble block for the St. Mark, Niccolò had fully dis-

charged his contractual obligations. He might have hoped to receive the sculptural commission as well, but he had no better claim to it than any other master; and since he served as a guarantor for Donatello, he apparently felt no resentment when the task was entrusted to the younger man. Semper (*D.* '75, p. 87) and Kauffmann (*D.*, p. 198, n. 30) have argued that Donatello could not have used the marble block procured by Niccolò, because the contract of 1411 stipulates a height of 4 braccia for the figure as against 3¾ braccia in the document of 1409. This discrepancy, however, is easily accounted for if we assume that the first measurement refers to the statue alone, while the second includes the base, which is specifically mentioned in the same passage. Niccolò's block had to be slightly taller than 3¾ braccia in order to accommodate a figure of that size; it might very well have turned out to be big enough for a somewhat taller statue than the guild had in mind at the start. The actual height of the St. Mark, including the cushion and plinth which are carved from the same block, corresponds to 4 braccia, that of the figure alone to 3⅔ braccia (based on the measured drawing of the statue in its niche in Riccardo and Enrico Mazzanti and Torquato del Lungo, *Raccolta delle migliori fabbriche antiche e moderne di Firenze*, Florence 1876, pl. xcIV[III]).

The documents do not yield a precise *terminus ante*

quem for the completion of the St. Mark. According to the entry of April 29, 1413, the statue and the tabernacle were still unfinished, although the wording suggests that not a great deal remained to be done. Insofar as the phrase *di quanto vi mancha* was meant to apply to the statue, it probably referred to matters of craftsmanship such as the decorative gilding specified in the contract and the finishing off of details (the cover of the book, for instance, must have been studded with metal ornaments of some sort, as indicated by the drill holes); these were the things Donatello was apt to neglect or to leave to his assistants (see our remarks above, p. 15). On the whole, we see no cogent reason to doubt that the decisive part of the work on the St. Mark was done in 1411-1412, in accordance with the deadline set by the contract.

In Florence, St. Mark was the patron saint of the retailers of cloth (cf. George Kaftal, *Iconography of the Saints in Tuscan Painting*, Florence, 1952, p. 678). The choice of this saint by the linen drapers was thus natural enough, especially since the latter also included the *rigattieri* (pedlars, dealers in notions), according to Franceschini, *loc.cit.* The strange, and apparently quite unprecedented, motif of the cushion beneath the feet of the statue might well be a special reference to the *rigattieri*, since its presence would be difficult to account for on purely technical or aesthetic grounds.

The artistic greatness of the St. Mark has been acknowledged by almost every Donatello scholar (Semper, *D.* '75, pp. 89ff, provides a particularly fine appreciation). Only Reymond (*Sc. Fl.* II, p. 90) deprecates it, except for the head, as "factice et de médiocre valeur" and sympathizes with the linen drapers who, according to Vasari, disliked it on first sight. Perhaps the most striking analysis of the statue may be found in the recent article by Wilhelm Vöge (*Festschrift Hans Jantzen*, Berlin, 1951, pp. 117-127). The eminent author is certainly right in rejecting the thesis, originated by Louis Courajod (*La sculpture à Dijon*, Paris, 1892), of Donatello's dependence on the Flemish-Burgundian realism of Claus Sluter, even though the connection he tries to establish between the drapery of the St. Mark and that of certain mid-thirteenth century niche figures in Reims Cathedral seems too tenuous to be very illuminating. Nor can the style of the St. Mark be derived from Nanni di Banco, as proposed by Semper (*D.* '87, p. 15) and again, with more vigor than logic, by Paolo Vaccarino (*Nanni*, Florence, 1951). Quite apart from the chronological

difficulties (well-summarized in Kauffmann, *D.*, pp. 189f, n. 32) there remains the fact that Nanni never produced a statue with the revolutionary qualities of the St. Mark; none of his figures has a fully balanced and secure stance, none shows as logical a relationship of body and drapery. Whatever the links between the St. Mark and the art of the past (Ulrich Middeldorf, *Art Bulletin*, XVIII, 1936, p. 574, has even pointed out a resemblance to Italian Romanesque heads of the Antelami school) the statue is in all essentials without a source. An achievement of the highest originality, it represents what might almost be called a "mutation" among works of art.

The evolutionary significance of the St. Mark would be difficult to exaggerate. Not only does it mark the first clear-cut break with the tradition of the International Style in Donatello's *œuvre*; as the earliest unequivocal instance of a Renaissance figure, antedating Masaccio by some crucial eight years, its impact must have been tremendous.[1] Nor was this impact confined to the opening phase of the Florentine Quattrocento. The written sources, from the *XIV uomini singhularj* to Bocchi's *Bellezze*, show clearly enough that the St. Mark was the first work of Donatello—indeed, the first Renaissance statue—to achieve "legendary" fame. For what these authors have to tell about our figure must be understood, not as factual truths but as legends reflecting its fame in tangible form. The claim that the commission for the St. Mark and the St. Peter went jointly to Brunelleschi and Donatello, we have already diagnosed as an offshoot, by analogy, of Manetti's account of the competition for the Baptistery Doors (see above, p. 11). Its purpose, obviously, was to enhance Brunelleschi's reputation as a sculptor by placing his name at the head of the list of Early Renaissance statuaries. (For the St. Peter, see below, pp. 222ff.) Billi, our oldest source for the story, seems to imply that Brunelleschi had some share in the ideation, if not the execution, of the two figures, and Vasari echoes this notion when he writes, in his *Vita* of Brunelleschi, that "Donatello brought them to completion" (*condusse a perfezione*). In the Donatello *Vita*, he mentions Brunelleschi only in connection with the St. Mark, which he must have regarded as by far the more important statue, and stresses that Filippo let Donatello finish the figure by himself, thus suggesting that the older (and greater) master generously relinquished the task to his less experienced friend and competitor.[2]

[1] The influence of the statue has never been adequately explored; the list of copies compiled by Kauffmann, *loc.cit.*, n. 31, merely serves to suggest the scope of the problem.

[2] Interestingly enough, Vasari's *Vita* of Nanni di Banco contains a tale built on much the same pattern, and equally fictitious, about Donatello as the mentor of Nanni, who appears here as a former pupil of Donatello: Donatello had been asked

to do the St. Philip at Or San Michele for the shoemakers' guild, but since they could not agree on the price the commission was shifted to Nanni, who promised to accept whatever payment the guild would see fit to give him. After finishing the statue, Nanni demanded a much higher fee than had Donatello, whereupon the guild agreed to have the latter arbitrate the dispute, in the belief that he would fix a price far below

That the St. Mark held the first place among the Or San Michele statues done in the *buona maniera moderna*, is evidenced further by the story, reported in Gelli and again in Vasari's *Vita* of Michelangelo, that the latter once said he had never seen a more convincing image of an honest man than this statue, and if the Evangelist was like that he could believe everything he had written. This anecdote confers upon our figure a distinction shared only by Ghiberti's East Doors, which Michelangelo, again according to Vasari, deemed worthy of being the Gates of Paradise.

The best-known as well as the most revealing legend about the St. Mark, Vasari's account of how Donatello overcame the linen drapers' dislike of the statue, has been consistently misunderstood. J. A. Crowe and G. B. Cavalcaselle (*A New History of Painting in Italy . . .*, II, London, 1864, Chapter x, p. 280) provide what appears to be the earliest instance of an interpretation that has been echoed countless times since: they quote the story as proof that Donatello commanded "the scientific application of the law of optics . . . the art of creating form so as to appear natural when seen at certain distances and heights." In much the same vein, Semper (*D.* '75, *loc.cit.*) regards the story as an illustration of Vasari's claim, made in connection with the Cantoria, that Donatello employed his judgment as much as his hands, since he fashioned his figures in such a way that in his studio they did not appear half as impressive as when set up in the places for which they were intended. Semper, too, speaks of the "optical principles of the ancients" which Donatello has applied in the St. Mark by exaggerating certain features so as to compensate for the distance from which the statue was to be viewed. Kauffmann (*D.*, p. 15) still echoes this approach; he even claims (pp. 10f) that Donatello consciously employed such "optical calculations" in the right-hand prophet above the Porta della Mandorla (see below, pp. 219f). No one has yet pointed out the particular "compensatory distortions" Donatello is supposed to have introduced into the St. Mark, although these distortions—assuming that there are any—ought to show up well in the photographs of the statue (since they are taken, not from the street level but from scaffoldings tall enough to afford an undistorted view such as the artist himself enjoyed while the figure was still in his workshop). The "optical principles of the Ancients" might, of course, have been known to Donatello from Vitruvius, who frequently refers to compensatory distortions of various sorts. However, as Bates Lowry has demon-

strated (in his paper, "Renaissance Interpretations of Vitruvius," read at the Annual Meeting of the College Art Association, New York, January 27, 1955), this aspect of Vitruvian theory did not enter into the architectural treatise of Leone Battista Alberti at all and seems to have attracted little attention until the High Renaissance. Under these circumstances it is highly unlikely that Donatello alone should have been a champion of compensatory distortion during the first half of the Quattrocento. Vasari's account, moreover, of the trick our artist played on the linen drapers does not necessarily imply any such calculated use of "optical principles"; nor was it so understood by Cinelli, who links it with the observation that Donatello refrained from giving his works a high surface finish, even at the risk of making them seem less attractive at close range, in order to preserve the vividness of his "artistic handwriting" (i.e., the chisel marks of the roughing-out stage). This emphasis on personal expression had been an important aspect of Renaissance aesthetic theory ever since Filarete, who was the first to point out the autographic character of artistic forms (cf. Julius Schlosser-Magnino, *La letteratura artistica*, Florence, 1935, p. 139). While Donatello's output of later years often exhibits an impatience with traditional standards of craftsmanship that fits Cinelli's remarks well enough, this is hardly true of the St. Mark. That a lack of finish was nevertheless imputed to our statue, must be regarded as a particularly high form of praise for its "modern" qualities. And the document of 1413, with its reference to the unfinished state of the figure and tabernacle, suggests that there might even be a vestige of historic fact behind the Vasari anecdote.

There is, however, another and equally significant aspect to the story. Kauffmann has observed (*D.*, p. 210, n. 130) that Donatello's pretended retouching of the St. Mark has an exact parallel in Vasari's *Vita* of Michelangelo: When the marble David had been hoisted into place, the Gonfaloniere Piero Soderini came to see it and criticized the nose. Michelangelo then mounted the scaffolding and pretended to retouch the nose, without actually changing it, whereupon the Gonfaloniere declared himself well satisfied; and "Michelangelo descended with feelings of pity for those who wish to pretend that they understand things of which they know nothing." Whether or not this anecdote was the source of our story, as Kauffman believes, is difficult to say (they may both have a common ancestor). In any event, its final sentence points

his own. Donatello, however, insisted that Nanni should receive more, rather than less, and when asked to explain his decision pointed out that Nanni, as a lesser master, had to labor longer and harder on such a figure than he himself would have, and should be paid justly for the time expended on it. There follows another anecdote in which Donatello again plays the part of the generous older master who comes to the rescue

when Nanni finds himself unable to fit the statues of the Quattro Coronati into their niche at Or San Michele. The common aim of all these stories, one might say, was to establish a kind of "pecking order" among the sculptors concerned, so that Nanni had to appear in the same relationship to Donatello as Donatello to Brunelleschi.

a moral that applies with equal force to the Donatello version: judgment in matters of art should be left to the experts, who command the special knowledge required; no layman should attempt it lest he make a fool of himself. Here again we have a basic tenet of Renaissance art theory, with antecedents reaching back to the mid-fourteenth century. Boccaccio, in the Decameron (VI, 5), had praised Giotto for "having brought back to light again that art which had lain buried for many centuries through the errors of those who preferred to paint for the delight of the ignorant rather than for the understanding of the judicious [*savi*]"; and Petrarch could say of a Madonna panel by Giotto in his possession that "its beauty is not understood by the ignorant but astounds the *magistri artis*"

(*Testamentum*, in: *Opera*, Basel, 1554, III, p. 1373; for similar passages elsewhere see Edgar Zilsel, *Die Entstehung des Geniebegriffs*, Tübingen, 1926, p. 336, n. 41).

The legend of how Donatello duped the linen drapers serves a twofold purpose, then: it tells us that the man of genius has the right to establish his own standards of perfection—standards of an aesthetic rather than of a technical kind—and to disregard the opinions of the uninformed, even if they happen to be his patrons, since his work can be fully understood only by the qualified minority. Our story, and the statue to which it was attached, may thus be said to embody some fundamental aspects of the new values that set the Renaissance artist apart from his mediaeval predecessors.

DAVID, WIDENER COLLECTION, NATIONAL GALLERY OF ART, WASHINGTON, D.C.

PLATES 8-9 Marble statue, unfinished; H. 162 cm; W. 50 cm; D. 42 cm *(1412, 1420-1430?)*

DOCUMENTS: none (but see below)

SOURCES

1550 Vasari-Ricci, p. 53 (Milanesi, p. 408): "In the houses of the Martelli there are many scenes of marble and bronze, among them a David three braccia tall . . ." (repeated almost verbatim in Borghini, *Riposo*, p. 320).

The earliest evidence linking the statue with the Martelli family is the Portrait of Ugolino Martelli by Bronzino in Berlin (Staatliche Museen, No. 338A), painted about 1540 (Ugolino, born 1519, appears to be about twenty years old), which shows the David on a Cinquecento pedestal in the courtyard of the Palace. The figure remained there until 1802, when (according to Balcarres, *D.*, p. 52) it was taken indoors to protect it from wind and weather. Semper (*D.* '75, p. 111) saw it on the staircase of the Palazzo Martelli. In 1916 it was sold by the Martelli family to Joseph E. Widener, Elkins Park, Philadelphia, with whose collection it passed to the National Gallery of Art.

On the strength of Vasari's testimony it has been taken for granted until very recently that the David was acquired by the Martelli family in Donatello's lifetime (Charles Seymour, Jr., *Masterpieces of Sculpture from the National Gallery of Art*, New York, 1949, p. 175, lists as the original owner Ruberto Martelli, in whose house Donatello was reared, according to Vasari). Such an assumption, however, seems more than dubious, as pointed out by Leo Planiscig (*Phoebus*, II, 1949, pp. 56f), who rejects the attribution to Donatello without having seen the original. Why, he

asks, do the predecessors of Vasari—Billi, the Anonimo Magliabechiano, and Gelli—fail to mention the David even though they speak of the Giovannino Martelli? Either the statue was not in the possession of the Martelli before Vasari's day, or it was not regarded as the work of Donatello. Planiscig does not choose between these alternative explanations but simply notes the apparent inaccuracy of Vasari's account. A far more thorough study of the problem was presented by Clarence Kennedy in a public lecture at the National Gallery of Art in January 1951. (Dr. Kennedy has generously permitted me to summarize his findings, which he expects to publish soon.) His starting point is the Bronzino portrait: why, he wonders, should Ugolino Martelli have wanted the David, rather than the Giovannino, to appear in the background? Was not the latter figure far better qualified for such a distinction, since, according to Vasari, it had the status of a revered family heirloom linked with the name of Ruberto Martelli?[1] Ugolino must have had some special reason for picking the less famous and unfinished statue, and the most plausible explanation—apart from the possible symbolic role of the David, to which the various books in the portrait might

[1] The Vasari passage relating to both statues in the first edition of the *Vite*, cited in full below, pp. 191f, clearly excludes the David from "the many things given by Donatello" to the Martelli, such as the Giovannino; only in the second edition does Vasari blur the difference somewhat by speaking of "many other things" instead of "many things" beside the David.

furnish a key—is pride of ownership. It would seem, then, that Ugolino had acquired the David shortly before the picture was painted. This hypothesis offers a number of advantages; it not only explains why our statue is not mentioned by Vasari's predecessors but furnishes a basis for reconstructing the history of the figure from its very beginnings. If Kennedy's original assumption is correct, there can be little doubt that Ugolino bought the David as a work of Donatello. Although not a direct descendant of Ruberto Martelli—his branch of the family began with Ruberto's brother Ugolino—he must have taken some pride in the tradition linking the rise of the great master with the generous patronage of the Martelli.[2] Without such a special interest in Donatello, and without the appeal of a truly great name, Ugolino might well have hesitated to acquire a statue so obviously unfinished and to some extent "spoiled."[3] Needless to say, this in itself does not prove the correctness of the attribution; still, it is useful to know that the name of Donatello was attached to the David before Vasari's time (Planiscig, *loc.cit.*, suspects that it was arbitrarily imposed on the statue by the author of the *Vite*). But where was the David before it entered Ugolino's collection about 1535-1540? Could it have been an heirloom in the hands of some other Florentine family which, for reasons unknown, decided to sell it at that time? The possibility, while it cannot be denied absolutely, seems remote. The positive appreciation of fragmentary or unfinished works of art is a Cinquecento development, as evidenced by the new interest in collecting the drawings of important masters; Vasari and his circle (see below, pp. 121f) certainly realized the aesthetic value of the autographic qualities of a piece such as our David (or the unfinished St. Matthew of Michelangelo), and the same may have been true of Ugolino Martelli. In the Early Renaissance such an attitude, if it existed at all, must have been very rare. Fragments

of classical sculpture were acceptable even then, of course, but one cannot imagine a fifteenth century collector wanting to buy the David Martelli, or Donatello presenting it to an important patron as a token of gratitude. Yet, oddly enough, our David is the only statue of Donatello that has been repeated on a small scale in bronze.[4] How are we to account for these replicas? Could there be a connection between them and the unfinished condition of the statue? According to Kennedy, there definitely is. He conjectures that the David, as a "spoiled" figure, never left the Donatello workshop during the master's lifetime; afterwards, it probably became the property of Bertoldo, who fell heir—we may assume—to the contents of the *bottega* and used the David as a sort of "study object" for himself and the younger sculptors who studied with him (hence the replicas). The youthful Michelangelo, too, must have known the David Martelli well, as Kennedy was able to demonstrate by a series of comparisons.[5] If the whereabouts of our statue are thus accounted for during the last third of the Quattrocento, there still remains a gap of about forty years until its acquisition by Ugolino. Since this interval coincides with one of the most unstable and eventful periods in the history of Florence (from the death of Lorenzo the Magnificent to the beginning of the reign of Cosimo I), the fortunes of the David are difficult to ascertain, although even here persistent research may eventually yield some clues.

The date of the David Martelli has usually been linked with that of the Giovannino. Wilhelm Bode (*Denkmäler der Renaissance-Skulptur Toscanas*, Munich, 1892-1905, pp. 19, 24) placed both in the 1420's; Balcarres (*D.*, p. 52) suggested 1415-1425; Venturi (*Storia*, VI, pp. 251f) thought them contemporary with the Campanile prophets. The date most frequently assigned to the two figures is "about 1430" (Schott-müller, *D.*, p. 124; Schubring, *KdK*, pp. 37f); Allan

[2] Vasari may have embroidered upon the story a bit but he surely did not invent it. In all probability, he reported what he had been told by a member of the family. How trustworthy this tradition is does not matter for our present purpose; the one thing that concerns us right now is that the Martelli of Vasari's day believed it to be true.

[3] That Donatello was highly regarded by collectors in mid-sixteenth century Florence may be gathered from a remark by Sabba da Castiglione, who complains of the dearth of good antique pieces on the market and lists Donatello as the next best choice; see his *Ricordi*, Venice, 1554, No. 109, p. 51, cited in Balcarres, *D.*, p. 90.

[4] Three such statuettes are known, in the Louvre, in the collection of Sir Kenneth Clark, and in the Berlin Museum. The latter specimen, shown for the first time in the Florentine Donatello exhibition of 1886, was long regarded as cast from the original wax model for the David Martelli; cf E. F. Bange, *Bronzestatuetten* (*Kaiser-Friedrich Museum, Die Italienischen Bildwerke der Renaissance . . .*, ed. Wilhelm Bode, II, 4th ed.), 1930, No. 25. Kauffmann (*D.*, p. 211, n. 135) defends this view against the arguments for a later date advanced by Martin Weinberger (*Zeitschrift f. bild. Kst.*, LXV, 1931-1932, p. 53). Nevertheless, the Berlin bronze must be regarded as a free

variant after the marble figure; it not only modifies the pose of the David in several important respects but incorporates certain details which could not have been part of the original design of the statue. Nor does the style agree with that of Donatello's bronze sketches as exemplified by the unchased parts of the statues for the High Altar in Padua. All three statuettes are the work of minor masters of the final third of the fifteenth century. A somewhat earlier though debased echo of our statue is the David on the doorframe of the Chapel of the Blessed Consoling Virgin in S. Francesco, Rimini, as observed by A. Pointner, *Die Werke des Bildhauers Agostino di Antonio di Duccio*, Strasbourg, 1909, pp. 106ff.

[5] Perhaps this explains a curious passage in Condivi's *Vita* of Michelangelo (1553, xxii); speaking of Michelangelo's bronze David, Condivi mentions the bronze David of Donatello in the Palazzo Vecchio and informs us that Donatello was much admired by Michelangelo except for one thing—he did not have the patience to give his works the proper finish, so that they look wonderful from a distance but lose some of their effect at close range. This remark certainly sounds strange on the lips of Michelangelo, the more so as the bronze David of Donatello does not justify such a stricture. Could Michelangelo have said something of the sort with the David Martelli in mind?

Marquand (*Art in America*, IV, 1916, pp. 358ff) puts them as late as c. 1440, while Kauffmann (*Sitzungs-berichte d. Kunstgeschichtl. Ges. Berlin*, Oct. 9, 1931, p. 4 and *D.*, pp. 43ff) prefers the middle or late 1430's. Cruttwell (*D.*, pp. 23, 48) is the only scholar to differentiate sharply between the dates of the two statues; according to her, the David was carved about 1405, when Donatello was "a mere boy," in contrast to the Giovannino, which she places not long before 1430. Such diversity of opinion reflects the uncertain stylistic character of the statue, its "unresolved" quality, suggestive of several different phases of Donatello's development. Cruttwell attributed these contradictory features to youthful inexperience and thought that the David had been abandoned by Donatello "in impatience at its obvious faults." Bertaux (*D.*, p. 122), on the other hand, saw them as evidence of incompetent assistants, who had worked from Donatello's wax model (preserved in the Berlin bronze statuette) and crippled the figure in the process. Here again Kennedy's approach, based on intimate knowledge of the original, offers a satisfactory solution: the David, he believes, went through several "campaigns," separated by considerable intervals, before Donatello gave it up as beyond rescue, so that it demands not one date but two or more. The earliest phase is represented by the design of the figure as a whole; it carries us back into the years 1410-1412, for the basic structure of the statue—the pose, the ponderation—has its closest counterpart in the St. Mark at Or San Michele (compare Pls. 6, 8a). We might recall at this point that on August 12, 1412, Donatello was granted 50 florins by the *operai* of Florence Cathedral for work done on the seated St. John Evangelist and on a marble statue of David (see above, pp. 12ff). This David, which cannot be identical with the marble David of 1408-1409, seems to have been abandoned, since it never appears again in the Cathedral records. Siebenhüner (see below, pp. 27f) believes that the unfinished block was sold to the armorers' guild and transformed into Donatello's St. George, but the latter statue, so far as I can see, shows no trace of having once been a David *in statu nascendi*. If this mysterious "David of 1412" has survived at all, it is far more likely to be the David Martelli. The identification, to be sure, cannot be proved, yet one wonders whether mere chance is sufficient to account for the coincidence of the documentary notice with the starting date of the statue. The second "campaign" reflected in the David Martelli belongs to the 1420's, according to Kennedy. Its most characteristic result is the head, whose strongly classical features, suggestive of the S. Croce Annunciation, had been noted by earlier scholars. Donatello probably also did some reworking of the arms and legs, as well as of the drapery, at this stage, but without conclusive results. Whether he returned to the task a third time remains open to question. I suspect, however, that some attempt to finish the statue was made at a later point by a hand other than Donatello's. The overly explicit and, as it were, "anecdotal" detail of the torn trouser leg on the right knee, and the conversion of the mass of marble behind the legs into a tree trunk of a curiously unimaginative sort, can hardly be credited to the master's own intention. Fortunately, they are not important enough to mar the impressive overall effect of this strangely serene yet heroic David. The figure is of particular interest not only because of its relationship to both the marble David of 1408-1409 and the bronze David (which in some respects may be viewed as a critique of ours) but as the only piece in marble that permits us to observe Donatello's working methods. The technical and artistic lessons it holds for us deserve to be more fully explored; thanks to Kennedy's reconstruction of the history of the statue, such a study has now become possible.

SCULPTURE OF THE ST. GEORGE TABERNACLE OR SAN MICHELE, FLORENCE

PLATES 10-12 *1417 (c. 1415-1417)*

ST. GEORGE, MUSEO NAZIONALE, FLORENCE

PLATES 10a, b, 11a, 12

Marble statue: H. 209 cm (without the base); W. (at the plinth) 67 cm

ST. GEORGE KILLING THE DRAGON

PLATES 10c, 11c

Marble relief, base of tabernacle;; H. 39 cm; W. 120 cm

GOD THE FATHER BLESSING

PLATE 11b

Marble relief, gable of tabernacle; H. 68 cm; W. 64 cm

DOCUMENTS

1417, February: The marble for the base of the tabernacle is sold to the armorers' and swordsmiths' guild by the workshop of Florence Cathedral.

(Milanesi, who published this notice [Vasari, II, p. 404n] cited neither its source nor its original wording; he presumably extracted it from the records of the Cathedral workshop. The date given by him, "February 1416," is probably Florentine style, transcribed directly from the original document, and thus refers to the following year [as suggested by Kauffmann, *D.*, p. 195, n. 6, and Paatz, *Kirchen*, IV, p. 540, n. 113].)

SOURCES

(1451-1464) Filarete, *Trattato dell'architettura*, book xxiii (ed. Wolfgang v. Oettingen, Vienna, 1890, p. 622): "When you have to do a St. Anthony, you should make him look alert (*pronto*), not timid. Such is the St. George as Donatello represented him; truly a most excellent and perfect figure. It is of marble, at Or San Michele in Florence."

(Before 1472) *XIV uomini singhularj in Firenze dal 1400 innanzi* (ed. Gaetano Milanesi, *Opere istoriche edite ed inedite di Antonio Manetti*, Florence, 1887, p. 164): "In the tabernacles on the exterior of Or San Michele [Donatello made] the St. George, the St. Peter, and the St. Mark, admirable works . . ."

1510 Albertini, p. 15: "In Or San Michele . . . St. Peter and Mark and George are by the hand of Donatello."

(Before 1530) Billi, p. 38 (repeated in Cod. Magl., p. 75): "In a pilaster at Or San Michele [Donatello did] the figure of St. George, which shows great vividness and alertness."

(c. 1550) Gelli, p. 59: "[Donatello] also did the figure of St. George in [Or San Michele], which appears always to be in motion, and a St. George slaying the dragon in low relief at the feet [of the statue], a miraculous work."

1550 Vasari-Ricci, II, p. 50 (Milanesi, p. 403): "For the armorers' guild he made a figure of the armed St. George, very vivid and proud; the head shows the beauty of youth, the brave spirit of the warrior, a true-to-life quality terrifying in its fierceness, and a marvelous sense of movement (*gesto di muoversi*) within the stone. And certainly no modern marble figure displays such life and spirit as have been achieved in this one by nature and art through the hand of Donatello. And on the base that supports the tabernacle of the St. George, Donatello did a low relief in marble of St. George killing the serpent, including a horse that is much praised. On the gable he did a God the Father in medium low relief." (A variant of this passage, much abbreviated and omitting the reference to the gable relief, appears in Borghini, *Riposo*, p. 319; Borghini adds that the St. George relief "is more easily praised than imitated.")

1552 Anton Francesco Doni, *I Marmi* (ed. Ezio Chiòrboli, Bari, 1928, pp. 9ff): "Peregrino e Fiorentino e una figura di Donatello," a scene in which the St. George, as one of the *dramatis personae*, tells how he once consoled an admirer of his who complained that the Hercules group of Baccio Bandinelli, a work of inferior merit, had been given a place of honor next to the Palazzo Vecchio while Donatello's masterpiece was hidden away in an inconspicuous spot: "I would rather deserve a throne and not be on it than be on it and not deserve it."

(Before 1584) Il Lasca (Anton Francesco Grazzini, 1503-1584): "In lode della statua di San Giorgio di mano di Donatello a Orsanmichele in Firenze," a licentious poem of 109 lines, dedicated to Giovambatista della Fonte. The author calls the statue "my beautiful Ganymede," praises its physical charms, and proclaims that he has found this *fanciuletto tanto bello* an ideal substitute for a live boy friend; what matter if his *amoroso piacere* be confined to looking—he is glad to be rid of the inconstancy, the fits of temper, and the jealousy of his former companions. (The poem is published in Carlo Verzone, *Le rime burlesche . . . di Anton Francesco Grazzini*, Florence, 1882, pp. 526ff. I

am indebted to Professor Edward Lowinsky of the University of California for bringing this text to my attention.)

1571 Francesco Bocchi, *Eccellenza della statua di San Giorgio di Donatello* . . . (first printed edition, Florence, 1584; most recently reprinted in Bottari-Ticozzi, *Lettere pittoriche* . . . , Milan, 1822-1825, IV, pp. 255ff; German translation, with notes, in Semper, D. '75, pp. 175ff, 249ff). The key terms of this lengthy and repetitious "appreciation" seem to be derived from Vasari's comments on the statue. Apart from its significance as the earliest monograph dealing with a monument that was already "historic" at the time of writing, Bocchi's treatise can claim our attention only in the context of Mannerist art theory, since its factual or descriptive content is practically nil. Cf. Julius Schlosser-Magnino, *La letteratura artistica*, Florence, 1935, p. 341.

1591 Bocchi, pp. 30f: "The St. George [Cinelli adds: made for the armorers' guild] is regarded as equal to the rarest pieces of Roman sculpture, and in the judgment of experts it surpasses them by its extreme vividness. The figure is very famous; it makes the keenest minds and the best artists stand in awed wonder at the sense of movement, the spirit infused so conspicuously into the marble by the great master. Many have celebrated it, both in verse and in reasoned prose; and not very long ago there was published a long treatise praising this supreme work of art as highly as it deserves to be praised, in everyone's opinion."

Sometime after 1628, the St. George was removed from the tabernacle of the armorers' guild and placed in that of the Madonna delle Rose on the south side of Or San Michele. According to Pietro Franceschini (*L'Oratorio di San Michele in Orto*, Florence, 1892, p. 75), this happened immediately after 1628, when the Madonna delle Rose, in gratitude for a miracle attributed to it, was transferred to the interior of the church, but the fact that Cinelli gives no hint of the new location of the St. George, is an *argumentum ex silentio* for dating the shift of our statue after 1677. A note in the second edition of Baldinucci's *Notizie* (III, Florence, 1768, p. 75) states that the event took place around the year 1700, a claim that seems to be corroborated by a note in Bottari's edition of Borghini (Florence, 1730, p. 257) suggesting that Baldinucci himself had been aware of the transfer of the St. George and had criticized it as aesthetically unsatisfactory. (C. v. Fabriczy, *Repertorium f. Kw.*, XXIII, 1900, p. 85, follows Franceschini; Milanesi, [*Vasari*, II, p. 403] accepts the date given in the Baldinucci note, while Semper [D. '75, p. 97] erroneously places the transfer in the year 1868.)

The reason for the relocation is obscure. It could hardly have been the desire to find a place where the statue would be less exposed to wind and weather

than in the shallow niche on the north side of the church (this is the purpose suggested by Semper, *loc.cit.*, and Milanesi, *Cat.*, p. 8), even though better preservation of the figure was one of the effects of the transfer (as acknowledged in the Baldinucci note, *loc.cit.*). Perhaps it was simply a belated response to such admonitions as that of Doni (see above), i.e., a wish to acknowledge the fame of the St. George by putting it in the most conspicuous and hallowed of all the tabernacles. Such damage as the figure has suffered is largely man-made, except for the streaky discoloration of the surface.[1] The forward edge of the shield has been nicked severely, and in 1858 someone threw a rock at the head and broke off the nose, which was restored immediately and, to all appearances, accurately.[2] It was probably this incident that led, in 1860, to the proposal to safeguard the statue by removing it to the Galleria delle Statue and to place a bronze replica in the original niche (Franceschini, *op.cit.*, p. 76). No action resulted, however, and in 1886-1887, when the five hundredth anniversary of Donatello's birth was being celebrated, the St. George still remained in the tabernacle of the Madonna delle Rose, as attested by the numerous publications issued on that occasion. Very soon thereafter, the statue was returned to its first location.[3] But by 1892 it had been

[1] Cruttwell (*D.*, p. 33) regards these stains as the remnants of "the bronze-coloured paint with which [the statue] was originally covered"; this assumption is hardly warranted, even though some parts of the armor may well have been gilt or painted originally.
[2] See Franceschini, *op.cit.*, p. 85. Cruttwell, *loc.cit.*, mentions an early marble copy of the head, in the cortile of the Palazzo

Quaratesi. This piece, which I have been unable to trace, may be identical with the one described by Semper (*D.* '75, p. 106) as "an early plaster cast of the head of the marble David."
[3] See Franceschini, *loc.cit.*, who also reports an abortive attempt to deepen the niche, apparently by putting a new marble facing on the tabernacle so as to make it project more strongly from the wall; somewhat earlier, the plain background of the

decided to return to the plan of 1860 (Franceschini, *loc.cit.*), and the statue was moved to the Museo Nazionale while a bronze copy took its place in the niche.[4]

The photograph shown in Pl. 10a was taken about 1890, when for a short while the St. George could actually be seen in the setting for which it had been intended. In one important respect, however, this view fails to reproduce the original appearance of the monument. Contrary to Kauffmann's belief (*D.*, p. 6) that Donatello gave his Christian soldier neither helmet nor weapons, in order to stress the role of St. George as a martyr (similarly Schubring, *Hb*, p. 40, and Planiscig, *D.*, p. 29), our statue must have displayed much the same military equipment that appears in the relief on the base of the tabernacle. It is indeed unlikely that the armorers and swordsmiths should have been content with less than a full complement of weapons and armor for their statue. But some of these had to be made of bronze and may well have disappeared even before the figure was shifted to the niche of the Madonna delle Rose. That the helmet and weapons did exist cannot be doubted: the right hand of the statue surely held something, and to judge from the shape and size of the deep cavity between thumb and index finger it was either a lance or a sword, tilted upward at a fairly steep angle. Our St. George must also have had the sheath of a sword strapped to his waist, as indicated by a drill hole beneath the left hand and two further drill holes on his left thigh (visible in Pl. 12c).[5] There are also several drill holes in the head: one in the lock in front of the left ear, another at the hairline, directly above the nose (Pl. 11a), and two each among the curls on either side of the head (Pl. 10b). Since these do not lie in one plane, they could not have served to anchor a halo. If they had any purpose at all—which can hardly be questioned—they must have been intended to hold a helmet in place. The modern beholder may be tempted to think of these accouterments as alien,

superimposed features. Certainly their absence today is not felt as a loss. And it does indeed seem probable that the objects themselves were not furnished by Donatello but by some specialized craftsman (possibly a member of the armorers' guild). Yet there are some indications that they were part and parcel of the master's original design: the firm grip of the right hand (Pl. 12b) can be accounted for only on the assumption that it was meant from the very start to hold the shaft of a lance or the hilt of a sword. Moreover, since our figure is somewhat less tall than the other marble statues made for Or San Michele about that time (i.e. the St. Mark and the St. Peter; see above, p. 16 and below, p. 222), this slight reduction in height (of 15 to 20 cm) suggests that Donatello made allowance for the helmet.

The helmet, lance, and sword thus seem to have belonged to the initial conception of our statue. Their shape, we may assume, is reflected quite accurately in the St. George of the base relief; after all, Donatello has taken considerable pains to give both figures the same suit of armor (for the character of the armor, see below, p. 29). This correspondence, however, leads to a further conclusion: since the military equipment which appears in the relief was, in all probability, copied from that of the statue, rather than vice versa, the statue is likely to have been executed first—perhaps one to two years earlier. Now we know that the armorers' guild acquired the "marble for the base of the tabernacle," i.e. the slab from which the relief was to be carved, from the Cathedral workshop in February 1417 (see above, p. 23); this event, then, may serve as a provisional *terminus ante quem* for our statue, yielding a date considerably more useful than the next closest *terminus ante*, 1419-1420 (provided by the "St. John" of Nanni di Bartolo, which derives in part from the St. George).[6]

In arriving at the years 1415-1416 for the execution of our statue, we do not depart significantly from the opinions of previous scholars. Most of them have been

niche had been decorated with marble paneling, which was removed soon after. Cf. Giuseppe Castelazzi, *Il Palazzo detto di Or San Michele*, Florence, 1883, pp. 39f.

[4] Paatz, *Kirchen*, IV, pp. 541f, n. 114. Franceschini had pleaded for a copy in marble, not only on aesthetic but also on historic grounds, since the armorers, as a lesser guild, were not permitted to have a bronze statue in their tabernacle.

[5] The angle and direction of the sword or lance is suggested by the staff in the right hand of Perugino's St. Michael, a figure directly inspired by our St. George (Triptych No. 288, National Gallery, London; Madonna in Glory with Saints, Florence, Accademia; the same type occurs once more among the Six Heroes in the Cambio, Perugia). In the preparatory drawing (Windsor Castle), significantly enough, this staff still appears as a sword. All four of these figures also show the scabbard in the position we have postulated for the St. George. When Raphael made a pen sketch of our statue about 1505 (in his

Large Sketchbook; Oskar Fischel, *Raphaels Zeichnungen*, II, Berlin, 1919, pls. 81ff) he did not record a helmet; there is, however, a line running from above the right ear to the forehead, indicative of some kind of head covering. The right hand is empty but shows vigorous *pentimenti*, as if the artist had tried to redefine its shape. The scabbard, too, has been omitted, yet one of the straps to which it was attached is clearly visible below the left arm.

[6] See below, pp. 228ff; Semper (*D.* '75, p. 99) and Kauffmann (*D.*, p. 203, n. 75) cite 1423, the date of the Tomb of Tommaso Mocenigo in SS. Giovanni e Paolo, Venice, which includes a figure clearly dependent on our statue, as the earliest *terminus ante*. Another early, though undated, echo of the St. George is the badly mutilated figure inscribed BAS . . . that once decorated the front of the Palazzo del Comune, Prato; it is now in the Palazzo Pretorio.

content to accept 1416, the date published by Milanesi for the sale of the marble for the base of the tabernacle, as documentary evidence for the date of the statue as well, without regard to the difference between the Florentine calendar and standard usage. (Paatz, *loc.cit.*, having changed Milanesi's date to 1417, favors the latter year.) Franceschini, *op.cit.*, p. 84, had placed the figure in 1415 without reference to the Milanesi document or any other explanation; he was followed in this by Reymond (*Sc. Fl.*, ii, p. 94), Fabriczy (*Jahrbuch Kgl. Preuss. Kunstslgn.*, xxi, 1900, p. 246) and, more recently, Kauffmann (*D.*, p. 195, n. 6), who pointed out that according to a decree of 1406 (published by Fabriczy, *loc.cit.*) any guild was to forfeit its tabernacle if it failed to provide a statue for it within ten years. This decree, however, is not an effective argument for 1416 as a *terminus ante*, since it does not seem to have been enforced. Our own procedure in dating the St. George, then, merely confirms the established view, but it does so in a fashion methodically more rigorous and without depending on criteria of style.

A radical reinterpretation of the history of our statue has recently been proposed by Herbert Siebenhüner, in a paper read at the Deutscher Kunsthistorikertag, Hanover, July 28, 1954 (reported in *Kunstchronik*, vii, 1954, pp. 266f). Siebenhüner cites an unpublished document according to which the armorers' guild, in October 1415, purchased a figure from the workshop of Florence Cathedral. This, he claims, must have been the mysterious marble David on which Donatello had been working together with the seated St. John (cf. the document Poggi 199, August 12, 1412, above, p. 13), and which the master now redefined as a St. George. Work on the David statue, Siebenhüner believes, was carried out during the years 1409-1413, and had reached a state so near completion that the St. George still bears the marks of his previous identity. Thus our figure would in the main represent a far earlier phase of Donatello's development than hitherto assumed, preceding the St. Mark rather than following it. An adequate discussion of this daring thesis must await the full publication of Siebenhüner's arguments, including the verbatim text of the document of October 1415. The brief summary available so far permits only tentative conclusions. There can be little doubt that the figure acquired by the armorers' guild was subsequently made into our St. George, but the document does not seem to indicate that it was a semi-finished statue rather than merely a roughed-out

block of marble, or that Donatello had done any work on it before: the term *figura* could be used for any *lapis* that was destined to become a statue, regardless of whether the sculptor had actually begun to shape it (the blocks for the four evangelists on the Cathedral façade were referred to as *figurae* before they were even allocated to the masters who were to carve them; cf. Poggi, *Duomo*, pp. 28f, docs. 162, 164, 172). That the armorers' guild bought a semi-finished statue is, of course, possible, although such was certainly not the normal procedure. Offhand, the most plausible interpretation of the Siebenhüner document would be that the Cathedral workshop served as a purveyor of marble to the armorers' guild, both for the St. George and the base relief, and that the "figure" was simply a block of suitable dimensions.[7] If this assumption is correct, the purchase of the "figure" would yield a valuable *terminus post* for our statue, confirming the generally accepted date of 1415-1416. Whether the block was procured by the Cathedral workshop for the St. George, by prearrangement with the guild, or whether it had originally been assigned to some other purpose within the compass of the Cathedral such as Donatello's second marble David, would then be quite irrelevant; after all, the documents do not tell us how much carving, if any, the master actually did on the second David. Siebenhüner's case thus depends entirely on the visual evidence of the St. George. Is it true that the pose and expression of the statue are incompatible with an image of the dragon-slayer, but appropriate for a Victorious David that stands halfway between Donatello's earlier version and the famous giant of Michelangelo? As tangible evidence of the David-identity of the figure, Siebenhüner cites the drill holes in the head, which in his opinion served to fasten a metal wreath, and the clenched right hand, supposedly designed to hold the sling (he tacitly assumes that this hand never held anything after the statue had become a St. George). Neither of these observations strikes me as at all convincing: if the second marble David was to have a wreath, why a metal one? And why should such a wreath have been installed before the statue was finished? Is it not far more plausible to assume that the object in question was a helmet? (That the holes actually did hold something is proved by the fact that some of them still contain remnants of corroded metal.) The argument concerning the right hand presents similar difficulties; to me, the vigorous clenching, as well as the size and direction of the hole, seem perfectly adapted to the hilt of a sword or the shaft of a

[7] The linen drapers, it will be recalled, had commissioned Niccolò di Pietro Lamberti to procure the block for the St. Mark from Carrara; since he frequently performed the same service for the Cathedral workshop, Niccolò may well have

been responsible for picking the St. George "figure" as well. Perhaps the armorers' guild wanted to avail itself of his technical experience but could do so only through the Cathedral workshop.

lance but not to the strap of a sling. Moreover, one is apt to ask how this hand (which, if Siebenhüner is right, must have been fully finished while the statue was still a David) could remain attached to the large unfinished portion of the block from which the shield was carved later on? After all, Siebenhüner implies that at the time of the transfer to the guild the statue could not have been much more than a raw mass of marble from the waist down, otherwise there would not have been enough material for the shield. How far the design of the figure as a whole is compatible with an image of St. George, is difficult to judge in view of the high degree of originality we must concede to Donatello and for lack of comparable statues of military saints in Florentine Renaissance sculpture (cf. my discussion of the formal and iconographic sources below). But is it really compatible with a Victorious David? Here our comparative material is far richer, and the answer we get from examining these other versions seems to me a clear-cut negative. The Victorious David may be either nude or lightly clothed (usually in garments appropriate to his status as a shepherd) but, so far as I know, he is never shown in full military armor, since this would directly contradict the Biblical text. The defiant stance of our statue is equally difficult to reconcile with Siebenhüner's hypothesis, since Donatello gave a mild, contemplative air to all three of his Davids.[8] The Michelangelo David, to be sure, is defiant (although not necessarily victorious, since there is no indication that Michelangelo ever intended to add the head of Goliath), and it certainly reflects the influence of our statue; but Michelangelo, who surely did not view the St. George as a crypto-David, was quite capable of taking over the defiant expression while changing the identity of the hero (he had already done so earlier in his St. Proculus at Bologna, anticipating the pose and expression of the marble David to a surprising degree). All this is the more plausible inasmuch as Michelangelo's well-known admiration for Donatello is documented for the time of the marble David by a sketch after Donatello's David of 1408-1409 (on the unpublished *verso* of the Uffizi drawing, Brinckmann No. 8, of c. 1503-1504, as pointed out by Johannes Wilde, *Italian Drawings, Michelangelo and His Studio, British Museum*, 1953, p. 6n). On the basis of the *Kunstchronik* summary, then, we cannot but reject the main thesis of Siebenhüner. The new document introduced by him appears to confirm, rather than to negate, our previous knowledge concerning the genesis of the St. George.

The formal and iconographic sources of the St.

George have been the subject of considerable comment. Reymond (*Sc. Fl.*, II, pp. 91f) had suggested a kinship with the St. Theodore at Chartres Cathedral; Max Dvořák (*Geschichte der italienischen Kunst*, Munich, 1927, pp. 79f) and more specifically Kauffmann (*D.*, p. 5) derive the pose from Gothic statues of military saints.[9] Such northern types undoubtedly have a place among the ancestors of our statue, but Kauffmann vastly exaggerates their importance. He sees the design of the statue so completely in terms of frontality that he even ventures to reconstruct Donatello's working procedure—the artist must have started by drawing an outline of the figure on the front face of the marble block. This view entirely disregards the powerful—and aesthetically decisive—spatial aspect of the pose, its subtle but effective *contrapposto*: the weight of the body is not evenly distributed but rests mainly on the forward leg; the left hip is thrust out; and the plane of the entire body, as well as of the shield, is oblique in relation to the plane of the arch that frames the statue. Here Semper's emphasis on the importance of the side views (*loc.cit.*), and the careful analysis of the ponderation in Schottmüller (*D.*, pp. 59f), do far greater justice to the true character of the work. In comparing the St. George with Donatello's previous statues, most scholars have linked it to the marble David. This relationship, however, while real enough (see above, p. 5) is more external than internal; we see it most clearly in such particulars as the piece of drapery clinging to the right leg of the St. George (although with fundamentally different effect) and the knot of the mantle (for which see above, p. 6). Structurally, the St. George derives not from the David but from the St. Mark, its immediate predecessor, even though these two are usually viewed in terms of contrast rather than of kinship. (Schubring, *HB*, p. 40, goes so far as to call them "opposite poles.") Apart from all the obvious differences of costume, physical type, and expressive purpose, the Evangelist shows an astonishing similarity to our statue in the slight leftward turn of the head, the forward thrust of the left shoulder, and the position of the arms. In fact, he would only have to take a small step forward with his left foot, simultaneously shifting his body weight, in order to assume the pose of the St. George. The St. Mark represents, as it were, the "normal," relaxed standing position from which the St. George has just departed (and against which the pose of the St. George demands to be measured). It is this, I believe, that Vasari had in mind when he praised our statue for its "marvelous sense of movement within the

[8] The earliest "defiant David" I know is the one by Andrea del Castagno in the Widener Collection of the National Gallery of Art, Washington, D.C., and here the gesture appears to be motivated by the special purpose of the painting, which decorates a leather shield.

[9] The specimen reproduced in Kauffmann, pl. 2, is not a St. George but a royal saint, as observed by Middeldorf, *AB*, p. 574.

stone." And what has "unhinged" the calm, self-contained pose of the saint? His knitted brow, his strained glance towards the left, tell us that it is a sudden awareness of danger from that direction. The pose of our figure must be understood as a gesture of the body in response to a danger signal. If we imagine the St. George fully armed, as he was meant to be, his fighting stance becomes even more dramatic and meaningful. This focusing of the entire design of the statue upon a specific psychological state is a truly revolutionary achievement, another "mutation," as far-reaching in its consequences as the new, functional conception of the human body that had made the St. Mark the earliest unequivocal instance of a Renaissance figure. The Renaissance itself was fully aware of the new dimension Donatello had conquered in the St. George: its writers, from Filarete on, stress "alertness" (*prontezza*) and "vividness" (*vivacità*) as the primary qualities of the statue, and Vasari, in calling it *fieramente terribile*, consciously evokes comparison with the art of Michelangelo. Even the poem by Grazzini must be regarded as a tribute, on its own peculiar level, not only to the proverbial fame of our figure—there were after all many other statues in mid-sixteenth century Florence that would have lent themselves better than ours to such a dubious purpose, iconographically speaking—but to its *vivacità*, its "living presence."

According to Kauffmann, *loc.cit.*, the youthful, beardless head of the St. George, as well as certain details of his costume, betray a relationship to Byzantine images of military saints (e.g., the St. George on the Harbaville Triptych) and their descendants in Italian Trecento art such as the Archangel Michael on the Orcagna Tabernacle in Or San Michele. He even suggests that the armorers' guild might have owned an older image of their patron saint that served as one of Donatello's models. Middeldorf, *loc.cit.*, also finds the costume of our statue evidence of an "obvious interest in Byzantine art," possibly transmitted through Venetian Gothic warrior types based on Eastern sources. However, the specimen he reproduces, a marble statuette in the Museum at Ravenna, strikes me as being no closer to our figure than the Florentine examples cited by Kauffmann (on the basis of O. v. Taube, "Die Darstellung d. hlg. Georg i. d. Italienischen Kunst," *Münchner Jahrbuch f. bild. Kst.*, VI, 1911, pp. 199ff, and W. F. Volbach, *Der hlg. Georg*, Strasbourg, 1917). They all help to define the iconographic background of our statue but none of them can claim any specific kinship to it. The actual source of the costume of the St. George is, I believe, so close at hand that it seems to have been overlooked so far: it is the soldiers on Ghiberti's panels for the North Doors of the Baptistery. Most of them, interestingly

enough, represent the same youthful, beardless type as our figure. The resemblance is particularly striking if we consider not only the statue but also the mounted St. George on the base relief (and its stucco replica in London, Victoria and Albert Museum, No. 7607-1861, which shows some of the details more clearly). While we cannot point to any single one among these Ghiberti soldiers as the direct model used by Donatello, taken collectively they do exhibit most of the features that distinguish the costume of our figure, including the helmet shown in the base relief (cf. especially the following scenes: Captivity, Christ before Pilate, Road to Calvary, Resurrection, Pentecost). Here the traditional military habit inherited from Byzantine art appears modified in two ways: Ghiberti has enriched it with classical surface ornament but at the same time he has introduced all sorts of realistic touches derived from the International Style. It is hardly surprising that Donatello should have taken advantage of this "modernized" type of armor, with further emphasis on its realistic aspect. A detailed study of the St. George by a specialist in arms and armor is badly needed in order to separate with greater precision the conventional from the functional elements of Donatello's design.

The base relief with the scene of St. George killing the dragon has been dated 1416 by the vast majority of scholars, usually on the basis of the Milanesi notice (Kauffmann, *D.*, p. 56, retains the date without conceding its documented status). The only dissenters are Pastor (*D.*, p. 55), who places the panel about 1428; Eric Maclagan and Margaret H. Longhurst (*Catalogue of Italian Sculpture*, Victoria and Albert Museum, 1932, p. 19), who believe it may be as late as c. 1430; and Planiscig (*D.*, p. 136), who dates it some four years after the statue. Assuming that Milanesi has given an accurate rendering of the factual content of the document in question, we see no reason to doubt that the "marble for the base of the tabernacle" was the slab from which our relief is carved. The transaction becomes far more meaningful if we think of it as involving not ordinary marble but a piece carefully selected for a special purpose. In view of the novel character of the base relief, with its subtle gradations of carving, it seems plausible enough that Donatello should have insisted on marble of the most flawless quality, and that such a piece could be procured only by special purchase from the Cathedral workshop. We cannot be sure, of course, that Donatello actually executed the relief as soon as the guild had provided him with the material. Yet in the ordinary course of events such would certainly have been the case; unless the likelihood of a delay can be demonstrated from internal evidence, there is nothing to

shake our confidence in the year 1417 as the date of execution of our panel.

The style of the St. George relief seems fully compatible with the accepted date of the work. So far as we know, this is Donatello's earliest relief, and it has all the freshness, the tentative, exploratory character of a first venture into *terra incognita*. At the same time we find here, in detail at least, a stronger link with the past than in any of the master's reliefs of the 1420's. The residual Gothic flavor of the figures has been noted repeatedly (most recently by Planiscig, *D.*, p. 30). Even the Princess, so strongly indebted to classical sources, still contains an echo of the fluid Gothic S-curve.[10] The horse is based, in part, on that in Nanni di Banco's relief beneath the St. Eloy at Or San Michele, or possibly on a common classical model (Kauffmann, *D.*, p. 215, n. 178). The St. George, on the other hand, clearly reflects the main outlines of the rider in Andrea Pisano's Horsemanship panel on the Campanile, whose pose, in turn, derives from the mounted soldiers in Roman battle reliefs (Schubring, *KdK*, p. xvii). For Donatello's purpose, the latter choice was somewhat unfortunate, since the Campanile horseman is riding *all'antica*, without stirrups and with his legs drawn up so as to permit maximum pressure against the body of the animal. Our St. George shows the same outmoded equestrian technique, even though he does have stirrups; he continues to cling to his mount with bent legs instead of standing in his stirrups and putting his full weight into the thrust of his lance. To my knowledge, this particular deficiency does not recur in any other versions of the subject, including those influenced by our relief. For the landscape features Kauffmann, *loc.cit.*, claims "close kinship" with a predella panel of 1388 in Bologna (Venturi, *Storia*, IV, fig. 675) as well as the influence of Hellenistic reliefs. These comparisons, however, are hardly more illuminating than the reference of Schottmüller (*D.*, p. 17, n. 3) to the landscape backgrounds of the reliefs on the front of the silver altar from the Florentine Baptistery (ill. in Reymond, *Sc. Fl.*, I, p. 206) as a possible point of departure for Donatello.

By far the most important, and historically most challenging, aspect of our panel is the rendering of deep, continuous space. This has been achieved, in part, through linear foreshortening, and in recent years the St. George relief has become the subject of considerable attention as an incunabulum of Renaissance perspective (Robert Oertel, "Die Frühwerke des Masaccio," *Marburger Jahrbuch f. Kunstw.*, VII, 1933, p. 14; Kauffmann, *D.*, pp. 58f; John White, "Developments in Renaissance Perspective—II," *Journal of the*

Warburg and Courtauld Institutes, XIV, 1951, pp. 44f; Ottavio Morisani, *Studi su Donatello*, Venice, 1952, pp. 88ff). There is a tendency, perhaps involuntary to some extent, among the authors of these analyses to overstate the case: Kauffmann calls our relief the earliest example of a consistently constructed "perspektivisches Raumbild"; Morisani states that the architecture shows "un'inflessibile rispondenza alla regola scientifica"; and even White, generally far more cautious, goes too far in claiming that the orthogonals of the squared floor on the extreme right vanish to the same point as those of the side wall. The most that can be said of them is that they run in the general direction of the main vanishing point. The entire building is not "constructed" with ruler and compass but sketched freehand, so that it defies any test of accuracy in the mechanical sense. For this very reason, it is quite impossible to deduce from it what rules, if any, of geometric perspective Donatello actually knew in 1417 (apart from the general and still imprecise notion of a single vanishing point for the orthogonals).

What he did *not* know is obvious enough: the vanishing point is not only placed too high in relation to the figures—it is also above, rather than on, the horizon. And the front of the building, visible on the extreme right, recedes instead of running parallel to the plane of the relief. Moreover, the lines of roof and lintel do not converge towards a secondary vanishing point on the right, as they should if an oblique view of the building was intended (cf. White, *loc.cit.*). The temptation to link our relief to the early perspective studies of Brunelleschi is, of course, a strong one, especially since Donatello's building is so conspicuously free from Gothic elements; its Corinthian pilasters and round arches anticipate the vocabulary, if not the proportions, of Early Renaissance architecture. But here again we must beware of overstatement. This arcade approaches the façade of the Ospedale degli Innocenti about as closely as Donatello's knowledge of foreshortening at that time does the full-fledged systematic perspective of Masaccio's Trinity mural.

Fundamentally, linear perspective—good, bad, or indifferent—only enhances but does not create the sense of depth conveyed by our relief to such an unprecedented degree. Even if we cover up the building on the right entirely, the illusion of depth is not seriously impaired. The real secret of Donatello's success is not his use of projective geometry but the novel mode of relief carving of which the St. George panel represents the earliest known instance. Compared to subsequent examples such as the Naples Assumption or the London Delivery of the Keys (see below, pp.

[10] Reymond, *Sc. Fl.*, II, p. 93, compares her to the Virgin in Ghiberti's Annunciation panel for the North Doors; for possible Ancient prototypes see Aby Warburg, *Gesammelte Schriften*, Leipzig, 1932, I, p. 13, and A. Meyer-Weinschel, *Renaissance und Antike*, Reutlingen, 1933, pp. 30f.

88ff, 92ff) this mode is still in an experimental stage here, and it seems entirely possible that our panel marks the actual discovery of the process, known as *rilievo schiacciato* ("pushed-in," "flattened-out" relief). The revolutionary qualities of the new mode are far from easy to define. Vasari, in Chapter X of the Introduction to his *Vite*, describes it as an extreme form of low relief, of the kind that may be seen on Aretine pottery, Ancient cameos, and coins, but this does not account for its special effectiveness in rendering space. Nor is *schiacciato* essentially a drawing engraved on the stone (Kauffmann, *D.*, p. 57, speaks of our panel as a picture drawn upon the marble surface in such a way that the subsequent carving of the relief seems hardly necessary to clarify the internal relationships). Genuine *Ritzzeichnung*—to borrow Kauffmann's term —occurs only in the squared floor of the building; everywhere else in our panel, linear grooves are used only to emphasize the contours of raised or sunken surfaces. On the other hand, it would be equally incorrect to view *schiacciato* as an ordinary relief whose forms have been subjected to proportional reduction in depth; the traditional rule, still followed by Ghiberti, according to which the plasticity of the forms varies in inverse ratio to their distance from the beholder, no longer applies to our relief: the haunches of the horse, for instance, are far more strongly modeled than the hooves, which show the same shallowness of carving as the trees of the background landscape. According to the "classic" categories of relief promulgated by Adolf von Hildebrand, *schiacciato* is a form of pictorial relief that encroaches upon the realm of painting by the inclusion of such features as landscape and architectural vistas. This definition, often applied to the St. George panel (e.g. by Schottmüller, *D.*, pp. 15f), regards *schiacciato* merely as the logical extension of a development that began with the pictorial reliefs of Hellenistic times; it fails to acknowledge the spatial unity and continuity that distinguishes Donatello's new mode from its predecessors, not only in degree but in kind. The Hildebrandian view also suffers from a built-in negative bias that is difficult to share today. The means by which *schiacciato* achieves its effects are, after all, sculptural rather than graphic or pictorial, so that the question of its technical legitimacy becomes quite irrelevant. Yet the new mode of relief may be termed "pictorial" in one very important sense; it does have a basic kinship with the new style of painting that emerged around 1420 in the work of Masaccio and the van Eycks. A *schiacciato* panel "reads" more like a picture than like a conventional relief, because the sculptor's primary concern here is not with plastic volume but with *valeurs* of light and shade. These tonal values, achieved through minute, precisely controlled gradations of the relief surface, make it possible to render distances in terms of atmospheric perspective and thus extend the illusion of depth to the farthest horizon. All this, of course, does not mean that *schiacciato* is to be regarded as an "imitation" of painting. Quite apart from the circumstance that the St. George panel antedates the earliest known examples of the kind of picture that might have inspired it, it should be obvious that the method itself is based on technical and aesthetic experience of a uniquely sculptural sort: only a marble carver supremely sensitive to the impact of his tools upon his material could have discovered how to exploit the incidence of light on sculptured form in such a way as to make it the counterpart of *chiaroscuro* in painting. (Unfortunately, the delicate surface of our panel has been damaged by stains and erosion, so that the full subtlety of the carving is difficult to observe today.)

For Ghiberti, whose reliefs were made by an additive rather than a subtractive process (i.e., they are raised against a pre-existing background, not carved into it), the visual unity of *schiacciato* was unattainable. Nevertheless, the North Door panels show certain pictorial tendencies—perhaps because of his early training as a painter—that make them the only contemporary antecedents for the St. George relief. In his attempts to extend the spatial depth of the scenes, Ghiberti sometimes resorts to extremely low levels of modeling for small areas, as in the distant views of the city gate in the Entry into Jerusalem and the Road to Calvary. This has the effect of "softening" the blank surface of the background so that it no longer acts as a mere neutral carrier; it absorbs the most distant and shallow forms and thus assumes some of the qualities of air-filled space. Another device of Ghiberti for gaining additional space is to let the forms emerge obliquely from the background, with smooth transitions from low to high relief (e.g. the God the Father of the Annunciation and the angels in the Nativity, the Temptation, and the Garden of Olives). In scenes with architectural settings, he achieves this effect by placing the structures at odd angles to the relief plane, or by bending them into curves (note the throne of St. John the Evangelist or the arcade in the Expulsion). Most of the buildings show a good deal of linear foreshortening, not as violent as that of the arcade in Donatello's panel yet similar in intent. Even the peculiar proportions of that arcade have their counterpart in Ghiberti's architecture, although they occur in Trecento painting as well. Needless to say, Ghiberti's approach to illusionistic space in the North Doors is hardly more than a faint adumbration of the principle of *schiacciato*. Still, it cannot be by-passed

as a stimulus to the young Donatello.[11] Here again, as in his early statues, our artist's starting point lies in Ghibertesque territory.

The gable relief showing God the Father Blessing has, until recently, received very little attention, even though Vasari explicitly claims it for Donatello. In the older literature it is mentioned only by Franceschini (*op.cit.*, p. 84, n. 2), Reymond (*Sc. Fl.*, II, p. 93), and Venturi (*Storia*, VI, p. 246), all of whom simply paraphrase Vasari's statement about the panel. Kauffmann (*D.*, p. 67) drew attention to its kinship with the Pazzi Madonna (compare Pl. 19b), and in the same year Lányi (*Ril.*, pp. 284ff) published a more detailed stylistic analysis, supported by an excellent photograph taken at his request (the relief had never been adequately reproduced before). That the piece should have been so largely overshadowed by its more famous companions is understandable enough, quite aside from the difficulty of inspecting it at close range. It is so much a part of the architectural framework of the niche that to most scholars it hardly seemed worth individual scrutiny. The half-length figure of God is indeed a traditional motif for the gables of the Or San Michele tabernacles—it occurs on all three of the niches whose sculpture was provided by Nanni di Banco—and Donatello's is no more prominent than the rest. Our relief is his only piece of architectural sculpture in a mediaeval setting. Even here, however, as Lányi has pointed out so well, the experimental spirit of Donatello comes to the fore: this gable relief is carved in *schiacciato*, as against the high relief of Nanni's gables, so that its plastic volume is rendered by illusionistic means and the triangular field assumes the character of a window from which the figure emerges. The molding of the frame has a curious double function that emphasizes the new relief concept; on the one hand, it belongs to the architecture of the niche, yet it also serves as a "window frame" which is an integral part of the relief—God the Father uses it as a sill on which to rest his book, and near the apex his halo overlaps it. Again in contrast to Nanni di Banco, Donatello has chosen a rigid frontal view, thus endowing his figure with a solemnity entirely appropriate to the subject. At the same time, this frontality must have presented a special artistic challenge that he was anxious to meet: how to create the appearance of a three-dimensional figure in space under such restricted conditions. He has solved the problem with the same means he had employed in the St. George panel, precise control of tonal values aided by bold foreshortening in certain details (the hands and the halo). We may confidently assume, then, that the God the Father is contemporary with the base relief. I place it in the same year but after, rather than before, its companion, because of what seems to me a slightly greater assurance in handling the technical problems of *schiacciato*. The same conclusion could be reached without reference to the St. George panel by comparing our figure with the statue of St. John the Evangelist, which it echoes in some respects across a gap of several years, or by considering its ancestral relationship to the Pazzi Madonna.

If the authorship of the gable relief is beyond doubt, the same can hardly be said of the design of the tabernacle itself. Franceschini (*op.cit.*, p. 84) states that Donatello received the commission for it in 1415. This claim, made without supporting evidence of any sort, was nevertheless accepted by Reymond (*Sc. Fl.*, I, p. 202; II, p. 92) and Bode (*Jahrbuch Kgl. Preuss. Kunstslgn.*, XXII, 1901, p. 2) even though both authors stressed the purely Gothic style of the niche. Bode accounted for this by assuming that the guild had insisted on a traditional design, so that Donatello's personal taste could assert itself only in the fine proportions and the spaciousness of the niche, while in the base relief he was free to introduce the architectural vocabulary of the Early Renaissance. Paatz, *Kirchen*, IV, pp. 540f, n. 113, inclines towards Bode's opinion but points out that the niche is a good deal shallower than those of the earlier tabernacles (the wall behind it contains a staircase that would have prohibited a greater depth). In the absence of documentary proof, there appears to be only one tangible argument among those adduced in favor of Donatello as the designer of the tabernacle: the lack of marble incrustation inside the niche. But this might just as well be due to external causes, such as a lack of money. It is certainly an insufficient reason to charge Donatello with responsibility for a structure which in every other respect is entirely conventional and unadventurous.

[11] Kauffmann, *loc.cit.*, places the early reliefs of Ghiberti in absolute opposition to the St. George panel and, rather inexplicably, cites Andrea Pisano and Brunelleschi's Competition Relief as precedents for the latter; cf. the well-taken objections of Middeldorf (*AB*, p. 583) who stresses—somewhat too emphatically perhaps—the basic similarity of aim in Ghiberti's and Donatello's reliefs.

MARBLE STATUES OF PROPHETS FOR THE CAMPANILE OF FLORENCE CATHEDRAL
MUSEO DELL'OPERA DEL DUOMO, FLORENCE

PLATES 13-17, 124e, f	*1416-1435*

	BEARDLESS PROPHET	
PLATES 13a, 15b	(east side, first niche from the left)	*(1416-1418)*
	H. 190 cm; W. of base 59 cm; D. of base 43 cm	

	BEARDED PROPHET	
PLATES 13b, 15a	(east side, fourth niche from the left)	*(1418-1420)*
	H. 193 cm; W. of base 64 cm; D. of base 44 cm	

	ABRAHAM AND ISAAC	
PLATES 13c, 14b, 15c	(east side, third niche from the left)	*1421*
	H. 188 cm; W. of base 56 cm; D. of base 45 cm.	

	ZUCCONE	
PLATES 15d, 16a, 124e	(west side, second niche from the left)	*(1423-1425)*
	H. 195 cm; W. of base 54 cm; D. of base 38 cm. Inscription: on front edge of plinth, OPVS DONATELLI	

	"JEREMIAH"	
PLATES 16b, 17a, b, 124f	(west side, third niche from the left)	*(1427-1435)*
	H. 191 cm; W. of base 45 cm; D. of base 45 cm. Inscriptions: on front edge of plinth, OPVS DONATELLI; on the scroll, GEMIA	

DOCUMENTS

A number of entries among the records of deliberations and disbursements by the *operai* of the Florence Cathedral workshop, in the archives of the Opera del Duomo, known, in part, to Semper (*D.* '75, pp. 276ff), Milanesi (*Vasari*, II, pp. 404, 427) and other scholars of the late nineteenth century (see Paatz, *Kirchen*, III, pp. 555ff, notes 458-460, 464-467). They were rendered most completely and systematically by Poggi (*Duomo*, pp. 37ff), whose numbering we reproduce. Also Michelozzo's *Catasto* Declaration of 1427, first published, incompletely, by G. Gaye (*Carteggio inedito . . .* , I, Florence, 1839, pp. 117f), fully transcribed by Cornel v. Fabriczy (*Jahrbuch Kgl. Preuss. Kunstslgn.*, XXV, 1904, Beiheft, pp. 61f) and again, independently but without substantial deviations, by Rufus Graves Mather (*Art Bulletin*, XXIV, 1942, p. 228).

1415, December 5 (*222*): Donatello has been commissioned to do two figures of white marble for the Campanile.

1416, March 11 (*224*): Donatello receives 10 florins for the two Campanile figures he is to carve.

1418, June 28 (*227*): Donatello receives an advance of 20 florins for a marble figure he is working on.

September 2 (*228*): Donatello is advanced 25 florins for a certain marble figure he is working on for the Campanile.

December 18-19 (*230, 231*): Donatello has finished a marble prophet for the Campanile, which has been appraised at 100 florins; he is to receive 45 florins as the sum still due him.

December 23 (*232*): Donatello has received an advance of 30 florins for a marble prophet for the Campanile.

1419, October 11 (*238*): Donatello receives an advance of 25 florins for a marble figure he is doing for the Campanile.

1420, July 24 (*243*): Donatello is credited with 95 florins, the appraised value of a marble figure he has done for the Campanile.

1421, March 10 (*245*): Donatello and Nanni di Bartolo called Rosso are jointly commissioned to do a second figure of marble for the Campanile. In Donatello's absence Nanni accepts the assignment in the name of both artists.

May 30 (*248*): Donatello and Nanni are advanced 20 florins for the figure of a prophet with a nude boy at his feet which they are doing for the Campanile.

August 4 (*249*): Donatello and Nanni are advanced 10 florins more for the prophet with his son at his feet which they are doing for the Campanile.

November 6 (*251*): Donatello and Nanni are to receive 95 florins, the remainder still due them for the figure of the prophet Abraham with the boy at his feet, which they have made for the Campanile and which has a value of 125 florins.

1422, September 1 (*255*): Four marble statues have been carved for the Campanile but are still in the workshop. These the master-in-charge of the *opera* is to install in their appointed places as quickly as possible.

1423, March 9 (*260*): Donatello receives 20 florins in part payment for a marble figure he is working on for the Campanile.

August 27 (*263*): Donatello receives 25 florins in part payment for a figure he is working on, and has almost finished, for the Campanile.

September 28 (*265*): The consuls of the *Arte della Lana* and the *operai* of the Cathedral declare void all outstanding commissions for statues that have not yet been started, and agree that the *operai* may not order any statues from now on without the consent of at least two-thirds of the consuls of the guild.

1425, May 16 (*272*): Donatello is to receive 18 florins in part payment for a marble figure he has made for the Campanile.

June 1 (*273*): Notwithstanding the previous resolution (of September 28, 1423), Donatello retains the commission for the figure he has just done for the Campanile, and the *operai* are free to grant him such payment for it as they deem suitable.

1426, February 18 (*279*): Three masters have been chosen by lot to appraise the marble figure just finished by Donatello.

March 18 (*280*): The marble figure recently completed by Donatello, which is a prophet for the Campanile, has been appraised at 95 florins; the master is to receive 26 florins as the remainder still due him.

1427, February 11 (*284*): Donatello receives 25 florins in part payment for a statue he is doing for the Campanile.

About July 11, Michelozzo's *Catasto* Declaration (the day and month are missing, but it seems plausible to assume that he made out his Declaration at the same time that he wrote Donatello's, which carries the above date; see Fabriczy, *op.cit.*, n. 1, and Rufus Graves Mather, *Rivista d'arte*, xix, 1937, p. 186): As the last of the commissions jointly undertaken by him and Donatello since they "became partners about two years ago," Michelozzo lists a marble figure 3⅓ braccia tall for S. Maria del Fiore, which is about three-quarters finished. He expects it to be appraised at 90 to 100 florins. They have already received 37 florins in advance.

1428, March 19 (*293*): Since at present it cannot be determined what statues the Cathedral still needs; since contracts for these statues might have to be canceled; since employees of the *opera* have often been getting advances, partly for fear of sudden dismissal; and since sculptors have been getting permission to carve their statues outside the Cathedral workshop, which has worked to the disadvantage of the *opera*: therefore it is now resolved that no statues will be commissioned for the next three years, beginning July 26, 1428.

1431, February 5 (*307*): The master-in-charge of the *opera* is to install three statues, which are now in the workshop, in certain vacant places on the Campanile.

1434, January 31 (*316*): Donatello is advanced 22 florins for a statue he is doing of the prophet Habakkuk.

1435, April 27 (*320*): The large figure made by Ciuffagni is to be placed on the façade of the Cathedral, and a figure by Donatello is to be placed on the Campanile.

June 15 (*322*): Donatello receives 10 florins in part payment for the marble figure of Habakkuk he is doing.

1436, January 11 (*323*): Donatello's Habakkuk has been appraised at 90 florins; the master is to receive 21 florins as the remainder still due him.

January 28 (*324*): Donatello is to be paid 15 florins for the block from which he carved the Habakkuk.

1464, August 8 (*331*): The very beautiful four statues on the side of the Campanile facing the church are to change places with those on the side facing the Baptistery, which are very crude in comparison.

SOURCES

(Before 1472) *XIV uomini singhularj in Firenze dal 400 innanzi* (ed. Gaetano Milanesi, *Opere istoriche edite ed inedite di Antonio Manetti*, Florence, 1887, p. 164): "Donatello made many things . . . of marble on the Campanile of S. Maria del Fiore facing the square."

1510 Albertini, p. 10: "The Campanile is adorned with . . . very beautiful statues, of which Donatello did the four facing towards the square and two facing towards the Porta dei Canonici."

(Before 1530) Billi, pp. 38f: "[Donatello did] . . . two figures on the Campanile, on the side towards the square: one is a likeness, drawn from nature, of Giovanni di Barduccio Cherichini, the other represents the young Francesco Soderini; [they are standing] side by side, towards the Canonica."

1537-1542 Cod. Magl., pp. 75f: "[Donatello] . . . made six marble figures for the Campanile: four on the side towards the square, the two in the center being portraits from life of Giovanni di Barduccio Cherichini and the young Francesco Soderini; and two figures on the opposite side, above the entrance to the Campanile, an Abraham sacrificing Isaac and the figure next to it."

(c. 1550) Gelli, p. 58: "[Donatello] . . . did three life-size marble figures on the Campanile: the Abraham with Isaac on the side towards the Canonica and the two in the center of the opposite side, the young one and that bald old man (*vechio zuchone*) next to him who seems to lack only the power of speech. Donatello was aware of this, too; according to an assistant of his who was present when he carved that figure, he kept saying, "Speak! Speak!" It is said that he modeled it from life and that the old man is Giovanni di Barduccio Cherichini and the young one Francesco Soderini, two friends of his whom he saw frequently."

1550 Vasari-Ricci, pp. 50f (Milanesi, pp. 404f): "On the front face of the Campanile he did four marble figures 5 braccia tall; the two in the center are portraits from life and represent the young Francesco Soderini and Giovanni di Barduccio Cherichini, today called il Zuccone. As the latter was held to be a very rare work and more beautiful than anything else he ever did, Donatello used to say, when he wanted to take a particularly impressive oath, "By the faith I bear to my Zuccone"; and while he was working on the statue, he would gaze at it and say, "Speak, speak, or the bloody dysentery take you!" On the side of the Campanile towards the Canonica, above the entrance, he did an Abraham about to sacrifice Isaac, and another prophet; these were placed in the center between two other statues." (A much shortened paraphrase of this passage appears in Borghini, *Riposo*, pp. 318f, a longer one in Bocchi, *Bellezze*, pp. 21f.)

1568 Vasari-Milanesi, VII, pp. 306f (description of the decorations in S. Lorenzo for the funeral of Michelangelo): "Inside the first chapel next to the high altar towards the old sacristy, there was a painting . . . showing Michelangelo in the Elysian Fields, and on his right, considerably over life-size, the most famous painters and sculptors of the ancients, each with a characteristic attribute. . . . And similarly on the left the illustrious artists of our own era since Cimabue: Giotto with a tablet showing the young Dante, as he had painted him in S. Croce; Masaccio, a portrait from life; and likewise Donatello, accompanied by his Zuccone of the Campanile. . . ."

1596 Bernardo Davanzati, preface of his translation of Tacitus' *Annales* into Tuscan (modern edition in *Opere*, ed. Enrico Bindi, Florence, 1852; the passage cited below is reproduced, with German translation, in Semper, *D '75*, pp. 123f, 257f, n. 105): "Thus the [verbal] peculiarities sanctioned by gentlemen and by usage are not vulgarisms but [sources of] energy and strength. Neither Homer nor Dante eschew them in their sublime poems whenever they express themselves forcefully. Everything, then, depends on the context. Donatello knew this well enough when he carved the eyes of the famous Zuccone on the Campanile of our Cathedral, which look as if they had been hollowed out with a spade; had he made them for the normal view, the figure would now appear blind, for distance devours diligence. And a generous recklessness (*sprezzatura magnanima*) renders the [artist's] concept more vivid rather than debasing it, as in portraying some great wrath, treachery, revolt, or fury, for instance, which takes not "proper" words but appropriate ones. Nor do the rough-hewn blocks of the great palaces diminish—nay, they enhance—the majestic effect of the structure."

The statues on the east side of the Campanile were presumably installed there soon after September 1, 1422 (cf. doc. 255); the rest originally stood in the niches of the north side, where they had been placed in 1431 and 1435 (cf. docs. 307, 320), until 1464, when they changed places with the Trecento statues on the west side. All the statues were removed from their niches for safekeeping in 1940. They have been in the Museo dell'Opera since their return to Florence ten years ago.

The literature on this series of figures reflects the difficulty of coordinating the individual statues with the appropriate documents, which refer not only to Donatello but also to Ciuffagni, Nanni di Bartolo, and Giuliano da Poggibonsi. Moreover, they concern the statuary *décor* of both the Campanile and the Cathedral façade without, in every case, distinguishing between the two concurrent projects. The entries cited above include all those in which the name of Donatello is mentioned, except for two (Poggi, docs. 226, 250) that appear elsewhere (see below, p. 225) since they refer to the so-called "Poggio," on which our master did not do any actual work. Of the eight statues that until recently occupied the niches on the east and west sides of the Campanile, only one can be eliminated without further ado as a possible work of Donatello and has never been so considered in modern times: the Obadiah, from the southernmost niche of the west side, signed by Nanni di Bartolo (see below,

pp. 228f). Another figure, the unnamed prophet from the second niche from the left on the east side, is so traditional in style that it, too, can be regarded as *hors de concours*; Poggi (*Duomo*, p. lviii) and Giulia Brunetti (*Bolletino d'arte*, XIII, 1934, p. 258) proposed to identify it as the Joshua that was left unfinished by Ciuffagni in 1417 and turned over to Donatello and Nanni di Bartolo for completion, but this suggestion has been clearly refuted by Lányi (*Statue*, pp. 267ff), who believed that the statue in question must be the prophet for the façade which Giuliano da Poggibonsi was commissioned to carve on December 30, 1422 (see Poggi, docs. 259, 264-266). In any event, it cannot be the Joshua, since it is carved from a single block while the Joshua, according to the documents, had a separately carved head (see below, pp. 225ff). Lányi (*op.cit.*) also eliminated a third figure, the "St. John" from the northernmost niche of the west side, which had hitherto been regarded as an unquestionable work of Donatello about 1415-1418. I, too, have come to reject it (see below, pp. 228ff). We are thus left with five statues, only one of which can be identified without question: the Abraham and Isaac, executed jointly by Donatello and Nanni di Bartolo between March and November 1421 (cf. docs. 245, 248, 249, 251 above; in doc. 245, the figure is called a second joint commission, apparently a reference to the unfinished Joshua of Ciuffagni, which had passed through both artists' hands; see below, pp. 225f).[1]

[1] The fact that Nanni could accept the commission for both himself and Donatello suggests that the two masters had entered into a kind of partnership somewhat like that between Donatello and Michelozzo a few years later. The arrangement

Since the Abraham was a joint commission, the documents do not record how much of the total price of 125 florins went to each artist, and we have no external data to help us in determining the division of labor. That the design of the group is by Donatello has been acknowledged by every critic; but most of them, from Schmarsow (*D.*, p. 19) and Tschudi (*D.*, p. 8) to Kauffmann (*D.*, pp. 32ff) and Planiscig (*D.*, p. 33), have credited Nanni with a major share in the execution, especially of the Isaac. As against this view, by now traditional, Ottavio Morisani (*Studi su Donatello*, Venice, 1952, pp. 123ff) rightly emphasizes the very high over-all quality of the carving, never properly assessed while the statue remained in its niche; even the head and body of Isaac now reveal an unsuspected subtlety of touch. Thus Nanni's labors would seem to have been confined to the essentially technical task of roughing-out the block after Donatello's design and to the carving of unimportant details such as the bundle of firewood or the back of the Abraham, which play no part in the aesthetic impact of the group. Morisani also corrects the overemphasis on the physical drama in previous interpretations of the work: Abraham is not "about to plunge the knife into his son" (as suggested by Schubring, *KdK*, p. xix, and Kauffmann, *loc.cit.*) but his tensed right arm is beginning to grow slack, the knife is sliding away from the boy's throat. In other words, we see the moment "after the event"—the angel has come and gone—rather than the climax itself, and for a few instants, while the father's gaze is still fixed upon the apparition, no movement occurs. Only thus could Donatello do justice both to the psychological demands of the story and to the formal necessity of a stable group fitted into the narrow Gothic niche. The compositional problem he faced is similar to that of the Abraham and Isaac groups on certain Early Christian sarcophagi, which may have inspired Donatello to some extent (Schubring, *loc.cit.*; Middeldorf, *AB*, p. 574), although the connection must not be exaggerated. Entirely without substance, as Morisani has pointed out (*op.cit.*, p. 130, n. 12), is the contention that Donatello's Abraham derives from the so-called Pasquino (Géza de Francovich, *Bolletino d'arte*, IX, 1929, p. 146, who cites it as proof of the master's Rome journey in 1402-1403).

The remaining documents permit the following conclusions: at the end of 1415, Donatello was commissioned to do two marble prophets for the Campanile; he began work on these in 1416 and finished one of them in 1418. By December, the statue had been appraised at 100 florins; the advance payments received by the master, amounting to 55 florins (docs. *224, 227, 228*), were deducted from the total, and disbursement of the remainder of 45 florins was authorized. For brevity's sake, let us designate this statue as D-I. The second prophet, D-II, must have been well under way late in 1418, for on December 23 Donatello was granted the sizeable advance of 30 florins for it. Another advance, of 25 florins, followed on October 11, 1419 (docs. *232, 238*), and on July 24 of the next year he was credited with 95 florins, the appraised value of the figure (doc. *243*). Presumably he received 40 florins at this point (i.e. 95 florins less 55 florins in advance payments), although the transaction is not among the published records. In any event, D-I, D-II, and the Abraham were among the four statues ready for installation on the Campanile on September 1, 1422 (doc. *255*); the fourth was either the Joshua of Ciuffagni, which Nanni di Bartolo had completed in April 1421 (doc. *247*), or Nanni's "Ulia," referred to as recently finished on September 22, 1422 (doc. *256*). Donatello's next Campanile figure, D-III, was appraised at 95 florins early in 1426 (docs. *279, 280*), and the master received a final payment of 26 florins for it, indicating that he had been advanced 69 florins. The recorded disbursements to him since the final accounting for D-II amount, however, to only 63 florins (45 florins in 1423, 18 in 1425; docs. *260, 263, 272*); the missing 6 florins, which he must have received, may be hidden in some other account book. A year later, on February 11, 1427, we learn that Donatello is at work on a fourth statue, D-IV, for which he receives an advance of 25 florins (doc. *284*). This, surely, is the same figure listed as a joint enterprise in Michelozzo's *Catasto* Declaration a few months later. Michelozzo states that he and his partner have been paid 37 florins so far for it, which means that a second advance payment, of 12 florins, was made between February and July 1427, even though it has not yet turned up in the account books. After this, for almost seven years, there is no further reference in the documents to any Campanile statues by Donatello, until, in 1434 and 1435, he receives a total of 32 florins in advance

may have been intended for this one project only, since Nanni carried out the "Ulia"-Obadiah independently the following year. Apparently it was the pressure of the *operai* for speedy delivery, so evident in the documents at this time, that brought the partnership about. On the other hand, Donatello himself may have wanted to ease the burden of his commitments by envisaging a more permanent association with Nanni. If such was the case, any further development of his plan became impossible when Nanni left Florence in the spring or summer of

1423. (He is last mentioned in Florence in Poggi doc. *261*, of March 30, 1423; doc. *268*, of February 11, 1424, refers to him as having been absent from the city for many months and being unable to return because of unpaid debts.) Still, it is possible that the partnership with Nanni helped to pave the way for Donatello's collaboration with Michelozzo, which may have begun as early as 1423-1424, rather than in 1425 (see below, pp. 54f).

payments for a Habakkuk which he completes by the end of the year. On January 11, 1436, the figure has been appraised at 90 florins and the master is about to be paid 21 florins as the final installment on this price. The place for which the Habakkuk was destined is not explicitly stated in the documents, but it must be identical with D-IV for the Campanile, since the 37 florins disbursed in 1427 for the latter statue amount to the difference between the appraised value of the Habakkuk and the total of 53 florins actually paid out for it (see docs. *316, 322, 323*). The financial computation proving the identity of D-IV with the Habakkuk was first made by Lányi (*Statue*, pp. 144ff), who thus put an end to the uncertainty that had prevailed among earlier authors on this score.[2]

Which of the Campanile statues correspond to D-I and D-II? Semper (*D. '75*, p. 106), whose opinion was generally accepted until the publication of Poggi's *Duomo*, claimed that one of the two must be the "St. John" but did not commit himself on the other. Schmarsow (*D.*, p. 18) and Tschudi (*D.*, pp. 7f) believed them to be the "St. John" and the beardless prophet of the east side (the latter, for reasons I have been unable to ascertain, was then known as a Habakkuk). Poggi (*Duomo*, p. lix) and Colasanti (*D.*, pp. 17ff) equated D-I with the beardless prophet and D-II with the bearded prophet of the east side, whom Schottmüller had quite arbitrarily dubbed a "Moses" (*D.*, pp. 50, n. 1; 63, n. 4; 121) while Schmarsow had identified it with the Joshua of Ciuffagni (*D.*, p. 19; see below, p. 226). Kauffmann (*D.*, pp. 23ff) and Nicholson (*op.cit.*, p. 99) returned to Schmarsow's view but specified the "St. John" as D-I (1416-1418) and the beardless prophet as D-II (1418-1420). The thorough analysis of the entire problem by Lányi (*Statue*, pp. 274ff) has finally vindicated the opinion of Poggi. With the "St. John" eliminated, there is indeed no other choice, unless we are willing to concede the possibility that D-I and D-II might be the Zuccone and the "Jeremiah." The documents do not help us here; after all, the four Campanile statues ready for installation on September 1, 1422, could have included the Zuccone and the "Jeremiah" instead of the beardless and bearded prophet, in addition to the Abraham. However, as Lányi (*loc.cit.*) has pointed out, the niches which the *operai* proposed to fill with those four statues must have been those of the east side rather than of the north side (which offers a poor view of its sculptural *décor* because it is so close to the southern flank of the Cathedral), so that D-I and D-II

are more than likely to be among the neighbors of the Abraham. Considerations of style lead to the same conclusion: the beardless and the bearded prophet can be viewed without difficulty as intermediary links in a chain connecting the St. Mark of Or San Michele with the Abraham, while the two prophets from the west side are clearly more advanced than the Abraham. The quality of execution of the beardless and bearded prophet, especially of the latter, has usually been assessed too low; here, as with the Abraham, inspection at close range reveals unsuspected virtues today. It is only in the drapery that an occasional lack of decisiveness suggests the hand of an assistant. Since these slight local weaknesses recur in very much more severe form in the "St. John," the assistant was probably the young Nanni di Bartolo, whose artistic beginnings would thus lie entirely within the Donatello workshop. (Giulia Brunetti, *Bolletino d'arte, loc.cit.*, postulates a pre-Donatellesque phase for Nanni on the basis of the second prophet from the left on the east side, which she believes to be in all essentials by him even though she identifies the figure with the unfinished Joshua of Ciuffagni.) As for the chronological sequence of the two statues, Poggi is surely correct in regarding the beardless prophet as the earlier; there is in its drapery a certain preference for curvilinear seams and a pliability that link it with similar residues of the International Style in the St. Mark and the St. George. The bearded prophet, on the other hand, is the immediate predecessor of the Abraham. The pensive pose reflects an ancient model of the "Thusnelda" type, and the majestic, idealized features approach those of the Abraham and the prophet's head of 1422 on the Porta della Mandorla (see below, p. 43). They hold no surprise for us, since Donatello had given the same kind of head to the St. John Evangelist and the St. Mark (Pls. 5d, 7). In contrast, the head of the beardless prophet is the first of its kind; here our artist achieves a degree of realism in the portrayal of old age that has its only parallels in certain heads of Claus Sluter's Moses Well (Reymond, *Sc. Fl.*, II, pp. 93f, sees Donatello as dependent on this "Burgundian realism" and cites the Burgundian parentage of Michelozzo as a link between Dijon and Florence; the connection need not be denied, but it is at best an indirect one; cf. also the opinions of Courajod and Vöge, cited above, p. 19). Francovich (*op.cit.*, p. 147) and Nicholson (*op.cit.*, p. 87) derive this head from Roman portrait busts and compare it, respectively, to specimens in the Capitoline Museum and the Vatican. At first

[2] Kauffmann (*D.*, p. 29) also assumes that the documents between 1423 and 1436 involve only two statues by Donatello; Poggi (*Duomo*, p. lx) and Colasanti (*D.*, pp. 17ff) regard D-IV and the Habakkuk as separate entities, in addition to D-III, which they identify with the "St. John" of the west side; Alfred Nicholson ("Donatello: Six Portrait Statues," *Art* ... *in America*, xxx, 1942, p. 80n) likewise divorces D-IV from the Habakkuk and identifies the latter with the "Poggio," on the ground that the documents do not specify the intended location of the Habakkuk. For the "Poggio" problem see below, pp. 225ff.

glance, these confrontations seem striking enough, yet one wonders if they—or others of the same sort—are sufficient to prove Donatello's acquaintance with Roman portraiture at that time. What links the head of the beardless prophet with the busts in question is not a quality of style but the recording of certain physiological effects of old age that could have been observed quite independently. However that may be, the features of the beardless prophet mark an important step in the artistic evolution of Donatello and of Early Renaissance art as a whole. In this head—the earliest of his career that could give rise to the legend of actual portraiture (see below, pp. 40f, 226)—our artist explores for the first time a realm of physical and psychological experience that was to find its fullest expression in the Zuccone and the "Jeremiah" (the "Poggio" head, which I attribute to Nanni di Bartolo, likewise derives from that of the beardless prophet; see below, p. 228).

The chronological relationship of the remaining two statues, the Zuccone and the "Jeremiah," poses a far more difficult problem. That one of them must be D-III (1423-1426) and the other D-IV (the Habakkuk of 1427-1435) has been established beyond reasonable doubt by Lányi. But which is the later of the two? For Lányi this question answers itself: since one of the figures is identified as a Jeremiah by the inscription on its scroll, the Zuccone must be the Habakkuk (Poggi, *Duomo*, p. lx, had used the same argument); here, he states, is a fact that needs no corroboration and cannot be shaken by stylistic arguments. As a consequence, he makes no attempt to show that the "Jeremiah" is earlier in conception than the Zuccone. Kauffmann (*D.*, p. 26) and Nicholson (*op.cit.*, p. 99), on the other hand, place the Zuccone before the "Jeremiah" on stylistic grounds, disregarding the inscription on the latter statue entirely, as had the majority of earlier scholars (e.g. Schmarsow, *D.*, pp. 19f; Tschudi, *D.*, p. 9; Schottmüller, *D.*, pp. 66f; Middeldorf, *AB*, p. 579). How is this impasse to be resolved? Must the documentary evidence be given greater weight than considerations of style? Curiously enough, the factual basis of Poggi's and Lányi's argument, i.e., the inscription on the scroll of the "Jeremiah," never seems to have been questioned (its authenticity is taken for granted also by Paatz, *Kirchen*, III, p. 557, n. 460). Nor indeed can there be any doubt of its Quattrocento character. But this is no assurance that it was placed on the statue by Donatello and therefore represents the original identity of the prophet. Could it not have been added later, perhaps on the occasion of the transfer of the four figures from the north to the west side of the Campanile in 1464? Lányi himself has

pointed out an "illegitimate" inscription among the statues of the west side—the DONATELLO on the plinth of the "St. John" (*Statue*, pp. 256ff); the words on the scroll of that figure appear to be equally "illegitimate" (see below, pp. 229f); perhaps the same is true of the "Jeremiah." Of one thing we may be certain: the scroll of our statue was not intended to carry an inscription. Not only is the available area far too small but the inner surface is turned away from the beholder, so that the ĞEMIA appears on the wrong side of the scroll, an arrangement strongly suggestive of an epigraphic "afterthought" for which I know of no precedents elsewhere. And why should Donatello have wanted to place an identifying label on this particular figure if he failed to do so in the case of the beardless prophet on the east side, where the scroll is both large enough and displayed in the conventional way for an inscription? Is it not significant that the bearded prophet as well as the Zuccone do not display their scrolls at all? In its own way, the scroll of the "Jeremiah" is equally unorthodox, since the prophet himself is reading from it instead of permitting us to do so. Under the circumstances, the ĞEMIA seems less puzzling if we regard it as a "postscript" than it would if we insisted on its authenticity. (Dr. Martin Weinberger was good enough to inform me that he has independently reached the same conclusion.) As to the reason for this "postscript"—and those on the "St. John"—we are reduced to speculation (see below, p. 230); nor can we explain why our statue received the name of Jeremiah rather than of some other prophet. Was there a tradition to that effect, or did the master-in-charge of the *opera* in 1464 exercise his own judgment, as he did in the case of the "St. John"? To modern eyes, the Zuccone appears far more suitable for the role of Jeremiah, but the Quattrocento may well have felt differently. In any event, it would be dangerous to base any kind of hypothesis on so subjective a response, especially since the documents provide no assurance that every Campanile prophet had a fixed identity from the start. The only safe course is to refrain from giving specific Biblical names to either statue.[3]

We are free, then, to settle the question of priority between the Zuccone and the "Jeremiah" (whom we shall continue to call that as a matter of convenience) on stylistic grounds alone. Kauffmann (*D.*, pp. 26, 29f) has gathered a wealth of arguments for placing the Zuccone in the mid-1420's: he points out that its drapery style in many ways recalls that of the St. Louis and of Masaccio's Pisa Altar; that the great diagonal of the mantle recurs in one of the caryatids of the Brancacci Tomb; and that the statue is so strikingly

[3] Schubring, *KdK*, p. xix, dubs the Zuccone a Job, because of the bald head and what he regards as a currycomb in the right hand of the statue; on closer inspection, the "currycomb" turns out to be a scroll pushed behind a loose-fitting belt.

unified in conception and execution as to preclude the possibility of a long-delayed and frequently interrupted working process. These are all, I believe, excellent reasons for equating the Zuccone with D-III (1423-1425; appraised early in 1426). The drastic expressiveness of the head also suggests analogies in Donatello's work of those years, notably the Trinity in the pediment of the St. Louis niche and the Herod of the Siena bronze panel. Its "Roman" character, stressed by Francovich and Kauffmann, is much more pronounced than that of the beardless prophet on the east side; a parallel phenomenon are the "Roman" heads of the executioners in the Siena panel. However, the priority of the Zuccone over the "Jeremiah" can be established on a purely morphological basis. The right arms of the two figures are so similar that one must be derived from the other, and it seems obvious that that of the Zuccone is the earlier; for there the sharp bend at the wrist is functionally necessary, since the hand serves as a wedge to fill the space between the loosely slung belt and the scroll (the thumb covers the upper, rolled-up end of the scroll, the lower end is hidden among the drapery). Thus the "Jeremiah," by process of elimination, becomes D-IV, begun in 1427 and completed in 1435 (appraised early in 1436). Whether it was actually "about three-quarters finished" as early as the filing date of Michelozzo's 1427 *Catasto* Declaration is difficult to say; such estimates tend to be exaggerated. Still, there can be little doubt that a good part of the work had been done by that time, since the whole cast of the statue is not very different from that of its predecessor.[4] Much of what has been said of the "Roman" character of the Zuccone applies *a fortiori* to the "Jeremiah" (Nicholson, *op.cit.*, p. 95, derives the head from a bust of Galienus); only the crinkly, unquiet drapery style indicates a later phase of Donatello's development in that it resembles the drapery treatment on the *Cantoria* frieze.

The artistic merit of the "Jeremiah" has been somewhat obscured by the fame of the Zuccone. While the latter is undoubtedly the greater work, both statues embody the same basic concept: they might be defined as contrasting variants of the togaed Roman *rhetor* imbued with the spiritual intensity of the Old Testament. This revolutionary interpretation, foreshadowed in the beardless and bearded prophets of the east side, has been carried farthest—one is tempted to say, too far—in the "Jeremiah," who thus takes his place as the last member of the series even in this respect, since he is the most overtly "rhetorical." Yet viewed from the street level, the Zuccone, because of the downward bend of the head, is the more effective "speaker." That, we may suppose, accounts for the various anecdotes

attached to the statue in the Renaissance and for the fanciful psychological interpretations of it among more recent authors (e.g. Schmarsow, *D.*, pp. 19f; Semper, *D.* '87, pp. 23f; and Kauffmann, *D.*, p. 24, who thinks the Zuccone may have been inspired by the appearance in Florence of S. Bernardino of Siena in 1424). The most frequently repeated story, that of the artist challenging the unfinished statue to speak, is simply a dramatization of the conventional compliment so often applied to great works of art in Antiquity and the Renaissance—that the statue needs only the power of speech in order to seem alive. (Cf. pp. 20, 29 above for similar references and anecdotes concerning the St. Mark and the St. George.) It was Vasari, we suspect, who added the picturesque phrase, *che ti venga il cacasangue*, to Gelli's more restrained version; it may not be coincidental that Michelangelo had used the same term to describe his own painful creative efforts (to Ammanati; in Chantelou, *Journal de voyage du chev. Bernin en France*, ed. Lalanne, Paris, 1885, p. 174). Donatello's supposed habit of swearing by the Zuccone again suggests the "aliveness" of the figure. And Bernardo Davanzati pays the figure a further compliment by citing it as a supreme example of *sprezzatura*, the "recklessness of genius" which connotes the highest degree of artistic inspiration in Cinquecento aesthetics. Similar claims had been made for the St. Mark and the Cantoria (cf. above, p. 20, and below, p. 121). There is, however, an older legendary tradition that concerns both the Zuccone and the "Jeremiah": the claim, first reported in Billi, that the two are likenesses, "from nature," of Giovanni di Barduccio Cherichini and Francesco Söderini. Needless to say, such is not the case, and the great majority of modern scholars do not even mention the supposed portrait identities of our prophets. Semper (*D.* '87, pp. 23f) was the last to take them at face value. To him, the two heads seemed to mirror the bitter factionalism of political fanatics, which he regarded as highly appropriate, since both men had been prominently associated with the banishment of the Medici in 1433; Francesco Soderini, in fact, had wanted to see Cosimo strangled rather than merely exiled (cf. Giovanni Cavalcanti, *Istorie fiorentine*, Florence, 1838, I, Book ix, pp. 493ff). That Donatello should have portrayed—and thus publicly honored—these enemies of his greatest patrons, never struck Semper as incongruous, so that he did not pursue the matter beyond the factual realm. For us, however, there is considerable interest in trying to determine when and how the story of the two portraits originated. The tradition must somehow be linked with the political fortunes of the Medici, for neither Giovanni di Barduccio Cherichini

[4] If, as Kauffmann (*D.*, p. 204, n. 82) suggests, Michelozzo had any share in the carving, it must have been a purely technical one; the forms of the finished figure do not betray his hand anywhere.

nor Francesco Soderini have any claim to distinction other than their participation, on the side of Rinaldo degli Albizzi, in the events of 1433. Because of this, they could hardly have been identified with the Zuccone and the "Jeremiah" during the sixty years when the Medici held sway in Florence after the return of Cosimo. On the other hand, circumstances favorable to the growth of our legend prevailed during the "interregnum" of 1494-1512 that followed the second expulsion of the Medici. The decision this time was made in an atmosphere of intense popular hatred, which vented itself in the sacking of the Medici Palace, and to prevent the return of the Medici became one of the main preoccupations of the new city government under the Gonfaloniere Piero Soderini. The resolve to defend the liberty of the Republic also came to be embodied in public monuments—the bronze David and the Judith of Donatello, which had been brought to the Palazzo Vecchio from the Medici Palace for this purpose (see below, pp. 77ff, 198ff) and the marble David of Michelangelo, similarly transferred from the Cathedral. In such a setting, we can well believe that the two Donatello prophets on the main side of the Campanile were converted into anti-Medicean monuments through identification with two prominent members of the conspiracy against Cosimo in 1433, especially since one of them was an ancestor of the Gonfaloniere. The events of that year, we may be sure, were now studied with great interest, as a lesson for the present; perhaps they were "rewritten" to some extent, too, so as to make them conform to contemporary reality. Donatello himself might have been declared an opponent of the Medici, despite all the work

he had done for them, by the simple expedient of making him an intimate of Giovanni di Barduccio Cherichini and Francesco Soderini (cf. Gelli's version of the story of the portraits). The claim concerning the portrait character of the two prophets would have been an easy one to launch, not only because of the highly individualized heads of the figures but because both of them so strongly suggested Roman orators, ancient defenders of republican liberty. (One wonders, in fact, whether they were still recognized as prophets at all in Piero Soderini's time; the sources never call them that, and even Vasari uses the term "prophet" only of the Abraham and the statue next to it on the east side of the Campanile.) If our conjecture is correct, the Zuccone and the "Jeremiah" underwent, in the years around 1500, a process of secularization analogous to that by which Donatello's marble David had been transformed from a prophet into a patriotic symbol (see above, pp. 3ff). Once the legend of their portrait identities had taken root, it remained attached to them regardless of any later changes in the political climate of Florence. Gelli and Vasari, we suspect, no longer knew in what context Giovanni di Barduccio Cherichini and Francesco Soderini had distinguished themselves. And the persistent retelling of the story ultimately led to further portrait identifications of an even more spurious kind, so that in Richa's day the two statues attributed to Donatello by Cinquecento writers on the façade of the Cathedral (i.e. the "old man between two columns" and the "Daniel," the latter recognized today as the Isaiah of Nanni di Banco) were known as likenesses of Poggio Bracciolini and Gianozzo Manetti.

"MARZOCCO" (THE LION OF FLORENCE)
MUSEO NAZIONALE, FLORENCE

PLATE 18 Sandstone (*macigno*): H. 135.5 cm; W. of base 38 cm; D. of base 60 cm *1418-1420*

DOCUMENTS

Three entries in the records of deliberations and disbursements by the *operai* of the Florence Cathedral workshop, in the archives of the Opera del Duomo. Published by Semper, *D.* '75 and C. J. Cavallucci, *S. Maria del Fiore* . . . , Florence, 1887.

1418 (Cavallucci, Appendix, p. 140; no day and month given): Donatello receives 12 florins for a sandstone lion he is carving for the column of the papal apartment.

1420, January 9 (Semper, p. 278, doc. 36): Donatello receives 5 florins in part payment for a sandstone lion that is to be placed on the column of the stairs in the courtyard of the papal apartment [at S. Maria Novella].

1420, February 21 (Semper, p. 278, doc. 37): Donatello receives 7 florins as final payment for the lion he has carved above the stairs of the papal apartment.

(Cavallucci, who does not reproduce the original wording of the document, adds that "the following year Donatello receives 7 florins under the same heading"; this entry is probably identical with Semper doc. 37, which would carry the date of February 21, 1419, "Florentine style." The dates given in Cavallucci are not adjusted to the modern calendar, while Semper's dates generally agree with those in Poggi, *Duomo*, whenever the same documents are transcribed by both authors, so that in our instance, too, Semper has presumably changed the year in conformity with present usage. Paatz [*Kirchen*, III, pp. 755 and 843, n. 547] states that the Marzocco was completed in 1421, on the assumption that Semper retained the Florentine style for his dates.)

SOURCES

Undated (from Cod. Strozz. xx, p. 49, as reported in the *Repertorio Strozziano di memorie laiche* in the State Archives, Florence; published by J. Wood Brown, *The Dominican Church of S. Maria Novella . . .*, Edinburgh, 1902, p. 90): "Donatello . . . is doing a sandstone lion to be put on the column of the stairs [of the papal apartment]."

For the architectural history of the papal apartment, built by the city government for the visit of Martin V in 1419, see Brown, *loc.cit.*, and Paatz, *Kirchen*, III, p. 676. The stairs which the Marzocco was meant to adorn were designed by Lorenzo Ghiberti and Giuliano Pesello;[1] they must have connected the apartment with the western wing of the *chiostro grande*, the larger of the two cloisters adjoining the church. The column referred to in the documents was obviously the newel post. When the stairs were demolished is not clear from the records. Martin Wackernagel (*Der Lebensraum des Künstlers . . .*, Leipzig, 1938, p. 44) may well be right in placing the event in 1515. In any case, the Marzocco does not seem to have been on public view for some three hundred years, since there is no mention of it in the biographic and topographic literature between 1500 and 1800. About 1812 the architect Giuseppe del Rosso, who had been charged with the restoration of the Palazzo Vecchio, used Donatello's Marzocco to replace another Marzocco in front of the Palace near the main entrance, as noted in Alfredo Lensi, *Palazzo Vecchio*, Florence, n.d. (c. 1910), pp. 294ff.[2] Donatello's statue remained in front of the Palazzo Vecchio until 1885, when to prevent further damage it was transferred to the Museo Nazionale and a bronze copy took its place (Lensi, *op.cit.*, p. 338). According to A. Ademollo (*Marietta de'Ricci*, Florence, 1840, I, p. 365) and E. Bacciotti (*Firenze illustrata*, IV, 1887, p. 242, as cited in Kauffmann, *D.*, p. 208, n. 112) the Marzocco once had a crown with a patriotic inscription. This statement applies not to Donatello's lion but to its predecessor, which for a time wore a crown bearing the following verse, composed in 1377 by Franco Sacchetti: *Corona porto per la patria degna, a ciò che libertà ciascun mantegna.*

(See the Catalogue of the Museo Nazionale, 1898, p. 62, where this information is cited from MS Ashburnham 574 of the Laurenziana.) The original Marzocco, minus its Trecento crown, is clearly discernible in the background of an early sixteenth century Portrait of a General, ascribed to Piero di Cosimo, in the National Gallery of London (No. 895), as well as in several other paintings (G. de Nicola, *Rassegna d'arte*, XVII, 1917, p. 154n). The same pictures also show the ornate marble pedestal that was to be occupied by Donatello's Marzocco in the nineteenth century; it was long believed to be a work of Donatello because of this association, but de Nicola, *loc.cit.*, has pointed out that its long, narrow shape is quite unsuitable for our figure, which is obviously intended to perch on a much smaller base (i.e., the columnar newel post mentioned in the documents). De Nicola thought that the pedestal might be by Donatello just the same; Colasanti (*D.*, p. 50) still shares this view. Kauffmann, *loc.cit.*, however, is surely right in rejecting the attribution. The style of the pedestal, he emphasizes, indicates a date of c. 1450 or later. This date coincides with the *terminus post* arrived at by Balcarres (*D.*, p. 67) on the basis of the armoreal bearings on the pedestal, which include those of Jean Count of Dunois as modified in 1452.

The attribution of our statue to Donatello was already current in the early nineteenth century (see Andrea Francioni, *Elogio di Donatello . . .*, Florence, 1837, p. 56: "The lion which now stands where the old Marzocco used to be is ascribed to Donatello"). It was questioned only by Milanesi (*Cat.*, p. 25) who refused to accept the Marzocco as identical with the lion mentioned in Semper's documents. His skepticism does indeed seem unwarranted, and the figure has

[1] Cf. Richard Krautheimer and Trude Krautheimer-Hess, *Lorenzo Ghiberti*, Princeton, 1956, p. 256.
[2] Lensi also cites the Chronicle of Matteo Villani to the effect that towards 1350 four stone Marzocci had been placed at the

corners of the Palazzo; in 1364, during the triumphal entry of the Florentine forces after their victory over Pisa, the prisoners were forced to humiliate themselves by kissing the rear of one of these Marzocci.

since been accorded a secure place among the canonical works of the master. Kauffmann (*D.*, pp. 40f) has rightly pointed out the dependence of the Marzocco on the countless lions in Florentine mediaeval sculpture, which ultimately derive from classical models. He also believes that Donatello must have studied the living animals that were kept in a special enclosure near the Palazzo Vecchio.[3] The Marzocco is indeed somewhat more naturalistic than its predecessors, especially in the formation of the back and the hind legs; yet the distinguishing quality that stamps it as a Renaissance work is not its realism but its "humanism"—the uncanny extent to which the animal physiognomy has been suffused here with the expressiveness and nobility of Donatello's human heroes. In studying the head of the Marzocco, one immediately thinks of the St. John from the Cathedral façade (Pl.

5d), the St. Mark of Or San Michele (Pl. 7), and especially of the Abraham on the east face of the Campanile (Pl. 15c). Kauffmann himself was well aware of these relationships, which are not confined to general impressions but extend down to such details as the shape of the eyes and the carving of the hair. There is, I believe, an important lesson in the fact that the Marzocco, despite its heraldic background, betrays so strong a resemblance to the master's other works of similar date. As the only documented piece of its kind, it provides us with a standard by which to measure any other heraldic or decorative pieces that have been claimed (or may be claimed in the future) for Donatello on the basis of style alone, such as the Martelli arms (Florence, Casa Martelli) and the Minerbetti arms (Detroit Institute of Arts), both of which I must reject on this basis.

[3] According to Giovanni Villani (*Historie*, lib. x, cap. 187), in 1331 the municipally owned lion and lioness produced two

cubs, an event that attracted a great deal of attention and was regarded as a powerful omen of future prosperity.

TWO BUSTS (PROPHET AND SIBYL)
PORTA DELLA MANDORLA, FLORENCE CATHEDRAL

PLATE 19a, c Marble reliefs; H. c. 64 cm each 1422

DOCUMENTS

An entry in the records of deliberations and disbursements by the *operai* of the Florence Cathedral workshop, in the archives of the Opera del Duomo. First published by Semper, *D.* '75, p. 279, doc. 43 (already mentioned in Baldinucci, I, pp. 427f, with incorrect date; see Paatz, *Kirchen*, III, pp. 489f, n. 227). The most complete transcription in Poggi, *Duomo*, p. 71, doc. 391.

1422, May 13: Donatello is to receive 6 florins for two heads of prophets that were missing in the relief of Nanni di Banco above the Porta della Mandorla and which he has carved and installed there.

SOURCES: none

The wording of the document makes it clear that these heads were not an afterthought but must have been part of the original design for the gable above the door. Since they did not belong to the main relief, Nanni di Banco apparently left them to the last and died (in 1421) before he could execute them. That the document refers to both heads as prophets even though the one on the right is clearly female, is entirely compatible with the status of sibyls as non-scriptural prophets. See Lányi, *Ril.*, pp. 295f.

The two busts, difficult to see properly from the street, attracted very little attention until recently, even though they were mentioned in passing by a number of authors (Schubring, *KdK*, omits them completely). Schmarsow (*D.*, p. 25) thought they might have been executed by Michelozzo, and Cruttwell (*D.*, p. 23) claimed that they show nothing of Donatello's style and "might be the work of any mediocre

craftsman." The excellent photos published by Lányi, *loc.cit.* (and reproduced again in our plates) have removed any such misapprehensions. Kauffmann (*D.*, p. 32) and Planiscig (*D.*, p. 39) accept the busts as the master's own work. While their intrinsic importance is certainly minor, the two heads are of considerable historic interest because of their precise date. Their strongly classical flavor, which links them to the heads on the base of the St. Louis tabernacle, was first noted by Semper, *D.* '87, p. 80 (see also below, p. 53). The male head likewise recalls those of the bearded prophet and the Abraham from the east façade of the Campanile (Pl. 15a, c). According to Lányi, the closest relatives of the sibyl in Donatello's work are the Salome and the Faith of the Siena Font (Pls. 29b, 31a); to me, the resemblance to the Pazzi Madonna (Pl. 19b) is even more striking.

THE PAZZI MADONNA
STAATLICHE MUSEEN, BERLIN-DAHLEM

PLATE 19b Marble relief; H. 74.5 cm; W. 69.5 cm; thickness of slab 8 cm *(c. 1422)*

DOCUMENTS: none

SOURCES: none

The panel was purchased in Florence for the Berlin Museum in 1886 (Wilhelm v. Bode, *Jahrbuch Kgl. Preuss. Kunstslgn.*, VII, 1886, p. 204; Bode and Hugo v. Tschudi, *Beschreibung d. Bildwerke d. Christl. Epochen Kgl. Museen, Berlin*, 1888, p. 15, No. 39; 2nd ed., vol. v, ed. Frida Schottmüller, 1913, pp. 15f, No. 30; revised ed., 1933, p. 7, No. 51). According to Bode (*Jahrbuch, loc.cit.*) the relief had been in the Palazzo Pazzi until the 1870's, when part of the Palazzo was demolished to furnish the site of the Banca Nazionale; after the death of the old Marchese Pazzi, his heirs sold the relief to an unnamed middleman from whom Bode was able to acquire it. Bode also states, however, that he did not see the relief until shortly before the purchase; his information about its origin evidently came from the dealer and is thus not wholly trustworthy, in the absence of any disinterested eye-witness reports on the panel *in situ*. C. J. Cavallucci (*Vita ed opere del Donatello*, Milan, 1886, p. 32) and Semper (*D.* '87, p. 61), who erroneously describes the material as sandstone, list the Conte Lamponi-Leopardi as the owner of the relief. Beyond that, its history cannot be documented.

Cavallucci, *loc.cit.*, who introduced the piece into the literature, claimed that it is the panel described by Bocchi-Cinelli, p. 369: "In the house of Francesco Pazzi there is a most beautiful marble Madonna in low relief by Donatello; the Christ Child, seated upon a cushion, is supported by the Virgin's right hand, while He, with His raised left hand, holds the veil that hangs from her head. It is charming in every part, the draperies are most beautiful, and the Virgin's tenderness towards her son is expressed with great art. . . ." This description clearly does not fit our relief in several specific details, and the identification, accepted by Bode (*Jahrbuch, loc.cit.*) and Cruttwell (*D.*, p. 134) has now been abandoned, although the name "Pazzi Madonna" remains in use as a convenient label. The alternative proposed by Bertaux, *D.*, p. 93 (and followed by Colasanti, *D.*, pp. 84f) is hardly more convincing; he identifies our piece with a "small marble panel by Donatello showing the Madonna with the Child in her arms," mentioned in the Medici inventory of 1492 (Eugène Müntz, *Les collections des Médicis au quinzième siècle*, Paris, 1888, p. 64). The value of this *tavoletta* is given as 6 florins, suggesting a far smaller object than ours (it was probably the tiny *schiacciato* panel with painted wings by Fra Bartolommeo which Vasari saw in the collection of

Cosimo I; see below, p. 86). The Pazzi Madonna might be the one seen by Vasari in the house of Antonio de' Nobili ("a marble panel by Donatello showing a half-length figure of the Madonna in low relief"—Milanesi, p. 417) or that owned by Lelio Torelli ("a marble panel of the Madonna by Donatello"—Milanesi, p. 418), but either description is far too brief for positive conclusions (Vasari, *ibid.*, also mentions two Donatello Madonnas in *mezzo rilievo*). In any event, our panel must have enjoyed considerable fame before it fell into neglect (it has been repeatedly broken and repaired; cf. Schottmüller, *loc.cit.*). Old stucco replicas of it occur in many collections; Schottmüller lists examples in Paris, London, Amsterdam, Strasbourg, the v. Beckerath Collection in Berlin, the Chiesa della Certosa in Bologna, and the Palazzo Davanzati in Florence; others may be found in Budapest, in the Convento della Calza, Florence, and in various private collections (see Rezio Buscaroli, *L'arte di Donatello*, Florence, 1942, pp. 152ff). The Madonna Orlandini of the Berlin Museum (Schottmüller, *op.cit.*, 1933, No. 55) is a much inferior marble variant dating from the middle years of the Quattrocento.

The authorship of the Pazzi Madonna remains beyond dispute. It is the one wholly unchallenged survivor among the countless panels attributed to Donatello since the 1880's, when Bode first raised the question of the master's "forgotten" Madonna reliefs (*Jahrbuch, loc.cit.*, and v, 1884, pp. 27ff; see also the long essays in the same author's *Italienische Bildhauer . . .*, Berlin, 1887, pp. 32ff, and in the various editions of *Florentiner Bildhauer . . .*, Berlin, 1902, 1910, etc.). In the past thirty years this vast and heterogeneous mass of material, which takes up such an undue amount of space in Schubring's *KdK* volume, has been subjected to increasingly ruthless sifting: Colasanti, *loc.cit.*, more rigorous in this respect than Kauffmann, retains only half a dozen pieces, and Planiscig rejects them all, except for our panel. There is general agreement, too, that the Pazzi Madonna belongs to the first half of Donatello's career. Bode and Schottmüller, noting a "youthful awkwardness" in the foreshortening of the Virgin's left hand and in some other details, had placed the panel in the early 1420's; Bertaux assigned it to the time of the Siena Dance of Salome; while Tschudi (*D.*, p. 33) and Planiscig (in his first Donatello monograph, Vienna, 1939, p. 37) dated it

as late as c. 1430. Colasanti, on the other hand, suggested the years between 1415 and 1420, and Kauffmann likewise proposed a date of c. 1418 for our relief (*D.*, pp. 67 and 218, nn. 203-207); he thought it so closely related to the style of the St. George, and especially to the God the Father of the St. George Tabernacle (Pl. 11b) that it must have been done immediately afterwards. The link with the gable relief (also observed by Lányi, *Ril.*, p. 292) is indeed instructive: both pieces show the same simplicity of contour, the same sense of volume, the same relation between figure and frame. Moreover, the linear foreshortening of the frame in the Pazzi Madonna, with the orthogonals converging upon at least three distinct vanishing points, is no closer to the mathematical perspective of Brunelleschi than is the foreshortening in the base relief of the St. George Tabernacle (see above, p. 30). Yet in other respects our panel seems so much more advanced than the God the Father that an interval of one or two years is hardly sufficient to account for the difference. In the gable relief, we still find noticeable traces of the smooth curvilinear drapery patterns of the International Gothic, just as we do in the mantle of the St. George; none of this survives in our Madonna, whose cloak is truly Masacciesque in its heaviness and angular severity. Masacciesque, too, is the deeply serious, almost melancholy expression of the Madonna and Child, as against the mild features of the God the Father. According to Kauffmann, *loc.cit.*, our panel preserves the archaic monumentality of Gothic Madonnas of the early Trecento; true enough, in a sense—but surely this is not simply the survival of an older tradition but the conscious return to a much earlier (and by then forgotten) type, in the

same way as Masaccio may be said to have "revived" the art of Giotto.[1]

Without entering into the problem of priority between Donatello and Masaccio, I believe the Pazzi Madonna demands to be placed at least four or five years later than the St. George ensemble, on the basis of the drapery style alone. The same conclusion is suggested by the astonishing classicism of the Virgin's profile, which immediately evokes the Prophet and Sibyl on the Porta della Mandorla (see above, p. 43; Pl. 19a, c). The resemblance even extends to such details as the shape of the ears, with their peculiarly elongated, droplike lobes; the foreshortened left hand of the Virgin, too, has its counterpart in the hands of the two busts of 1422. Such radically foreshortened hands, as well as classical profiles of a similar kind, still occur in the Siena Dance of Salome, begun one or two years later, but there the entire flavor of Donatello's style is changed: the majestic calm, the simplicity and clarity of the Pazzi Madonna have given way to nervous movement, to a new excitability, both physically and psychologically. Besides, Donatello has now suddenly gained a technical command and an interest in the artistic exploitation of linear perspective far superior to what he knew of these matters when he carved the Pazzi Madonna. It is true that he could —and probably did—acquire this knowledge rather quickly once he felt the need for it; yet the fact that our panel contains no hint of it indicates that he must have finished it before he started work on the Siena relief. There are various reasons, then, why the Pazzi Madonna should be placed in the immediate vicinity of the Porta della Mandorla busts, about 1422 (Planiscig, *D.*, p. 40, also arrives at this date, thus vindicating the original judgment of Bode and Schottmüller).

[1] The example cited by Kauffmann as "closely related" to our panel, a Madonna in the Pinacoteca at Lucca, Inv. No. 160, is far less close to it than another, much more important picture, Ambrogio Lorenzetti's Madonna in the Museum at Massa Marittima; the latter work corresponds to ours in so many features— the profile view of the Child's head, his gesture of grasping the edge of the Virgin's garment below the neck, the position of

the Virgin's hands in supporting the Child, the visible sole of the Child's right foot—that one is tempted to postulate a direct connection, especially since this particular combination of details seems to have been extremely rare. See Dorothy C. Shorr, *The Christ Child in Devotional Images in Italy during the XIV Century*, New York, 1954, pp. 41, 46.

SCULPTURE OF THE ST. LOUIS TABERNACLE
OR SAN MICHELE, FLORENCE

PLATES 20-24, 25b *1423 (c. 1422-1425)*

PLATES 20-23b ST. LOUIS OF TOULOUSE, MUSEO DELL'OPERA DI S. CROCE, FLORENCE
Gilt bronze statue; H. 266 cm; W. (at floor level) 85 cm; D. (maximum) c. 75 cm

TABERNACLE, NOW CONTAINING VERROCCHIO'S ST. THOMAS GROUP
PLATES 20, 23c-24, 25b Marble; H. 560 cm; W. (pediment) 243 cm; Niche opening:
H. 298 cm; W. 116 cm

DOCUMENTS

Several entries in the record, very incompletely preserved, of deliberations of the Councils of the Parte Guelfa and in the corresponding record of the Merchants' Tribunal (*Mercanzia*). Most of them

were summarized in Pietro Franceschini, *S. Michele in Orto*, Florence, 1892, pp. 87ff. C. v. Fabriczy then published the full texts ("Donatellos Hl. Ludwig u. s. Tabernakel . . . ," *Jahrbuch Kgl. Preuss. Kunstslgn.*, XXI, 1900, pp. 242ff). They have recently been republished, with two important additions, by Giovanni Poggi in *Donatello, San Ludovico*, New York, Wildenstein & Co. n.d. [1949], pp. 8f, 18f.

1423, May 14 and 19 (Fabriczy, pp. 247f; Poggi, doc. I): The Council of the Parte Guelfa authorizes the disbursement of 300 florins to the officials in charge, in order that the image of St. Louis which is to be placed in the pilaster [niche] at Or San Michele, may be brought to completion (*ut perfici possit*).

1425, November 24 and 28 (Fabriczy, *loc.cit.*; Poggi, doc. II): The Council resolves that on the Saint's day the Captains of the Parte Guelfa are to present an offering to St. Louis at Or San Michele, in addition to the offering at S. Croce on the same day.

1460, January 14 (Poggi, doc. III): The Council of the Parte Guelfa deliberates that whereas a marble tabernacle at Or San Michele had been made about the year 1422 for the statue of St. Louis, and the statue had subsequently been removed since it was adjudged undignified for the Parte Guelfa to be placed on a par with the guilds; and whereas this tabernacle now stands empty and, as it were, abandoned, in a condition unworthy of the Parte Guelfa; therefore it is to be sold at a fair price, which will be determined by Piero di Cosimo de'Medici and Antonio di Migliore Guidotti who are among the six *operai* in charge of building operations at the Palazzo di Parte Guelfa; and the proceeds of the sale are to be used to finish the ceiling of the Audience Hall of the Palazzo.

1460, January 21 (Poggi, doc. IV): The Merchants' Tribunal together with the consuls of the five major guilds having decided, on December 29, 1459, to buy the tabernacle of the Parte Guelfa at a price to be set by Piero di Cosimo de'Medici and Antonio di Migliore Guidotti, and the Parte Guelfa having subsequently agreed to sell on the same terms, the two arbiters now report to the Merchants' Tribunal that the price of the tabernacle is to be 150 florins, including all the ornamentation, the supports, and other attachments (*cum omnibus suis ornamentis et fulcimentis et pertinentiis et circumstantiis*).

1463, March 26 (Fabriczy, pp. 250ff; Poggi, doc. V): The Merchants' Tribunal, acknowledging a three years' delay due to lack of funds, finally approves the purchase price of the tabernacle, including the title, the device, and the ornaments attached thereto by the Parte Guelfa (*nomen et signum et ornamenta ibidem existentia*).

1463, March 29 (Fabriczy, *loc.cit.*; Poggi, doc. VI): The Merchants' Tribunal appoints five *operai*, representing the major guilds, who are to replace the device of the Parte Guelfa on the tabernacle with that of the Mercanzia and to procure a statue for the niche.

1463, September 28 (Fabriczy, *loc.cit.*; Poggi, doc. VII; originally published by Allan Marquand, *American Journal of Archaeology*, VIII, 1893, p. 153): The Merchants' Tribunal approves payment of 25 florins to Luca della Robbia for the medallion with the device (*signum et arma*) of the Mercanzia which he has made and is to install above the tabernacle, in accordance with the commission he had received in January or February of the same year.

1487, December 28 (Fabriczy, p. 258; brief excerpt in Poggi, doc. VIII): The Signoria, acting on a petition of the Merchants' Tribunal, agrees to bear the cost of "perfecting" the tabernacle containing the bronze group of Christ and St. Thomas, which is lacking in several things, such as capitals, a *mensola*, and the *arme della casa*, to be made of marble; and of certain repairs to the clock on a house at the Mercato Nuovo where the Mercanzia maintains an office for assaying metals. The total expenditure for these two purposes, however, must not exceed 30 florins.

SOURCES

(1472-1483) Codex of Buonaccorso Ghiberti, Florence, Bibl. Naz., fol. 27 (Semper, *D.* '75, p. 315; Fabriczy, pp. 251f; Poggi, p. 5; for the date see Robert Corwegh, *Mitteilungen Kunsthist. Inst. Florenz*, IV, 1910, pp. 156ff): "The figure of St. Louis, not including the gold and the tabernacle at Or San Michele/ To Donatello for his own work and that of his assistants (*di chi a ttenuto cho lui*), 449 florins/ for 3277 pounds of brass/ for 350 pounds of wax/ for 122 pounds 3 oz. 4 d. of copper and iron/ for charcoal 4 florins 94 lire . . ." (Part of an entry listing the cost of various bronzes. A similar list, by an anonymous compiler of c. 1515-1520 who must have had access to the Ghiberti Codex, is preserved in the Uffizi; it contains the following statement: "The St. Louis that is on the façade of S. Croce was made by Donatello and cost 449 florins, all expenses being to his charge." See Semper, Fabriczy, Poggi, *loc.cit.*)

1510 Albertini, p. 15: "At Or San Michele [Donatello] made the marble tabernacle containing the bronze statues of Christ and St. Thomas by Andrea del Verrocchio."

"On the façade [of S. Croce] . . . is St. Louis the bishop, by the hand of Donatello."

(Before 1530) Billi, p. 38 (repeated in Cod. Magl., p. 75): "[At Or San Michele Donatello did] the tabernacle that now contains the bronze figures of Christ and St. Thomas by Andrea del Verrocchio."

(c. 1550) Gelli, p. 59: "Donatello made the marble tabernacle on the façade of Or San Michele facing the church of St. Michael, which contains the Christ and St. Thomas in bronze; they were made later by his disciple, Andrea del Verrocchio, and are held to be a most beautiful and perfect work." "He made the bronze St. Louis that stands above the portal of [S. Croce] and is said to be his least beautiful figure; when a friend asked him one day why he had made a statue so clumsy and unlike his [usual] manner, he replied that he believed he had never made a statue that was truer or closer to nature than this one. And when his friend laughed at this, he added: 'I had to show that this man renounced a kingdom for the sake of becoming a friar. What sort of a person did that make him, do you think?'"

1550 Vasari-Ricci, pp. 50, 57 (Milanesi, pp. 403f, 416): "[At Or San Michele] facing the church of St. Michael [Donatello] made the marble tabernacle for the Mercanzia, in the Corinthian order, without any trace of the Gothic style; it was intended for two statues, which he refused to make because of a disagreement about the price. After his death, Andrea del Verrocchio did these figures in bronze."

"Above the door of S. Croce there is still to be seen today a bronze St. Louis by [Donatello], five braccia tall. When reproached that this was a clumsy figure and perhaps the least successful of all his works, he replied that he had made it that way on purpose, since the Saint had been a clumsy fool to relinquish a kingdom for the sake of becoming a friar."

Vasari-Ricci, II, p. 173 (*s.v.* "Andrea Verrocchio"; Milanesi, III, p. 362, slightly shortened and rephrased): "It happened that the Council of Six of the Mercanzia had commissioned Donatello to make a marble tabernacle, which is on the exterior of Or San Michele, across from the church of St. Michael. When it was finished and installed, the Six wanted to order a bronze [group of] St. Thomas who places his finger in the wound of Christ; but they could not agree on the price, since some of them favored Donatello for the commission, while others insisted on Lorenzo Ghiberti. Both sides were so stubborn that they never carried out their plan during the lifetime of Donatello and Lorenzo. Thus it came to pass that Andrea . . . was proposed for the commission by his friends."

1591 Bocchi, p. 160: "On the exterior [of S. Croce] above the center portal there is a bronze St. Louis by Donatello. The artist did not like this figure, which through accident had been made rather hastily, and did not number it among his best efforts. Still, it is prized today as the work of a master of limitless ability, lifelike and betraying great knowledge."

The earliest witness to attest the presence of our statue on the façade of S. Croce is Albertini. It remained in the niche above the main door until the building of the present façade in 1860, when it was shifted to a corresponding position on the interior façade wall (Vasari-Milanesi, II, p. 416, n. 6). In 1903 it was removed to the refectory, which in 1908 became the Museo dell'Opera di S. Croce (see Paatz, *Kirchen*, I, p. 678, n. 492, and Poggi, *op.cit.*, p. 5 and n. 2, referring to *Arte e storia*, XXII, 1903, p. 67, and *Il Marzocco*, August 30, 1908). The statue was exhibited in Paris, at the Exposition de l'art Italien au Petit Palais, in 1935 (*Catalogue*, p. 309, No. 1028); and at the Wildenstein Gallery, New York, and in several American museums in 1949, after spending the war years in a tunnel (Poggi, *loc.cit.*). On its return to Florence in 1945, the figure was for a brief moment placed in the niche at Or San Michele from which Verrocchio's St. Thomas group had been removed. The photograph reproduced in Pl. 20 was taken on that occasion.

The available records do not disclose when our statue came to S. Croce.[1] That our statue was transferred to S. Croce from Or San Michele cannot be established from the documentary evidence. Semper (D. '87, p. 80) had been the first to connect the figure with the tabernacle of the Mercanzia, on the basis of the entry in the Ghiberti Codex from which it appeared that Donatello had made a bronze St. Louis for a tabernacle at Or San Michele. When the testimony of Buonaccorso Ghiberti was confirmed by Franceschini's discovery of the Parte Guelfa document of 1423, Semper's hypothesis gained general acceptance, inasmuch as it seemed highly improbable that Donatello should have produced two bronze statues of St. Louis for external niches. Still, the latter possibility could not be entirely excluded, and Curt Sachs (*Das Tabernakel mit Andrea del Verrocchios Thomasgruppe* . . . , Strasbourg, 1904) propounded it vigorously, maintaining that the St. Louis made for Or San Michele had been lost, if it was ever completed. (Similarly Bertaux, *D.*, p. 52, and *Études d'histoire* . . . , Paris,

1911, p. 96.) Lányi, too, was not entirely sure that the S. Croce statue was the one ordered by the Parte Guelfa; in his unpublished notes, he pointed out that according to a document in Giuseppe Richa's *Notizie istoriche delle chiese Fiorentine* . . . , I, Florence, 1754, pp. 15f, St. Louis had been the patron saint of the Parte Guelfa as early as 1309, and that this must have been Louis IX, King of France, who became a saint in 1297, while Louis of Toulouse was not canonized until 1317. Fortunately, all such doubts have now been laid at rest by an observation of Bruno Bearzi (published in Poggi, *op.cit.*, p. 25), who examined the floor of the niche when the statue was temporarily placed in the tabernacle of the Mercanzia in 1945, and discovered a small inlay of 2″ x 2″ near the spot where the crozier touched the ground. Closer examination showed that the crozier was meant to fit into a socket about 1″ deep in the floor of the niche; the inlay to close this cavity must have been made at the time the Verrocchio group was placed in the tabernacle.

There can be no question, then, that our statue was made for this particular tabernacle. How long it remained there, and why it was removed, we do not know. The first of the documents newly discovered by Poggi tells us only that in January 1460 the niche had been empty for some time. The "official" explanation for this state of affairs is clearly no more than a face-saving device to hide the real facts. It may well be that the sale of the tabernacle was brought about by political pressure (as suggested by Fabriczy, *op.cit.*, pp. 251f); in that event, it is possible that the statue was removed several years before the actual sale, as a gesture of appeasement. However that may be, the Parte Guelfa must have been anxious to preserve the function of the statue as a public symbol of its ancient prestige. From this point of view the niche above the center door on the façade of S. Croce offered the next best location, since it, too, had long been associated with the Parte.[2] Aesthetically, and even physically, the S. Croce niche made a poor choice indeed: not only was it far too high above the observer's level; in all

[1] Paatz, *loc.cit.*, thought he had found a picture of it *in situ* on a mid-fifteenth century *cassone* panel (Yale University Museum, Jarves Collection, No. 33; Paul Schubring, *Cassoni*, Leipzig, 1923, pp. 253f, No. 140, pl. xxvii), but the figure in question bears little resemblance to ours. It is in all probability a painted image of earlier date (as suggested by Schubring, *loc.cit.*; similarly Poggi, *op.cit.*, p. 15), surrounded by adoring angels that could still be seen, badly faded, a hundred years

ago. F. Moisè, who described them (*S. Croce di Firenze*, Florence, 1845, p. 88), thought that they must have been intended to accompany an image of the Holy Cross rather than of St. Louis.

[2] On the Yale *cassone*, which shows the niche before the arrival of our statue, the coat of arms of the Parte Guelfa appears above the door; cf. Poggi, *op.cit.*, p. 15.

likelihood it also turned out to be too shallow for our statue, since it had never been meant to hold sculpture in the round. A careful examination of the figure in its present condition bears out our conjecture. The statue, which consists of many separate pieces bolted together, is open in back and thus gives the impression of having been designed strictly for a frontal view; in fact, its balance is so bad that it cannot sustain itself without some external support from behind. Such, however, was not the case originally. The back and side views (Pl. 22a, c) show a number of round holes of even size near the edges of the pieces of drapery that frame the open back of the figure. These holes must have served for the bolting on of several additional pieces of drapery which, in all probability, closed the back of the figure completely and gave it enough support to make it self-sustaining. Unless we are willing to assume that Donatello miscalculated the depth of the statue in relation to that of the niche to such an extent that he himself had to unbolt and discard those pieces of drapery in the end—a fairly remote possibility, I should think—we can explain the mutilation of the figure only as a consequence of its transfer to S. Croce. The disappearance of another missing part, the crook of the crozier, may possibly be due to the same cause, although it could have been lost through accident or theft. The elaborate knob of the crozier has five compartments, three of them occupied by escutcheon-holding *putti*; the other two, on the side away from the beholder, were left empty from the very start.

In his account of the cleaning of the St. Louis (*loc.cit.*) and in a subsequent article ("Considerazioni di tecnica sul S. Lodovico . . . ," *Bolletino d'arte*, XXXVI, 1951, pp. 119ff), Bearzi has provided a valuable technical analysis of our statue. The fact that it was cast in so many separate pieces, he points out, does not indicate a lack of casting skill; it was made necessary by the exigencies of fire gilding (i.e. the sublimation of gold amalgam), which Donatello employed here in preference to the simpler but less durable alternative of applying leaf gold. In order to be fire gilt, an object has to be turned over live charcoal, and this was clearly impracticable in the case of a statue larger than life-size. Bearzi concludes that the commission the artist received from the Parte Guelfa must have specified this method of gilding, which had been used previously by Andrea Pisano and Ghiberti for the Baptistery Doors. To apply it to a piece of sculpture in the round on the monumental scale of the St. Louis was a novel and daring idea, and considering the difficulty of the task Donatello's solution was equally daring. He proceeded—to use Bearzi's apt phrase—like a tailor cutting a bronze garment for an imaginary mannequin, designing and shaping each piece so skillfully that the "seams" can be detected only on close inspection. To assemble a statue in this fashion involved considerable risk; the casting technique of the time was such that some degree of distortion in the individual pieces was almost inevitable, and this could easily spoil the "fit" of the whole. Bearzi has drawn attention to several areas where Donatello had to make adjustments by partial recasting, notably the left shoulder, which was raised by the insertion of a strip about 3 cm wide (visible in Pl. 22c). That our artist should have taken the trouble to make this particular correction, demonstrates his profound regard for the structure of the invisible body beneath the drapery, which is the controlling factor of his design and the key to his success. Without it, he could never have achieved a statue of such organic unity in the face of every technical obstacle. As long as the St. Louis stood above the main portal of S. Croce, visible only in a strongly foreshortened (and therefore distorted) view, its true merits may have been difficult to recognize. Vasari's criticism of it must be understood in this light. His negative remarks are largely to blame for the unenthusiastic comments on our statue among nineteenth century scholars. (Semper, *D*. '87, p. 80, still speaks of the head as *träumerisch-blöd*, which is only a little less harsh than Vasari's *goffo*.) Since its transfer to the Museo dell'Opera di S. Croce, the historic and aesthetic importance of the figure has been more readily acknowledged. In the recent literature only Planiscig (*D*., p. 38; also in Poggi, *op.cit.*, pp. 21f) still shares Vasari's attitude; as against the St. George, he insists, the St. Louis is retardataire and "essentially Gothic." Both Schottmüller (*D*., pp. 62f) and Kauffmann (*D*., pp. 27f) have justly emphasized the Renaissance character of our statue, especially the compelling functional logic and the textural richness and variety of the costume, unrivaled by any other work before 1425. In this respect the St. Louis marks a very striking advance beyond the "early" group of Campanile prophets, which immediately precedes it in date. The technical necessity that prompted Donatello to conceive our statue as an intricate shell without a body, also provided him with a splendid opportunity to explore the dynamics, the "feel" of drapery more thoroughly than ever before. The effects of this experience are clearly apparent in his work of the following years (e.g. the Virtues of the Siena Font, for which see below, pp. 72ff), so that they form a valuable aid in fixing the chronology of the undated pieces. If the St. Louis was in fact Donatello's first commission in bronze—its only rivals for this distinction, the S. Rossore and the image of John XXIII, are less precisely

datable—we could hardly imagine a more ambitious debut.

Yet the technical ability of our master in this field has been persistently questioned, despite the fact that his *œuvre* includes the most impressive and varied body of bronze sculpture by a single artist in the entire history of art. The first author to insist on Donatello's deficiency as a bronze caster was Semper (*D.* '75, pp. 316f), who cited a dictum of Pomponio Gaurico (in *De sculptura*, Florence, 1504) that "Donatello never did his own casting but always employed the services of bell founders," a passage from the autobiography of Benvenuto Cellini (written 1558-1566) to the effect that Donatello always seemed to have had the greatest difficulties with his casting, and the fact that the S. Rossore and the Padua bronzes were cast by professional founders. Semper also conjectured that Vittorio Ghiberti, the son of Lorenzo, probably helped with the casting of the St. Louis (he thought that the Codex of Buonaccorso, which gives the price of the statue, had been composed by Vittorio), and decided further that Donatello induced Michelozzo to become his partner about 1425 because he needed the latter's skill as a bronze caster (presumably acquired in the shop of Ghiberti). From then on, the "expert caster Michelozzo" gained general acceptance among Donatello scholars, despite the lack of any indication that Michelozzo had anything to do with casting while he was associated with Ghiberti.[3] Fabriczy (*op.cit.*, p. 253) took the next step: he concluded that the helper or helpers who, according to the notice in the Ghiberti Codex, had worked with Donatello on the St. Louis, was none other than Michelozzo. This, in turn, led Schottmüller (*D.*, p. 121) to assert as a fact that the statue had been cast by Michelozzo. Schubring (*KdK*, pp. xxff; *HB*, p. 43) coupled the same statement with the claim, based on a remark of Tschudi (*D.*, p. 14), that the forms of the St. Louis still have the "carved" look of stone sculpture, thus betraying Donatello's lack of experience in bronze. This entire train of arguments is curiously self-contradictory. That Donatello habitually drew upon the aid of specialized craftsmen for the technical aspects of his bronzes may be inferred from several documented instances, so that we need not hesitate to accept Pomponio Gaurico's remark as essentially correct. How indeed could he have done otherwise? Surely his practice in this respect was the rule, rather than the exception among Renaissance sculptors. Only a man like Ghiberti, with his large and stable workshop organization, could afford to maintain a foundry of his own. But if Donatello entrusted his wax models to professional founders, then the technical deficiencies of his bronzes do not tell us anything about his own bronze casting ability. They simply reflect the precarious technology of large-scale casting at that time—after all, even Ghiberti had bad luck with his St. Matthew, which had to be partially recast—and perhaps a certain lack of patience on Donatello's part with the niceties of the craft. As for the role of Michelozzo, we cannot prove, of course, that he had nothing to do with the casting of the St. Louis; to assign him this technical responsibility would be an entirely tenable conjecture if it were true that his knowledge of casting was the basis of his association with Donatello in the years to come. But while Semper's theory is a possible explanation of the partnership of the two masters, it is not, in my view, the most plausible one. An alternative solution to the problem will be considered later (see below, pp. 55f).

The date of the St. Louis has ceased to be a matter of controversy. Semper (*D.* '75, p. 315) had at first placed it near the end of Donatello's career, on the erroneous assumption that Vittorio Ghiberti had helped to execute it. Schmarsow (*D.*, p. 40) found a facial resemblance between our statue and the bust of St. Lawrence (now identified as S. Leonardo; see below, pp. 236f) in the Old Sacristy of S. Lorenzo, and accordingly dated it about 1440. Semper (*D.* '87, p. 80) and Semrau (*D.*, p. 48) accepted this suggestion while Tschudi (*loc.cit.*) argued for a date before 1425 on more general stylistic grounds. His judgment was confirmed by the documentary evidence published a few years later; and even those scholars who denied that the S. Croce figure was identical with the one commissioned for Or San Michele, did not depart significantly from Tschudi's dating. According to the Parte Guelfa resolution of May 1423, our statue seems to have been well under way then, since the disbursement of 300 florins was authorized "so that it may be completed." We cannot say, however, just how far advanced the work actually was. The sum involved represents two thirds of the total price that Donatello received for the figure, according to the Ghiberti Codex, but since the document does not specify him as the recipient it is possible, and indeed likely, that a significant share of those 300 florins was meant to cover the cost of the fire gilding, which must have been quite considerable and which apparently was not paid to Donatello since it is not included in the price given in the Codex. Fabriczy (*op.cit.*, p. 247) assumes that the statue must have been finished before the end of 1425, because in November of that year the Parte Guelfa resolved to bring a solemn annual offering at Or San Michele on St. Louis' Day. The same *terminus ante* is indicated by the fact that neither Michelozzo nor Donatello refer to our figure in their

[3] The only documented instance of his having done any sculptural bronze casting at all is the capital of the Prato Pulpit, of

1433; see below, p. 115.

tax declarations for the *Catasto* of 1427. (Michelozzo's, published by Fabriczy, *Jahrbuch Kgl. Preuss. Kunst-slgn.*, xxv, 1904, Beiheft, p. 62, lists the works under-taken jointly by both artists since they became part-ners "about two years ago"; Donatello's, printed in Giovanni Gaye, *Carteggio inedito . . .*, I, Florence, 1839, pp. 120ff and Semper, *D.* '75, pp. 310f, mentions the commissions received by him before the start of the partnership but not yet fully paid for.) The date when Donatello began work on the St. Louis cannot be determined with the same precision. Fabriczy noted that the Parte Guelfa resolutions of 1423 and 1425 are recorded in a collection of similar resolutions whose dates range from February 26, 1419 (modern style) to October 25, 1426; and since the volume contains no other references to our statue, he thought that the St. Louis and its niche must have been commissioned about 1418. Even if we accept this conclusion—which in view of the fragmentary preservation of the Parte Guelfa records is far from mandatory—it provides only a *terminus ante* for the start of Donatello's labor. Inas-much as some of the sculptural *décor* of the niche is closely related to the master's work of 1422 (see below, p. 53), we may assume that the statue, too, was not begun until after 1420.

The St. Louis Tabernacle has been a bone of schol-arly contention for more than half a century. The dis-pute concerning its date and authorship is of consid-erable interest, both historically and methodologically, even though the data at our disposal are probably not sufficient for a definitive solution of all the problems involved. Semper, the first to assign a specific date to the tabernacle, placed it in the 1460's, along with the statue (*D.* '75, p. 288); later on, he shifted both to the years around 1440 (*D.* '87, p. 80), following the opin-ion of Schmarsow (*D.*, p. 40). The latter subsequently decided that the niche proper, as well as the two rows of brackets supporting the base, had been added after-wards, when the tabernacle was being readied for Verrocchio's St. Thomas group (*Festschrift zu Ehren d. Kunsthist. Inst. Florenz*, Leipzig, 1897, pp. 38ff, reprinted from a series of articles written for the *Nationalzeitung* in 1889; also published in Italian in *La vita nuova*, I, 1889, Nos. 11-13). Tschudi, who dated the statue before 1425 (*D.*, p. 14), expressed no opin-ion on the tabernacle. Franceschini's claim (*op.cit.*, p. 88), on the basis of the Parte Guelfa records, that the tabernacle must have been ready to receive the St. Louis by 1423, did not upset the prevailing opinion: Heinrich v. Geymüller continued to date the taber-nacle towards 1450 ("Die Architektonische Entwick-lung Michelozzos . . . ," *Jahrbuch Kgl. Preuss. Kunst-*

slgn., xv, 1894, pp. 254f; cf. also Stegmann-Geymüller, *Die Architektur der Renaissance in Toscana*, Munich, 1885-1907, IIb, *s.v.* "Donatello"); so did Reymond (*Sc. Fl.*, I, p. 203; II, pp. 95, 160), who contended that the document of 1423 does not permit any inferences about the date of the tabernacle. It was only when Fabriczy, too, proclaimed the tabernacle a work of the early 1420's (*op.cit.*, pp. 247ff) that the problem began to attract wider attention. In advocating the early date, Fabriczy did not rely on the Parte Guelfa resolutions of 1423 and 1425 alone; he cited formal and stylistic argu-ments as well, which led him to reject Schmarsow's "two-stage" theory except for the double row of brack-ets (he identified those with the *mensola* referred to in the document of 1487). Wilhelm v. Bode immedi-ately adopted the same point of view ("Donatello als Architekt . . . ," *Jahrbuch Kgl. Preuss. Kunstslgn.*, XXII, 1901, p. 52), but another group of scholars—Marrai, Supino, Gerspach—insisted, on grounds of style, that the tabernacle could not have been designed until the 1460's, i.e., that it was built for the Mercanzia, not for the Parte Guelfa, and for the St. Thomas group rather than the St. Louis. Their dispute with Fabriczy, carried on mostly in the pages of *L'Arte* (IV, V, 1901-1902) has been well summarized by Paatz (*Kirchen*, IV, p. 532) and need not be recapitulated here.[4] Sachs (*op.cit.*) and Geymüller (*Architektur, op.cit.*, *Nach-trag*, 1906, *ad* IIb, "Donatello") also supported a late dating of the tabernacle. Nevertheless, the victory went to Fabriczy, whose main argument, the resem-blance between the St. Louis Tabernacle and the archi-tectural framework in Masaccio's Trinity fresco, was indeed a compelling one. His dating was accepted without dissent in the entire Donatello literature from Schottmüller (*D.*, p. 121) to Kauffmann (*D.*, p. 229, n. 316), so that, to all appearances, the matter seemed settled. Yet the contrary view had not been entirely forgotten: after a lapse of some three decades Planis-cig (*D.*, pp. 35ff, 138) evolved a variant of it which, although highly improbable, is not without interest. A figure as "Gothic" as the St. Louis, he argued, could never have been intended for so pure a Renaissance setting; in any event, the present niche is too small for the statue, aesthetically speaking. The tabernacle orig-inally built for the St. Louis must have been a con-servative structure not too different from the St. George Tabernacle. It gave way to the present niche after c. 1440 because, according to Planiscig, it proved un-suitable for the St. Thomas group that the Mercanzia wanted to put there. Vasari may be right in stating that the latter commission originally went to Dona-tello. The new archival discoveries of Poggi (*op.cit.*)

[4] The measured drawing of the St. Louis in the niche, made for Supino (in *L'Arte*, V, 1902, p. 184) exaggerates the height of the statue by about 10 cm, a not insignificant error since the drawing was meant to prove that the statue would look awk-ward in this setting.

and the physical evidence offered by Bearzi (*ibid.*) that the St. Louis had actually occupied the present tabernacle, did not cause Planiscig to abandon his thesis but only to modify it; in his brief essay on the statue (Poggi, *op.cit.*, pp. 21f) he suggested that the tabernacle of c. 1422 mentioned in the document of January 14, 1460, was the original, Gothic one, which had in the meantime been replaced for reasons unknown, probably in the 1430's—an admirable display of tenacity in the face of overwhelming odds. The Schmarsow hypothesis, too, has been revived, rather surprisingly, in a recent essay by Ottavio Morisani (*Studi su Donatello*, Venice, 1952, pp. 103ff). Morisani's starting point, like that of Planiscig, is the conviction that the tabernacle of the Mercanzia does not form an aesthetically satisfactory setting for the St. Louis. The original niche, he claims, was a rectangular recess framed by the base, the pilasters, and the entablature of the present tabernacle; the rest was inserted after 1463 in order to provide an appropriate background for the St. Thomas group. The double row of brackets also was added at that time. Morisani links these extensive labors with the petition of 1487 for money to "perfect" the tabernacle, but fails to mention that the Signoria thought the work could be done for less than 30 florins. Since we do not know how much of this sum the Mercanzia spent on the tabernacle—part of the money, it will be recalled, had to be used for repairing the clock at the Mercato Nuovo—the scope of the "perfecting" is difficult to estimate; in any event, the amount was sufficient only for repairs or minor additions to the structure. Fabriczy (*op.cit.*, p. 258) had identified the *mensola* mentioned in the petition with the double row of brackets (the term also denotes a horizontal, "tablelike" slab, especially when used in the singular). This feature, however, could not have been added then; it is already present in a drawing of the empty tabernacle in the Codex of Buonaccorso Ghiberti which must have been made between 1472 and 1483. According to Geymüller (*Architektur, op.cit.*, 1906), who had examined them minutely, the brackets are part of the original tabernacle. Their shape, too, bespeaks an early date, since they are the immediate ancestors of the scroll brackets supporting the sarcophagus of the Coscia monument, a circumstance not without interest for the problem of the authorship of the St. Louis niche (see below). The *capitelli* and *arme* referred to in the petition of 1487 are equally puzzling; here again the Ghiberti Codex drawing shows no gaps to be filled (the only detail that is missing is the sculpture on the base, which was probably omitted for simplicity's sake). A more decisive objection to Morisani's thesis is his inability to cite any other rectangular niches with aedicula frames in the early Quattrocento. The Parte Guelfa

tabernacle—if we accept his findings—would thus be the only example of its type, and a far more radical departure from the architectural practices of the period than the present structure, which, after all, does have some precedents and analogies in the 1420's (apart from Masaccio's Trinity fresco, cf. especially the St. Matthew tabernacle of Ghiberti, dated 1419-1422; further objections to Morisani's thesis are cited by A. Marabottini in *Commentari*, v, 1954, pp. 256ff).

Even the spiral fluting of the columns argues against Morisani. The tabernacles of Ghiberti's St. John and of Donatello's St. Mark still show the familiar "corkscrew" colonnettes of Italian mediaeval art, attached to paneled pilasters; our tabernacle follows this precedent but translates it into the architectural vocabulary of the Early Renaissance. Interestingly enough, the spirally fluted columns of the St. Louis niche are not derived from late classical architecture (where we find them as decorative elements on sarcophagi and in ivories such as the Stilicho Diptych in Monza, and occasionally on a monumental scale as well, e.g. on the Porta dei Borsari, Verona, and the Tempio di Clitunno near Spoleto). Their source is the Florentine Baptistery, which shows spirally fluted columns, surmounted by a curious combination of Ionic and Corinthian capitals, supporting the segmental pediments above the center windows on the main sides of the building (i.e., the windows directly above the doorways; see Pietro Toesca, *Storia dell'arte italiana*, I, 2, Turin, 1927, fig. 332, p. 546, and Paatz, *Kirchen*, II, p. 183; in Rome, too, spirally fluted columns were not unknown at this time, as proved by the examples—with Ionic capitals—on the early Dugento façade of S. Lorenzo fuori le mura). Since the Baptistery was then believed to be an ancient "Temple of Mars" converted to Christian use, the pioneers of Early Renaissance architecture doubtless regarded spirally fluted columns as an orthodox classical form. Their appearance on the St. Louis Tabernacle suggests an analogy with the base of the throne in Masaccio's Madonna in the National Gallery, London, which is derived from the strigillated sarcophagi of late antiquity. Yet the taste for spiral flutings did not survive for long; spirally fluted columns occur again in the frames of the two niches on the façade of the Palazzo della Fraternità dei Laici in Arezzo (by Bernardo Rossellino, 1433-1435) and in the slightly later tabernacle at Impruneta, in both cases as obvious reflections of the St. Louis niche, and on the bronze chandelier in Pistoia Cathedral which Maso di Bartolomeo executed soon after 1440 (cf. Renato Piattoli, *Rivista d'arte*, xvi, 1934, pp. 191ff; Maso, like Bernardo Rossellino, was strongly influenced by Michelozzo, a circumstance not without significance for the problem of the authorship of the St. Louis Tabernacle, on which see below, pp. 55f).

After 1450, in contrast, spirally fluted columns are no longer found in Florentine art, so far as I have been able to determine (the one exception being the two columns topped by statues on the North Pulpit of S. Lorenzo, Pl. 105b): they seem to have been eliminated from the decorative repertory as "impure" several decades before the supposed "perfecting" of our tabernacle in 1487.

The argument for regarding the present tabernacle in its entirety as identical with the one built about 1422 for the Parte Guelfa, does not rest on architectural evidence alone. It receives powerful support from the style of the sculptural *décor*. Some parts of it—the wreath-holding *putti* on the base, the heads and garlands on the architrave—are hard and dry in execution, with little individuality of touch; the rest, while not necessarily by Donatello's own hand, is close enough to the master's style to permit comparisons with his other works during those years. That the heads at the corners of the base, inspired by similarly placed masks on Roman sarcophagi, recall the prophet and sibyl of 1422 above the Porta della Mandorla (see above, p. 43, Pl. 19a, c), had already been noted by Semper (*D.* '87, p. 80). Actually, this observation fits only the head on the right (Pl. 23c); the other, carved from a separate piece of marble, is a restoration.[5] Morisani (*op.cit.*, pp. 120f) rightly emphasizes the close relationship between the "authentic" head and those of the bearded prophet and the Abraham from the east façade of the Campanile (Pl. 15a, c).

The Trinity symbol in the pediment (Pl. 24a) appears to belong to the next phase of Donatello's development. Here the "classicism" of the prophet and sibyl of 1422 has given way to a greater fluidity of form, to more realistic detail and, above all, to a strained expressiveness that is quite new in the master's style. These features point towards the mid-1420's; the nearest relatives of the three faces of the Trinity occur in the Dance of Salome panel on the Siena Font (cf. especially the head of Herod, Pl. 29a) and among the heads in the Delivery of the Keys (London, Victoria and Albert Museum; Pls. 39-40). The artistic importance of the Trinity has been badly underestimated by Kauffmann (*D., loc.cit.*), who ascribes it to Michelozzo because of its "krasse Physiognomik" without discussing it further. Morisani, *loc.cit.*, in contrast, claims it for Donatello in both conception and execution (as does Fabriczy, *op.cit.*, p. 250). The invention of this triple head is indeed worthy of Donatello, even though the carving may not be entirely his. The ornamental detail is, of course, the work of assistants. It should be noted that the Trinity is not framed by a wreath, as often stated in the literature, but, far more appropriately, by a circular nimbus of overlapping formalized clouds.[6]

The two angels in the spandrels (Pl. 24b, c) have been almost completely neglected so far. Morisani, *loc. cit.*, intent on supporting his main thesis, denounces them as weak imitations of the flying *putti* on the base, so modest in quality that no definite date can be assigned to them. Nothing could be further from the truth than this harsh verdict, in my opinion; while their carving is less distinguished than that of the Trinity, it is far more sensitive than that of the flying *putti*, and the conception is strikingly fresh and vigorous. They are done in a low relief closely approaching *schiacciato*, not only physically but also in the illusionistic rendering of volume and space. While the base of the tabernacle is treated as a solid, neutral surface to which the relief forms are attached, the spandrel areas have been transformed, aesthetically speaking, into "windows" much like the gable relief above the St. George niche (Pl. 11b), and their frames have the same characteristic double function: they belong not only to the architectural realm but also to that of representation, overlapping the figures and being in turn overlapped by them. Especially striking is the way the arch of the niche is utilized as a support in both instances; the

[5] Cf. Poggi (*op.cit.*, p. 16, n. 13) correcting Sachs (*op.cit.*, p. 26) who believed that both heads had been redone in the sixteenth century. According to Andrea Francioni, *Elogio di Donatello . . .*, Florence, 1837, pp. 51f, n. 9, the tabernacle was beginning to show signs of decay; since these are no longer in evidence today, they must have been repaired since then, probably in the mid-nineteenth century, as noted by Kauffmann, *D.*, p. 229, n. 316. The head at the left-hand corner of the base was, in all likelihood, replaced at that time.

[6] This feature, as well as the triple halo, clearly refutes the suggestion of Martin Wackernagel (*Der Lebensraum des Künstlers in der florentinischen Renaissance*, Leipzig, 1938, p. 217) that the three faces may here be a symbol of Prudence rather than of the Trinity; the study of the three-faced *Prudentia* cited by him (Erwin Panofsky, *Studien d. Bibl. Warburg*, XVIII, 1930, p. 4) has no bearing on our subject. Wackernagel also claims that the three-faced Trinity was the emblem of the Parte Guelfa, since it is found again above the portal of the Sala dei Capitani in the Palazzo di Parte Guelfa, but this conclusion would be warranted only if the latter specimen antedated ours, which is not the case. (Giuseppe Marchini, "Aggiunte a Michelozzo," *La Rinascità*, VII, 1944, p. 48, dates the Trinity relief in the Sala dei Capitani c. 1422-1425, immediately after that of the St. Louis niche, and attributes it to Michelozzo; in my opinion, it is a work of c. 1470, Verrocchiesque in flavor, even though the portal itself clearly belongs to the early 1420's. The relief must have been added after the sale of the St. Louis niche—perhaps as a sort of symbolic reminder of it—and may indeed have been paid for with some of the proceeds from the sale, which had been allotted to the embellishment of the Palazzo; cf. the document of January 14, 1460.) The motif of the three-faced Trinity occurs repeatedly in Florentine Quattrocento sculpture (cf. Alfredo Lensi, *Dedalo*, VI, 1925-1926, p. 764; Morisani, *loc.cit.*; also G. J. Hoogewerff, "Vultus trifrons, emblema diabolico, imagine improba della SS. Trinità," in *Rendiconti, Pontificia Accademia Romana di Archeologia*, XIX, 1942-1943, pp. 205ff). All of these instances are later than the pediment of the St. Louis tabernacle, and most of them are clearly inspired by it, but the connection with the Parte Guelfa is by no means plain in every case.

angels kneel on it, and the God the Father of the St. George Tabernacle rests his book on it. Our spandrel reliefs, then, exhibit a uniquely Donatellesque approach to architectural sculpture. They would be recognizable as the direct successors of the gable relief of the St. George niche even if we knew nothing about their history or location. Donatello himself must have roughed them out before he turned them over to an assistant who finished the carving. (Perhaps he did this only for the spandrel on the right, which is noticeably superior to its companion in both design and execution.) The two angels are important to us also because they reveal, for the first time, Donatello's interest in strenuous motion of the body. We may regard them, in that respect, as the earliest ancestors of the frantically dancing figures on the frieze of the Cantoria (Pl. 49a, b).

If Donatello's inventive power is evident throughout the sculptural *décor* of the St. Louis Tabernacle—with the possible exception of the flying *putti* on the base—the authorship of the architectural framework as a whole remains uncertain. Several literary sources (though not the documents, contrary to the claim of Poggi, *op.cit.*, p. 13) credit the design to Donatello, but the earliest of them, Albertini's *Memoriale*, is almost ninety years later in date than the monument itself, so that the reliability of these witnesses is far from absolute. The dispute over the author of the tabernacle began in 1886 with some remarks by Schmarsow (*D.*, pp. 24ff) concerning the nature of the collaboration between Donatello and Michelozzo. Schmarsow did not believe that Michelozzo's function was exclusively, or chiefly, that of a bronze caster; he suggested instead that the younger man had been taken into partnership with Donatello because of his ability as an architect, a field in which Donatello himself had little experience at that time. Accordingly, he credited Michelozzo with the architectural framework of the monuments undertaken jointly by the two masters (the Coscia and Brancacci Tombs, the Prato Pulpit), and in a slightly later study (*Nationalzeitung*, 1889; reprinted in *Festschrift, op.cit.*) he gave him a share in the design of the St. Louis Tabernacle as well. Semrau elaborated upon this general thesis (cf. his review of Hans Stegmann, *Michelozzo*, in *Repertorium f. Kw.*, XIII, 1890, pp. 193f; also *D.*, pp. 41ff). Contrasting the architecture of the Coscia and Brancacci Tombs and of the Prato Pulpit with that of the S. Croce Annunciation and the Cantoria, he concluded that the first group must be the work of a professional architect closely dependent on Brunelleschi, while the second exhibits a willful and highly personal style in which the disciplined language of architectural forms is subordinated to the "picturesque" (*malerisch*) ensemble effect. If, as he assumes, these sharply dif-

ferent attitudes are characteristic of Michelozzo on the one hand and Donatello on the other, then the St. Louis Tabernacle clearly belongs to the former. In further support of this attribution, Semrau also points out similarities with Michelozzo's portal in the Capella del Noviziato of S. Croce. Hans and Carl Stegmann (in Stegmann-Geymüller, *op.cit.*) also followed the line of argument initiated by Schmarsow, although more cautiously, while Geymüller (*Jahrbuch, op.cit.*) deprecated the importance of Michelozzo and insisted that Donatello himself had designed the architectural framework of all the monuments in question. Reymond, on the other hand (*Sc. Fl.*, II, p. 160) wholeheartedly accepted Semrau's point of view; he even attributed to Michelozzo the altar tabernacle in the church of Impruneta on the strength of the St. Louis Tabernacle (of which it is an obvious but inferior echo).

The Schmarsow-Semrau thesis received a severe setback with the publication of Fabriczy's evidence for dating the St. Louis Tabernacle in the early 1420's. If the structure was finished by 1425, when the partnership of the two masters began (according to Michelozzo's *Catasto* of 1427), could Michelozzo still be held responsible for the design? And if Donatello was able to create so important an incunabulum of Early Renaissance architecture without the aid of his partner, why should he not also have designed the framework of the Coscia and Brancacci Tombs and of the Prato Pulpit? Such was the argument of Fabriczy (*op.cit.*, pp. 250f) and of Bode (*loc.cit.*), who denied that the two groups of monuments distinguished by Semrau were fundamentally different in conception (against Fritz Wolf, *Michelozzo . . .*, Strasbourg, 1900). Among more recent authors, the issue has been posed less sharply. Most of them, having accepted not only the early date of the St. Louis Tabernacle but the Geymüller-Fabriczy-Bode view of Donatello as an architectural designer, assign the tabernacle to the older master but admit the possible assistance of Michelozzo in a secondary capacity. Paatz (*Kirchen*, IV, pp. 531ff, n. 102) still shares this point of view. Morisani, in his Michelozzo monograph (Turin, 1951, pp. 22ff), allots a somewhat larger share of responsibility to Michelozzo but fails to establish a clear-cut division of labor among the two partners (he claims the St. Louis Tabernacle and the Brancacci Tomb for Michelozzo while crediting Donatello with the main outlines of the Coscia Tomb and the Prato Pulpit). Only Middeldorf (*AB*, pp. 574f) comes to grips with the core of the problem: what was Donatello's personal style of architectural decoration, and when and how did it develop? Like Semrau, he finds this style exemplified in the Cantoria and the S. Croce Annunciation, as against the "partnership projects"—the Coscia and Brancacci Tombs and

the Prato Pulpit—which strike him as adaptations of Brunelleschi's style without the highly individual touch of the great sculptor. The St. Louis Tabernacle, according to Middeldorf, clearly belongs to this latter group of monuments; if Michelozzo designed them, as seems likely, the main credit belongs not so much to him as to Brunelleschi, the fountainhead of the new architectural style. Thus there is no necessity, Middeldorf suggests, to assume that the architecture of Masaccio's Trinity mural must be dependent on the St. Louis niche, or vice versa. Both monuments may well be separate reflections of the same source, i.e. the body of ideas originated by Brunelleschi and freely circulated among his friends.[7]

Viewed in this light, our problem is no longer to decide whether Donatello or Michelozzo designed the St. Louis Tabernacle *ab ovo*, but whether Donatello was capable of adapting the vocabulary and syntax of Brunelleschi's style to this particular task without the intervention of a professional architect such as Michelozzo. What, then, do we know of Donatello's tastes and abilities as an architectural designer before and during the early 1420's? The architectural elements in his reliefs up to that time are scanty and far from impressive. The blind arcade in the St. George panel of 1417 testifies to his early contact with Brunelleschi but in other respects the building still recalls the background architecture of Ghiberti, and the foreshortening is notable for its lack of accuracy (see above, pp. 30f); the niche of the Pazzi Madonna (see above, p. 44), some five years later, shows a similar indifference to the rules of mathematical perspective. Fabriczy (*Filippo Brunelleschi*, Stuttgart, 1892, pp. 67f), Geymüller (*Jahrbuch, op.cit.*), and Bode (*op.cit.*, p. 27) have seen evidence of Donatello's architectural ability in the fact that in 1418 he collaborated with Brunelleschi and Nanni di Banco on the first model of the dome of Florence Cathedral, for which the three masters were jointly paid 45 florins on December 29, 1419 (see doc. 43 in Cesare Guasti, *La cupola di S. Maria del Fiore*, I, Florence, 1857, p. 25). This sum, however, represents only the cost of the model as a physical object; for that task, the help of two sculptors and stonecarvers was certainly important, but the architectural and engineering ideas which the model was meant to demonstrate must have been Brunelleschi's alone. There can be little doubt, on the other hand, that in working on the model Donatello learned something—and perhaps a

good deal—about architectural design.[8] A tangible echo of the experience thus gained may be seen in the knob of the crozier of St. Louis (Pl. 23a, b), a truly astonishing piece compared to the sparseness of Donatello's architectural designs in the St. George panel and the Pazzi Madonna. It is a miniature *tempietto*, crowned by a ribbed dome of pointed shape strikingly similar to that of the Cathedral.[9] Among all of Donatello's works before 1425, this knob provides the only visual evidence that might sustain the traditional attribution of the tabernacle, and it has indeed been cited repeatedly as containing all the essential elements of the tabernacle in nuclear form (Geymüller, *Jahrbuch, op.cit.*, pp. 254f; Bode, *op.cit.*, p. 46; Colasanti, *D.*, p. 46). Yet the features the two works have in common—the fluted Corinthian pilasters and the apsidal niche topped by a shell—belong to the basic repertory of Early Renaissance architecture and are thus quite impersonal. What gives the knob design its individual flavor is the free combination of Renaissance and Gothic forms: the pilasters have buttresses attached to them, a classic entablature supports a ribbed, pointed dome, and the pediments, open at the bottom, have turned into a zigzag ornament. There is also a peculiar interdependence of architecture and sculpture: two of the three escutcheon-holding *putti* lean against the buttresses. All these characteristics point towards the "picturesque" style of the S. Croce Annunciation and the Cantoria; they are the hallmark of Donatello's personal taste. The tabernacle, in contrast, represents an orthodox, pure combination of Brunelleschi elements (except for the spiral fluting on the Ionic columns and some other ornamental details), without that willful, "picturesque" quality so conspicuously present in the crozier knob.

If the style of the tabernacle is basically un-Donatellesque, it is equally lacking in any features that can be positively identified as characteristic of Michelozzo, whose personality at this time is singularly difficult to grasp. That the tabernacle recalls his later work in certain respects may be readily granted, but these resemblances do not prove common authorship. On the other hand, considering the adaptability and lack of assertiveness of Michelozzo's style—at least in his younger years—it seems entirely possible that he was involved with the St. Louis niche, although in a capacity more technical than artistic. Perhaps the actual circumstances might be visualized as follows: Dona-

[7] Cf. Piero Sanpaolesi (*La sacristia vecchia di S. Lorenzo*, Pisa, 1950, p. 14), who points out that the Barbadori Chapel in S. Felicità, which he dates as early as 1417-1418, might have inspired the architectural setting of the Trinity mural; if he is right, the same would hold true for the St. Louis niche.

[8] In this connection it is interesting to recall that according to Manetti's *Vita* of Brunelleschi, Donatello "never once glanced at the architecture" when the two friends were together in

Rome studying ancient monuments; ed. Elena Toesca, Rome, 1927, p. 20.

[9] L. H. Heydenreich ("Spätwerke Brunelleschis," *Jahrbuch Preuss. Kunstslgn.*, LII, 1931, p. 17) has shown that the design of the knob is related in several respects to Brunelleschi's design for the lantern of the Cathedral dome, and that both have a common ancestry in slightly earlier goldsmith's work.

tello, in all likelihood, was commissioned to do both the statue and the tabernacle (the entry in the Ghiberti Codex carries a strong implication to this effect; why should the tabernacle have been specifically excluded in stating the cost of the statue, unless the two were habitually thought of as parts of the same commission?). Faced with this unaccustomed task, he consulted his friend Brunelleschi, with whom he had shortly before worked on the model of the Cathedral dome. The two of them then sketched out the structure in general terms, Brunelleschi suggesting the architectural organization and Donatello deciding on the sculptural *décor*. The basic design having been thus determined, Donatello felt the need for an associate or "subcontractor" with the necessary technical experience to carry it out in detail, procure the materials, supervise the carving of the individual blocks, and be responsible for the construction work. He chose Michelozzo, who may have seemed particularly suitable because he had assisted Ghiberti with the St. Matthew, a commission that also involved both a statue and a tabernacle. Michelozzo's success in carrying out the St. Louis Tabernacle finally led to the partnership arrangement of 1425, after Donatello had been offered another commission demanding an architectural framework, i.e. the Coscia Tomb.[10] If our conjecture is correct, it would permit us to reconcile—within limits—the contrasting viewpoints of Geymüller and Semrau: Michelozzo may indeed have begun his association with Donatello in the role of an uncreative subcontractor or architectural entrepreneur, but before long he became a designer in his own right and, in the Coscia and Brancacci Tombs and the Prato Pulpit, made an important artistic contribution as well.

[10] It would be instructive to know the exact legal meaning of the term *compagno*, which both artists used in their *Catasto* Declarations of 1427 to describe the partnership; Michelozzo also stated that he had been a *compagno* of Ghiberti during his work on the St. Matthew, even though his position was clearly a subordinate one. Perhaps the term could be used for any relationship outside of regular salaried employment, regardless of whether the partnership was equal or not.

RELIQUARY BUST OF ST. ROSSORE
MUSEO DI SAN MATTEO, PISA

PLATE 25a Gilt bronze; H. 56 cm; W. 60.5 cm *1422-1427*
(c. 1424)

DOCUMENTS

Three entries in Donatello's *Catasto* Declarations of 1427 and 1430. Their first, incomplete publication by Giovanni Gaye, *Carteggio inedito . . .* , I, Florence, 1839, pp. 121f, was supplemented by further excerpts in Semper, *D.* '75, pp. 310f; a complete transcription, including not only the declarations (*portate*) but also the *campioni* (i.e. the summaries of the declarations, with statements of tax liability, in the official ledgers) has been made by Rufus Graves Mather, "Donatello debitore oltre la tomba," *Rivista d'arte*, XIX, 1937, pp. 186ff, from the originals in the State Archives in Florence. The records of the Order of the Cavalieri di Santo Stefano, containing references to the translation of the relic (and reliquary) of St. Rossore from Florence to Pisa in 1591, are also in the State Archives. These were excerpted by Giuseppe Fontana and published posthumously by his son, Giovanni Fontana (*Un'opera del Donatello esistente nella Chiesa dei Cavalieri di S. Stefano di Pisa*, Pisa, 1895, pp. 11ff).

1427, July 11: The friars of Ognissanti owe Donatello 30 florins or more for a bronze half-length figure of St. Rossore. He in turn owes 15 florins to Giovanni di Jacopo degli Stroza for the repeated casting of a figure of St. Rossore and for other things.

1430 (day and month not recorded): The friars of Ognissanti still owe Donatello 30 florins [according to Mather, 20 florins] for a half-length figure of bronze.

1591, October 29: Cappone Capponi, Prior of the Church [of S. Stefano dei Cavalieri], receives somewhat more than 2 scudi to cover the cost of transporting the head of St. Rossore, donated by Lodovico Covi.

November 3: 24 pounds of white wax have been consumed on that date during the solemn translation of the head of St. Rossore [to the Church of S. Stefano].

November 12: Further expenses are listed in connection with the ceremonial translation of the head of St. Rossore (22 pounds of gunpowder for a salute as the relic was carried across the Ponte Vecchio, and 4 sacks of thyme for eight masses).

November 29: The cabinetmaker Girolamo di Giovanni is to receive 5 lire and 5 scudi for a base for the head of St. Rossore.

S O U R C E S : none

St. Rossore, also known as Lussorio or Russorio, was beheaded near Cagliari in Sardinia under Diocletian (*Acta Sanctorum*, August 21). His head, preserved as a relic in Pisa, was brought to Florence by the friars of Ognissanti in 1422 (Scipione Ammirato, *Istorie fiorentine*, XVIII; cited in Fontana, *op.cit.*, p. 6). The friars, of the Order of the Umiliati, retained the church and monastery of Ognissanti until 1554 or 1561, when they ceded it to the Franciscans and moved, together with their relics, to S. Caterina degli Abbandonati. The order was suppressed in 1570 by Pius V, who turned all its properties in Florentine territory over to the Cavalieri di S. Stefano, assigning the revenues therefrom as a perpetual benefice to the family of the Covi from Brescia. In 1591, the Capitani of the Bigallo purchased the Church of S. Caterina from Lodovico Covi, with the consent of the Grand Master of S. Stefano, and converted it into a home for foundlings. (See Fontana, *loc.cit.*; based on Giuseppe Richa, *Notizie istoriche delle chiese fiorentine . . .*, IV, 1756, pp. 259ff, and VII, 1758, pp. 97f; cf. also Paatz, *Kirchen*, I, pp. 430, 433, nn. 11-13, and IV, pp. 407, 438, nn. 11, 12.) Donatello's bust was probably commissioned soon after the transfer of the relic to Florence in 1422; by mid-1427, it had been delivered to the friars. Even though its whereabouts until 1591 is not recorded, there is no reason to doubt that it remained in the church of the Ognissanti until 1554 or 1561, and subsequently in S. Caterina until its transfer to Pisa and its installation in the Church of S. Stefano there. For these latter events we have the explicit testimony of the documents unearthed by Giuseppe Fontana. Apparently Lodovico Covi presented the head of St. Rossore to the Cavalieri in appreciation of their consent to the sale of S. Caterina. That the gift included not only the relic itself but also the reliquary, is indicated by the reference, on November 29, to a newly made wooden base, which in all probability is the very one that still supports the bust. Moreover, Fontana (*op.cit.*, pp. 13f) has found the bust listed and described in all the inventories of S. Stefano after 1591. After the Second World War, the reliquary was removed to the Museo di S. Matteo, and exhibited in the *Mostra della casa italiana* at the Palazzo Strozzi, Florence, in 1948.

Since its rediscovery (Semper, *D.* '75, p. 280, and Milanesi, *Cat.*, p. 9, believed it to be lost), the bust has found little favor among Donatello scholars until recent years, despite its excellent documentation. The older authors mention it only in passing, and many of them regard it either as a workshop piece or assign a major share of the execution to Michelozzo (Wilhelm v. Bode, *Denkmäler der Renaissance-Sculptur Toscanas*, Munich, 1892-1905, p. 189; Schottmüller, *D.*, p. 122; Schubring, *KdK*, pp. 170, 201; Cruttwell, *D.*, p. 59; Kauffmann, *D.*, p. 32; Dell'Acqua, *Pantheon*, XVIII, 1936, pp. 396f). Middeldorf even pronounced it the work of "an unassuming craftsman somewhere about 1600" (*Burl. Mag.*, LIV, 1929, p. 188; in *AB*, p. 579, he remains unconvinced by Kauffmann's arguments for the authenticity of the bust). This general skepticism—apparently a phenomenon of the history of taste closely analogous to the equally widespread dislike of the St. Louis (see above, p. 49)—was not dispelled until Lányi's careful examination of the work (*Probl.*, pp. 14ff). Since it is referred to only in Donatello's personal *Catasto* Declaration, Lányi points out, rather than among the pieces for which Donatello and Michelozzo were jointly responsible, the latter cannot have had anything to do with the execution of the bust; indeed, the bust must have been commissioned before the start of the partnership, like the Siena Dance of Salome. Curiously enough, the scholars who insisted on seeing the collaboration of Michelozzo in the St. Rossore, also believed that Michelozzo had entered the partnership in the capacity of expert bronze caster (see above, p. 50), even though in this instance we know that the casting was done by another man, Giovanni di Jacopo. Here, then, is a further argument against the assumption that Michelozzo's role as a *compagno* of the older master was essentially that of a casting expert. Why should not Giovanni di Jacopo also have cast the St. Louis, which is closely related to the St. Rossore in both style and technique (the bust, too, is cast in separate pieces and fire-gilt; see Lányi, *loc.cit.*, and above, p. 49), and perhaps the Coscia effigy and the Siena bronzes as well? After all, Donatello owed him not only for the bust but for other things. The claim that Michelozzo helped to carry out the St. Rossore is actually little more than a convenient "escape clause" under which Donatello could be relieved of sole responsibility for a work that seemed, for whatever reason, to be below his standard. Only Kauffmann has attempted to point out specifically Michelozzesque qual-

ities in the bust: he finds them in the softness of the drapery, in the chasing of the seams and armor, and in the rigid quality of the face, which somehow reminds him of Ghiberti's St. Matthew and of Michelozzo's connection with that statue, and which he sees reflected in the St. Augustine on the lunette of S. Agostino at Montepulciano, even though he observes that the head of St. Rossore as a whole represents a Donatellesque type. The two comparisons baffle me completely: the St. Augustine, greatly inferior to the St. John of the same lunette, is not by Michelozzo but by a poor assistant, and as for the drapery and the chasing, on what basis can Michelozzo be held responsible for them?

Still, there is indeed something about the bust that does not look "right." Lányi has attempted to solve this problem from the technical point of view. In its present condition, the reliquary consists of five separate pieces (not counting the oval brooch attached to the left shoulder, shown in Pl. 25a; it has since been removed as a later addition): the bust proper, the collar, the head, and the two sections that cover the opening at the top of the head. Of these, Lányi believes the collar to be a later addition; it is loosely attached with three bolts, its workmanship is less precise than that of the two larger pieces, and it interferes with the short chin beard of the saint (the point of the beard has been ground off in order to make it fit over the collar). These observations can be supplemented by others: as an item of costume, the collar is both superfluous and functionally wrong, since it overlaps the seam of the mantle (note especially the left shoulder); its crimped edge has been partly cut away in back and on the right shoulder, another indication that the collar was superimposed on the bust; it lacks the incised ornament so conspicuously present along the seam of the mantle and on the armor; and, finally, it is the only part of the saint's costume that has no parallel in the Quattrocento (cf. the careful analysis of the armor in Kauffmann, *D.*, p. 206, n. 97). Could it be that such a collar was worn by the Cavalieri di S. Stefano, and that they endowed the St. Rossore with it so as to make him one of their own? (The brooch, too, was added in the Seicento.) However that may be, all the evidence available without actually taking the reliquary apart seems to favor Lányi's suggestion. The relation of the head to the shoulders would no doubt become freer and more organic if the collar were to be eliminated.

Another feature of the bust that might raise doubts such as those expressed by Middeldorf, is the mustache and chin beard, which imparts to the otherwise severe head something of the elegance of a seventeenth century cavalier. Here again Lányi has proposed a plausible explanation by pointing out that this fashion also existed in the later Trecento. But why should Donatello have adopted so outmoded a tonsorial habit? Perhaps it would be well, in this connection, to keep in mind the peculiar character of his task. After all, the head of St. Rossore probably was housed in a reliquary of some sort—possibly a wooden bust—even before it came to Florence, and Donatello may have been asked (or may have decided on his own) to retain some aspects of the older work. Or he might have introduced the "Trecento beard" simply in order to suggest a certain traditional quality in a face that otherwise displays many of the realistic and individual touches of a portrait. Lányi has rightly stressed this portrait-like character and related it to the similarly individualized features of the Campanile prophets, although I find myself unable to accept all the conclusions he draws from his analysis of this aspect of the St. Rossore.

The exact date of the bust, within the five-year span 1422-1427, can be determined only on stylistic grounds. If it seems likely, for the reasons mentioned above, that the work was commissioned fairly soon after the arrival of the relic in Florence, the fact that the friars still owed Donatello 30 florins for it in mid-1427 does not permit any inference concerning the date of delivery. Nor can we be sure how large a part of the total price this debt represents. The St. Louis, it will be recalled, cost 449 florins, exclusive of the fire-gilding (see above, p. 47); by analogy, the St. Rossore ought to have cost about 100 florins, not counting the expense of gilding the bust. Thus in 1427 the artist had already been paid at least two-thirds of the total due him, some of it undoubtedly before he delivered the work, in accordance with the general custom at that time. But since the friars continued to owe him 20 (or perhaps 30) florins for another three years or more, we have no way of estimating their rate of payment; for all we know, they may have owed Donatello those 30 florins ever since 1424. According to Giovanni Poggi (*Donatello, San Ludovico*, New York, Wildenstein & Co., n.d. [1949], p. 13) the St. Rossore is closely related to the St. Louis, so that its style indicates a date nearer to 1422 than to 1427. Planiscig (*D.*, p. 41) also dates the bust before 1425, although for the spurious reason that it was not cast by Michelozzo. The resemblance to the St. Louis is evident enough, quite apart from the similarity of technique, in the "feel" of the drapery as well as in certain facial details (mouth, eyes, ears). Yet the St. Rossore seems equally close to the Coscia effigy in a number of ways: the undulating seam of the mantle, the "hairpin curves" of some of the folds, the ornamental use of Kufic lettering (compare Pl. 27b), and certain realistic details of the head that do not yet occur in the St. Louis, such as the incised creases on the neck and the crow's feet (compare Pl. 27a, c). In the Coscia head, these realistic

features are a necessary part of the total characterization, while in the St. Rossore they seem less well integrated with the facial structure (which, insofar as it resembles the St. Louis, still retains a certain idealized quality). They remain on the surface, as it were, like the incised stubble of beard on the cheeks, which strikes us as a bit too neat and regular (in the "Jeremiah" and the Zuccone, where we find it again, it looks much more natural). The various observations, taken together, suggest a position halfway between the St. Louis and the Coscia effigy for our bust. If Donatello received the commission in 1422 or 1423, he probably did not go to work on it until the St. Louis and its tabernacle were out of the way, i.e. until 1424; by the time he completed the reliquary, perhaps a year later, he may already have begun the Coscia effigy, simultaneously carrying forward the Campanile prophet which he finished in 1426 (see above, pp. 37ff).

EFFIGY OF BALDASSARE COSCIA (JOHN XXIII) BAPTISTERY, FLORENCE

PLATES 26-27 Bronze (including the cushion and the draped litter); L. 213 cm *1425-1427*

DOCUMENTS

1419, December 22. Last Will of Baldassare Coscia (published, from the Medici archives, by Giuseppe Richa, *Notizie istoriche delle chiese fiorentine . . .* , v, 1757, pp. xxxviff, and by G. Canestrini, *Archivio storico italiano*, IV, 1843, pp. 292ff; reprinted in Fritz Burger, *Geschichte des Florentinischen Grabmals . . .* , Strasbourg, 1904, pp. 390f): The executors are to choose a Florentine church for his tomb. The cost of the monument, and of a chapel to be built [for it] and endowed, is to be met from his estate, at the discretion of the executors. He leaves to the Baptistery several holy relics, including the finger of St. John the Baptist, as well as 200 florins for appropriate settings for these relics. As his executors he names Bartolommeo di Taldo Valori, Niccolò da Uzzano, Giovanni d'Averardo de'Medici, and Vieri Guadagni.

1421, January 9. An excerpt from the statutes, accounts, and minutes of the merchants' guild (Arte dei Mercatanti or Calimala) recording negotiations between the executors of Coscia's will and the officers of the guild, who were responsible for the Baptistery (published by C. J. Cavallucci, *Arte e storia*, VII, 1888, p. 36, and reprinted in Vasari, *Le vite . . .* , ed. Karl Frey, I, Munich, 1911, p. 341): In the absence of Giovanni de'Medici, three executors plead the desire of the deceased to be buried in the Baptistery and to have a chapel built there. Palla Strozzi, speaking for the officers, denies permission for the chapel, which would spoil the interior of the church; only the tomb itself may be built, but it must be of modest size (*breve et honestissima*) so as not to obstruct the entrance. This is deemed sufficient, since to be buried in the Baptistery is no small honor in itself.

1424 (day and month not given, hence may be 1425 according to the modern calendar). Another excerpt from the same source as above, published in Vasari-Frey *op.cit.*, p. 342: The tomb of Baldassare Coscia is being built in the Baptistery.

1427, January 28. An entry in the records of deliberations by the *operai* of the Florence Cathedral workshop (published by Cornel v. Fabriczy, "Michelozzo di Bartolomeo," *Jahrbuch Kgl. Preuss. Kunstslgn.*, XXV, 1904, Beiheft, p. 46): The head of the workshop is authorized to sell to Taldi Valori four panels (*tabulas*) of white marble, at the usual price, for the tomb of John XXIII.

1427, about July 11. Michelozzo's *Catasto* Declaration (the day and month are missing, but it seems plausible to assume that Michelozzo made out his Declaration at the same time that he wrote Donatello's, which carries the above date; see Fabriczy, *op.cit.*, p. 61, n. 1, and Rufus Graves Mather, *Rivista d'arte*, XIX, 1937, p. 186; first published, in incomplete form, in Giovanni Gaye, *Carteggio inedito . . .* , I, Florence, 1839, pp. 117f; fully transcribed in Fabriczy, *loc.cit.*, and again, inde-

pendently, in Rufus Graves Mather, "New Documents on Michelozzo," *Art Bulletin*, XXIV, 1942, p. 228): Michelozzo states that he and Donatello became partners about two years earlier, and lists the joint commissions on which they are working. The first of these is a tomb in the Baptistery for Cardinal Baldassare Coscia of Florence; of the total price, 800 florins, they have already received and spent about 600, and the monument is still not completed, so that they cannot yet give an accounting for the project, although they will try to stay within the financial limits of the contract. He owes 5 florins for lime and bricks for this monument.

SOURCES

1475, September 12, Pietro Cennini, letter to Pirrino Amerino (ed. Girolamo Mancini, *Rivista d'arte*, VI, 1909, p. 223): "And between the altar [of the Baptistery] and the New Testament doors there rises the tomb of John XXIII, who had been Pope at one time, enhanced by statues two cubits tall and other ornaments; on it rests the reclining bronze effigy of the deceased, the work of Donatello."

1510 Albertini, p. 9: "[In the Baptistery there is] the bronze tomb of Pope John, by the hand of Donatello; the marble ornaments are by his disciples."

(Before 1530) Billi, pp. 42f (repeated in Cod. Magl., p. 77): "[Donatello] made the tomb of Pope John in the Baptistery, with all its ornaments except for one figure, which is by Michelozzo; it is the figure of Faith, holding a chalice and having arms of uneven length.

(c. 1550) Gelli, p. 58: "[Donatello] is said to have done the tomb of Pope John in the Baptistery, except for the figure with the chalice, representing Faith, which is supposed to be by Michelozzo; but there are many who do not believe that this is a work by Donatello."

1550 Vasari-Ricci, II, p. 48 (Milanesi, pp. 399f, slightly rephrased): "In the Baptistery of Florence Donatello made the tomb of Pope Giovanni Coscia, who had been deposed by the Council of Constance; it was erected at the behest of Cosimo de'Medici, who was a great friend of said Coscia. Donatello did the effigy, of gilt bronze, and the Hope and the Charity, which are of marble, while his disciple Michelozzo did the Faith." (The same account, in shortened form, repeated in Bocchi, p. 13.)

Vasari-Ricci, II, *Vita* of Michelozzo, p. 63: "Michelozzo thus made a Faith of marble on the tomb of Pope Giovanni Coscia in the Baptistery of Florence, after a model by Donatello."

1568 Vasari-Milanesi, II, *Vita* of Michelozzo, p. 432: "Donatello made use of [Michelozzo's] services for many years, because of his great skill in working marble and in casting bronze; this is attested by the tomb in the Baptistery of Florence which Donatello made for Pope Giovanni Coscia, as I have related before, but which was for the most part carried out by Michelozzo; his statue of Faith, two and a half braccia tall, is a very beautiful figure and does not suffer by comparison with the Hope and Charity next to it, which are by Donatello."

Baldassare Coscia, as John XXIII (since 1410) one of the antipopes of the Great Schism, had been deposed in 1415 by the Council of Constance, which two years later elected Martin V. He formally acknowledged the authority of Martin V in 1419, at the urging of Niccolò da Uzzano, who had offered him sanctuary in Florence after ransoming him, with the financial aid of Giovanni d'Averardo de'Medici, from captivity under Louis III of the Palatinate (see Burger, *op.cit.*, p. 89; Kauffmann, *D.*, p. 47). It is thus only natural that Coscia should have named these powerful supporters among the executors of his last will. Their attitude towards him may be gathered from the funerary inscription, which identifies the deceased only as IOANNES QUONDAM PAPA XXIII, as well as from other details of the tomb which the executors must have determined. While the effigy itself is devoid of papal insignia (which would have been difficult to see in any event), the three coats of arms beneath the sarcophagus are clearly meant to perpetuate Coscia's

claim to papal authority: the papal coat of arms in the center is flanked by the Coscia escutcheon (*coscia* = leg, thigh), surmounted by the tiara on the left and the cardinal's hat on the right. Coscia himself must have selected for his tomb the Baptistery, the most hallowed spot in Florence, as the best place to assert this claim, but for reasons of tact—and tactics—he expressed his desire only indirectly, through a lavish gift of relics. The bequest undoubtedly made it easier for his executors to overcome the objections of the merchants' guild; there may well have been protracted negotiations about the exact shape and size of the monument, which in the end turned out to be a good deal more conspicuous than Palla Strozzi had intended when he insisted that it be *breve et honestissima*. In any event, there can be little doubt concerning the symbolic importance of the site. Had his executors wished to emphasize their loyalty to the reigning pope, they would have buried Coscia in the monastery of S. Maria Novella, where he had humbled himself before Martin V. (Burger, *op.cit.*, p. 90, argues that Coscia would have preferred to be buried elsewhere but that the authorities chose the Baptistery in an attempt to preclude a monumental tomb; such a view is directly contradicted by Palla Strozzi's emphasis on the great honor of being buried in the Baptistery.) That the deposed pontiff enjoyed considerable support in Florence, and that his tomb became an object of civic pride, is attested by Ferdinando Leopoldo del Migliore, *Firenze città nobilissima illustrata*, Florence, 1684, pp. 95f, who quotes the report of an eyewitness, Petriboni, concerning the lavish public funeral of Coscia. Del Migliore also relates that Martin V objected vehemently to the inscription on the tomb (the purposeful ambiguity of *quondam papa* was a particular affront, since it could be read to mean that Coscia was still Pope at the time of his death) and asked the city government to have it changed to BALDASSARE COSCIA NEAPOLITANVS CARDINALIS—a request that was curtly refused. While he does not cite an exact source for this account, Del Migliore states that the action of the government was recorded by Ser Piero Doffi, Notary to the Signoria, indicating that the story is based on reliable authority.[1] In any case, there seems no reason to question the authenticity

of the incident. We may assume, therefore, that the monument was finished and open to public view before Martin's death in 1431, as pointed out by Kauffmann, *D.*, p. 96, n. 313.[2]

The physical condition of the monument remains unchanged except for the removal of the original polychromy, indicated in a colored sketch in the Codex of Buonaccorso Ghiberti.[3] This explains the present appearance of the marble surfaces, which are not white—as we might expect on the basis of the document of January, 1427—but show various shades of discoloration due to residual pigment and medium and to the cleaning process itself. Two pen drawings in the Uffizi (Nos. 660, 661, cat. orn.), once regarded as sketches for the tomb by Donatello, are Cinquecento works by an unknown hand, with minor deviations from the design of the monument (see Burger, *op.cit.*, p. 391, figs. 218, 219).

The date when the tomb was commissioned is not known. Older scholars (Semper, *D.* '87, p. 43; Wilhelm v. Bode, *Denkmäler der Renaissance-Skulptur Toscanas*, Munich, 1892-1905, p. 18; Schottmüller, *D.*, p. 120; Cruttwell, *D.*, p. 55) assumed that the order was placed as early as 1420 although the execution was delayed until 1424/25-1427. There is, however, no positive evidence for such a five-year delay. The mere fact that the executors were negotiating with the merchants' guild about the location and size of the tomb a year after Coscia's death, does not imply that they were on the point of actually ordering the monument. Perhaps they did, in which case the original commission would have gone to Donatello alone. But the testimony of Michelozzo, who lists the tomb among the projects "we have been working on since we became partners some two years ago," certainly favors the assumption that the monument was a joint undertaking from the very start. Since Michelozzo places it at the head of his list, as the partnership project closest to completion, we may well infer that the Coscia Tomb was the first commission the two masters accepted together. (See above, pp. 55f, on their possible collaboration before the start of the partnership.) The phrase, "some two years ago" (*in due anni o incirca*) need not be taken too literally; in the context, it is no more than an incidental remark, for Michelozzo's tax

[1] The full reference may be hidden among the mass of notes left behind by Del Migliore; this material, which according to Vasari-Milanesi, III, pp. 231, 389, is preserved in the Magliabechiana, has never been systematically exploited.

[2] Vasari-Milanesi, II, p. 399, n. 2, attaches special significance to the fact that the Pope's request went to the Priori, rather than to Cosimo de'Medici, and that the latter was not consulted when the Priori decided to retain the original wording. If Cosimo had indeed been circumvented in this affair as an avowed partisan of Coscia, we would be able to date the complaint of Martin V after the death of Giovanni d'Averardo in 1429, but Del Migliore does not mention Cosimo at all, so that the Milanesi note turns out

to be sheer speculation based on Vasari's erroneous claim that the tomb was built at the behest of Cosimo. Burger, *loc.cit.*, also links Cosimo with the commission, on the basis of Ferdinand Gregorovius, *Geschichte d. Stadt Rom . . .* , VI, Stuttgart, 1867, p. 653n; but here again, the ultimate source appears to be Vasari.

[3] Florence, Bibl. Naz., Cod. Magl. XVII, 2, fol. 70; see Semper, *D.* '87, p. 44, and Robert Corwegh, *Mitteilungen Kunsthist. Inst. Florenz*, I, 1910, p. 171; the colors are not to be regarded as wholly reliable, since the sketch deviates from the original in various architectural details as well; cf. Ottavio Morisani, *Michelozzo Architetto*, Turin, 1951, p. 24 and fig. 4.

The Sculpture of Donatello

liability did not depend on the exact length of his association with Donatello. Thus the partnership—and the work on the Coscia Tomb—could easily have begun several months before mid-1425. This possibility must be kept in mind when we consider our earliest documentary reference to the monument, which informs us that work on the tomb had started sometime in 1424, Florentine style. Since we do not know the day and month, all we can really gather from this notice is that by March 24, 1425, the construction of the tomb was under way, and that there is one chance out of four that the actual date of the document falls within the first three months of 1425. How far advanced the project was at that time we do not know for certain, but the very fact that official notice was taken of it would seem to indicate that the building activities inside the Baptistery had just started and were being reported to the officers of the guild as a newsworthy event. An earlier date for the monument has been proposed by Giuseppe Fiocco, who claims that the tomb of Tomaso Mocenigo in SS. Giovanni e Paolo, Venice, begun in 1423, already reflects the influence of the Coscia Tomb (*Dedalo*, VIII, 1927, p. 362; the same suggestion in Louis Courajod, *Leçons . . .*, II, Paris, 1901, p. 592, and more recently in Leo Planiscig, "Die Bildhauer Venedigs . . .," *Jahrbuch Kunsthist. Slgn. Wien*, N. F. IV, 1930, pp. 59ff). While Kauffmann, *loc.cit.*, is undoubtedly correct in denying this relationship, the two tombs do have an element in common that poses an interesting problem: the front of the Mocenigo sarcophagus is decorated with five shell niches containing Virtues in high relief. These niches are separated by ornamented strips, rather than by Corinthian pilasters as in the Coscia Tomb, and the five Virtues in no way reflect their Florentine counterparts; apparently the same basic motif was used independently in the two monuments. But if so, where did it originate? Curiously enough, there are no precedents for rows of shell niches with Virtues in Tuscan funerary sculpture, whereas we do find them quite often in Venice and Padua. The Mocenigo Tomb is clearly based, in this respect as in others, on the somewhat earlier tomb of Antonio Veniero in the same church.[4] The Virtues of the Coscia Tomb, then, would seem to be, directly or indirectly, of North Italian Gothic origin. How the motif came to be incorporated into this particular monument we cannot say; perhaps the type had spread farther south than we realize at present, so that we need not go all the way to Venice for the immediate source of the Coscia Virtues. On the other

hand, it is not inconceivable that Donatello or Michelozzo made a trip to northeastern Italy before 1425. Michelozzo, we know, was in Padua in 1430 (see Fabriczy, *op.cit.*). Could he have established connections there during a previous journey? His first teacher and employer, Ghiberti, had visited Venice from October to December, 1424, during an outbreak of the plague in Florence, and it is tempting to think that Michelozzo might have accompanied him.[5] Another attempt to prove that the design of the Coscia Tomb must date from 1423 or 1424 was made by Géza de Francovich, who observed that the hexagonal tabernacle rising above the Siena Font reflects the influence of our monument (*Bolletino d'arte*, IX, 1929-1930, pp. 152ff; the resemblance had already been observed by Burger, *op.cit.*, pp. 98f). Francovich claimed that this tabernacle, which is indeed quite obviously dependent on the niches and pilasters of the Coscia Tomb, was designed before Jacopo della Quercia's departure for Bologna in 1425. Since then, however, Pèleo Bacci has proved beyond doubt that Quercia did not receive the commission for the tabernacle until June 20, 1427 (*Jacopo della Quercia, nuovi documenti . . .*, Siena, 1929, p. 174, entry from the records of the Siena Cathedral workshop). The master finally returned to Siena in September of the following year, and since he must have traveled via Florence we may assume that he saw the Coscia Tomb, which at that time was either finished or very close to completion. His design for the tabernacle, made immediately afterwards, shows how strong an impression the monument had left upon his mind.

The exact date when the Coscia Tomb was unveiled to the public cannot be determined. Our one reliable *terminus ante*, 1431 (on the basis of the complaint of Martin V about the inscription), is not very illuminating; from Michelozzo's *Catasto* Statements it seems highly probable that the project was completed a good deal earlier than 1431, since three-fourths of the total price of 800 florins had already been spent by mid-1427. Michelozzo implies that in the end he and Donatello may have to exceed the stipulated financial limit. They probably did, but we do not know for certain by how much. The statement of Del Migliore, *loc.cit.*, that the monument cost 1,000 florins is inherently plausible and carries considerable weight, even though he does not reveal his source. The effigy alone must have been priced at close to 500 florins, to judge from the prices for comparable works recorded in the Codex of Buonaccorso Ghiberti (see above, p. 47): Dona-

[4] There is, however, another tomb by Pietro di Niccolò that does derive from the Coscia Tomb: the monument for Raffaelo Fulgoso in the Santo of Padua, ordered 1429 according to Planiscig, *loc.cit.* Here we find only three niches, separated by pilasters instead of strips, and the Virtues echo those in Florence, as Balcarres, *D.*, p. 75, has pointed out.

[5] In that case, he would have left Ghiberti's workshop immediately upon his return in order to become the partner of Donatello; Ghiberti may be hinting at this when, in a letter to Giovanni Turini of April 16, 1425, he complains of the ingratitude of "those who used to be my collaborators." See Semper, *D.* '75, p. 279.

tello's St. Louis, a larger but less expensively made figure, cost 449 florins without the gilding, Ghiberti's St. Matthew 650 florins. We do, however, have a more significant—if not absolutely certain—*terminus ante* for the lower part of the structure in the date of Quercia's return from Bologna in September 1428. His tabernacle design reproduces the architectural framework of the Coscia Virtues in such detail that it must have been based on the tomb itself, rather than on a small-scale model or sketch, unless we are willing to explain the resemblance through Pagno di Lapo Portigiani, who began to work on the Siena Font as a marble carver in early June, 1428, and continued in this minor capacity under Jacopo della Quercia until March of the following year.[6] Before that, Pagno had spent 18 months in the workshop of Donatello and Michelozzo, according to his father's *Catasto* Declaration of August 8, 1428 (see below, p. 90). That he left the two masters and went to Siena may mean that his services were no longer needed, which would indicate that the marble structure of the Coscia Tomb was completed by mid-1428.

As a pioneering achievement of Early Renaissance decorative architecture, the Coscia Tomb is second only to the St. Louis Tabernacle at Or San Michele. Its influence on the sepulchral monuments of the new era, rightly stressed by Burger and Kauffmann (*loc.cit.*), can hardly be overestimated and reaches far into the sixteenth century. Because of this generally acknowledged importance (Reymond, *Sc. Fl.*, II, p. 155, is among the very few who have criticized it as badly proportioned and "gothicizing") the tomb inevitably became a subject of contention in the protracted dispute centering on the St. Louis niche. Is the design essentially Donatello's own creation, or should it be credited to Michelozzo? Since we have reviewed both sides of the controversy in some detail before (see above, pp. 51ff), there is no need to recapitulate the arguments here. The majority, following Geymüller's and Bode's estimate of Michelozzo, regard Donatello as the designer of the monument and assume that the younger master contributed no more than the architectural details (thus Colasanti, *D.*, p. 53; Kauffmann, *loc.cit.*; Paatz, *Kirchen*, II, p. 205; and most recently Morisani, *op.cit.*, p. 23). Those, on the other hand, who share the point of view of Semrau and the Stegmanns, believe that Donatello contributed only the effigy and left everything else to Michelozzo (e.g. Planiscig, *D.*, p. 48). So far as the architectural composition of the monument is concerned, this is my own conviction as well, for reasons that have in part been set forth on p. 55 above (the marble sculpture presents a more complex problem and will be dealt with separately below). Surely the austere and rational design of the Coscia Tomb is even less compatible with the "picturesque" spirit of the S. Croce tabernacle and the Cantoria than is the St. Louis niche. It points, rather, to the framework of the Prato Pulpit, which, although far more lavish in detail, shows the same clean separation of the architectural and sculptural spheres. Scholars of the Geymüller-Bode persuasion usually account for this contrast by postulating a radical change in Donatello's architectural taste as a result of his Roman sojourn in 1432-1433. Such a view, however, raises a number of difficulties: it takes for granted that the S. Croce Tabernacle was designed after 1433, even though the sculptural style of the work strongly favors an earlier dating (see below, pp. 103ff), and it fails to explain why the impact of Rome should have resulted, not in an increase of classical qualities (as we might expect) but in the very opposite. There is indeed no compelling reason to attach decisive significance of this sort to Donatello's Rome journey (see below, p. 100). Does it not seem far more plausible to link the supposed change of Donatello's style to the dissolution of his partnership with Michelozzo? Nor can it be sheer chance that almost all the partnership projects of which we have certain knowledge involve architectural settings (i.e. the Coscia, Brancacci, and Aragazzi Tombs and the Prato Pulpit). After all, we need not suppose that the two masters accepted only joint commissions while their partnership lasted (Donatello, at least, also worked for his own account, and we cannot assume that all of these independent commissions had come to him before 1425); apparently they acted as a team only when the nature of the project was such as to call upon the particular abilities of both. To contrast the design of the Coscia Tomb with that of the Brancacci Tomb, to the disadvantage of the latter, has little evidential value, even though it is one of the main arguments of Geymüller, Bode, and their followers. If the ensemble of the Brancacci Tomb strikes us as less successful, we have no way of knowing to what extent this may be due to the special circumstances of the commission (conformity to a Neapolitan tomb type demanded by the patron, changes in the course of installation beyond Michelozzo's control) rather than to the artistic inferiority of the designer.

The bronze effigy of Baldassare Coscia has been unanimously acclaimed as one of Donatello's masterpieces. Those authors who regard Michelozzo's function in the partnership as that of an expert in the technical handling of bronze (see above, pp. 50ff), credit him with the casting and perhaps the chasing, but there is nothing in the records to bear out such a

[6] Bacci, *op.cit.*, documents on pp. 211ff; in 1435 and 1436, he was again associated with Quercia, for whom he procured, in Florence, seven blocks of marble.

claim. For all we know, the image may have been cast by Giovanni di Jacopo, who had cast the St. Rossore about 1424 (see above, p. 56). To produce a monumental bronze figure such as this must have taken considerable time—two to three years, we may assume, under ordinary circumstances. By mid-1427 the work was either finished or well under way, since its probable cost accounted for about half the total price of the monument and the two partners had already spent 600 florins, or 75 per cent of the contractual price for the entire project. Thus the effigy, in all likelihood, was modeled about 1425 and represents Donatello's style of that time. A comparison with the other bronzes—the St. Louis, the St. Rossore, and the Siena relief—antedating the 1427 *Catasto* suggests the same conclusion: the ideality, the Masacciesque grandeur of the St. Louis have been abandoned for a more realistic and expressive style already hinted at in the St. Rossore (cf. our analysis above, p. 58). The drapery treatment of the effigy, with its rippling surfaces, its sharply defined but smoothly curving ridge-like folds that often terminate in hairpin loops, recalls many similar passages in the Siena panel, especially among the costumes of the cluster of figures on the right. It is here, too, that we find a passionate concern with the expression of feelings by physiognomic means, and this again seems analogous to what our artist has projected into the features of Coscia's head, heavy-lidded, porcine, yet even in death still twitching with animal energy and animal appetites. The awesome vitality of this face stands in complete contrast to the sunken, deflated forms of those effigies produced with the aid of death masks, a widespread custom in Trecento and Quattrocento Italy (see Joseph Pohl, *Die Verwendung des Naturabgusses in der italienischen Portraitplastik* . . . , Würzburg, 1938, pp. 20ff). Donatello, who must have seen Coscia at public functions in 1419, has "re-created" the personality of the deceased, both physically and psychologically, on the basis of what he knew and remembered about him, rather than in any narrow, literal sense. Twenty years later, in the Gattamelata, he achieved, by a similar process, an even more eloquent "ideal likeness" of a great individual. Unfortunately, the Coscia effigy is placed so high that its many splendid qualities can be seen at close range only with the aid of a ladder, even though the bier is slightly tilted for better visibility. One cannot help wondering, therefore, whether Donatello might not have modeled the effigy before the architectural design of the tomb had been given definite shape, so that he did not yet know precisely what the physical relationship between the image and the be-

holder would be. The fact that he gave the bier a forward tilt indicates his desire to display the effigy effectively, and one is tempted to assume that he would have tilted it even more had he designed it for the monument in its present form.

Of the marble sculpture, only the *putti* on the sarcophagus have in recent times occasionally been attributed to Donatello's own hand (Bode, *loc.cit.*; Colasanti, *D.*, p. 54; Paatz, *loc.cit.*). Otherwise, scholars during the past fifty years have been unanimous in assigning the execution and, for the most part, also the invention of all the reliefs to the master's collaborators and disciples, notably Michelozzo and Pagno di Lapo. There can indeed be no doubt that the qualitative level of these pieces precludes execution by Donatello. Such a view, moreover, conforms to the oldest sources on the subject, Cennini and Albertini, as against Billi and Vasari (the skepticism of Gelli is of particular interest in this context). The fanciful notion that Michelozzo did the Faith while Donatello made the other two virtues was still accepted by Semper, *loc.cit.*, but has been discarded long since; the three figures are clearly by the same hand.[7] Now it has long been noted that the Coscia Virtues bear a strong resemblance to the two bronze virtues which Donatello made for the Siena Font (Balcarres, *D.*, p. 75, seems to have been the first to point out the relationship). And since the Siena figures are greatly superior in quality, it has been generally assumed that the Coscia Virtues are debased echoes of them. This, if true, would yield a *terminus post* for the lower part of the Coscia Tomb; the Siena Virtues could not have been started until the summer of 1427, the first payment for them dates from September of the following year and the last six months later, indicating that they were done in the course of 1428 (see below, p. 72). Yet, as we have argued earlier, there are excellent grounds for assuming that the Coscia Virtues were finished by mid-1428, i.e. before the first payment for the Siena figures. While the two "timetables" are not mutually exclusive, they do impose an uncomfortably tight schedule on the Coscia Virtues. Could they by any chance be earlier than their Sienese counterparts? The possibility, I think, is at least arguable. Despite their resemblance, the Coscia Virtues are not slavish repetitions of those in Siena; they might be variants, rather than copies partly misunderstood. Furthermore, their quality of execution is so dry and mechanical that one wonders whether the man who did the actual carving was capable of the feat of adapting them from the Siena figures. Is it not conceivable that they were executed after small-scale plastic sketches by Donatello, and that the latter then re-used some of

[7] Vasari's curious re-evaluation of the Faith in the Michelozzo *Vita* of the second edition follows his general tendency to "build up" the importance of that artist; cf. H. W. Janson, *Art Bulletin*, XXIV, 1942, pp. 327f.

the same forms when he had to model the two Siena Virtues? Some such hypothesis might be the most satisfactory solution of our problem, and not from the chronological point of view alone; for the attribution of the Coscia Virtues to the hand of Michelozzo strikes me as less and less tenable the more I think about it. The sculptural personality of Michelozzo can be reconstructed only from his work in Montepulciano, it seems to me, and if we proceed backwards in time on that basis we find his individual style not in the Coscia Virtues but in the Madonna of the lunette, which despite some awkwardnesses is superior to them in every way. It shows no discrepancy between invention and execution, and can be linked easily with the mourning angels of the Brancacci Tomb and the earlier components of the Aragazzi Tomb. The Virtues may possibly be the work of Pagno di Lapo, although his personal style—if indeed he ever had one—is difficult to grasp. In any event, whoever did them could not also have done the Madonna. As for the front of the sarcophagus, I am again inclined to assume a sketch by Donatello, who employed the same device of *putti* unrolling a scroll at the foot of the Pecci slab (Pl. 32a). It was executed, I believe, by the same conscientious but insensitive craftsman who did the Virtues, the lion supports of the bier, and the frieze of angels' heads and garlands at the base of the monument.

GILT BRONZE SCULPTURE FOR THE FONT IN THE BAPTISTERY, SIENA

PLATES 28-31 — 1423-1434

THE FEAST OF HEROD
Relief: H. and W. 60 cm
PLATES 28-29 — 1423-1427 (c. 1425)

FAITH AND HOPE
Statuettes: H. 52 cm
PLATES 30-31b — 1427-1429 (c. 1428)

DANCING ANGEL, ANGEL WITH TRUMPET, ANGEL WITH TAMBOURINE
Statuettes: H. 36 cm
PLATES 31c, d, e — 1429

The last-named figure, the only one of these pieces to have become detached from the font, belongs to the Staatliche Museen, Berlin.

Lost or destroyed: TABERNACLE DOOR (H. c.40 cm; W. c.20 cm) — 1434 (c. 1430?)

DOCUMENTS

A series of records in the archives of the workshop of Siena Cathedral, published in C. F. v. Rumohr, *Italienische Forschungen*, II, Berlin, 1827; Gaetano Milanesi, *Documenti per la storia dell'arte senese*, II, Siena, 1854; Carl Cornelius, *Jacopo della Quercia*, Halle, 1896; and Pèleo Bacci, *Jacopo della Quercia, nuovi documenti . . .*, Siena, 1929, who added greatly to the material and corrected many errors of his predecessors. Also Donatello's *Catasto* Declarations of July 11, 1427, and 1430, excerpted in Giovanni Gaye, *Carteggio inedito . . .*, I, Florence, 1839, pp. 120ff, supplemented by Semper, *D.* '75, pp. 310f, and newly transcribed by Rufus Graves Mather from the originals in the State Archives, Florence, in "Donatello debitore oltre la tomba," *Rivista d'arte*, XIX, 1937, pp. 186ff.

1423, May (Bacci, p. 124): Donatello is paid 50 lire 1 soldo by the Cathedral workshop in behalf of Jacopo della Quercia.

1425, March, early (Bacci, p. 158): The Cathedral workshop decides to request the return of the money advanced to the Florentine masters who are doing scenes for the font [i.e., Ghiberti and Donatello], since all the delivery dates have lapsed and nothing is finished.

August 18? (Cornelius, p. 40): Donatello is referred to as having made (*ci ha fatto*) one of the two scenes originally allocated to Jacopo della Quercia.

1427, April 7-11 (Bacci, pp. 167f): The chamberlain of the Cathedral workshop has been to Florence in order to fetch the relief by Donatello.

April 13 (Bacci, *loc.cit.*): Donatello's relief has arrived in Siena.

May 9 (Milanesi, p. 134): Donatello and Michelozzo write to the *operaio* of Siena Cathedral asking for speedy payment of the 50 florins that had been promised to them and inquiring about the identities of those figures which are still needed [for the font], since they now have the leisure to carry them out with care.

July 11, from Donatello's *Catasto* Declaration: He is to receive 180 florins from the *operaio* of Siena Cathedral for a story in bronze "which I made for him some time ago." He owes Jacopo della Quercia 40 florins in connection with the same story, as well as 10 florins to Giovanni Turini for assisting him with the story and 25 florins to the *operaio* for the gilding.

October 8 (Milanesi, p. 135; Bacci, p. 178): Donatello is to receive 720 lire, which equals 180 florins, for the scene of "the head of St. John being brought to the king's table." This is one of the two subjects originally allocated to Jacopo della Quercia; it was then transferred to Donatello, who has already been paid 50 lire 1 soldo in advance some time ago on behalf of Jacopo della Quercia; the latter was to have done this scene and another but did not do it.

Between October 6 and 30 (Bacci, p. 179): Donatello has been paid 662 lire 19 soldi for one of the scenes for the font.

1428, September 25 (Bacci, pp. 219f): Donatello receives 100 lire in advance for two gilt figures for the font.

October 26 (Bacci, *loc.cit.*): The *operaio* disburses 160 lire in connection with two gilt figures for the font.

1429, March 12 and April 1 (Bacci, *loc.cit.*): Donatello receives 120 lire for two figures.

April 18 (Bacci, p. 221): Donatello has so far received a total of 380 lire 15 soldi for the two gilt bronze figures he has made for the font.

April 22 (Milanesi, p. 135; Bacci, p. 223): Donatello receives 20 lire in part payment for the tabernacle door (*sportello*) of the font.

April 16 (Bacci, p. 242): Donatello receives 4 lire 16 soldi for 12 pounds of wax for "certain nude infants" for the font.

April 27 (Bacci, *loc.cit.*): Donatello receives 38 lire for the purchase of bronze. On the same day he serves as godfather at the baptism of a daughter of the goldsmith Tommaso di Paolo (Bacci, *Francesco di Valdambrino*, Siena, 1936, pp. 385f).

1430, from Donatello's *Catasto* Declaration (day and month unknown): The Sienese owe him about 25 florins "for certain labors." [This item is not explicitly linked with the font, but if it were meant to refer to a private commission such as the Pecci slab, Donatello would presumably have listed his debtor by name.]

1434, August 18 (Rumohr, pp. 359f; Milanesi, pp. 159ff; see also Bacci, pp. 221f): Final accounting for the figures, at the insistence of Donatello, who had sent his *garzone* Pagno di Lapo to press his demands before the Cathedral workshop. Donatello has been paid a total of 738 lire 11 soldi so far; since he was to receive 720 lire for "certain gilt bronze figures" for the font, he has overdrawn his account by 18 lire 11 soldi. But because he has also made a bronze tabernacle door which was rejected by the Cathedral workshop, he is granted a fee of 38 lire 11 soldi in order that the time and effort spent on it might not be a complete loss, thus leaving him a credit of 20 lire. The door itself is to be returned to the master, through Pagno di Lapo, and the 20 lire are to be paid to the Sienese goldsmith Tommaso di Paolo, who is representing Donatello in this transaction.

SOURCES: none

Vasari knew of Donatello's share in the sculptural decoration of the Siena Baptistery Font only in vague and uncertain terms. He does not mention it in the Donatello *Vita*, but in that of Ghiberti he refers to Jacopo della Quercia, Donatello, and Vecchietta as the other three masters that contributed to the sculpture of the font; and in the Vecchietta *Vita* he states that the latter artist "completed a bronze relief begun by Donatello" as well as "some bronze figures cast by Donatello but finished entirely by him," and thus "at last brought the font to completion" (Milanesi, III, pp. 77f). Apparently Vasari was unable to identify the particular pieces in question. Among the six reliefs, he could distinguish only the two by Ghiberti, which he singles out for individual mention. Of the others, he claims three for Quercia, but without naming the subjects, while Turini is not mentioned at all. Thus we have no reason to believe that he was referring to the Feast of Herod as the "Donatello-Vecchietta" panel (as assumed by Wolfgang Kallab, *Vasaristudien*, Vienna, 1908, p. 265; cf. Kauffmann, *D.*, p. 216, n. 183). In any event, the fact that Donatello received full payment for all his contributions to the font—except for the rejected tabernacle door—indicates clearly enough that he did not deliver anything unfinished. Vasari's report has all the earmarks of a local tradition motivated by a desire to increase the share of native artists in this famous monument, which must have been as much of an object of pride to the Sienese as the Baptistery Doors were to the Florentines.[1]

The Feast of Herod is one of the two panels commissioned of Jacopo della Quercia on April 16, 1417. On October 9, 1419, the records of the Siena Cathedral workshop show that Quercia had received an advance of 120 florins for "two stories which he is to make for the font" (Bacci, *Quercia, op.cit.*, p. 123). Cornelius, *loc.cit.*, misread the key word (*finire* instead of *fare*), and concluded that Quercia must have started work on both reliefs, since he was called upon merely to finish them. This raised the possibility that the Feast of Herod might, in part, be based on Quercia's design.[2] However, the style of the panel gave no evidence of collaborative effort, and the thesis that Quercia had

had a share in its execution was abandoned long before Bacci published his corrected reading of the 1419 document (cf. the protests against the Cornelius-Pastor view by Wilhelm Bode, *Jahrbuch Klg. Preuss. Kunstslgn.*, XXII, 1901, p. 45, and Schubring, *KdK*, p. 195). The same fate befell the belief of Schmarsow (*D.*, pp. 27ff), based on certain resemblances between the Feast of Herod and Quercia's Zachariah panel, that Donatello owed an important artistic debt to Quercia (approvingly cited by Tschudi, *D.*, p. 13 and Bertaux, *D.*, p. 73; rejected by Semper, *D.* '87, p. 38 and Bode, *loc.cit.*). The two reliefs do indeed show a number of similarities, both in detail and in general disposition; as long as it was assumed that Quercia's had been modeled between 1417 and 1419 (even though it was not cast until a decade later), its influence on Donatello seemed plausible enough. But since Bacci has proved (*Quercia, op.cit.*, pp. 248ff) that the panel was executed entirely between 1428 and 1430, the influence must have flowed in the opposite direction, just as it did in Quercia's design for the tabernacle of the font (see above, p. 62). Schmarsow, *loc.cit.*, also launched another hypothesis that gained little support among his colleagues: he thought that the architectural setting of the Feast of Herod, with its elaborate perspective vista, must have been designed by Michelozzo, whose connection with the panel he deduced from the letter to the *operaio* of May 9, 1427, signed by both masters.[3] It is true that the two artists had been partners for about two years when they wrote the letter, but Schmarsow and those who followed him (Semrau, *D.*, p. 71, with reservations; Frey, *Cod. Magl.*, pp. 30ff) failed to consider that the design of the relief very probably antedates the beginning of the partnership; that Donatello alone was paid for it; and that the panel is mentioned only in Donatello's personal *Catasto* Declaration of 1427, not among the joint commissions listed in Michelozzo's, as pointed out by Bode, *loc.cit.* Apparently, then, the letter must be regarded as a piece of business correspondence, signed by both partners to lend it particular weight; it may well have been drafted by Michelozzo, who seems to have had greater facility in clerical mat-

[1] The name of Vecchietta may have entered the story because of a later incident that offered an analogous situation; in 1457, Donatello's bronze statue of St. John the Baptist for Siena Cathedral was delivered with one arm missing, so that it had to be completed by a local master (possibly Vecchietta; see below, p. 197). By a not unfamiliar process of extension, the claim that Donatello's work was finished by a native artist could have been transferred, as time went on, to the sculpture on the font. (Milanesi, *loc.cit.*, note, states that in 1478 Vecchietta repaired the foot of one of Donatello's *putti* on the font; this, if his claim is correct, must have been a very minor job, since it has left no visible traces. More likely, this notice concerns the Turini

putto farthest to the left, whose left foot shows a repaired break above the ankle.)

[2] Pastor, *D.*, pp. 56f, had arrived at the same conclusion by misinterpreting the documents published by Milanesi; he thought that on taking over the commission Donatello had paid Quercia an indemnity.

[3] Pastor, *loc.cit.*, on the basis of the same letter, is uncertain about the authorship of the architectural background but ascribes to Michelozzo the entire group of foreground figures on the right and the two children on the left; this capricious notion has found no defenders.

ters than Donatello (he also wrote Donatello's *Catasto* Declaration of 1427). So far as the architectural setting of the panel is concerned, it certainly marks a new departure for Donatello, since it demonstrates for the first time his mastery of the perspective resources of the Early Renaissance (see below, p. 69); in acquiring the technique of linear projection, he must have had outside help (probably from his friend Brunelleschi), but once he knew it he was fully capable of applying it wherever the occasion demanded. The architecture of the Feast of Herod is the direct ancestor of all the equally elaborate and imaginative settings among the master's later works such as the Lille panel, the St. John *tondi* in the Old Sacristy of S. Lorenzo, and the four large bronze reliefs in Padua (Semper, *D.* '87, p. 37). Moreover, Michelozzo had no interest—and, probably, little ability—in the designing of such backgrounds. His two reliefs in Montepulciano, the only ones he did that are comparable to the Feast of Herod, show a consciously "anti-pictorial" approach to the problem of space. Nor does the letter of 1427 justify the assumption that our panel was cast by Michelozzo (proposed by Bode, *loc.cit.*, and recently repeated by Planiscig, *D.*, p. 43 and Ottavio Morisani, *Studi su Donatello*, Venice, 1952, p. 151); had he done so, we would expect the relief to be listed among the joint commissions in his *Catasto* Declaration, or to find his name among Donatello's creditors in the latter's *Catasto*. (See also my remarks above, pp. 50, 57.)

The date of execution of the Feast of Herod falls within the four-year span of 1423-1427. The commission could have been transferred to Donatello at any time between 1419 and 1423, when he received an advance payment of 50 lire 1 soldo, but we know from the final accounting of October 8, 1427, that this was the only advance our master had been paid (his joint plea with Michelozzo for 50 florins on May 9, 1427, remained unanswered), so that it probably marks the beginning of the actual work on the panel. There is, in any event, no documentary basis for the claim of V. Lusini (*Il S. Giovanni di Siena*, Siena, 1901, p. 37) that the commission was given to Donatello in 1421 (cf. Colasanti, *D.*, p. 22). Of greater importance is the question whether the relief represents our master's style of 1423-1425, or of 1425-1427. According to Cornelius, *loc.cit.*, a document of 1425 refers to the panel as "made" (*fatto*), even though the work did not reach Siena until two years later. Géza de Francovich ("Appunti su Donatello . . . ," *Bolletino d'arte*, IX, 1929, p. 169, n. 25) saw a puzzling contradiction here, since the interval seemed to him far too long for the chasing and gilding of the relief; Colasanti, *loc.cit.*, tried to resolve the apparent conflict by assuming that Donatello withheld delivery for two years until he

was assured of payment. Actually, the delay does not present a problem, it seems to me. The status of the Cornelius document of 1425 is somewhat uncertain, since its transcription was not checked by Bacci (who does not mention it at all), but it appears to be confirmed by Donatello's statement, in the 1427 *Catasto* Declaration, that he made the relief "some time ago." As for the decision of the Siena Cathedral workshop in March, 1425, to retrieve the money advanced to Ghiberti and Donatello for the font reliefs, it tells us only that the panels were not yet finished and that the original delivery dates had lapsed. How Donatello responded to this demand is not known, but Ghiberti's reaction, which we do know, provides a useful analogy. He wrote at once (March 10, 1425) to the *operaio*, assuring him that the two panels in question were almost finished, and towards the end of June he dispatched the raw cast of his Baptism to Siena for inspection (Bacci, *Quercia, op.cit.*, pp. 158f), even though the *operaio* had already sent Giovanni Turini to Florence to verify the true state of affairs. Yet Ghiberti's reliefs were not formally delivered to the Siena Cathedral workshop until October 30, 1427 (Bacci, *Quercia, op.cit.*, pp. 183f), three weeks after the Feast of Herod. Is it not plausible to assume, then, that the latter, too, had been cast, or was about to be cast, by mid-1425? Had Donatello been far behind Ghiberti in his work, Turini would have reported so to the *operaio*, and some sort of official action would have been taken; if, on the other hand, the Feast of Herod was in the same stage of completion as the Baptism and the Captivity of St. John in mid-1425, a reference to it as *fatto* later in the same year would be entirely natural. Nor can we assume that the labor of chasing Donatello's cast took less time than that of surface-finishing the Ghiberti panels. Thus our relief, to all appearances, was modeled in 1423-1425 and reflects, in the main, Donatello's style of those years. Such a view also finds support in the resemblance of various details of the Feast of Herod to other works of our master executed before 1425: the head of Herod recalls the Trinity on the St. Louis Tabernacle (see above, p. 53; the derivation from the God the Father of the St. George Tabernacle, proposed by Planiscig, *D.*, p. 46, seems less convincing), and the viol player in the middle ground echoes the general outlines of the Pazzi Madonna (Pl. 19b). The radical—and slightly awkward—foreshortening of the hands of the figure next to Herod again suggests the same feature in the Pazzi Madonna, as well as in the two busts of 1422 on the Porta della Mandorla (Pl. 19a, c).

The high quality of the chasing indicates that Donatello did most of it himself. In his *Catasto* Declaration of July, 1427, he acknowledges a debt of 10 florins to Giovanni Turini for assisting him with the

panel, but since the relief had been shipped to Siena only two months previously, Turini's share in the chasing could not have been very significant. The 10 florins may simply represent the value of Turini's labor in fire-gilding the panel (as against the 25 florins which Donatello, in the same *Catasto*, listed as his debt to the *operaio* for the gilding; these probably represent the price of the gold which the Cathedral workshop provided for this purpose). The real puzzle of the 1427 *Catasto* are the 40 florins Donatello owed to Jacopo della Quercia; they are quite distinct from the 50 lire 1 soldo paid to our master in 1423, which were deducted in the final accounting of October 8, while the 40 florins were not. Did they represent a "private" debt, perhaps a sort of commission payment? Perhaps it was through the influence of Quercia that the Siena Cathedral workshop ordered the Feast of Herod from Donatello, rather than from Ghiberti (who at that time—about 1423—would have been the obvious choice, because of his intimate association since 1416 with the font project). Could there have existed a feeling of coldness, of rivalry between Quercia and Ghiberti, as Bacci has suggested? (Cf. *Quercia, op.cit.*, p. 160.)

In analyzing the artistic character of our panel, most scholars have centered their interest on the fact that this is the first relief, not only in the work of Donatello but of the entire Early Renaissance, displaying the newly discovered linear perspective. Older authors tend to stress the systematic, "constructed" aspect of the background space (Semper, *D.* '87, pp. 35ff; S. Fechheimer, *Donatello und die Reliefkunst*, Strasbourg, 1904, pp. 29ff; Bertaux, *D.*, pp. 73f), while more recent ones emphasize its imaginative quality and its function as a dramatic stage setting for the figures (Kauffmann, *D.*, pp. 62f; Giulio Carlo Argan, *Journal of the Warburg and Courtauld Institutes*, IX, 1946, pp. 116ff, and John White, *ibid.*, XIV, 1951, pp. 45f; Morisani, *op.cit.*, pp. 153f; and Richard Krautheimer and Trude Krautheimer-Hess, *Lorenzo Ghiberti*, Princeton, 1956, p. 244). That Donatello's perspective here is no longer empirical but based on theory, can hardly be doubted; if, as White, *loc.cit.*, has observed, the orthogonals do not all meet in a single vanishing point, the deviations are so slight that they can be verified only with a ruler. I suspect that they crept in during the process of chasing, rather than in the original design. Mathematical exactitude for its own sake was never Donatello's ambition, yet it seems plain that from the very start he assumed a single vanishing point for the orthogonals, slightly above the center of the panel, on the eye level of the three figures seated at the table. At the same time, the

geometric definition of space was certainly not an aim in itself for him. Considered as a projection of "real" architecture, the setting of the Feast of Herod is hardly plausible; it could never be built as we see it. Its purpose, clearly, is to enhance the action by providing a separate "stage" or compartment for every phase of the drama and—what is no less important—by forming a firm and continuous structural roster against which the *dramatis personae* can play with the utmost freedom.

Viewed by themselves, the foreground figures do indeed lack the "compositional unity" demanded by classicistic standards. Eugène Müntz (*Donatello*, Paris, 1885, p. 46) found this "fault" so disturbing that he hesitated to attribute it to Donatello. To Semrau (*D.*, p. 71) the background of the panel seemed a separate entity only superficially linked with the lower zone, thus indicating the intervention of Michelozzo. Perhaps the most severe critique of the "shortcomings" of our relief was uttered by Schottmüller (*D.*, pp. 15ff) who insisted on judging it by the theoretical criteria of Hildebrand. In recent years, on the contrary, the interdependence of architecture and figures has been duly recognized. As Planiscig, *D.*, p. 45, and Morisani, *loc.cit.*, have pointed out, the architectural setting of the Siena panel foreshadows those of the Paduan reliefs, both in its correlation with the dramatic narrative and in its emphasis on planes paralleling the relief surface.[4] Still, the misgivings of the older scholars have helped to draw attention to the experimental quality of Donatello's relief technique here, a technique equivalent to *schiacciato* in the background but otherwise far closer to Ghiberti's than to our master's previous reliefs in its gradations of plasticity among the foreground figures (the heads of Salome and of the soldier proffering the head of St. John are actually modeled in the round). Since the Feast of Herod is Donatello's first bronze relief, we may wonder whether the "Ghibertesque mode" was imposed upon him by the nature of the commission (which had to fit into a Ghibertesque framework) or whether he adopted it as appropriate to the relief material, which was novel for him. However that may be, he succeeded in merging the two elements without sacrificing the visual unity of the whole. Unlike Ghiberti, he does not place the foreground figures on a "shelf" that protrudes forward beyond the frame; thus the frame acts as a true "window" through which we view the space beyond, arranged in layers parallel to the "pane" of the window. The height of the space corresponds to that of the frame, but its lateral extension is unlimited: the architecture on either side continues behind the frame, and several of the figures are

[4] Cf. also the observations of Kauffmann, *loc.cit.*, who suggests Sienese Trecento precedents for the vista through successive rooms.

cessive rooms.

shown in the act of fleeing into the wings. The sight of the severed head sets off an emotional explosion whose force can spend itself only to the sides; for the three figures seated at the table, there is no escape, even though they shrink away from the horrible salver as far as the wall behind them permits. Ghiberti, we may be sure, would never have countenanced a scene so "fragmentary," so opposed to traditional narrative in its concentration on a single moment and on the reality of psychological experience.

All the more puzzling, therefore, is the fact that the severed head of St. John appears twice in our relief, so that we are faced, not with one event but with a sequence. Why did Donatello introduce the element of continuous narrative into this particular panel? He had never used it before, nor do we find it in any of his subsequent reliefs. Did his contract with the Sienese authorities specify more than one episode? This seems unlikely, for the other five panels on the font are all devoted to single scenes, and the document of October 8, 1427, the only one to mention the subject of Donatello's "story," defines it simply as "the head of St. John being brought to the King's table." We may assume, then, that the decision to show a sequence of events within one frame, so curiously similar to Ghiberti's procedure in the East Doors of the Baptistery, was made by Donatello without external pressure. The reasons for it will, I believe, be better understood after a discussion of the iconographic background of our subject.

The sources of Donatello's Feast of Herod have never been fully investigated. The expressive power and originality of the composition seemed so impressive to Donatello scholars that their efforts have been largely confined to a search for classical influences among the individual figures. The results, so far, are not very conclusive: the Salome may evoke memories of dancing muses, the head of Herod may bear some resemblance to a satyr or Silenus, and the profiles of the heads in the background may suggest Roman coins, but none of these claims can be substantiated by confrontation with specific models that Donatello might have drawn upon, so that the extent of his indebtedness to Ancient art, here as elsewhere, remains difficult to define.[5] In contrast, the relationship of our scene to Trecento representations of the same subject has received little attention. Kauffmann, the only author to mention it, confines himself to a passing reference to the Giotto fresco in the Baroncelli Chapel of S. Croce and the slightly later one by Pietro Lorenzetti in S. Maria dei Servi in Siena (*D.*, p. 63; Venturi,

Storia, VI, p. 254, had claimed a complete departure from traditional iconography for our panel). There is some uncertainty even about the factual content of the scene. Herod and Salome stand out clearly enough, despite their lack of royal insignia, but where is Herodias? She can hardly be the figure seated next to Herod (as stated by Planiscig, *D.*, p. 45, and Wolfgang Lotz, *Der Taufbrunnen des Baptisteriums zu Siena* [in the series, *Der Kunstbrief*], Berlin, 1948, p. 12), since that is clearly a male guest reproaching the king for the death of the Baptist. And what are the events alluded to in the background? According to the Scriptural account (Matthew 14: 6-11; Mark 6: 21-28) the circumstances of St. John's death were as follows: During a banquet on the birthday of Herod, his daughter Salome danced before him and his guests, whereupon he promised to grant her anything she wished. Salome then consulted her mother Herodias (who was not present at the banquet), returned immediately, and asked for the head of St. John on a platter. Herod, reluctantly but unwilling to break his word before his guests, commanded a soldier of the guard to bring the head; the soldier beheaded St. John in prison, brought his head on a platter and gave it to Salome, who gave it to her mother. In Byzantine iconography, as represented by the mosaics on the dome of the Baptistery in Florence, this narrative is condensed into three scenes: Salome's dance at the banquet; the decapitation, in the presence of Salome; and the delivery of the head. In this last scene, Salome returns to the banquet table, followed by the executioner, and hands the platter to Herodias, who sits next to the king. Here, then, we have two banquet scenes—the dance of Salome and the delivery of the head to Herodias—and their compositional similarity made it easy for later artists to compound them into one. Giotto, however, followed a different course in his S. Croce fresco; he combined all three events of the Byzantine cycle within a single frame but differentiated them in terms of past, present, and future. As a consequence, he does not show the decapitation itself, only the prison tower with the headless body of the Saint.[6] In the center section, the executioner brings the head to Herod, who sits at the banquet table with two male guests; Salome is still dancing, to the music of a viol player; two servants, behind her, stare fixedly at the head, one of the guests raises his left hand in a gesture of abhorrence, and the king motions to the executioner to hand the platter to Salome. Herodias, who has been omitted from the banquet scene, appears in a separate compartment

[5] Semrau, *D.*, pp. 72ff; Fritz Burger, "Donatello und die Antike," *Repertorium f. Kw.*, xxx, 1907, pp. 2ff; Colasanti, *D.*, p. 103; A. Meyer-Weinschel, *Renaissance und Antike*, Reutlingen, 1933, pp. 30ff; Kauffmann, *D.*, p. 216, n. 186.

[6] This detail, on the extreme left, is no longer visible in the fresco but can be seen in a panel in the Louvre which is a faithful copy of Giotto's design, by a follower of Agnolo Gaddi; see Ilse Falk and Jenö Lányi, *Art Bulletin*, xxv, 1943, p. 144 and figs. 34, 40.

on the right, where the kneeling Salome places the platter in her mother's lap. The queen's absence from the feast seems entirely logical; Giotto, following the Bible rather than Byzantine pictorial tradition, thought of her as working her evil purpose behind the scenes, so that she emerges as a direct participant only at the end of the story. This banquet scene must have left a strong impression on Donatello's mind; it has the same *dramatis personae* that appear in the foreground of the Siena panel, and it even shows, in the outraged guest and the staring servants, a first hint of the psychological drama of Donatello's composition. The latter element, significantly enough, is lost in the copies after the S. Croce fresco. Nor do we find it in the reliefs of Andrea Pisano's Baptistery doors, which represent a curious mixture of Giottesque and Byzantine iconography (cf. Falk-Lányi, *op.cit.*). Andrea tells the story in four panels: the dance of Salome at the banquet (clearly a simplified version of Giotto's banquet scene, containing only the viol player, two guests, Herod and Salome); the decapitation (without Salome but in the presence of two guards); a second banquet scene where a kneeling servant presents the platter with the Saint's head to Herod, who directs him towards Salome (she stands, with her arms folded in a gesture of waiting, at the far end of the table); and the delivery of the platter to Herodias, directly inspired by the Giotto fresco. The third of these panels contains several formal elements that recur in the Siena Feast of Herod—the placing of Herod and Salome at opposite ends of the table, and the kneeling servant with the platter (whom Andrea had developed from a kneeling attendant serving wine to Herod in the third of the Baptistery mosaics mentioned above; see Falk-Lányi, *op.cit.*, fig. 35). In the Donatello relief, however, this kneeling figure has assumed the role of the executioner in the Giotto fresco (where he is standing); and Donatello remains faithful to Giotto's iconography also in retaining—and multiplying—the servants behind Salome. Could he have followed the same procedure of combining elements from Giotto and Andrea Pisano in the background of his composition as well? Did he place the two lateral scenes of the S. Croce fresco *behind* the central event, modifying them with ideas from the corresponding panels of Andrea's doors? If our view is correct, then the two fierce-looking heads visible behind the first arch to the left are the counterpart of the two soldiers who witness the decapitation in the second frame of Andrea's sequence; the viol player appears in the same plane with them because in the Giotto fresco, too, he is placed in the "wing" that relates to the execution of the Saint, even though functionally he belongs to the banquet scene. And the event seen through the second set of arches must be the delivery of the head to Herodias (as sur-

mised by Pastor, *loc.cit.*). Hers is the second of the three heads to the right—she has long hair, like Andrea's Herodias, held in place by a bandeau instead of a coronet; the adjoining heads, whose horrified expressions are in striking contrast with that of the queen, belong to her maid servants (these also occur in the corresponding scene of Masolino's fresco cycle in the Baptistery of Castiglione d'Olona). But why is the platter not being delivered by Salome? Here the only explanation we can offer is that Donatello simply refused to show the same character twice on his "stage" (the head on the platter he may have regarded as an object, a "prop," and thus not subject to this rule, which seems to have been motivated more by aesthetic than by logical considerations); so he seized upon the youth who brings the platter to Herod in Andrea's second banquet scene, and substituted him for Salome. All these permutations may, at first glance, strike the reader as a needlessly complicated game of musical chairs not much in keeping with the boldness of Donatello's invention. Nevertheless, they are instructive, for they demonstrate with particular force how vital a role the art of the early Trecento played in our artist's creations of the 1420's (cf. my remarks above, pp. 44f). One further detail of the Siena panel demands clarification: the two terror-stricken children on the far left. Both are rushing from the scene while their heads remain convulsively turned towards the head on the platter. The lower one has stumbled and is raising himself from the ground. The poses and costume of these two are so classical in flavor that one suspects Donatello of having borrowed them directly from ancient art; and there certainly is no precedent for them in the iconography of the Feast of Herod. Yet the fleeing *putto*, at least, derives from a mediaeval tradition; his pose is the same as that of the youth who rushes out of the picture in Niccolò di Pietro Gerini's Martyrdom of St. Matthew in S. Francesco, Prato (two centuries later Caravaggio was to use it again for the boy on the extreme right of his famous canvas in S. Luigi dei Francesi). The idea might have been transmitted to Donatello through the Gerini fresco, but Gerini surely did not invent it. There must have been older examples of it in the Florentine Trecento. The figure probably belonged to the repertory of the Giotto school (of which Gerini was one of the final descendants). But the origin of the type can be traced further back still; our figure occurs in the Martyrdom of St. Lawrence, a fresco of the early ninth century in S. Vincenzo al Volturno near Montecassino (E. Bertaux, *L'art dans l'Italie méridionale*, I, Paris, 1904, p. 95, fig. 31; more recent bibliography in Robert Oertel, *Die Frühzeit der Italienischen Malerei*, Stuttgart, 1953, p. 209, n. 20). The fleeing, horror-stricken youth, then, must stem from Early Christian scenes

of martyrdom. His ultimate source, we may be sure, was classical. Donatello probably sensed its ancient origin; in any event, he "re-classicized" the Giottesque prototype on which his *putto* is based, and thus adapted it to the needs of Renaissance art. That he should have introduced into King Herod's banqueting hall this witness at a saint's martyrdom seems entirely appropriate under the circumstances: it emphasizes once again the central fact that governs his composition—the impact of violent death upon the living.

When Ghiberti, on May 21, 1417, received the commission for two of the six bronze reliefs for the font, his contract with the Siena Cathedral workshop included a provision that "the six figures to be made for the Font" would not be contracted for until after the first of Ghiberti's panels had been completed and submitted for approval (see Milanesi, *Documenti, op.cit.*, pp. 89f). The figures in question were the Virtues at the corners of the basin, since at that time no work was being done as yet on the upper part of the font and its sculptural *décor*. Apparently Ghiberti expected to receive the order for some, or perhaps all, of the Virtues upon satisfactory completion of one of his reliefs. A decade later, he still nourished this hope; in a letter to the Sienese authorities, written soon after September 26, 1427, he stated that he had undertaken to do four figures along with the two reliefs, and asked for confirmation of that order (Milanesi, *op.cit.*, p. 124; cf. Bacci, *Quercia, op.cit.*, p. 182). Whether he was referring to a real commitment of any sort, we do not know; he may simply have been trying to force the hand of the Cathedral workshop. But since he spoke of four figures, rather than six, we gather that two of them had already been ordered from somebody else. These must be the Faith and Hope carried out by Donatello. When were they actually commissioned? Presumably during the summer or early fall of 1427, for on May 9 of that year, in their joint letter, Donatello and Michelozzo had inquired, rather cautiously, about "the names of those figures which are still needed," without specifying the number. They had probably been told not long before that they might expect to receive an order for some of the figures, but they did not know for certain how many. Perhaps Donatello was given the commission for the Faith and Hope soon after, in lieu of the 50 florins that had been promised to him and Michelozzo; the partners had asked for speedy payment of this sum in the same letter, but they failed to receive it. However that may be, Michelozzo did not share the commission. All the payments for the two Virtues, totaling 380 lire (95

florins), went to Donatello alone. Since he received no money in connection with this order until September 25, 1428, we may assume that he allowed a year to pass before he did any work on the figures. Once he had started, he completed the task in short order; six months later, in the spring of 1429, both Virtues were delivered and paid for in full.[7]

The positions of the two Virtues—Faith in the niche between Ghiberti's Baptism panel and his John before Herod, Hope between the latter and the Feast of Herod—appear to be those originally assigned to them. As Kauffmann has observed (*D.*, p. 31), Donatello has made both of them turn strongly to the right, orienting them towards the front of the Font (marked by the small raised podium beneath the Baptism panel). Both have suffered minor physical damage: the fire gilding has been partly rubbed off, probably as a result of overzealous cleaning, Hope has lost her left thumb, and Faith the attribute she once held in her right hand. It was probably a long, slender cross, to judge from a small piece still remaining between the fingers; immediately below her right shoulder there is a knoblike bit of bronze that must have served to hold it in place.

Apart from the recurring suggestion that Michelozzo may have cast them, the authorship of the two Virtues has never been seriously questioned. Schottmüller (*D.*, p. 70) was the only one to postulate the help of assistants and to attribute the execution of the Faith to Michelozzo. Her opinion has found no echo among other scholars. Except for Cruttwell (*D.*, p. 61), who speaks of them as "somewhat conventional," most authors have gone out of their way to praise the figures as masterpieces, a judgment which I fully share. As Donatello's earliest female statues, monumental in conception despite their small size, the Virtues would be of considerable importance under any circumstances; their high quality—in great contrast to their "poor relations" on the Coscia Tomb (see above, p. 64)—and their securely established date makes them doubly significant. Chronologically, they serve as an anchor for less well documented works such as some of the Campanile statues, the S. Croce Annunciation, and several others (see above and below, pp. 39f, 76, 107). Artistically, they are both a revelation and something of a puzzle. Despite resemblances in detail to earlier works (e.g. the head of the Faith, which recalls that of Salome as well as the Sibyl on the Porta della Mandorla), the two figures display a lyricism of feeling and an ideality of form such as Donatello had never achieved before. Poised and graceful, yet entirely free from classicistic coldness, they are truly classical creations in the most elevated

[7] Meanwhile, one of the four figures referred to in Ghiberti's letter had been assigned to Goro di ser Neroccio, the other three to Giovanni Turini, apparently because Ghiberti complained

about the price at which his two reliefs had been appraised; he had wanted 240 florins apiece but had to be content with 210, while Donatello received only 180 florins for the Feast of Herod.

sense of that term. Kauffmann, who was particularly struck with these qualities, sensed their kinship with the art of Ghiberti and compared our Virtues to the attendant angels in the Baptism of Christ on the Siena Font (D., p. 81). His point is well made; between the Feast of Herod, packed with physical and expressive energy, and the Faith and Hope, there is much the same contrast of attitude that separates the Coscia effigy from the Pecci slab (compare Pls. 27 and 32a). Donatello had, of course, drawn inspiration of various kinds from Ghiberti before (cf. above, pp. 7, 11, 29ff), but that he should have turned "Ghibertesque" at this particular point remains something of a surprise. Was it perhaps because he felt himself to be in direct or indirect competition with the older master here (see the history of the commission as outlined above) and wanted to demonstrate his ability to match the qualities he expected to find in the other four Virtues? In mid-1428, when he began work on his two figures, he may still have been under the impression that the others would be furnished by Ghiberti.[8]

The rejected tabernacle door and the nude angels were executed immediately after the delivery of the two Virtues, in the course of 1429. That Donatello made three angels—or, at any rate, not more than three—for the hexagonal tabernacle rising from the font, is to be inferred from the fact that on September 26, 1431, Giovanni Turini was paid for "three nude little angels" (Bacci, *Quercia, op.cit.*, p. 244). Prior to the publication of this document, there was considerable divergence of opinion among scholars as to the number and identity of Donatello's *putti* for the Siena Font. Milanesi (*Cat.*, p. 11) credited our artist with two of those still *in situ* but did not specify which; he assumed, by analogy with the commissions for the Virtues, that Turini had made three *putti* and Goro one. Semper, on the other hand, gave only one figure to Turini and three to Donatello: the trumpet blower and two more whom he incorrectly describes as playing cymbals and castanets (apparently he meant the second and third *putti* from the left; D. '87, p. 39). Tschudi, too, spoke of three Donatello *putti* on the font (D., p. 13), one blowing the trumpet and the others dancing. One of the latter, he noted, is reproduced in a bronze *putto* in the Museo Nazionale, Florence. Reymond (*Sc. Fl.*, II, p. 98) followed the opinion of Milanesi but added a reference to the replica of one of the two Donatello angels, in the Museo Nazionale. This statuette, whose pose does indeed recall that of Donatello's dancing *putto* in Siena (i.e., the third from the left), was to gain general acceptance in the years to come as an authentic work of our master, made for the Siena Font and abducted to Florence at some later date. Meanwhile, Wilhelm Bode had acquired from the British collector Murray Marks a bronze *putto* of the same size as those in Siena and Florence, which he donated in 1902 to the Berlin Museum (Inventory no. 2653). He published it in 1902 (*Jahrbuch Kgl. Preuss. Kunstslgn.*, XXIII, pp. 76ff) as "the missing Donatello angel from the tabernacle of the Siena Font." At present, he stated, there are five *putti* on the font, two by Turini and three by Donatello; the statuette in Florence is a repetition of one of the latter. The Berlin *putto* raises the number of Donatello's angels to four and completes the series. In a footnote he conceded, however, that when he first saw the font in 1870 there had been only four *putti* on it, while now there were five of them. (Semper, too, writing in the mid-1880's, mentions only four figures.) The text of Bode's *Denkmäler der Renaissance-Skulptur Toscanas* (Munich, 1892-1905, p. 20) again refers to three Donatello angels in Siena, which are reproduced on plate 62 of the same work; but the second of the three, surprisingly enough, turns out to be the statuette in the Museo Nazionale! The fifth *putto* proved to be an elusive creature indeed; Schottmüller (D., p. 84) makes no mention of it—she speaks only of "Turini's ball player" (i.e., the second figure from the left) and three Donatello *putti* in Siena. The Berlin statuette she defines as "originally intended for Siena" (but presumably never placed there), and the Florence one as a repetition of one of the three Donatello *putti* in Siena (she insists that the Florence statuette is wingless, a mistake based on the only photographic view of the figure then available, which happens to hide the wings). Schubring (*KdK*, p. 195) likewise confines the number of *putti in situ* to four, two each by Turini and Donatello; the Berlin and Florence specimens (the latter again "wingless") are both by Donatello, who made them for the font. Venturi (*Storia*, VI, p. 272) recapitulates Schubring's opinion, while Cruttwell maintains that Donatello executed three angels for the font and that the trumpet blower is the only surviving member of the trio. She rejects both the Berlin and the Florence statuettes as greatly inferior in modeling (D., pp. 61f). Bertaux further compounded the confusion (D., p. 86); he followed Bode in claiming there is only one empty place on the tabernacle of the font, i.e. that originally occupied by the Berlin *putto*. Of the three Donatello *putti* supposedly still *in situ*, he reproduces two, but one of them is actually the Florence statuette, taken from Bode's *Denkmäler* and mislabeled the same way.

[8] The records concerning the Virtues executed by Giovanni Turini and Goro di ser Neroccio do not reveal the exact date of commission, but from the pattern of payments published by Bacci, *Quercia, op.cit.*, pp. 224ff, it seems probable that they were not ordered until some time in 1428, since they were completed one to two years later than Donatello's.

In the text, Bertaux informs us that the *putto* in Florence, "wingless" and "playing the castanets," is smaller than the Siena figures and probably a study for one of them which was then cast for a Florentine collector of the period. Once again the fifth *putto* on the font—Donatello's third—is allowed to slip from our grasp unseen. Our next witness is the Sienese architect Arturo Viligiardi, who at the end of the First World War wrote an impassioned plea for the return of the Berlin *putto*, which he wanted to have included among Italian reparation claims upon Germany ("Una meravigliosa opera d'arte mutilata," *Rassegna d'arte senese*, xII, 1919, p. 11). He did not demand the return of the statuette in Florence, even though he was sure that it, too, had been removed from the Siena Font. In fact, he said, a careful examination of the remaining four *putti* had yielded clear evidence that attempts had been made to steal all of them at one time or another. When Bacci, ten years later, published the documentary evidence referred to above regarding the number of *putti* made by Turini, he again spoke of four, rather than of five, statuettes remaining *in situ*. Three of these he claimed for Turini, one for Donatello (he does not specify which); the two missing statuettes, also by Donatello, are those in Berlin and Florence (*Quercia*, op.cit., p. 243, n. 3). Colasanti (*D.*, p. 23; pls. lii-lv) accepted Bacci's conclusion that Donatello could not have made more than three *putti* for the font; according to him, they are the Berlin statuette and the third and fourth from the left of those still *in situ* (he does not state how many *putti* remain on the font altogether), but he also reproduces the Florence statuette as a work of Donatello, though without linking it to the font. Kauffmann's point of view (*D.*, p. 211, n. 136) coincides with Colasanti's. He, too, omits any reference to the total number of *putti* left *in situ*. The most detailed discussion of our subject to date is the article by Jenö Lányi (*Burl. Mag.*, LXXV, 1939, pp. 142-151), which demonstrates by careful analysis of style that the Florence statuette lacks the vitality and organic cohesion of the other three *putti* previously identified as Donatello's, and must therefore be eliminated from our master's *œuvre*. Lányi attributes it to a Sienese master of the late Quattrocento.[9] The Florence statuette, Lányi assumes, must have been made in some connection with the font, since it matches the others in size, but it could not have formed part of the original sextet of *putti* there; for only one of the figures is actually missing, the three by Turini still being *in situ*. Stylistically, Lányi's demonstration is wholly convincing. The Berlin statuette does indeed form a closely knit "trinity" with the other two Donatello *putti*, if all three of them are turned so as to show their intended main view (i.e., with the hinge of the shell towards the beholder; see Pl. 31c, d, e). In this grouping, the tambourine player is on the left, the dancer in the center, and the trumpeter on the right. However, the article also contains a number of inaccuracies. Did Lányi actually see three Turini *putti* on the font? They must, of course, have existed at one time, but only two of them are ever mentioned elsewhere in scholarly literature. And there are in fact only four *putti*, not five, on the font altogether today; the two positions above Prudence and Justice, at the back of the tabernacle, are empty. Lányi's third Turini *putto*, then, appears to be the ghost of the elusive fifth statuette which, according to Bode, had reappeared on the font shortly before 1900. I can offer only one explanation of this mystery to the bewildered reader: in his *Jahrbuch* footnote, Bode does not claim that he saw the fifth *putto* in Siena; he states, rather, that he became aware of it through a plaster cast of the font made for the Berlin Museum, which showed five statuettes instead of four. The cast, unfortunately, has long since disappeared, but I strongly suspect that the supernumerary *putto* on it must have been a cast of the statuette in Florence. This would also explain how the latter figure came to be reproduced in Bode's *Denkmäler* as one of the three Donatello *putti* still *in situ*. Who added the Florence statuette to the cast of the font, and thus caused all the mischief, is difficult to ascertain—probably a Sienese with a sense of injured local pride, like Signor Viligiardi. Lányi also refers to a "removal of the *putti* from the lower to the upper zone of the Font" on the basis of Bacci (*Quercia*, pp. 270ff) who shows "their original position." Bacci does indeed give a reconstruction of the font as it was intended to look before the addition of the tabernacle, i.e. with a second, smaller water basin above the main basin. His drawing (p. 275) has the four angels that are still *in situ* standing on the rim of this upper basin, but he does not claim that they ever actually stood there; he only suggests that they would have looked more natural on the edge of a water basin, because they are placed on shells ("like river sprites of the sacred Jordan"). The upper basin, although contemplated, was never carried out, so far as we know, and the tabernacle, executed between 1428 and 1430, must have been designed before either Donatello or Turini went to work on their *putti*. These, then, were intended for the top of the tabernacle from the very start. Lányi is certainly right, however, in assuming that those still remaining *in situ* did not originally

[9] Ludwig Goldscheider (*Donatello*, London, 1941, p. 20) finds the *putto* similar to a *putto* atop a ciborium in the Fontegiusta church at Siena by Giovanni delle Bombarde, who was active in Siena after c. 1470; in the caption of pl. 40, however, he describes the same figure as "workshop or follower of Donatello, about 1430."

stand at the particular corners they now occupy; the Donatello threesome, greatly superior to (as well as earlier than) the Turini figures, must have been given the most advantageous positions, at the front. One of the Turini angels disappeared, or was replaced, before long; the figure now in Florence was made as a substitute for it, we may assume, probably about the time when, according to Milanesi, Vecchietta repaired the foot of another *putto* on the font (see above, p. 67). When the Florence and Berlin *putti* were stolen we do not know, except that one figure was missing in the eighteenth century (as noted in the catalogue of Italian bronzes in the Berlin Museum, in connection with the tambourine player).

The use of the shell as a base, a feature shared by all six of the statuettes (although only the ones by Donatello have shells encircled by wreaths), undoubtedly has iconographic significance. The symbolic connotations of the shell, however, are too broad and manifold—Baptismal, Mariological, and otherwise —to justify the very specific interpretation proposed by Bacci. In choosing to design a dancing *putto* accompanied by tambourine and trumpet, Donatello may have been thinking of Psalm 150 (compare the Cantoria of Luca della Robbia), but if so, Turini did not continue the idea.

The evolutionary importance of the Siena *putti*, for both Donatello and Early Renaissance art as a whole, has been stressed by almost all the scholars cited before. About six years younger than the escutcheon-

holding nude infants on the crozier of the St. Louis, they are not only a good deal larger but far more highly developed. Inevitably, there have been frequent claims of classical influence for them, but no relationship to specific ancient prototypes (such as that to Reinach, *Répertoire de la statuaire . . .*, IV, p. 260, no. 2, suggested for the tambourine player in the Berlin Catalogue) have been established so far. The classical influence here is to be found in the solid, smooth, convex forms of which the bodies of our *putti* are composed, rather than in their poses or gestures. Each of them shows a vigorous *contrapposto* combined with a spiral twist of the body so as to yield an extraordinary variety of possible views; almost any angle of approach reveals new and rewarding aspects. Such free movement in three dimensions was a new achievement for Donatello. It has no precedent among his earlier statues. Only the figure of Hope, pivoting on its own axis, approaches a similar effect. Nor did our master continue, in the years to come, to explore the compositional principle he had broached in the Siena *putti*, even though he undoubtedly learned valuable lessons from them in other respects (cf. below, pp. 83, 146). The three statuettes thus have a strangely isolated position in Donatello's *œuvre*. Only from the vantage point of a much later stage in the development of Renaissance sculpture can we realize their full significance, a significance that lies beyond the bounds of the Quattrocento, since these are the earliest harbingers of the *figura serpentinata*.

TOMB SLAB OF GIOVANNI PECCI, BISHOP OF GROSSETO
SIENA CATHEDRAL (pavement)

PLATE 32a

Bronze relief; L. 247 cm; W. (center section) 88 cm

Inscription: above the scroll, OPVS DONATELLI

*1426 or later
(c. 1428-1430)*

DOCUMENTS: none

SOURCES: none

The slab, cast in three separate pieces, is presumably still in its original location. It was introduced into the Donatello literature by Semper, *D.* '75, p. 280 (the material mistakenly identified as marble) and has been mentioned in almost every monograph on the artist since then, although usually with little or no comment. Even Kauffmann (*D.*, pp. 91f) confines himself to the observation that the Pecci Tomb is in some respects closer to the effigy of the Coscia Tomb than to the slabs of Donatello's Roman sojourn (Crivelli and Martin V; see below, pp. 101ff, 232ff and Pls. 41b, 123a).

Giovanni Pecci died on March 1, 1426, according

to the funerary inscription. In his last will, made a few days earlier, he had left careful instructions concerning his burial in an honorable part of the Cathedral and on how the cost of the funeral was to be met (published in *Miscellanea storica senese*, 1893, p. 30; summarized in Balcarres, *D.*, pp. 86). The date of the tomb is usually given as 1426 (only Planiscig, *D.*, pp. 47, 139, is cautious enough to phrase it "after 1426"), sometimes also as 1427 (Milanesi, *Cat.*, p. 11, and *Vasari*, II, p. 415, n. 2, perhaps on the erroneous assumption that the date on the slab is reckoned according to the "Florentine style" and thus corresponds to March 1, 1427, of the modern calendar; actually, Siena

75

followed the "Pisan style," which in this instance requires no adjustment). Yet the death of Pecci provides no more than a *terminus post quem* for the execution of the slab; nor do we know when the tomb was commissioned. The fact that there is no mention of it in Donatello's and Michelozzo's *Catasto* Declarations of July 12, 1427, permits two possible conclusions: the slab was either finished and paid for then, or it had not yet been started. On the face of it, both alternatives are equally plausible. If the commission was placed promptly, Donatello certainly could have carried it out in a year's time; the matter of the price, too, might have been settled without delay, and payment made in full. On the other hand, at this very time the two partners had several more important commitments that must have kept them fully occupied—the Feast of Herod for the Siena Font, the Coscia Tomb and the Brancacci Tomb, not to mention Donatello's continuing work for the Florence Cathedral workshop. Is it likely that under these circumstances Donatello should have been willing to assign a higher priority to the Pecci Tomb than to his other projects? I think not. However that may be, a final decision concerning the date of the slab can be made only on stylistic grounds.

The choice before us is actually a fairly narrow one. If the Pecci Tomb was not made in 1426-1427, it must have been produced between 1427 and 1430. Its formal affinities are all with Donatello's works of the later 1420's, rather than of the following decade. There is, first of all, the intense effort to create an illusion of space and volume—an illusion still extraordinarily effective today, even though the more prominent parts of the relief have been worn off—despite the extreme shallowness of modeling required for a slab whose surface was meant to be level with the church floor. The character of the entire work is in fact that of a *schiacciato* relief in bronze, strikingly different from Ghiberti's slightly earlier and far more traditional bronze slab for the tomb of Leonardo Dati in S. Maria Novella.[1] While *schiacciato* effects also occur in the Siena Feast of Herod as well as in Donatello's later bronze panels, they are confined to the background; the Pecci slab is unique in that here the *schiacciato* mode is dominant rather than supplementary. Apparently Donatello decided on this method because it was the only way to make a virtue of the peculiar limitations imposed on him by the task at hand. It is almost as if the very flatness and compactness of the floor slab had challenged him to introduce the greatest possible variety of spatial effects. His design is replete with bold foreshortenings, overlappings,

and perspective tricks keyed to an observer standing at or near the foot end of the slab. The deceased is lying on a troughlike bier that resembles an architectural niche such as that of the St. Louis tabernacle or the niches of the three virtues on the Coscia Tomb. Its foot end is cut off straight, showing the semicircular cross-section, and the inside surface is decorated with rectangular panels which further emphasize its concavity. This bier is supported by four short square legs, two of them visible at the foot end; they rest on a rectangular platform that is somewhat wider than the bier and marks the plane farthest from the beholder. Two long carrying poles, with protruding ends to serve as handles, are attached to the sides of the bier. The illusionistic element even enters into the funerary inscription, which is not placed directly on the plaque at the foot of the bier but on a bulging scroll held by two boldly foreshortened *putti*.

All this brings to mind Donatello's enthusiastic, and still somewhat naïve, exploitation of perspective effects in the Siena Feast of Herod panel. The basic ingredients of the ensemble, on the other hand, recall—indeed, presuppose—the effigy and sarcophagus of the Coscia Tomb, with its trough-shaped bier on a rectangular platform and its funerary inscription on a scroll held by angels; Donatello has simply re-used these elements, projecting them onto the slab of the Pecci Tomb. Now, the Coscia effigy was in all probability made between 1425 and 1427, and the design for the tomb as a whole may have been fixed as early as 1424 (see above, p. 62), but a comparison of the two effigies reveals significant differences in style suggesting that the Pecci slab was designed several years later than its prototype. The drapery of the Coscia statue has a fluent, rippling rhythm (note the wavelike folds of the chasuble) with rounded, loop-shaped breaks; in the Pecci slab, the breaks are sharp and angular, and the folds of the chasuble have a "crushed" quality. The long, slender figure of the bishop with its small, delicate head looks almost fragile as against the stocky proportions, the huge head and hands of the Papal effigy. Much the same contrast, significantly enough, may be observed between the Salome of the Siena relief (Pl. 29b), which is contemporary with the Coscia statue, and the figures of Faith and Hope made for the same font in 1428-1429 (Pls. 30-31b). In fact, the two Virtues approach the style of the Pecci Tomb more closely than does any other work of Donatello.[2] Here, surely, is the most persuasive argument for placing our slab at the very end of the 1420's.

The signature of the Pecci Tomb has a number of

[1] The slab was done between 1423, the year of Dati's death, and 1427, when it is mentioned in the *Catasto* Declaration of Ghiberti as finished but not yet fully paid for—an instructive analogy to our problem and a further argument in favor of a

post-1427 date for the Pecci Tomb.

[2] Except perhaps the Crivelli Tomb, for which see below, p. 101 and Pl. 41b; its surface, however, is so badly abraded as to render comparison difficult.

peculiarities that require comment. Not only does it appear in a rather awkward place, so that the scroll overlaps it, cutting off about one-fifth of each letter at the bottom, but the shape of the letters, and especially their spacing, is greatly inferior to that of the funerary inscription. We have only five other signatures of Donatello: those on the Zuccone and "Jeremiah" (Pl. 124e, f), as well as the barely legible one on the Crivelli Tomb, are roughly contemporary with ours, while those on the Gattamelata and the Judith (Pls. 71, 98a) are about two decades later.[3] All of them, in contrast with that on the Pecci Tomb, are masterpieces of epigraphy, carefully placed so that nothing interferes with them. Thus it is difficult to suppress the suspicion that the Pecci signature is an afterthought; had the master intended to sign the slab from the very start, he could easily have provided an appropriate space for it, as he did in the case of the Crivelli Tomb, where the signature follows after the funerary inscription on the rim. To find the artist's name placed above that of the deceased is, to say the least, an anomaly. Another puzzling aspect of the Pecci signature is that, unlike those on the Crivelli Tomb and the Gattamelata (the only other signed works by our master outside his native city) it reads OPVS DONATELLI rather than OPVS DONATELLI FLOREN-TINI. And why the haphazard quality of the lettering? A detailed comparison of the signature with the funerary inscription strongly suggests that while the latter was carefully laid out in the wax model and cast with the rest of the tomb, the former was chiseled into the bronze after the casting, and more or less in freehand fashion at that. We must assume, I think, that this was done by Donatello himself. What might have caused the "afterthought" we are no longer in a position to ascertain. Perhaps we should bear in mind, however, that when he was at work on the slab the idea of putting his name on his work was still a very recent one with Donatello. He had, presumably, applied it only once before, to one of his last two Campanile statues (see above, p. 33), and there, too, it may well have been an afterthought, since the front face of the plinth did not have to be specially shaped for the signature.

[3] The signature on the right-hand pulpit in S. Lorenzo must be regarded as posthumous; see below, p. 215.

DAVID, MUSEO NAZIONALE, FLORENCE

PLATES 32b-35 Bronze statue; H. 158 cm; diameter of wreath c. 51 cm *(c. 1430-1432)*

DOCUMENTS

None relating to the commission or original location of the statue. The following two entries in the record of deliberations of the Signoria, in the State Archives of Florence, were transcribed by Gaetano Milanesi and published by Eugène Müntz, *Les collections des Médicis . . .* , Paris, 1888, p. 103:

1495, October 9: Two bronze statues, a David in the courtyard of the palace of Piero de'Medici and a Judith in the garden of the same palace, are to be turned over to the *operai* of the Palazzo Vecchio, together with their pedestals (*cum omnibus eorum pertinentiis*); the *operai* are to install them there in whatever places they deem suitable.

October 14: Marco Cappello, the macebearer of the Signoria, reports that all the above objects (which included several other items beside the two bronze statues) have been duly consigned to the *operai*.

SOURCES

1469 *Delle nozze di Lorenzo de'Medici con Clarice Orsini nel 1469; informazione di Piero Parenti fiorentino*, Florence, 1870, nozze di Florestano ed Elisa dei Conti De Lardarel (edited anonymously; a description of the wedding festivities based on the eye-witness account of Cosimo Bartoli, from Strozzi MS xxv, 574 of the Magliabechiana, now MS II, iv, 324 in the Biblioteca Nazionale, Florence; Alfred v. Reumont, *Lorenzo de'Medici*, Leipzig, 1874, I, pp. 276f, questions the identification of the writer as Piero Parenti): "There were no pantry tables for the silverware, only tall counters covered by tablecloths in the middle of the courtyard around the beautiful column on which stands the bronze David, and in the four corners four bronze basins. . . ."

1495 Luca Landucci, *Diario* . . . , ed. Iodoco del Badia, Florence, 1883, p. 119: "On December 9, 1495, a David was brought from the house of Piero de'Medici to the Palazzo Vecchio and placed in the center of the courtyard there."

1501, June 22, letter written in Lyons by Pier Tosinghi and Lorenzo de'Medici to the Ten of the Balìa in Florence; published in Giovanni Gaye, *Carteggio* . . . , II, Florence, 1840, p. 52: "The Maréchal de Gié (Pierre de Rohan) . . . has asked us to write to the Signoria that he would like to have a bronze David like the one in the courtyard of the Palazzo Vecchio, and that he will pay the cost of casting such a figure. . . ."

1504 Record of the meeting, on January 25, of a commission to advise on the best location of Michelangelo's marble David, published in Gaye, *op.cit.*, II, pp. 455ff; Francesco di Lorenzo Filarete, the herald of the Signoria, proposes to substitute the marble David for the Judith on the *ringhiera* of the Palazzo Vecchio or, as a second choice, to substitute it for the bronze David in the courtyard of the Palace: "The David of the courtyard is an imperfect figure, because the backward leg is awkward" (*perchè la gamba di drieto è schiocha*).

1510 Albertini, p. 17: "In the Palazzo Vecchio . . . on the ground floor there is a bronze David on a column of varicolored marble."

1511 Landucci, *op.cit.*, p. 312: "Towards midnight on November 4, 1511, two lightning bolts hit Florence; one hit the Palazzo Vecchio . . . and severed a certain bronze belt on the base of the David in the courtyard. . . ." Giovanni Cambi, *Storie*, ed. Ildefonso di San Luigi, cited by del Badia, *loc.cit.*, note 1: "[The lightning bolt hit] a bronze David by Donatello on a column resting on a base with four leaves (*fogliami*), in the center of the courtyard of the Palazzo [Vecchio], and broke one of the four leaves into three pieces."

(Before 1530) Billi, pp. 38f: "[Donatello made] the bronze David which is now in the courtyard of the Palazzo Vecchio."

1537-1542 Cod. Magl., p. 77 "[By Donatello] is the bronze David, now in the courtyard of the Palazzo Vecchio. He did this so well that it deserves to be ranked with the rare and beautiful works of the Ancients; if it were more lifelike [than it is], it would have been alive rather than a bronze figure."

(c. 1550) Gelli, p. 59: "Donatello made . . . the youthful bronze David in the courtyard of the Palazzo Vecchio, a marvelous work; according to the bronze sculptors, there is nothing more perfect and without fault than this."

1550 Vasari-Ricci, p. 51: "In the courtyard of the Palazzo Vecchio there is a life-size bronze David who has cut off the head of Goliath and places his raised foot on it; in his right hand he holds a sword. This figure is so natural in its lifelike pose (*vivacità*) and its rendering of the soft texture of flesh (*morbidezza*) that it seems incredible to artists that it was not formed from the mold of an actual body. This statue once stood in the courtyard of the Medici Palace and was brought to its present place upon the exile of Cosimo."

Vasari-Ricci, II, pp. 144f (*s.v.* "Desiderio da Settignano"; Milanesi, III, p. 108): "In his youth he made the pedestal of Donatello's David which is in the courtyard of the Palazzo Vecchio in Florence; here Desiderio fashioned some very beautiful marble harpies, and some vine-tendrils of bronze, very graceful and well conceived."

1553 Ascanio Condivi, *Vita di Michelangelo Buonarroti*, xxii (ed. Antonio Maraini, Florence, 1944, pp. 31f): "And in order not to leave any sculptural material untried, he cast . . . a life-size bronze statue at the request of his friend Piero Soderini, which was sent to France; and likewise a David with Goliath at his feet. The bronze David that is to be seen in the center of the courtyard of the

Palazzo Vecchio is the work of Donatello, an outstanding master of this art and much praised by Michelangelo except for one thing—he lacked the patience to give his pieces a clean finish, so that they looked marvelous from a distance but did not live up to their reputation when viewed at close range."

1564 Benedetto Varchi, *Orazione funebrale . . . fatta nell'essequie di Michelagnolo . . .* (trans. Albert Ilg in *Quellenschriften . . .*, VI, Vienna, 1874, p. 107): "In bronze he cast innumerable figures, including . . . a David with Goliath at his feet, made not so much in imitation of as in competition with the one by Donatello in the Palazzo Vecchio, which he admired and commended greatly."

1568 Vasari-Milanesi, p. 406 (addition to the description of the bronze David from the 1550 text): "Duke Cosimo has now had a fountain placed on the site of this statue and had it taken away, reserving it for another courtyard he is planning to make in the rear of the Palace, where the lions used to be kept."

Vasari-Milanesi, VI, pp. 143f (*s.v.* "Baccio Bandinelli"): ". . . Baccio took to the Pope in Rome a very fine model of a nude David cutting off the head of Goliath, which he planned to do in marble or bronze for the courtyard of the Medici Palace in Florence, where Donatello's David had stood before it was taken to the Palazzo Vecchio when the Medici Palace was sacked. . . . On his return to Rome, Baccio pleaded with the Pope, through Cardinal Giulio de'Medici, that friend of men of talent, to commission him to do some statue for the courtyard of the Medici Palace in Florence. Hence he went to Florence and carved a marble Orpheus . . . [which] Cardinal Giulio placed in the courtyard of the Palace . . . on a carved pedestal by the sculptor Benedetto da Rovezzano. But Baccio never gave thought to architecture, nor did he consider the genius of Donatello, who had put his David on a simple column upon which he had placed an open-work base, so that passers-by might look from the street entrance right through to the entrance of the second courtyard; Baccio, without such understanding, put his statue on a heavy and massive base, blocking the view covering the aperture of the second entrance, so that the passer-by cannot see whether the Palace has only one courtyard or whether it continues beyond."

Vasari-Milanesi, VI, p. 604 (*s.v.* "Giovanni Francesco Rustici"): "Not long after [1515] Rustici made for the same Cardinal [Giulio de'Medici] a model for a bronze David similar to that of Donatello, made for Cosimo the Elder, as we have mentioned before; it was to be placed in the first courtyard, whence Donatello's had been removed. This model received much praise but was never cast in bronze, because of Rustici's procrastination. Thus Bandinelli's marble Orpheus was placed there, and the clay David of Rustici, which was a very fine work, unfortunately fell into neglect."

1591 Bocchi, p. 37 (Cinelli, p. 87; his additions are placed in brackets here): ". . . in the center a bronze *putto* . . . by Andrea Verrocchio . . . and in a simple wall niche under the arcade there is another bronze David, who has cut off the head of Goliath, a noble and marvelously expert statue by Donatello that is universally praised. [In this niche there is now a Hercules who has overcome Cacus, by Vincenzo Rossi of Fiesole. . . .]

The recorded history of the statue begins with the wedding of Lorenzo the Magnificent in 1469. Presumably, the figure had occupied the center of the courtyard of the Palazzo Medici since the early 1460's, perhaps even since the early 1450's (if the courtyard was completed by then; the building was begun in 1444, as proved by Aby Warburg in *Mitteilungen Kunsthist. Inst. Florenz*, I, 1909, p. 85), for the pedestal, according to Vasari, was made by the young Desiderio da Settignano (1428-1464). Vasari's description of the way the statue was displayed in the courtyard of the Medici Palace can hardly be regarded as reliable—one suspects that he based it on the installation he himself had seen in the courtyard of the Palazzo Vecchio—but there can be little doubt that the transfer of the figure in 1495 included the base and

the column on which it had stood before (cf. Alfredo Lensi, *Palazzo Vecchio*, Florence, 1929, pp. 84, 115, nn. 83 and 84; in 1498, four coats of arms were added to the column). We may assume, therefore, that the pedestal with harpies and bronze foliage referred to by Cinquecento authors had been occupied by our statue as long as the latter remained in the courtyard of the Medici Palace, i.e. that it antedates the wedding of Lorenzo. But we do not know whether it was made for our statue or for this specific setting; both the statue and the harpy-pedestal might, after all, have come to the Medici Palace together from another location, or the pedestal might have been originally intended for a different statue.[1] Vasari, surely, was not in a position to know about these matters, and we today can no longer verify his statements, since the pedestal is lost. Apparently it became detached from the statue in the late 1550's, when both of them had to yield their place to the fountain topped by Verrocchio's Dolphin-Putto (cf. Lensi, *op.cit.*, p. 178; Francesco del Tadda and others were working on the fountain from 1555 on). Soon after, the David was put in the niche to the left of the doorway near the stairs, where Donatello's Judith had stood between 1504 and 1506 (see below, pp. 198ff). Bocchi saw it still in the same position, but in 1592 the niche was empty once more, and the Samson and the Philistines by Pierino da Vinci was installed in it on the advice of Ammanati (Lensi, *op.cit.*, p. 252). Shortly before, Buontalenti had remodeled the rear part of the Palazzo, and the David had been placed in the center of the courtyard (Lensi, *loc.cit.*). How long it remained there is uncertain; Cinelli only notes the new occupant of the niche (mistaking Pierino's Samson for a Hercules by Vincenzo de'Rossi) but fails to give the new location of our statue. Had it been removed from public view? Eighty years later, Giovanni Bottari mentions it as being "in a room on the second floor."[2] Filippo Baldinucci, on the other hand, informs us that the figure "is preserved in the royal gallery" (*Notizie de'professori . . .*, III, Florence, 1728, *s.v.* "Desiderio da Settignano"). Perhaps Bottari meant to refer to the second floor of the Uffizi, rather than of the Palace itself, in which case there would be no conflict between the two statements. However that may be, it is difficult to avoid the im-

pression that from the middle of the Cinquecento on, the reputation of the David had begun to decline; after its removal from the first courtyard, it never regained the status of a public monument, while the Judith, in eclipse since 1504, was reinstated at that very time through its new location in the Loggia dei Lanzi. As a commentary on the history of taste, these various shifts are not without interest. Clearly, the Judith with its violence and formal complexity was more compatible with the ideal of the *figura serpentinata* than the David, which may well have seemed awkwardly static and expressionless in comparison. Significantly enough, the writings of Benvenuto Cellini invariably cite the Judith, never the David, whenever the author wants to epitomize the greatness of Donatello, even though Cellini's masterpiece, the Perseus, owes as much to the one as to the other (cf. the well-indexed edition of his *Opere*, ed. Giovanni Palamede Carpani, Milan, 1806-1811). It was not until two centuries later, with the approach of a new classicism, that the fortunes of our statue rose once more. According to the Uffizi guides of the late eighteenth century, it had a conspicuous place in the *sala dei bronzi moderni*, where it was probably put by Antonio Cocchi, *custode antiquario* since 1738, who rearranged and rationalized the displays of the gallery in accordance with the growing neoclassicistic taste of the time. (Planiscig, *D.*, pp. 50f, gives 1777 as the date of the transfer of the figure to the Uffizi, but without citing his source.) Meanwhile, the harpy-pedestal had disappeared (a faint echo of it might be seen in the pedestal of the Cellini Perseus), perhaps as early as the years around 1560. Baldinucci (*loc.cit.*) is the only post-Vasarian source to mention it, but whether he actually saw it seems highly doubtful, since his description of the piece is no more than a direct paraphrase of Vasari's.[3] After the David entered the Museo Nazionale in the 1880's, it was placed on a base, which it still occupies, taken from the Opificio delle pietre dure (Filippo Rossi, *Il Museo del Bargello . . .*, Milan, 1952, *ad* pl. 8). Physically, the statue is undamaged and complete except for a square hole in the center of Goliath's helmet, which must have held a knob or crest of some sort (Pl. 33b). The cast shows numerous faults and holes.[4] Most of them, however,

[1] According to Wilhelm Bode, *Jahrbuch Kgl. Preuss. Kunstslgn.*, XXII, 1901, p. 38, n. 1, the base of Donatello's Judith was designed for the bronze David and mistakenly combined with the Judith in the course of the removal of both statues in 1495; Giacomo de Nicola has shown, however, that the Judith base could not very well have belonged to any other figure; cf. *Rassegna d'arte*, XVII, 1917, p. 154 and below, pp. 200f.

[2] *Raccolta di lettere . . .*, III, Rome, 1759, p. 234, n. 2, in connection with a letter of August 17, 1549, from Antonio Francesco Doni to Alberto Lollio, which refers to "a column in the center of the courtyard [of the Palazzo Vecchio], on which there is a most worthy David of Donatello."

[3] His text, permitting the inference that both the statue and the pedestal were in the Uffizi, apparently inspired the futile attempt to identify the pedestal among those of the ancient statues in the gallery; cf. *Reale Galleria di Firenze illustrata*, IV, ii, 1819, pp. 185ff. Cruttwell (*D.*, p. 84, n. 3), unaware of Vasari's description of the pedestal, suggested that Baldinucci's reference to *arpie* is a misprint for *arpe*, and pointed to a marble pedestal in the Palazzo Vecchio decorated with musical instruments, including harps.

[4] It was this fact, one suspects, that inspired the remarks of Cellini (*Vita*, II, lxiii) on Donatello's deficient casting technique.

have been repaired with such care that they in no way detract from the beauty of the work, even at close range. The David certainly does not exemplify the lack of finish for which Michelangelo, according to Condivi, reproached our master (for the possible implications of this passage, see above, p. 22).

Concerning the origin of the figure we are reduced to speculation. Vasari's claim that it was made for Cosimo de'Medici appears to be sheer guesswork based on nothing but the fact that it once stood in the courtyard of the Medici Palace; his trustworthiness here is especially suspect since he confuses the exile of Cosimo with that of Piero di Lorenzo. Milanesi (*Cat.*, p. 19) connected the commission of the statue with a document in the records of the Siena Cathedral workshop, according to which, in 1457, Urbano da Cortona received 25 ducats to purchase metal for a half-length figure of Goliath that Donatello was to produce in Florence (published in Gaetano Milanesi, *Documenti per la storia dell'arte senese*, II, Siena, 1854, pp. 296f, no. 208), but this notion has been rightly disregarded by all later scholars. Equally unfounded is the assumption (suggested by Milanesi, *loc.cit.*) that the bronze David was made for a fountain, and that its pedestal included a spout in the shape of a bronze mask. Schubring (*KdK*, p. xxix) even claimed that this spout is the one exhibited under No. 2 in the first gallery of bronzes in the Museo Nazionale; later on, he further conjectured (*ibid.*, 2d ed., 1922) that the statue must have been made for a Medici villa and subsequently transferred to the Palazzo courtyard.[5] Thus we must depend on internal evidence alone for any conclusions regarding the original location, the function, or the original ownership of the David. To find a satisfactory answer to all these questions is probably the single most difficult problem of Donatello scholarship, and may well prove impossible. Clearly, however, none of them can be settled without reference to the date of the statue. This, therefore, must be our first concern.

Since Tschudi (*D.*, p. 13), most authors have placed the David in the years around 1430, usually on the basis of its similarity to the *putti* of the Siena Font. Pastor's dating of about 1442 (*D.*, p. 68) was endorsed only by Frey (*Cod. Magl.*, pp. 303f) and, more recently, by Fritz Knapp (*Italienische Plastik*, Munich, 1923, p. 38) and Ludwig Goldscheider (*Donatello*, London, 1941, p. 29), while Reymond (*Sc. Fl.*, II, p. 119) and Cruttwell (*D.*, p. 83) favored the mid-1430's, soon after Donatello's return from Rome. The late date of 1457 tentatively proposed by Milanesi (*loc.cit.*) was

disregarded entirely until Kauffmann, for altogether different reasons, arrived at the same conclusion (*Sitzungsberichte, Kunstgeschichtliche Gesellschaft Berlin*, October 9, 1931, and *D.*, pp. 159ff). This revolutionary post-Paduan interpretation of the statue seems to have made few converts among the specialists (only Middeldorf, *AB*, p. 576, voices a cautious assent), and I, too, have come to reject it in favor of the early dating advocated by Tschudi. Yet Kauffmann's is the most ambitious attempt so far to solve the riddle of the bronze David. A detailed review of his arguments thus promises to clarify our own thinking about the figure and its many problems. It also has considerable interest from the purely methodological point of view. Kauffmann starts with the assumption that the statue was commissioned by the Medici for the courtyard of their new Palazzo, which, if correct, would force us to place it after 1453. On this precarious base, he then piles up circumstantial evidence from every quarter. Had the David been made before Donatello's departure for Padua, Desiderio, born 1428, would have been in no position to do the pedestal; if Vasari's information is right, the pedestal must have been done in the 1450's, a further indication of the late date of the statue. Kauffmann never stops to wonder, though, why Donatello did not furnish the figure with a pedestal of his own. This ought to have struck him as odd since he regards the David as a companion-piece to the Judith, which does have a base by Donatello. Regardless of whether or not his claim regarding the relationship of the two statues is valid (see below, p. 83), we cannot but assume that if Donatello was commissioned to do the David for the courtyard of the Medici Palace he would also in the natural course of events have been called upon to provide the base. Thus Kauffmann, in order to uphold his dating of the figure, should have rejected Vasari's statement about the pedestal instead of citing it in his favor. For if we trust Vasari, the most obvious conclusion to be drawn from his words is that "the young Desiderio" (i.e. Desiderio from c. 1448 on) was asked to do the base of the David because Donatello had not yet returned from Padua, which means that the statue must have been finished before Donatello's departure and could not, therefore, have been ordered for the courtyard of the Palace, which was begun in 1444. All this hardly furnishes a decisive argument against Kauffmann, since Vasari could very well have been in error, but it weakens his case rather than fortifying it. Another reason for placing the statue in the 1450's, according to Kauffmann, is that its influence on other Florentine

[5] The source of this error, as pointed out by Kauffmann (*D.*, p. 160), was a statement by Giovanni Gaye (*Carteggio*, I, Florence, 1839, p. 572) identifying the bronze David purchased by the Signoria in 1476 from the Medici Villa of Carreggi as

Donatello's, even though the statue in question was the one by Verrocchio; Kauffmann also emphasizes that none of the early sources speak of water spouts on the base of our figure, and that the statue itself, unlike the Judith, has no such orifices.

masters cannot be felt until after the middle of the century; only then do we find the same assured and fully ponderated stance in the work of Castagno, Gozzoli, Bertoldo, Bellano, Pollaiuolo, and Verrocchio. Such a negative claim can never be definitive, since it is always in danger of being upset by some new discovery or observation; all we need is a single exception to disprove the rule. In this particular case, the exception, which Dr. Richard Krautheimer was kind enough to point out to me, seems to be Ghiberti's Samson statuette in the frame of the East Doors of the Baptistery. Its lithe body, rather surprising for the "Hercules of the Old Testament"; the position of the legs; the emphatic *contrapposto*, with the right hip strongly thrust out (notice in particular its angular contour, very exceptional for Ghiberti): all these suggest the influence of our David. The correspondence is perhaps not quite so obvious as to remove every possible doubt, but to me it appears striking enough. Nor do we have to rely upon it entirely. Kauffmann's argument could be answered in other ways as well. It may, after all, take a few decades for the impact of a great pioneering achievement such as our statue to be fully absorbed by lesser artists. Or the belated influence of the David might be due to its having been in a fairly inaccessible place until the 1450's. Once he had drawn attention to the fact that other masters after the middle of the century were preoccupied with artistic problems akin to that of the David, Kauffmann ought to have tackled the far more crucial question of whether Donatello himself shared these interests in his old age. He does cite the St. Jerome in Faenza (see below, p. 248 and Pl. 128), which, however, quite apart from being a highly problematic attribution, looks altogether "wooden" when compared to our figure. Among the undoubted statues of Donatello's late years —the Venice St. John, the Mary Magdalene, the Siena St. John—we not only fail to detect any concern with ponderation and physical balance but they evince an approach to the human body diametrically opposed to what we see in the David. Kauffmann circumvents this difficulty by linking our statue with a series of figures which, he insists, demonstrate the concern of the late Donatello with nudity as an expression of Christian humility: the Crucifix at Padua and the Adam on the back of the Madonna's throne on the Padua High Altar, the Faenza St. Jerome, and the St. Sebastian that the master, according to Vasari, carved for a Paduan convent. His argument here is not very consistent: apparently he thinks of nudity in the literal sense, i.e. the display of the pudenda, since he stresses the fact that the Paduan Christ was modeled without a loincloth. But surely he cannot assume that this Christ was ever actually exhibited to the faithful without a loincloth? And on what grounds does he imply that "Christian nudity" demands the baring of the pudenda? By Kauffmann's own definition, then, the St. Jerome is the only instance of a true nude on his list, since the others show no more than the conventional degree of nudity.[6] This hardly provides an adequate basis for interpreting the nakedness of our David in terms of Christian humility. Nor does Kauffmann explain how the elaborate military boots of the hero can be reconciled with such a view. The next argument proceeds on an entirely different plane: the David, Kauffmann claims, is the first Renaissance figure to embody a canon of proportions, it follows the canon laid down in Leone Battista Alberti's *De statua* and matches a proportion study of the Leonardo school (reproduced on his pl. 28). Now, *De statua* is the latest of the Alberti treatises, with 1464 a *terminus post* for its dedication, and Kauffmann thinks it significant that the David should represent an ideal of formal perfection codified for the first time after the middle of the century, although he admits that Alberti might have been influenced by our statue in formulating his canon. Even if the relationship of the David to the Alberti canon could be established beyond all doubt (it is always difficult to be sure in such matters), its evidential value would be small indeed; after all, as Kauffmann is well aware, Donatello and Alberti must have known each other ever since the 1430's, and the latter may have formulated his canon long before the completion of *De statua*. Kauffmann seems to assume that a concern with canons of proportion was "in the air" in the 1450's and 1460's, but the dated monuments of those decades fail to bear him out. If our David shows the influence of the canon defined in *De statua*, it is, so far as I have been able to discover, the only figure to do so before the High Renaissance.

In his analysis of the style of the statue, Kauffmann concedes the influence of antiquity in general terms while observing that the smooth, fluid modeling of the body approaches the style of Ghiberti, a further argument, he thinks, for the post-Paduan origin of our figure (apparently on the assumption that on his return from Padua Donatello was deeply impressed with the East Doors of the Baptistery, installed during his absence). Unfortunately, he fails to mention any other instances

[6] The original loincloth of the Padua Christ was probably a good deal fuller than the present one; its shape must have been rather like that of the loincloth on the small crucifix in the hand of St. Francis on the Padua High Altar; the pudenda of the Adam on the back of the Madonna's throne are hidden, as usual, by a bunch of leaves; as for the St. Sebastian, he may or may not have been completely nude, but the one on the bronze plaque in the Musée Jacquemart-André, Paris, which Kauffmann regards as a possible echo of the lost statue, has his loins covered.

of this "Ghibertesque" phase in the late work of our master. Where indeed would he find them? Surely not in the Siena St. John and the Judith, supposedly the closest relatives of the David! The naturalistic, pitted, undulating surface of these two works offers the strongest possible contrast to the tightly controlled, stereometrically simplified shapes of our statue, just as their emotional and physical violence seems utterly incompatible with the calm lyricism of the David. On the other hand, the modeling of the David does have a good deal in common with that of the Siena *putti*, which displays much the same taut quality. These Kauffmann passes over in silence, although they had frequently been cited as evidence for dating our statue about 1430. He omits them again in discussing the harmoniously balanced stance of the David, for which they provide an important precedent. Instead, for lack of more relevant material among Donatello's late works, he refers to the standing *putti* on the pedestal of the Gattamelata (which are so badly preserved as to be barely recognizable) and the Icarus on one of the medallions after ancient cameos in the courtyard of the Palazzo Medici (which has nothing to do with Donatello). Even when he speaks of the wreath that forms the base of the David, Kauffmann cites only the base of the Column of Trajan and similar ancient pieces that might have suggested the idea, without so much as a hint that the Siena *putti*, too, stand on wreaths. Why all this strenuous circumventing of evidence assembled by earlier scholars? Kauffmann's next argument supplies the answer: the David must be post-Paduan because it forms part of an elaborate symbolic program that includes the Judith as well as the eight medallions in the courtyard of the Medici Palace. Both statues, he asserts, were meant as representations of Humility, so as to counteract the popular murmurings about the material splendor of the Medici household. That David and Judith had often been paired in the Middle Ages under the common heading of *humilitas* is certainly true, and for all we know our statues may indeed have had this significance in the eyes of Cosimo and Piero de'Medici. But why must we assume that they were both commissioned for such a program? The *humilitas* aspect of the Judith is established through the inscription on its pedestal (see below, p. 198); is it not possible—and plausible—that the David assumed the role of a *humilitas* image through association with the Judith, without necessarily having been intended for it at the time of its creation? Here Kauffmann is blinded by his *idée fixe* of Donatello as a cryptomediaeval spirit who created wherever possible great cycles rather than isolated works of art. He feels that Donatello himself must have played an active part in working out the unified sculptural program for the Palace, hence the David,

the Judith, and the medallions were all executed together, regardless of the Procrustean methods it takes to fit them into such a hypothesis (cf. the objections of Middeldorf, *loc.cit.*). Enmeshed in the coils of this *boa constrictor* (to borrow the classic term of Erwin Panofsky for a beast from whose attacks none of us is immune), Kauffmann provides what strikes me as a complete misreading of the stylistic character of the David; he asks us to accept not only the nudity of the hero as an attribute of Christian humility but also the downward glance, which to Kauffmann resembles that of the St. Francis in Padua and brings to mind Savonarola's description of the humble one ("he is to bend his head modestly . . . he smiles in silence"). In a final burst of *Sinngebung* at any price, he even proclaims the bronze David Donatello's last statue so that he can close the circle of the master's *œuvre* by pointing out his "return" to the theme of the marble David of 1408-1409, the earliest monumental figure of his youthful days. The "Medici cycle," however, cannot be closed by the same sort of verbal legerdemain. The medallions (whose attribution to Donatello Kauffmann tries to rehabilitate, p. 249, n. 566, after the grave doubts expressed by earlier authors) do not yield easily to unified symbolic interpretation. The key to the riddle, according to Kauffmann, is the *tondo* with the centaur, since the latter carries the Medici arms on his back. On closer inspection, however, these turn out to be an ordinary basket of fruit, with leaves attached, as Lányi was able to demonstrate in a public lecture at the Warburg Institute, London, shortly before his death. The simple truth of the matter seems to be that there is no such thing as a Donatellian "Medici cycle"; the medallions, the Judith, and the David remain separate entities, despite their physical proximity, and demand to be understood without reference to each other.

Our analysis of Kauffmann's interpretation of the David has led us to reaffirm some of the older arguments in favor of dating the figure in the years around 1430. To these several more are to be added. According to Kauffmann (*D.*, p. 243, n. 507), the ornament on David's boots and on the helmet of Goliath confirms the late origin of the statue; he refers in this connection to the bronze Crucifixion relief in the Museo Nazionale and the S. Lorenzo Pulpits, which do indeed show the recurrence of some of the individual motifs. He resolutely refrains, however, from comparing the ornamental repertory of the David with that of the S. Croce tabernacle, which offers an infinitely better match. Indeed, the similarity is so striking and specific as to place the two works in the closest chronological relationship. Almost every single decorative motif on the David has its counterpart in the S. Croce Annunciation. The sharply defined scales or feathers that

fill the paneling on the pilasters of the tabernacle occur on the neckguard of Goliath's helmet and on David's sword (see Pls. 33b, 34a); the scroll-and-palmetto ornament on the upper part of the hero's boots may be found on the cuffs of the angel's sleeves; and the tendrils within ornamental compartments on Goliath's helmet (below the visor) and on David's boots (below the knee and on the instep) are almost identical with those on the brackets and the background paneling of the tabernacle. We also encounter the short vertical flutings from the curved base of the tabernacle on the neckguard of Goliath's helmet and along the open-toed edges of David's boots, as well as on the bottom seam of the Virgin's mantle and on her sandals. Finally, the winged wreath of the tabernacle is curiously similar to the wreath and wings of our statue, even though here the wings are attached to Goliath's helmet. But it is not merely the ornament that links the David to the S. Croce Annunciation; if we make allowance for the difference in technique and material, we find the same facial structure in the features of the statue and of Mary and the Angel (compare especially Pls. 35 and 44a, b, c). This classicistic type, in turn, is closely related to that of the mourning angels and caryatids of the Brancacci Tomb, which were carved about 1428 by Michelozzo under strong Donatello influence. On grounds of style, then, there can be little doubt that the bronze David belongs to the same idealistic and lyrical phase of Donatello's style that begins with the "Ghibertesque" Siena Virtues and continues with the Siena *putti* and the S. Croce tabernacle. In this context, Kauffmann's imputation of Ghibertesque qualities to our statue is entirely justified.[7] As the climactic work within this classicizing trend, the David would seem to fit best into the very early 1430's.

Having discarded both the late dating and the symbolic interpretation proposed by Kauffmann, we find ourselves confronted again with the enigmatic qualities of the statue. What message was it meant to convey to the beholder? That it did have a message we can hardly doubt; otherwise why all the puzzling details? But the context into which these features can be fitted continues to elude us. How, for instance, are we to "read" the triumphal scene enacted by *putti* on the visor of Goliath's helmet? It has long been recognized as a free variant of the same composition, on an ancient sardonyx from the Medici Collection in the Naples Museum, that formed the model for one of the medallions in the courtyard of the Medici Palace (cf. Ernst Kris, *Meister u. Meisterwerke d. Stein-*

schneidekunst in der Italienischen Renaissance, Vienna, 1929, p. 22; also Aldo Foratti, "I tondi nel Palazzo Riccardi . . . ," *L'arte*, xx, 1917, p. 25). Our version, however, is so sketchily modeled that we can no longer be certain whose triumph this is, especially since all the participants are *putti*. Equally strange are the huge wings attached to the helmet of Goliath, the more so as they are clearly intended to be seen as actual, "live" wings rather than as metal ornaments. Then we have the ornate military boots of David, which contrast both with his nudity and with his bucolic hat, betasseled and beribboned and wreathed in laurel. Kauffmann is right, I believe, in deriving the shape of this headgear from a type of hat popular in the fourteenth and fifteenth centuries for hunting and travel, rather than from the classic petasus of Mercury (note especially the side view, Pl. 35a, which shows the strongly projecting front part of the brim). Lányi, in the London lecture referred to previously, seized upon these attributes for an interpretation of the statue as a compound of David and Mercury, claiming the hat and boots as attributes of the ancient god. Apparently he had in mind such later images of Mercury as that on the Sperandio medal of Alessandro Tartagni, nude except for boots and petasus (G. F. Hill, *A Corpus of Italian Medals . . .*, London, 1930, no. 381, p. 97, pl. 67). At first glance, such a Mercury allusion might indeed seem plausible, but upon further reflection it raises more questions than it answers. Why should this "David-Mercury" be shown as a frail boy? For a David, this would be understandable (though by no means obligatory), but not for a Mercury. And why have the telltale wings been omitted from the hat and the boots? (Lányi regards the wings on Goliath's helmet as a hint at the ankle-wings of Mercury— hardly a convincing suggestion.) Moreover, high boots of the classic, open-toed kind and fitted with wings were not the exclusive prerogative of Mercury in the Quattrocento (they are worn by the blind Cupid of Antonio di Ser Cola on the bronze grating of the Cintola Chapel in Prato Cathedral; cf. *Commentari*, III, 1952, pl. xxx), nor was Mercury habitually represented nude (he usually wears a cloak and a short tunic in Early Renaissance art). And, last but not least, there is the question whether a syncretistic merger of David and Mercury was conceivable as early as c. 1430-1440; this point would have to be established before Lányi's hypothesis could lay claim to serious consideration.

That the clue to the meaning of the David must be found in the realm of humanistic thought, rather than

[7] One overtly Ghibertesque detail overlooked by Kauffmann is the helmet, with its flaring neckguard; it belongs to a type that occurs often enough on both the North and East Doors of the Baptistery but cannot be easily matched anywhere else, so far as I have been able to determine; cf. the discussion of the

armor of the St. George, above, pp. 29f. The wings are a fanciful addition, more Northern than Italian in flavor, although winged helmets do occur occasionally in Early Renaissance art, especially on painted *cassoni*.

in that of religious symbolism pure and simple, nevertheless seems plain enough. Yet one may wonder whether orthodox iconographic methods can really do justice to the puzzling character of the figure. A strong relation to antiquity, not only aesthetic but in content as well, is suggested by its pervasive classical air, but even that tends to elude closer definition. Certainly all attempts so far to derive the David from specific ancient statues or statuary types have met with little success (August Hahr, "Donatellos Bronze-David und das Praxitelische Erosmotiv," *Monatshefte f. Kunstw.*, v, 1912, p. 303; O. Sirèn, "Donatello and the Antique," *American Journal of Archaeology*, xviii, 1914, p. 439; Colasanti, *D.*, pp. 96f). The structure of the body, as Kauffmann has rightly stressed, is quite unclassical; its forms, while decisively simplified, are not at all idealized. In fact, their realism is such that we cannot altogether blame Vasari for comparing the figure to a cast from a living model. The classical flavor of the David thus stems from psychological far more than from formal causes: here, as in ancient statues, the body speaks to us more eloquently than the face, which by Donatello's standards is strangely devoid of expression. Try as we may, we cannot penetrate the quiet musing of this boy. There is no hint of the emotional and physical strain that must have accompanied the cutting off of the head; no hint even of David's awareness of what he has done. Psychologically, he seems the counterpart not of Judith (least of all Donatello's Judith!) but of Salome—*le beau garçon sans merci*, conscious only of his own sensuous beauty. Here we must take account of an aspect of Donatello's personality which, for understandable reasons, has not been mentioned in the literature: his reputation as a homosexual. This is known to us from a collection of *Facetiae* printed in Florence in 1548 but compiled in the late 1470's by an author intimately connected with the Medici household. Their modern editor and translator has attributed these stories, somewhat rashly perhaps, to Angelo Poliziano (Albert Wesselski, *Angelo Polizianos Tagebuch*, Jena, 1929). There are several hundred of them, including a considerable number that would not bear retelling today in polite company. Many of the anecdotes involve historic personalities, but artists are not often mentioned, except for Donatello, the only one who appears more than once. Seven stories are told about him, and three of these hint at his emotional involvements with apprentices:

No. 230 (p. 118): "The less long will he stay with me!" This phrase has already become proverbial, and this is its origin: the sculptor Donatello took particular delight in having beautiful apprentices. Once someone brought him a boy that had been praised as particularly beautiful. But when the same person then showed Donatello the boy's brother and claimed that he was even prettier, the artist replied, "the less long will he stay with me!"

No. 231 (pp. 118f): "He laughed at me, and I at him." This, too, derives from Donatello. Once he had quarreled with a young disciple of his, who thereupon had run off to Ferrara. So Donatello went to Cosimo [de'Medici] and asked for a letter to the Count of Ferrara, insisting that he was going to pursue the boy, come what may, and kill him. Cosimo, familiar with Donatello's nature, gave him the letter but he also let the Count know, by a different route, what kind of a man Donatello was. The Count then gave Donatello permission to kill the boy wherever he might find him, but when the artist met his disciple face to face, the latter started to laugh as soon as he saw him and Donatello, instantly mollified, also laughed as he ran towards him. When the Count asked Donatello later whether he had killed the boy, he got the reply, "No, dammit. He laughed at me, and I at him."

No. 322 (p. 168): Donatello used to tint (*tigneva*) his assistants, so others would not take a fancy to them.

The significance of these anecdotes does not depend on their precise point, which is only dimly discernible in translation, since it rests on colloquialisms and *double-entendres* whose meaning is no longer clear. Nor do we have to regard them as exact historic truth. It is their general tenor, rather than their factual reliability, that matters. And this tenor reflects a conduct that must have struck even the notoriously tolerant Florentines as remarkable (cf. the comments of Wesselski, *op.cit.*, pp. xxxif, on the reputation of Quattrocento Florence as a "modern Sodom"). Since the stories were recorded within a dozen years after the artist's death, we can hardly dismiss them as pure fiction. In all likelihood, they were based on memories of actual incidents, however embroidered. Does not our David, too, fit the image of the artist conveyed by these tales? He is not a classical *ephebos* but the "beautiful apprentice"; not an ideal but an object of desire, strangely androgynous in its combination of sinewy angularity with feminine softness and fullness. For an understanding of the emotional background of the work, it may be useful to recall that its creation coincides with the publication of a series of epigrams, written in Siena by the young humanist Antonio degli Beccadelli (Panormita), under the title *Hermaphroditus*, extolling—among other things—the delights of pederasty with unexampled frankness and enthusiasm. These poems, which created a considerable scandal, need not be regarded as reflecting the author's personal inclination or experience; they represent a literary genre patterned on the Roman satirists, and the humanists defended them on the ground that what is offensive in real life is not necessarily so in the poetic

realm (see the account in George Voigt, *Die Wieder-belebung des classischen Alterthums* . . . , Berlin, 1881, I, pp. 480ff). Yet the *Hermaphroditus* is symptomatic of a cultural and moral climate in which the praise of *voluptas*, physical or spiritual, was not merely an intellectual exercise. Viewed in this light, the ambiguous content of our statue is perhaps not wholly surprising. Its message, however difficult to define, has little to do with the *ethos* of Biblical heroes. A hundred years earlier, Boccaccio had pleaded for the divorce of aesthetic from moral values in his Defense of Poetry: "Would you condemn painting and sculpture if Praxiteles . . . had carved the shameless Priapus

. . . rather than the chaste Diana, or if Apelles—or our own Giotto, whose equal he was—were to show Mars lying with Venus, instead of the law-giving Jupiter on his throne?" (*Genealogie deorum*, XIV, 6). While the bronze David could hardly be called a "shameless Priapus," the figure may well have had priapic associations for an age that knew the Spinario on its column in the Lateran as a *priapus ridiculus* and could apostrophize even Donatello's St. George as "my beautiful Ganymede" (see above, p. 24). Whether or not such was the case, our statue would seem to be the first major work of Renaissance art to pose Boccaccio's question in visual form.

MADONNA WITH ANGELS
MUSEUM OF FINE ARTS, BOSTON

PLATE 36 Marble relief; H. 33.5 cm; W. 32.2 cm; thickness of slab (*c. 1425-1428*)
2 cm (at the edges) to 3 cm (center)

DOCUMENTS: none

SOURCES: none (but see below)

The panel was acquired by the Boston Museum in 1917 through the bequest of Quincy Adams Shaw, who had purchased it in Europe some twenty years before. It is said to have come from a church in Rome (Wilhelm Bode, *Denkmäler der Renaissance-Skulptur Toscanas*, Munich, 1892-1905, p. 42, pl. 151, and *Florentiner Bildhauer der Renaissance*, 1st ed., Berlin, 1902, pp. 119f, 200 [2d ed., 1910, pp. 95, 172]; Allan Marquand, *Art in America*, I, 1913, p. 211; *Bulletin of the Museum of Fine Arts, Boston*, XVI, 1918, p. 19; *Catalogue, Quincy Adams Shaw Collection*, Museum of Fine Arts, Boston, 1918, pp. 6f). The previous history of the relief is not documented, although the piece could not have been entirely unknown in earlier days. Kauffmann, the first scholar since Bode to devote more than perfunctory attention to the "Shaw Madonna" (*D.*, pp. 69, 218f, nn. 213-218), found a stucco replica (sold at the Lempertz Sale, Cologne, 1907) as well as a large drawing after it, of c. 1600, in the Uffizi (No. 9124, Santarelli Collection, as "School of Schidone"). He has also suggested that our panel may be identical with the "marble *schiacciato* relief of a Madonna with the Child in her arms, by Donatello, in a wooden frame with scenes in miniature by Fra Bartolommeo," which Vasari saw in the *guardaroba* of Duke Cosimo I (Milanesi, p. 416). The framing tabernacle, Vasari informs us elsewhere (Milanesi, IV, p. 176), had been ordered by Piero del Pugliese, a previous owner of the relief; the painted wings showed the Nativity and the Circumcision on the inside surfaces and the Annunciation, in grisaille, on the outside. These panels

are preserved in the Uffizi (No. 1477), where their history can be traced back to the Medici Inventory of 1589. The Donatello relief to which they were attached may well be the same as the *tavoletta* appraised at 6 florins in the Medici Inventory of 1492 (see above, p. 44). Kauffmann's hypothesis has been pursued in greater detail by Georg Swarzenski, with interesting—though hardly conclusive—observations concerning the influence of the Shaw Madonna on Fra Bartolommeo (*Bulletin of the Museum of Fine Arts, Boston*, XL, 1942, pp. 64ff). The identification is indeed a tempting one; as Swarzenski has pointed out, *schiacciato* reliefs as small as the Shaw Madonna are not likely to have been produced in large numbers. Only one further composition on the same tiny scale has come down to us: the Madonna panel by Desiderio da Settignano in the Victoria and Albert Museum, London (stucco replica in the Berlin Museum; a marble variant, with arched top, formerly in the Collection of Gustave Dreyfus, Paris), and that does not fit the proportions of the painted wings in the Uffizi. The size of these wings, to be sure, is even smaller than that of our relief (20.5 x 9 cm for the Nativity, 18.5 x 9 cm for the Circumcision). Both Kauffmann and Swarzenski have postulated a framework of exceptional width for the tiny panels in order to make them fit the Shaw Madonna. This discrepancy, however, is much less serious than it might appear at first glance, because the present measurements of the two panels are not the original ones. After they had been detached from the tabernacle they were trimmed in such a way as to

inflict considerable damage on the Annunciation, cutting off the angel's hands and profile as well as the bottom edge of his garment; the panel with the Virgin Annunciate was cut an additional 2 cm at the bottom. Originally each panel must have been at least 11 cm wide and considerably more than 20 cm tall. Now, our Madonna relief is bounded by a plain rim 1.8 cm wide which was surely meant to be covered by a more ornate wooden frame; we may assume, therefore, that in the tabernacle the relief proper (30 x 28.5 cm) as well as the wings were framed with moldings that must have been at least 2.5 cm wide. Thus the painted surface of each wing could not have been larger than 30 x 11.8 cm, and may well have been slightly less. The original width of the two Uffizi panels, then, matches these specifications almost exactly; their vertical dimension cannot be reconstructed with the same precision, but there is nothing to prevent us from assuming that it might have been as much as 30 cm. In any event, their original format must have been unusually tall and narrow, since the trimming of the panels would be difficult to explain on any other basis. Apparently, after the dismantling of the tabernacle the wings were treated as separate paintings of the Nativity and Circumcision, without regard to the grisaille scene on their outer surfaces. The trimming may have had the double purpose of fitting them into pre-existing frames and of giving them more conventional proportions. The fact that the painted figures are very much smaller in scale than Donatello's Madonna, constitutes no objection to Kauffmann's hypothesis; given the peculiar format of the panels and the narrative subjects to be represented, they could hardly have been larger. Vasari, indeed, stresses their tiny size by terming them *figurine a guisa di miniatura.* All these considerations, it is true, do not add up to proof positive, yet they are more than sufficient, it seems to me, to give a high degree of plausibility to the thesis that the Shaw Madonna is identical with the relief owned by Piero del Pugliese.

Kauffmann (*loc.cit*) also was the first to explore the iconographic background of our relief among the "Madonnas of Humility" of Trecento and early Quattrocento painting. Most of these show the Virgin seated on the ground, but towards 1400 she could be placed on a bank of clouds as well (e.g. Lorenzo Monaco, Siena Pinacoteca, No. 157). This "celestial version" of the Madonna of Humility has since been investigated further by Millard Meiss in the context of his detailed study of the subject as a whole, although without reference to the Shaw Madonna (*Art Bulletin*, XVIII, 1936, pp. 447f, and *Painting in Florence and Siena after the Black Death*, Princeton, 1951, p. 139). The type originated in the third quarter of the Trecento—the earliest specimens are to be found in the circle of Nardo di Cione—apparently by combining the original Madonna of Humility with the legend of the Virgin in the sun revealed to Augustus by the sibyl. As a result, Meiss points out, the "celestial version" tended to assume a remote and visionary character; the Child often sits upright, with his right hand raised in blessing, instead of clinging to the Virgin's bosom, and the Madonna, too, is apt to glance at the beholder, rather than at the Child. Our panel, interestingly enough, re-introduces the intimate mother-child relationship of the "earthly" Madonna of Humility into the "celestial version," and thus represents something of an iconographic novelty. Donatello's treatment of the angels also departs from the established pattern: instead of flanking the Madonna in formal poses of adoration, they cluster about her almost as if they were supporting the bank of clouds on which she is seated.

The Shaw Madonna has been viewed with some doubt by a number of critics. Lord Balcarres (*D.*, p. 81) notes a lack of refinement in the angels' heads, as does Cruttwell (*D.*, p. 135), who criticizes the execution of the whole as somewhat coarse and the expression of the Child and the angels as verging on vulgarity: "The heads are ill-modeled, and there is a lack of breadth in the treatment that should prevent the attribution to Donatello's own hand." Colasanti, too, claims that the panel must have been executed, at least in part, by a pupil (*D.*, p. 86); Goldscheider (*Donatello*, London, 1941, p. 41) calls the treatment Desideriesque; and Planiscig pointedly omits it altogether from his two monographs. These judgments, however, were based not on acquaintance with the original but on the rather harsh Bruckmann photograph in Bode's *Denkmäler*, which for many years remained the only one available and was therefore reproduced again and again (*KdW*, Colasanti, etc.). In my view, the magnificence of conception of the Shaw Madonna is fully matched by the execution of the central group, and if the expression of some of the angels' heads seems not fully controlled, we can find the same kind of sketchiness among the smaller angels' heads of the Naples Assumption and the London Delivery of the Keys. In our panel it may be a bit more obtrusive because the scale is so much smaller: with faces the size of thumbnails, and the depth of the carving so shallow that it must be measured in fractions of millimeters, the sheer problem of controlling the action of his tools may well have overtaxed the patience of Donatello, except in the really important areas. A certain roughness, or even crudeness, of detail must be taken for granted in all of the master's sketches—witness the stucco roundels with scenes from the life of St. John in the Old Sacristy (Pls. 60-61). Wherever we meet Donatello's first, direct, "raw" conception, it

is the design as a whole and the relation of each figure to this totality that is uppermost in his mind, rather than the definition of the parts. We feel no need, therefore, to assign any part of the Shaw Madonna to a lesser hand. In the case of a work on so intimate a scale, a division of labor seems improbable under any circumstances, quite apart from the likelihood that at the time our panel was made nobody except Donatello himself really knew the technique of *schiacciato* carving.

The date of the Shaw Madonna is suggested by its kinship, in style and even in iconography, with the Naples Assumption, which has been acknowledged by all scholars. Bode thought it might have been done during Donatello's Roman sojourn, in 1432-1433, since the relief is said to have come from that city (the same argument also in Colasanti); Schottmüller (*D.*, p. 124) dates it a bit earlier, around 1430, while Kauffmann places it in the immediate vicinity of the Assumption (i.e., about 1427), which he regards as its source, stylistically and iconographically. I myself feel less sure of the priority of the Naples relief, although I share Kauffmann's conviction that the two works are extremely close to each other. The form and expression of the Shaw Madonna's head, as well as the gesture of the Child, still seem to contain an echo of the Pazzi Madonna, which might indicate a slightly earlier date than that of the Naples panel. In any event, however, there can be little doubt that our relief was produced between about 1425 and 1428.

ASSUMPTION OF THE VIRGIN
TOMB OF CARDINAL RAINALDO BRANCACCI, S. ANGELO A NILO, NAPLES

PLATES 37-38 Marble relief; H. 53.5 cm; W. 78 cm 1427-1428

DOCUMENTS

An entry in Michelozzo's *Catasto* Declaration of 1427, which lists, among other things, the joint commissions on which Donatello and Michelozzo were working at that time (they had become partners "about two years ago"). The text was first published, in incomplete form, in Giovanni Gaye, *Carteggio inedito . . .*, I, Florence, 1839, pp. 117f; Cornel v. Fabriczy transcribed the entire document ("Michelozzo di Bartolommeo," *Jahrbuch Kgl. Preuss. Kunstslgn.*, xxv, 1904, Beiheft, pp. 61ff). A second, independent transcription agrees with Fabriczy's rendering in all matters of substance (Rufus Graves Mather, "New Documents on Michelozzo," *Art Bulletin*, xxiv, 1942, p. 228). Gaye, *loc.cit.*, also published a reference to the tomb from the 1427 *Catasto* Declaration of Cosimo and Lorenzo di Giovanni de'Medici.

1427, about July 11 (the day and month are missing, but it seems plausible to assume that Michelozzo made out his Declaration at the same time that he wrote Donatello's, which carries the above date; see Fabriczy, *loc.cit.*, note 1, and Rufus Graves Mather, *Rivista d'arte*, xix, 1937, p. 186): Donatello and Michelozzo have done about one quarter of the work on the tomb of Cardinal Rainaldo Brancacci of Naples, which they are doing in Pisa; they expect to receive a total of 850 florins for this commission and have already been given 300 florins, with the understanding that they will bear all expenses, including the transportation of the monument to Naples (*e a tutte nostre spese l'abiano a conpiere e condurre a napoli*).

(Gaye, p. 118n; day and month not given): Michelozzo and Donatello are listed among the debtors of Cosimo and Lorenzo di Giovanni de'Medici, to whom they owe 188 florins, 1 (soldo), and 11 (grossi) on account of the Brancacci Tomb (*per una sculptura del Chardinale de branchacci*).

SOURCES

1550 Vasari-Ricci, p. 53 (Milanesi, p. 409, slightly shortened; the omitted words are placed in brackets here): "He also made a marble tomb for an archbishop in Naples, which was sent there [from Florence by boat] and is in S. Angelo di Seggio di Nido; it includes three statues that support the sarcophagus on their heads, and on the sarcophagus itself a scene in low relief of such beauty that it has received infinite praise."

1560 Pietro de Stefano, *Descrittione de i luoghi sacri della città di Napoli*, Naples, 1560, fol. 33r:
"Sant'Angelo nel seggio di Nido is a church built by . . . Rainaldo Brançacci, Cardinal of SS. Vitus and Marcellus . . . around 1400; he then died in 1418. . . . Within there is a beautiful marble tomb containing the mortal remains of the Cardinal, without a funerary inscription (*epitaphio*)."

According to the funerary inscription, Rainaldo Brancacci died on March 27, 1427, only three and a half months earlier than the date of Michelozzo's *Catasto*. Thus the tomb must have been commissioned before the death of the Cardinal, unless we are willing to assume that Michelozzo gave a vastly exaggerated estimate of the work already accomplished (he might conceivably have done so for tax purposes—perhaps he wanted to suggest that most of the 300 florins received on account had gone for materials and wages, in order to reduce his tax liability). The monument is said to have been ordered by Cosimo de'Medici, who served as executor of the Cardinal's last will, although this tradition cannot be documented. The earliest source for it appears to be Cesare d'Engenio Caracciolo, *Napoli sacra*, Naples, 1624, pp. 260f (cf. Ottavio Morisani, *Michelozzo architetto*, Turin, 1951, p. 87). D'Engenio also repeats the statement of Pietro de Stefano concerning the lack of a funeral inscription, and adds that in his own day the family had provided an epitaph. He then gives the text, both of the brief inscription above the sarcophagus and of the much longer one on the marble tablet to the right of the tomb. The latter is indeed of the early seventeenth century—it carries the date 1605—but the former matches the lettering on the Coscia Tomb and the Pecci slab so well that it cannot be later than the rest of the monument. Pietro de Stefano must have overlooked it, because of its unusual location; in fact, his claim that there was no *epitaphio* may have persuaded the Brancacci family that the old inscription was inadequate for so distinguished an ancestor, and that a more elaborate one, in a more conspicuous spot, was desirable. That Cosimo de'Medici should have had a direct connection with the monument seems entirely plausible, since Rainaldo Brancacci had long been identified with the cause of Baldassare Coscia (John XXIII), whom he had crowned in Bologna in 1410 and whom he had advised to accept the hospitality of the Florentines in 1419, after the victory of Martin V had become inevitable.[1] If the original order for the tomb came from the Cardinal himself, it may very well have been Cosimo who suggested Donatello and Michelozzo, whose work on the Coscia Tomb must have been fairly well advanced by then; as executor, he would have paid the two masters after Brancacci's death, and he probably did so before, too, since the Cardinal was his client. In any event, he and his brother Lorenzo listed themselves as creditors for 188 florins (out of 300) disbursed to Michelozzo and Donatello by mid-1427 for the monument. It is possible, of course, that these 188 florins were paid out between March 27 and July of 1427, in which case they would be, properly speaking, a debt owed by our two masters to the Cardinal's estate. On the other hand, the payments made to Donatello by the Medici in 1426, of which Semper, *D. '75*, pp. 280 (No. 54), 310, has published a fragmentary record, probably concern the early labors on the Brancacci Tomb, at least in part. They are recorded in the fragment of a ledger for the years 1424 to 1426 of the Pisa branch of the banking firm of Averardo di Francesco de'Medici, with whom Donatello had an account. The ledger lists two deposits to his credit from "the Medici of Florence," presumably Cosimo and Lorenzo, who had no branch of their own in Pisa and thus made use of their cousin's firm to do business there.[2] The first deposit, of 30 florins, dates from April 6, 1426; the second, of 80 florins, from August 6. There are 21 withdrawals covering the same four months, mostly of small sums from one to six florins paid to Donatello in cash, for a total of slightly more than 69 florins.[3] Only a few of the entries record the purpose of the expenditure: on April 16, Donatello pays 10 florins for marble; on April 30 he withdraws 2 florins for a piece of marble; on June 20 6 florins are paid for him to one Andrea di ser Rufino, agent of the Opera [del Duomo], for a block he had purchased from the Opera; and on August 3 a man who had sold Donatello a boat (*barcha*) receives 16 florins. Our master, then, must have been in Pisa almost continuously from April 6, 1426; he is recorded there also on July 24 and December 18 as a witness for payments to Masaccio, and on October 14 as a guarantor for Pippo di Giovanni di Gante.[4]

[1] See P. Mazio, *Di Rainaldo Brancacci Cardinale*, Rome, 1845, and Nino Cortese, *Enciclopedia italiana*, VII, 1936, p. 686; what connection, if any, the Cardinal had with the Florentine Brancacci family, has never been clearly determined; for the role of the Medici as supporters of John XXIII, see above, p. 60.

[2] I am indebted for all this information, which Semper, *loc.cit.*, failed to note, to Dr. Florence Elder de Roover. Dr. Gino Corti was kind enough to transcribe for me the relevant

entries, on fols. 106 and 113 of the ledger, which is preserved in the State Archives of Florence, Mediceo avanti il Principato, Filza 133, No. 3.

[3] For the accurate interpretation of these data I must again record my gratitude to Dr. de Roover.

[4] L. Tanfani-Centofanti, *Donatello in Pisa*, Pisa, 1887, pp. 5ff, and *Notizie di artisti . . .*, Pisa, 1898, pp. 176ff; the documents are dated in the "Pisan style," according to which the year 1427 began on March 25, 1426, Roman style, so that there

While these documented dates must not be regarded as limiting Donatello's stay in Pisa to the period from April to December 1426, or as indicating his continuous absence from Florence, they do suggest that he spent most of those nine months in Pisa (as against separate brief trips, which he must have made quite often both before and after 1426; according to Michelozzo's *Catasto* Declaration of the following year, the two partners owned a mule, which they needed for their frequent business trips). Thus the Pisan "branch office" referred to in Michelozzo's *Catasto* Declaration of 1427 must have been established not later than the spring of 1426;[5] its *raison d'être*, we may suppose, was the commission for the Brancacci Tomb, which the two masters probably received early in 1426, or perhaps late in 1425. It must have taken several months, and considerable correspondence, to reach agreement on a final design (I imagine that the partners received a general description from Naples of the kind of tomb the Cardinal wanted, in conformity with Neapolitan usage at that time, whereupon Michelozzo tried to match these specifications on the basis of Florentine Trecento monuments and submitted a design that had to be modified in various ways before it won approval). Contrary to the often expressed opinion of Donatello scholars, the plan of the Brancacci Tomb, with its free-standing caryatids, is far closer to such Florentine precedents as the Orsi Tomb by Tino di Camaino (cf. W. R. Valentiner, *Tino di Camaino*, Paris, 1935) or the Pazzi Tomb by Alberto di Arnoldo (S. Croce) than to the traditional Neapolitan type. The two large mourning angels behind the effigy also recall a Florentine model, the Aliotti Tomb in St. Maria Novella. Once the problem of the design was solved, a considerable amount of time and labor must have been spent in procuring, measuring, and roughing in the required blocks of marble, so that the project had, in all likelihood, not advanced much beyond this stage in mid-1427. Concerning the date of completion and shipment to Naples, we know nothing except that the monument is never mentioned again in the *Catasto* Declarations of either master (1430, 1433, 1442, etc.), a circumstance which, unfortunately, does not yield a definite *terminus ante*. There is, however, one other fact that may have a bearing on our problem: on August 8, 1428, both partners are referred to as being—and, by implication, as having been for some time—in Pisa.[6] The Brancacci Tomb, it seems to me, provides by far the most plausible reason for this Pisan work period. We may also assume that the partners were anxious to finish the monument as quickly as possible, even at the cost of neglecting some of their other commitments, in order to escape the expense of maintaining a secondary workshop in Pisa for this purpose. It is thus highly probable that the tomb was completed and shipped by the end of 1428.[7] Since the Assumption panel is not likely to have been tackled until the rest of the tomb was fairly well advanced, the most logical date for it would be the latter half of 1427 or the following year.

Modern scholars have been practically unanimous in regarding the Assumption relief as Donatello's only contribution to the Brancacci Tomb, and in holding Michelozzo responsible for the architectural design and for most of the sculpture (Colasanti, *D.*, p. 53, is the only one to assign the effigy and perhaps also the two mourning angels to Donatello, but without defending his claim in detail). Since I find myself in full agreement with the prevailing view, I shall confine my attention to the Assumption panel.[8] So far as I know, the subject of our relief has no precedent among Trecento tombs. Whether it was specified by

is a whole year's difference between the Pisan and Florentine calendars. Some Donatello scholars, notably Kauffmann, *D.*, p. 68, and Planiscig, *D.*, p. 49, disregard this shift and place Donatello in Pisa from July to December 1427.

[5] From May 1421 to May 1426 Donatello rented a house in Florence near S. Spirito belonging to the Frescobaldi, as we know from a series of entries in account books from the family archives of the Frescobaldi published by Pasquale Papa in *Miscellanea d'arte*, I, 1903, pp. 49f. Could it be that he discontinued his lease at this particular time because he had decided to open a "branch office" in Pisa? The Frescobaldi property seems to have been a workshop. The artist's living quarters were in another house, also near S. Spirito, which he rented from Guglielmo Adimari. In his *Catasto* Declaration of 1427, he gives the latter address as his residence and states that he owes two years' rent on it. For the location of Donatello's workshop in Florence at various times see the long note in Semper, *D.* '75, pp. 235ff.

[6] In the *Catasto* Declaration of Pagno di Lapo, made out by his father Lapo di Pagno, and filed a year late, Lapo reports that his son is abroad and Donatello and Michelozzo are in Pisa, so that a dispute about Pagno's wages for 18 months' work for the two partners cannot be settled. The document is published in Cornel v. Fabriczy, "Pagno di Lapo Portigiani," *Jahrbuch Kgl. Preuss. Kunstslgn.*, XXIV, 1903, Beiheft, p. 126.

[7] Its installation in Naples may have been supervised by Pagno di Lapo, as suggested by Morisani, *loc.cit.*; or, more likely perhaps, by Nanni di Miniato, called Fora, who was in Naples from 1428 to 1433, according to two letters he wrote from there to Matteo Strozzi on September 28, 1428, and December 10, 1430, respectively, and according to his *Catasto* Declaration of 1433. See Cornel v. Fabriczy, "Nanni di Miniato," *Jahrbuch Kgl. Preuss. Kunstslgn.*, XXVII, 1906, pp. 74ff. In 1427, Nanni had worked for Michelozzo; in his *Catasto* Declaration of 1430, as well as in the letter of the same year, he refers to a three-year-old debt of 8 florins still owed him by the latter master. Vasari-Milanesi, III, p. 248, and Fabriczy, *loc.cit.*, conclude from this that Nanni must have assisted Donatello and Michelozzo with the Brancacci Tomb in Pisa, and that he probably went with Michelozzo to Naples in order to help install the monument. There is no evidence, however, that Michelozzo made the journey.

[8] The significance of the caryatids and mourning angels for certain undated works of Donatello is discussed elsewhere (see pp. 39, 84, 99, 115).

the Cardinal or suggested by the artists, it is a decisive departure from tradition, which demands the Dead Christ—the *imago pietatis*—or the Resurrection on the front of the sarcophagus.[9] In replacing the devotional reference to the Passion with a scene conveying the hope of the deceased for his own assumption into Paradise, the iconographic program of the Brancacci monument reflects the new attitude towards death that distinguishes the tombs of the Renaissance in general from their mediaeval predecessors. The next step in this development may be seen in the Aragazzi Tomb, where the same idea is expressed through the monumental figure of the Risen Christ flanked by adoring angels—a Risen Christ without soldiers and tomb, no longer the wraithlike figure of Gothic art but endowed with all the physical majesty of a classical god; the Montepulciano Christ is, in fact, more akin in many ways to the Christ of the Ascension as represented on the Pistoia Pulpit of Fra Guglielmo than to the Christ of the Resurrection, even though the figure derives from the Resurrection panel of Ghiberti's North Doors. From here the road leads to the Forteguerri monument of Verrocchio in Pistoia, which shows Fra Guglielmo's Ascension converted into an ecstatic vision beheld by the kneeling Cardinal. If we view the Brancacci Tomb in this evolutionary context, we may be able to explain why our panel represents the Assumption of the Virgin, rather than the Ascension; perhaps the symbolic analogy between Christ and an ordinary mortal, even a prince of the Church, was rejected as too presumptuous, so that the corresponding scene from the life of the Virgin had to be substituted for the Ascension. That the analogy was intended is strongly suggested by Donatello's characterization of the Virgin as a humble old woman who shrinks in fright from this overwhelming new manifestation of Divine favor, just as she once shrank from the Angel of the Annunciation. It is the eloquent contrast between the surging joyfulness of the angelic host and a mute, wide-eyed Virgin who is the very opposite of the Queen of Heaven, that gives our relief its deeply moving quality. To regard this unique conception of Mary as a mere consequence of Donatello's "naturalism" (Kauffmann, *loc.cit.*) seems hardly sufficient. Even such a detail as the simple chair on which the Virgin is seated reinforces her human, mortal aspect. In earlier representations of the subject, she sits on a bank of clouds (as in the Giottesque fresco in S. Croce) or, more frequently, on an arc within the mandorla; Orcagna, in his Or San Michele tabernacle, places her on a throne backed by a canopy of stars, thus sug-

gesting her status as the Queen of Heaven, but Donatello's chair certainly does not have this connotation. Still, our master probably took the idea of using a concrete piece of furniture from Orcagna's relief, which also anticipates the characterization of the Virgin as a woman of advanced years, both in her physiognomy and her matronly costume. Kauffmann, *loc.cit.*, thought it necessary to postulate that Donatello had been influenced by Fra Guglielmo's Ascension in Pistoia, in order to account for the horizontal format of our relief as against the vertical arrangement of earlier Assumptions. There exist, however, several Trecento examples of the subject that provide ample precedent for our composition; the S. Croce fresco already referred to, and the Orcagna Assumption in Or San Michele, are only slightly wider than they are tall, but the main relief of the original outdoor pulpit at Prato Cathedral is even more emphatically horizontal than the Brancacci panel.[10] In the S. Croce fresco, interestingly enough, the knees of the Virgin are turned slightly towards the right, much as they are in our relief. The number of angels supporting the Virgin varies greatly in earlier Assumptions; there may be as few as four, or as many as twenty. Yet Kauffmann may well be correct in attaching symbolic importance to the fact that Donatello used seven (not counting the tiny winged heads protruding from the clouds here and there); this feature is found in Nanni di Banco's great relief above the Porta della Mandorla of Florence Cathedral, as well as in the Prato panel mentioned before, where the Virgin is surrounded by seven seraphim.

The style of our relief is fully consistent with the date suggested by the documentary evidence. Many of the angels recall the youthful figures in the Siena Feast of Herod and, even more emphatically, the two Siena Virtues, with their more slender proportions and greater fluency of movement. Thus, while the records are not quite sufficient to prove beyond cavil that our panel was produced in 1427-1428, we can well afford to accept their testimony at face value (as has indeed been done by every Donatello scholar since Gaye). Yet the design of the Assumption shows a harmony and eurythmic grace that are startlingly new in Donatello's work; neither the Siena relief nor the earlier *schiacciati* lead us to anticipate this quality. True, the angels in our composition are the direct descendants of the princess in the St. George panel and of the Siena Salome, but the latter figures represent a specific type, they remain curiously isolated, like quotations, within the narrative context of the design. The angels of the

[9] The Death of the Virgin—in which her soul rather than her body is seen being carried heavenward—does occur on some Trecento tombs, e.g. that of Francesco Dandolo in the Frari, Venice.

[10] The latter work was undoubtedly known to Donatello, since he and Michelozzo received the contract for replacing the pulpit on July 14, 1428, before they finished the Brancacci Tomb; see below, pp. 108ff.

Assumption, in contrast, with their interwoven movements of plunging and soaring, are joined together into a living wreath of celestial beings that dominates the entire scene; here, for the first time, ecstatic joy has found complete physical expression. It is surely not by chance that this work, so prophetic of the dancing angels at Prato and on the Cantoria frieze, should have been completed at the very time when Donatello and Michelozzo received the commission for the Prato Pulpit.

ASCENSION AND DELIVERY OF THE KEYS TO ST. PETER
VICTORIA AND ALBERT MUSEUM, LONDON

PLATES 39-40 Marble relief; H. 41 cm; W. 114.5 cm *(1428-1430)*

DOCUMENTS: none

SOURCES

1492 Inventory of the collections of Lorenzo de'Medici (Eugène Müntz, *Les collections des Médicis au quinzième siècle*, Paris, 1888, p. 63): "A marble panel, in wooden frame, with an Ascension by Donatello in half relief (*mezzo rilievo*)."

1591 Bocchi, p. 185: "[In the house of the Salviati there is] a marble panel in low relief by Donatello, representing Christ who gives the keys to St. Peter. This work is held in high regard by artists for its rare qualities of invention and design. Much praise has been given the figure of Christ, the eager expression of St. Peter, and the tender gesture of the kneeling Madonna, who is of venerable and devout aspect."

The panel (No. 7629-1861) was acquired by the Victoria and Albert Museum in 1860 from the Gigli-Campana Collection (Eric Maclagan and Margaret H. Longhurst, *Catalogue of Italian Sculpture*, 1932, p. 19; cf. A. M. Migliarini, *Museo di sculture del risorgimento raccolto . . . da Ottavio Gigli*, Florence, 1858). When and from whom the Marchese Campana obtained it, has not been recorded although it is said to have been purchased for him in Florence (John Charles Robinson, *South Kensington Museum, Italian Sculpture . . . , a Descriptive Catalogue*, 1862, p. 15). Semper's statement (*D. '87*, p. 59) that the panel was once in the Casa Valori is unsupported by any published evidence (in *D. '75*, p. 268, he refers to the house of the Salviati instead). There can be no doubt that this is the same relief described in Bocchi-Cinelli. The identification with the Ascension panel in the Medici inventory of 1492, first proposed by Cornel v. Fabriczy (*Archivio storico dell'arte*, I, 1888, p. 187), is not quite certain but seems highly plausible; our panel might well have come into the possession of the Salviati family through the marriage of Lucrezia, daughter of Lorenzo de'Medici, to Jacopo Salviati, as suggested by Semrau (*D.*, p. 76n). The relief has an old wooden frame which may be the one mentioned in the inventory.

The original purpose and location of the panel are unknown. Its long, narrow format and the unusual subject suggest that the relief was produced as part of some larger ensemble, rather than for independent display. Of the various hypotheses so far proposed, the least plausible is that of Alfred Gotthold Meyer (*Donatello*, Bielefeld-Leipzig, 1903, p. 59), based on the erroneous assumption that the Virgin is not ordinarily included in Ascension scenes. Meyer explains her presence here as a special reference to—perhaps even a portrait of—Donatello's mother Orsa, who died between 1427 and 1433 in the parish of S. Pier Gattolini (hence the Delivery of the Keys), and conjectures further that the London relief may have been intended for her tomb. Schubring (*HB*, pp. 46, 75) tries to combine this view with his own earlier theory, according to which our panel was meant to form the central part of the predella of the Altar of St. Peter in Florence Cathedral.[1] The difficulty here is threefold: documentary evidence (Poggi, *Duomo*, pp. 216f, No. 1080) shows that in April 1439 Luca was commissioned to do two marble altars, dedicated respectively to SS. Peter and Paul, and that Donatello had made a wax model for the latter only (there is no evidence that either project was ever completed); the two panels actually executed by Luca (now in the Museo Nazionale) show much higher relief than the London Ascension; and a date of c. 1440 seems about ten years

[1] *Berichte d. kunsthist. Gesellschaft*, Berlin, 1904, pp. 4ff, and *Luca della Robbia*, Bielefeld-Leipzig, 1905, p. 28; Allan Marquand, *Luca della Robbia*, Princeton, 1914, p. 42, is the only scholar to endorse Schubring's proposal.

too late for the style of our panel. A third theory was launched by Tschudi (*D.*, p. 17), who thought it likely that the relief was made during Donatello's Roman sojourn in 1432-1433, both because of the choice of subject and because of its kinship with the Entombment on the St. Peter's tabernacle. Domenico Gnoli ("Le opere di Donatello in Roma," *Archivio storico dell'arte*, I, 1888, p. 25) went a step further and proposed to link the Ascension with St. Peter's directly. Both variants of this view have been widely accepted (Semrau, *D.*, p. 75f; Wilhelm v. Bode, *Denkmäler der Renaissance-Skulptur Toscanas*, Munich, 1892-1905, p. 25; Schottmüller, *D.*, pp. 23f, 124; Cruttwell, *D.*, p. 67). While the style of our panel is not incompatible with the early 1430's, its original location cannot be inferred from the mere fact that it represents the Delivery of the Keys. If, moreover, the work had really been commissioned for a Roman church, we would be at a loss to explain how it could turn up in the private collection of Lorenzo the Magnificent sixty years later. A number of scholars, aware of these difficulties, have refused to speculate on the original purpose of the panel. Judging purely on the basis of style, they generally place it nearer the Siena Feast of Herod and the Naples Assumption than the Rome Entombment, i.e. in the late 1420's or about 1430 (Semper, *D.* '87, p. 59; Reymond, *Sc. Fl.*, II, p. 102; Bertaux, *D.*, pp. 78f; Maclagan, *loc.cit.*; Colasanti, *D.*, p. 55; Planiscig, *Donatello*, Vienna, 1939, p. 36). Kauffmann, too, favors a date immediately after the Naples relief (*D.*, pp. 69ff) but advances yet another proposal concerning the origin of the work (p. 220, n. 222): that it was intended for the base of the niche containing the statue of St. Peter at Or San Michele, in analogy with the *schiacciato* relief beneath the St. George, since the measurements of the two panels (and niche openings) are approximately the same. He concedes, however, that the Ascension was never installed there, and suggests that the butchers' guild may have suddenly decided to abandon its plans for completing the decoration of the tabernacle, whereupon the base relief passed into private hands. For Kauffmann, who regards the St. Peter at Or San Michele as a work of Donatello, this hypothesis has a special attraction, although it does not really depend on the authorship of the statue (which must be five to ten years earlier than our panel in any event; see below, pp. 222ff). Yet there is one decisive objection to it, as pointed out by John Pope-Hennessy (*Donatello's Relief of the Ascension . . .*, Victoria and Albert Museum Monograph No. 1, 1949, p. 5); the St. George relief is far simpler in design than ours, and the foreground forms project more strongly, so that the composition remains visually effective even when viewed at some distance. The Ascension, in contrast, is the most delicate and atmospheric of all of Donatello's *schiacciati*; its physical depth of carving is extremely shallow throughout. If such a panel, which carries the principle of pictorial relief to its farthest limits, were installed as far from the ground as the St. George relief, its subtleties would be largely wasted. The composition is much too complex, the chiaroscuro too subdued to carry for more than a few feet (Bertaux, *loc.cit.*, fittingly characterizes it as "un bas-relief de lointain," with the entire foreground omitted). Here if anywhere Donatello has worked for inspection at close range.[2]

If his Or San Michele thesis seems unsatisfactory, Kauffmann has nevertheless added greatly to our understanding of the iconographic background of the London panel. Donatello's method of representing the Delivery of the Keys, he points out, derives from Florentine Trecento models such as the Strozzi Altar of Orcagna in S. Maria Novella and a parchment drawing of c. 1400 attributed to Lorenzo di Bicci in the Uffizi, which show St. Peter receiving the keys from a Christ in Majesty enthroned in the sky within a mandorla of seraphim.[3] Moreover, Kauffmann shows that the unique combination of the Delivery of the Keys with the Ascension in our relief is likewise based on a local Florentine tradition, although not a pictorial one. His proof is a description, in the *Itinerario* of Abraham Bishop of Souzdal, who visited Florence in 1439, of the Ascension play performed annually in S. Maria del Carmine (from Alessandro d'Ancona, *Origini del teatro italiano*, Turin, 1891, I, p. 253; the relevant passages are quoted more fully, in translation, by Pope-Hennessy, *op.cit.*, pp. 7f). The setting of this *sacra rappresentazione* shows the Mount of Olives, with Jerusalem in the background; in the final scene, Christ appears in the center, with the Virgin to his right, St. Peter to his left, and the rest of the apostles ranged on either side. After taking leave from them all, He hands the keys to St. Peter and ascends out of sight on a cradle, masked by painted clouds, that is hoisted slowly to an aperture above the stage.

It remained for Pope-Hennessy to explore the full implications of Kauffmann's discovery. The analogies between the Carmine play and Donatello's relief are so striking, he observes, that the panel must have had some direct connection with this particular church.

[2] It must be admitted, though, that the depth of the carving is easily misjudged from photographs, all of which show the relief in a strongly raking light in order to register sufficient contrast. Those reproduced in Pope-Hennessy, *op.cit.*, avoid this distortion of values, but only at the expense of clarity of detail.

[3] For the iconographic antecedents of this type see H. D. Gronau, *Andrea Orcagna und Nardo di Cione*, Berlin, 1937, pp. 14f; the Uffizi drawing, published by Mario Salmi, *Rivista d'arte*, XVI, 1934, pp. 66ff, is also reproduced in Pope-Hennessy, *op.cit.*, p. 6.

This clue has special weight in view of the fact, frequently acknowledged by previous scholars, that the Ascension reflects the style of Masaccio to a greater extent than does any other work of Donatello. The entire composition, as well as the figure types, with their simple contours and heavy draperies, show the unmistakable influence of the Tribute Money; in fact, as Pope-Hennessy notes, the fourth apostle from the right in our panel is a direct adaptation of the pointing St. Peter in the left half of the Brancacci Chapel fresco. Recalling the documented association of the two masters (see above, p. 89), Pope-Hennessy suggests that the Ascension may actually have been executed as the predella of an altar or tabernacle for the Brancacci Chapel. Could that be the reason, he asks, why the central event of the Delivery of the Keys was omitted from the St. Peter cycle of Masolino and Masaccio?[4] Perhaps the completion of the project was interrupted by Donatello's Roman journey and discontinued when the Brancacci were exiled by Cosimo de'Medici in 1434.

Pope-Hennessy wisely refrains from insisting that this hypothesis offers a definitive answer to our problem. Yet his proposal, while probably not susceptible to further proof, seems far superior to the rest, since it is the only one to take satisfactory account of all the data at our disposal: the iconographic peculiarity of the panel, its formal and stylistic character, its position in the chronology of Donatello's development, and even the circumstance that it passed into the collection of the Medici. The "Brancacci thesis" may also help to dispel such doubts as have been voiced occasionally concerning the attribution of the relief to Donatello. Pastor (*D.*, pp. 66f) regards the Ascension as a work of the late Quattrocento, on grounds so vague and general that his view is difficult to discuss in specific terms. Planiscig, who arrives at the same conclusion (*D.*, p. 53, in contrast to his earlier monograph, *op.cit.*), states his reason clearly enough—the London panel is closely related to the Entombment on the St. Peter's tabernacle, which he regards as the work of a secondary artist imitating the late style of Donatello. (For a review of this opinion, which I regard as erroneous, see below, p. 98.) Even if we were to grant Planiscig's premise—the late date of the Rome Entombment—we should have to reject his conclusion; for the Ascension, as Kauffmann and others have rightly stressed, still recalls the Siena Feast of Herod and the Naples Assumption far more concretely than does the Entombment (the Christ and the angels also show striking similarities to the Shaw Madonna; cf. Pl. 36). Besides, Planiscig has failed to take

into account one piece of evidence that serves to establish the date of the Ascension as prior to Donatello's departure for Padua without involving any consideration of the master's artistic development. Among the very few identifiable works which Vasari attributes to "Simone, the brother of Donatello," there is a Baptism of Christ on the baptismal font of Arezzo Cathedral (Milanesi, II, p. 460; omitted in the first edition). This panel was pronounced very close to Donatello's own style by Cornel v. Fabriczy ("Simone di Nanni Ferrucci," *Jahrbuch Kgl. Preuss. Kunstslgn.*, XXIX, 1908, Beiheft, p. 2); and Frida Schottmüller, who published a photo of it, called it "almost entirely by Donatello's own hand" ("Zur Donatello-Forschung," *Monatshefte f. Kunstwiss.*, II, 1909, pp. 38ff). There can be little doubt that these estimates are much too optimistic; they are based, not on the two main figures, which do not resemble any work of Donatello in the least, but on the angels and the trees, carved in a much shallower relief that approaches *schiacciato*. Here we find a very distinct similarity to the corresponding details in the Ascension, i.e. the two angels on the extreme left and the large tree on the extreme right—so much so, in fact, that the "Master of the Arezzo Baptism" may actually have had a very minor share in the execution of the London panel.[5] Now the Arezzo Font has the usual hexagonal shape, but only three sides are decorated with narrative scenes, the others have coats of arms (Milanesi, *loc.cit.*, n. 5); the two reliefs flanking the Baptism of Christ are the work of an extremely retardataire and provincial carver who is far closer to International Style Gothic than to the Early Renaissance (reproduced in Schottmüller, *loc.cit.*): they might have been done as late as c. 1440 but hardly later than that. And since there is no indication of any significant interval in time between the center panel and its companions (presumably all three reliefs were ordered simultaneously, though from two different masters), we can be reasonably sure that the Baptism of Christ, too, must have been done before the middle of the century. The London relief, which it in part reflects, may thus be placed about 1440 at the latest. (For a discussion of the "Simone" problem, see below, pp. 232ff.)

But this circuitous method of refuting Planiscig's contention can be of interest only to the most hardened skeptic. For the rest of us, the Ascension presents no chronological difficulties. Quite aside from all comparisons of detail, the panel demands to be placed at the end of the 1420's on the basis of its spatial treatment, which is entirely different from Masaccio's.

[4] For the complete program, including the lost sections, see Paatz, *Kirchen*, III, pp. 201ff, 225.

[5] The carving of the tree on the right does seem a bit dry and overexplicit compared to the rest of the relief. It may have been this contrast that led Lord Balcarres (*D.*, pp. 95f) to think that some parts of the panel had been left unfinished.

Whereas in the Tribute Money the horizon is placed at the eye level of the figures, producing an isocephalic line of heads, Donatello employs a *di sotto in su* perspective, with the horizon slightly below the bottom edge of the relief. (For an analysis of this feature, cf. Schottmüller, *loc.cit.*, and John White, "Developments in Renaissance Perspective, II," *Journal of the Warburg and Courtauld Institutes*, XIV, 1951, pp. 48f.) The antecedents for this step are to be found in the two *schiacciati* that approach the Ascension in many other ways as well—the Naples Assumption and the Shaw Madonna. Here the view from below is implicit, rather than precisely measurable, since both scenes take place among the clouds, although the effect is unmistakable;

Donatello suggests it by a variety of devices, such as showing us the "underside" of the floating angels and eliminating any head room above the main figure. In the Ascension he still does the same (the upper edge actually cuts right through the head of the tiny angel to the right of Christ) but the landscape setting now permits him to define the beholder's eye level quite explicitly. By forcing us to glance upward like the apostles and the Virgin, he makes us share their inner experiences as well, and thus achieves an emotional impact and a dramatic unity that presage the narrative power of the St. John *tondi* in the Old Sacristy, the Miracles of St. Anthony in Padua, and ultimately the bronze pulpits of S. Lorenzo.

TABERNACLE OF THE SACRAMENT
SAGRESTIA DEI BENEFICIATI, ST. PETER'S, ROME

PLATES 41a, 42 Marble; H. 225 cm; W. 120 cm *(1432-1433)*

DOCUMENTS: none

SOURCES

1550 Vasari-Ricci, p. 55 (Milanesi, p. 414): "Then [Donatello] left Florence and went to Rome . . . and . . . at that time he made a stone tabernacle for the Sacrament, which today is in St. Peter's."

Vasari-Ricci, IV, p. 384, *s.v.* "Pierino del Vaga" (Milanesi, V, pp. 625f): "Because of the enthusiasm for the new construction work, the Sacrament at St. Peter's was not being properly honored. Accordingly, the deputies of the Company [of the Sacrament] decreed that a chapel should be erected for it in the middle of the old church. This chapel was built by Antonio da Sangallo, partly from left-over ancient marble columns, with additional decorations of marble, bronze, and stucco; in the center he placed a tabernacle by Donatello, as a further adornment. [Pierino] made a very beautiful canopy above it, with many small Old Testament scenes alluding to the Sacrament."

The tradition reported by Vasari must have lapsed in the seventeenth century, since no tabernacle by Donatello is mentioned in descriptions of the new St. Peter's until 1886, when Schmarsow (*D.*, p. 32) identified it in its present setting and reintroduced it into the literature.[1] The original location of the tabernacle can only be surmised. There is no reason to doubt that it was made for St. Peter's. In stating that "it is in St. Peter's today," Vasari does not necessarily imply that it came from some other church (as assumed by Schmarsow, *loc.cit.*); he is merely referring to the recently completed new installation by Antonio da Sangallo. Domenico Gnoli ("Le opere di Donatello in Roma," *Archivio storico dell'arte*, I, 1888, p. 25) has suggested that the tabernacle was made for S. Maria della Febbre, i.e. the Roman mausoleum adjoining

Old St. Peter's on the south which in the sixth century became the church of St. Andrews and seven hundred years later came to be known as S. Maria della Febbre, from the name of the icon that now occupies the center of our tabernacle. This hypothesis, however, carries little conviction, since the original purpose of the tabernacle was obviously to contain the Eucharist. The circumstance that at some later date it came to serve as the frame of the Madonna della Febbre hardly permits us to conclude that the two works must have shared the same location in earlier times. The grating or *sportello* that originally occupied the center of the tabernacle has never been traced. It certainly was not the marble relief of a Madonna with Angels from the Lanz Collection, Amsterdam, which has been suggested for this purpose.[2] The measurements fit fairly

[1] Kauffmann (*D.*, pp. 229f, n. 320) erroneously states that this had already been done in the Lemonnier edition of Vasari's *Vite*, III, Florence, 1848, p. 259; the note in question simply

repeats the comment of Bottari in the Rome edition of the *Vite*, I, 1759, p. 33, appendix, for which see below.

[2] See A. Pit, *Münchner Jahrbuch d. bild. Kunst.*, VII, 1912, p.

well—75 x 43.2 cm for the Lanz relief, 83 x 49 cm for the opening—but the subject is iconographically unsuitable for a *sportello* protecting the Sacrament, and marble is far too heavy and brittle a material to be used for doors of this kind; all the authentic examples of Renaissance *sportelli* known to us are either of bronze or of wood. Moreover, the Lanz relief is a truncated, enlarged copy after a bronze plaque in the Louvre whose proportions do not fit the tabernacle. (The bronze panel is a work of the later Quattrocento attributed to Bertoldo.) Much the same arguments apply to the oval *schiacciato* relief of a Madonna and Angels in the W. L. Hildburgh Collection, London, which has been published by its owner with the suggestion that it once formed the central part of the *sportello* of our tabernacle.[3]

We may assume, then, that the original place of our tabernacle was not far from the main altar, in the western part of Old St. Peter's, according to the general custom at that time.[4] Thus the tabernacle would have become detached when this entire section of the basilica was demolished right after 1506 (or perhaps even earlier, when the Rossellino Choir was built); the fact that it did not perish from neglect, as did so many of the art treasures from Old St. Peter's, suggests that it was regarded as an object of importance, aesthetically as well as liturgically, and was stored away for re-installation in the new structure.[5] Vasari's remark about the Sacrament being paid insufficient honor at this time, undoubtedly reflects the point of view of the religious *compagnia* that insisted on building a special chapel for the Sacrament in the nave as soon as the surviving portion of the old church (i.e. the eastern half) had been walled off from the new construction and "re-activated" for religious services under Paul III in 1538.[6] We are tempted to think, therefore, that our tabernacle may have been associated with certain Eucharistic observances before 1506, and that the new chapel was conceived as an appropriate setting for this hallowed object, which could hardly have been a mere "further adornment" as claimed by Vasari. The appearance of the Sangallo Chapel, located in the space between the fifth and sixth columns on the south side of the nave (according to the Alpharano plan of 1590, where it bears the number 44), is known from several pictorial representations (see Kauffmann,

loc.cit.), including one detailed drawing on fol. 26 of the Album in the Archivio capitolare of St. Peter's (Cerrati, *op.cit.*, fig. 4). This drawing does not show the Donatello tabernacle, but its accuracy in detail is highly doubtful, since it was made after the demolition of the chapel: the inscription informs us that the paintings by Pierino del Vaga had been given to Cardinal Farnese and Cardinal Borghese. The chapel must have been destroyed late in 1605 or soon after (Cerrati, *loc.cit.*), when the "rump church" of Old St. Peter's was finally torn down. At this point, our tabernacle became "lost," for even such experts on the history and topography of St. Peter's as Giovanni Ciampini (*De sacris aedificiis . . .*, Rome, 1693, chap. 4, no. 44) and Filippo Bonanni (*Templi vaticani historia*, Rome, 1696, p. 41) are silent on its whereabouts. Bottari, *loc.cit.*, writing half a century later, assumed that it had been transferred to the Cappella del Sagramento, where it was eventually replaced by the bronze tabernacle of Bernini (c. 1675). This opinion is still cited by Kauffmann, *loc.cit.*, even though it rests on pure conjecture. It is, in fact, directly contradicted by Bonanni, who states that the Bernini tabernacle took the place of an older one designed by Baldassare Peruzzi in 1524 (*op.cit.*, p. 110; the same statement, without reference to Bonanni, in Gnoli, *loc.cit.*). Now Bonanni may possibly have mistaken the Donatello tabernacle for the Peruzzi work (assuming that there actually was a tabernacle in the Cappella del Sagramento before Bernini's); he knew from Vasari, whom he cites in both instances, that there had been two tabernacles of the Sacrament in the eastern part of Old St. Peter's prior to its demolition: that of Donatello, in the Sangallo Chapel, and that of Peruzzi, in the Chapel of Sixtus IV on the southern flank of the church (see Vasari-Milanesi, IV, p. 601). Both had become "disposable," and Bonanni might have mistakenly assumed that the tabernacle in the Cappella del Sagramento was that of Peruzzi because the tomb of Sixtus IV (whose original location he knew to be the chapel of Sixtus IV) had also been transferred there. On the other hand, Bonanni may well be correct; if the authorities, upon completion of the Cappella del Sagramento in the 1620's, were faced with a choice between the Donatello and the Peruzzi tabernacles, they would certainly have preferred the latter,

55 and Ludwig Goldscheider, *Donatello*, London, 1941, pp. 23f, who reproduces a composite photograph showing the Lanz panel superimposed on the opening of the tabernacle.

[3] *Art Bulletin*, XXX, 1948, pp. 11ff; the size of the oval is 41 x 33 cm; cf. my note, *ibid.*, pp. 143ff, and Dr. Hildburgh's reply, *ibid.*, pp. 244ff.

[4] For the location of such tabernacles in the fifteenth century, cf. Joseph Braun, *Der Christliche Altar*, Munich, 1924, II, pp. 588ff, and Vincenzo Casagrande, *L'arte a servizio della chiesa, I: La casa di Dio*, Turin, 1931, p. 102.

[5] Apparently Bramante did not install any of these "displaced monuments" in the templelike housing he erected to protect the main altar and *confessio* of the old church until the completion of the new, since he thought of it as purely temporary.

[6] The chapel was begun in 1542 and consecrated in 1548; cf. the documents in Carl Frey, *Jahrbuch Kgl. Preuss. Kunstslgn.*, XXXIV, 1913, Beiheft, pp. 65, 125, no. 503, and Michele Cerrati, *Tiberii Alpharani de basilicae vaticanae . . . structura*, Rome, 1914, p. 64, n. 1.

which was so much closer to their own taste than a work of the early Quattrocento could hope to be. On the face of it, then, it seems advisable to rely on Bonanni, as against Bottari, in this matter, and to search for an alternative explanation of what happened to the Donatello tabernacle after 1605.

Here, in the absence of any other clues, we must turn to the history of the Madonna della Febbre, which is somewhat more fully known than that of the tabernacle. Sometime after 1506 (probably still under Julius II; cf. Cerrati, *op.cit.*, pp. 119f, n. 9) the ancient rotunda of S. Maria della Febbre was converted into the sacristy of St. Peter's, and the Madonna image was assigned a new place in the "old sacristy" at the southeast corner of the church (cf. Onofrio Panvinio, *De praecipuis urbis Romae basilicis . . .*, Rome, 1570, p. 47). This altar was disestablished in 1608, according to Grimaldi (cited in Cerrati, *loc.cit.*), and for a number of years the image seems to have had no fixed location. After the completion of the subterranean *grotte nuove* of Maderno, the Madonna della Febbre was given a third home to the right of the *confessio* beneath the main altar (Bonanni, *op.cit.*, p. 154, no. 91, indicating the exact location of the altar in the ground plan of the *grotte*, pl. 47). Francesco Torrigio (*Le sacre grotte Vaticane*, Rome, 1635) does not mention the Madonna della Febbre, but there is reason to believe that the new altar was established about that time, for in 1631 the Madonna was endowed with a crown by the Chapter of St. Peter's (see [Raffaele Sidone and Antonio Martinetti] *Della Sacrosancta Basilica di S. Pietro . . .*, Rome, 1750, II, p. 219). In 1697, the Child, too, received a crown, in order to mark the return of the image to the rotunda of S. Maria della Febbre, where it stayed until 1776, when the former mausoleum was torn down to be replaced by the present "new sacristy" of Carlo Marchionni, completed in 1784. However, in 1697-1776 the image did not occupy its original niche in the rotunda but a different one, where the Benefiziati were buried (Sidone and Martinetti, *loc.cit.*); this explains how the Madonna della Febbre came to occupy its present place in the Sagrestia dei Beneficiati of the Marchionni sacristy. It is mentioned there soon after the completion of the new structure, although without reference to its frame (Mariano Vasi, *Itinerario istruttivo di Roma . . .*, 1794 edition, II, p. 695). The earliest author to mention our tabernacle in this connection appears to be V. Briccolani (*Descrizione della Sacrosanta Basilica Vaticana*, 3rd ed., Rome, 1816, p. 137) who states that the Madonna had an "ornato antico di pietra istoriato, e munita di cristallo" (quoted in Hildburgh, *op.cit.*, p. 16).[7]

The peregrinations of the Madonna della Febbre during the sixteenth, seventeenth, and eighteenth centuries have no direct bearing on the history of our tabernacle. Still, they suggest several conjectures. If, as we may assume, both the image and the tabernacle entered the Sagrestia dei Beneficiati together soon after 1784, it seems likely that the two had been combined before; without some previous connection between them, such an installation would be difficult to explain. The Madonna, after all, was assigned its present place for precise antiquarian and religious reasons—it had been in the niche of the Benefiziati in the old rotunda. Must we not postulate an equally good reason for the presence of the tabernacle, under these circumstances? There is some indication, then, that towards the end of the eighteenth century our tabernacle was regarded as the traditional frame for the Madonna della Febbre. Since when had it filled this function? The history of the Madonna suggests two dates as the most probable: about 1631 and about 1696, i.e., either the installation of the image in the *grotte nuove* or its return to S. Maria della Febbre, both occasions marked by the bestowing of crowns. Of the two, the earlier one seems to be favored by a number of circumstances. The Sangallo Chapel, it will be recalled, where our tabernacle had been since the 1540's, was demolished some three years before the same fate befell the altar of the Madonna in the "old" sacristy as described by Panvinio and Alpharano. As an object of considerable importance but without any immediate purpose, the tabernacle must have been stored away for future use, and the logical repository for it were the *grotte*, the destination of so many sculptural and pictorial *disjecta membra* from Old St. Peter's. Had the tabernacle remained in the *grotte* until the building of the Marchionni Sacristy, it would surely have been mentioned and reproduced in the detailed and richly illustrated monograph of Filippo Dionisi, *Sacrarum vaticani basilicae cryptarum monumenta*, Rome, 1773. Since it is not, we are tempted to think that our tabernacle became the frame of the Madonna della Febbre when an altar was built for the image in the *grotte nuove*, and that it left the *grotte* together with the image 65 years later. This hypothesis, precarious though it is, appears to be the only one that fits all the peculiar aspects of our case—the failure of all the Baroque topographers of St. Peter's to identify our tabernacle, as well as its eventual placement in the Sagrestia dei Beneficiati.

So far as access to the tabernacle is concerned, the

[7] The *cristallo* has since disappeared; it must have occupied the circular cavity in the lower frieze, which is now filled with a mosaic plaque. This minor repair may have provided the opportunity for a general restoration of the tabernacle, since several of its corners have been patched with new pieces of marble.

new location proved hardly more advantageous than the previous ones, since the Sagrestia dei Beneficiati was not regularly open to visitors, so that the true identity of the piece remained hidden for another hundred years. Since its rediscovery, the tabernacle has received a good deal of attention, yet some scholars seem to have based their discussion on photographs rather than on acquaintance with the original, as evidenced by a persistent tendency to describe its material as travertine. Semper (*D*. '87, p. 62), who was the first to do so, was corrected by Gnoli, *loc.cit.*, but this did not keep others from making the same mistake (including, most recently, Planiscig, *D.*, p. 141). Wilhelm v. Bode even went so far as to call the tabernacle "only an inexpensive piece of decoration" because of the cheap material ("Donatello als Architekt...," *Jahrbuch Kgl. Preuss. Kunstslgn.*, XXII, 1901, p. 30). Semper must have thought of it in similar terms, and for the same reason, since he regarded it as part of the *décor* for the coronation of Emperor Sigismund (which Donatello had helped to prepare, according to Vasari; see below, p. 232). This curious notion, too, has been perpetuated by more recent authors.

The date and authorship of the St. Peter's tabernacle have, until very recently, been regarded as established beyond dispute through the testimony of Vasari, although Tschudi (*D.*, p. 17) and Bode (*loc.cit.*) found the execution of some parts "hasty" and not entirely by the master's own hand. Planiscig (*D.*, pp. 53f) goes much further than that; he not only stresses the weakness of both the architectural framework and the sculptural parts but insists that the Entombment relief "imitates a much later phase of Donatello's art" (presumably the large Entombment panel on the back of the Padua Altar; see Pl. 88) so that the tabernacle must be dated in the second half of the century, rather than in the early 1430's. In consequence, he attributes it to a late Donatello follower, possibly Isaia da Pisa. It is true, of course, that Vasari's authority, here as elsewhere, is far from absolute. He could only report the local tradition concerning our tabernacle, and in the course of a hundred years the general tendency to attach major names to minor monuments might have made a Donatello original out of the work of an imitator. It is also conceivable—though highly unlikely if our reconstruction of its history is correct—that this is not the tabernacle Vasari wrote about. If, on the other hand, we conclude on stylistic grounds alone that our tabernacle must have been done in the early 1430's and that its design is not merely Donatellesque but the master's own, then the words of Vasari assume considerable weight. Thus Planiscig's arguments deserve to be examined in detail; at the very least they provide a useful test of hitherto unchallenged assumptions.

That the decorative framework has certain weaknesses can be readily admitted; the ornament is dry and lifeless, and the angels, too, lack the vitality of comparable figures in Donatello's *œuvre*, such as the angels on top of the Siena Font or the S. Croce Annunciation. But these are weaknesses of execution, not of conception, it seems to me. The basic design of the tabernacle is so original, so uniquely characteristic of Donatello in its "picturesque" compounding of architectural and sculptural elements (see above, p. 54) that it could have sprung only from the master's own mind, rather than from that of the assistant who appears to have done most of the actual carving (probably from a wax model or a large drawing). Its relationship to both the Prato Pulpit and the S. Croce Annunciation has been rightly noted by most previous authors (see below). As for the Entombment, the nearest kin has long been acknowledged to be the London Delivery of the Keys (Pls. 39-40), which Planiscig rejects for this very reason. Since the London panel is neither dated nor documented, we must leave it aside for the time being, but the Naples Assumption (Pls. 37-38), although not quite so close, provides analogies enough to assure us that there cannot be more than a few years' difference in date between it and the St. Peter's Entombment. In linking our relief with the late style of Donatello, Planiscig must have thought of the frantic gestures and expressions of the two women with streaming hair on the left, and of their counterparts in the Padua Entombment. Apparently he regarded this maenadlike frenzy of grief as an invention of the master's Paduan years. Or did he believe that the Roman relief was derived specifically from the one in Padua? Surely the resemblance between the two, compositionally as well as in detail, is not sufficient to bear out such an assumption. In the Roman panel, the "frantic women" are a secondary element, deliberately contrasted with their mute, solemn, Masacciesque companions who dominate the scene, while in Padua it is they who set the mood, so that their outbursts of unchecked emotion reverberate throughout the rest of the design. The *stile concitato* of the Paduan relief almost certainly implies the influence of ancient scenes of death and burial such as those on the Meleager sarcophagi (see below, p. 187). The same has been claimed for the Rome Entombment (Schmarsow, *loc.cit.*; Josef Strzygowski, *Zeitschrift f. bild. Kunst.*, XXII, 1887, pp. 155f; Semper, *D.* '87, p. 62; Schottmüller, *D.*, p. 22; Fritz Burger, "Donatello und die Antike," *Repertorium f. Kw.*, XXX, 1907, pp. 101ff) but here the only tangible instance of direct classical influence is the woman on the extreme left; the scene as a whole, including the "frantic women," is based on a tradition that can be traced back to Giotto and ultimately to Byzantine art (cf. Tschudi, *loc.cit.*, and

Kauffmann, *D.*, pp. 66f). The wailing women in Simone Martini's small Entombment in the Berlin Museum (No. 1070A) display their grief as drastically as Donatello's, and the moving figure of St. John, who turns away from the dead Savior with his face buried in his hands, occurs on the extreme right in both compositions. This conscious harking back to the early Trecento can be felt in several of Donatello's reliefs of the 1420's, such as the Pazzi Madonna and the Siena Feast of Herod (see above, pp. 44, 71f). In the latter work, the gestures and expressions of the King Herod and several of the bystanders are hardly less violent than those of the Rome Entombment (cf. Semper, *loc.cit.*), while the Masacciesque aspects of our relief immediately recall the London Delivery of the Keys. Purely on the basis of style, then, the St. Peter's tabernacle cannot be dated later than the beginning of the 1430's, since the Entombment scene is still so closely linked to Donatello's work of the previous decade. The very fact that this is a *schiacciato* relief argues against Planiscig: Donatello himself produced no panels of this type after his departure for Padua, so far as we know, and among the younger men who followed in his wake the exacting technique of *schiacciato* does not seem to have been at all popular, with the one conspicuous exception of Desiderio da Settignano. It is difficult to imagine, therefore, how a lesser artist of c. 1460 could have done a *schiacciato* such as the Rome Entombment in imitation of Donatello's style of c. 1430 without betraying some Desiderio influence (of which our relief shows no trace). And how could an imitator have conceived the extraordinarily bold idea of integrating the relief with the framework of the tabernacle by means of the curtain attached to the cornice? This device has the same characteristic double function, partaking as it does of both the pictorial and architectural sphere, that we find in the frames of the master's earlier reliefs under similar circumstances (the God the Father of the St. George tabernacle, the spandrels of the St. Louis niche; cf. above, pp. 32, 53). But the curtain here has two further purposes: it emphasizes the slight *di sotto in su* perspective of the scene (note the left foot of the old man on the left, which shows that the horizon is meant to be just below the bottom edge of the panel), and it has a symbolic value as well— it reveals what would ordinarily remain veiled as too sacred, too precious for everyday viewing. As Kauffmann, *loc.cit.*, has pointed out, the arrangement is derived from tomb sculpture, where angels pulling back a curtain to reveal the effigy of the deceased had

been a familiar feature since the early Trecento. Since the same device occurs in the Brancacci Tomb, it must have been thoroughly familiar to Donatello, so that we are not surprised at its re-use in a new context a few years later.

The design of the St. Peter's tabernacle has evoked a number of contradictory estimates. Reymond, representing one extreme, acclaimed it as pure Early Renaissance in style, with every Gothic residue left behind (*Sc. Fl.*, II, pp. 101f; a similar view in Colasanti, *D.*, pp. 48f). Kauffmann, on the other hand, declared it a Gothic structure overlaid with Renaissance detail, as against the classical aedicula of the S. Croce tabernacle; in St. Peter's, the angels atop the pilasters still resemble Gothic pinnacle figures like the two youthful prophets of the Porta della Mandorla, while those on the pediment above the S. Croce Annunciation have become true *acroteria* (*D.*, pp. 82, 98f). To Middeldorf, who agrees with this analysis (*AB*, p. 573), the contrast between the two tabernacles demonstrates the impact of the Roman sojourn, which enabled Donatello, after his return, to slough off "every old-fashioned tendency." Reymond and Colasanti, on the contrary, had seen the effect of the master's Roman experiences in the St. Peter's tabernacle itself. Both these views are based on the premise that the trip to Rome was a decisive event in Donatello's career—the beginning of a new phase of his development rather than merely a convenient fixed point for the historian concerned with the chronology of the master's œuvre. Behind this assumption there is the long-standing dispute over the question whether the sojourn of 1432-1433 was the first or the second visit of Donatello to the Eternal City. According to the "Manetti" *Vita* of Brunelleschi (ed. Elena Toesca, Florence, 1927, p. 20; repeated by Vasari-Milanesi, II, p. 337), Brunelleschi and Donatello had spent some time in Rome together about 1403-1404. Since the late nineteenth century, most Donatello scholars have either questioned this trip or denied it altogether, on the ground that the master's early work gives no evidence of direct contact with Rome, while the architectural historians (Fabriczy, Geymüller) were inclined to accept it. Venturi (*Storia*, VI, pp. 237f) concluded that the journey must have taken place about 1400, because of the classical influences in Brunelleschi's competition relief for the North Doors of the Baptistery.[8] The case for the early visit was reopened by Géza de Francovich, who claimed that Donatello's Abraham and Isaac group, finished in 1421, shows the influence of the Pasquino (*Bolletino d'arte*, IX, 1929, pp. 146ff; see above, p. 37); and

[8] He points especially to Brunelleschi's use of the *spinario* pose, but this, the most tangible instance of a classical motif in the panel, still represents the mediaeval *spinario* tradition, rather than a direct echo of the famous Roman bronze; see William

S. Heckscher, "Dornauszieher," in *Reallexikon z. Dtsch. Kunstgeschichte*, IV, Stuttgart, 1955, cols. 289ff, and the literature cited there.

this in turn produced new counterarguments by L. H. Heydenreich (*Jahrbuch Preuss. Kunstslgn.*, LII, 1931, pp. 8ff), Colasanti (*D.*, pp. 99f), and Kauffmann (*D.*, p. 201, n. 54).[9] It was perhaps inevitable that, in contrast with this elusive first sojourn, the well-established presence of Donatello in Rome during 1432-1433 should have been credited with major consequences upon the artist's style. The problem might have seemed less important had it not been for Vasari's assurance (Milanesi, p. 414) that Donatello went to Rome "seeking to imitate as much as possible the works of the ancients." With these words as a point of departure, any attempt to assess the significance of the two visits was bound to turn into a discussion of classical influences on Donatello, a far broader problem and a particularly vexatious one. A great many individual instances of such influence have been claimed, but the result remains strangely inconclusive, even though the master's interest in ancient art is well attested by contemporary sources. It is often difficult to distinguish the mediaeval transmission of a classical motif from its direct "revival," and even in those cases where dependence on a classical model without intermediaries seems certain, we can hardly ever be sure which particular ancient statue or relief served as the source. And since classical sculpture was easily accessible to Donatello in Florence, Pisa, and elsewhere in Tuscany, the task of defining the impact of Rome upon him in terms of classical influence holds little promise of success. Colasanti, in fact, admits as much (*loc.cit.*) and warns that the search for classical sources in Donatello's art will do more harm than good unless conducted with great discernment and caution (he himself does not quite live up to this injunction); Ottavio Morisani, in a recent essay, goes even further in decrying the "tempting game of influence hunting": to him Donatello's relation to ancient art appears as "pure spiritual consonance," not as the imitation of particular traits ("I due miti della critica Donatelliana," in *Studi su Donatello*, Venice, 1952, p. 61; cf. the critical remarks of A. Marabottini in *Commentari*, v, 1954, pp. 256ff). That, surely, is begging the question—spiritual affinity does not exclude specific borrowings. What we need in order to understand Donatello's highly selective and individual ways of drawing inspiration from classical sources, is a more precise investigation of every single case, not only from the point of view of formal relationships but from that of the symbolic and expressive meaning attached to an-

cient motifs in the Middle Ages and the Renaissance.[10] Such an approach might even turn up an instance or two of specifically Roman monuments that Donatello must have seen, but whether this would help to clarify the question of the two Roman journeys seems highly doubtful. Why indeed must we give such importance to this trip (or trips)? In doing so, are we not superimposing the conditions of a later time upon the early Quattrocento? When Vasari wrote of Donatello's visits to Rome, he thought of the city as it was then—the world capital of art, famous not only for its ruins of Imperial Roman architecture but for its magnificent collections of ancient sculpture and the great monuments of Raphael and Michelangelo. These three attractions had made Rome a pilgrimage goal for every artist of ambition, and their impact upon the visitor could be overwhelming, especially if he came from a distant region. But does the same hold true for the Rome of 1403 or 1433, still under the shadow of exile and schism? Did Brunelleschi and Donatello really think of the city as "la fonte perenne dell'arte" (Venturi, *loc.cit.*)? For the architect, to be sure, there were the ruins; sculpturally, however, Rome at that time could offer little beyond those comparatively few monuments that had been on display throughout the Middle Ages, surrounded (and obscured) by the lore of the *mirabilia urbis Romae* (cf. Krautheimer, *loc.cit.*). Donatello surely saw them, but was that the purpose of his trips? How much of a revelation were these monuments, which must have been familiar to him beforehand, in one way or another, as part of his cultural and artistic heritage? Whatever the answer to this question, it seems clear that a Roman sojourn could not have meant for Donatello what it did for so many later artists. Perhaps it was a rather casual experience to him. In any event, we have no right to assume *a priori* that its effect must be traceable, directly and immediately, in the master's work. Why, moreover, should his Roman experiences have been concentrated in one or perhaps two trips? Is it not likely that he went several times, without his absence being recorded and for reasons not necessarily connected with his interest in antiquity? We all tend, it seems to me, to underestimate the amount of traveling people did in times past. And surely the 200-mile trip from Florence to Rome was not a major adventure in Donatello's day.[11] We have, in fact, at least one concrete bit of evidence implying our artist's presence

[9] With particular emphasis on the problem of chronology: Donatello was working under Ghiberti late in 1403, and for the Cathedral workshop three years later, while Brunelleschi spent several months of 1404 in Florence; this would still leave the possibility of a Roman trip for both artists about 1405. But see above, Vol. I, p. xiv, no. 5.

[10] Such as the exemplary discussion of "Ghiberti and An-

tiquity" in Richard Krautheimer and Trude Krautheimer-Hess, *Lorenzo Ghiberti*, Princeton, 1956, pp. 277ff, 337ff.

[11] The same has been pointed out concerning the Roman sojourns of Brunelleschi by Piero Sanpaolesi, *La sacristia vecchia di San Lorenzo*, Pisa, 1950, pp. 7f; cf. also Krautheimer, *op.cit.*, p. 320.

in Rome in 1430 or shortly before. In a letter written from Rome on September 23 of that year, Poggio Bracciolini mentions some ancient heads of gods which he expects to receive from Chios, and continues: "I have something here, too, that I shall bring back home [to Florence]. Donatello has seen it and given it the highest praise." Donatello might, of course, have inspected the piece in question several years before Poggio acquired it, but the tone of the letter suggests that the *expertise* was a recent one, in which case Donatello must have gone to Rome soon after his participation in the siege of Lucca in the spring of 1430 (Semper, D. '75, p. 281), perhaps in order to escape further unpleasantness.[12]

All this may help to explain the widely varying views of the St. Peter's tabernacle we have noted earlier. Its design, I suspect, does not yield a clear-cut illustration of Donatello's Roman "lessons," either posi-

tively or negatively. If it is less advanced than Reymond has claimed, it also is not nearly so Gothic as it seems to Kauffmann and Middeldorf. Does the contrast between it and the S. Croce tabernacle really demonstrate an overcoming of "old-fashioned tendencies"? Or are the two works too different in character to permit a straightforward comparison? It certainly seems so to me. After all, in designing a wall receptacle for the Sacrament our artist had to take the well-established Gothic type of tabernacle as his point of departure (for examples see Casagrande, *op.cit.*), while in the case of the S. Croce Annunciation he was not hampered by such precedents. Thus we can hardly be surprised to find that the St. Peter's tabernacle retains certain Gothic qualities. What *is* surprising—since this, so far as we know, is the earliest Renaissance tabernacle of its kind—is that the Gothic traits are not more conspicuous.

[12] The Poggio letter is cited by Semper (*D.* '75, p. 258, n. 109) but without giving the source and omitting the place and date. I am greatly indebted to Dr. Richard Krautheimer for supplying me with the full text from *Poggii Epistolae*, ed. Tommaso Tonnelli, I, Florence, 1832, lib. IV, ep. xii, pp. 322ff.

TOMB SLAB OF GIOVANNI CRIVELLI
S. MARIA IN ARACOELI, ROME

PLATE 41b Marble relief; L. 235 cm; W. 88 cm *1432-1433*
Inscription: on the rim, upper left, OPVS DONATELLI FLORENTINI

DOCUMENTS: none

SOURCES: none

The present location of the tomb, against the wall to the right of the monument of Cardinal Lebrett near the main portal, dates from 1881 (Domenico Gnoli, "Le opere di Donatello in Roma," *Archivio storico dell'arte*, I, 1888, p. 26). Before then, the slab had been set in the floor of the church at the entrance to the Chapel of the Ascension (cf. Vincenzo Forcello, *Iscrizioni delle chiese . . . di Roma*, Rome, 1869, I, p. 132, no. 490) but it could hardly have been made for that particular spot. The rather thin panel was broken in two a great many years ago above the hands (the edges of the break are worn and rounded), and the rim shows several deep indentations. Apparently the two pieces were reunited when the tomb formed part of the pavement in front of the Chapel of the Ascension, otherwise one or the other of the nineteenth century scholars who saw it there would have mentioned its fragmentary condition (e.g. Gnoli, *loc.cit.*, Vasari-Milanesi, II, p. 419, n. 4, or Semper, *D.* '87, pp. 61f). Obviously, however, there must have been a time when the slab was used as flooring material pure and simple. The original site of the tomb is unknown. It may even have been in a different church; the

earliest written reference to the slab, in the Padre Francesco Casimiro's *Memorie istoriche della Chiesa . . . di Santa Maria in Aracoeli* (p. 203), dates from 1736. (The same author also provides the first mention of Donatello's signature. He claims to have seen a drawing for the tomb in the Biblioteca Albani.) Gnoli, *loc.cit.*, has suggested that originally our slab may have been installed in such a way that it was raised above the floor surface, rather than level with it. While this was theoretically a privilege reserved for papal sepulchers such as those of Martin V and Sixtus IV, the rule could not have been observed very strictly in practice, for in 1566 Pius V ordered the removal of all nonpapal tombs protruding above the floors of churches (Bull "Cum primum," par. 6; *Bullarium*, 1566, IV, ii, p. 285; see Balcarres, *D.*, p. 83). There were also a good many shifts and removals of tombs in Cinquecento and Seicento Rome for other reasons, and the Crivelli slab might have fallen victim to any one of these. If it was on public view in its original location during these centuries, the complete lack of any reference to it among the voluminous guidebook literature to Roman churches would be

difficult to understand, inasmuch as these guidebooks do mention a number of spurious works by our master.[1] Under the circumstances, there may be some significance to the fact that Domenico Maria Manni, in the notes to his edition of Baldinucci's *Notizie* (III, Florence, 1768, "Donatello," p. 80) places our slab in S. Maria sopra Minerva. This has hitherto been regarded as an ordinary mistake, but on the other hand S. Maria sopra Minerva did undergo a wholesale removal of tombs at one point. Could the monks at S. Maria in Aracoeli have told Manni that the Crivelli Tomb had come from S. Maria sopra Minerva? If one further conjecture be permitted, we are even tempted to suggest that our slab lay neglected in S. Maria in Aracoeli until the Padre Casimiro discovered the Donatello signature; that as a consequence the tomb suddenly aroused a measure of interest; and that because of this newly gained importance the two separate pieces were reassembled and placed in the location that was to be theirs until 1881.

The inscription on the rim, now partly obliterated, is oriented in such a way as to make it clear that the slab was intended for horizontal rather than vertical installation. It has been transcribed, with minor variations, by Casimiro, *loc.cit.*, Alfred v. Reumont (*Geschichte der Stadt Rom*, Berlin, 1868, III, 1, p. 526), Forcella, *loc.cit.*, Milanesi (*Cat.*, p. 13), Gnoli (*loc.cit.*), Cruttwell (*D.*, p. 70), and Colasanti (*D.*, p. 28). In the rendering that follows, the uncertain portions are indicated by brackets: HIC IACET VENE[RABILIS VIR DNVS IOHES] DE CRIVELLIS DE MEDIOLANO ARCHIDIACONVS AQVILEGEÑ ET C[ENSOR] MEDIOLAÑ AC LITTERAR[UM APOSTOL]ICAR SCPTOR ET ABBREVIATOR. QVI OBIIT A.D. M. CCCCXXXII DIE XXVIII[I] IVLII PONT S DNI EVG[ENII PP] IIII [A II] CVIVS ANIA REQVI[ESC]AT IN PACE AMEN OPVS DONATELLI FLORENTINI. Milanesi, *loc.cit.*, mistakenly describes the material of the slab as bronze, and calls the deceased an archbishop rather than an archdeacon; both errors are occasionally met with in the later literature as well.

The Crivelli Tomb must have been carved within less than a year's time after the death of the Archdeacon on July 28 or 29, 1432; in April, 1433, Pagno di Lapo had been sent to Rome by the *operai* of Prato Cathedral in order to persuade Donatello to return (see below, p. 110), and before the end of the following month our master was indeed back in Florence, since his *Catasto* Declaration of that year is dated May 31 (see Giovanni Gaye, *Carteggio inedito* . . . , I, Florence, 1839, p. 122). The pressure of time may help to account for the unadventurous quality of the design, which echoes the Pecci Tomb but reverts to a more

conventional type: the bier has now become a straightforward architectural niche, yet the position of the effigy is the traditional mixture of standing and lying, like that in Ghiberti's tomb slab of Leonardo Dati (cf. Semrau, *D.*, p. 47, and Kauffmann, *D.*, p. 91). The niche itself, with the two angels in the spandrels above the arch, is a reflection of the St. Louis Tabernacle, as pointed out by Wilhelm v. Bode ("Donatello als Architekt . . . ," *Jahrbuch Kgl. Preuss. Kunstslgn.*, XXII, 1901, p. 29). The interest in perspective illusion, so strong in the Pecci slab, has almost disappeared here, while the depth of the carving is actually somewhat greater. The quality of the execution is hard to estimate because of the severe abrasions suffered by the relief. Only a small oblong section in the lower left-hand corner, which Balcarres (*D.*, p. 83) regarded as "restored at an early date," retains something of the original surface. In this area—unfortunately, not a very important one—the drapery style is strongly reminiscent of the Pecci Tomb, and the carving not unworthy of Donatello's own hand. To judge from this sample, the Crivelli effigy may well have been a more impressive figure than we are apt to imagine on the basis of its present sorry state. The two angels at the top, on the other hand, show nothing of the master's style; they must have been carried out by an assistant, along with the rest of the decorative framework, probably guided by a general sketch that did not define these details too closely.

As one of the *primordia* among Early Renaissance tombs in Rome, the Crivelli slab was of considerable importance for local masters. Gnoli, *loc.cit.*, speaks of numerous other slabs reflecting the design of ours, in S. Maria in Aracoeli, S. Maria del Popolo, the Museo Industriale, etc., but without identifying them further. One of these, the tomb of a canon named Io. Scade, on the second pier to the right in S. Maria del Popolo, imitates the Crivelli slab very closely (cf. Semrau, *loc.cit.*, note 2, who mistakenly calls the deceased a Cardinal, and Bertaux, *D.*, pp. 98f, note). Robert Corwegh (*Zeitschrift f. bild. Kunst*, XIX, 1908, pp. 186ff) proposed to attribute the Scade slab to Donatello, even though its date, now obliterated, is recorded as 1454 by Laurentius Schrader, *Monumentum Italiae . . . libri quattuor*, Helmstedt, 1592, fol. 160, and as 1452 by Forcella (*op.cit.*, on the basis of a reading by Cassiano del Pozzo). The design of the badly worn slab represents a decorative flattening of the Crivelli Tomb, and the workmanship, insofar as it can be judged at present, may be that of the local carver who had done the framework of the Crivelli slab two decades earlier.

loc.cit.; the figure is also reproduced in Schubring, *KdK*, p. 182.

[1] An interesting case of this kind, the wooden statue of St. John the Baptist in the Lateran, is discussed in detail by Gnoli,

ANNUNCIATION TABERNACLE, S. CROCE, FLORENCE

PLATES 43-46 *Macigno* (limestone), with residual gilt and polychromy; the six *putti* of terracotta. *(c. 1428-1433)*

TABERNACLE
H. 420 cm; W. (base) 248 cm; W. (top) 274 cm

NICHE
H. 218 cm; W. 168 cm; D. 33 cm

STANDING *PUTTI*
H. 76 cm (without base)

DOCUMENTS: none

SOURCES

1510 Albertini, p. 16: "[In the church of S. Croce, Donatello] made the stone Annunciation."

(Before 1530) Billi, pp. 22f: "[Andrea del Castagno made] a St. Jerome and a St. Francis in S. Croce in the Cavalcanti Chapel."

p. 27 (Cod. Petrei): "[Fra Filippo Lippi] made a predella for the Annunciation of S. Croce."

pp. 40f: "[Donatello made] the Annunciation in the church of S. Croce and the tabernacle in the Cavalcanti Chapel with its beautiful ornaments."

1537-1542 Cod. Magl., p. 77: "In S. Croce [Donatello] made the tabernacle and the Annunciation in the Cavalcanti Chapel with its beautiful ornaments and various heads and figures."

p. 97: "[Fra Filippo Lippi] painted in the church [of S. Croce] the predella of the Annunciation Altar by Donatello; he did this at Donatello's request."

p. 98: "[In S. Croce Andrea del Castagno did] a St. Jerome and a St. Francis at the corner next to the Cavalcanti Chapel, that is, the Annunciation of Donatello (*nel cantone a canto alla cappella de Cavalcanti . . .*)."

(c. 1550) Gelli, p. 59: "[Donatello made] in the church of S. Croce, in the Cavalcanti Chapel, the niche (*mitria* in Mancini's transcription; apparently a misreading of *nichia*) with the tabernacle and its ornaments of *macigno*."

1550 Vasari-Ricci, pp. 46f (Milanesi, pp. 397f, slightly rephrased): "In his youth [Donatello] made many things, which were not highly valued because they were so many. But the work that established his reputation and made him well-known was an Annunciation of *macigno* stone, placed at the altar and in the Chapel of the Cavalcanti in S. Croce. For it he made an ornament designed in the grotesque style, with an elaborate and curving base and surmounted by a quarter-circle, with six *putti* holding garlands who seem afraid of the height and cling to each other for reassurance. But he showed even greater mastery in the figure of the Virgin, who, frightened at the sudden appearance of the Angel, moves timidly but gently as if she were about to flee, yet at the same time turns towards him who salutes her, with beautiful grace and modesty, so that her face displays the humble gratitude due the bestower of the unexpected gift, especially a gift as great as this. Here Donatello also showed, in the masterfully draped garments of the Madonna and the Angel, his awareness of the nude bodies underneath, thus demonstrating a desire to rediscover the beauty of the ancients, which had remained hidden for so long. He gave evidence in this work of such facility and assurance, that one marvels no less at the ease of execution than at the ingenuity and knowledge that enabled him to carry it out."

Vasari-Ricci, ii, p. 121 (Milanesi, p. 672 slightly rephrased): "[Andrea del Castagno] also did in S. Croce, in the Cavalcanti Chapel, a St. Francis and a St. John the Baptist, most excellent figures."

Vasari-Ricci, II, p. 130 (Milanesi, III, p. 37): "[Pesello] also did, in the Cavalcanti Chapel in S. Croce, beneath the Annunciation of Donatello, a predella with small figures, showing scenes from the life of St. Nicholas."

1584 Borghini, *Riposo*, p. 318 (paraphrase of Vasari's description of the S. Croce Annunciation, considerably shortened).

p. 334 (paraphrase of Vasari's statement concerning the two saints by Andrea del Castagno in the Cavalcanti Chapel).

p. 635: "[In S. Croce Alessandro del Barbiere painted] the fresco decoration, with the canopy and angels, above the Annunciation of Donatello."

1591 Bocchi, pp. 153f (Cinelli, pp. 316-318): "In the Cavalcanti Chapel [of S. Croce] there is the very beautiful Annunciation of *macigno* by Donatello, a stupendous achievement. Words cannot convey the marvelous beauty of the Madonna, the divine, rather than human, quality of her carriage, and her noble devotion and reverence. At the sudden sight of the Angel the Virgin shrinks back with a most graceful gesture; the head is wonderfully done, and the shy expression of her face conveys her thoughts at this memorable instant, as described in the Gospels. This figure is clothed so masterfully that her nobility and majesty can be felt in the costume as much as in every other aspect of her. The Angel next to her, gracefully bending his knee, has all the bearing of a heavenly creature. Even though he does not speak, his face and gesture suggests that he is about to utter the words that will give voice to his thoughts. The Madonna and the Angel are so admirable in design and so exquisitely fashioned that they can hold their own against any other work of art, however great; but their lifelike quality is unrivaled. Very beautiful, too, is the ornament, interspersed with grotesque motifs; on it are six garland-holding *putti* of rare beauty, who gaze downward as they cling to each other for fear of falling. It is incredible how strikingly they display the beauty of this supreme artist's workmanship. While the entire work has long been admired by every knowledgeable person, the experts continue to give it the most extravagant praise." (Cinelli adds: "The fresco decoration of the canopy and angels above the Annunciation is by Alessandro del Barbiere.") "The two figures in fresco, a St. John the Baptist and a St. Francis, are by Andrea del Castagno. One can see that they are beautiful in color. Because they were so highly valued, the section of the wall on which they are painted was preserved when, in 1566, all the walls were removed that obstructed the magnificent nave of the church. It was then installed in its present place with much care and expense."

The present location of the Annunciation tabernacle, against the south wall of the church in the sixth bay, is that described by Borghini and Bocchi (the fresco decoration of Alessandro del Barbiere was removed in the early nineteenth century; cf. F. Moisè, *Santa Croce di Firenze*, Florence, 1845, p. 142). Whether it is identical with the Cavalcanti Chapel referred to by Vasari and his predecessors, cannot be established with assurance. Paatz (*Kirchen*, I, pp. 594, 641, n. 256) assumes that the original Cavalcanti Chapel, containing both our tabernacle and the fresco of St. John and St. Francis by Domenico Veneziano, was attached to the wall surrounding the monks' choir in the eastern part of the nave, and that upon the razing of this choir in 1566 the two monuments were transferred together to their present site. The tabernacle and the fresco, it is true, are mentioned as belonging to the Cavalcanti Chapel in sources prior to 1566, but the evidence for placing this chapel at the monks' choir is strangely contradictory. Bocchi's assertion, twenty-five years after the event, that the fresco was painted on the wall of the choir, has the positive ring of an eye-witness account and cannot be disregarded.[1] But if Bocchi is right, and the fresco

[1] Paatz, *loc.cit.*, also adduces an account, supposedly of about 1579, from Saturnino Mencherini, *S. Croce di Firenze*, Florence, 1929, pp. 41f, to corroborate Bocchi, but this is no more than a verbatim copy of the Bocchi-Cinelli text; Baldinucci's statement, in his Life of Castagno, about the transfer of the fresco is likewise based on Bocchi, it seems, since it contains no new information. Some inferences as to the original location of the fresco might be drawn from the architectural framework, brought to light by the recent cleaning, which shows a vanishing point considerably below and to the right of the two figures. Cf. the catalogue of the Mostra di quattro maestri del primo rinascimento, Florence, 1954, pp. 87f and pl. xlvi.

was indeed salvaged from the wall of the monks' choir, does that in itself prove the transfer of the tabernacle as well? Why does he connect only the fresco with its previous site? Would not the transplanting of the tabernacle have been equally worthy of mention? And is it not strange that Vasari, who was so directly involved with the internal remodeling of S. Croce, should have failed to take note of the relocation of the Cavalcanti Chapel in the second edition of the *Vite*, issued two years after the demolition of the monks' choir? As further proof of his hypothesis Paatz cites the tomb slab of Cavalcanto di Lapo Cavalcanti (who died in 1371), which is set in the floor of the nave and thus presumably marks the place of the Cavalcanti Chapel before 1566. By the same token, however, it could be argued that the Chapel was always located where it is today; for below the Domenico Veneziano fresco there is another Cavalcanti Tomb (Benedetto, Ridolfo, and Guido), marked by a marble plaque that gives the original date, 1374, and records renovations of the tomb in 1570 and 1815 (the text reproduced in Moisè, *op.cit.*, p. 141). Moreover, Paatz disregards an important source which directly contradicts his claim: an inventory of the chapels of S. Croce that must have been made not long after the destruction of the monks' choir and is preserved in a later copy by Francisco Antonio Benoffi in the Biblioteca Oliveriana at Pesaro (MS 1687; published in Mencherini, *op.cit.*, pp. 26f). It lists the "Chapel of St. Mary Annunciate, given to Giovanni di Lorenzo Cavalcanti in 1524 by Mainardo di Bartolommeo Cavalcanti," and further on enumerates four chapels, those of the Zati, Covoni, Malegonnelle, and Spinelli, which were attached to the monks' choir and thus destroyed in 1566. The inventory is clearly incomplete; its purpose, apparently, was to provide a record of the old and established chapels, since in most instances it gives dates of foundation or transfer going back as far as the thirteenth century. The year 1566 is the latest date mentioned, and no account is taken of the Vasarian chapel scheme (for which see the inventory of 1597, Mencherini, *op.cit.*, pp. 27ff). It seems likely, therefore, that the inventory was compiled before the internal remodeling of the church had advanced very far. In any event, its author still knew the particular chapels that were removed along with the monks' choir, and we may assume that if the Cavalcanti Chapel had been among them he would have noted this. Instead, he places our Chapel next to that of the Serristori, i.e., in its present location, and implies that it had been there at least since 1524. One other factor deserves mention as an argument—perhaps a decisive one—against Paatz's conjecture: the background of the niche of the tabernacle is recessed more than 30 cm into the wall. Allowing an additional 5

to 7 cm for the thickness of the slabs that form the back of the niche, we must assume that the wall had to be excavated to a depth of at least 40 cm before the tabernacle could be installed. It seems highly unlikely to me that the walls of the monks' choir, whose function was essentially that of screens, should have been heavy enough to accommodate so deep a niche. According to Paatz's estimate (*op.cit.*, p. 593) these walls were *mannshoch*, or a little less than 2 m tall; thus our tabernacle, which is more than 4 m high, would have had to be installed as a free-standing monument on top of the choir wall, like certain painted panels that were displayed in this fashion. The physical difficulties arising from its height, depth, and weight, it seems to me, make such a solution most unlikely. But if the tabernacle is still in its original location, how can we reconcile Bocchi's testimony concerning the transfer of the Domenico Veneziano mural with the pre-1566 references to the mural as being in the Cavalcanti Chapel? A possible answer to our problem is suggested by the text of the Anonimo Magliabechiano, which defines the location of the mural as "at the corner next to the Cavalcanti Chapel." Could this not mean the corner of the choir wall next to the sixth bay of the south aisle of the church? The fresco and the tabernacle may have faced each other directly, so that the entire area between them could have been referred to as the Cavalcanti Chapel, especially if, as seems likely (cf. Moisè, *op.cit.*, pp. 108f), there was a grating to separate this chapel from its neighbors. The mural, in other words, could have been transferred to its present place after the razing of the choir wall without ever leaving the immediate confines of the Cavalcanti Chapel. We can afford, therefore, to take both Bocchi and our other sources at their word without concluding that the transplanting of the fresco implies the relocation of the tabernacle. While the matter cannot be definitely settled without a detailed technical investigation, it seems far safer, on the basis of the evidence available at present, to assume that the tabernacle is still in its original place.

In 1884, the tabernacle was cleaned and the original gilding restored (Paatz, *op.cit.*, p. 642). Ten years later, Luigi del Moro rediscovered the two reclining *putti*, which had been removed and badly damaged due to circumstances unknown (but not, as Paatz suggests, in the course of the supposed transfer of the tabernacle in 1566, since Bocchi expressly mentions six *putti*). In 1900 they were restored to their original positions (see *Arte e storia*, XIII, 1894, p. 47, and XIX, 1900, p. 150).

The identity of the patron who commissioned the tabernacle remains obscure. Kauffmann (*D.*, p. 222, n. 246) has suggested Niccolò Cavalcanti, who may

have been the brother-in-law of Lorenzo di Giovanni de'Medici and whose name fits the subject of the predella panel beneath the tabernacle as described by Vasari. This predella, presumably the one now in the Casa Buonarroti, may indeed have been ordered by Niccolò (unless it belongs to the Carrand Triptych in the Bargello, as suggested by Bernard Berenson, *Italian Pictures of the Renaissance*, Oxford, 1932, p. 341), but surely not at the same time as the tabernacle, since its date is close to the middle of the century (cf. Paatz, *op.cit.*, p. 596, n. 563). If it was made for the Cavalcanti Chapel, it must have been intended for the altar table. How, indeed, could it have been attached to the tabernacle, which would have overshadowed it completely, both in the physical and the artistic sense? In any case, the assumption that Niccolò ordered the predella does not permit us to infer that the same patron is likely to have ordered the tabernacle some two decades earlier.

Iconographically, Donatello's Annunciation represents a type that seems to have been coined about 1350 in Florentine painting but remained extremely rare before the Quattrocento: the combination of kneeling Angel and standing Virgin in a unified interior setting. According to Kauffmann, the only author to concern himself with this aspect of the work (*D.*, p. 79), most of the salient features of the composition are anticipated in two Trecento examples, an Annunciation Altar in the Accademia, Florence,[2] and a predella panel by Giovanni da Milano in the Palazzo Venezia, Rome.[3] In both of these panels, the Virgin is indeed strikingly similar to Donatello's; she has risen from her chair and responds to the sudden entrance of the angel by drawing away from him, but her impulse to flee has been arrested and her head turns towards the angel. In the Accademia picture, even her gestures correspond to those of the S. Croce Virgin—her right hand is placed over the left breast, and the right holds an open book—and the exact frontal view of the chair behind her likewise recalls our tabernacle.[4] However, the setting of the Accademia panel shows the traditional portico scheme, with the two figures separated by a pillar; in the Palazzo Venezia picture, the scene takes place inside the Virgin's chamber, but there is a conspicuous lectern in the center of the room, interposing a barrier similar to the portico scheme (cf. Robb, *op.cit.*, p.

489). Nor do the two panels referred to by Kauffmann provide an antecedent for the gesture of Donatello's angel, since in them the angel's right hand is stretched out towards the Virgin (in the Accademia picture, his left hand reaches across to the right thigh in a manner reminiscent of our figure). Here Donatello seems to have utilized another type that occurs—although rarely—among Annunciations of the later Trecento: the kneeling Angel without attributes, his arms crossed in a gesture of reverence. This figure may be found in the anonymous fresco on the entrance wall of S. Maria Novella, Florence, in a slightly later fresco by Spinello Aretino in the Annunziata, Arezzo (Robb, *op.cit.*, figs. 9, 38), and in a panel by an Orcagna follower in S. Spirito, Prato (*L'Arte*, XVI, 1913, p. 212, fig. 3). The latter picture also shows a completely unobstructed space between the figures; the Virgin, who remains seated, has put aside her reading at the approach of the angel, and her open book rests not on a lectern but on a low bench that runs along the back wall of the chamber. This wall, interestingly enough, is decorated with large intarsia squares, a feature that suggests the ornamental paneling of Donatello's Annunciation. Kauffmann (*D.*, p. 80) believes that the background of the niche in our tabernacle represents the Mariological symbol of the *porta conclusa*; an attractive suggestion, but if this was Donatello's intention, why did he not make it plain to the beholder? How are we expected to know that the paneling is attached to a door, as distinct from the back wall of the room, without some unmistakable sign such as a clearly emphasized center seam (there is a seam here, since the relief is carved from two blocks, but the joint is so smooth that it can be seen only at close range), a conspicuous lock or bolt, or a separate door frame, especially when the Virgin's chair stands in front of it? Wherever the *porta conclusa* does occur in Annunciations of this time (e.g. Domenico Veneziano, Fitzwilliam Museum, Cambridge; Piero della Francesca, S. Francesco, Arezzo), it is not only characterized as a door beyond a shadow of a doubt but it is an exterior door, in the wall of the courtyard rather than of the Virgin's chamber—as indeed it should be if it is to fulfill its symbolic function of shutting off the domain of the Virgin against the outer, everyday world.[5] Under these circumstances, it seems unlikely that Donatello had any such idea in mind.

[2] Raymond v. Marle (*The Development of the Italian Schools of Painting*, III, The Hague, 1924, p. 546, fig. 303) identifies it as Agnolo Gaddi; Berenson (*op.cit.*, p. 11) attributes it to Andrea da Firenze; Roberto Salvini (*Rivista d'arte*, XVI, 1934, p. 220) places it close to Giovanni da Milano.

[3] David M. Robb, "The Iconography of the Annunciation . . . ," *Art Bulletin*, XVIII, 1936, pp. 480ff, fig. 10.

[4] The disposition of the Virgin's arms, including the rare feature of the open book, appears to be an invention of Duccio, who introduced it in his Annunciation in the London National Gallery.

[5] An Annunciation of the late Trecento in the Accademia, Florence, by the "Master of the Accademia Annunciation," shows a door in the paneled wall that forms the background of the scene, between the Angel and the Virgin; significantly enough, however, this door is ajar, since it leads into the bedchamber.

His conception of the scene is strikingly direct and simple, omitting all the customary symbolic paraphernalia so as to make the relationship between the two figures as immediate and humanly moving as possible. He has retained only the book held by the Virgin (for the symbolic meaning of this detail see Robb, *op.cit.*, pp. 482ff), and this, too, is not so much an attribute as a clue to her startled posture—she has been interrupted without warning in her pious meditations. It is this emphasis on the dramatic rather than the symbolic content of the encounter that has prompted the artist to reduce the setting to a minimum, so that even the indispensable chair loses its reality; it has been flattened out into an ornamental shape that blends with the background. For the same reason, the center of the composition remains empty. Donatello had used the same device in the Feast of Herod on the Siena Font, where this central void has the centrifugal force of an explosion. In the Annunciation, it has the opposite effect; it draws the two figures together, like complementary arcs irresistibly attracted to each other. The wide fame of the tabernacle in the sixteenth century, as reflected in the eulogies of Vasari and Bocchi, is based on this strong yet delicate interdependence.

The fame of the group may also explain why Vasari believed it to be Donatello's first major work. Apparently he associated it with the equally well-known wooden crucifix in the same church, which was stamped as an early work by the anecdote concerning the competition between Donatello and Brunelleschi (see above, pp. 7ff) and which follows as the next item in Vasari's narrative. The early date of the tabernacle was accepted almost without question until 1886 (Leopoldo Cicognara, *Storia della scultura . . . in Italia*, 2d ed., Prato, 1820ff, IV, p. 87, was the only dissenter from Vasari's view). Semper (*D.* '75, pp. 106ff) placed it immediately after 1406 and linked the numerous classical features of the architectural framework with Donatello's first Roman journey (even though during this sojourn our artist "never once glanced at the architecture," if we are to believe the "Manetti" *Vita* of Brunelleschi). C. J. Cavallucci (*Vita ed opere del Donatello*, Milan, 1886, pl. 1) connected the tabernacle with the founding of the Cavalcanti Chapel, which he claimed took place in 1406 (perhaps on the basis of Semper's reference to the conquest of Pisa in that year and to the role of Bernardo Caval-

canti in this victory). Schmarsow (*D.*, p. 11), the first since Cicognara to protest against the customary dating of the work, proposed to put it in the chronological vicinity of the Or San Michele statues, and Tschudi (*D.*, pp. 17f) decided that it could not have been done until after Donatello's return from Rome in 1433, because of the resemblance of its architectural elements to the St. Peter's tabernacle and the Cantoria. His arguments and conclusions have been followed, with no more than minor deviations, by all subsequent scholars. The majority assign the work to the mid-1430's (Reymond, *Sc. Fl.*, II, pp. 108f; Schottmüller, *D.*, p. 40; Schubring, *KdK*, p. 47; Cruttwell, *D.*, pp. 79f; Semrau, in Thieme-Becker, *Lexikon*, IX, Leipzig, 1913, p, 422; Colasanti, *D.*, pp. 55f; Kauffmann, *D.*, p. 79; Planiscig, *D.*, pp. 67f, 142; Morisani, *Studi su Donatello*, Venice, 1952, p. 146).[6] A smaller number prefer a date of about 1430 (Frey, *Cod. Magl.*, p. 305; Wilhelm Bode, *Jahrbuch Kgl. Preuss. Kunstslgn.*, XXII, 1901, p. 32; Venturi, *Storia*, VI, p. 269). So far as the architectural aspects of the tabernacle are concerned, a date of c. 1435 does indeed seem plausible enough; their similarity to the Cantoria framework has been commented on by almost every author, and Kauffmann (*D.*, p. 82) lays particular stress on their more highly developed classical qualities as against the St. Peter's tabernacle (cf. the concurring opinion of Middeldorf, *AB*, p. 573; for my own view, see above, p. 101). The individualistic and "picturesque" style of the S. Croce tabernacle architecture, so clearly divorced from any collaboration by Michelozzo, has likewise been cited as a reason for dating the work after the presumed cessation of the partnership in 1433.[7] The style of the two figures, on the other hand, undeniably points to the late 1420's. Kauffmann, *loc.cit.*, has summed up the observations of numerous earlier scholars in this respect; he notes that the closest relatives of the Angel and the Virgin are the two Virtues of the Siena Font (see above, p. 72), and stresses their "Ghibertesque" qualities, which suggest the angels in the Baptism of Christ on the Siena Font. The classical flavor, especially of the heads, strikes him as so pronounced that he even tries to relate them to a specific ancient model such as the Three Graces at Siena.[8] There can indeed be little doubt that the S. Croce Annunciation belongs to that brief and uniquely lyrical and idealistic phase of Donatello's

[6] Gerald S. Davies (*Burl. Mag.*, XIII, 1908, pp. 222ff) claims 1433 as a *terminus post* for the tabernacle on the rather curious ground that its influence is not yet felt in the terracotta Annunciation of 1433 in Arezzo Cathedral, presumably the first known work of Bernardo Rossellino, while the latter's Annunciation group of 1447 at Empoli is clearly based on Donatello's.

[7] Only Semrau, *D.*, pp. 44f, and Planiscig, *loc.cit.*, give Michelozzo a share in the design, but without arguing the point in detail.

[8] Cf. Morisani, *op.cit.*, p. 145, who not only shows that

Donatello is unlikely to have seen this group before he carved the S. Croce Annunciation but, with some justice, objects to an exaggerated emphasis on the "classicism" of the two heads. His remarks might well have extended to the attempt of Charles Picard (*Revue archéologique*, 6e sér., XXVIII, 1947, pp. 77f) to link the S. Croce Virgin with Attic fifth century sculpture; Picard cites the Athena at Frankfort and the first metope on the north side of the Parthenon, which was mistaken for an Annunciation in the Middle Ages and thus escaped mutilation.

development represented by the Siena Virtues, a phase distinguished from his "classicism" of the early 1420's (as exemplified by the Prophet and Sibyl on the Porta della Mandorla, for which see above, p. 43) by a far greater subtlety and animation of the sculptured surfaces. Thus the years 1428-1430 would seem to fit the niche relief of our tabernacle far better than the mid-1430's. But what of the architecture? Could that have been conceived at so early a date? Here our answer must be that we do not know. The mere fact that it is different from the architecture of the "partnership projects" (the Coscia and Brancacci Tombs, the Prato Pulpit) of the later 1420's does not justify the conclusion that Donatello did not develop a distinctive style of his own in this field until after his return from Rome (as maintained by Middeldorf, *AB*, p. 575). While our tabernacle is certainly related to that of St. Peter's,[9] I cannot follow Kauffmann's view that the S. Croce design presupposes the Roman one; the two works are too different in scale and purpose to form a simple evolutionary sequence, the more so since the St. Peter's tabernacle was carried out by assistants to a far greater degree than ours (cf. above, p. 98). A far more striking resemblance exists between the S. Croce tabernacle and the architecture of the Cantoria—or, to be exact, the lower half of the Cantoria. If we are called upon to decide which of these two is the earlier, a peremptory judgment is difficult, but a number of considerations would seem to point to the tabernacle. Some of its decorative elements recalls our artist's previous experience to a greater degree than do those of the Cantoria,[10] and the architecture as a whole has a more sharp-edged, precise quality and more delicate articulation, as against the fleshy opulence of the substructure of the Cantoria. Nor does it presuppose Roman monuments to the

same extent (for its possible dependence on Etruscan sources see Carl Stegmann and Heinrich v. Geymüller, *Die Architektur der Renaissance in Toscana*, Munich, 1885-1907, II,b). Inasmuch as the lower half of the Cantoria was, in all likelihood, designed and executed before the balustrade (see below, p. 127) and may therefore be dated 1433-1435, the framework of the S. Croce tabernacle can be plausibly assigned to the years 1430-1432. Considering the size and scope of the commission, it seems only natural to assume that Donatello did not execute it all at once. He started, I believe, with the Annunciation relief and then, perhaps after some delay occasioned by the unsettled conditions of 1430, proceeded to the frame. The terracotta *putti*, whose kinship with those of the Prato Pulpit has been rightly stressed by Kauffmann, would thus be the latest part of the monument. Our artist may well have added them only after his return from Rome in the spring of 1433, on the basis of his intervening experience with the St. Peter's tabernacle; they appear to be an afterthought—though a highly ingratiating one—rather than an integral part of the design. (Kauffmann is quite right in describing their function as that of *acroteria*, in contrast to the angels on top of the St. Peter's tabernacle, which might be defined as Gothic pinnacle figures, but their very independence from the rest of the structure warns us against using them as a determinant for the date of the tabernacle as a whole.) There need be no quarrel, then, between those who have placed the entire work about 1430 and the advocates of a date some five years later. By spreading the execution of the tabernacle over four or five years, we not only give each faction its due but we gain a valuable link between Donatello's pre- and post-Roman development.[11]

[9] Davies, *loc.cit.*, has observed that they share, among other things, the rosette with radiating ribs—a motif that does not occur in the master's later works.

[10] The masks on the capitals echo those at the corners of the base of the St. Louis niche, and the winged wreath suggests the winged cloud-nimbus of the Trinity on the pediment of the same work.

[11] The role of the Roman journey, or journeys, has been discussed at some length above, pp. 99ff.

SEVEN BALUSTRADE RELIEFS OF DANCING ANGELS
OUTDOOR PULPIT, PRATO CATHEDRAL

PLATES 47-48 Marble, with mosaic background; H. 73.5 cm; W. 79 cm *1433-1438*

DOCUMENTS

Two contracts, as well as numerous entries concerning disbursements and materials, among the records of the Prato Cathedral workshop (*Opera del Cingolo*), now in the State Archives, Florence. They were published by Cesare Guasti (*Il pergamo di Donatello pel Duomo di Prato*, Florence, 1887, pp. 12ff; reprinted in *Opere*, IV, Prato, 1897, pp. 466ff). Cornel v. Fabriczy, "Michelozzo di Bartolomeo,"

Jahrbuch Kgl. Preuss. Kunstslgn., XXV, 1904, pp. 71ff, gives another transcription of the contracts which differs from Guasti's only in some details of spelling and punctuation.

1428, July 14 (Guasti, pp. 12-15; Fabriczy, pp. 71-73): Contract for the pulpit between the *operai* and Donatello and Michelozzo, signed by the latter master on behalf of both partners. It stipulates that the buttress (*pilastro quadro*) on the new façade of the Cathedral is to be changed into a fluted pilaster (*colonna quadra schanalata*) fit to serve as the support of the pulpit. For the pulpit itself, the two masters must follow the model they have made and deposited in the sacristy; everything must be of white Carrara marble and in accordance with the following dimensions: the lowest part of the pulpit, starting at a height of 5¼ braccia above the ground, is to be a cornice on which there shall be two angels with the function of consoles or brackets (*una cornicie in sulla quale sia due spiritelli in luogho di gocciole*), each two braccia tall and decorated with foliage, as shown in the model; above these angels a heavy cornice carved with dentils, and above that a projecting platform (*mensolato*) carved with leaves and profiles. The floor of the pulpit is to rest on this platform, and between the two there may be foliage ornament or whatever shall please the *operai*. The round parapet of the pulpit is to be divided into six compartments, in accordance with the model. On these there are to be carved angels holding between them the coat of arms of Prato, as shown in the model, or something else if the *operai* approve. The floor of the pulpit is to measure 5⅔ braccia [in diameter]; the outside of the parapet is to have *colonne* (columns or pilasters) and projecting cornices as shown in the model. As for the work that will have to be done on the façade of the church above the floor level of the pulpit, the two masters shall provide, without extra charge, the design and the technical procedure, engaging craftsmen of their choice at the expense of the *opera*. The latter will also pay for all the materials needed for the masonry work, while the cost of the material and other expenses for the pulpit itself shall be borne by the two masters, who promise to have everything finished by September 1, 1429. The final price will then be determined by an outside arbiter, Lorenzo Sassoli. In the meantime, the two masters are to receive 350 florins, in six installments: 50 florins in August, October, and January, 100 florins the following April, and 50 florins in July and September.

July (Guasti, p. 27): 21 florins have been paid to Donatello and Michelozzo by the *opera*.

July 30–November 21 (Guasti, p. 26, summarizing twelve items): A total of 318 lire has been paid to Donatello and Michelozzo.

November 27 (Guasti, pp. 15, 23; Fabriczy, p. 74): Written confirmation of their promises by Donatello and Michelozzo, who pledge themselves, in case of failure to complete the pulpit in accordance with the terms of the contract, to make full restitution to the *opera* of any money or material received. Andrea di Nofri of Florence signs with them as their guarantor. Sandro di Marcho, who had gone to Florence as the representative of the *operai* to get this pledge, receives 15 soldi for his trip.

1429, December 8-January 20, 1430 (Guasti, p. 26, summarizing eighteen items): During this period a total of 220 lire 12 soldi has been paid to Donatello and Michelozzo.

1430, February 11-July 31 (Guasti, *loc.cit.*, summarizing twenty-seven items): A total of 247 lire 7 soldi has been paid to the two masters during this interval.

1431, August 17-March 15, 1432 (Guasti, *loc.cit.*, summarizing sixteen items): A total of 231 lire 3 soldi has been paid to the two masters during this interval.

1432, March 19-September 18 (Guasti, *loc.cit.*, summarizing fourteen items): A total of 86 lire 10 soldi has been paid to the two masters during this interval.

1432, September 1-July 26, 1433 (Guasti, *loc.cit.*, summarizing seventeen items): A total of 274 lire has been paid to the two masters during this interval.

1433, April (Guasti, p. 23): Pagno di Lapo has been sent to Rome by the *operai* in order to fetch Donatello and his partner, who have failed to complete the pulpit; he is to receive 16 lire for this service. Chambio di Ferro, who spent four days in Florence arranging for Pagno's trip and securing letters from Cosimo and others to urge Donatello to return and finish the pulpit, is to be paid 4 lire.

July (Guasti, p. 16): The dismantling of the old pulpit has begun.

August 14-October 18 (Guasti, pp. 20, 26, summarizing thirty-five items): The two masters have received a total of 316 lire during these two months, including the cost of 25 pounds of wax for the model [of the bronze capital].

October 18-December 19 (Guasti, p. 27, summarizing seventeen items): A total of 134 lire 6 soldi has been paid to the two masters during this period.

December 9 (Guasti, p. 20): Michelozzo has been given 439 bricks "when he cast the bronze [capital]."

1434, April 17-September 2 (Guasti, p. 27, summarizing five items): A total of 18 lire 15 soldi has been paid to the two masters.

May 27 (Guasti, pp. 17-19; Fabriczy, pp. 77f; first published, incompletely, in Fernando Baldanzi's *Descrizione della Cattedrale di Prato*, Prato, 1846): Contractual agreement concerning the completion of the pulpit, between the *operai* and Donatello *et alios*. Donatello is to receive 25 florins apiece for the marble panels he will carve *propria manu* for the pulpit. Lorenzo Sassoli is again named as arbiter. Both parties bind themselves to observe the terms of this and all previous agreements under penalty of 200 florins.

June 19 (Guasti, p. 19; first published in his *Opuscoli descrittivi e biografici di belle arti*, Florence, 1874, p. 240): Letter of Matteo degli Organi, from Florence, to the *operai*, informing them that Donatello has finished "that marble relief," which is being highly praised by local experts. Matteo further assures the *operai* that Donatello has every intention to render them good service; they ought to show their appreciation now that he is so well disposed towards them, since a master such as this cannot be found every day, and send him some money for the approaching holiday [apparently the Birth of St. John the Baptist, June 24]. Donatello, Matteo adds, is the kind of man who is satisfied with any modest meal (*è huomo ch'ogni picholo pasto è allui assai, e sta contento a ogni cosa*).

August 3 (Guasti, p. 23): The pulpit has been appraised; the masters who came for this purpose have consumed 4 lire's worth of food and drink.

September 2 (Guasti, p. 24): Donatello and Michelozzo are charged with 1 lira 15 soldi cartage for three loads of marble, i.e. three reliefs.

September 24-28 (Guasti, *loc.cit.*): Maso di Bartolommeo is credited with four days' work in fitting the brackets [of the pulpit].

October 1-March 18, 1435 (Guasti, p. 27, summarizing fourteen items): Donatello and Michelozzo have been paid a total of 168 lire 11 soldi during this period.

October 14-22 (Guasti, p. 24): Donatello and Michelozzo are charged with 6 lire 10 soldi for sixty-five pounds of lead used by Maso [di Bartolommeo] in attaching the brackets [of the pulpit].

October 22 (Guasti, *loc.cit.*): Donatello and Michelozzo are charged with 16 lire 10 soldi, the amount that has been paid to three master masons for their appraisal of the pulpit.

November 2-6 (Guasti, *loc.cit.*): Maso di Bartolommeo is credited with five days' work; he has finished laying the floor [of the pulpit] and started building the pilaster.

December 14 (Guasti, p. 25): Between August 28 and November 6, Maso di Bartolommeo has spent thirty-six days working on the pulpit for Donatello and Michelozzo.

1435, February (Guasti, p. 20): A reference to the "iron support of the bronze capital made by Michelozzo."

July 18 (Guasti, p. 16): The canopy of the old pulpit has been dismantled.

October 2-December 24 (Guasti, p. 27, summarizing six items): A total of 30 lire 4 soldi has been paid to Donatello and Michelozzo.

November (Guasti, p. 25): Donatello and Michelozzo are charged with eight lire 10 soldi, the cost of a second appraisal of the pulpit.

November 6-June 3, 1436 (Guasti, p. 27, summarizing six items): A total of 26 lire 18 soldi has been paid to Donatello and Michelozzo.

1436, March 6-October 3, 1438 (Guasti, *loc.cit.*, summarizing ten items): A total of 669 lire 2 soldi has been paid to Donatello and Michelozzo during this interval.

April (Guasti, p. 25): Donatello has received 96 lire in part payment for three marble reliefs, which are not yet finished, out of a total of 240 lire, the amount still owed him for the three unfinished panels and for another one, in Prato, which is finished.

June 3 (Guasti, *loc.cit.*): Donatello and Michelozzo are charged with 3 lire 6 soldi for transporting the three reliefs from Florence to Prato; this includes the cost of one trip the carters made in vain [i.e. when the panels were not ready, contrary to promise].

November 17 (Guasti, *loc.cit.*): Maso [di Bartolommeo] has been sent to fetch Donatello, but the latter has refused to appear [literally: he has made fools of us].

1438, July 14 (Guasti, *loc.cit.*): The marble reliefs have been installed on the pulpit.

August 8 (Guasti, p. 20): Payment for nails used in making the scaffold for installing the bronze [capital] on the pulpit.

September 3 (Guasti, p. 26): The capital and the coats of arms of Prato [on the pulpit] have been gilt.

September 17 (Guasti, *loc.cit.*): Donatello and Michelozzo are to be paid 700 lire for the seven marble reliefs they have made for the pulpit. This amount includes the cost of the marble, but they are to receive additional payment for their work and material cost in filling the background of the reliefs with gold mosaic. The latter amount has been agreed to by Donatello and will be paid through Lorenzo di Giovanni de'Medici.

[The documents do not seem to include a final accounting. According to the payment records summarized in Guasti, pp. 26f, Donatello and Michelozzo had received a total of 2,829 lire 14 soldi 6 grossi between 1428 and 1438, or 707 florins. While this amount may not be entirely accurate—some items are probably duplicated, others omitted—it comes reasonably close to what the two masters could expect to be paid; two years later Donatello's Cantoria, a somewhat larger project, was appraised at 896 florins. The claim of Milanesi (*Vasari*, ii, p. 410, n. 1) that the pulpit cost 300 florins, is without substance, being based on the faulty rendering of the contract of 1434 in Baldanzi's *Descrizione*.]

SOURCES

(c. 1450) *Nabucodonosor, Re di Babilonia*, religious drama of unknown authorship, first printed in *Rappresentazioni sacre* . . . , v, Florence, 1558; the scene involving Donatello is reproduced in

Semper, *D.* '75, pp. 321f: [The King wants to see himself adored as a god on earth, and orders his chamberlain to find the greatest sculptor, who is to create a gold statue of the King. The chamberlain recommends Donatello.]

 Nebuchadnezzar: Go fetch him quickly!

 Chamberlain to Donatello: Master, be it known to you
 That you are in the presence of our King.

 Donatello: I must depart soon because
 I have to do the Pulpit of Prato.

 Chamberlain: An urgent matter—

 Donatello: Quite so; but I must also do the Dovizia for the market that is to be placed
 on the column, so right now I cannot take on any more work.

 Donatello to the King: Before your magnificence,
 I have come, greatest of Kings!

 Nebuchadnezzar: I understand you are a man of prowess and diligence in the art
 of statuary.

 Donatello: Your Majesty may rest assured
 That I am fully master of my art.
 Whatever you want done I shall do gladly
 And with dispatch obey your word.

 Nebuchadnezzar: Master, I want you to fashion
 A golden statue, sixty elbows high
 Bearing my features, and its width
 Shall be six elbow-lengths.
 And make it thus that in the open field
 Its beauty be the wanderer's beacon.
 Go set to work without delay; I shall
 Instruct you where to place it when it's ready.

 Donatello: Your Majesty's command shall be fulfilled
 Without defect; now to begin the labor!

1510 Albertini, p. 20: "The marble pulpit of the [Cathedral] square [at Prato] where the Girdle of the glorious Virgin is shown, is by Donatello."

1537-1542 Cod. Magl., p. 78: "By [Donatello's] hand is the pulpit in Prato, where the Girdle is displayed."

(c. 1550) Gelli, p. 60: "In Prato [Donatello] did the pulpit where the Girdle is displayed, as well as the decoration of the pulpit."

1550 Vasari-Ricci, p. 53 (Milanesi, p. 409f): "In Prato [Donatello] made the marble pulpit where the Girdle is shown. On its parapet he carved a dance of children, so beautiful and marvelous that they may be said to display the same perfection as his other works. He also made two bronze capitals supporting the pulpit. One is still there, the other having been carried off by the Spaniards, who sacked this part of the country."

1584 Borghini, *Riposo*, p. 320: "In Prato, a town ten miles from Florence, he made the marble pulpit on which the Girdle of the Glorious Virgin is shown; the dancing children he carved on it are so beautiful and alive that they stun every beholder."

The first outdoor pulpit at Prato Cathedral for the display of the famous relic, the Girdle of the Virgin, had been a wooden one, commissioned before 1211 (Guasti, *op.cit.*, p. 10). In 1330 the Chapter decided

to replace it with a marble pulpit showing the Assumption, the story of St. Stephen, and two angels (Guasti, *loc.cit.*), but the project was not executed until 1357-1360. This long delay may help to explain the changes in the sculptural program; the balustrade reliefs of the Trecento pulpit, rediscovered by Kauffmann (*D.*, p. 221, n. 226), actually show the Death of the Virgin, the Assumption with St. Thomas, the Coronation, and the Recovery of the Relic. Since they consist of two wide and two narrow panels, the pulpit must have been rectangular in shape. It occupied the same corner as the present structure, and was not removed until July 1433, although the decision to replace it had been made twenty years earlier. Late in 1413 Niccolò di Pietro (called Pela), who was in charge of building the new façade of the Cathedral, received instructions concerning "the impost blocks at the corner for the new pulpit" (Guasti, *op.cit.*, p. 12).

Despite the wealth of documents, the history of the Donatello-Michelozzo pulpit during the decade 1428-1438 is far from clear. It has been generally assumed (most recently by Ottavio Morisani, *Michelozzo Architetto*, Turin, 1951, p. 90) that after the signing of the contract of 1428 no work was done on the project until Donatello's return from Rome in the early summer of 1433. Such, however, could hardly have been the case; according to the disbursement records published by Guasti, the two masters received almost 300 florins, or two fifths of all the money they were to be paid, between July 1428 and September 1432 at fairly regular intervals, an indication of continuous and substantial activity. The same may be concluded from the entry concerning Pagno's mission to Rome on April 1, 1433, which refers to Donatello and his partner as having failed to complete the pulpit. The fact that it was Donatello in particular whom the *operai* wanted to get back on the job—they even enlisted the aid of Cosimo de'Medici—suggests that the remaining part of the work was largely sculptural. And surely the old pulpit would not have been dismantled in July of the same year unless the new one, or its architectural framework, had been far enough advanced at that time for the labor of installation to begin. We may well assume, therefore, that by mid-1433 most of the lower half of the pulpit (i.e. of the zone between the bronze capital and the balustrade) was ready to be put together. The carving of this ornate ensemble of moldings, brackets, and panels must have taken con-

siderable time. It also represents a sizable investment of material and wages, so that it could account for a major share of the disbursements recorded between 1428 and 1433. Nor is this view incompatible with the changes made in the original design for the pulpit during those same years. The differences between the model described in the contract of 1428 and the present structure concern three aspects of the work: its level above the ground (the present structure begins at a height of about 7 braccia [actually 420 cm] as against 5¾); the area now occupied by the bronze capital, where the two marble angels serving as consoles would have been placed; and the balustrade, which was originally divided into six compartments, rather than seven, and showed escutcheon-holding *putti* instead of dancing ones.[1] The zone between the console angels and the balustrade, on the other hand, is described in terms that fully match its present appearance. Its design would have been affected by only one of the three changes we have noted above, i.e. the decision to divide the balustrade into seven instead of six compartments. This called for two additional brackets (fifteen rather than thirteen) and correspondingly narrower spaces between them. The ornamented panels filling these spaces are thus the only part of our zone that could not have been carved until after the redesigning of the balustrade. Their style is indeed different from the rest; the soft, fleshy plant forms of these panels still hark back to Late Gothic models, as against the crispness of the decorative carving, based on classical sources, on the brackets and cornices. The same retardataire type of ornament may be seen on the underside of the canopy above the pulpit, executed in 1438-1441 by Maso di Bartolommeo (see the document in Guasti, *op.cit.*, pp. 27f). Maso, then, must also have done the panels between the brackets, perhaps as late as 1436-1438, and without guidance from Michelozzo or Donatello.

When was the original design of the pulpit modified? So far as our documentary information is concerned, this could have happened at any time between 1428 and 1433, but the circumstances favor the latter year. The first of the three changes we noted—an increase in the distance of the pulpit from the ground—concerns a matter that is not likely to have come under serious consideration until the base of the new pulpit was ready to be installed. The other two changes have to do with the sculptural *décor* rather than with the architectural framework. After Donatello's return from

[1] Kauffmann (*D.*, p. 221, n. 227) assumes that these six fields were separated by columns rather than by double pilasters, but the wording of the contract does not warrant such a conclusion. In the architectural terminology of the time, a pilaster of one of the classic orders was called *colonna quadra* or, quite often, simply *colonna*, while an ordinary pier or buttress was a *pilastro*. Since the contract gives only passing attention to the architectural aspect of the balustrade as shown in the model, the term *colonne* would have been entirely adequate as a reference to the double pilasters, if we prefer to believe that they belonged to the original design of the pulpit. There is little reason to doubt that they did, inasmuch as Michelozzo at this very time had used double pilasters of the same kind in the Brancacci monument.

Rome, when the sculptural part of the project was at last on the point of getting under way, our master must have proposed to substitute dancing angels for the heraldic figures shown in the model; as a result, the balustrade reliefs assumed a new importance within the scheme of the pulpit, and the decision to switch from six panels to seven can be best understood in this context. For it meant that the center of the balustrade would now be marked by a relief rather than by the dividing line between the third and fourth panels—certainly a far better arrangement aesthetically.[2] The elaborate bronze capital represents a further enrichment of the sculptural program, although its height (c. 90 cm, or 1½ braccia) is somewhat less than that of the two marble angels 2 braccia tall specified in the contract. Actually, the original notion of angels serving as consoles was not abandoned; the garlanded angel emerging between the abacus and the body of the capital still has the same function.

The bronze capital, modeled and cast in the latter half of 1433 but not installed until five years later, has been a source of puzzlement ever since Vasari promulgated the story that the second capital was carried off by marauding Spaniards (which, if true, must have happened in 1512). Guasti (*op.cit.*, pp. 20f) has pointed out that the documents never mention more than one capital, including an entry of August 23, 1553, which authorizes negotiations about "completing the deficient part of the capital beneath the pulpit."[3] This does not explain, however, why only one side of the corner pilaster received a capital in 1433-1438. Surely, such could not have been our masters' intention. Nor is it plausible to assume that they had planned to produce a second capital but never got around to doing so. How, one wonders, could the two pieces be joined together without an awkward gap? Judging from the design of the existing capital, this would have been difficult indeed. Moreover, why should they have thought of two separate capitals when what they had to produce was really a single (two-sided) corner-capital? Would it not have been far more satisfactory, technically as well as aesthetically, to model and cast the two faces as one unit? That, I am convinced, is the way they actually proceeded; and the proof is to be found in the peculiar relationship between the front surface of the capital

and the narrow side-piece around the corner to the left (Pl. 47b, c). The latter area, not quite a third as wide as the front, is clearly a fragment; its decoration, instead of being adapted to its small space, simply repeats the ornamental system of the front face. This sidepiece, then, must have been designed to have the full width of the pilaster. It even had the same kind of console-angel that appears on the front of the capital: this figure has been cut off, only the tip of its left wing is still visible, in the exact spot where we would expect to find it. But if the capital as we see it today has suffered mutilation, if the two sides originally had the same width, then the undamaged face could not have been intended for the position it now occupies; it was meant for the south side of the pilaster, *ubi deficit*, while the mutilated part is a remnant of the face intended for the west (or façade) side of the pilaster. In other words, the left-hand corner of the present capital was designed to mark the center of the L-shaped cast. That this interpretation is correct can be seen from the slightly nonsymmetric character of the decorative scheme. Thus the existing console-angel leans towards the left, thereby giving the curious impression of trying to escape his load; if we visualize him on the other side of the pilaster, he would be straining in the proper direction, i.e. towards the exposed corner. The console-angel that has disappeared must have done the same: his left wing-tip is at the same distance from the corner of the abacus as the right wing-tip of his companion. One further bit of evidence for our view may be found in the two reclining angels. The head of the one to the left is turned more strongly than that of the other, as if his attention had been attracted by something around the corner. And so indeed it has; for the angel on the narrow face of the capital has taken off his wreath and is peering through it at his well-behaved neighbor. The way the capital is mounted today, this ingratiating notion of a little game of peekaboo is entirely lost upon the beholder; played around the exposed angle of the capital, it would be most effective. Who then spoiled the game? Who mutilated one face of the capital and thus made the present "wrong" installation necessary? No marauding Spaniards, obviously. There must have been an accident, probably in the casting of the piece or perhaps in the chasing, which damaged that side. Maybe attempts at recasting were made, and failed.

[2] Kauffmann (*D.*, pp. 72f) thinks that the number of panels has a symbolic significance linked with the Assumption of the Virgin, since Donatello had used seven angels in his Naples Assumption relief (see above, p. 91); this may have been an additional consideration, even though one wonders if Kauffmann is right in claiming that the theme of the dancing angels is derived from the iconography of the Assumption. The examples he cites—the Assumption relief from the Trecento pulpit at Prato, Orcagna's tabernacle at Or San Michele, the

gable relief of the Porta della Mandorla, etc.—show flying angels who either play musical instruments or help to carry the Virgin aloft but who can be defined as "dancing" only in the metaphoric sense of the term.

[3] *De perficiendo seu de novo fiendo il capitello sotto il perbio della Cintola ubi deficit*; the term *deficit* would seem to refer, not to a recently stolen piece but to something that was never there to begin with.

In any event, we shall have to assume that the damage had not been repaired by the time the rest of the pulpit was finished and installed, so that the *operai*, anxious to complete the project, had no choice but to accept the imperfect piece and to agree to the present mounting of it, with only a simple stone boss above the south side of the pilaster. This also helps to explain why the capital was the last of all the parts of the pulpit to be installed, even though it had been modeled and cast six to nine months before the completion of the first balustrade panel. The reason for the delay is not far to seek; presumably the repairing of the damaged piece was the responsiblity of Michelozzo, who had cast it, but Michelozzo, between 1434 and 1438, was preoccupied with the completion of the Aragazzi Tomb in Montepulciano. Perhaps the accident we have postulated here was simply a bit of bad luck such as might befall any master at a time when large-scale bronze casting technique was still something of a hit-or-miss affair. Yet there is a certain irony in the circumstance that this accident should have occurred in connection with our only documented instance of Michelozzo's activity as a bronze caster. It hardly serves to increase our confidence in his expert knowledge of this field, so often proclaimed by all those who viewed his role in the partnership with Donatello as that of a bronze casting specialist (see above, pp. 54ff, 57).

The documents do not inform us which of the two partners designed the architectural framework of the pulpit. It has been claimed persistently for either artist by the participants in the dispute over the nature of the partnership. Those who followed Bode and Geymüller in minimizing the creative ability of Michelozzo attributed the design to Donatello, while the adherents of Schmarsow and Semrau championed Michelozzo as the architectural designer, not only of the Prato Pulpit but of all the "partnership projects" (see the summary of these opposed views above, pp. 54ff, 63). As the last of the joint commissions undertaken by our two masters, the Prato Pulpit poses this issue more sharply than the rest, since its time of execution coincides, in part, with that of Donatello's Cantoria. The contrasting character of these two works has not been adequately stressed by the Bode-Geymüller faction and their modern successors (Colasanti, *D.*, p. 47; Kauffmann, *loc.cit.*; Morisani, *op.cit.*, pp. 27f; cf. in contrast Semrau, *D.*, pp. 49f, and more recently Middeldorf, *AB*, p. 575): grammatically correct use of the architectural vocabulary of Brunelleschi at Prato, complete lack of orthodoxy and a "picturesque" interpenetration of the sculptural and architectural spheres in the Cantoria. Granting that the design of the pulpit as we see it today was conceived, in its main outlines, at the time of the first contract, it still seems difficult to

believe that the same artist could have invented the radically different plan of the Cantoria five years later, even if we make every possible allowance for the impact of Donatello's Roman sojourn of 1432-1433 (see above, pp. 99ff). My own belief is that Michelozzo must be held responsible not only for the architectural framework of the pulpit but also for the sculptural program described in the contract of 1428. The two console-angels recall the caryatids of the Brancacci Tomb (which at that time must have been near completion), and the six pairs of escutcheon-holding angels proposed for the balustrade are hardly the kind of invention characteristic of Donatello.

The design, if not necessarily the actual modeling, of the bronze capital has been attributed to Donatello by the vast majority of scholars, including Semrau (*loc.cit.*) and, more recently, Kauffmann (*loc.cit.*) and Planiscig (*D.*, p. 65). Those who claimed its invention for Michelozzo were persuaded to this view, for the most part, not by the style of the piece but by a too literal interpretation of the document of February 1435, which refers to the capital as "made by Michelozzo" (Guasti, *op.cit.*, p. 20; Hans Stegmann, *Michelozzo*, Munich, 1888, p. 36, and in *Die Architektur der Renaissance in Toscana*, ed. Carl Stegmann and Heinrich v. Geymüller, Munich, 1885-1907, II, p. 5; Frey, *Cod. Magl.*, p. 307; Pastor, *D.*, p. 60). Among recent authors, the capital has been acknowledged as a creation of Michelozzo only by Lányi ("Donatello's Angels . . . ," *Burl. Mag.*, LXXV, 1939, p. 151, n. 11; without supporting arguments), Morisani (*loc.cit.*, under strongly Donatellesque inspiration), and, with certain strictures, Giuseppe Marchini ("Di Maso di Bartolomeo e d'altri," *Commentari*, III, 1952, pp. 114f). The chief argument usually advanced against Michelozzo—that the design is too imaginative and fails to show his architectural discipline—loses a good deal of its force if we examine the capital within the context of the pulpit project as a whole, rather than in isolation. Its basic shape is certainly unorthodox: a combination of abacus and scrolls with a rectangular panel resting on an egg-and-dart base. Structurally, this might be described as a frieze with the superimposed features of a capital. In order to understand its genesis, we must keep in mind the specifications of the contract of 1428, which called for the conversion of the corner buttress of the façade into a fluted pilaster. Why was this never done? One glance at the present structure supplies the answer—the buttress is so wide (95 cm, or about 1½ braccia) in relation to the height prescribed in the contract (5¼ braccia) that it could have been changed into a reasonably proportioned pilaster only by a drastic reduction of its width. The model of 1428 must have shown a Corinthian pilaster of the type usually employed by Michelozzo (i.e. a fairly slender

one, which in this case could not have been wider than ¾ braccia), surmounted by a standing angel 2 braccia tall whose maximum width could not well have exceeded one braccio. The practical difficulties implicit in this scheme were probably not appreciated until 1433, when the lower part of the pulpit proper was ready for installation. At that point the two artists must have realized that the "slenderizing" of the existing buttress simply could not be accomplished in an aesthetically satisfactory manner; for, in order to keep the new pilaster centered beneath the pulpit, it would have been necessary to pare down the buttress symmetrically (i.e. to cut away the same amount on both sides of its center line). So they decided not to tamper with the buttress and to abandon the notion of the classical pilaster altogether. This meant that the two tall, narrow console-angels above the pilaster also had to be replaced with a new design, adapted to the width of the original buttress. When we consider that the height of that buttress below the bronze capital is only four times its width, it should be obvious that no conventional classical capital could have been fitted to it; the circumstances demanded an unorthodox form, a hybrid of one kind or another. Viewed in this light, our bronze capital does not seem nearly as "un-structural" as it might be. Its decoration, after all, whether figures or ornament, remains completely on the surface and does not obscure the basic shapes to which it is attached; it could all be scraped off, as it were. If we apply the same test to the framework of the S. Croce Annunciation, we can, I believe, come to only one conclusion: the Prato capital must have been designed by Michelozzo. Its ornamental vocabulary has analogies in the work of both masters, since it was to a large extent the common property of the period, but the particular relationship between the decoration and the structural core of the capital, and even the details of modeling, can be matched only in the *œuvre* of Michelozzo. Thus the pilaster capitals on the facade of S. Agostino at Montepulciano show the same basic pattern of scrolls against a flat, rectangular panel, and the Christ Child in the lunette seems to me strikingly similar to the console-angel at Prato, both in facial expression and in the handling of the forms, while the two reclining angels on our capital strike me as the close relatives of those on the frieze of the Aragazzi Tomb. That frieze also shows a similar use of ribbons to fill the empty spaces. The entire decorative scheme of the capital has a careful, arranged look, a "slackness," an insistence on symmetry, that are foreign to the spontaneous energy of Donatello's ornamental designs. Another telling bit of evidence in favor of Michelozzo is the angel with the wreath on the truncated side; its pose is clearly derived from that of the two *putti* on the sarcophagus

of the Coscia Tomb. Donatello, so far as I know, never repeats himself in this fashion. The four large angels on the capital, then, bear the unmistakable mark of Michelozzo's hand. In addition, there are eight smaller ones, of three different sizes; these show a greater degree of animation and are thus closer to Donatello in spirit, if not in quality of execution. They may well have been added by Maso di Bartolomeo, as suggested by their resemblance to similar small figures on Maso's bronze candlestick in Pistoia Cathedral and his part of the bronze grating around the Chapel of the Sacred Girdle at Prato (cf. Marchini, *loc.cit.*, and pl. xxix).

With the casting—and presumably the chasing—of the bronze capital Michelozzo's work on the pulpit seems to have come to an end. In any event, his name is not mentioned in any of the documents concerned with the carving of the balustrade panels. If he continues to appear in the records until 1438, it is only in the financial accounts, where debits and credits were entered under the name of both partners to the very last. What, we may ask, happened to the partnership of the two masters after 1433? Here no clear-cut answer can be given on the basis of the known documents, and perhaps none would be possible even if we were in a position to consult the artists themselves. The partnership, it seems, was always a limited one; it covered only certain projects that were undertaken jointly but left each master free to accept individual commissions as well. Thus the fact the Michelozzo did not figure as cosigner of the written agreement of May 1434 does not indicate that the partnership had been formally dissolved—it probably never was; he is, after all, referred to quite explicitly, if indirectly, as the "others" who, together with Donatello, form one party to the agreement (the plural *et alios* must not be taken literally; the phrase is a legal *terminus technicus* familiar in abbreviation to this day). Since the agreement dealt with an aspect of the pulpit that concerned Donatello alone—i.e. the price of the balustrade reliefs—there was no need to mention Michelozzo by name. The agreement itself surely was not intended to supersede the basic contract of 1428 (which was, in fact, reaffirmed in the solemn promise to observe all previous agreements) but to supplement it; there had been a change in the original plan for the balustrade, and this had to be spelled out. (A similar document may have existed relating to the bronze capital.) Michelozzo, then, remained a partner of Donatello with respect to the Prato Pulpit until the completion of the project, even though he apparently was not expected to take part in the production of the balustrade panels. For all practical purposes, we may suppose, the partnership came to an end within a year after Donatello's return from Rome, but Michelozzo retained

his legal and financial interest in the Prato enterprise for another four years, until the two masters had received the last payment and squared their accounts.

According to the agreement of 1434, the seven balustrade panels were to be Donatello's own handiwork; they are specifically defined as *eius propria manu*, thus excluding the collaboration of the *alios*. This, we may be sure, was not intended to prevent him from using assistants (the modern concept of *Eigenhändigkeit* did not yet exist then), but it does seem to eliminate Michelozzo, who had the status of an independent master rather than of a subordinate. While the wording of the agreement need not be viewed as an iron-clad guarantee against the possible participation of Michelozzo, it makes it highly unlikely that he had a share in producing those reliefs. Yet most scholars have drawn the opposite conclusion, interpreting *alios* as a reference to several lesser artists who were to help Donatello with the execution of the panels, notably Michelozzo, Pagno di Lapo, and Maso di Bartolomeo. Since the quality of the carving is very uneven, there have been a number of attempts to identify the personal styles of these various assistants in some, or all, of the seven reliefs. Thus Tschudi (*D.*, p. 15) regarded only the first panel from the left as carried out by Donatello himself and assigned the rest to the hand of Michelozzo; Semper (*D.* '87, p. 55) saw the help of Michelozzo in the first, sixth, and seventh panels; Pastor (*loc.cit.*) attributed the first two to Michelozzo, the next three to Donatello, and the remaining pair to an unknown, clumsy assistant; and Siegfried Weber (*Die Entwickelung des Putto in der Plastik der Frührenaissance*, Heidelberg, 1898, pp. 50ff) proposed an even more complicated division of labor, according to which the first panel was carried out by Michelozzo, the second perhaps by Agostino di Duccio, the third by Buggiano, the fourth by an unknown hand, and the sixth probably by Pagno. Among recent authors, Planiscig (*D.*, p. 66) has linked the name of Michelozzo with the last three reliefs (counting, as always, from the left), while Marchini (*op.cit.*, pp. 115f) assigns the third panel to Maso, the fifth to Michelozzo, and the sixth to Pagno (the first two, he suggests, were carried out by unknown assistants reflecting the manner of Desiderio da Settignano and Luca della Robbia, respectively). These varied opinions hardly deserve to be analyzed in detail; they are, for the most part, set forth without tangible evidence of any kind, and the measure of disagreement they exhibit among themselves indicates both their arbitrary character and the inherent difficulty of the problem they propose to solve. On the basis of the available records, we cannot connect the

name of any of the men working around Donatello with the execution of the balustrade reliefs. The participation of Michelozzo, as we have shown above, is highly improbable. Maso, to be sure, can be linked to the pulpit enterprise from 1434 on by documentary evidence, but he seems to have worked on the spot, in Prato, while the balustrade reliefs were produced in Florence (this is documented for four of them, and may be inferred for the rest as well); moreover, his contributions to the project, so far as we know them, were confined to the carving and installing of various parts of the architectural framework (the unpublished sections of the Prato account books would have to be checked in order to establish this point securely). In the case of Pagno di Lapo, there is no assurance that he had anything to do with the pulpit at all; the mere fact that the *operai* sent him to Rome in the spring of 1433 does not permit us to conclude that he had been working on the pulpit.[4] Fabriczy ("Pagno di Lapo," *Jahrbuch Kgl. Preuss. Kunstslgn.*, XXIV, 1903, Beiheft, p. 120) is on equally unsafe ground when he includes Pagno among the *alios* of the 1434 agreement simply because he was sent to Siena some months later as Donatello's *garzone* (see above, p. 66). In a way, the very lack of any reference to Pagno among the Prato records concerning the work on the pulpit might be said to increase the likelihood of his having assisted Donatello with some of the balustrade reliefs in Florence, but that he actually did so must be proved on stylistic grounds alone, and his artistic personality —if, indeed, he had one—remains as elusive as ever.

We are thus faced with the same difficulty here that confronts us in the Cantoria reliefs and wherever else we find Donatello making use of assistants to carry out his designs: the individual contributions of these lesser men can never be clearly distinguished, for their own style always seems to yield under the impact of Donatello's overwhelming personality. All of the Prato panels are surely based on more or less detailed sketches by the master, but so far as their execution is concerned I can only agree with the great majority of Donatello scholars, who have felt it impossible to differentiate among the participating hands. All that can be said in this respect with any degree of assurance is that the three reliefs farthest to the right are distinctly inferior to the others, both in composition and workmanship. They also show greater affinity with the left half of the frieze and the lateral panels of the Cantoria. The Prato reliefs, then, seem to fall into two rather clear-cut groups. This agrees with the documentary evidence we have, which tells us that the first of the panels was finished in June 1434; that the marble blocks for three more panels had been

[4] He may very well have been picked for the errand because of his association with Donatello and Michelozzo in 1426-1427; nor was he in Prato at the time, since the *operai* had to send another man to Florence in order to arrange Pagno's mission.

turned over to Donatello three months later; that in April 1436 three reliefs—presumably those mentioned before—were unfinished but were delivered two months later; and that by July 1438 all the reliefs had been installed. Evidently four reliefs were made in 1434-1436 and three in 1436-1438. The latter group must be the three panels on the right, hastily conceived, crudely executed, and given the least conspicuous positions (i.e. those towards the flank of the church). Among the other four, we may expect one to stand out: the earliest, which according to the letter of Matteo degli Organi received such high praise from the experts in Florence. Here, however, we are likely to be disappointed; the choice, for me at least, is not easy to make. Eliminating the second panel from the left as the weakest of the group, and also rejecting the first panel (although less decisively) as but slightly superior to the second, which it otherwise resembles in many ways, I find myself wavering between the third and fourth. They have been nominated for this distinction before; the third by Cruttwell (*D.*, pp. 74f), the fourth by Marchini (*loc.cit.*), who argued that it occupies the place of honor in the center of the balustrade and that it seems to have been especially famous in the Quattrocento, since there is a drawing after it, attributed to Pisanello, in Berlin.[5] The central position of the panel might be of some significance if each relief had been installed on the pulpit immediately after its delivery, for in that event it is not implausible to assume that the most conspicuous field would have been filled first. But this procedure presupposes an independently constructed architectural framework for the balustrade, and no such framework ever existed, since the pilasters and the reliefs they frame are carved from the same block. Thus the first panel to be delivered could not have been installed all by itself in 1434. It is not impossible, however, that the *operai* decided to start installing the balustrade two years later, after the arrival of three more panels (all in the same shipment, as the documents show); four reliefs together would have been enough to form a fairly stable arc and to cover the more important half of the balustrade. That this was actually done is suggested by the fact that the other three reliefs, occupying the least favorable positions, are so clearly set

apart from the first group stylistically. External evidence, then, does not help us to decide which of the two panels under consideration is the one mentioned in Matteo's letter. (We can hardly assume that the *operai*, or Donatello, thought of it as deserving a place of honor merely because it was the "first-born.") But can we really be sure that this "original" relief must be artistically superior to the rest? After all, Matteo degli Organi, as the whole tone of his letter shows only too clearly, wrote not as a detached observer but as an ardent partisan of Donatello. The famous organ builder, who was something of a temperamental genius himself,[6] must have been a close personal friend of our artist. Did he not perhaps exaggerate the response of the experts to the panel, the better to plead Donatello's cause? However that may be, neither of the two reliefs in question seems to me entirely by the master's own hand. The matter is particularly difficult to judge inasmuch as the surfaces of all the panels suffer from the effects of weathering. On broader stylistic grounds, I would tend to give priority to the third relief, rather than the fourth, because the angels here seem closest, in both type and behavior, to those of the St. Peter's tabernacle and to the *putti* of the Siena Font (see Pls. 42b, c, 31c, d, e). Their movements, too, are less frantic, and the composition more self-contained, than anywhere else on the balustrade, so that among all the Prato panels this one is farthest in spirit from the frenzy of the Cantoria frieze. The exact chronological relationship of these two works and their sculptural *décor* appears so complex as to discourage any attempt at disentangling it on the basis of the available records, yet it would be of some interest to identify the first of the Prato reliefs. For at the time it was produced, in 1433-1434, Donatello had not yet conceived the bold idea of filling the Cantoria balustrade with a continuous frieze; his design for it consisted of a sequence of separate panels similar to those of the Prato Pulpit and of Luca's Cantoria (see below, p. 127). None of these panels for the first Cantoria project was ever executed, but there probably were small-scale sketches for them, and the earliest of the Prato reliefs—once we know which one it is—would give us some notion of what they looked like.

[5] Cf. Kauffmann, *D.*, p. 221, n. 227, who also lists a number of terracotta copies after the Prato panels. According to George F. Hill (*Pisanello*, London, 1905, p. 25) the drawing in question

does not show the entire fourth relief but only one figure from it.

[6] Cf. his troubles with the *operai* of Florence Cathedral, recounted in Poggi, *Duomo*, pp. cxxxff.

*Critical Catalogue*

CANTORIA, MUSEO DELL'OPERA DEL DUOMO, FLORENCE

PLATES 49-53. Marble, with gold and colored mosaic inlay. 1433-1439

*PLATES 49-53* Marble, with gold and colored mosaic inlay *1433-1439*

RECONSTRUCTED ENSEMBLE
H. 348 cm; L. c.570 cm
Square fields between brackets, H. and W. 92.5 cm (including frame)

ANGEL FRIEZE
H. 98 cm; L. 522 cm (front), 132 cm (sides)
Columns, H. 108 cm

Lost: considerable portions of the architectural framework of the balustrade (see below). For the two bronze heads originally attached to the second and third field between the brackets, see below, pp. 123ff.

[The two bronze *putti* holding candelabra in the Musée Jacquemart-André, Paris, claimed as part of Donatello's Cantoria by Paul Schubring (*Luca della Robbia*, Leipzig, 1905, p. 19) and Robert Corwegh (*Donatello's Sängerkanzel* . . . , Berlin, 1909, pp. 23f), have been convincingly eliminated from the master's œuvre by Lányi (*Pragm.*, p. 129, and *Mitteilungen d. Kunsthist. Inst. Florenz*, v, 1939, p. 213), who attributed them to Luca della Robbia and pointed out that they had belonged to Luca's Cantoria, where they were seen by Vasari (Milanesi, II, p. 170) and later authors. There is no testimony linking such figures with Donatello's Cantoria.]

DOCUMENTS

A series of entries in the records of deliberations and disbursements by the *operai* of the Florence Cathedral workshop, in the archives of the Opera del Duomo. They were published, piecemeal, by Cesare Guasti (*La Cupola di S. Maria del Fiore*, Florence, 1857, p. 89), Semper (*D. '75*, pp. 282ff), C. J. Cavallucci (*S. Maria del Fiore* . . . , Florence, 1887, Appendix, pp. 141f), Frey (*Cod. Magl.*, p. 299), and Bernardo Marrai (*Arte e Storia*, XIX, 1900, pp. 3ff). Reproduced most completely and systematically in Poggi, *Duomo*, pp. 257ff, under the following numbers:

1433, July 10 (*1286*): The *operai* authorize Neri di Gino Capponi, one of their members, to order from Donatello a marble pulpit, to be placed above the door of the second, "new" sacristy; and to decide upon the subject, conditions, price, and delivery date, except that the cost must not exceed that of the pulpit ordered from Luca della Robbia.

November 14 (*1287*): Donatello is to be paid 40 florins for each piece [= panel] of his pulpit that is equivalent to those of Luca della Robbia, provided the workmanship is at least as good as Luca's; if it should be better, he may receive up to 50 florins per panel. Donatello must finish each piece within three months after receiving the block, which will be furnished by the *opera* but for which he must give security through a reliable bondsman.

November 19 (*1288*): Donatello, at work on the pulpit, receives 15 florins in part payment for it.

November 23 (*1289*): The master-in-charge of the *opera* is to see to the repairing of the window of the chapel where Donatello is at work on the pulpit, and to purchase a linen curtain for it. Lotto di Giovanni di messer Forese Salveti receives 15 florins for a block that has been purchased from him and turned over to Donatello for the pulpit.

December 10 (*1290*): Donatello receives 4 florins as advance payment for the pulpit he is working on.

December 15 (*1291*): A cartage charge of 11 soldi has been incurred for the above-mentioned block.

December 23 (*1292*): Donatello receives 10 florins as advance payment for the pulpit he is working on. (*1251*): Francesco d'Andrea Fraschetta, stonecarver and supplier of white marble, is to be paid 60 lire for a block 5 braccia long, which Donatello is working on for the pulpit, and for two other pieces, each 2 braccia long, for the pulpit of Luca della Robbia.

December 30 (*1293*): Donatello receives 11 florins in part payment for the work he is doing on the marble pulpit. (*1252*): The *operai* have commissioned Francesco d'Andrea Fraschetta of Settignano to quarry at Carrara and to bring to Florence a block larger than those used for tombs,

and of a size and shape to be specified by Filippo Brunelleschi and Battista d'Andrea, the master-in-charge of the *opera*, for the pulpit being made by Donatello, as well as two pieces of marble . . . for the pulpit of Luca della Robbia.

1434, March 18 (*1294*): Donatello, who is working on the marble pulpit, receives 15 florins.

1435, February 22 (*1295*): The *opera* has bought from Francesco d'Andrea Fraschetta and his helpers, for 29 florins, two marble blocks which they had procured for Donatello's pulpit but which the latter had refused to accept since they were not of the right size.

March 2 (*1296*): Donatello receives 4 florins on account of the pulpit he is doing, so that he will be able to pay the masters who are working with him.

April 8 (*1297*): Donatello is advanced 10 florins for the marble pulpit.

April 11 (Cavallucci, *loc.cit.*; Semper, *loc.cit.*, doc. 77; not in Poggi): The master-in-charge of the *opera* is to utilize for the lantern of the large dome a certain block that had been procured for the Donatello pulpit but did not fit the requirements.

1436, February 17 (*1298*): Donatello receives 4 florins on account of the marble pulpit he is doing.

August 14 (*1299*): The master-in-charge of the *opera* is to provide Donatello with a marble tomb block [*lapidem marmoris sepulture*—apparently a standard size then in use; see *s.v.* "December 30, 1433"] for the cornice of the pulpit; also with another marble block for the sides of the same pulpit.

August 17 (*1300*): Donatello receives 8 florins in part payment for the marble pulpit he is doing.

December 19 (*1301*): Donatello receives 12 florins in part payment for the marble pulpit he is doing.

1437, January 21 (*1302*): Donatello receives 30 florins in part payment for the marble pulpit he is doing.

March 19 (*1303*): Donatello receives 40 florins in part payment for the marble pulpit he is doing.

1438, May 19 (*1304*): Donatello receives 40 florins in part payment for the marble pulpit he is doing.

June 20 (*1305*): Gualterotto de'Riccialbani, provisor [of materials for the *opera*], is directed to furnish Donatello with enough marble of the kind necessary for completing the pulpit. Donatello receives 50 florins in part payment for the marble pulpit he is doing.

August 28 (*1306*): Donatello receives 50 florins in part payment for the marble pulpit he is doing.

October 14/15 (*1307*): Donatello receives 150 florins in part payment for the pulpit he is doing.

October 30 (*1308*): Donatello is to be given the two pieces of marble he needs in order to finish the pulpit, which is almost completed.

November 17 (*1309*): One of the several masters who have been assigned to help Donatello with the pulpit, will be needed in the Cathedral workshop for eight days; he is to be designated by the master-in-charge, Battista d'Andrea.

December 16/17 (*1310*): Donatello receives 50 florins in part payment for the pulpit he is doing.

1439, February 5 (*1311*): Donatello is reimbursed 7 florins spent in buying marble for the pulpit he has made.

October 12 (*1312*): Donatello is to be given 300 pounds of bronze for a certain head that is to be made for an opening beneath the pulpit, to match the other head.

December 16 (*1313*): Donatello receives 50 florins for the pulpit.

1440, January 12/February 5 (*1314*): Donatello receives 100 florins in part payment for the pulpit he has made and installed in the Cathedral.

1446, February 23/26 (*1315, 1316*): After consultation with experts, the *operai* have set the price of

Donatello's pulpit at 896 florins; this is to cover, down to the present day, the cost of all the work and all the material, whether marble or bronze, used for the angels and for the two heads Donatello has made and installed.

February 28 (*1317*): The *opera* promises Cosimo de'Medici and his associates to pay the residual amount still due Donatello for the pulpit within six months of the day when Donatello will have cast the doors of the sacristy allocated to him.

1456, February 29 (*1414*): Payments are authorized to the painter Piero Chellini and to the heirs of the goldbeater Piero for the gilding of the foliage of a "crown" above the small organ on the pulpit of Donatello.

August 9 (*1318*): The heirs of the goldbeater Piero are to be paid 20 lire 13 soldi for 600 pieces of goldleaf they have supplied for gilding the two bronze heads that were beneath the pulpit of Donatello.

SOURCES

(c. 1475) *Vita di Brunellesco*, attributed to Antonio Manetti (ed. Elena Toesca, Florence, 1927, p. 66): "[Donatello] knew little of architectural settings (*quadro*), as is evident from his pulpit in S. Maria del Fiore and the other pulpits or any similar work involving architectural design."

1510 Albertini, p. 9: "There are in [S. Maria del Fiore] two sacristies with two organs; the ornament of one [organ] is by Donatello. . . ."

(Before 1530) Billi, p. 40 (repeated, with minor changes, in Cod. Magl., p. 76): "[Donatello did] the decoration of the organ of the old sacristy, that is of the lesser organ, in marble in S. Maria del Fiore. These figures are only roughed out and not finished, yet from the ground level they are more effective and seem more strongly modeled than those of the main organ, by Luca della Robbia, which have been finished with care but look less well from the ground."

(c. 1550) Gelli, p. 58: "[Donatello] made [in S. Maria del Fiore] the decoration of the old organ; these figures, even though only roughed out, look marvelous from the ground level."

1550 Vasari-Ricci, I, *s.v.* "Luca della Robbia," p. 249: ". . . the *operai* were moved to commission from him the marble ornament of the organ above the new sacristy of S. Maria del Fiore. There he represented choirs of music with diligence and subtlety; some figures are singing, and even though they are high up one can see the breath swelling their cheeks, as well as the beating of the hands of the conductor on the shoulders [of those in front of him]. In the same panels he imitated both sounds and dance movements . . . , finishing it all very much more neatly than Donatello did. For the [marble ornament] of Donatello shows more decisive skill and more masterly vividness, which are not produced by technical perfection. . . . Among outstanding artists the sketches always are more forceful and vivid than the finished works. The heat of inspiration lets the artist express his idea in an instant, and this can never be done by the diligent labor demanded for highly finished works."

Vasari-Ricci, p. 49 (Milanesi, p. 401, slightly rephrased): "[Donatello] did the decoration of the organ above the old sacristy in the church of S. Maria del Fiore], with roughly carved figures which, viewed from the ground, seem truly to be alive and in motion; whence it might be said of him that he used his judgment as much as his hands in his work."

1568 Vasari-Milanesi, II, pp. 170f, *s.v.* "Luca della Robbia," addition to the comparison between Luca and Donatello cited above: "Above the cornice of this ornament Luca made two nude angels of gilt bronze, beautifully finished as was the whole work, which was considered most rare. Donatello, on the other hand, who later did the ornament of the other organ opposite this one, used much

more judgment and skill than Luca, as will be said in the proper place; for he left almost all of the work in the rough, instead of finishing it neatly, so that from a distance it looks much better than Luca's does. Despite all its good design and diligence, the smooth, high finish of Luca's work causes the eye to lose it at a distance and not to see it clearly, while this is not true of the sketchy carving of Donatello. Artists ought to pay much attention to this, because experience shows that all things seen at a distance, whether paintings, sculpture or anything else of like sort, look bolder and more forceful if they are a skillful sketch than if they are fully finished. Apart from the effect of the distance as such, it often happens that the sketch, born in an instant in the heat of inspiration, expresses the artist's idea in a few strokes; too much effort and diligence, on the contrary, sometimes will sap the power and insight of those who never know when to leave well enough alone. Those who realize that all the arts of design, and not painting alone, are similar to poetry, know that as the poems composed in a state of poetic rapture are the true and good ones, and superior to those produced with effort, so the works of men who excel in the arts of design are better when they result from a single impulse of that rapture than when they are produced little by little with toil and persistence. He who knows what he wants to do from the very first—as he should—will always attain perfect realization with great ease. Yet since the minds of men are not all of the same stamp, there are also some, though not many, who do not do well unless they proceed slowly."

Vasari-Milanesi, p. 401, addition to the description of Donatello's Cantoria: "Inasmuch as many of his works look beautiful as long as they remain in the places for which they were made, but when they are moved elsewhere, in another light or higher up, their appearance changes and they seem the very opposite of what they were before. Thus Donatello made his figures in such a way that in his workshop they did not look half as well as in the places for which they were intended." (Repeated in Borghini, *Riposo*, pp. 318f.)

The original purpose of the Cantoria does not emerge clearly from the documents. The term "Cantoria" (singers' pulpit, choir loft) is of purely modern coinage, and has been retained here for no other reason than convenience. While Luca della Robbia's Cantoria is referred to from the very start as the "organ pulpit" (*perghamo degli orghani*; Poggi, doc. *1241*, April 9, 1432) and can thus be linked with the commission for a new organ given to Matteo da Prato that same year (cf. Poggi, p. cxxxi), we have no such assurance for Donatello's. A few years later, however, as the new organ was approaching completion, the old or "small" organ was installed on the Donatello Cantoria and, in 1448-1449, provided with a wooden housing (Poggi, p. cxxxvi) to match that of the new instrument. These wooden enclosures seem to have covered the entire width of each Cantoria, rising to a considerable height, if we can trust our only visual source, a print of 1610 by Matteo Greuter (Poggi, fig. 89) that shows them in rather sketchy fashion. Was there room for singers as well behind these screens, at least in the case of Donatello's pulpit? The early sources give no hint of this, since they describe both pulpits simply as "organ decorations." Only Bocchi-Cinelli (pp. 59f) suggests a difference of functions, referring to Luca's Cantoria as "the figures of the organ" and to Donatello's as "the musicians' loft where the other organ is." Because of the contradictory use of the term "old sacristy" by Vasari, Bocchi-Cinelli, and other early writers, the exact location of Donatello's Cantoria remained in doubt until Poggi (p. cxxviii, n. 2) settled the matter by proving that it had been above the entrance to the sagrestia dei Canonici, on the south side of the church (against Corwegh, *op.cit.*, pp. 21ff, who placed it on the north side, above the bronze doors of Luca della Robbia). The balustrades of both pulpits were dismantled in 1688, on the occasion of the wedding of the Grand Duke Ferdinand; on the brackets, which remained in place along with the reliefs in between them, very much larger wooden balconies were erected, extending over the entire width of the wall and accommodating more than a hundred singers, while the balustrade reliefs were used to decorate two orchestra stands in the choir.[1] Unfortunately, the orchestra stands were purely

[1] Cf. Alessandro Segni, *Memorie de'viaggi e feste per le nozze . . .*, Florence, 1688, p. 63, cited in Poggi, p. cxxix. Segni justifies the dismantling on the ground that these "exquisite reliefs" had been "eaten up" by their distance from

the beholder and could now, at last, be enjoyed more fully; apparently he placed little stock in Vasari's claim that Donatello's Cantoria panels were calculated for long-range viewing. That the reliefs of the bracket zone remained *in situ* is to be

temporary, and after the wedding the Cantoria reliefs were stored away and forgotten (Bottari, in his edition of Borghini's *Riposo*, Florence, 1730, p. 256, n. 2, declares that their whereabouts are unknown). Their architectural framework suffered an even worse fate; much of it disappeared altogether, since the individual parts were used for repairs like ordinary pieces of marble (Marrai, *op.cit.*, pp. 11f). Only the columns of Donatello's balustrade survived intact, protected, as it were, by their unusual shape and surface decoration, which made re-use difficult. At the beginning of the last century, the balustrade reliefs were again displayed to the public in a room of the Opera del Duomo; in 1822 they were transferred from there to the Uffizi Gallery (Marrai, *loc.cit.*). In the early 1840's (Marrai, *loc.cit.*: 1845; Poggi, *loc.cit.*: 1841; Paatz, *op.cit.*, p. 377: 1844-1846) the wooden balconies of 1688 resting on the lower portions of the two pulpits were replaced by the present stone structures, and the brackets, reliefs, and moldings that had remained *in situ* so far were stored in the Opera del Duomo. Finally, towards 1870, all these *disjecta membra* were brought together in the Museo Nazionale, where they were exhibited as fragments, together with the balustrade panels from the Uffizi. The first impulse towards reconstructing the two pulpits came from Emilio Marcucci, who discovered a small piece of the upper cornice of Donatello's Cantoria (Marrai, *op.cit.*, pp. 13f); an official decision to do so followed in 1883, but the actual work was slow in getting under way and seems to have taken about a decade, in the course of which it was decided to install the recomposed pulpits in the newly founded Museo dell'Opera del Duomo. The public controversies connected with the entire process are hardly worth recounting in detail (cf. the bibliographical data in Paatz, *op.cit.*, p. 599, and Poggi, *loc.cit.*). The reconstruction had been entrusted to Luigi del Moro, who encountered little difficulty with the Donatello Cantoria once he had identified a set of small columns in the courtyard of the Opera del Duomo as belonging to that pulpit (Marrai, *loc.cit.*). The only design problem he could not solve on the basis of surviving original parts was posed by the fact that the columns were 14 cm taller than the sculptured frieze. He finally closed this gap by means of a concave strip above the frieze, decorated with the same mosaic inlay. Reymond (*Sc. Fl.*, II, pp. 106f) has pointed out, with good reason, that it would have been preferable to raise the frieze in relation to the columns by placing it on a plinth, and to fill the remaining space above with a narrow carved molding. Such a solution had actually been contemplated in Del Moro's first reconstruction drawing (illustrated in Corwegh, *op.cit.*, p. 6); it would not only conform to the framing of the reliefs on the balustrade of the Prato Pulpit but would also be in accord with the original installation of the Cantoria high above the church floor. Heinrich Brockhaus (*Zeitschrift f. bild. Kst.*, XIX, 1908, pp. 160f) further postulated an inscription on our pulpit, analogous to that on Luca's Cantoria but chosen from Psalms 148 and 149, which he proclaimed as the theme of Donatello's frieze (this had already been suggested previously in Balcarres, *D.*, p. 113). However, the words of these Psalms have no specific bearing on our reliefs, since they contain only one passing reference to the dance (*Filii sion ... laudent nomen eius in choro*), while in Luca's Cantoria the correlation of text and image is precise and extensive. Nor would an inscribed band fit the style of our pulpit. Corwegh (*op.cit.*, p. 28), again for rather far-fetched reasons based on the symbolic interpretation of Donatello's Cantoria, objected to the ornamentation of the top cornice, which Del Moro had derived from the small original fragment (in the reconstructed pulpit, this piece appears above the second pair of columns from the right). Instead, he proposed an alternating arrangement of vases and shells, separated by acanthus leaves, with the vases directly above the columns. Here the simpler sequence chosen by Del Moro seems far more in harmony with the decorative scheme of the zone below the frieze. The reconstituted ensemble of the Cantoria was to remain on view in the Museo dell'Opera del Duomo for almost half a century. After Italy's entry into the Second World War, it was taken apart once more and removed for safekeeping. Since the reopening of the Museo some seven years ago, the various parts of the pulpit have been displayed only separately.

The two bronze heads mentioned in the documents of October 12, 1439, and February 23/26, 1446, had been regarded as lost (cf. the Catalogue of the Museo dell'Opera del Duomo, Florence, 1904, pp. 34ff). There can be no doubt that the openings beneath the pulpit for which they were made (termed *bucha sive foramen* in the document of 1439) are the two *oculi* between the inner brackets. The available records, unfortunately, do not indicate whether the heads remained in place until the brackets themselves were removed; since they are not mentioned in any of the sources, they may well have been detached a good deal earlier. Nor do the documents suggest what kind of heads they were. Schubring (*KdK*, p. xxxiv) thought of them as masks, and Cruttwell (*D.*, p. 77) believed them to have been lions' heads. Her conjecture, although unsupported, is not necessarily wrong, yet it seems likely that the heads in question were human;

inferred from the description in Follini-Rastrelli, *Firenze antica . . .*, II, Florence, 1790, p. 226; see Paatz, *Kirchen*, III, pp. 598ff, n. 648.

otherwise we could reasonably expect to find some qualifying phrase or term among the several references to them in the documents. Corwegh (*op.cit.*, pp. 12, 13, 26f) identified them with two bearded bronze heads of unknown origin in the Museo Nazionale, which were then regarded as antique but which he dated in the first half of the Quattrocento. Poggi (pp. cxxviif) and D. v. Hadeln (*Repertorium f. Kw.*, XXXII, 1909, pp. 382ff) immediately rejected this proposal, on the ground that the heads did not fit the *tondi* of the Cantoria and were certainly not the work of Donatello. Later authors have expressed the same opinion (Colasanti, *D.*, p. 28; Planiscig, *D.*, p. 63). Nevertheless, the two heads were transferred to the Museo dell'Opera del Duomo in the 1930's and mounted on the *tondi* (set in new plaques of colored marble). Today they are again on display, along with the marble panels of the Cantoria. Lányi (*Probl.*, p. 23) proposed to identify another bearded bronze head, still in the Museo Nazionale and of undoubted Quattrocento origin, with one of those from the Cantoria, but without stating his reasons (see below, p. 247 and Pl. 127c, d). This thesis, too, has failed to win endorsement from other scholars.

In my view, the Corwegh proposal is far from implausible. The size of the two heads (39 cm from the tip of the beard to the top of the head) is well adapted to the diameter of the *tondi* (63 cm inside the frame), nor can there be any doubt that they were meant to be mounted against a vertical surface above the eye-level of the beholder, while the same is emphatically not true of the head referred to by Lányi.[2] The very existence of the heads might be said to constitute a strong argument in Corwegh's favor; after all, would it not be an amazing coincidence if these two matching heads, of the right size and material for the Cantoria, had been produced for some other purpose? So far as I know, there is not another pair anywhere in Italy that could be substituted for ours. Considering the circumstances, the question of authorship is of secondary importance in determining whether or not our heads belong to the Cantoria. That they are not the work of Donatello is clear enough; in fact, they do not even reflect the master's style sufficiently to be labeled as "workshop pieces" (compare the head at the right-hand corner of the base of the St. Louis Tabernacle, Pl. 23c, or the heads on the capitals of the Annunciation Tabernacle in S. Croce, Pl. 46a, b, c). At first glance, both seem so completely dependent on ancient models that we can well understand why they were

at one time regarded as antique. Yet upon more careful study we become aware of subtle differences between the two heads: the one on the left (in the present installation; see Pl. 51e, f) is so superior to its companion that the relation between them can only be described as that of original and copy. Could it be that this head is an *ancient* original? At the very least, it must be acknowledged as an extraordinarily faithful replica of an ancient piece, which in turn served as the model of the second head. In the latter there is a consistent loss of plastic values and expressive power, detail for detail.[3] Perhaps this difference in artistic level is the key to our problem if we keep in mind the peculiar language of the document of 1439: we learn from it, not that Donatello had to make two heads but that he was to provide one head, which had to match another that was already there. A later entry, to be sure (February 23/26, 1446), refers to "the two [bronze] heads Donatello has made and installed"; but this might either be a slip on the part of the writer (if our artist contributed only one head, this fact may not have been remembered clearly seven years later), or the reference to "making and installing" could be interpreted as a hint that one of the heads was only installed but not made by Donatello (the "making and installing" applies to the two heads alone, not to the angels mentioned in the same sentence). However that may be, the language of the documents certainly does not prohibit the assumption that Donatello was called upon to furnish only one bronze head. And if this task meant no more than the copying of an ancient head (or of the replica of an ancient head), our master would have been more than likely to turn it over to some lesser man; after all, he employed assistants to a very conspicuous extent for the marble reliefs of the Cantoria as well (see below). Such a hypothesis may also help to explain how the two heads came to be added to the Cantoria in the first place. Corwegh, *loc.cit.*, regarded them as representing prophets; but if this is true, why does not Luca's Cantoria show the same feature? Iconographically, prophets seem equally unnecessary in both pulpits. Why, moreover, was there no provision for the two heads from the very start? The documents certainly suggest that they were added as an afterthought. Why were they copied so directly from the antique? And why were they not made of marble like the rest of the pulpit? In the shadowy recesses between the brackets, the dark bronze must have been almost impossible to see, and the gilding of the heads in 1456 may be regarded as an attempt to

[2] In the composite photograph of the Cantoria published by Corwegh (*op.cit.*, p. 2) the heads are shown from the wrong angle and on far too large a scale in relation to the *tondi*.

[3] The present state of scholarship does not seem to provide reliable criteria for determining whether one of the two heads is ancient or whether both are pseudo-antique works of the

Quattrocento. A somewhat similar problem has recently been analysed by Elena Toesca ("Il cosidetto Omero degli Uffizi," *Bolletino d'Arte*, XXXVIII, 1953, pp. 307ff), who recognized a supposedly classical "Homer" bust as a Renaissance piece that seems to reflect monumental bronze heads such as those from the Cantoria.

make them stand out more effectively. (At present, the two heads show no trace of gilding, but since they were gilt with goldleaf rather than by the more expensive and durable process of fire gilding, this is in no way extraordinary.) Thus, as long as we think of them as prophets, the presence of the heads on the Cantoria remains puzzling, not only iconographically but also aesthetically and technically. If our analysis of their style is correct, all these difficulties might be resolved by postulating a sequence of events as follows: in the later 1430's, a newly discovered ancient bronze head of monumental size came to Donatello's attention (i.e., the head to the left, or its model) and caught his fancy to such an extent that he proposed to add it, and a matching copy, to the Cantoria, which was well under way at that time. Our artist's interest in such finds, as well as his reputation as an expert judge of ancient art, is well attested; Nanni di Miniato, in two letters (September 28, 1428 and December 10, 1430), refers to two classical sarcophagi found between Lucca and Pisa which "Donatello has praised as good pieces" (Semper, *D.* '75, p. 311; the full texts in Cornelius v. Fabriczy, *Jahrbuch Klg. Preuss. Kunstslgn.*, XXVII, 1906, pp. 74ff). Poggio Bracciolini, writing from Rome (Sept. 23, 1430; see above, p. 101), also mentions some ancient object that had been inspected and praised by Donatello. And Donatello himself owned some classical pieces in the 1430's, according to Ciriaco d'Ancona, who visited both Donatello and Ghiberti and saw "many ancient images as well as new ones of marble and bronze made by them."[4] Apparently Donatello decided to incorporate the two heads in the Cantoria because he thought of the whole lower half of the Cantoria as "the zone of antiquity."[5] For the two marble reliefs on either side of the bronze heads, significantly enough, are direct copies after ancient works, in striking contrast to the rest of the panels.[6] Exact "quotations" of ancient art such as these do not occur at random in Donatello's *œuvre*. Whenever we do find them—on the helmet of Goliath in the bronze David, on the medallion of the bronze bust in the Museo Nazionale, on the base of the Judith—they would seem to have a particular

meaning. In the present instance, this meaning is suggested by the fact that the four "ancient" *putti* are nude and wingless (as against those of the upper zone), and intentionally so, since their classical prototypes have wings as well as little cloaks (clearly visible in the Ravenna fragment). There would seem to be, then, a conscious juxtaposition of the two regions here: Christian jubilation on the balustrade, supported by the pagan realm of classical antiquity below. In this context, the two bronze heads are no longer an alien element. Without losing their own identity, they have been integrated into a larger whole, alongside the "pagan offerings" of the flanking reliefs (fruit bowl and altar torch).[7]

Our interpretation of the program of the Cantoria lends further weight to the arguments advanced by various scholars against the nineteenth-century view of Donatello's dancing angels as essentially pagan in spirit (e.g. Eugène Müntz, *Donatello*, Paris, 1885, p. 42; Bertaux, *D.*, pp. 112ff). While the Cantoria frieze does not illustrate any particular Psalm (as claimed by Brockhaus and Corwegh), this "bacchanalian revel" is surely meant to take place in the celestial sphere, and Kauffmann (*D.*, p. 72) may well be right in linking the wreaths and the flower-strewn ground with the veneration of S. Maria del Fiore, the Virgin of the flowers, even though he probably overstates his case when, on the basis of the Prato Pulpit, he attributes a specifically mariological significance to the dancing-angel motif and claims both Luca's and Donatello's Cantoria as parts of a great mariological cycle culminating in the stained-glass window of the Coronation (cf. the cautionary remarks of Middeldorf, *AB*, p. 575, n. 8). Significantly enough, the relationship of our frieze to the dancing *putti* on ancient sarcophagi and funerary urns, although practically a standard *topos* of Donatello literature, is at best no more than a very general one. The various comparisons adduced up to now (see Corwegh, *op.cit.*, pp. 34, 38; O. Sirèn, *Essentials in Art*, London, 1920, pp. 108f, fig. 13; and Arduino Colasanti, "Donatelliana," *Rivista d'arte*, XVI, 1934, pp. 45ff) match neither the individual poses nor the fluid rhythmic movement of Donatello's dancers. Themati-

[4] See the biography by his friend Scalamonti, in Giuseppe Colucci, *Delle antichità Picene*, XV, Fermo, 1792, p. 91. Semper (*D.* '75, p. 312), the first to draw attention to this passage, places the event in 1437, but this must be an error since Scalamonti's biographical notices stop with the year 1435. The visit must have taken place about 1434, when Ciriaco was in Florence after attending the coronation of the Emperor Sigismund. Cf. Georg Voigt, *Die Wiederbelebung des classischen Alterthums . . .*, 2d ed., I, Berlin, 1880, p. 277.

[5] The installation recalls the small heads emerging from roundels on the frame of Ghiberti's East Doors, as well as the *imagines clipeatae* of Hellenistic and Roman art; on the latter, cf. Giovanni Becatti in *Le Arti*, IV, 1942, pp. 172ff and the literature cited there.

[6] Corwegh (*op.cit.*, pp. 33, 38) has found the model of the

relief on the left in a fragment of the so-called "Throne of Ceres" in Ravenna, and of the other in a badly mutilated section of the so-called "Throne of Neptune" in the Museo Archeologico, Milan; the format and framing of the two reliefs, however, betrays the influence of Early Christian ivories such as the Probianus Diptych; cf. below p. 137.

[7] Intriguingly enough, the concept of pagan antiquity supporting the Christian era occurs at the same time in Northern European art; the Last Communion of Saint Mary Magdalene, one of the panels of Lucas Moser's Tiefenbronn Altar of 1431, shows a statue of the Madonna on a bracket supported by a mutilated male nude figure that is clearly the pagan counterpart of a Synagogue. For a more detailed interpretation of this subject, cf. H. W. Janson, *Apes and Ape Lore . . .*, Studies of the Warburg Institute, Vol. 20, London, 1952, pp. 119ff.

cally, their performance is better explained as a free and dynamic version of the round dances so often encountered in Trecento art (cf. Kauffmann, *D.*, pp. 73f). Neither this source nor the dancing *putti* of ancient art, however, explain the wreaths that play such a conspicuous part on the right-hand side of the main frieze. In shape these wreaths are the direct descendants of the wreaths on the bases of the Siena *putti* and the bronze David, but their use on the Cantoria is so extraordinary that one cannot help wondering about the origin of this particular idea. The only antecedent that has come to my attention (I owe it to the kindness of Dr. Ernst Gombrich) occurs on Byzantine ivory caskets, which often show one or more *putti*—or maenads reduced to the size of *putti*—dancing with wreaths.[8] Apparently these figures developed from a combination of the classic floating *putti* or victories with wreaths and various types of ancient dancers. Their gestures and movements are very much more violent than those of any dancing figures in ancient art, so that in this respect, too, they recall the Cantoria frieze. The caskets themselves must have been highly valued in mediaeval Italy; a good many of them are still in Italian collections today. In the Early Renaissance these tiny ivory carvings were probably appreciated in much the same way as ancient gems. Donatello could easily have seen them in various church treasuries (in which case they may well have had the double interest of hallowed Christian objects echoing classic beauty). That he did indeed derive the wreath-dance of the Cantoria frieze from this source is confirmed by one curious detail: Because of their small scale, the wreaths on the caskets often appear reduced to rings or hoops; and on the right-hand side of the Cantoria frieze one of the wreaths (that in the center, behind the third column from the right) is actually a combination of wreath and hoop. Donatello, it seems, started to carve a hoop but suddenly decided to change it into a wreath, perhaps because he realized that hoops would not be emphatic enough for his purpose (see Pls. 49a, 52b). Or did he reduce part of the wreath to a hoop because he found it technically or aesthetically necessary in this particular spot? However that may be, the composite form shows that he associated wreaths with the notion of rings or hoops, a rather odd circumstance unless we are willing to draw upon the explanation suggested above.

The architectural framework of the Cantoria has been generally viewed as reflecting the impressions gathered during Donatello's Roman sojourn of 1432/

33, which had acquainted him with both ancient architecture and the work of the Cosmati (Reymond, *Sc. Fl.*, II, pp. 105f; Wilhelm Bode, *Jahrbuch Kgl. Preuss, Kunstslgn.*, XXII, 1901, pp. 33f; cf. also Middeldorf, *loc. cit.*). The "Roman" quality is evident enough in the bracket zone, where the wealth of ornamental motifs (however unorthodox their combination) shows a knowledge of the lavishly decorated cornices of Imperial Roman buildings such as that of the Temple of Vespasian or of the Temple of Concord. In the balustrade, however, an entirely different character prevails; here the only element that might indicate a connection with Rome are the columns, for which certain late Roman and Early Christian sarcophagi have been cited as a source (Mela Escherich, "Donatellos Beziehungen zur Altchristlichen Kunst," *Repertorium f. Kw.*, XXXI, 1906, p. 522). Kauffmann is surely right in stressing their mediaeval precedents such as the tomb of Cardinal de Braye at Orvieto (*D.*, p. 78). Nor do we need to assume that Donatello's use of mosaic inlay was inspired by Roman Cosmati work; he could just as easily have taken the idea from Florentine examples such as the thirteenth century pulpit in S. Miniato. It is curious indeed how the division of the Cantoria into an "ancient, pagan zone" and a Christian one, which we have postulated for the sculpture, can be felt in the architectural framework as well. The columns are mediaeval rather than classical not only in their aesthetic function but also in shape and proportion, and even the mosaic of the two zones shows the same contrast: in the lower half, it is "ancient," i.e. composed of tesserae that form solid surfaces, while above it is mediaeval, consisting of carefully shaped small disks and fan-shaped pieces, each one set into a separate recess within the marble surface. Thus the difference in the style of the two zones appears to have not only the aesthetic purpose of making the balustrade seem light and "transparent," as against the solid weight of the bracket zone. It has a symbolic function as well, paralleling the contrast in the sculptural program. Little wonder, under these circumstances, that the decorative system of the Cantoria balustrade has no analogies in Donatello's *œuvre*. It is a unique solution that grew from the peculiar conditions of the task the master had set himself, while the style of the lower zone recalls a number of his other works, both earlier and later (the St. Peter's Tabernacle, the S. Croce Annunciation, and the surviving architectural bits of the Padua High Altar).[9]

[8] Cf. Adolph Goldschmidt and Kurt Weitzmann, *Die Byzantinischen Elfenbeinskulpturen*, I, Berlin, 1930, pl. XIA, Louvre; XIVE, Cividale; XXB, Florence, Museo Nazionale; XXIA, Baltimore, Walters Art Gallery; XXVIIIA, Leningrad; XXXVIIIA, New York, Metropolitan Museum; XLIIC, Pisa, Museo Civico; XLIVA, Ivrea, Cathedral.

[9] The Cantoria in S. Lorenzo, which used to be claimed for Donatello by Bode, *loc.cit.*, and others (cf. Paatz, *Kirchen*, II, pp. 503, 572f, n. 229), is surely not his work, but a much weakened imitation, at least twenty years later in date, of the Cathedral Cantoria. It seems inconceivable—all other considerations aside—that the master should have repeated the "zoning"

The documents relating to the Cantoria, though numerous, are not sufficiently explicit to provide a clear picture of the chronological sequence in which the various parts of the work were produced. Pastor (*D.*, pp. 64f) and Siegfried Weber (*Die Entwickelung des Putto in der Plastik der Frührenaissance*, Heidelberg, 1898, pp. 58ff) have claimed that the two side panels of the balustrade relief must have been produced earlier than the main frieze, since they are closer in style to the angels of the Prato Pulpit. Unfortunately, however, the Prato panels, too, were done piecemeal over several years, and there is no assurance that they were all designed in 1433/34 (see above, p. 118). According to Kauffmann (*D.*, pp. 220ff, nn. 224, 239, 240), Donatello was at work on the left half of the main Cantoria frieze as early as December 1433, but this conclusion, as well as certain others, is based on a somewhat hasty reading of the documents.[10] It might indeed be argued that the left half of the frieze, with its heavy-set figures and choppy movement, is closer to the Prato panels than the right half; if it were just a matter of deciding which of the two halves Donatello was working on at the end of 1433, Kauffmann would certainly be right. Yet the document in question (Poggi, doc. *1251*) tells us only that a block 5 braccia long had been turned over to our master in connection with the pulpit, so that Kauffmann's identification of it as one half of the main frieze rests on nothing but the length of the block. Now, the over-all width of the Cantoria (as distinguished from that of the main frieze) is just under 10 braccia; a block of 5 braccia, therefore, is likely to have been intended for the structural framework of the pulpit, which must have included a number of pieces of that size. The two halves of the frieze measure just over 4⅓ braccia, so that they were, in all probability, carved from panels no more than 4½ braccia long.[11] While we cannot categorically deny the possibility that Donatello had already tackled the main frieze less than six months after receiving the commission for the pulpit, such undue promptness—not to say haste—is hardly in accord with the master's usual working habits. There is, moreover, another argument against this assumption: Kauffmann interprets the document of November 14, 1433, as an agreement concerning the price and delivery date of one specific

relief (one of the smaller panels, since the maximum fee for it is set at 50 florins). This, if correct, would be a clear indication that Donatello started work on the sculptural *décor* of the pulpit at the earliest possible moment. But the text of the entry speaks not of one piece but of every piece (*ongni pezo*), i.e. it fixes the conditions of price and delivery for all the reliefs of the Cantoria, and the three months' limit, too, is a general rule to discourage procrastination, rather than a deadline based on the date of the agreement. The document in question, then, merely shows that by November 1433 Donatello must have produced and submitted a design for the Cantoria as a whole, on the basis of which the *operai* set the price and other stipulations for the sculptured panels. The number of these panels is not stated, but their size can be inferred from the price and from the reference to Luca's reliefs as a standard.[12] It thus appears that the sculptural *décor* of Donatello's Cantoria, as specified in the document of November 14, 1433, consisted of a considerable number of reliefs of more or less uniform size, none of them larger than those of Luca. But if this is true, then the original design of our Cantoria must have been far closer to Luca's than to the plan that was finally carried out. Like the Prato Pulpit, it called for a series of separately framed panels, rather than for a continuous frieze on the balustrade. Our previous observations concerning the division of the Cantoria into a Christian and a pagan zone, and the difference in style between the upper and lower halves, point to the same conclusion: that the design of the pulpit underwent a decisive change while the work was in progress. I should think that the labors carried out in 1433/34 were confined to the architectural framework of the lower half; that the balustrade was redesigned towards 1435,[13] and that, after almost complete stagnation in 1434, the work on the project was resumed slowly in 1435 and then proceeded at an ever faster pace through 1436 and the next two years, so that on October 30, 1438, the pulpit could be referred to as "almost completed" (Poggi, doc. *1308*). The pattern of payments, as reflected in the documents, is characteristic: between November 1433 and March 1434, Donatello received his first fees, in five installments totaling 55 florins; in 1435 and 1436, he collected only 14 and 24 florins more, respectively, followed by 70

of his original Cantoria without a sculptural "key" to its significance.

[10] In the resolution of July 10, 1433, the choice of subject is not left to the artist, as Kauffmann asserts, but to Neri Capponi, one of the *operai*.

[11] One of them may be the "tomb-size block" referred to in the entry of August 14, 1436; "tomb-size" seems to have been a set dimension, implying not only the length but also the width and thickness customarily demanded for sepulchral slabs. The fact that this block was meant for the "cornice" of the pulpit need not disturb us, since the significance of "cornice"

at that time was vague indeed. The entire balustrade of the pulpit could well have been referred to as the "cornice" of the structure.

[12] On August 26, 1434, the latter had completed four panels, for two of which he was to receive 60 florins apiece while the other two, smaller in size, were estimated as being worth 35 florins each; see Poggi, doc. *1258*.

[13] This may have been the reason why Donatello, in February of that year, rejected two marble blocks for the pulpit as not being of the right size; see above, Poggi, doc. *1295*.

florins early in 1437. The next year, however, brought him 340 florins, and in the winter of 1439/40 he received another 150, making a total of 653 florins, or close to three quarters of the final price of 896 florins as determined in 1446 (Poggi, docs. *1315, 1316*). The sculptural parts of the Cantoria, then, must have been executed for the most part in 1436-1438. Their lack of detailed finish, so frequently commented upon ever since the *Libro* of Antonio Billi, is better explained by this tight schedule than by any subtle aesthetic calculations. We can well believe that Donatello counted on distance and dim light to hide the often rather crude carving of the Cantoria reliefs; but to regard the "sketchiness" of the work as carefully controlled by the artist's *giudizio dell'occhio*, and to acclaim it as the reason for the superiority of Donatello's Cantoria over Luca's, is sheer fancy. If we believe Donatello's work to be superior to Luca's, this is due to the greater daring and expressiveness of his design as a whole, rather than to the supposed "impressionism" of the carving.[14]

The uneven quality of the Cantoria reliefs, and the fact that the actual carving was done largely by assistants, has long been acknowledged. The documents do not mention these lesser men by name, and to discover their identities on the basis of style alone is as difficult here as in the Prato panels. Leaving aside the lateral panels of the balustrade and the two reliefs between the brackets, scholars have noted important differences between the two halves of the main frieze. Wilhelm Bode (*Denkmäler der Renaissance-Skulptur Toscanas*, Munich, 1892-1905, p. 30) attributed the execution of the left side to Buggiano and that of the right to an unknown but superior assistant of Donatello. Weber (*loc.cit.*), too, gave the left half to Buggiano, while claiming the foreground figures of the right half for Donatello himself and the background figures for Agostino di Duccio. According to Corwegh (*op.cit.*, pp. 48ff), Donatello did some carving on both halves of the frieze, although his hand is more conspicuous on the right half; Buggiano executed most of the left half, as well as the lateral panel on the right, and Michelozzo did the lateral panel on the left. More recent authors have been silent on this subject, except for Lányi, who once claimed the entire left half for Michelozzo (*Pragm.*, p. 129) but did not pursue the matter,[15] and Giuseppe Marchini, who suggested that one of the figures on the left half of the frieze might have been carved by Maso di Bartolomeo (*Commentari*, III, 1952, p. 117, n. 10; cf. above, p. 117, for Maso's connection with the Prato

Pulpit). Any attempt at a precise division of participating hands does indeed seem doomed to remain inconclusive; however weak his assistants, Donatello always managed to superimpose his own spirit upon their handiwork on the Cantoria reliefs, obliterating for the moment any "normal" marks of their individual styles. If Buggiano helped to execute some parts of the Cantoria, we have no way of proving that he did; the two holy water basins by his hand in the sacristies of the Cathedral, on which Bode, Weber, and Corwegh based their claims, are much closer to Luca della Robbia in style than to Donatello. As for Michelozzo, his very distinctive personal style as seen in the Aragazzi monument at Montepulciano again recalls Luca, not Donatello. We are thus left with the one observation on which there is general agreement, i.e. that the right half of the frieze is much superior to the left, not only in the quality of the carving but compositionally as well. Kauffmann's remarks concerning the closer relationship of the left half with the Prato reliefs are very much to the point. The design of this panel lacks the continuity of the other side; the figures are concentrated in two distinct groups, and the pattern of their movements is far from clear. The large heads and heavy bodies likewise recur in the Prato Pulpit, along with certain details of drapery. The analogies even extend to such features as the classical open-toed boots worn by one of the Cantoria angels; we find them again in the sixth and seventh of the Prato panels. These two are the least exposed of the set, since they face towards the flank of the church, as well as among the weakest in execution, and therefore, in all probability, the last to be delivered and installed. If the same rather clumsy assistants executed the left half of the Cantoria frieze, the latter may very well have been a hasty sequel to the right half, rather than its predecessor (as maintained by Kauffmann). Donatello, hard pressed for delivery, may have combined some of his sketches for the Prato reliefs into a small-scale model that did not provide enough guidance for the carvers, so that his intentions were distorted in the process of execution. Nevertheless, the design of the left half of the frieze betrays a certain awareness of the columns in front, as if it had been made after the architectural framework of the balustrade was definitely fixed, while the other half does not—I am tempted to say, "not yet"— show such a correlation. However that may be, it is only on the right-hand side that Donatello's highly original conception of the Cantoria balustrade as a compound of architecture and sculpture can be found

[14] Still cited, on the basis of Vasari, by some modern scholars such as Bertaux (*D.*, p. 115) and Ottavio Morisani (*Studi su Donatello*, Venice, 1952, pp. 98f); cf. my remarks above, pp. 20, 40, on the "lack of surface finish" in Renaissance art theory.

[15] In *Burl. Mag.* LXXV, 1939, p. 151, n. 11, he confines himself to the statement that only the right side is Donatello's own work.

unimpaired. Here alone, where the dancers form a continuous circle, does the perforation of the relief ground and columns with mosaic inlay, and their resultant "transparency," have its full effect in creating the illusion of spatial depth. Schottmüller's fine analysis of this unique relief mode (*D.*, pp. 40f), although meant for the frieze as a whole, applies to the right half far more' than to the left, and thus unintentionally points up the contrast between the two sides.

THE FEAST OF HEROD, PALAIS DES BEAUX-ARTS, MUSÉE WICAR, LILLE

PLATES 54-55 Marble relief; H. of slab 50 cm; W. of slab 71.5 cm; H. of relief, (*c. 1433-1435*)
without molding, 43.5 cm; W. 65 cm

D O C U M E N T S : none

S O U R C E S : none (but see below)

The early history of the panel is unknown. It probably belonged to the Medici, for the inventory of the collections of Lorenzo the Magnificent made in 1492 lists "a panel of marble with many figures in low relief and other things in perspective, i.e. of St. John, by Donatello, 30 florins" (Eugène Müntz, *Les collections des Médicis au quinzième siècle*, Paris, 1888, p. 64; the identification with the Lille relief was suggested to Müntz by Louis Courajod). That this was our panel seems the more likely inasmuch as the motif of the stairs on the right is reflected in the famous early Michelangelo Madonna relief in the Casa Buonarroti (Alfred Gotthold Meyer, *Donatello*, Leipzig, 1903, p. 83; Kauffmann, *D.*, p. 216, n. 189, does not think the relationship convincing). The ownership of the panel after 1494, when the Medici collections were dispersed, cannot be traced; neither Vasari nor Bocchi mentions it among the various marble reliefs by Donatello they saw in private collections. According to Kauffmann, *loc.cit.*, the panel may have come to France in the early Cinquecento, since the architectural setting was copied in part by Rosso Fiorentino in one of the drawings for the Achilles cycle at Fontainebleau. Rosso, however, could just as easily have seen the relief while he was still in Italy and taken a sketch after it to Fontainebleau, along with other records of Italian compositions that had impressed him during his formative years. The fact that our panel turned up three centuries later in the collection of Jean-Baptiste Wicar, the engraver, painter, and former "fine arts commissioner" of Napoleon's army who had spent most of his adult life in Italy, strongly suggests that the work did not leave its native soil until after Wicar's death in 1834. The inventory of the objects he had willed to the city of Lille, taken on May 21 of that year in Rome, includes "un petit bas-relief de St. Jean" which is almost certainly identical with our panel (Giulio Romano Ansaldi, "Documenti inediti per una biografia di G. B. Wicar," *Memorie della R. Accademia Nazionale dei Lincei, Classe di scienze morali . . .*, serie VI, vol. v, fasc. v, Rome, 1936, p. 491). Since the relief had at that time not yet been recognized as a work of Donatello, no special importance was attached to it. That, we may assume, is the reason why we find no explicit mention of it among the voluminous papers dealing with Wicar's activities as an art collector. Thus its provenance is impossible to ascertain.[1] The Musée Wicar at Lille was opened to the public in 1849 in the new Hôtel de Ville, and seven years later the first catalogue was issued (our relief is No. 1912). Since 1892 the collection has been housed in the Palais des Beaux-Arts (for the history of the Musée, cf. Beaucamp, *loc.cit.*).

Although mentioned as early as 1864 in Charles C. Perkins, *Tuscan Sculptors*, I, p. 146n, the Lille relief scarcely entered the Donatello literature of the next twenty-five years. Subsequent authors, while acknowledging the correctness of the attribution (which had been questioned by Milanesi, *Cat.*, p. 27; according to Perkins, *loc.cit.*, the first scholar to pronounce the panel a work of Donatello was J. C. Robinson), confined themselves for the most part to a few cursory remarks; only Schottmüller (*D.*, pp. 23, 28ff, 112), Kauffmann (*D.*, pp. 63ff) and Ottavio Morisani (*Studi su Donatello*, Venice, 1952, pp. 158ff) have written more searchingly about the panel.

The date of the work is not easy to fix with precision. Louis Gonse (*Musée de Lille, le Musée Wicar*, Lille-Paris, 1878, pp. 102f) placed it in the immediate vicinity of the bronze relief of the same subject on the Siena Font. Wilhelm Bode, too, at first regarded our panel as a direct echo of the Siena one, and dated it soon after 1427 (*Denkmäler der Renaissance-Skulptur Toscanas*, Munich, 1892-1905, p. 20; similarly Balcarres, *D.*, p. 72). Later on, the same author pronounced the figures of the Lille relief akin to the

[1] Perhaps our panel was among the four crates of bas-reliefs that Wicar wanted to send from Leghorn to Rome in 1807, according to a letter published by Fernand Beaucamp, *Le peintre Lillois Jean-Baptiste Wicar*, Lille, 1939, II, pp. 555ff.

sculpture of the St. Peter's Tabernacle and interpreted the architecture as a reflection of Roman ruins, which led him to date it in 1433 or immediately thereafter (*Jahrbuch Kgl. Preuss. Kunstslgn.*, xxii, 1901, p. 31; this opinion adopted by Meyer, *loc.cit.*, Bertaux, *D.*, p. 104, Cruttwell, *D.*, pp. 68f, and Colasanti, *D.*, p. 47). Reymond, meanwhile, had assigned our panel to the end of the 1430's, the time of the *tondi* in the Old Sacristy of S. Lorenzo, which exhibit much the same relationship of figures and architecture (*Sc. Fl.*, ii, p. 114; his view followed in Schottmüller, *D.*, p. 125, Venturi, *Storia*, vi, pp. 292f, and Oskar Wulff, *Donatello*, Leipzig, 1922, p. 15). Eugène Müntz (*Donatello*, Paris, 1885, p. 92) even placed it in the master's Paduan years, evidently because of the prominent architectural setting. Schubring (*KdK*, pp. 124, 199f) favored the same view and suggested that the panel might have been ordered by a Venetian (the stairs remind him of those of the Doge's Palace).

That the linear perspective of the Lille relief is far more advanced than that of the Siena Feast of Herod, hardly needs to be pointed out. For Schottmüller, who carried out a detailed comparison of the two works from the point of view of spatial projection, the more complete mastery of this element represented a "memorable advance" of Donatello as an artist (*D.*, p. 112), while Morisani, on the basis of a similar analysis half a century later, arrived at the opposite conclusion: the architecture, he says, has overpowered the figures and thus emptied the scene of all dramatic tension. Kauffmann's approach is less invidious; he stresses—very properly, in my opinion—the continuity of many basic features common to both panels, and defines with great care the one decisive difference between them, which is Donatello's use, in the Lille relief, of the method of perspective construction described in Leone Battista Alberti's *De pictura*. This scheme is based on a module, or unit of measurement, representing one braccio, or one-third the height of a man standing on the base line at the bottom of the picture; the base line is to be marked off in these units (that of the Lille panel contains nine of them), and the vanishing point must be on a line three units above the base line, corresponding to the eye level of a man who stands on the base line. Our panel follows all these rules. Albertian, too, as Kauffmann points out, is the isocephaly of all the figures standing on the tiled floor

of the courtyard, whatever their distance from the beholder. Kauffmann wisely refrains from postulating 1435, the year *De pictura* was completed, as a *terminus post* for the Lille relief; Alberti, he believes, only codified a body of knowledge that must have been available to the artists around Brunelleschi for at least a decade (since he bows to these "founding fathers" of the new art, including "our dear friend Donatello," in the Dedication of his treatise). Nevertheless, Kauffmann assumes that our panel (which also seems to reflect certain other, less mathematical key concepts of Alberti's, such as *varietà* and *composizione*) presupposes the influence of Alberti, whom Donatello could have come to know from 1428 on; he proposes a date of 1434 for the Lille relief, about halfway between the St. Peter's Tabernacle and the *tondi* of the Sagrestia Vecchia. This, I believe, is a thoroughly acceptable conclusion if perhaps too precise. Donatello's procedure in the Lille panel is actually a good deal more systematic than Kauffmann realized: the vanishing point is not only three units above the base line but three units from the left edge and from the top of the relief, whose dimensions are proportioned in the ratio 6:9 (43.5 x 65 cm). The module, then, is 7.25 cm. It recurs so persistently throughout the design, even in details where the perspective scheme does not make its use necessary (e.g. the width of the strip of sky above the railing in the upper center), that Donatello must have inscribed his composition within a regular grid based on the module. Such a concern with rules and measurements goes far beyond the recommendations of *De pictura*; in Donatello's *œuvre* it is a unique experiment that can hardly be accounted for otherwise than through intimate contact with the fully formulated theories of Alberti.[2]

Yet, despite his sudden theoretical bent, Donatello had not forgotten the Siena Feast of Herod. The successive layers of architectural space in the Lille relief, as well as numerous details, still recall the earlier work. The quality of the carving suggests the London Delivery of the Keys more than any other of the master's marble *schiacciati* (note especially the Masacciesque group by the gate in the background), and the liberal use of classical figure-types likewise points to the early 1430's.[3] So does the cluster of men next to the stairs, whom Bode (*Jahrbuch, loc.cit.*) had recognized as the next of kin of the adoring angels on

[2] Richard Krautheimer and Trude Krautheimer-Hess (*Lorenzo Ghiberti*, Princeton, 1956, pp. 245ff) point out that the Joseph and Jacob panels of the East Doors, which they date c. 1434-1435, also show the base line divided into nine braccio units, and that the foreground figures have a height roughly equal to three of those. The vanishing point, however, lies higher and is not definable in terms of the braccio module, apparently because Ghiberti wanted to avoid the isocephaly implicit in Alberti's rule for fixing the horizon line. The "module-grid" of the Lille panel has no analogy, so far as I know, among either

reliefs or paintings at this time.

[3] E.g. the reclining nudes in the pediment, apparently inspired by Etruscan models (cf. the small stone pediments from Vulci exhibited in the Museo Nazionale di Villa Giulia, Rome); the woman on the bench in the left foreground; the Salome; the sleeping *putto* and the bystander on the stairs; Kauffmann, *D.*, p. 217, n. 197, cites ancient prototypes for the Salome and the woman on the bench, whom he wrongly identifies as Herodias.

the St. Peter's Tabernacle. Thus a date of 1433-1435, between Donatello's return from Rome and the completion of *De pictura*, becomes a practical certainty for our panel.

There remains one further question: what lessons did Donatello derive from his experiment with the pictorial mathematics of Alberti? Or must we follow Morisani in regarding the Lille panel as an isolated, and essentially fruitless, departure from the main path of the master's development? That Donatello has sacrificed much of the dramatic cohesion and expressive force of the Siena relief is plain enough, but he has also gained something very important: a spatial setting that no longer depends on the figures. In all his previous reliefs, including the Siena Feast of Herod, the effectiveness of the spatial illusion would be irreparably damaged if the figures were to disappear; the pictorial space is truly a "framework," incapable of surviving without them. In the Lille panel, on the contrary, the actors could walk off the stage, as it were, or redistribute themselves in the scene, without altering the rational clarity and intelligibility of their spatial environment. It is only now that Donatello has fully conquered for himself the new method of space projection which Masaccio had used so triumphantly in his Trinity mural; without the severe discipline of Alberti's system he might never have succeeded, since the joys of mathematical construction were surely

alien to his temperament.[4] Nor did he have to cling to this rigorous procedure in order to retain the lessons he had learned in the process of doing the Lille panel. A single experience with module and grid was sufficient for him. Its fruits may be seen in all of the master's subsequent reliefs, and especially in the *tondi* of the Old Sacristy: the figures, unburdened of their space-creating responsibility, achieve a new freedom to move about, to group themselves within their vastly expanded setting. And the architecture itself now becomes a challenge to Donatello's imaginative powers. Paradoxically enough, the rationality of representational method only serves to heighten the irrational quality of the structures themselves. Herod's palace in the Lille relief has nothing in common with Roman ruins; it is, in the happy phrase of Balcarres, "full of hidden things, reminding one of the mysterious etchings of Piranesi." This strange, dreamlike quality is already hinted at in the background of the Siena panel but its full force strikes us only now. The Lille relief thus opens up a new area of aesthetic experience; through it, we enter the world of architectural fantasy that was, in the end, to give birth to the *Prigioni*. Viewed in these terms, our panel holds a place in Donatello's *œuvre* hardly less important than that of its Sienese predecessor, even if it be the lesser work of art.[5]

[4] According to the Uccello *Vita* of Vasari, he used to twit his friend, who took pride in perspective projections of *mazzocchi* and similar multifaceted bodies, by saying that "such things are useful only in marquetry."

[5] Another relief composition with elaborate background architecture, the bronze plaquette in the Louvre showing Christ healing the Woman Possessed, has recently been claimed as a work of Donatello, contemporary with the roundels in the Old Sacristy of S. Lorenzo and the Lille Feast of Herod, by Piero Sanpaolesi, *La sacristia vecchia di San Lorenzo*, Pisa, 1950, pp. 6f. This interesting panel, previously attributed to Brunelleschi by Roberto Longhi, *La Critica d'arte*, v, 1940, pp. 161f, pls. 119, 120, displays a complete absence of that imaginative element which I have attempted to define above; the architectural setting here is almost "academic" in its rationality and symmetry. It has nothing to do with Brunelleschi's style, as Sanpaolesi has rightly pointed out, but neither does it recall Donatello, although the door frames bear some resemblance to those of the bronze doors in the Old Sacristy. The figures, too, incorporate some Donatellesque gestures, yet they show a conspicuous lack of narrative power. I believe the plaquette to be a product of the second half of the century. The elaborate frame is entirely different in style and may be a good deal earlier.

SCULPTURAL DECORATION OF THE OLD SACRISTY, S. LORENZO, FLORENCE

PLATES 56-65		*(1434-1443)*
	Reliefs in painted stucco	*(1434-1437)*
PLATES 56b-57	SS. STEPHEN AND LAWRENCE: SS. COSMAS AND DAMIAN two reliefs above the doors flanking the altar niche; H. c. 215 cm; W. c. 180 cm (without molding and frame)	
PLATES 58-59	THE FOUR EVANGELISTS	
PLATES 60-61	FOUR SCENES FROM THE LEGEND OF ST. JOHN THE EVANGELIST (Vision on the Isle of Patmos; Raising of Drusiana; Liberation from the Cauldron of Oil; Apotheosis) eight roundels below the dome; diameter c. 215 cm (without molding)	
PLATES 62-65	*Two bronze doors* H. 235 cm; W. 109 cm (for measurements of individual panels see below, p. 138)	*(1437-1443)*
PLATES 62-63	"MARTYRS' DOOR"	
PLATES 64-65	"APOSTLES' DOOR"	

DOCUMENTS: none

SOURCES

(1460-1464) Filarete, *Trattato dell'architettura*, book xxiii (ed. Wolfgang v. Oettingen, Vienna, 1890, p. 623): "If you have to do apostles, do not make them look like fencers, as Donatello did in the two bronze doors in the sacristy of S. Lorenzo in Florence."

Idem, book xxv (*ed. cit.*, p. 675): "[The sacristy of S. Lorenzo in Florence] is decorated to the utmost, including the bronze doors which were made by Donatello, the finest sculptor [of our time]."

(c. 1475) *Vita di Brunellesco*, attributed to Antonio Manetti (Ed. Elena Toesca, Florence, 1927, pp. 65f): "The small doorways flanking the chapel of the sacristy were left to be finished later, since it had not yet been decided whether the doors were to be made of wood or of some other material . . . ; there were then only the openings in the wall, with arches above for stability. When it had been decided that the doors should be of bronze and adorned with figures, as they are today, the commission for them was given to Donatello, who also had to design the limestone porticoes and the rest of the decoration for the doorways. He did this with such pride and arrogance that he installed them without ever consulting Brunelleschi, presuming on his authority as the master of the bronze doors, even though he knew little of architectural settings (*quadro*), as is evident from his pulpit in S. Maria del Fiore, the other [pulpits] and any similar work involving architectural design. What he did in the sacristy, individually and collectively, utterly lacked the grace of Brunelleschi's forms. When Donatello realized this, he became very indignant at Brunelleschi and detracted as much as he could from the latter's achievement and fame. Some insignificant people sustained him, but Brunelleschi laughed at this talk and attached little importance to it. At last, however, when Donatello persisted in his presumptuous remarks, Brunelleschi composed certain sonnets in his own defense—some of them are still in circulation—so as to let the world know that he was not responsible for the porticoes of the bronze doors or anything else on those walls between the corner pilasters."

(c. 1485) Vespasiano da Bisticci, *Vite di uomini illustri del secolo XV, s.v.* "Cosimo de'Medici" (Semper, D. '75, p. 313; translation, by William George and Emily Waters, London, 1926, p. 224): "He took great delight in his dealings with painters and sculptors, and had some work by each master in his house. He had a particular understanding for sculpture, being a generous patron of sculptors and of all worthy artists. He was a good friend of Donatello and of all painters and sculptors; and because in his time the sculptors found scanty employment, Cosimo, in order not to have Donatello be idle, commissioned him to do some bronze pulpits for S. Lorenzo and some doors which are in

the sacristy. He ordered the bank to pay every week enough money for the master and his four assistants, and in this way supported him."

1510 Albertini, p. 11: "In the sacristy [of S. Lorenzo], which is very beautiful and richly furnished, there are the stories of the four evangelists, and other saints in half-relief, as well as two bronze doors; all this is by the hand of Donatello."

(Before 1530) Billi, pp. 40f (repeated in Cod. Magl., p. 76): "[Donatello did] in the sacristy of S. Lorenzo the bronze doors, even though they are not very graceful. . . ."

1547, December 7, Baccio Bandinelli, letter to Cosimo I (Semper, *D.* '75, p. 315; Giovanni Bottari and Stefano Ticozzi, *Raccolta di lettere* . . . , I, Milan, 1822, pp. 71f): "When he did the pulpits and doors of bronze in S. Lorenzo for Cosimo il Vecchio, Donatello was so old that his eyesight no longer permitted him to judge them properly and to give them a beautiful finish; and although their conception is good, Donatello never did coarser work."

(c. 1550) Gelli, p. 58: "First of all, when he was still young, [Donatello] did the bronze doors in the Old Sacristy [of S. Lorenzo], along with the roundels of half-relief and other figures in the vault."

1550 Vasari-Ricci, II, pp. 36f (Milanesi, II, pp. 369f), *s.v.* "Brunelleschi": "No sooner was the roofing-in of the sacristy completed than Giovanni de'Medici passed away, leaving in his place his son Cosimo . . . who pursued this work with more ardor, so that while one thing was being started another was being finished. Having taken up this project as a pastime, he kept at it almost continuously. It was he who made Brunelleschi finish the sacristy while Donatello did the stucco [reliefs], the ornamental door frames of stone, and the bronze doors."

ibid., p. 57 (Milanesi, pp. 415f), *s.v.* "Donatello": "After his return [to Florence from Siena, Donatello] did the sacristy of S. Lorenzo in stucco for Cosimo de'Medici, i.e. four roundels at the base of the vault with the stories of the four evangelists in perspective, partly painted and partly in bas-relief. He also made there two very beautiful small doors of bronze in bas-relief, with the apostles, martyrs, and confessors; and above these some flat niches, one containing St. Lawrence and St. Stephen, the other St. Cosmas and St. Damian." (A shortened paraphrase of this passage in Borghini, *Riposo*, p. 321.)

1591 Bocchi, p. 256 (Cinelli, p. 514): "At the base of the vault [in the Old Sacristy of S. Lorenzo] there are by Donatello four roundels with four figures of stucco representing the evangelists in low relief. But the two small bronze doors, also in low relief, and likewise by Donatello, are most highly prized by every artist. They show the apostles, martyrs, and confessors in the most beautiful and graceful poses the human mind could envisage. In design and vividness they equal the finest works. The draperies are so much admired that . . . the most famous artists imitate them, thereby attesting their merit in their own works. In some niches are SS. Lawrence, Stephen, Cosmas and Damian, of very beautiful appearance and likewise by Donatello. Thus the artists visiting this place enjoy the sweetest delight imaginable, wherever they may turn their glance, so much do they appreciate the singular artistry of this master, who has remained without peer in all his endeavors."

The present condition of the stucco roundels dates from 1911-1912, when they were freed from an old coat of whitewash, restoring insofar as possible their original appearance (cf. Paatz, *Kirchen*, II, p. 563, n. 197). Remnants of the original coloring, along with later restorations, may also be seen in the reliefs above the bronze doors. The material of the stucco panels has sometimes been mistaken for terracotta (e.g. Wilhelm Bode, *Denkmäler der Renaissance-Skulptur Toscanas*, Munich, 1892-1905, pp. 31ff; Balcarres, *D.*, p. 133; and Planiscig, *D.*, pp. 70ff, 143, who unaccountably defines the reliefs above the doors and the four evangelists as polychrome terracotta while referring to the roundels on the pendentives as painted stucco). The character of the bronze doors was until recently obscured by a peculiar surface incrustation, which misled several scholars (e.g. Pastor, *D.*, p. 71, who calls them "a raw cast without any chasing"). Their cleaning in 1946-1947 under the supervision of Bruno Bearzi has revealed an extraordinarily well controlled and finely modulated surface.

While the sculptural *décor* of the Old Sacristy in

stucco and bronze is not attested as the work of Donatello by documentary evidence, the plentiful testimony of the sources has been accepted by all scholars as tantamount to proof positive.[1] The dating of the ensemble, on the other hand, has proved to be a thorny problem. Here the sources contradict each other, and the search for an indisputable *terminus ante* has so far proved disappointing (see below). As for a *terminus post*, the only secure one is the completion, in 1428, of the architectural structure (cf. Paatz, *op.cit.*, p. 466, and Piero Sanpaolesi, *La sacristia vecchia di San Lorenzo*, Pisa, 1950, p. 16). Thus Donatello could, in theory, have done all or part of his work as early as the late 1420's or, except for his Paduan decade, at any time thereafter. Since the nature of his task in the Old Sacristy has no parallels in the rest of his *œuvre*, these reliefs are not easy to fit into the master's development, and as a consequence every possible alternative has been proposed at one time or another. Semper (*D.* '75, pp. 286, 313), relying on Vespasiano da Bisticci and Bandinelli, grouped the bronze doors with the S. Lorenzo Pulpits, Donatello's latest works; the story of the quarrel between Brunelleschi and Donatello over the door frames he regarded as reflecting the architect's general dissatisfaction with the sculptural *décor* of the sacristy, and on this basis he dated the stucco reliefs 1442-1444, immediately before Donatello's departure for Padua. Tschudi (*D.*, p. 22) and several others adopted the same view, while Schmarsow (*D.*, pp. 40ff) placed the entire cycle, including the bronze doors, in the years 1435-1443. The latter dating came to be accepted by most scholars (Semper, *D.* '87, pp. 74f; Wilhelm Bode, *Denkmäler der Renaissance-Skulptur Toscanas*, Munich, 1892-1905, pp. 31ff; Reymond, *Sc. Fl.*, II, pp. 110f; Schubring, *KdK*, pp. 70f, 197; Bertaux, *D.*, pp. 129ff; Cruttwell, *D.*, pp. 95ff). For the bronze doors, Eugène Müntz claimed a *terminus ante* of c. 1438, because of their influence on Luca della Robbia's panel of Logic and Dialectic on the north side of the Campanile of Florence Cathedral, executed in 1437-1439.[2] Semrau accepted the date of c. 1440-1443 for all of Donatello's work in the sacristy except the roundels on the pendentives, which he regarded as post-Paduan (*D.*, pp. 79f; Thieme-Becker, *Lexikon*, IX, 1913, pp. 422f). Cornel v. Fabriczy thought he had discovered documentary support for Semrau's view in a poem of c. 1460, written in praise of Cosimo and his sons, that refers to the sacristy as "what [Cosimo]

has done and is doing" (*Jahrbuch Kgl. Preuss. Kunstslgn.*, XXVIII, 1907, pp. 40ff); it is by no means clear, however, whether the author of the poem meant only the sacristy here or the church of S. Lorenzo in general. In either event, all we can gather is that some sort of work was still going around 1460—hardly a surprise, in view of the rich interior furnishings of both the sacristy and the edifice as a whole—but there is no reason at all to link Donatello with these labors. Schottmüller (*D.*, pp. 26, 126) conceded that Semrau and Fabriczy might be correct, while Venturi (*Storia*, VI, pp. 285ff; similarly Colasanti, *D.*, pp. 59ff) dated the entire ensemble in the years 1439 to 1444, between the completion of the Cantoria and Donatello's departure for Padua. Planiscig (*D.*, pp. 70ff) held much the same view; according to Vespasiano da Bisticci, he claimed, the decoration of the sacristy was not yet finished at the time of the death of Lorenzo de'Medici in 1440 (a more careful reading of the passage shows that Vespasiano meant only the church itself, not the sacristy), and the work must have been finished when Donatello left for Padua, otherwise Brunelleschi could not have written the sonnets mentioned in his *Vita* (for this question see below, p. 139). Kauffmann, who provides by far the most thorough discussion of the subject so far (*D.*, pp. 85ff), wisely refrains from attaching too much importance to these bits of external evidence; his dating of the sacristy sculptures in the latter half of the 1430's (concurred in by Middeldorf, *A.B.*, p. 579) is based mainly on a combination of stylistic, iconographic, and general historical reasons. The bronze doors he considers the latest members of the ensemble. Many years before, Pastor (*D.*, pp. 76f) had argued the opposite: according to him, the doors must have been done in 1428-1433, before Donatello's Roman sojourn, and the stuccoes immediately after the artist's return, about 1434. This alternative, disregarded by other scholars, has recently found a champion in Sanpaolesi (*op.cit.*, pp. 19ff), who maintains that the entire sculptural scheme of the sacristy was designed as early as 1427-1428, even though he fails to substantiate his thesis in terms of Donatello's artistic development during the late 1420's.

For purposes of analysis, it seems advisable to concentrate on the stucco panels first, since they are more directly linked to the architecture of the sacristy. The bronze doors—and their frames—represent a special problem that demands separate consideration. San-

[1] Of the pieces in marble and terracotta that used to be attributed to our master, only the bust of St. Leonard is still being claimed for him today (see below, pp. 236f); for the others—the marble sarcophagus of the parents of Cosimo de'Medici, the marble railing of the altar niche, the holy-water basin in the shape of a classical vase, and the terracotta medallions of angels' heads on the frieze—cf. Paatz, *op.cit.*, pp. 497f, 563ff, nn. 199, 202, 203, 204; the sarcophagus is not ascribed to Donatello by Vasari, in the *Vita* of Brunelleschi, as Paatz

mistakenly avers—the passage in question (Milanesi, II, p. 370) merely states that the monument was ordered by Cosimo.
[2] *Histoire de l'art pendant la renaissance*, I, Paris, 1889, p. 554; for the date of Luca's relief, see Poggi, *Duomo*, pp. lx, 58, docs. 325-327; Bode, *Jahrbuch Kgl. Preuss. Kunstslgn.*, XXI, 1900, pp. 3, 28, believes that Luca arrived at his design independently; the resemblance, striking at first glance, is not quite close enough to compel us to accept Müntz's thesis.

paolesi, *loc.cit.*, assumes that the sculptured roundels were planned by Brunelleschi himself, and that their execution was turned over to Donatello only because Brunelleschi found himself too busy with the Cathedral dome. (In support of his notion, Sanpaolesi cites the roundels on the pendentives of the Pazzi Chapel, which he attributes to Brunelleschi, as had Fabriczy and Venturi before him; cf. also his recent article, *Bolletino d'arte*, xxxviii, 1953, pp. 225ff). That the *tondi* are an integral part of the architectural design, as Sanpaolesi claims, can hardly be disputed; it does not follow from this, however, that Brunelleschi had anything to do with their sculptural program. For all we know, he may have intended them as blind *oculi*, and the plastic decoration may have been an afterthought, at the insistence of the Medici family. If the roundels were conceived as sculptured medallions from the very start, we cannot but wonder at Brunelleschi's lack of concern with the problem of visibility. For not only the narrative scenes but also the more boldly modeled evangelists are difficult to "read" from the floor of the sacristy, both because of their distance from the beholder and because they receive most of their light from below (hence the difficulty of photographing them effectively). Donatello's extensive use of color must be viewed, at least in part, as an effort to remedy this condition. And the glazed terracotta medallions on the pendentives of the Pazzi Chapel, which are closer to the beholder, bolder in color, and have larger figures in relation to their size, tend to suggest that Brunelleschi—if indeed he is responsible for them—knew well enough how to cope with the problem that appears unresolved in the sacristy *tondi*. The character of our stucco reliefs, then, argues against Sanpaolesi's assumption that they were part and parcel of Brunelleschi's design. It seems more plausible, in fact, aside from all considerations of their style, to place them several years after the completion of the architectural structure. The same conclusion is suggested by what we know of Donatello's career in those years and by the political events of the time. Since the roofing-in of the sacristy was finished in 1428, Donatello could not very well have started work on the stuccoes until the following year (some allowance must be made for the finishing of the interior wall surfaces). Yet at that time he may have visited Poggio in Rome (see above, p. 101), and in 1430 he, together with Brunelleschi, Ghiberti, and Michelozzo, took part in the siege of Lucca (Semper, *D.* '75, p. 281). Two years later, we find him working in Rome, where he may well have gone in 1431 (see above, pp. 102, 108) and whence he did not return until the

spring of 1433 (see above, p. 110). Meanwhile, the war against Lucca had led to ever greater political difficulties for the Medici, culminating in their exile (October 1433-September 1434)—not exactly an auspicious time for Cosimo to devote himself to the sculptural embellishment of the sacristy built by his father. Thus the winter of 1434-1435 would seem to be just about the earliest date we can suggest for the start of Donatello's work without straining our sense of probability.[3] Much the same conclusion can be reached on grounds of style. The two panels above the doors and the four evangelists are closely related to the S. Croce Annunciation; their rich "Roman" ornament recalls that of the Cantoria (cf. especially Kauffmann, *D.*, pp. 89ff). The derivation of the evangelists from a Byzantine tradition, suggested by Kauffmann, *D.*, p. 89,[4] helps to explain the details of some of the poses, although the deeply introspective St. John seems to reflect the St. John on Ghiberti's North Doors as well. The elaborate thrones and desks, on the other hand, are fanciful variants of Roman motifs, similar in form and spirit to the "pagan altars" below the Cantoria balustrade (see above, pp. 125f, and Pl. 51a, d). Entirely unprecedented, so far as I know, is the use of the symbols of the evangelists as "animated lecterns"; Donatello must have evolved it, with typical Renaissance logic, from the scroll-holding symbols that appear as bearers of the Divine revelation to the evangelists of mediaeval art (the lion of St. Mark on Ghiberti's North Doors still has this form). Yet these symbols are no mere adjuncts to the furniture of the roundels. Magnificently alive and expressive, they remain the evangelists' source of inspiration, in contrast to the "carved" pagan genii embellishing the desks and thrones, even though these, too, are energetic, spirited beings (note especially the dramatic pair—almost an Eros and Anteros—on the side of St. Mark's desk, the most graceful nudes in Donatello's entire *œuvre*). All of these features are prophetic of Padua: the symbols of the evangelists are the ancestors of those on the High Altar, the thrones point towards the throne of the Madonna, with its sphinxes and the Fall of Man (a sphinxlike creature serves as the armrest of St. Matthew), and the genii anticipate those on the armor and saddle of the Gattamelata. The two panels above the bronze doors lack these elaborate settings; the two pairs of saints show less internal movement, in pose and drapery, than the Evangelists and are thus closer to the S. Croce Annunciation, while the ornament of the frames is a free repetition of the vases and tendrils on the St. Peter's tabernacle. On the other hand, the Roman costumes of SS. Cosmas

[3] Kauffmann, *loc.cit.*, also adduces iconographic reasons for dating the program between the death of Giovanni d'Averardo in 1428 and that of Cosimo's brother Lorenzo in 1440: Giovanni must have been dead because the scenes from the life of his patron Saint are in the "heavenly" sphere beneath the dome,

while SS. Lawrence and Cosmas appear on the same level above the bronze doors, indicating that both Lorenzo and Cosimo were still alive. This argument does not strike me as compelling.
[4] Not by A. M. Friend, *Art Studies*, v, 1927, pp. 115ff, as claimed by Paatz, *op.cit.*, p. 563, n. 198.

and Damian[5] are directly akin to the garb of the evangelists. These reliefs, then, would seem to be the earliest part of the ensemble; they were done, I think, in 1434-1435, to be followed by the *tondi* in the course of the next two or three years.[6]

The four scenes from the legend of St. John the Evangelist invite comparison with the master's other *schiacciato* reliefs. Their most striking feature is the small scale of the figures and the depth and complexity of their spatial setting. Moreover, the pictorial space here in no way depends on the figures, which are treated as actors moving freely on a wide and stable stage without ever coalescing into massed, dominant groups such as those of the Delivery of the Keys in London or the Paduan St. Anthony panels. This scattering of small figures, singly or in small clumps, at varying distances from the beholder has its only parallel in the Lille Feast of Herod, with its Albertian systematization of space, a work of c. 1433-1435 (see above, pp. 129f), rather than in the Paduan reliefs or the S. Lorenzo Pulpits. The Siena Feast of Herod, designed about 1425, clearly represents a much earlier phase of Donatello's development (see the analysis above, p. 131). But the St. John roundels also go beyond the Lille panel in various ways: the figures, no longer cowed by their spatial framework, have regained their freedom of action and expression, so that the narrative once more has the dramatic intensity which is missing at Lille. Another new device is the effective use of *repoussoir* figures overlapped by the frame, and the handling of perspective depth shows greater freedom and assurance. Two of the scenes, the Vision on Patmos and the Liberation from the Cauldron of Oil, retain many features of the traditional iconography for these subjects, as seen on the predella of the St. John Altar ascribed to "Giovanni del Ponte" in the National Gallery, London (No. 580; cf. Kauffmann, *D.*, p. 93), although the settings, needless to say, have been tremendously expanded. The sweeping landscape view of Patmos recalls the background of the London Delivery of the Keys, especially in the shape and function of the trees, and the figure of God is akin to that of Christ in the London panel. The Raising of Drusiana, in contrast, has been given a bold new setting—a massive, barrel-vaulted Renaissance hall that has no counterpart at that time in pictorial representations of architecture or in actual buildings. An even more astounding feat of Donatello's spatial phantasy is the Apotheosis of the Saint; here the architecture seems as visionary as the event itself. These structures, rationally inexplicable, belong to the world of the stage alone. The crowding of cells and compartments produces a strangely oppressive effect—one thinks of cages and prisons, as if the artist had wished to create a tangible image of the Neoplatonic *carcere terreno* from which the Saint escapes into the unconfined spaces beyond. His upward flight is further emphasized by the strong *di sotto in su* perspective, which makes the verticals of the buildings converge and thus produces a reeling sensation of height.[7] To call this scene an anticipation of the "pictorial dynamics of the Baroque," as Kauffmann has done, hardly does justice to its true character. It is not in the artifices of a Pozzo but in the work of the young Giorgio de Chirico that we encounter perspective vistas as intensely charged with emotion as these.

To his contemporaries, the bronze doors were Donatello's most important achievement in the sacristy of S. Lorenzo. Filarete implicitly acknowledges their fame in his unflattering reference to the apostles as fencers; for the point of the passage is borrowed directly from Alberti's *De Pictura*, where we read that "it befits a runner to flail his arms as much as his legs, but a discoursing philosopher should show restraint rather than behave like a fencer" (*Kleinere Kunsttheoretische Schriften*, ed. Hubert Janitschek, Vienna, 1877, p. 113). Alberti also enveighs against those who for the sake of suggesting movement and vivacity will twist their figures into incongruous poses, showing front and back at the same time; the result, he warns, will be "fencers and acrobats without any artistic dignity" (*ibid.*, p. 127; I owe my acquaintance with these passages to the kindness of Dr. Richard Krautheimer). Filarete evidently wanted to cite a concrete example to illustrate such lack of concern with decorum, and the Donatello doors must have struck him as the most widely known work that would fit his purpose. That he nevertheless thought highly of the doors is suggested not only by his second mention of them, in book xxv, but by an earlier, indirect reference. His description of the Cathedral of Sforzinda (book ix; ed. v. Oettingen, p. 298) includes three pairs of bronze doors, one by Ghiberti, one by Donatello, and one by himself, similar to those he had made for St. Peter's. Here, then, Donatello appears as a maker of bronze doors whose reputation is exceeded only by that of Ghiberti. Filarete's acquaintance with the Sacristy doors also provides a definite *terminus ante quem* for them (as Kauffmann, *D.*, p. 225, n. 280, has pointed out). His most recent opportunity to study them before he embarked on his *Trattato* was in 1456, when he came to Florence for the purpose of familiarizing himself with the design of hospitals in prepara-

[5] See Kauffmann, *loc.cit.*; I cannot share his belief that St. Cosmas is a portrait of Cosimo de'Medici.

[6] A further argument for dating the reliefs above the bronze doors about 1434 is provided by the cherubs' heads in the spandrels (see Pl. 57), which resemble those in the stained glass window of the Coronation of the Virgin; see above, pp. xiii f.

[7] The horizon is assumed to be half a radius below the bottom edge of the roundel; cf. the analysis by John White, *Journal of the Warburg and Courtauld Institutes*, xiv, 1951, p. 49.

tion for the task of building the "Great Hospital" in Milan; we may be sure, therefore, that the doors were completed by that time. This fact in itself is not very illuminating, but it does permit us to conclude that Donatello could hardly have done the doors after his return from Padua, i.e. in 1454-1456. Despite their modest scale, the four bronze panels represent a very considerable amount of work, artistically as well as technically, and the recent cleaning has shown that they were executed with great care, Bandinelli's remarks to the contrary. If we consider that during the same two-year interval our master also produced several statues (see below, pp. 192, 193, 198) and that he may have been in Siena part of the time, it seems highly unlikely, to say the least, that the sacristy doors could have been designed, modeled, cast, and chased within the brief span at our disposal. For all practical purposes then we may subtract a dozen years from the *terminus ante* established by Filarete's Florentine visit of 1456. As a piece of external evidence for the pre-Paduan origin of the doors, this argument appears more reliable than the testimony of the Brunelleschi *Vita*, which proves only that the porticoes and the reliefs above them were made before the architect's death in 1446 (the doors themselves might conceivably have been added later). An earlier—and to me wholly convincing—*terminus ante* for the doors is yielded by the four scenes from the life of St. Geminianus in Modena, the earliest known work of Agostino di Duccio, signed and dated 1442. These are framed by the same distinctive leaf moldings employed by Donatello for the panels of the doors, and Mr. Maurice Shapiro, who is completing his doctor's dissertation on Agostino di Duccio at New York University, has observed that several of the figures in the Modena reliefs derive from Donatello's bronze doors.

From the point of view of style there can be little doubt that the doors belong to the same phase of Donatello's development as the rest of his sculptures in the sacristy. Most of the individual panels seem to be the direct descendants of the two pairs of standing saints above the doorways, and the figures themselves often recall the physical types of the four evangelists. Some of them (those at bottom left of the "Martyrs' Door" and center right of the "Apostles' Door") display a turbulent motion comparable to the frieze of the Cantoria; and the double lectern of the fourth right-hand panel on the "Apostles' Door" is strikingly similar to the "pagan altar" on the relief between the fourth and fifth bracket of the Cantoria (see above, p. 125; also Pl. 51d). Finally, even the relief mode, otherwise unparalleled in the master's work, has analogies among the roundels (note the two genii on the

desk of St. Mark, Pl. 59b) and on the Cantoria (the *putti* panels between the brackets, Pl. 51a, d); in all these instances, the background remains blank and the figures stand on the frame, yet there is no sacrifice of depth—the beholder automatically interprets the relief ground not as a solid plane but as empty space. Donatello employs several devices in order to achieve this effect. One is the differential surface treatment: in the doors, the background has been carefully smoothed and the sculptured surfaces roughed up with systematic chisel marks, while in the Cantoria panels the smooth marble bodies are contrasted with the mosaic texture of the background. More important, however, is the relation between figure and frame: one foot almost invariably overlaps the bottom of the frame, thereby persuading us that this line coincides with the horizon and is thus not really a line but the edge of a plane extending indefinitely into depth. The vertical sides of the frame are likewise endowed with a three-dimensional quality—the figures may grip them, lean against them, overlap them or be overlapped by them. This method of space projection without linear perspective has certain precedents, in a limited sense, among the artist's earlier works, such as the gable relief of the God the Father Blessing on the St. George Tabernacle and the two angels in the spandrels of the St. Louis Tabernacle (Pls. 11b, 24b, c); both of them, characteristically enough are pieces of "architectural sculpture." Donatello must have thought of the frames of the bronze doors as being equivalent to the structural framework of tabernacles, hence he fell back upon—and at the same time perfected—the same kind of relief he had used before in such a context, a very low relief that remains illusionistic yet does not disrupt the continuity of the background surface. Nevertheless, the bronze door panels (and their cognates on the Cantoria) are distinguished by special features that demand a further explanation. Their frames are surely influenced by those of the bronze doors of Bonanus at Pisa Cathedral, as Kauffmann has pointed out (*D.*, pp. 89f),[8] and the disputing pairs of figures may reflect the apostles on the door jambs of the Pisa Baptistery (Kauffmann, *loc.cit.* and pl. 20).[9] But Kauffmann, intent on establishing a parallel between the revival of Romanesque sculptural ideas by Donatello and of Tuscan Romanesque architecture by Brunelleschi, has overlooked another source of at least equal importance: Early Christian ivory diptychs. Colasanti (*D.*, pp. 59f) cites the Probianus Diptych for the paired figures in its lower part, but actually this ivory, and other members of the same group, is far more closely related to the sacristy doors in other ways. Here, and only here, do we find the same near-

[8] Note especially the spacing of the rosettes; the Pisa doors are well reproduced in Albert Boeckler, *Die Bronzetüren des Bonanus . . .* , Berlin, 1953, figs. 1-35.

[9] The attempt of Charles de Mandach (*Revue de l'art ancienne et moderne*, XXII, pp. 433ff, based on a suggestion of Louis Courajod) to derive the sacristy doors from those of Lyons Cathedral no longer merits detailed analysis; cf. Colasanti, *D.*, p. 61.

square proportion of the panels, the same kind of ornamented molding, and a strikingly similar relationship of the figures to the frame and the background of the relief. That Donatello should have drawn inspiration from these precious small-scale works on the threshold of antiquity and the Middle Ages, constitutes a further link between the sacristy doors and the Cantoria, which also shows the influence of Byzantine ivories (see above, pp. 125f). Clearly, then, Kauffmann's dating of the doors in the late 1430's seems the only possible one. The process of chasing may well have extended into the early 1440's, so that the doors were probably not ready to be installed until shortly before Donatello's departure for Padua. Kauffmann (*D.*, pp. 93f) has also drawn attention to some slight differences between the two doors: in the "Apostles' Door," the two figures of each panel are less actively related to one another, the panels themselves are about 1 cm wider (36.5 x 34.5 cm, including the molding, as against 36.5 x 33.5 cm), and the two at the bottom are about 1.5 cm taller than the rest. The latter difference may have been necessitated by a small error in calculating the size of the panels, frames, etc. within the over-all dimensions of the doors; in the "Martyrs' Door," this problem has been solved by the use of slightly wider frames, so that the panels are all of the same height. It seems reasonable to assume, therefore, that the "Apostles' Door" as a whole is somewhat earlier in date than the "Martyrs' Door," which in its lower half contains the boldest and most dynamic of all the panels.

The iconography of the two doors carries on the two main themes of the stucco reliefs. The topmost pairs of figures on the "Martyrs' Door" are the special Medici saints—Stephen and Lawrence, Cosmas and Damian—followed by sixteen other martyrs identified only by their books and palm fronds. On the "Apostles' Door," the program is more complex; the four figures at the bottom are immediately recognizable as the four fathers of the Church—Ambrose and Jerome, Gregory and Augustine—while in the top row only three figures carry attributes to reveal their identities: St. John the Baptist in the panel on the left, SS. Peter and Paul on the right. The Baptist's companion, however, is surely his namesake, St. John the Evangelist, to whom the sacristy is dedicated (Kauffmann, *D.,* p. 86). In the next row we find, on the left, SS. Andrew and James Major, who carry their appropriate attributes, and on the extreme right St. Bartholomew, who holds a knife in his left hand; the fourth figure

is thus likely to be another apostle. The eight saints of the third and fourth row are not distinguished by individual attributes. Kauffmann calls them confessors, without noting that the second, third, and fourth figures of the fourth row carry quills and are shown in the act of writing. They must be evangelists, by analogy with the program of Ghiberti's North Door.[10] But what of the first saint in the fourth row? He, too, ought to be an evangelist, yet he carries no quill. If we regard this as an oversight and identify him as the fourth evangelist, we find ourselves in a difficult situation, for we would then have to assume that Donatello has represented St. John the Evangelist twice. Moreover, the program of the four top rows would be quite unintelligible, since it would include the four evangelists, St. John the Baptist, St. Paul, and ten other figures, five of which we have recognized as apostles (St. John the Evangelist, St. Peter, St. Andrew, St. James Major, and St. Bartholomew). The other five, presumably, are apostles also. Yet ten apostles, rather than twelve, are an impossibility. At this point we might recall that two of the four evangelists were apostles as well (i.e., St. John and St. Matthew). Could Donatello have intended these two to do double duty in order to provide a full complement of apostles here? Unfortunately, our count of ten apostles in the three top rows already includes St. John the Evangelist, so that we could add only one of the figures in the fourth row—St. Matthew—to the series; and eleven apostles seem just as absurd as ten. There appears only one rational solution to this puzzle: the first figure in the fourth row (the one without the quill) is the missing twelfth apostle, substituted for St. John the Evangelist (who, because of his special importance as the patron Saint of Giovanni d'Averardo de'Medici, has been placed in the top row, alongside St. John the Baptist, the patron Saint of Florence). By means of this bold displacement, Donatello has achieved a coherent scheme that reconciles traditional iconography with the special requirements of the Medici: the four fathers (bottom row), the four evangelists (Matthew, Mark, and Luke in the fourth row, John in the first), the twelve apostles (two in the first row, four each in the second and third, and two in the fourth), plus St. Paul and St. John the Baptist (first row).[11]

By far the most difficult problem concerning Donatello's work in the sacristy of S. Lorenzo are the two porticoes of the bronze doors, which according to the "Manetti" *Vita* so displeased Brunelleschi that they

[10] That the analogy was a conscious one is shown by the fact that Donatello has arranged his four fathers in the same sequence as Ghiberti's, and by the further circumstance that in both cases the St. Jerome is the only bareheaded figure.

[11] It may be useful to recall here that Christ had designated twelve among his numerous disciples as apostles. This number was reduced to eleven by the defection of Judas, but immediately after Christ's death the eleven apostles elected Matthias to take Judas' place, so that there might be twelve of them to witness His Resurrection (Acts, 1:21ff). Not long thereafter, St. Paul became the first, and the greatest, of the "post-Resurrection" apostles, whose number had not been fixed in advance by Christ himself; he thus belongs in a different category from the original Twelve.

ruptured the long-standing friendship of the two masters. The details of the story have been doubted (Wilhelm Bode, *Jahrbuch Kgl. Preuss. Kunstslgn.*, XXII, 1901, p. 36, and Kauffmann, *D.*, p. 96, defend the porticoes as aesthetically necessary; cf. the objections of Middeldorf, *AB*, p. 575) but its basic factual content—i.e. that the porticoes were designed by Donatello—has gone unchallenged. Unhappily, the testimony of the sources (Vasari, too, credits the porticoes to our master) seems to be diametrically opposed to the visual evidence in this case; for not only are the porticoes an alien and disturbing element in the *ensemble* of the sacristy interior but their heavy, smooth, and somewhat inarticulate classicism is utterly different from Donatello's architectural taste as we know it from the S. Croce Annunciation and the Cantoria. There is, needless to say, no reason to question the *bona fides* of the biographer; his story surely was not invented of whole cloth. On the other hand, experience warns us not to take every word of it on faith. Like other stories from the same *Vita* or from Vasari (see above, pp. 10f, 19f, 40f) it is likely to be a compound: part fact, part conjecture, and part parable. Let us then examine the various elements in it, matching them against the visual evidence of the porticoes, and assess their reliability in the context of our general knowledge of the masters involved and of the patterns of legend formation during the Early Renaissance.

First of all, we can assume that the porticoes are not significantly different in date from the doors themselves—that they were installed in Brunelleschi's lifetime. Nor is it difficult to believe in his dissatisfaction with their shape and their general effect. We may be sure, however, that his reaction did not depend on the identity of the man responsible for the porticoes; it was motivated by the character of the work, not by a grudge against a particular individual. Now, let us suppose the porticoes were designed by someone other than Donatello, an artist of lesser stature; is it not likely that his intrusion upon so august a territory should have been forgotten fairly soon, and his work credited to the greater master who had done everything else on those walls? The author of the *Vita*, whether or not it was Antonio Manetti, must have been quite young still at the time of Brunelleschi's death. He wrote about the doors and porticoes thirty to forty years later—an interval amply sufficient, I believe, for the operation of the principle that "the big names swallow the little names" (for analogous instances see below, pp. 224f, 230f). Since we rejected Donatello as the designer of the porticoes on the basis of style alone, we must again rely on the visual evidence in any effort to find a more persuasive attribution for them. And here the name that immediately comes to mind is that of Michelozzo. It was he, after all, who more than any other artist of the time showed

a fondness for Ionic columns (in the loggia of the Villa at Careggi, the cloister and library of S. Marco, and in S. Maria delle Grazie, Pistoia; see Ottavio Morisani, *Michelozzo architetto*, Turin, 1951, figs. 69, 93ff, 100, 157) and strongly protruding pediments (S. Croce, portal of the Cappella del Noviziato; Pistoia, S. Maria delle Grazie; Morisani, *op.cit.*, figs. 143, 157). The proportions of our porticoes, to be sure, seem unusually squat for Michelozzo, but this can be explained by the special conditions of the site. If we may trust the *Vita*, the wall openings for the doors had been left unfinished by Brunelleschi; it is likely, therefore, that the door frames and porticoes were built only after the bronze doors were ready to be installed. (It would have been risky to do otherwise, since the doors, due to distortion in the casting, might not have fitted the frames exactly.) Thus Michelozzo—if our hypothesis is correct—had to adapt his porticoes to the exigencies of a wall space already pre-empted by the stucco reliefs of the four Medici saints and by the dimensions of the bronze doors, which compelled him to use an unusually narrow entablature and a very low pediment if he wanted to avoid cutting into the stucco reliefs. (The fit is uncomfortably tight at that—see Pl. 57.) Circumstantial evidence, too, favors Michelozzo as the author of the porticoes. The bronze doors, as we have suggested earlier, were probably not finished until Donatello was on the point of departing for Padua. At this very time, however, in 1444, Michelozzo began the construction of the new Medici Palace. This, as well as his earlier association with Donatello, would have made him a natural choice for completing a job that circumstances had forced Donatello to leave unfinished. Brunelleschi, we may assume, felt understandably slighted; after all, had not his own design for the palace been rejected? (See Billi, ed. Frey, pp. 34f; also Vasari, ed. Milanesi, II, pp. 371, 433.) And when he saw the unfortunate effect of the finished porticoes, he gave vent to his displeasure in some witty and sharp-tongued verses (Vasari calls him "facetissimo nel suo ragionamento e molto arguto nelle risposte"), but probably without naming names; according to the author of the *Vita*, who seems to have known some of them, the poems simply informed posterity that Brunelleschi must not be held responsible for those clumsy structures.

At this point, we shall have to consider one apparent obstacle to our hypothesis. In an anthology of verse compiled by Girolamo Baruffaldi, *Rime scelte de' Poeti ferraresi* (Ferrara, 1713, p. 16), there is an epigram in madrigal form addressed to "Donato," and credited to Brunelleschi. Achille Pellizzari, who introduced the poem into the scholarly literature on Brunelleschi as a writer (*Rassegna bibliografica di letteratura italiana*, XXVII, 1919, pp. 310ff), was dubious of its

authorship for reasons of style,[12] while Alessandro Chiappelli linked it with the story of the porticoes and interpreted it as one of the "defensive" poems mentioned in the *Vita* (*Arte del rinascimento*, Rome, 1925, pp. 191ff).

> Tell me frankly, Donato,
> Who deserves the greater praise:
> He who sounds the trumpet within the barrier
> Or he who would rather compete in butting?
> But you, who take such pride
> In all your many triumphs,
> Bid silence to the tattlers
> And work in peace;
> Then you will gather by the handful
> The most coveted praise of all,
> For by remaining your true self
> You will serve your own good.

The third and fourth lines (*Cholui che in lizza suona el serpentone, O cholui che più cozza in paragone*) are somewhat puzzling at first glance. Chiappelli interprets them to mean that he who plays his instrument within his own proper limits (i.e., he who does what he is competent to do) is preferable to those who stubbornly insist on competing in areas beyond their capacity. This reading would fit the complaint of Brunelleschi against Donatello as described in the *Vita*, but it misses the true meaning of the text, which can be understood only on the basis of an allusion to jousting or a similar "butting contest." Such events took place *in lizza*, in an area marked off by barriers, and were punctuated by trumpet signals. The poet clearly assumes that the jousters, who accept the risks of action, are better than those who merely produce the accompanying sounds (i.e., the tattlers, *quella gente sì loquace*). The import of the poem, then, is a warning to Donato not to join or encourage the idle talkers and to stick to his work; there is no hint of Donato's having encroached upon the author's own field of competence. Assuming that Donato is Donatello and the author Brunelleschi (which is probable but not certain), the situation alluded to in the poem would seem to be one in which the sculptor had expressed some criticism of Brunelleschi's architecture and thereby aligned himself with the anti-Brunelleschi

faction. He is being reproached for "sounding the trumpet" in a contest where he is not among the competitors, or, to put it more concretely, for presuming to have authoritative opinions in a field he does not practice: "Stick to sculpture, where you can accomplish something, and stay away from controversies in architecture, where all you can do is talk." The implications of the poem thus do not fit the story of the porticoes at all; there, after all, according to the *Vita*, Donatello had not talked but acted, with unfortunate results. The verses must relate to some other dispute, probably one involving a project of greater public importance and on a more monumental scale. From all accounts, such disputes were the rule, rather than the exception, during the major part of Brunelleschi's career, and apparently the great architect quite often resorted to poetry in defending himself. He may well have composed more than this one poem against Donatello, as the *Vita* suggests. Their content may be hinted at in the author's remark on how little Donatello knew of architectural settings, and his reference to the Cantoria and similar works. Could the friendship of the two masters have come to an end because of Brunelleschi's distaste for the unorthodox and "picturesque" style of decorative architecture Donatello had developed in the 1430's? The seeds of this style can be detected a good deal earlier (see above, pp. 32, 53ff), but in the 1420's Donatello had left the designing of architectural frameworks to Michelozzo, so that his own, very different approach did not come to the fore until the next decade. And the Cantoria, as the most conspicuous embodiment of Donatello's own architectural ideas, could well have been the *casus belli*.[13] Surely it is far more worthy of this distinction than the Sacristy porticoes, which, in principle, are not nearly so far removed from Brunelleschi's ideas. But since Brunelleschi had also written a poem against the porticoes, we can hardly blame the author of the *Vita* for assuming that these verses, too, were addressed to Donatello. Considering the tendentious character of the *Vita* (see above, pp. 10f), the story of the porticoes contains a surprising amount of historic truth. If, in order to reconstitute this truth, we were led to assign the porticoes to Michelozzo, we have gained a good deal more than we have lost.

[12] Its inclusion in a Ferrarese anthology is explained by the compiler's note that the paternal ancestors of Brunelleschi had come from Ferrarese territory.

[13] In his capacity as Cathedral architect, Brunelleschi seems to have had a certain administrative or supervisory connection with the Cantoria project, as suggested by Poggi (doc. *1293*, cited above, pp. 119f): on December 30, 1433, he and the master-in-charge of the *opera* were called upon to specify the dimensions of a marble block for Donatello's Cantoria. Was this the block which Donatello rejected and which was subsequently utilized for the lantern of Brunelleschi's dome? (See above, p. 120, *s.v.* "April 11, 1435.") Perhaps these notices contain a reflection of the conflict between the two masters.

BUST OF A YOUTH, MUSEO NAZIONALE, FLORENCE

PLATE 66 Bronze; H. 42 cm; W. 42 cm *(c. 1440)*

DOCUMENTS: none

SOURCES: none

Nothing is known of the history of this piece prior to the 1880's. The Catalogue of the Museo Nazionale issued in 1898 (pp. 65f) gives no date of acquisition, thus indicating that the bust was regarded as belonging to the old stock of the Grand-Ducal collections. I have been unable to find any reference to it among the older guidebooks to the Uffizi, but this is hardly surprising in view of the fact that it was not then attributed to Donatello (see below); most of the *bronzi moderni* on display in the eighteenth and early nineteenth centuries were not considered worthy of individual mention by the authors of the guides. Since its entry into the Donatello literature, the bust has been shown twice outside its homeland: in the Exposition de l'art italien au Petit Palais, Paris, 1935 (*Catalogue*, p. 311, no. 1032, with bibliography) and at the Museum of Modern Art, New York, in 1940 (*Italian Masters lent by the Royal Italian Government*, no. 1, pp. 14ff).

The earliest printed references to the piece, so far as I know, occur in the Donatello monographs of 1886-1887. We do not learn from them, however, who originated the attribution. It may have been Wilhelm Bode, who is credited with the suggestion that the bust represents the son of the Gattamelata, Giovanni Antonio da Narni (cf. Tschudi, *D.*, p. 24). This identification, accepted by Eugène Müntz (*Donatello*, Paris, 1886, p. 71) and Semper (*D.* '87, pp. 84f) came to be viewed with increasing distrust by later scholars, who retained it only as a convenient label (Cruttwell, *D.*, p. 121, emphasizes that the features bear no resemblance to those of the effigy on the tomb of Antonio da Narni in the Santo of Padua). It is indeed nothing but a romantic fiction, without the slightest factual support, and deserves to be abandoned without further ado. The only available clue to the subject of the bust is the large oval medallion, whose close kinship to an ancient cameo owned by the Medici had been recognized by Semper, *loc.cit.* It shows a nude, winged youth, with a staff in his left hand (apparently the stock of a whip), driving a *biga*, a chariot drawn by two horses. Rudolf Wittkower ("A Symbol of Platonic

Love . . . ," *Journal of the Warburg Institute*, I, 1938, pp. 260f) has pointed out the symbolic meaning of this scene as the image of the soul according to Plato's *Phaedrus* (translated by Leonardo Bruni in 1423). He relates the bust to the revival of Platonism by the humanist friends of Cosimo de'Medici about 1440, and concludes that it must have been commissioned by Cosimo himself. The medallion, he believes, stamps the sitter as under the tutelage of Plato's Heavenly Eros, "guardian of beautiful boys." That our medallion was indeed intended as the Platonic image of the soul, is proved by a detail that escaped Wittkower's attention: the clearly differentiated behavior of the two horses. The animal in the front plane rears back in unruly fashion while the other strives forward. This corresponds exactly to one aspect of the metaphor as expounded by Socrates—the horses of the *divine* soul are both of noble breed and move in harmony, while those of the *human* soul are mixed, one being noble and good, the other ignoble and bad.[1]

The attribution of the bust to Donatello, once launched, went substantially unchallenged for half a century. The only dissenters were Milanesi (*Cat.*, p. 26), who placed it among the "doubtful or wrongly attributed works" without giving his reasons; Semrau (*D.*, p. 95n), who claimed it for Niccolò Baroncelli, apparently because of its resemblance to the St. Louis on the Padua High Altar (see Pl. 80a), which he also attributed to Baroncelli;[2] and Venturi (*Storia*, VI, p. 296), who assigned our bust, in which he found a certain "lack of strength," to a follower of Donatello. (Colasanti, *D.*, pl. cliii, labels the bust "Donatello?", without discussing it.) Recently, however, Donatello's authorship has been contested on both stylistic and iconographic grounds. Lányi (*Probl.*, pp. 16ff) subjects the bust to a detailed comparison with the St. Rossore, the only documented bust by our master, and the head of the Gattamelata, and notes that these two have a more individual, portraitlike character than the "idealized, classicistic" Youth, even though the latter "doubtless represents a contemporary individual" while the others do not (the Gattamelata being

[1] The contrasting movement of the two horses does not occur on the Medici cameo or in any other classical *biga* representation, so far as I have been able to ascertain, and seems to be extremely rare in the Renaissance. I have found only one clear-cut example of it among all the medals and plaquettes of the later Quattrocento and the Cinquecento cited as showing the Platonic chariot (cf. Wittkower, *loc.cit.*, n. 6), on the reverse of a medal by the learned Paduan, Giulio della Torre, inscribed

AURIGA PLATONIS (specimens in Berlin and Turin; G. F. Hill, *A Corpus of Italian Medals of the Renaissance. . .* , London, 1930, no. 565, p. 145, pl. 102).

[2] August Schmarsow, to whose remarks in *Repertorium f. Kw.*, XII, 1889, p. 206, Semrau refers in this connection, had claimed only the so-called Lodovico Gonzaga bust in the Berlin Museum for Baroncelli.

a posthumous, "reconstructed" portrait). He concludes that there is no evidence to show that Donatello ever did any portraits apart from the traditional context of funerary monuments; the author of the Museo Nazionale bust (for which Lányi proposes a date of 1460-1480) must be at least one generation younger than our master and belongs to a more refined phase of the Florentine Quattrocento with which Donatello has nothing in common. André Chastel (*Proporzioni*, III, 1950, pp. 73f) supports these conclusions with further arguments; where in Florentine sculpture before the middle of the century, he asks, do we find a style so *antiquisant*, so redolent with the spirit of the Platonic symbolism of the medallion? According to Chastel, the Bruni translation of *Phaedrus* had little general impact. It was Marsilio Ficino's Commentary of 1475 that really brought the Platonic image of the soul into fashion, as indicated by the fact that all the other known instances of it in the visual arts are at least twenty years later than the supposed date of our bust. If the Youth belongs to the age of Ficino, rather than of Bruni, its author is clearly not Donatello but perhaps the late Desiderio or Mino da Fiesole.

All these arguments are a good deal less conclusive than they may seem at first glance. Lányi, with all his insistence on rigorous method, unquestioningly assumes that the bust represents a contemporary individual (as had all previous scholars). But can we really be so sure of that? Considering the classicistic flavor of the piece, it could hardly be maintained that the features of our Youth are too individual to admit of any other alternative. Nor does the bust become any less puzzling if we regard it as a portrait than if we do not. Inherently, it seems to me, our Youth is no more portraitlike than Michelangelo's Brutus. If the Brutus had come down to us without any documentation, would he not, as the master's only "portrait" bust, pose much the same problem as our piece? A case could certainly be made for the Platonic Youth as a Quattrocento counterpart of the Brutus, even though the identity of the classic hero he represents—historical, mythical, or literary—is difficult to establish. (But then, how would we be able to prove that Michelangelo's bust is a Brutus on the basis of internal evidence alone? The classic cameo he used is a far less specific clue than our medallion.) In any event, the very limited evidence at our disposal permits us to argue either way. If our bust is a portrait, it is certainly a highly idealized one (could it represent the καλός of the Florentine Platonists, "assimilated" to the role of Phaedrus?) and must not be judged by ordinary standards of portraiture, so that Lányi's comparisons are hardly as cogent as he believed them to be. As for the argument of Chastel concerning the *antiquisant* style of our bust, does it not apply with equal force

to the bronze David? The impassive serenity of David's features, his nudity, and the emblematic *trionfo* transposed from a classic cameo onto the helmet of Goliath, surely convey much the same spirit as does our Youth. To cite the supposed chronological gap between the *auriga Platonis* on our medallion and all other instances of the same motif as evidence of the late date of the bust, is a risky procedure, to say the least: not only can it be invalidated at any time by some inconvenient example hitherto overlooked, but the underlying assumption is a dangerous one. Iconographic studies are replete with examples of similar time intervals, apparent or real, between the first known appearance of a given motif and its adoption by other artists.

Thus neither Lányi nor Chastel can be said to have arrived at a final adjudication of our problem. Their arguments, like those of skilled prosecuting attorneys, tend to be subtly biased against the defendant. While I shall not arrogate to myself the role of the final judge in this dispute, I should like, for the sake of the ultimate verdict, to present the case for the defense, as it were. While our Youth may be viewed as the humanistic counterpart of mediaeval reliquary busts (cf. Witthower, *loc.cit.*), a comparison with the St. Rossore is apt to be misleading, both because of the difference in date and because of the difference in age and human type. The latter objection also applies to the Gattamelata, even though here the treatment of certain details—the shape of the ears, the texture of the hair—is not dissimilar. A far more decisive test would be to match the head of our bust with other youthful, classical heads in Donatello's established *œuvre*. Of these, fortunately, we have a fairly long and continuous series, ranging from the St. Louis at S. Croce, the Faith of the Siena Font and the bronze David to the youthful saints on the Padua High Altar (SS. Louis, Daniel, and Justina). Such a comparison (see Pls. 21a, 21c, 30a, 31a, 35, 80a, 83b) not only reveals what strikes me as a strong "family resemblance" of our head to the rest; it also places our bust in the interval between the bronze David and the Paduan saints. The latter are generally closest to the bust, and the St. Daniel (Pl. 80c) in particular seems extraordinarily similar if we make allowance for his semi-finished surface. Had Lányi been able to extend his photographic campaign to the High Altar statues, he might well have changed his mind about the authenticity of our bust. On grounds of style, then, the Platonic Youth has a good claim to be retained as a work of Donatello shortly before the master's departure for Padua, or about 1440. (This is the date advocated by most earlier scholars; see Tschudi, *D.*, p. 24; Semper, *D.* '87, pp. 84f; Reymond, *Sc. Fl.*, II, p. 116; Schubring, *KdK*, p. 68; Kauffmann, *D.*, pp.

52f.) Several further observations point in the same direction: the surface treatment of the drapery, hair, and medallion has much in common with the technique of the bronze doors of the Old Sacristy and the "finished" (i.e. fully chased) portions of the High Altar statues (compare especially the garments of the St. Louis, Pl. 78a). And the cameo-medallion, too, fits into the context; its function as a symbolic commentary on the meaning of the figure is anticipated by the classic *trionfo* on the helmet of Goliath at the feet of the bronze David, even though the significance of the latter scene is less clear.[3] Donatello used the same device again in the Judith group, where Holofernes, otherwise nude from the waist up, wears a

symbolic medallion on his back to draw attention to his *superbia* (see below, p. 203 and Pl. 100b). The style of this medallion, though obviously more agitated, is not very different from ours. Finally, the *auriga* shows considerable similarity with the two nude horsemen on the back of the Gattamelata (see Pl. 73b). There are thus few aspects of the bust that cannot be accounted for, in one way or another, within the framework of Donatellesque forms and ideas. To remove the work from our master's *œuvre* would be a real loss, which could be compensated for by an equivalent gain only if it were possible to assign the piece to some other important artist with a decisively greater degree of conviction.

[3] See above, pp. 84f; it may be of interest to note that the ornament on the chariot of our *auriga* also occurs on the sandals

of the bronze David and on the base of the S. Croce Tabernacle.

"ATYS-AMORINO," MUSEO NAZIONALE, FLORENCE

PLATE 67 Bronze; H. 104 cm *(c. 1440)*

DOCUMENTS: none

SOURCES

1568 Vasari (Milanesi, pp. 417f): "In the house of Giovan Battista, son of Agnolo Doni, a noble Florentine, there is a metal statue of Mercury by Donatello, 1½ braccia tall and clothed in a certain bizarre fashion; it is very fine indeed, and as choice as the other things that adorn this beautiful house."

1677 Cinelli, p. 564: "In the house of . . . Angelo Doni . . . an ancient bronze statue of a child, 2 braccia tall, nude from the waist up; his left [arm is] raised, and his right gestures as if in laughing astonishment. He has wings on his shoulders, winged shoes on his feet, and a belt around his waist; the legs are covered by a thin fabric, a snake coils underfoot, and the shoes let the bare feet show through. The parts that ought to be private are bared. On the belt there are some small vases strung together. He is crowned with a hoop that has a small rose in the center. [The figure] is considered a Perseus, and by others a Mercury. [It is] beautiful in every part and esteemed. . . ."

Despite the small discrepancy in measurements—the figure is actually 1⅔ braccia tall—there can be no doubt that both Vasari and Cinelli refer to our statue. The piece remained in the Doni collection until June 1778, when it was sold to the Uffizi Gallery for 600 scudi by Pietro Bono Doni (R. *Museo Nazionale, Catalogo*, 1898, p. 64). In 1935, it was shown in the Exposition de l'art italien au Petit Palais, Paris (*Catalogue*, p. 310, no. 1030). According to Kauffmann (*D.*, p. 214, n. 170) the name of the previous owner is inscribed on the back of the figure. I have been unable to verify this. (Was it perhaps a painted inscription that has since been removed?) Kauffmann (*loc.cit.*) has also drawn attention to the condition of the arms, which are attached to the trunk as separate pieces; he believes them to be a Baroque restoration, both on

grounds of style and because of the awkward way they are joined to the shoulders. Moreover, he claims, they do not fit Cinelli's description of the gesture. The latter argument does not seem very compelling to me, since Cinelli's words are far from precise. Nor do I find the modeling of the arms incompatible with the rest of the figure. That they are joined to the body in somewhat clumsy fashion is certainly true, but this strikes me as a technical rather than an artistic imperfection; it also seems more in keeping with the still rather precarious state of bronze casting technique in Donatello's day than with that of the Seicento. The arms might, of course, have been broken off by accident, and re-attached or restored without sufficient care, after Vasari and Cinelli saw the figure. Yet a mishap resulting in the loss of both arms seems

highly unlikely for a bronze statue of the modest size of ours. I should prefer to assume that the accident occurred in the casting process, which produced several other imperfections as well (note the large hole above the right temple and the smaller one among the locks above the left eye). There is, furthermore, the peculiar fact that the right arm shows a second break—or a severe casting fault—just above the elbow. Nothing short of an automobile collision could account for such multiple fractures (if we persist in placing the accident after the completion of the statue).[1] If the arms of our "Atys" turned out badly and had to be recast, Donatello, always impatient in technical matters, may well have left the repairing of the damage to some lesser man. While the latter certainly did not perform his task with any degree of distinction, we need not charge him with having departed from Donatello's original design. The angle at which the arms are attached to the body fits both the tilt of the shoulder line and the muscular structure of the chest.[2]

That the arms deserve to be regarded as authentic is not without importance for the iconographic riddle posed by our figure, which has so far defied solution. All we can say with assurance is that none of the designations hitherto proposed is satisfactory. (I am retaining the name Atys merely as a convenient label.) Vasari seems to have been no less puzzled by the statue than were his modern successors; in calling it a Mercury he took his clue from the winged feet, without regard to the other attributes. The alternative title of Perseus, recorded by Cinelli, rests on the same basis.[3] In the Uffizi catalogue of 1782 (pp. 52f; cited in Ludwig Goldscheider, *Donatello*, London, 1941, pp. 20f) our figure is identified as a Cupid, apparently on the assumption that it had originally held a bow and arrow in its hands. Semper (*D.* '75, p. 269) at first subscribed to the same hypothesis but rejected it later (*D.* '87, p. 72), proposing instead—for no apparent reason—to dub the statue an allegory of "carefree love" (*Sorglosigkeit der Liebe*). Tschudi (*D.*, p. 14) and Schottmüller (*D.*, p. 51, n. 1) did not enter into a discussion of the problem; they called the figure a Cupid, but without conviction, as did Reymond (*Sc. Fl.*, II, p. 119) and Wilhelm Bode (*Denkmäler der Renaissance-Skulptur Toscanas*, Munich, 1892-1905, p. 20). The latter added the suggestion that the attributes might be based on a misinterpretation of

a classical Hippolytus figure (which attributes, and which figure, he had in mind I cannot imagine). Siegfried Weber (*Die Entwickelung des Putto in der Plastik der Frührenaissance*, Heidelberg, 1898, p. 71) called the figure an image of Harpocrates, but most of the attributes do not fit, quite apart from the fact that Harpocrates, "the god of silence," is invariably represented with his right index finger pressed to his lips. Alfred G. Meyer (*Donatello*, Bielefeld-Leipzig, 1903, p. 78) introduced the notion that our statue derives, at least in part, from Roman Atys figures such as the specimen in the Louvre, with its characteristic trousers revealing the self-mutilation of the Phrygian shepherd. Since then, most scholars have been content to refer to our figure as a combination of Atys and Cupid, even though it is obvious that Donatello could not have understood the meaning of the Roman Atys images (if indeed he knew any of them). Meyer's thesis thus rests on a purely formal relationship and does not clarify the significance of our statue. Unfortunately, the alternatives suggested by those who rejected the Atys designation are equally unpromising. Venturi (*Storia*, VI, pp. 272f) terms the figure a "little satyr" (*faunetto*), since it has a tiny tail. According to O. Sirèn (*American Journal of Archaeology*, XVIII, 1914, p. 446; also *Essentials in Art*, London, 1920, pp. 103ff) our statue is an "Amor-Hercules," because of the snake underfoot; Sirèn relates it to ancient *putti* with the attributes of Hercules, and believes that it originally held a snake in either hand. Goldscheider suggests instead (*loc.cit.*) that it held a golden apple, and identifies it as Mercury bringing the apple to Paris, on the basis of a passage in the *Golden Ass* of Apuleius (which, however, mentions none of the numerous other attributes of our figure). Charles Picard ventures even further afield (*Revue archéologique*, 6e sér., XXVIII, 1947, p. 77) in terming the figure, with some hesitation, a "winged snake-killing Mithra."

The trouble with all these interpretations is that they rely, more or less arbitrarily, on a single detail. A truly convincing solution will not only have to account for the entire range of attributes displayed by our statue; it must also be meaningful within a Quattrocento frame of reference. Such a solution—a far from easy task—is not yet in sight, but from what has been written on the subject we may draw at least some negative lessons. Thus it seems unlikely that

[1] It may be useful to recall here the analogous case of the bronze St. John in Siena Cathedral, which was delivered with one arm missing (see below, p. 196), surely as the result of a casting accident. Donatello probably dispatched the statue in this imperfect condition because the Sienese authorities were pressing him for it; he never supplied the missing piece, perhaps because of some financial quarrel (as suggested by Vasari) or because he was preoccupied with other, more interesting tasks.

[2] In any event, they are far less alien to the rest of the statue than the right arm of the Siena St. John, which immediately betrays itself as a later addition.

[3] In classical mythology, Mercury is endowed with winged shoes, not winged feet, a distinction usually observed in ancient art but not in mediaeval and Renaissance representations of the messenger of the gods; he lent the winged shoes to Perseus who, thus airborne, succeeded in slaying Medusa and freeing Andromeda.

our "Atys" could have been meant to represent a specific character from ancient mythology; the bewildering variety of his attributes suggests, rather, that he is some sort of personification or allegory invented by the antiquarian learning of a Florentine humanist. Perhaps this is the reason why Vasari was no longer able to "read" the statue correctly. Or could it be that our figure had originally held something in its hand that served to clarify its meaning, and that this key attribute had become lost before Vasari's time? I am inclined to assume that such was indeed the case: apparently our *putto* once held a light object between the thumb and middle finger of his left hand—an object that must have been a source of pleasure to him, judging from his radiant smile and admiring gaze. (Robert Corwegh, *Donatellos Sänger-kanzel . . .*, Berlin, 1909, p. 37, explains the gesture of the arms by assuming that the "Atys" was meant to balance a large bowl on his head. There is indeed, as Corwegh has observed, an opening with a knob-like closure at the top of the head, but this feature can be accounted for easily enough as the hole for scraping out the earthen core of the statue. Moreover, since the hands of the *putto* could not have touched the bowl, Corwegh must have visualized it as teetering dangerously on top of the head; so far as I know, there is no precedent for such a notion anywhere in Quattrocento art.)

Before we can venture to guess what the *putto* might have held in his hand, we shall have to find the common theme that unites the other attributes, and here again some negative observations are necessary. The snake, for instance, probably has nothing to do with those that attack the infant Hercules, since our *putto* makes no effective attempt to crush it; it emerges from beneath the toes of his right foot and curls over the left, rising against the lower part of the leg, with its head turned towards the beholder. Instead of trying to bite, it seems to be on entirely friendly terms with our figure. As for the trousers, they resemble those of the Roman Atys images only in their failure to cover the pudenda. Their cut (a separate "hose" for each leg) and method of support (one-point suspension from a heavy leather belt) have no antecedent in ancient art but can be found in mediaeval and Renaissance representations of peasants, as noted by Reymond, *loc.cit.* The wide rustic belt, with its heavy buckle, is even more strikingly "modern"; it has an ornament, not of "small vases" (as Cinelli puts it) but of poppyheads (correctly described in the Uffizi Catalogue of 1782, *loc.cit.*; usually overlooked by later scholars). Cinelli also makes a small error in his definition of the head ornament: it is not a hoop but a heavy

cord whose tasseled end hangs down between the wings of the figure. None of these details, individually or collectively, can be linked with a central theme sufficiently clear-cut to reveal the meaning of the statue as a whole. Yet the central theme may be implicit in the pose and expression, suggestive of an unrestrained *joie-de-vivre*, a somewhat tipsy gaiety, as if our *putto* were about to break into a dance step although no longer quite steady on his legs. Perhaps this bacchanalian air is the clue we need. In that event, our figure might have been intended as a kind of "genius of wine," or a personification of *Ebrietas*. And the lost attribute in his left hand could have been a cluster of grapes or a wine cup. Most of the other features, I believe, are not too difficult to fit into such a framework: the friendly snake and the satyr's tail can be accepted as Bacchic attributes on the basis of the ubiquitous snakes and satyrs in Roman bacchanals, and the poppyheads may well be a reference to that kindred form of *ebrietas* induced by opium.[4] The rustic belt and trousers suggest the rural wine festivals that were—and still are—such a persistent feature of Mediterranean life. Perhaps it is no mere coincidence that Reymond found these same trousers among the vinicultural workers in Benozzo Gozzoli's frescoes in the Camposanto of Pisa. One might even think of the famous Triumph of Bacchus by Velazquez, with its casual merging of mythology and peasant genre. The uncovering of the pudenda need not be regarded as a conscious display; after all, the trousers of our *putto* are not really trousers properly speaking but individual sheaths intended to protect the legs against cuts and bruises such as one might get while working among the underbrush; in the Gozzoli murals, they are worn with other garments that cover the pudenda, but a *putto*, being traditionally nude, could hardly be expected to follow the same rule. If, on the other hand, we choose to interpret this feature as having a purpose of its own, we would still be on safe ground, since nudity in this specific sense has a long-standing connection with drunkenness; the Quattrocento knew it not only from the Biblical account of Noah and his three sons but also in classical bacchanals new and old (compare the wine-drinking *putti* on the base of Donatello's Judith, Pl. 99a), and even in burlesque scenes such as the drunken pedlar robbed by monkeys (cf. H. W. Janson, *Apes and Ape Lore . . .*, Studies of the Warburg Institute, Vol. 20, London, 1952, pp. 220f). This leaves only one attribute unaccounted for—the wings sprouting from the ankles of our figure. As a reference to Mercury, they are admittedly difficult to understand in a Bacchic context. It should be noted, however, that they were not

[4] A still life attributed to Caravaggio in the Boston Museum of Fine Arts conveys the same notion by combining a wine bottle with a bunch of large poppies.

the exclusive property of the divine messenger. In ancient art they could on occasion be worn by other airborne deities as well (e.g. Eos, on an Etruscan terracotta *acroterium* of the sixth century B.C. in the Berlin Museum).[5] A careful search might well turn up further specimens of this sort, especially among Etruscan pieces which could have influenced the Quattrocento. There is in fact at least one clear-cut example in the immediate vicinity of Donatello's "Atys"; the elaborate bronze enclosure of the Cappella del Sacro Cingolo in Prato Cathedral shows, among many other things, a blind Cupid with bow and quiver, nude except for the winged boots on his feet.[6] What associations ankle-wings as such could have evoked in the minds of fifteenth century humanists is, needless to say, hard to ascertain. On the other hand, considering the extreme complexity of the symbolic ideas connected with the Bacchic cult in the Renaissance,[7] it is not inconceivable that our statue actually had a mercurial—or better, "hermetic"—aspect. After all, in his role of Psychopompos Mercury, too, could guide the soul into realms of mystic transport. All these matters call for a good deal of further research if our tentative interpretation of the "Atys" is to be placed on a solid footing. It is also possible that some day a text specifically applicable to our statue will turn up among the humanistic writings of the period. In the meantime, our hypothesis offers an approximate answer that is not incompatible with the details of the work and accords well with its expressive content.[8]

That the "Atys" is a work of Donatello has not been disputed in modern times (Lányi, *Probl.*, p. 23, lists it as "in part" by our master, apparently on the basis of Kauffmann's claims concerning the arms). Among older scholars, Milanesi (*Cat.*, pp. 27f) was the only one to regard it as antique; since he thought that the figure might represent either an Etruscan or an Asiatic deity, his reasons for trusting Cinelli rather than Vasari seem to have been mainly iconographic. The

puzzling subject matter may also explain how the Doni family (whose opinion Cinelli undoubtedly reflects) could proclaim the statue as classical against the explicit testimony of Vasari. Or did the back-dating of the work enhance its desirability in the eyes of its owner? If he were sufficiently antiquarian-minded, such a motivation need not be excluded; one is reminded of Sabba da Castiglione, who complained of the dearth of good antique pieces on the market and listed Donatello as the next best choice (*Ricordi*, Venice, 1554, No. 109, p. 51; cited in Balcarres, *D.*, p. 90). The Baroque era, none too discriminating in such matters, could hardly be expected to disavow the ancient origin of our *putto*. Instead, it tried to fortify the statue's claim to authenticity as a classical work by inventing a fanciful "excavation report" according to which it had been found in a cave, with one arm missing.[9] Whether our *putto* was bought for the Uffizi as a bona fide antique is difficult to say: the 1782 catalogue definitely labels it Donatello, while that of 1790 admits the possibility of its being classical (p. 14; cited in Kauffmann, *D.*, p. 214, n. 170).[10]

What was the original location and purpose of the "Atys"; for whom was it made? These questions must go unanswered, and few scholars have dared to speculate on them. Semper's belief (*D.* '87, pp. 72f) that the figure must have been made for Cosimo de'Medici and may have served as a fountain, has no factual basis whatever. The only justifiable inference, considering the esoteric character of the work, is that it must have been a private commission from someone deeply immersed in humanistic learning. The style of the figure struck the Donatello scholars of two or three generations ago as closely akin to that of the Siena *putti* and the bronze David, so that the date they suggested for it was invariably the early 1430's. Kauffmann, having subjected our *putto* to a more considered analysis, arrives at a somewhat later date (*D.*, p. 52). To him, the statue seems related primarily to the Cantoria

[5] A slightly later example, which has since been acquired by the British Museum, is the engraved Etruscan bronze mirror from a Roman private collection reproduced in M. Delachausse [Causeus], *Romanum Museum sive Thesaurus . . .*, Rome 1707, III, pl. xix; it shows a winged male figure holding a lotus flower and a lyre.

[6] He also has wings on his shoulders; see Giuseppe Marchini (*Commentari*, III, 1952, pl. xxx, figs. 13, 15 and pp. 109, 118f) who identifies the figure as the work of Antonio di Ser Cola, executed soon after 1447. Another nude *putto* on the same part of the enclosure has a "friendly" snake coiled about his left arm.

[7] Cf. the Patera Martelli of the Victoria and Albert Museum, once ascribed to Donatello (Schubring, *KdK*, p. 184, reproduces it as the work of a follower) and not much later in date than our "Atys."

[8] Dr. Edgar Wind has recently been kind enough to suggest to me an alternative interpretation of the figure as an Eros Pantheos, i.e. an Eros combined with the attributes of several other gods (cf. Pauly-Wissowa, *Real-Encyclopädie . . .*, revised

ed., XVIII[3], Waldsee-Stuttgart, 1949, p. 746). Whether such a compound image of Eros was known to the Quattrocento, visually or textually, remains to be determined.

[9] This story, credited to Bocchi, is reported in a Napoleonio guide to the Uffizi, *Galérie Impériale et Royale de Florence*, p. 79; I was able to consult only the second edition, issued in 1818; the original must have been published some ten years earlier. A parallel instance, even more astonishing in its way, is the Montorsoli Satyr from the Palazzo Barberini, now in the City Art Museum, St. Louis; it, too, was mistaken for an antique original and published as such, with detailed commentary, in Joachim Standrart, *Sculpturae veteris admiranda . . .*, Nuremberg, 1680, p. 63.

[10] According to Milanesi (p. 418), it was Luigi Lanzi who championed the return to the Donatello attribution and had the figure exhibited among the modern bronzes, but this distinction in reality belongs to Antonio Cocchi, who became curator of the Uffizi in 1738 (cf. *Descrizione della Reale Galleria di Firenze*, Florence, 1792, p. 286).

frieze, and certain details suggest the Bust of a Youth in the Museo Nazionale as well as the *putti* of the Padua High Altar. Planiscig, too, places the "Atys" close to 1440 (*D.*, pp. 68f, 143), on the ground that the nude body seems more evolved here than in the bronze David. I find myself in substantial agreement with the latter two opinions. The internal structuring of the torso, it seems to me, already suggests some of the qualities so conspicuously present in the Padua Crucifix, even after all due allowance is made for the vastly different character of the two works. There is, moreover, an iconographic argument as well for dating our *putto* close to 1440: its intricate allegorical significance suggests the same background that inspired the Platonic emblem on the Bust in the Museo Nazionale (see above, p. 141). The bust, too, is prophetic of Donatello's Paduan style of the later 1440's, and thus demands a date shortly before the master's departure from Florence. Inasmuch as the mysterious Youth and the equally puzzling "Atys" are the only known works of Donatello based entirely on humanistic thought, it seems plausible to link them in other ways. Apparently Donatello moved in this rather special orbit only once in his lifetime, and only for a few years, so that both pieces were probably conceived during the same brief phase of the artist's career.

CRUCIFIX, S. ANTONIO, PADUA

PLATES 68-69 Bronze; H. c. 180 cm; W. c. 166 cm *1444-1447*

DOCUMENTS

A number of entries in the account books of the workshop of S. Antonio, in the Archives of the Arca del Santo. Excerpts printed in Bernardo Gonzati, *La Basilica di S. Antonio di Padova descritta ed illustrata*, Padua, 1854, I, p. lxxxv. More complete publication in A. Gloria, *Donatello fiorentino e le sue opere mirabili nel tempio di S. Antonio di Padova*, Padua, 1895, pp. 4ff (reprinted in Camillo Boito, *L'altare di Donatello e le altre opere nella Basilica Antoniana di Padova*, Milan, 1897, p. 39). Luigi Guidaldi has published some additional entries in *Il Santo*, IV, iv, 1932, p. 284.

1444, January 24 (Gloria, p. 4): Donatello's account is charged with 4 lire 12 soldi for 46 pounds of iron for making the crucifix. The metal has been received by his partner, Master Giovanni (*maestro Zuan so compagno*).

June 19 (Gloria, p. 5): Donatello has received white wax worth 21 lire for making the crucifix.

1447, June 19 (Gloria, p. 8): The stonecarver Giovanni Nani da Firenze receives 28 lire 10 soldi for a pedestal (*sotopé*) he has made for the Christ in the *capella grande* above the great altar of the choir. The *sotopé* consists of two pieces [of stone] and measures 32 *py*—cubic feet, according to Gloria—including the cornice around it.

1449, January 7, 9, 29 (Gloria, p. 12): Payments to the painter Nicolò for painting the cross of the crucifix, and to an unnamed lady who is gilding the cross.

January 22 (Gloria, *ibid.*): Master Andrea dalle Caldiere is paid for a copper *diadema* (crown of thorns or nimbus) he had made for the crucifix.

February 11 (Gloria, *ibid.*): Bartolommeo da Castegnaro is paid for gilding the *diadema* of the crucifix.

After February 11 (Gloria, *ibid.*): Payment for the wood used for the cross of the crucifix.

June 23 (Gloria, p. 13): Donatello receives 89 lire as the remainder of the money owed him for the crucifix.

1487, December 28 (Guidaldi, *loc.cit.*): The beauty of the choir stalls cannot be fully seen because of the columns supporting the crucifix; it is resolved, therefore, to remove these columns and to place the crucifix on a marble base in the center of the entrance to the choir.

1548 (Guidaldi, *loc.cit.*): The inventory of that year lists a blue cloth with painted stars and six wooden gilt candlesticks in connection with "the high crucifix in the center of the church."

SOURCES

1590 Valerio Polidoro, *Le religiose memorie . . . nelle quali si tratta della chiesa del glorioso S. Antonio*, Venice, 1590, cited by Boito, *op.cit.*, p. 29: "On the highest part [of the choir screen façade there is] the reverend image of the Savior crucified, in gilt bronze and of great beauty . . . by Donatello of Florence."

According to the documents, the crucifix was modeled during the first half of 1444; it must have been cast, therefore, in the fall of that year. Donatello's partner, "Master Giovanni," mentioned in the entry of January 24, was identified by Gonzati, *loc.cit.*, with Giovanni da Pisa. This has led many scholars, from Tschudi (*D.*, p. 26) to Colasanti (*D.*, pp. 29f), to assert that Giovanni da Pisa collaborated in the execution of the crucifix (Schubring, *KdK*, p. 199, holds him responsible for "the overly detailed treatment of the body"). Actually, however, Gonzati's suggestion is far from plausible, as Gloria, *op.cit.*, p. xiii, has pointed out: the name of Giovanni da Pisa does not appear in the Santo records until February 11, 1447 and after (see below, p. 163), nor is he ever called *compagno*. The "Master Giovanni" of 1444, Gloria believes, must be the stonecarver Giovanni Nani of Florence who figures in the account books from April 3, 1443 on as engaged in various labors, including the choir screen.

The exact date of the completion of the crucifix is unknown. It must have been finished by mid-1447, since at that time it was on a stone pedestal above "the great altar of the choir" in the *capella grande*, a location usually interpreted as the old main altar, the predecessor of Donatello's (Guidaldi, *op.cit.*, p. 273; Kauffmann, *D.*, p. 104, seems to think the altar was attached to the choir screen). The architectural framework of the new altar was erected in the course of 1449 (see below, pp. 170ff), so that the old altar must have been demolished then.[1] The crucifix at that time was presumably moved to the spot which it occupied until December 28, 1487. That the reinstallation took place early in 1449 is also indicated by the various payments in January and February. Unfortunately, however, the new setting is difficult to visualize from the scanty information about it in the document of 1487. To what sort of structure did the "columns (or pilasters) supporting the crucifix" belong? And where are we to imagine this structure, which inter-

fered with a full view of the choir stalls? Was there perhaps an altar opposite the "entrance to the choir" (i.e., the central opening in the choir screen façade), to which the crucifix had been attached after its removal from the old High Altar in the choir? If this assumption is correct, the altar itself would have remained intact (the altar table as such not being tall enough to obscure the choir stalls behind it), so that the word *altare* would not have to be mentioned in the resolution of 1487. In any event, after the demolition of the "columns" the crucifix was mounted above the central opening of the choir screen façade.[2] It remained there until 1651-1652, when that part of the screen was taken down and the rest rebuilt, partly with old materials (cf. A. Prosdocimi, *Rivista d'arte*, XXI, 1939, pp. 156ff, and Rolf Band, *Mitteilungen des Kunsthistorischen Instituts in Florenz*, V, 1940, pp. 329ff). The crucifix then became part of the Baroque High Altar, which survived until 1895 (see the photographs reproduced in Guidaldi, *op.cit.*, figs. 5, 19). Since that time it has been in its present position above the "reconstituted" Donatello High Altar (see below, p. 171). Physically, the figure is well preserved, except that the present loincloth is a Baroque addition (as first pointed out by Colasanti, *D.*, p. 143n). The body was modeled entirely nude, like that of the Brunelleschi crucifix in S. Maria Novella and several others of the period (cf. Kauffmann, *D.*, p. 234, n. 387); the shape of the original loincloth is suggested by the small crucifix in the hand of the St. Francis on the High Altar (see Pl. 78b). The *diadema* made for the crucifix in 1448-1449 by Andrea del Caldiere has likewise disappeared.

The stylistic aspects of the work have been well analyzed by Schottmüller (*D.*, pp. 81f), Colasanti (*D.*, p. 67), and Kauffmann (*D.*, pp. 120f). The powerfully modeled body structure is the culmination of Donatello's studies of the nude, beginning with the early wooden crucifix in S. Croce, but unlike the latter every anatomical detail here conveys a spirit of heroic

[1] Kauffmann, *loc.cit.*, asserts that there was no high altar in the Santo until the donation of Francesco Tergola on April 13, 1446, made it possible to commission one from Donatello. So far as I can see, this claim is inherently implausible—could the monks have done without a high altar since the structural completion of the church in the early Trecento?—and lacks

any support among the documents. Moreover, the text of the Tergola donation (cited below, p. 163) specifically provides for *constructione pale ad altare magnum . . . et non alibi*, implying the existence of a high altar that was to be adorned with a *pala*.

[2] The latter must have been similar to that in the Frari, Venice; cf. Gloria, *loc.cit.*, and Guidaldi, *op.cit.*, pp. 275f.

suffering. The head, with its fluid yet disciplined treatment of hair and beard, recalls several of the martyrs and apostles on the bronze doors of the Old Sacristy in S. Lorenzo (probably the artist's last pre-Paduan work, as suggested above, p. 137) and anticipates in a curious way the head of Holofernes in the Judith Group (see Pls. 96, 100a).

The bronze crucifix is Donatello's first known work in Padua. The account book entry of January 24, 1444, provides the earliest documentary proof of his presence in that city. We do not know when he arrived there, but he could not have left Florence earlier than 1443, for at some time during that year he had rented a house with a garden, an *apotheca*, and other buildings there near the Cathedral (according to a document published in Domenico Maria Manni's edition of Filippo Baldinucci's *Notizie . . . ,* III, Florence, 1768, p. 81, n. 2; reproduced in Semper, *D.* '75, p. 236). What had brought the master to Padua? The statement of Vasari that it was the commission for the Gattamelata monument (see below, pp. 154f) has been generally disregarded ever since Gloria, on the basis of certain account book entries newly transcribed by him, launched the thesis that our artist came to Padua at the invitation of the Arca del Santo in order to design the choir screen of the church and to do the bronze crucifix. Some authors even went so far as to claim that Donatello was to "superintend the restoration of the church."[3] According to Gloria and Fabriczy, Donatello furnished the design for the choir screen, a double arcade placed across the nave at the crossing.[4] Venturi pointed to the Quattrocento paneling in the present choir enclosure as evidence confirming Gloria's thesis, and attributed the triangular bronze insets with angels' heads to Donatello himself (*L'Arte,* x, 1907, pp. 276ff and *Storia,* VI, pp. 298ff). All this tended to suggest some sort of connection between the choir screen and the bronze crucifix. Gloria had hinted at such a link, but his successors did not insist on it; only Kauffmann, *loc.cit.,* maintained that the crucifix was intended from the start for an altar attached to the screen. It is indeed possible that the installation of the crucifix "above the great altar of the choir" in 1447 was only temporary; that the "columns" which formed its pedestal from about 1449 to 1487 were contemplated as early as 1443. On the other hand, there is nothing to prevent us from assuming that the crucifix was commissioned for the "great altar of the choir" (the Tergola donation, after all, could not have been antici-

pated in 1443), or for the central arch of the choir screen (which may not have been finished in 1449; in that event, both the placement "above the great altar" and the installation "on columns" would have been temporary). Or maybe none of the three known locations of the crucifix represents the original purpose for which it was made. So far as I can see, there is little to choose among these alternatives, even if we give full credence to Gloria's claim concerning the reason why Donatello came to Padua. Can we regard it as reasonably certain that our master designed the choir screen? Unfortunately, here again the evidence is far from decisive. It rests on two account-book entries of mid-1449 (Gloria, *op.cit.,* pp. 13, 14), according to which on June 23 Donatello was credited, among many other things, with 285 lire "for the God the Father [of the High Altar] and the choir façade"; three days later the same amount is mentioned again, this time with the notation that it represents payment "for a stone God the Father on the cupola of the altar and for work in supervising the carving of the marble parapet of the choir" (*per exercitarse in fare fare quelo antipeto del curo de marmoro*). The sum involved here is not large, and since a sizeable part of it—approximately one half, I should think—represents the cost of the God the Father panel, the payment for the marble parapet of the choir screen cannot have been much more than about 150 lire, a rather modest fee if we consider that it corresponds to what Donatello received for two of the twelve small bronze panels of standing angels. By themselves, these two entries would hardly warrant the far-reaching conclusions of Gloria. There are, however, two earlier entries which Gloria adduces as proof that Donatello was working on the choir screen at the very beginning of his Paduan sojourn: on March 30, 1444, Master Bartolomeo's account is charged with two ducats, which have been paid to the stonecarver Donato, who has been working on the arches of the gallery of the crossing (*Donà[to] tagia pria el quale à lavorà[to] in li archi de la balchonà[ta] de lo lavoriero de la ✠ [crociera]*); and twelve days later Master Bartolomeo is charged with one ducat, representing the final payment to Donato and Aberto for their work on the arches of the gallery of the crossing (*a Donà[to] et Aberto per resto de el lavoriero de li archi de la balconà[ta] . . .*). "Master Bartolomeo" is Bartolomeo di Domenico, who on July 10, 1443, had been credited with 1500 lire for the work he had undertaken, i.e. "the façade in the middle of the church, of white and

[3] Cruttwell, *D.,* p. 102; or to construct the *tribuna* of the choir (Wilhelm Bode, *Jahrbuch Kgl. Preuss. Kunstslgn.,* XXII, 1901, p. 40; Schubring, *Urbano da Cortona,* Strasbourg, 1903, p. 17, and *KdK,* p. xlii). These sweeping generalizations were refuted by Fabriczy (*L'Arte,* VI, 1903, pp. 376f), who had endorsed Gloria's original findings and formulated them even

more precisely (*Archivio storico italiano,* 5. serie, XVII, 1896, pp. 186ff).

[4] Its shape and location had been defined by Gonzati, *op.cit.,* pp. 67ff, on the basis of Polidoro's description of 1590; cf. Prosdocimi, *loc.cit.*

red Veronese stone, as per the written contract . . . ;" the contract itself does not seem to have survived, but the above passage leaves no doubt that the commission for the choir screen had been given to Bartolomeo. As the master-in-charge, he appears very frequently in the account books from now on, together with various stonecarvers working under him. The "Donato" of March 30 and April 11, 1444, belongs to the latter group. Could he be identical with Donatello? That, it seems to me, is not only unlikely but practically impossible. First of all, Donatello is usually called "Master Donatello of Florence" or "Donatello of Florence"; to find him referred to simply as "Donato" in two entries that give the title of Master to Bartolomeo would be most unusual. And why should he have been working on the arches of the screen as a subordinate of Bartolomeo if, as Gloria believes, he came to Padua in order to design the entire work? Is it not almost grotesque to think that Donatello had been induced to leave Florence, abandoning important commissions there, in order to carve decorative details of the Santo choir screen under Master Bartolomeo? No, this "Donato" must have been a journeyman carver, like his companion Aberto (whose name appears only once in the Santo records), who worked on the screen for a short time and earned between two and three ducats—about fifteen lire—in the process (the small amount suggests ordinary wages rather than a master's fee). We are thus left with the two entries of 1449, which do prove, at that comparatively late stage of the project, that Donatello did some work on the screen. But his contribution then could not have involved the design of the whole, since the basic framework of the screen was executed in 1444. He seems to have furnished the designs, or superintended the carving, of the marble paneling between the arches of the screen.[5] Whatever he did here gives the impression of an incidental assignment, undertaken at a time when he could conveniently do so inasmuch as he was engaged in the similar task of superintending the

architectural framework of the High Altar (see below, pp. 170f), rather than of a major responsibility dating back to 1443.

Such, I submit, are the conclusions to be drawn *sine ira et studio* from the available evidence. The choir screen—for which, let us not forget, Bartolomeo di Domenico and the Santo authorities had signed a contract prior to July 10, 1443—must be eliminated as the reason of Donatello's coming to Padua. An alternative assumption would be that it was the commission for the bronze crucifix which brought him there. One cannot help wondering, though, whether this could have been enough of an inducement. The exact price of the crucifix is not known, but by analogy with those paid for the bronze statues of the High Altar—40 ducats each for the six Saints, 60 for the Madonna (see below, p. 165, *s.v.* "June 26, 1448")—we can estimate it at approximately 50 ducats, or between 250 and 300 lire. This agrees well enough with the records: apart from the final payment of 89 lire in 1449, Donatello was given materials worth 25 lire 12 soldi in 1444, as well as 140 lire for unspecified purposes (entries of June 18 and 26, 1444; Gloria, *op.cit.*, p. 5), totaling just over 250 lire. It is hardly conceivable that for the sake of this comparatively modest commission Donatello should have been willing to leave his native city and thereby to forego the much more important task of doing the bronze doors of the Cathedral sacristies, which had been allocated to him in 1437.[6] Moreover, he could have accepted the commission for the crucifix, made it in Florence, and sent it to Padua either by ship or overland. (The arms seem to have been cast separately, like those of the "Amor-Atys"; see above, pp. 143f.) The reason for Donatello's going to Padua, then, remains obscure. We may, however, postulate that it must have been a commission, or the firm prospect of one, so large that it had to be carried out in Padua, and more ambitious than the sacristy doors of Florence Cathedral.[7] Having

[5] The surviving Quattrocento parts of the present choir enclosure are indeed vaguely Donatellesque in style, although the master's own hand cannot be felt anywhere. The same is true of the bronze angels' heads claimed for him by Venturi, *loc.cit.*

[6] One of the two pairs was subsequently withdrawn from him and transferred to Michelozzo, Luca della Robbia, and Maso di Bartolomeo; the contract for them, of February 28, 1446, is published in Fabriczy, "Michelozzo di Bartolomeo," *Jahrbuch Kgl. Preuss. Kunstslgn.*, xxv, 1904, pp. 90f, and Allan Marquand, *Luca della Robbia*, Princeton, 1914, pp. 196f; cf. also Poggi, *Duomo*, p. 262, doc. *1317*. The second pair continued to be reserved for Donatello—the Cathedral authorities evidently hoped that he would do them after his return from Padua; they were never carried out.

[7] These, it must be remembered, are considerably larger than those of the Old Sacristy in S. Lorenzo; the Luca della Robbia doors measure 414 cm in height and 216 cm in width. At the time he received the commission for the Cathedral sacristy doors

in 1437, Donatello was so busy with other, still unfinished enterprises that he had to postpone this new project, which would have made severe demands on his time and energy. There is some reason to believe, however, that shortly before his departure for Padua he was about to start work on the Cathedral sacristy doors; why else should he have rented a house and workshop near the Cathedral in 1443? He did so, I suspect, in order to enlarge his working space for an important commission and also in order to give the *operai* of the Cathedral easy access to the work in progress. It does not seem unreasonable to assume that Donatello would have had to carry out a task such as the Cathedral sacristy doors on his own premises, rather than in the quarters of the Opera del Duomo, which had ample facilities for stonecarving operations of every sort but probably not for major bronze casting projects. (Although he presumably would have turned the actual casting over to a bellfounder, in accordance with his usual practice, Donatello would have needed ample space for a "task force" of assistants to help him in preparing the models and in the chasing of the raw casts.)

eliminated the choir screen project as chimerical and the crucifix as insufficient, and with the knowledge that the commission for the High Altar postdates the Tergola donation of April 13, 1446 (see below, p. 169), we face the choice either of abandoning the pursuit or of falling back upon Vasari. Perhaps the Gattamelata monument is not so implausible an explanation for Donatello's trip after all. It certainly fits all the postulates that we laid down before. And from the chronological point of view the death of the General in January 1443 is equally convenient. Is it not possible that by the middle of the year his heirs and executors had offered the commission to Donatello, who thereupon came to Padua but found himself confronted with various complications and delays, so that in order to make use of his enforced leisure he undertook to make the bronze crucifix for the Santo? But how, one wonders, did the heirs of Gattamelata happen to choose Donatello, rather than a local sculptor? That is difficult to say; they could have heard of him in any number of ways, possibly through Palla Strozzi, the prominent Florentine exile in Padua, whose son Onofrio authorized payments for the statue in 1447 (see below, p. 152). Or their choice of a Florentine master may be related to the fact that shortly before, in 1441-1442, the Ferrarese had entrusted the equestrian monument of Nicolò d'Este to two Florentine sculptors (see below, p. 158). They might also have been advised by Florentine artists temporarily resident in Padua, such as Giovanni Nani, Donatello's *compagno* in the preparatory work on the bronze crucifix (according to the entry of January 24, 1444; on June 18, he received the undesignated payment of 100 lire debited to Donatello). It hardly matters which of these various possibilities we prefer. What does matter is that the Gattamelata, rather than any of the Santo projects, brought our artist to Padua. Only on this assumption can we fully understand why he went—and why he stayed as long as he did. The great equestrian monument seems to have commanded his primary allegiance, so that he was willing to brave all sorts of frustrating delays in order to "see it through" until the final settlement and erection of the statue in the fall of 1453 (see below, p. 152), long after his artistic labors on it had been completed. One cannot escape the impression that he felt he had accomplished his mission as soon as the statue was at last placed on its pedestal, for he must have left Padua very soon thereafter, despite the fact that he had a similar dispute still pending with the Santo authorities over the High Altar. Five of the seven altar statues remained technically "unfinished" (i.e., only partly chased; see below, p. 183), and the Arca owed him—or withheld—a considerable sum of money, but apparently in this instance neither artistic nor financial reasons could keep him in Padua; he returned to Tuscany and was content to pursue his claims from there (cf. the document of March 24, 1456, below, p. 167).

Whether or not this conjecture is correct, the leasing of these rather ambitious quarters in 1443 can hardly mean that Donatello was about to depart for Padua, as suggested by Kauffmann, *D.*, p. 103, who interprets the *apotheca* of the rental contract as a storage warehouse instead of a *bottega*.

EQUESTRIAN MONUMENT OF ERASMO DA NARNI, CALLED GATTAMELATA
PIAZZA DEL SANTO, PADUA

PLATES 70-73	Bronze statue, marble base, on limestone pedestal; H. of statue c. 340 cm.	*1447-1453*
	L. c. 390 cm; H. of pedestal and base c. 780 cm; W. c. 410 cm	*(1445-1450)*
	Inscription: on front of marble base, OPVS DONATELLI · FLO ·	

The two marble reliefs of *putti* with the arms of the Gattamelata in the upper part of the pedestal (H. c. 120 cm; W. c. 175 cm) are modern copies installed in 1854. The badly weathered originals are in the passageway leading from the Church of S. Antonio to the Cloister.

DOCUMENTS

A number of entries in an account book of Onofrio di Palla Strozzi, in the Museo Civico, Padua, recording disbursements in connection with the monument; first published in A. Gloria, *Donatello fiorentino e le sue opere mirabili nel tempio di S. Antonio di Padova*, Padua, 1895, p. 7, and reprinted in Camillo Boito, *L'Altare di Donatello e le altre opere nella Basilica Antoniana di Padova*, Milan, 1897, p. 45. Also a notarized agreement concerning the price of the monument, in the State Archives, Florence, which acquired it from private hands in 1855; first published by Gaetano Milanesi in *Archivio storico italiano*, n.s., II, 1855, pp. 47ff, and reprinted in Giovanni Eroli, *Erasmo Gattamelata da Narni, suoi monumenti e sua famiglia*, Rome, 1876, pp. 201ff.

1447, May 16 (fol. 67 of the account book; all the entries relating to our monument are orders from Onofrio Strozzi to Giovanni Orsato, a Paduan banker, to pay specific sums to Donatello or to others at Donatello's request): The stonemason Chimento da Fiesole is to be paid, at Donatello's request, 6 ducats 4 lire 15 soldi, for wages up to the above date.

May 16 (fol. 67v): The stonemason Lazaro is to be paid, at Donatello's request, 66 lire in final payment for the stones furnished by him up to the above date for the pedestal (*pilastro*).

May 16-June 2 (fols. 67v, 68): Other payments to Lazaro, referred to but not transcribed by Gloria, *loc.cit*.

(For this and the following entries no day or month is given; they all appear on fol. 67 or on one of the following two folios): Bernardino della Seta is to be paid, at Donatello's request, 95 lire 17 soldi for various building materials, cartage, and excavating and building the foundation of the pedestal for the horse of the Gattamelata.

The stonecarver Giampiero of Padua is to be paid, at Donatello's request, 15 lire 4 soldi for working on the pedestal. The same is to be paid 8 lire 16 soldi as the remainder of his wages for 20 days' work on the stones of the pedestal up to June 23.

The stonecarver Batista is to be paid, at Donatello's request, 1 ducat in part payment for stones for the steps of the pedestal.

Donatello is to be paid 1 lire 2 soldi as the cost of digging and filling the pit where the hind part of the horse has been cast, and 18 soldi for cartage of this piece from the foundry to his house.

The stonecarver Piero di Giovanni da Como is to be paid 4 lire 4 soldi for three and a half days' work on the stones of the pedestal. (Gloria, *loc.cit*., refers to another, unspecified payment to the same Piero.)

Giorgio da Scutari is to be paid, at Donatello's request, 5 lire for five days' work at 20 soldi per day, carving the doorway of the pedestal.

Donatello is to be reimbursed 16 lire in expenses he has paid out between March 10 and May 20 for cartage of the models of horse and rider to the foundry, for earth [for the core] and other items.

Francesco Guadagni is to be paid 3 ducats 30 lire 16 soldi at Donatello's request for bringing copper and tin from Venice to Padua for the chest and body of the horse of the Gattamelata.

Andrea Calderaro is to be paid, at the request of Donatello, 8 ducats for his work in casting the various parts of the horse.

Francesco della Lionessa is to be paid 44 ducats 2 lire 18 soldi, which he had advanced out of his own pocket in connection with the Gattamelata monument, according to Michele da Foce, secretary of Gentile della Lionessa.

Donatello is to be paid 2 ducats for his personal living expenses; since he is working and cannot come for the money in person, it is to be handed to his apprentice Bastiano.

Donatello is to be paid 4 ducats for his personal living expenses.

1453, June 29-October 21: Eight arbiters, four each named by the two contending parties, are to impose a binding settlement on Donatello, living in Padua, and Giovanni Antonio, son and heir of Gattamelata, represented by his secretaries, Michele da Foce and Valerio da Narni, concerning the price of the horse and rider of the Gattamelata monument. They stipulate, first, that both parties must live up to the terms of the settlement on penalty of 200 ducats; and that Donatello must, as he has promised, spend the month of September in placing the horse and rider on the pedestal, the

cost of the installation to be borne by the estate of Gattamelata. On July 3 in Padua the arbiters, having inspected the horse and rider, and having considered not only the time and expense but also the great mastery and mental power expended on the work, set the price at 1,650 ducats, less the moneys paid to Donatello so far, of which he is to be given a careful accounting before the horse and rider are emplaced. On October 21 Michele da Foce and Valerio da Narni are enjoined to pay Donatello by the end of November the amount still due him.

SOURCES

1443-1452 Giantonio Porcello de'Pandoni, *Commentarii comitis Iacobi Picinnini sive Diarium* . . . (1452), in Muratori, *Rerum italicorum scriptores*, xx, Milan, 1731, p. 98: ". . . I also composed an epitaph for Gattamelata . . . at the request of his son and of Gentile [della Lionessa] . . .

> Munere me insigni, et statua decoravit equestri
> Ordo Senatorius et mea pura fides."

(This epitaph was used on the tomb of the Gattamelata in S. Antonio, erected in 1457-1458, but with some slight changes in the last two lines:

> Munere me digno et statua decoravit equestri
> Ordo Senatorum nostraque pura fides.

Their meaning might be rendered either as "The Senate [of Venice] and my pure faithfulness rewarded me with worthy gifts and an equestrian statue" or, less obviously, as "The Senate rewarded me with worthy gifts and my pure faithfulness earned me an equestrian statue." Cf. Milanesi, *op.cit.*, p. 49.)

(1448-1449) Ciriaco d'Ancona, Epitaph for Gattamelata, cited by Eroli, *op.cit.*, pp. 221f (a slightly different version in Colucci, *Delle antichità Picene*, xv, Fermo, 1792): ". . . The Senate decreed that this equestrian statue be made as a monument to his loyalty and virtue in the year of our Lord 1447." (According to Emil Jacobs, "Cyriacus von Ancona und Mehemmed II," *Byzantinische Zeitschr.*, xxx, 1929-1930, p. 197, Ciriaco was traveling in the Balkans from October 1443 until late in 1448, and again from 1449 to 1454. The winter of 1448-1449 thus seems the only plausible date for the epitaph, since Ciriaco must have died soon after 1454.)

(1443-1454) Francesco Barbaro, Epitaph for Gattamelata, cited by Eroli, *loc.cit.*, from a manuscript in the Biblioteca Guarneriana, Friuli: ". . . This equestrian statue was erected to him by Gentile della Lionessa . . . and Giovanni Antonio, his son."

(c. 1455) *Urbis Romae ad Venetias Epistolion*, ed. A. Medin, in *Atti e memorie, R. Accademia di scienze di Padova*, n.s., xix, iii, 1902-1903 (originally published by Ireneo Affò in [Basinio] *Basini Parmensis poetae opera praestantiora*, ii, Rimini, 1795, p. 37, but according to its modern editor probably by a Milanese humanist): ". . . Hoc ego non Curiis sanctis, magnisque Camillis/ Hoc non Scipiadae dederam, certoque Catoni./ At ut nescio quem mellatam munere Gattam/ Insigni, et facto donasti ex aere caballo,/ Praemia magna fugae subitae, rerumque tuorum/ Discrimen dubium, Patavinae dedecus Urbis,/ Quo fugit infelix statua mostratur ahena." (Rome satirically reproaches the Venetians for having honored the Gattamelata as none of the classic Roman heroes had been honored; his great flight from the enemy has been rewarded by a bronze monument of both himself and the horse on which he fled.)

(Shortly before 1457) Bartolomeo Facio, *De viris illustribus*, ed. L. Mehus, Florence, 1745, p. 51: "[Donatello] also made [in Padua] the bronze equestrian statue of the Gattamelata . . . an extraordinary work."

(After 1457) Michele Savonarola, *Libellus de magnificis ornamentis Regie civitatis Padue*, in Muratori, *Rerum italicorum scriptores*, xxiv, xv, ed. A. Segarizzi, Città di Castello, 1902, p. 32: ". . . Gattamelata is represented on a bronze horse . . . near the west corner of the church of S. Antonio; he sits there with great magnificence like a triumphant Caesar. His bones, however, are buried inside the church in a very ornate tomb."

(1460-1464) Filarete, *Trattato dell'architettura*, book xxiii (ed. Wolfgang v. Oettingen, Vienna, 1890, pp. 622f): "Do not as [Donatello] did in his equestrian statue in memory of Gattamelata, which is so inappropriate that it has received little praise. For if you have to portray a man of our own times, do not show him in ancient costume but in clothes that he would actually be wearing."

(1477-1479?) "The Diary of Politian," a collection of anecdotes, first printed in Lodovico Domenichi, *Facetie*, Florence, 1548; critical edition by Albert Wesselski, *Angelo Polizianos Tagebuch*, Jena, 1929, pp. 27f, No. 44: "[Donatello] did a bronze statue of the Captain Gattamelata, and as he was being pressed too hard for it he took a hammer and smashed its head. When the Signoria of Venice heard this, they summoned the artist and told him, among other threats, that his own head was going to be smashed, like that of the statue. And Donatello replied, "That's all right with me, provided you can restore my head as I shall restore that of your Captain." (Vasari-Milanesi, iii, pp. 367f, tells a variant of the same story but substitutes Verrocchio and the Colleoni monument.)

(c. 1500) Marin Sanudo, *Le vite de'Duchi di Venezia*, in Muratori, *Rerum italicorum scriptores*, xxii, Milan, 1733, col. 1106: "On January 16 [1443] the magnificent Gattamelata of Narni, our Captain General, died, and the Signoria decided to spend up to 250 ducats to honor him with a state funeral attended by the Doge. He was buried in the church of the Santo in Padua, where a memorial chapel was prepared for him, with a raised casket and an epitaph; and the Signoria, in recognition of his faithful service, caused an equestrian statue of him to be made by the Florentine Donatello, which was placed at the entrance to the grounds of the church of the Santo in Padua."

(c. 1520) Marcantonio Michiel, *Notizia d'opere del disegno*, ed. Theodor Frimmel, Vienna, 1888 (*Quellenschriften* . . . , ed. Eitelberger von Edelberg, N. F. i), p. 4: "The bronze equestrian statue of Gattamelata on the Piazza del Santo [in Padua] is the work of Donatello."

(Before 1530) Billi, pp. 42f (repeated in Cod. Magl., p. 78): "In Padua [Donatello did] a horse, with the Gattamelata on it, of bronze, outside the church of S. Antonio."

(c. 1550) Gelli, p. 60: "In Padua [Donatello] did the horse and the statue, in bronze, of the captain Gattamelata outside the church of S. Antonio; while he was working on it, the Venetians would not pay him the money he needed, so one morning he broke off the head of the statue, whereupon the Venetians threatened him by saying, 'What would you say if we cut off your head, too?' He replied, 'Nothing, if you knew how to reattach it as well as I know how to do it with the Gattamelata's head.' When they heard that, they gave him money and he finished the statue."

1550 Vasari-Ricci, pp. 53f (Milanesi, pp. 410f, slightly rephrased): "At that time the Signoria of Venice, having heard of his fame, sent for him in order to have him do the memorial to Gattamelata in Padua, which was the bronze equestrian monument on the Piazza di S. Antonio. Here one sees the chafing and snorting of the animal, as well as the boldness and pride of the rider, expressed in most lifelike fashion. Donatello showed himself so marvelously skilled in the proportions and quality of the great cast, that it can stand comparison with any antique in movement, design, skill, proportion, and diligence. Thus it not only filled with amazement all those who saw it then but it has the same effect on everyone who sees it today. As a result the Paduans tried in every way to make him their fellow citizen and keep him there by all sorts of favors." (A much shortened paraphrase in Borghini, *Riposo*, p. 320.)

1551 Paolo Giovio, *Elogia virorum bellica virtute illustrium* . . . , Florence, 1551, pp. 113f, *s.v.* "Gattame-lata": "Because of his outstanding fidelity and great prowess, the Venetians decided to honor him, by public decree, with an equestrian statue, and had it made by the finest sculptor of that time, whose name was Donatello the Florentine. He, fittingly imitating the art of the ancients, produced with great skill a perfectly beautiful statue of an armored knight holding the baton, which is admired even today by learned artists. It is located in Padua, in the area that faces the façade of the church of St. Anthony. He was buried in the same church, after a most famous funeral celebration . . ." (then follows the epitaph from the tomb of the Gattamelata).

1560 Bernardino Scardeone, *De antiquitate urbis Patavii* . . . *libri tres* . . . *eiusdem appendix, De sepulchris insignibus exterorum Patavii iacentium*, Basel, 1560, p. 374: "In his time [Bellano] was very famous in all Italy; he was the favorite disciple of the great Florentine Donatello, who cast the equestrian statue of Gattamelata, which stands in the open in the large cemetery of the afore-said basilica [of S. Antonio]."

Ibid., p. 399: "An equestrian statue [of Gattamelata] in the form of an armored knight holding the baton, was erected in the open in the vast area outside the church by public decree of the Venetian Senate, because of his outstanding fidelity and great prowess; it is a splendid work, made by Donatello, the finest sculptor of his day, and is admired by all even now. Inscribed on it are the words, OPUS DONATELLI FLORENTINI."

1571 Francesco Bocchi, *Eccellenza della statua di San Giorgio di Donatello* . . . (first printed edition, Florence, 1584; German translation, with notes, in Semper, D. '75, pp. 175ff, 249ff), includes a paragraph of conventional praise for the Gattamelata monument, based on Vasari (Semper, *op.cit.*, p. 194).

The physical history of the monument can be deduced with considerable precision from the payment records of 1447. In the spring and early summer of that year, the various pieces of the equestrian statue (their exact number is not known and could be determined only by a minute technical examination) were cast in the shop of the bell-founder Andrea del Caldiere, the same master whose services Donatello utilized for the casting of the bronzes for the High Altar (see below, pp. 163ff); the pedestal was being erected at the same time, an indication that our master was pursuing the entire project at a rapid pace, under pressure from his patrons (as suggested by the anecdote about the head). It seems likely, in fact, that he had committed himself to finish the monument by the end of the year; why else should Ciriaco d'Ancona have included the date 1447 in his epitaph? The designing and modeling of the statue, therefore, must have been done for the most part in 1446, and some preparatory work may go back as far as 1445. According to the arbitration agreement of 1453, the statue was finished but not yet installed in June of that year. Donatello placed it on the pedestal in September, and by October 21 nothing further remained to be done, otherwise the arbiters would not have insisted so strongly on the final payment to the master. We may assume, however, that the chasing of the cast was in all likelihood completed several years before 1453,

since little could have been done after 1450, when Donatello became involved in various new projects in Mantua and Modena (see below, pp. 188f). As to the date and circumstances of the commission we are, unfortunately, much less well informed. Donatello could have received it at any time between 1443 and 1446, but who gave it to him? According to the epitaph of Francesco Barbaro, the monument was erected by Gentile della Lionessa and Giovanni Antonio, Gattamelata's son. The arbitration agreement of 1453 mentions only Giovanni Antonio, while most of the other epitaphs and other sources assert that the statue was decreed by the Venetian Senate. Milanesi, *loc.cit.*, concluded on the basis of the 1453 document that the Senate could have been involved only to the extent of permitting the erection of the monument, which in every other respect was entirely a family matter, and that the commission came from Giovanni Antonio. This has been the accepted opinion ever since, yet the problem is not nearly as simple as that. One of the few documentary notices we have about Giovanni Antonio informs us that in 1447, when the monument was already well under way, he was "about to come of age" (cf. Eroli, *op.cit.*, p. 40), or not yet 21 years old. As a minor, he was legally incapable of carrying out a business transaction such as the commissioning of our statue, nor does it seem plausible that a youth between 17 and 19 years could have conceived so

extraordinary a monument.[1] Moreover, as Kauffmann has emphasized (*D.*, p. 133), the monument has some aspects of a tomb, a mausoleum, and was probably ordered in response to the wishes of Gattamelata, whose last will, dated June 30, 1441, contains elaborate stipulations concerning his burial (published in Eroli, *op.cit.*, pp. 343ff). These may be summarized as follows: Should the testator die in Padua, his tomb is to be in the Santo; it must be of stone and "honorable, in keeping with his *Magnificentia.*" The executors are to determine the details as they see fit and may spend between 500 and 700 ducats for the tomb and the funeral; if they wish, they may build a chapel with an altar dedicated to St. Francis, so long as the total expense does not exceed 700 ducats. Although Gattamelata himself had obviously imagined a comparatively modest tomb inside the church, his executors may very well have decided that nothing but an equestrian monument out in the open air, patterned on the tombs of the Scaligeri in Verona, was sufficiently in keeping with the *Magnificentia* of the captain. In that event, the statue must have been commissioned by the executors of the will, who were the widow, Giacoma Gentile della Lionessa, and Michele da Foce, Erasmo's secretary (cf. the document of December 18, 1442, in Eroli, *op.cit.*, p. 348) who subsequently served Gentile della Lionessa in the same capacity. The will also names Giacoma, Gentile and Michele da Foce as the guardians of Giovanni Antonio (who in 1441 was about 14 years old). Thus Michele may have acted not only as the secretary of Gentile but as co-executor of the estate and as one of the guardians of Giovanni Antonio when he issued financial instructions in connection with the statue in 1447. Perhaps the most plausible assumption is that at the start the monument was being thought of as the tomb for which provision had been made in Gattamelata's will, and that the commission for it came from the executors, Giacoma and Michele, who were acting for the deceased; but that the project soon grew beyond the financial limit of 700 ducats set in the will, which made it necessary to draw upon Gattamelata's estate for the additional funds needed. The estate, however, had gone to Giovanni Antonio as *heres universalis* (see the text of the will, Eroli, *loc.cit.*). He was still a minor, so the step that involved him in the commission had to be taken by his three guardians, Giacoma, Michele, and Gentile. Of these three, only Michele was in a position to concern himself actively with the making of

the monument; Giacoma was living with her son in Verona, and Gentile commanded the Venetian troops in the field.[2] When Giovanni Antonio came of age, about 1448, the responsibility for the monument devolved upon him alone, but by that time the final form of the monument had already been determined. All the important decisions relating to it thus appear to have been made by his guardians, surely with his approval but not at his initiative. The Barbaro epitaph, which mentions Gentile before Giovanni Antonio, indicates that Gentile, certainly the more conspicuous public figure of the two, also was primarily responsible for the conception of the monument. He died in 1453, probably before the arbitration agreement of June 29-October 21, since Michele da Foce had by then become the secretary of Giovanni Antonio (who had inherited Gentile's estate; cf. Eroli, *op.cit.*, p. 41). As for the role of Onofrio Strozzi, all we can gather from the disbursement orders of 1447 is that he was the banker who had been entrusted with Giovanni Antonio's fortune by the guardians of the youth. Kauffmann's assertion (*D.*, p. 103) that Palla and Onofrio Strozzi promoted the financing of the monument is an unwarranted inference. To speculate on this slender basis that Palla Strozzi had helped to bring Donatello to Padua (Milanesi, *loc.cit.*, Gloria, *op.cit.*, p. xxi; approvingly cited by Kauffmann, *loc.cit.*, and Planiscig, *D.*, p. 101) seems even more incautious, especially since the proponents of this idea do not believe Vasari's claim that it was the commission for the Gattamelata monument which lured Donatello from Florence. (On the latter question see above, pp. 149f.)

But what part, if any, did the Venetian Senate play? Was it merely that of passive acquiescence, as suggested by Milanesi, *loc.cit.*? His opinion, despite the protest of Eroli (*op.cit.*, pp. 216ff) has been so thoroughly accepted that the problem is not even mentioned in the more recent Donatello literature. Yet the almost unanimous testimony of the epitaphs and other Quattrocento sources surely cannot be disregarded without some explanation. Lányi, who regarded the statue as a funeral monument pure and simple,[3] was fully aware of this. In a lecture at the Warburg Institute in 1939, the notes for which have survived, he drew attention to the fact that the Venetian Senate had honored Gattamelata by granting 250 ducats for a state funeral (see Sanudo, cited above, whose account is confirmed by the memorial address of Giovanni Pontano da Bergamo in honor of the deceased

[1] In 1447 he was not even a resident of Padua; according to the document cited by Eroli, he was living in Verona with his mother and his tutor.

[2] Gattamelata's command had been transferred to him and Giovanni Antonio late in 1442, when the General was already incapacitated by illness and old age, but Gentile seems to have been in actual command; in 1451 he was formally

appointed Captain General; cf. Eroli, *op.cit.*, p. 348, and George v. Graevenitz, *Gattamelata und seine Verherrlichung durch die Kunst*, Leipzig, 1906, p. 29.

[3] *Probl.*, p. 19; the article for the *Journal of the Warburg Institute* that he refers to as forthcoming (*ibid.*, n. 20) remained unwritten.

captain, delivered in Padua on February 12, 1443, and published in Eroli, *op.cit.*, pp. 354ff; Pontano speaks of "the grief of Venice, expressed in that famous funeral celebration at public expense which the Venetian Senate decreed . . ."). This event, Lányi thought, had misled later writers into claiming that the monument, rather than merely the funeral, had been decreed by the Senate. Such a hypothesis, however, is clearly inadequate; how can we impute so elementary an error to Ciriaco d'Ancona, or to Porcello, who states that he wrote his epitaph at the request of Giovanni Antonio and Gentile della Lionessa and whose text was actually inscribed on the Gattamelata Tomb inside the Santo? Sanudo, to be sure, was farther removed from the events in question; but since his information on the funeral has proved so accurate, why must we disbelieve what he says about the statue? Now, it must be admitted that if the monument is simply a tomb there seems no reason why the Venetian Senate should have been concerned with it. But can we really say that the monument was conceived as nothing but a tomb? The ground on which it stands used to be the cemetery of the Santo, as attested by Scardeone (see above); according to Harald Keller ("Ursprünge des Gedächtnismals in der Renaissance," lecture at the Zentralinstitut für Kunstgeschichte, Munich, March, 1954, summarized in *Kunstchronik*, VII, 1954, pp. 134ff) it retained this function until 1763, and the body of Gattamelata actually reposed in the base of the monument until 1651, when his ashes were transferred to the family chapel inside the Santo. The latter claim (whose source I do not know) can hardly be correct. Nor was the tomb of Gattamelata in the family chapel intended to be a cenotaph, as Keller asserts. Its history, fortunately, is well documented: on November 15, 1456, after the death of her son, Giacoma applied for, and soon thereafter received, a space inside the Santo in order to build there a chapel dedicated to SS. Francis and Bernardino (Eroli, *op.cit.*, p. 179; Vittorio Lazzarini, *Il Santo*, IV, 1932, pp. 228ff). Her last will, made on April 25, 1457, stipulates that she be buried in "the chapel of SS. Francis and Bernardino which she had built in accordance with her husband's testamentary desire and in memory of her son" (Eroli, *op.cit.*, pp. 365f); and a codicil of May 23, 1459 (Eroli, *op.cit.*, p. 369) mentions the expenditure of 2,500 ducats on the chapel she had built and where "she had ordered to be placed the bodies of her husband and her son, as well as her own body." Meanwhile the commission for the chapel and the two tombs (one with a male effigy *armato ad antiquam*, the other *ad modernam*) had gone to a local master, Gregorio di Allegretto (the contract, of De-

cember 17, 1456, is published in Lazzarini, *loc.cit.*), who promised to complete the whole project by February 17, 1458. Shortly thereafter, Michele Savonarola notes that the body of the Gattamelata is buried, not inside the equestrian monument but in an ornate tomb within the church. Thus, if the remains of the Gattamelata ever reposed in the base of Donatello's statue, they must have been removed about 1458, rather than in 1651. But in actual fact, as Kauffmann pointed out in the discussion following Keller's lecture (*Kunstchronik, loc.cit.*), the base of the monument makes no provision for burial; the door frames on the lower part, although perhaps intended to suggest a mausoleum, are not real doors. The oval upper part may have been meant to represent a sarcophagus (Kauffmann, *D.*, p. 133) but it, too, is not a real sarcophagus. Clearly, then, it was the equestrian monument, rather than the tomb in the family chapel, that had the function of a cenotaph.

Even as a cenotaph, the Gattamelata monument might have been purely a family matter, of no concern to the Venetian Senate. Yet, as Kauffmann, *loc.cit.*, has rightly emphasized, it is at the same time a "monument to fame." The arbitration agreement of 1453 explicitly describes the statue as "made because of the great fame of Gattamelata" (*facti . . . pro insigni fama ipsius*) and defines the pedestal as "a column" (*una columpna*; the term could mean either a column or a pilaster), nor do we find the slightest hint at funerary significance in any of the sources.[4] Significantly enough, even the location of the statue in the cemetery of the Santo is mentioned only once, by Scardeone. There can be no doubt, therefore, that it was the nonfunerary aspects of the work which impressed the contemporary beholder. We can hardly afford to disregard so valuable a clue to the true meaning of the statue. What these nonfunerary qualities are can perhaps be best understood by comparison with earlier equestrian monuments. Condottieri like Gattamelata had been honored in this fashion long before the middle of the Quattrocento, both in Northern Italy and in Tuscany. The earliest example, Simone Martini's fresco of Guidoriccio dei Fogliani in the Palazzo Pubblico, Siena (c. 1330) is also the most extraordinary, since it was clearly intended as a public honor commemorating the conquest by Guidoriccio of the fortresses of Montemassi and Sassoforte in 1328. All the other instances we know of in Tuscany are funerary in character—catafalques, tombs, or cenotaphs (the distinction is often difficult, for lack of complete information). Thus the Florentines seem to have planned an equestrian figure above the tomb of Piero Farnese in the Cathedral as early as 1367. Thirty years

[4] Graevenitz, *op.cit.*, p. 47, claims to have found one reference to the monument as "sepultura Gathamelatae," but fails to say where; since the passage has not been identified by subsequent scholars, I wonder if it really exists.

later, the statue was actually carried out (it survived until the early nineteenth century; cf. Paatz, *Kirchen*, III, p. 502, n. 260), while John Hawkwood had to be content with a painted imitation.[5] The 1390's also produced a painted and a sculptured equestrian figure in Siena; that of Giovanni d'Azzo Ubaldini was a panel, perhaps executed as part of the catafalque, and the statue of Gian Tedesco, made of wood and tow, may have served the same purpose (supposedly by Jacopo della Quercia; destroyed in 1506; see Vasari-Milanesi, II, pp. 110f, n. 2). We thus have five equestrian Condottieri monuments in Tuscany before 1400, all of them official, public memorials decreed by government authority. In Northern Italy, we know of no examples as early as these, although they may have existed.[6] The wooden statue of Paolo Savelli (soon after 1405) in the Frari, Venice, suggests an analogy with that of Gian Tedesco in Siena. According to Litta (*Famiglie celebri italiane*, X, Milan, 1874, *s.v.* "Savelli di Roma," tav. x, based on an unidentified source) Savelli "was honored by a solemn funeral in S. Francesco (*sic!*) dei Frari and above his cold remains a noble equestrian monument was raised at the expense of the [Venetian] Republic." Considering the cheap material of the statue, we are tempted to assume that it was part of the catafalque at the state funeral.[7] The other surviving specimen, the stone monument of Cortesia Sarego in S. Anastasia, Verona, antedates the Gattamelata statue by only fifteen years (Sarego died in 1432). It may be a cenotaph, as suggested by the inscription beneath the sarcophagus.[8] Its design, with the statue framed by a tentlike curtain that is being withdrawn by two armored attendants, represents a secularized version of the Brenzoni Tomb in San Fermo, Verona.[9] The circumstances under which the Sarego monument was erected are unknown, so that we cannot say whether it was authorized or commissioned by the state, but on the basis of the Tuscan precedents and the Savelli Tomb it is not unlikely that some such official action was involved. However that may be, all the monuments we have surveyed

differ from the Gattamelata in one very important respect: they are, or were, placed indoors and attached to walls. If Erasmo da Narni had an equestrian statue in mind when he made provision for his tomb in 1441, it must have been of this type. Free-standing equestrian statues out of doors were not unknown at that time, needless to say, but they were the privilege of sovereigns: the Scaligeri tombs of Verona in the Trecento,[10] and the bronze statue of Nicolò d'Este in Ferrara, the first "modern" equestrian monument, ordered soon after 1441 and executed by two Florentines, Antonio di Cristoforo and Nicolò Baroncelli.[11] The idea that free-standing equestrian monuments, especially those of bronze, displayed in a public place out of doors, are a form of glorification restricted to the holder of the highest secular authority, has survived far into modern times; in the Middle Ages, we may assume, it carried particular weight as a tradition inherited from Imperial Rome. Who but a sovereign would have dared to substitute his own image for that of the Marcus Aurelius (then regarded as representing Constantine the Great), of the Regisole in Pavia, of the famous Justinian monument in Constantinople, or of the equestrian statue of Theodoric which Charlemagne had brought from Ravenna to Aachen? How many equestrian statues of mediaeval emperors there may have been we do not know; that the tradition survived (although in stone rather than in bronze) is proved by the two examples that have come down to us, the monument to Otto I in Magdeburg and the famous "Rider" of Bamberg Cathedral, whom Otto von Simson has identified as Frederick II.[12] It is tempting to consider the Scaligeri tombs as an offshoot of this Imperial lineage; Can Grande I, the first member of the famous family to have an equestrian statue above his tomb, not only was an ardent Ghibelline and partisan of Emperor Henry VII but a man whose ambitions went far beyond local sovereignty (the title he adopted was not "canine" in origin, although it soon came to be misinterpreted in that sense, but taken from the Mongolian Grand Khans of Cathay, the

[5] He, too, was to have had a sculptured monument; the painted equestrian figure of c. 1400 was redone in 1436 by Paolo Uccello, who had been instructed to follow the pattern of the older work; cf. Paatz, *op.cit.*, pp. 491f, n. 236.

[6] Scardeone, *op.cit.*, p. 312, describes an equestrian statue above a marble tomb in the Eremitani representing a knight who charges with his lance, supposedly Francesco Frassalasta; if this identification is correct, the monument would belong to the early Trecento.

[7] The *Enciclopedia biografica e bibliografica "Italiana,"* serie XIX, III, "Condottieri, capitani, tribuni," ed. Corrado Argegni, p. 145, states that Savelli is buried in Perugia; if this claim, which I have been unable to verify, is correct, the Frari monument would be a cenotaph.

[8] Removed in 1625; cf. Giovambatista da Persico, *Descrizione di Verona...*, I, 1820, p. 243, n. 4, where the text is recorded.

[9] An interesting analogy to such an arrangement is the monu-

ment of Ludovico Camponeschi, soon after 1432, by Gualtiero Alemanno in S. Giuseppe, Aquila, except that here the equestrian statue appears under a Gothic canopy. Below it the deceased is represented again, as a recumbent effigy flanked by large standing angels somewhat like those of the tomb of Tedice degli Aliotti in S. Maria Novella, Florence. The style of the sculpture is strongly North Italian.

[10] And their echo, that of Bernabò Visconti in Milan, now in the Castello Sforzesco; cf. Costantino Baroni, *Scultura gotica lombarda*, Milan, 1944, pp. 110ff.

[11] Unveiled 1451, destroyed 1796; cf. the discussion of this work, with bibliography, in Werner Haftmann, *Das Italienische Säulenmonument*, Leipzig, 1939, pp. 145f.

[12] *Review of Religion*, 1940, pp. 257ff; there is reason to believe that the figure was originally meant to be placed on the exterior of the Cathedral.

"Emperors" of those then still almost mythical regions; cf. Leonardo Olschki, *Art Bulletin*, xxvi, 1944, p. 103). Viewed in this perspective, the Gattamelata Monument must be acknowledged as a daring thing indeed: here for the first time a nonsovereign receives an honor that had hitherto been claimed only by heads of state, be they emperors or local tyrants.[13] Once we realize how novel—not to say revolutionary—the Gattamelata monument is within its own category, some of the contemporary comments on it appear in a new light. Along with admiration for the statue as a work of art, there must have been an undercurrent of feeling against its "presumption." We find such a reaction at its strongest in the author of the *Urbis Romae ... Epistolion*, who chides the Venetian Republic for glorifying Gattamelata as none of the military heroes of the ancient Roman Republic had been honored (he probably inferred this from Pliny), but we can also sense it in Michele Savonarola's description of the statue as a "triumphant Caesar" and in Filarete's objections to its "inappropriate" ancient costume.[14] The sculptural details on the saddle and armor reinforce this impression.[15] Lányi, in the lecture referred to previously, presented an elaborate iconographic interpretation of them in terms of Christian funerary symbolism: the four nude *putti* decorating the front and back of the saddle are angels who carry the deceased heavenward, as in the Assumption relief of the Brancacci Tomb, and the six dancing and music-making *putti* on the back of the Gattamelata's belt are connected with the symbolism of Virtues (as on the Siena Font), so that they, too, have a sepulchral significance, since Virtues appear on tombs. The whole monument, in fact, according to Lányi's view, is meant to be "the ascension of the Gattamelata." Unfortunately, there is not a single overt reference to Christianity anywhere on the statue or its pedestal. Nude winged infants in the Quattrocento are not necessarily angels; they may also be genii *all'antica*, and that

is what the context suggests in our case. Even Lányi had to admit the classical derivation of many of the motifs, such as the winged head on the breastplate, a modified *gorgonaion*; the flying *putti* on the saddle-cloth, descended from the Victories on Roman triumphal arches but holding *treccie*, the braids that form Gattamelata's coat of arms, instead of wreaths; and the two nude horsemen (the one on the left carrying a flame in his palm) on the back of the saddle. The latter might be linked with a passage in Book I of Plato's *Republic* describing a horse race in which the participants pass torches to each other, in honor of the goddess (oral suggestion to Lányi of Dr. Edgar Wind); whatever their specific source, the notion of the handing on of the Flame of Life is not a Christian one.[16] Lányi also cited the "rams' skulls" on the stirrups as a "well-known ancient symbol of death" (actually, they are not skulls but heads, with the ears clearly visible); only the two cats' heads on the pommel seem to have resisted his ingenuity, since they cannot possibly mean anything more profound than the "totemic animal" of Gattamelata, which also appears on the crest of his helmet in the two marble panels on the pedestal. On the other hand, Lányi gave the shell beneath the pommel its full symbolic weight as an emblem of pilgrimage, eternity, and resurrection, although he failed to explain why Donatello should have concealed this important symbol so well that it is practically invisible. The ornamentation of the statue, I am afraid, simply will not yield to Lányi's approach; wonderfully expressive and animated as it is, its purpose is not to reveal hidden metaphysical meanings but to further the impression of the military hero *all'antica* conveyed by the monument as a whole. Even the "mausoleum doors" of the pedestal—the only clear-cut element of mortuary significance—do not belong to the tradition of Christian tombs; Donatello must have taken them from Roman sarcophagi.[17] One

[13] The only exception to this rule, in intention if not in reality, is the marble equestrian monument which the Romans decreed for Giovanni Vitelleschi in 1426; it was to be placed *in Capitolio* but, significantly enough, the decree was never carried out and perhaps not even intended to be carried out; cf. Hanfmann, *op.cit.*, pp. 144f. The marble equestrian statue decreed by the Pope a quarter of a century later for another Condottiere, Antonio da Rio [Rido, Ridio] according to Scardeone, *op.cit.*, p. 350, was of the traditional indoors kind. The monument, executed not long after Antonio's death in 1450, is a relief in architectural frame surmounting a sarcophagus with mourning genii, in the vestibule of S. Francesca Romana. The inscription informs us that it was ordered by Antonio's son, but this does not exclude a Papal authorization. The type is analogous to that of the Bentivoglio monument of 1458 in S. Giacomo maggiore, Bologna.

[14] That the armor was consciously meant to be "all'antica" is confirmed by the effigy on the Gattamelata tomb, whose armor clearly reflects that of our statue; in the contract (Lazzarini, *loc.cit.*) it is defined as "armato ad antiquam."

[15] Structurally, the armor corresponds in most respects to contemporary pieces; cf. Graevenitz, *op.cit.*, pp. 36ff.

[16] Moreover, the two horsemen at once suggest the Platonic *biga* of the medallion on the bronze bust in the Museo Nazionale; see Pl. 66a.

[17] This derivation is strongly suggested by the fact that the door on the east side of the monument is ajar, as are the gates on Roman sarcophagi (e.g. Pisa, Camposanto; Salomon Reinach, *Répertoire de reliefs ...*, iii, Paris, 1912, p. 125, No. 1). The door on the west side is closed. That the pedestal of the monument was indeed meant to evoke funerary associations *all'antica*, rather than in the Christian sense, is indicated by the drawing of a fictitious equestrian statue in the Louvre sketchbook of Jacopo Bellini (fol. 49; Victor Goloubew, *Les dessins de Jacopo Bellini ...*, Brussels, 1908, i, xxxiv); the horse here clearly reflects that of the Gattamelata monument as it appears in our Pl. 70b, while the base has the shape of a Roman tombstone. To what extent Donatello's pedestal was intended to suggest a burial chamber, is difficult to say, since its peculiar design has no clear-cut analogies anywhere; Hanfmann's reference to the

might almost say that the funerary aspect of the monument is no more than a concession to past practice, a sort of formal excuse for a memorial whose "presumptuous" and "inappropriate" character would otherwise have been too glaringly evident.

Given the nature of the work, it seems inconceivable that the Venetian Senate was not in some important way concerned with its creation. Instead of assuming with Milanesi that the state merely placed its *nihil obstat* upon the resolve of the surviving members of the family to erect an equestrian monument to the dead captain, I believe that the initiative came from the Senate in the form of a decree granting the Gattamelata the privilege of an equestrian statue as a special posthumous honor. That alone, it seems to me, would explain the epitaph of Ciriaco d'Ancona (who could not very well have composed it much later than 1447; otherwise his reference to this particular year is incomprehensible) and the peculiar fact that the Porcello epitaph, although intended for the monument, was attached to the tomb instead (it is the only one of the three texts we know that could be so used, since it speaks of "an equestrian statue" rather than of "this equestrian statue"; apparently the family took great pride in the Senatorial decree and wanted it remembered). That the Senate did not commission and pay for the monument, need not disturb us unduly. Having spent a conspicuous sum on the state funeral, they may well have thought the decree sufficient. Or perhaps Venetian usage in this respect was different from that prevailing in Tuscany, where the tradition of equestrian figures as a state honor for Condottieri was of longer standing. The Colleoni monument, it is true, was commissioned by the Senate, but Colleoni had, for all practical purposes, "purchased" the statue by coupling his petition for it with a bequest of many thousands of ducats to the State. He had wanted a bronze equestrian statue of himself to be erected on the Piazza di S. Marco—surely in analogy with the Gattamelata monument, which occupies the equivalent site in Padua.[18] It is not without significance for our argument that the Senate found the choice of location too "presumptuous" and shifted the statue to a less conspicuous open space. Could it be that they still felt somewhat stung by the gibes that had been directed at them in connection with the Gattamelata? One suspects that the Senate, in decreeing the Gattamelata monument, had visualized something comparable to the Paolo Savelli statue (perhaps it is more than coincidence that both are attached to Franciscan churches), rather than a "triumphant Caesar" uncomfortably close in conception to the Scaligeri tombs and thus apt to arouse the specter of which every republic stood in constant fear—that of the Condottiere who seizes the reins of sovereignty. If the Senate reacted with a degree of displeasure to the completed statue, we have a possible explanation for the strange fact that the monument never received an inscription (apart from Donatello's signature) and that one of the epitaphs composed for it was later used in connection with the tomb of Gattamelata. The Barbaro epitaph, which omits mention of the Senate decree and tells us instead that Gentile della Lionessa and Giovanni Antonio "statuam hanc . . . faciundum curaverunt," may have been an attempt to formulate an acceptable text after the other two had been vetoed (it is the only one of the three that could have been composed after the completion of the monument in 1453). Why the tomb and chapel in the Santo were not undertaken until 1456, is difficult to say. The reason may simply have been a lack of funds. After all, the 700 ducats set aside in Gattamelata's will for his tomb and/or chapel, must have been used for the monument instead, and the arbitration agreement of 1453 indicates that Giovanni Antonio, even though his father's "universal heir," found it a burden to pay for the rest of Donatello's work. As for the widow, she probably was not in a financial position to start the project independently until after the death of her son.[19]

Scaligeri tombs (*op.cit.*, p. 148) is hardly an adequate explanation, nor does it account for his refusal to acknowledge the Gattamelata as a true *Säulenmonument*. After all, the pedestal is termed a *pilastro* and *columpna* in the documents. Could the rounding off of the narrow sides have been meant to emphasize this "columnar" quality? I suspect that Donatello knew, through verbal and perhaps also pictorial sources, of the columns supporting the Regisole in Pavia and the Justinian monument in Constantinople (an account of the latter might well have come to him from Ciriaco d'Ancona), and that his design for the Gattamelata base reflects this awareness. Surely the height of the pedestal must in part be held responsible for Michele Savonarola's description of the monument as a "triumphant Caesar." Unfortunately, the available sources, literary and pictorial, are insufficient to provide a clear notion of what those columns in Pavia and Constantinople really looked like. That they were of orthodox shape is difficult to imagine, because of the size of the statues they supported (their diameter must have been between 4 and 5 m, demanding a height of at least 35 m). Perhaps they were columns only in the same metaphoric sense as the Gattamelata pedestal, in which case Donatello's design may well have a good deal more in common with them than hitherto suspected. For descriptions and visual representations of the Regisole and Justinian statues, see Haftmann, *op.cit.*, pp. 48, 121.

[18] The Regisole was similarly placed in relation to the Cathedral of Pavia, as Kauffmann (*D.*, pp. 134, 236, n. 413), has pointed out; so was the Justinian monument in relation to Hagia Sophia.

[19] He died intestate, having revoked his will on August 26, 1455, while suffering from a grave head wound; cf. the document in Eroli, *op.cit.*, pp. 364f; how much of his estate went to his mother under these circumstances I have been unable to ascertain, but it seems reasonable to assume that she received a considerable share.

Our hypothesis concerning the reaction of the Venetian Senate to the monument offers one further advantage: it throws Donatello's achievement into sharper focus. For if we are right in believing that the statue decreed by the Senate was meant to be of the same type as the Savelli and Sarego memorials, we may also assume that the original commission to Donatello called for that kind of monument rather than for a free-standing "triumphant Caesar" in bronze, unless we are willing to credit Gentile della Lionessa, Michele da Foce, and Giovanni Antonio da Narni with the most exceptional imaginative powers. The circumstances thus tend to confirm what has often been tacitly taken for granted—that Donatello is to be credited not only with the carrying out of this new concept of the equestrian monument but with the creation of the concept itself. It was he who interbred the Scaligeri tombs with the Marcus Aurelius and the new Nicolò d'Este monument in Ferrara,[20] thereby coining a new type of memorial in which the emphasis is shifted from the funerary aspect to the presentation of the deceased as a hero *all'antica* (how far the latter idea was anticipated in the statue of Nicolò d'Este remains to be further investigated), and then "sold" this far more ambitious project to his patrons.[21] That Donatello was entirely capable of modifying the wishes of his patrons in important—and sometimes decisive —ways, can be taken for granted. One documented instance, analogous to what we have assumed in the case of the Gattamelata, is the project for an equestrian statue of Borso d'Este which the City of Modena wanted Donatello to do; he persuaded the authorities to change the material from marble to gilt bronze and promised them, on March 10, 1451, to complete the monument within a year, but for reasons unknown failed to carry it out, despite two years of further negotiations and preparatory labors.[22]

The aesthetic analysis of the Gattamelata monu-

ment, usually in terms of a comparison with the Marcus Aurelius on the one hand and the Colleoni on the other, has been carried through at varying length by a great many scholars. Kauffmann (*D.*, pp. 133ff) provides a thorough and well-balanced summary, with ample citations of the relevant literature. Only one point may need clarification here: a number of authors (Graevenitz, *op.cit.*, pp. 35f; Kauffmann, *loc.cit.*) have claimed that the head of Donatello's statue is in essence, an accurate likeness, since its features are remarkably similar to those of the effigy on the tomb of the Gattamelata in the Santo. The resemblance is indeed plain, but its evidential value is negligible; instead of postulating an earlier portrait as the common source of both heads, it seems far more plausible to assume that the author of the tomb, who was little more than a conscientious craftsman, simply copied the features of the Donatello statue (which, after all, had been modeled ten years earlier), just as he did with the *ad antiquam* armor of the effigy. Had the two masters worked from the same prototype, we might expect to find this prototype reflected in some of the other posthumous portraits of the general, but such is not the case.[23] Nor does it appear likely that either artist had a death mask at his disposal. Gattamelata died as an old man of at least seventy years of age who had been gravely incapacitated by a series of strokes (the document of December 18, 1442, reproduced in Eroli, *op.cit.*, p. 348, calls him "inhabilis et senex"), while the head of Donatello's statue shows him in vigorous middle age. He has created a face whose power of individuality is the greater because it is an "ideal reconstruction" of Gattamelata at the height of his career. Like the rest of the statue, the head is a "portrait *all'antica*" instinct with Roman intellectuality and nobility. As a likeness, however, it is no more "authentic" than the head of the St. Francis on the High Altar in the Santo.

[20] About the latter he is likely to have been well informed, since competing models for it were executed by two Florentine sculptors in 1443, when Donatello, in all probability, passed through Ferrara on his way to Padua; see Haftmann, *loc.cit.*

[21] There is, interestingly enough, more than a hint of glorification *all'antica* in the Sarego monument; while Sarego's armor is *alla moderna*, he is bareheaded, like the ancient equestrian statues and the Gattamelata; and the two attendants holding back the curtain that frames him are costumed *all'antica*. The Colleoni monument very carefully avoids the *all'antica* flavor of the Gattamelata; the armor, though richly ornamented, is

strictly "modern," and the attitude of the rider, as well as his size in relation to the horse, is comparable to the Sarego statue rather than to Donatello's.

[22] For the documents see G. Campori, *Gli artisti italiani e stranieri negli Stati Estensi*, Modena, 1855, pp. 185ff; also Giulio Bertoni and Emilio P. Vicini, *Rassegna d'arte*, v, 1905, pp. 69ff.

[23] Cf. the thorough survey of the available material in Graevenitz, *op.cit.*, pp. 47ff; the portrait ascribed to Bonsignori in *Pantheon*, IV, 1929, p. 350, derives from the Donatello statue, as pointed out by Kauffmann, *loc.cit.*

HIGH ALTAR, S. ANTONIO, PADUA

PLATES 74-88

<div align="right">1446-1450</div>

PLATES 78-83b

Bronze statues

ST. FRANCIS; H. 147 cm

ST. LOUIS OF TOULOUSE; H. 164 cm

ST. PROSDOCIMUS; H. 163 cm

ST. ANTHONY OF PADUA; H. 145 cm

ST. DANIEL; H. 153 cm

ST. JUSTINA; H. 154 cm

THE VIRGIN AND CHILD ENTHRONED; H. 159 cm
(on the back of the throne, the Fall of Man in relief)

PLATES 75b-77, 83c-87

Bronze reliefs

TWELVE ANGEL PANELS; H. 58 cm; W. 21 cm

FOUR SYMBOLS OF THE EVANGELISTS; H. and W. 59.8 cm

FOUR MIRACLES OF ST. ANTHONY; H. 57 cm; W. 123 cm
(The Ass of Rimini; The Speaking Babe; The Irascible Son;
The Heart of the Miser)

THE DEAD CHRIST WITH TWO ANGELS; H. 58 cm; W. 56 cm

PLATE 88

Limestone relief

THE ENTOMBMENT OF CHRIST; H. 138 cm; W. 188 cm

Missing

The ewer of St. Prosdocimus. The present vessel was made in 1751 by a certain Venier (Boito, *op.cit.*, p. 33).

The crooks of the crosiers of SS. Louis and Prosdocimus. The present crooks were presumably supplied by the same Venier who replaced the ewer of St. Prosdocimus.

Perhaps—if it was ever executed—the model of the City of Padua on top of the oval base in the right hand of St. Daniel.

Four limestone reliefs, each containing one figure, which flanked the Entombment; cf. below, document of April 26, 1449, and Michiel. Giuseppe Fiocco (*Padova*, vi, 1932, pp. 5ff; *Burl. Mag.*, lx, 1932, pp. 198ff) thought that he had rediscovered part of this set in two fragmentary panels of Paduan origin in the Fondazione Salvatore Romano, Florence, but this claim carries little conviction. See below, p. 235.

A God the Father of limestone, from the topmost zone of the architectural superstructure; cf. below, document of June 26, 1449.

The entire architectural framework except, very probably, for a pair of limestone volutes similar to those of the S. Croce tabernacle, now placed above the entrance to the library of S. Antonio. Both are corner pieces, consisting of two scrolls at right angles to each other (H. 35 cm; W. 38.5 cm; diameter of scrolls 30 cm). These fragments, found among the foundations of the choir during excavations conducted by Boito in the early 1890's, were published as belonging to the high altar by Fiocco (*Il Santo*, iii, 1930, pp. 1ff; *Burl. Mag.*, *loc.cit.*).[1]

DOCUMENTS

The majority are from the archives of the Arca del Santo, which contain the complete set of account books from mid-1446 to 1450. Excerpts printed in Bernardo Gonzati, *La Basilica di S. Antonio di Padova descritta ed illustrata*, Padua, 1854, i, pp. lxxxvff; substantially complete publication in A. Gloria, *Donatello fiorentino e le sue opere mirabili nel tempio di S. Antonio di Padova*, Padua, 1895, pp. 5ff (reprinted in Camillo Boito, *L'altare di Donatello e le altre opere nella Basilica Antoniana di Padova*, Milan, 1897,

[1] Kauffmann (*D.*, p. 118) suggested that the two bronze *putti* holding candelabra in the Musée Jacquemart-André, Paris, may have been part of the Santo Altar, where their position corresponded to that of the standing angels on top of the S. Croce tabernacle; this hypothesis receives no support from the documents or sources relating to the altar, and the *putti* themselves have since been shown to have belonged to the Cantoria of Luca della Robbia. See above, p. 119.

pp. 39ff). Additions and corrections: V. Lazzarini in *Nuovo archivio veneto*, serie 2, XII, 1906, pp. 161ff; Luigi Guidaldi in *Il Santo*, IV, 1932, pp. 239ff; Rolf Band in *Mitteilungen des Kunsthistorischen Instituts in Florenz*, V, 1940, pp. 334ff (Band also reprints the most important of the previously published documents but, unfortunately, in no consistent order).

Among the numerous records, in the account books of the Arca, of disbursement or credit to Donatello and others in connection with the work on the high altar, some do not specify the materials or services involved. They have been omitted in the following digest, except for those concerning important sums or yielding otherwise significant information. There frequently are two separate entries for the same item, the first authorizing payment, the other recording it; these appear below compounded into one. Proper names are given their standard modern spelling whenever possible, since to reproduce the inconsistencies of the records in this respect would serve no useful purpose.

1446, April 13 (Gloria, p. 5; Band, doc. *15*): The Arca di S. Antonio accepts a gift of 1500 lire from Francesco Tergola for a new high altar (*pala altaris magni*) and agrees to the stipulation that the donor's coat of arms be placed thereon. (Another, briefer reference to this donation, on July 13, in Gloria, p. 6 and Band, doc. *25*.)

1447, February 11 (Gloria, p. 6; Band, doc. *1*): Donatello receives 2 lbs. 3 oz. of white wax for modeling the heads of the figures for the altar (*anchona*). He also receives, in his own name, 100 lire 10 soldi for himself and his assistants (*garzon*): Urbano [da Cortona], Giovanni da Pisa, Antonio Chellini, and Francesco del Valente, as well as for Nicolò [Pizzolo] the painter, his "disciple or assistant" (*desipollo over garzon*); they are to make the high altar in the choir (*anchona over palla . . . al altaro grande del curo*).

April 4 (Gloria, p. 6): Andrea dalle Caldiere receives 228 lire for 500 lbs. of bronze he has supplied to Donatello for casting "angels and certain other things" for the *anchona*.

April 22 (Gloria, p. 6; Band, doc. *23*): Donatello receives 11 lire 8 soldi for his *garzon* Sebastiano.

April 28 (Gloria, p. 6; Band, doc. *16*): 625 lire from the estate of Beatrice d'Avanzo are added to the funds for the high altar. (Gloria mistakenly places this document in 1446, as pointed out by Band, p. 317, n. 14; the later date is confirmed by another reference to the same donation in Guidaldi, p. 281, doc. I.)

April 29 (Lazzarini, p. 165; Band, doc. *58*): Contract of the officials of the Arca with Donatello, Nicolò [Pizzolo] the painter, Urbano [da Cortona], Giovanni da Pisa, Antonio Chellini, and Francesco del Valente. The latter five are defined as "sculptors and disciples of Donatello," but another sentence refers to "Donatello, Nicolò, and the aforenamed disciples." The contract concerns ten bronze angels and four bronze evangelists, setting their price at 12 and 16 ducats, respectively. The angels have already been cast, and the six *magistri* are enjoined to clean them with the utmost diligence, so that there will be no spots or holes left, and goldsmiths and other experts will accept the pieces as ready for gilding. The artists also agree to make a groove or molding around the frame of the angel panels, if the officials should request it (*unum canale vel redundinum circa cornicem . . . angelorum*). The same conditions cover the evangelists, which have been modeled in wax and are ready for casting; they have the shape of animals, "as painted" (*sunt in forma animalium, prout pinguntur*), and are 1½ foot square. The artists must refrain from any work on other commissions until they have completed these tasks, on pain of having to refund all the money received, plus damages and interest. Of the price agreed upon, 30 ducats 36 soldi have already been disbursed to Nicolò (who has received almost four ducats) and the other four assistants (between six and seven ducats each). The rest will be paid as the work proceeds. (A summary of this contract appears in the account books of the Arca under the date of April 27; see Gloria, p. 6 and Band, doc. *13*.)

May (Gloria, p. 7): Andrea dalle Caldiere has received 1352 lbs. of metal (i.e. copper) and 38 lbs. of tin for the casting of angels and evangelists.

May 10 (Gloria, p. 7; Band, doc. *28*): Andrea dalle Caldiere receives 39 lire 18 soldi for having cast ten angels, two evangelists, and one of the miracles of St. Anthony for the high altar (*anchona over palla de lo altaro grande*).

June 9 and 10 (Gloria, p. 7; Band, doc. *30*): Donatello receives 68 lire 8 soldi for Antonio Chellini, his helper (*so garzon*). Francesco, a member of Andrea's shop involved in the casting of the figures for the altar (*che geta le figure de la anchona*), receives 5 lire 10 soldi for material for a pair of hose, which had been promised to him apart from the price of the casting.

June 23 (Lazzarini, p. 167; Band, doc. *17*): Contract between the officials of the Arca and Donatello setting the price of the four miracles of St. Anthony at 85 ducats apiece, and of the statues of SS. Francis and Louis at 40 ducats each. Three of the reliefs, the Ass of Rimini, the Speaking Babe, and the Irascible Son, which the master had modeled in wax (*formavit in cera*), are already cast (*fusse sunt ex ramo rudes et imperfecte*), while the two statues are either ready for casting or have already been cast (*similiter conducte sunt ex cera*). The fourth panel, the Heart of the Miser, has not yet been started (*superest ad formandum*). All these pieces must be cleaned and finished to perfection, so that experts will judge them ready for gilding. Donatello must proceed without delay and complete the work within eight months' time, otherwise the officials reserve the right to transfer the commission to other hands, and Donatello will be penalized to the extent of fifty ducats, plus damages. (A summary of this contract appears in the account books of the Arca under the same date; see Gloria, p. 6 and Band, doc. *14*.)

June (Gloria, p. 7): Payments are made by Donatello to his *garzon*, Giovanni da Pisa, Antonio Chellini, Urbano *da Fiorenza*, and Francesco del Valente, in each case for "the angel and the evangelist." The amounts, too, are practically identical—38 lire plus 11 to 14 soldi for each *garzon*. Nicolò [Pizzolo] the painter receives 21 lire 14 soldi for an angel.

August 4 (Gloria, p. 8; Band, doc. *18*): Donatello's account is charged with 300 lbs. of metal which have been sent to the foundry for casting the fourth of the miracles. (For Band, doc. *20*, also placed under August 4, 1447, see below under June 5, 1448.)

September (Gloria, p. 8): Payments to four "disciples of Donatello": to Giovanni da Pisa, 159 lire 10 soldi for work on an angel and an evangelist, which he had to "clean" (i.e. chase); to Antonio Chellini *da Pisa*, 159 lire 12 soldi; to Urbano *da Pisa over Cortona*, 159 lire; to Francesco del Valente *da Fiorenza*, 158 lire 12 soldi. Nicolò the painter—who, unlike the others, is not defined as *disipolo de Donato*—receives 68 lire 8 soldi.

November 15 (Gloria, p. 8; Band, doc. *19*): Andrea dalle Caldiere has been paid 2 ducats, equaling 11 lire 8 soldi, for casting the last miracle.

November 21 (Gloria, p. 8): Donatello has paid 59 lire 2 soldi to Polo d'Antonio da Ragusa, described as his *lavorante* or *garzon*, in the presence of Francesco Squarcione the painter.

December 19 (Gloria, p. 8, under September): Payment of 12 lire 16 soldi to Antonio Chellini, as his last installment for an angel that had been cast "by the hand of Donatello" and which he had to clean.

1448, February 9 (Gloria, p. 9): Donatello pays small sums to Giacomo the goldsmith, his *garzon*, and to Francesco d'Antonio Piero, his *lavorante*. (A Giacomo, presumably identical with this one, appears two more times in the account books: on June 26, 1448, as Giacomo di Baldassare da Prato, a

lavorante of the master, and on January 1, 1449, as Giacomo da Prato, a *disipolo*; a *garzon* Francesco appears again on December 22, 1448.)

March 4 (Gloria, p. 9; Band, doc. *65*): 5 lire 18 soldi spent for lumber and carpentry (?) in connection with the statues of the altar (*per cara doa legne. carezaura. tayaura . . . per sechar le figure grande per la pala*).

April 5 (Gloria, p. 9): Donatello pays 12 lire to Giovanni, his *garzon*. (This *garzon* is mentioned again on May 28; he is presumably identical with the Giovanni da Padova who appears as a *disipolo* on September 3, 1448.)

April 23 (Gloria, p. 9; Band, doc. *4*): Donatello receives 14 lire as reimbursement for money he has spent on eight columns and capitals (*colone con . . . capiteli*); they are part of a [provisional] altar to be erected for St. Anthony's Day, so as to demonstrate the design of the *pala over ancona* to the foreigners.

April 24, 26, 29, 30; May 8, 11, 20 (Gloria, pp. 9, 10; Band, docs. *5, 6, 7, 8, 9,* and *10* [ined.]): Payments of small sum for materials—nails, ironwork—and wages to a journeyman carpenter and a blacksmith for the provisional altar (*aparechio de laltaro per la demonstrazion de la pala*).

May 18 (Gloria, p. 10; Band, docs. *11, 12*): 6 lire 10 soldi paid to Simion Botazaro for columns (*colonele*) and [other] work connected with the "adornment" of the altar. 2 lire 5 soldi paid to the porters who carried the statues from [Donatello's shop in] the Casa del Pesce to the church for the *demonstrazion*.

May 25 (Gloria, p. 10; Band, doc. *21*): 1 lira 4 soldi paid to the porters who took the statue of the Madonna from the foundry to the church.

June 5 (Gloria, p. 10; Band, doc. *22*): Andrea dalle Caldiere has cast seven statues, for which he is to receive 27 ducats. (A detailed accounting of the value of various quantities of metal used in the casting, including 2770 lbs. furnished by Andrea up to May 27, 1448, is placed under June 5 in Gloria, p. 10 and Band, docs. *31, 32*. Another notice concerning the 2770 lbs. of metal provided by Andrea up to May 27, 1448, "for casting five statues of saints for the altar," appears in Gloria, p. 8 and Band, doc. *20*, under August 4, 1447. Band, following Gloria, assumes that the date referred to is actually May 27, 1447, and concludes that the five statues must have been cast by August 4 of that year. It seems more plausible, however, to accept "May 27, 1448" at face value and to regard this notice as a later addition to the entry of August 4, 1447. Cumulative entries of this sort are not infrequent in the account books of the Arca.)

June 21 (Gloria, pp. 10, 11; Band, docs. *31, 29*): A final payment of 101 ducats to Andrea dalle Caldiere. 75 lbs. of wax, at 10 soldi per pound, have been given to Donatello for the purpose of repairing the statues of the *pala*.

June 26 (Gloria, p. 11; Band, doc. *2*): Accounting of various sums due Donatello: for four bronze angels cast and finished by him, in accordance with an earlier contract, 12 ducats apiece; for his work on another angel, 3 ducats; and on behalf of Antonio Chellini, as the final payment for yet another angel, 1 ducat. For the seven statues of the Madonna and SS. Prosdocimus, Louis, Francis, Daniel, Anthony and Justina he is to receive, again in accordance with an earlier contract (*pato e convenzion*), 300 ducats. Of the total of 352 ducats, he has already been paid all but 105 ducats 2 lire 2 soldi.

July 1 (Gloria, p. 11; Band, doc. *33*): Donatello is to receive 85 ducats apiece for the four miracles, which he still has to finish (*a fato over de[ve] compire*); this does not include certain gold and silver "adornments" to be applied by him.

July 1-December 7 (Gloria, pp. 11, 12; Band, docs. *35, 34, 36*): Donatello receives various sums for the purchase of gold and silver, *per argentare e indorare la pala*.

November 30 (Gloria, p. 12; Band, doc. *46*): 18 lire paid to the stonecutter Nicolò da Firenze and his two helpers.

December 7 (Gloria, p. 12): 30 lire paid to Donatello for stone he had brought from Nanto, for the high altar.

1449, January 1 (Gloria, p. 12; Band, doc. *49a*): Nicolò da Firenze and his two helpers must deliver, by February 12, eight marble columns (*colonete*) on which work has already been started; they are to be paid 200 lire for this.

January 8 (Gloria, p. 12, under January 1): 17 lire 2 soldi paid to Oliviero, a *disipolo* of Donatello. (A second reference to Oliviero occurs on April 10; see below.)

January 29 (Gloria, p. 12; Band, docs. *37, 38*): Donatello has applied gold and silver to the four miracles and receives 90 ducats for this, in accordance with an estimate by six masters.

January 29 (Gloria, p. 12): 79 lire 16 soldi paid to Donatello for the purchase of marble.

February 12 (Gloria, p. 12; Band, doc. *49b*): Nicolò da Firenze and his two helpers are paid 200 lire, in accordance with the stipulation dated January 1, for the eight marble columns (*cholone*) for the altar, four of them rectangular (*quare*) and the others round with flutings (*a chanaleti*).

February 22 (Gloria, p. 12; Band, docs. *47, 48*, under January 1 and 29): Nicolò and his two helpers, Meo and Pippo, are paid 60 lire for work on the "stone that goes behind the altar" and some marble moldings (*cornixe*). This represents 60 man-days of labor, at 20 soldi (= 1 lira) per man-day.

April 2, 4 (Gloria, p. 13; Band, docs. *61, 62*): Squarcione receives 5 lire 14 soldi for painting the *altipeto* (= *antipeto*, altar frontal) or *pavimento* of the high altar.

April 2, 23, May 6, 14 (Gloria, p. 13; Band, docs. *39, 40, 41*): Donatello receives various sums for gold and for gilding.

April 10 (Gloria, p. 13; Band, doc. *40*): 2 florins, or 11 lire 4 soldi, paid to Oliviero for gilding the angels.

April 26 (Gloria, p. 12; Band, docs. *44, 45* [ined.]): The Arca agrees to pay Donatello 500 lire for five large stone slabs carved by him representing the Entombment of Christ.

April 30 (Gloria, p. 13; Guidaldi, p. 266, no. 4; Band, doc. *49c,d*): 48 lire paid to the stonecutter Meo for eight bases for the marble columns (*colone*).

May 2 (Gloria, p. 13): 8 lire 3 soldi paid to the mason Giovanni da Bolzano for several days' work on the *pala*.

May 12 (Gloria, p. 13; Band, docs. *63, 64* [ined.]): 82 lire to the stonecutter Antonio da Lugano for numerous moldings (*cornixe*) and large blocks (*priede grande*) for the "inside and outside of the altar" (*dentro e de fuore de la pala*).

May 14 (Band, doc. *69* [ined.]): 5 lire 14 soldi paid to a stonecutter for a piece of marble "for three bases."

May 19, 28, June 14 (Gloria, p. 13; Band, doc. *42*): Meo and his partner, Nicolò Chocari, receive 25 lire 4 soldi for 21 days' work on the "cornices" of the altar. Donatello is given 16 lire 16 soldi for gold to be applied to the "cornices." Andrea dalle Caldiere receives 120 lire 18 soldi for 192 lbs. of copper supplied by him "to make the cornices of the altar."

May 30 (Band, doc. *72* [ined]): The painter Antonio receives 1 lira 13 soldi for painting one "cornice."

May, June 23 (Gloria, p. 13; Band, doc. *71*): The potter Antonio Moscatello receives 8 lire 10 soldi for making "certain flowers" (*fioroni*). He receives 59 lire 12 soldi for *quareti* (= *quadrelli*, tiles) and border strips (*liste*) for the steps of the high altar.

June 23 (Gloria, p. 13; Guidaldi, p. 249; Band, docs. *70, 60, 43*): Nani da Firenze receives 29 lire for making steps of Nanto stone for the back of the high altar. The stonecutter Bartholomeo receives 150 lire for steps of white and red Veronese stone, of a total length of 95 feet, for the high altar. The ironworker Giovanni da Trento receives 14 lire for 195 lbs. of iron for making a grating (*gradela*) in back of the high altar. Donatello is paid 136 lire 16 soldi for making two bronze angels; 113 lire for casting and "adorning" the *pietà* (i.e. the Dead Christ), plus 50 lire for metal for the *pietà*; 285 lire for "adorning" four evangelists and twelve angels; 205 lire 4 soldi for 400 lbs. of metal used in casting the statues and the evangelists.

June 26 (Gloria, p. 13; Band, doc. *59*): Donatello has received 250 lire, also 2526 lire 6 soldi "to square his account" (*per saldo*). He is still to receive 1485 lire 6 soldi, also 50 ducats (285 lire) for a God the Father of stone above the "cupola" of the altar (*de sora de la chua grande dal altaro*), as well as 114 lire for a trip he made to supervise the quarrying of alabaster blocks, and for other work on the altar.

October 17, November 18, December 15; January 5, 15, February 11, March 10, April 16, 1450 (Gloria, p. 13): Various small amounts paid to Donatello.

1450, March 10 (Gloria, p. 14): Donatello is paid six and a half ducats for a column (*colona*).

June 11 (Gloria, p. 14): 1 lira paid to the porters who carried the statues from the house of Donatello to the altar.

June 17 (Gloria, p. 14, under February 11): Donatello has been paid 350 lire and is still to receive 2525 lire 6 soldi.

July (Gloria, p. 14): Donatello is still to receive 1697 lire 15 soldi.

1456, March 24 (Ravenna, Archivio Arcivescovile, Q. 8821; from Conte Marco Fantuzzi, *Monumenti ravennati de'secoli di mezzo . . .* , Venice, 1801, v, p. 187, reprinted in Semper, *D.* '75, pp. 319f and Milanesi, *Cat.*, p. 56): Donatello, in Florence, appoints the stonemason Francesco di Simone of Ravenna his authorized agent (*procurator*) for the purpose of collecting the debt still owed him for the statues and *décor* (*pro figuris et ornamentis*) of the altar of S. Antonio, Padua.

SOURCES

(Shortly before 1457) Bartolomeo Facio, *De viris illustribus*, ed. L. Mehus, Florence, 1745, p. 51: "He [Donatello] made in Padua the St. Anthony as well as the images of certain other saints on that same famous altar."

(c. 1520) Marcantonio Michiel, *Notizia d'opere del disegno*, ed. Theodor Frimmel, Vienna, 1888 (*Quellen-schriften . . .* , ed. Eitelberger von Edelberg, N. F. I), pp. 2ff: "In the church of the Santo above the high altar the four bronze figures in the round grouped around the Madonna, and the Madonna; and below these figures on the retable the two storiated bronze bas-reliefs in front and the two in back; and the four evangelists at the corners, two in front and two in back, in bronze bas-relief, but half-length figures; and behind the altar, beneath the retable the Dead Christ with the other figures around him, together with the two figures on the right and the two on the left, also in bas-relief but of marble; [all these] were made by Donatello."

(Before 1530) Billi, p. 42 (repeated in Cod. Magl., p. 78): "In Padua [Donatello] made . . . a marble *pietà* with the Marys, a most excellent work, for the front of the high altar."

1. *Plan showing distribution of reliefs according to Band, 1940*

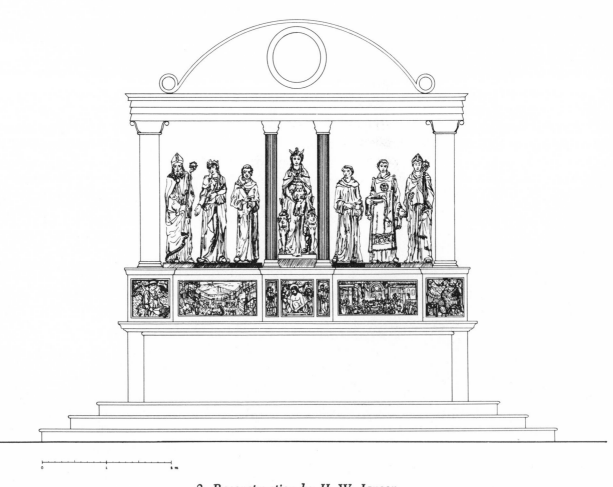

2. *Reconstruction by H. W. Janson*

168

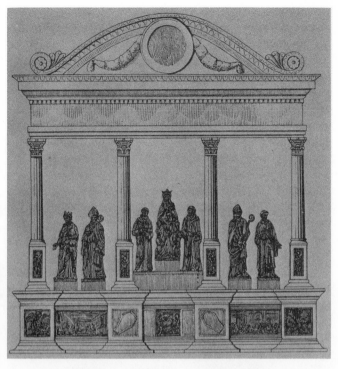

3. Reconstruction by v. Hadeln, 1909

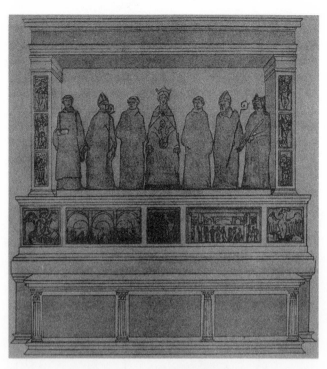

4. Reconstruction by Kauffmann, 1935

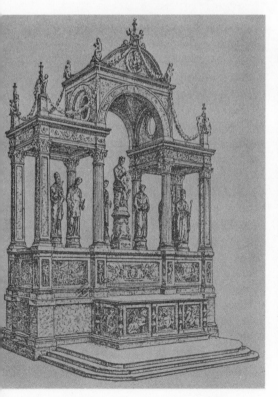

5. Reconstruction by Cordenons, 1895

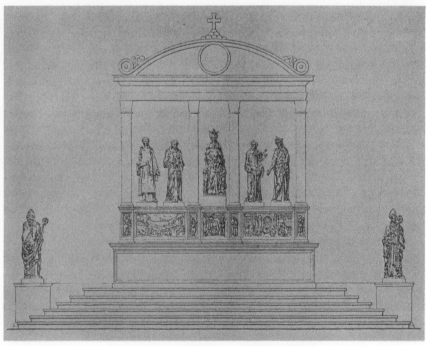

6. Reconstruction by Planiscig, 1947

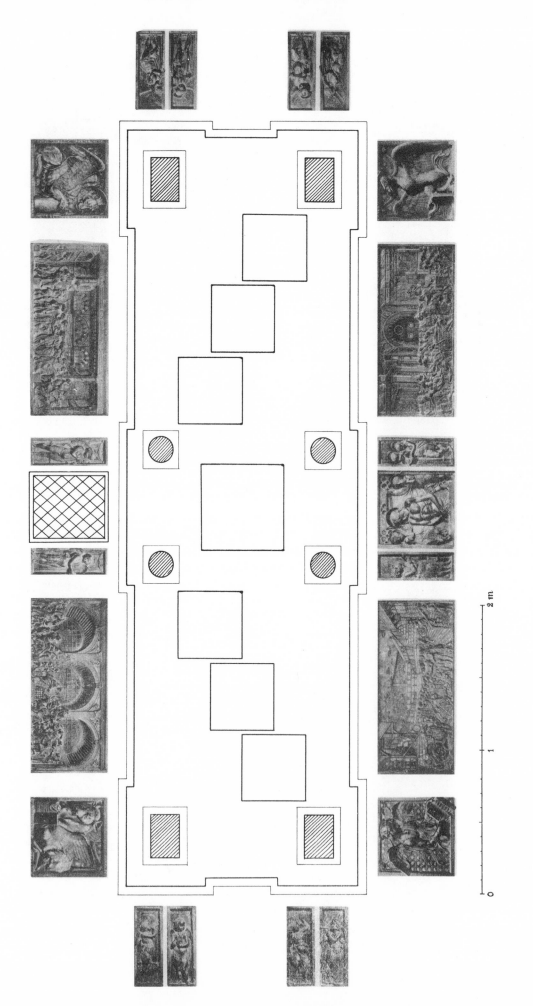

7. Ground Plan showing distribution of reliefs according to Janson

1547, Baccio Bandinelli, letter to Cosimo I, December 7 (Giovanni Bottari, *Raccolta di lettere . . .* , Milan, 1822-1825, I, p. 70): "Some who were with Donatello have told me that he always had eighteen or twenty assistants (*garzoni*) in his workshop; otherwise he never could have completed an altar of St. Anthony in Padua, together with other works."

1550, Vasari-Ricci, p. 54 (Milanesi, p. 411, slightly rephrased): "Because of this (i.e. the success of the Gattamelata) the Paduans sought by every means to make him a fellow citizen and to keep him there by all sorts of favors. In order to detain him, they commissioned him to do the scenes from the life of St. Anthony of Padua on the predella of the high altar in the church of the friars minor. These bas-reliefs have been carried out with such judgment that the outstanding masters of this art form are struck dumb with admiration when they regard the beautiful and varied compositions with such crowds of remarkable figures placed in diminishing perspective. For the front of the altar, he similarly made the Marys weeping over the dead Christ." (A much shortened paraphrase in Borghini, *Riposo*, p. 320.)

HISTORY AND RECONSTRUCTION

Thanks to the copious documentary data, the chronology of the Altar and of its component parts can be determined in considerable detail, even though the exact date of the commission itself is not known to us. The project may have been initiated by the gift of Francesco Tergola in April 1446; or the donation may have been made with reference to an already existing plan, as suggested by Band (*op.cit.*, p. 318). In connection with the latter possibility, Wolfgang Lotz (*Jahresberichte, Kunsthistorisches Institut in Florenz*, 1939-1940, unpaginated) has pointed to an altar commissioned in 1437 by the Paduan Convent of S. Prosdocimo from the sculptor Aegidius of Wiener Neustadt, then resident in Padua. The contract, published by Erice Rigoni in *Atti e memorie della R. Accademia . . . in Padova*, XLVI, 1929-1930, pp. 401f, specifies an *ancona sive pala altaris* 6½ feet square, divided into 5 *campos sive partes*; the center field is to be occupied by a Madonna and Child Enthroned, with angels, while the others are to contain SS. Prosdocimus, Anthony, Justina, and Catherine, all of them *relevate de creda cotta vel lapidea*. At the top there is to be a God the Father with the Orb, above a St. Peter Martyr. The contract further mentions four more saints, the four evangelists, and six fluted columns. The project could not have been carried very far, and seems to have been abandoned; for Aegidius, who had received an advance of 87 lire on July 8, 1437, fell gravely ill the following spring and must have died soon after. There was, however, a drawing or model for it (referred to in the contract) which the Arca del Santo could well have had in mind when, eight years later, they drew up specifications for Donatello's altar. The general similarity of the two projects is certainly intriguing, even though the S. Prosdocimo Altar apparently did not involve free-standing statues (as assumed by Lotz, *loc.cit.*) but large relief panels of terracotta.[2]

Band, *loc.cit.*, figures the total cost of the Santo Altar at about 3000 ducats, with one third of this amount representing Donatello's personal fees, while the funds provided by the two private donors came to no more than about 370 ducats (1 ducat = 1 florin = 5 lire 14 soldi). The sculptural work does not seem to have been started until the latter half of 1446, at which time Donatello and the Arca del Santo must have entered into the (lost) master contract referred to in the account books on June 26, 1448.

The further history of the altar falls into two distinct periods (see Band, *loc.cit.*). During the first phase, terminated by the provisional erection of the altar on St. Anthony's Day (June 13), 1448, Donatello and his assistants confined themselves to work in bronze; the columns and capitals mentioned in April and May of that year were of wood and belonged, not to the permanent architectural framework but to the temporary structure that was to "demonstrate the design of the altar to the foreigners." Nor did Donatello's workshop, which in 1447 and early 1448 consisted of five main assistants and at least four lesser *garzoni* or *lavoranti*, include any stonecutters until the winter of 1448-1449, so far as we can gather from the records. In fact, this first group of helpers seems to have been a kind of "task force" assembled for the specific purpose of carrying out the bronze pieces with the greatest possible dispatch. In February, 1447, Donatello was already engaged in modeling some of the statues (presumably the St. Francis and the St. Louis); at the end of April, the angel panels had been cast, and the four symbols of the evangelists were ready for the foundry. Two months later we read that three of the miracles of St. Anthony have been cast, while the

[2] Cf. the terracotta relief of the Madonna and six saints that forms the center of the altar by Nicolò Pizzolo in the Ovetari Chapel of the Eremitani, which in this respect seems to echo the S. Prosdocimo altar project.

fourth still remains to be modeled; by now the St. Francis and the St. Louis have also reached the casting stage. In August, the last miracle goes to the foundry. Meanwhile the master's assistants proceed with the laborious task of cleaning and finishing the casts of the angels and evangelists. Towards the end of May 1448, the seven statues have been cast, and all the bronzes specified in the various contracts are being mounted on the provisional altar in preparation for St. Anthony's Day.

As for the character of this temporary framework, we know only that it involved a good deal of carpentry as well as some ironwork, and that it called for eight columns with capitals (doc. April 23, 1448). These must have been of wood, to judge from their low price, as pointed out by Gloria (p. xvi). What purpose could they have served? The most natural assumption is that they supported an entablature or canopy of some sort, thus forming a tabernacle to house the seven statues (cf. Band, p. 320). In any event, they must have been of some importance, otherwise Donatello would hardly have concerned himself with them directly. He undoubtedly arranged for them to be made, according to his own specifications, by some craftsman in wood. One wonders if this could have been the Simion Botazaro who, on May 18, received payment for some *colonele* and other decorative work for the altar. A *botazaro* (= *bottacciajo*) is a cooper; if, as seems plausible, the *colonele* of May 18 are identical with the *colone* of April 23 (see Band, p. 322; the two terms could be used interchangeably in the account books of the Arca), we may conclude that the eight columns were made of staves, like elongated barrels. This ingenious and economical method of construction not only helps to explain the small cost of the columns, it fortifies our conjecture that they must have been of reasonably large size. We must also keep in mind the purpose of the wooden structure as repeatedly stated in the documents, i.e. to show off the design of the altar as a whole. Obviously, then, it was not merely a scaffolding for the display of the sculptural parts but a fair approximation of the permanent architectural framework as Donatello visualized it at that time.

The second phase of the campaign extends from mid-1448 to June 13, 1450, when the altar was presumably consecrated. While the temporary framework had been erected with the ostensible aim of impressing the out-of-town visitors on St. Anthony's Day, Donatello and his patrons must have studied the effect of the ensemble with equal interest. Whether this "dress rehearsal" led to any changes in the architectural design, we cannot venture to guess. Apparently, however, it suggested the need for some further bronze reliefs; a year later (doc. June 23, 1449), Donatello

had completed two additional angels, thus increasing the number of these panels to twelve, as well as the relief of the Dead Christ between angels (referred to in the documents as a *pietà*). By this time, all the bronze panels—but not all the statues—were finished in accordance with the contractual specifications, i.e., they had been cleaned, smoothed, and enhanced with applied gold and silver. Meanwhile, the stone framework had become the center of activity, and the character of the working force under Donatello had changed accordingly. From November 1448 on, we find references in the account books to the stonecutter Nicolò da Firenze, to his two assistants, Meo and Pippo, and a few months later to other stonecutters and masons. The most conspicuous architectural parts mentioned in these entries are eight marble *colone*, evidently corresponding to the wooden ones in the provisional installation; four of them were fluted columns, the others pilasters. Nicolò and his two helpers finished these on February 12, 1449, after more than a month of work; bases for them were delivered separately some two months later. The entire structure seems to have been substantially completed by the end of June. Donatello himself carved the monumental Entombment of Christ on five limestone slabs prepared for him by Nicolò, Meo, and Pippo, and destined for the back of the altar (only the center panel is preserved), as well as a God the Father of the same material for the "cupola." During the spring of 1449 we also encounter frequent references to "cornices," a broad term evidently applied to a considerable variety of ornamental carvings; some of these were of marble, some of lesser materials, and others of bronze. The steps of the altar, mentioned in May and June, were of red and white Veronese marble and limestone, with terracotta ornaments (probably on the risers). There was also some use of alabaster—we do not know for what exact purpose—and certain parts of the altar were painted and gilded.

All these intense and varied activities during the first half of 1449 suggest a determined effort to finish the altar in time for St. Anthony's Day. Although this goal was not achieved, the structure must have been very close to completion by the end of June, as indicated by the general squaring of accounts at that time. To judge from the character of the account book entries, very little work was done on the altar during the next twelve months; there are no further references to the numerous assistants and workmen mentioned before. Finally, on June 11, 1450, the statues were brought into the church, and during the following weeks Donatello received various payments, but six years later the Arca still owed him a considerable amount.

The exact location of the altar is known to us from

a small Cinquecento sketch of the ground plan of S. Antonio, roughly calibrated in Venetian braccia (Uffizi, No. 1868; Boito, p. 11, fig. 5; Guidaldi, pp. 271ff, dates it as early as 1457-1477). It shows the altar placed at the far end of the choir, close to the arcade of the ambulatory.

The archives of the Santo contain no further references to the altar until the summer of 1579, when the officials of the Arca decided to have it replaced by a new and much larger structure designed by Girolamo Campagna and Cesare Franco, utilizing the Donatello bronzes as well as the stone Entombment (see Gonzati, I, pp. 85ff; additional documentary data in Guidaldi, pp. 285f). Two drawings, a plan and an elevation, are connected with this enterprise (Uffizi, Nos. 3205A, 3206A; photos Soprintendenza 18430/31, 18462; published by Raffaello Niccoli in *Rivista d'arte*, xiv, 1932, pp. 114f). The elevation (which does not agree with the plan, as pointed out by Kauffmann, p. 110) shows a far more ambitious design than was finally executed, including numerous additions to the Donatello sculptures; it may be linked with the document in Guidaldi, *loc.cit.*, according to which four sculptors, Alessandro Vittoria, Francesco Segala, Girolamo Campagna, and Francesco Franco, submitted competitive designs. Campagna's project won out.

This altar, completed in 1582, was modified in 1591 (doc. in Guidaldi, p. 287) and again in 1651. The latter structure still incorporated most of Donatello's sculptures; the others were dispersed in various parts of the church.[3] The God the Father and the four lateral Entombment panels from Donatello's altar had probably been discarded as early as 1579. In the mid-nineteenth century, Gonzati put in a strong plea for reassembling the scattered pieces: "If Donatello could raise his head from the grave, he would curse the abandon of the delirious Seicento no less than the culpable inertia of later times, which still refuses to make amends for the sins of the past." His wish was fulfilled, albeit in a manner far short of perfection, by the architect Camillo Boito, who designed the present altar in 1895.

Boito's rather peremptory claim, in *Archivio storico dell'arte*, serie II, 1895, pp. 141ff, and in his monograph of 1897, to have restored the authentic setting of the Donatello sculptures, has long since been refuted by scholarly opinion (only Reymond, *Sc. Fl.*, II, p. 134, endorses it without complaint). Apart from the inclusion of the bronze crucifix and of a late fifteenth century *sportello* showing the Risen Christ, two pieces entirely unrelated to the original program of the altar, Boito committed the fundamental error of assuming

that there had been no architectural superstructure of any kind. Banking on the term *colonete*, he believed that the columns mentioned in the documents could only have been small-scale, decorative supports for the *mensa* or the retable, similar in shape to those on the base of the Marzocco, which he used as models for his own design. As for the *chua grande* (doc. June 26, 1449) Boito insisted that it must have been part of the old high altar, rather than of Donatello's structure, since the great master could not possibly have wanted his statues to be obscured by so elaborate a framework. Among subsequent attempts to reconstruct the altar, only that by Charles de Mandach (*Saint Antoine de Padoue et l'art Italien*, Paris, 1899, p. 199) shares this basic premise; it shows the seven statues on top of a huge three-storied retable, with all the bronze reliefs mounted on its front in direct contradiction to the testimony of Michiel.

Another early reconstruction, by the architect F. Cordenons (*L'Altare di Donatello al Santo*, Padua, 1895; reproduced in Paul Schubring, *Urbano da Cortona*, Strasbourg, 1903, p. 33, and *KdK*, p. xliii) acknowledges the importance of the superstructure (Fig. 5). Here the *chua* has the shape of a groined vault resting on four columns above the center of the retable; its frontal arch is surmounted by a segmental pediment which contains a relief of God the Father blessing. Three statues—the Madonna, on a tall pedestal, flanked by SS. Justina and Anthony—appear beneath this vault, the others are placed under flat stone canopies supported by the columns and, at the corners of the retable, by four pilasters. Cordenons' drawing shows the twelve angel panels and the four miracles of St. Anthony in the upper zone of the retable, with the angels mounted on the projections beneath the columns and pilasters; two of the miracles are placed on the flanks of the structure, in the conviction that these elaborately detailed and important scenes could not have been intended for the rear of the altar (Schubring endorses this demonstrably incorrect view). The other bronze panels are set in the front and sides of the *mensa*.

As a successful critique of Boito, the Cordenons scheme won general approval even from those scholars who realized its various shortcomings, such as the airy, Lombard-Venetian character of the architectural setting (cf. the review in *Repertorium f. Kw.*, xxiii, 1900, pp. 72ff; Wilhelm Bode, *Cicerone*, 8th ed., p. 421; Schottmüller, p. 67). It provided the point of departure for a more detailed reconstruction of the altar by Detlef von Hadeln (*Jahrbuch Kgl. Preuss. Kunstslgn.*, xxx, 1909, pp. 35ff). In the meantime,

[3] Their exact location is given in Giambatista Rossetti, *Descrizione delle pitture, sculture, ed architetture di Padova...*, I, 1765, pp. 37ff, and in subsequent *guide*, also in Gonzati,

loc.cit., and Boito, pp. 11ff; Boito, fig. 41, and Guidaldi, figs. 5, 15, 19, reproduce photographs of the Baroque Altar.

however, Adolfo Venturi (*L'Arte*, x, 1907, pp. 276ff, and *Storia*, vi, pp. 298ff) had injected a new factor into the problem; he contended that certain richly decorated fifteenth century pilasters built into the choir screen of S. Antonio had originally been part of the Donatello altar. This theory, later recognized as untenable (see below), was fully accepted by von Hadeln, who concluded from the scale of the pilasters that the entire structure must have been of very considerable size. He further postulated, on the basis of an unfortunate error in Gloria's transcription of the document of February 12, 1449 (*chavaleti* for *chanaleti*; rectified by Guidaldi, p. 265) that the columns of the superstructure had rested on tall pedestals. As a consequence, his reconstruction (Fig. 3) assumed such heroic dimensions—the ground plan measures 720 x 350 cm—that the sculptural parts of the altar were almost crushed by the massive forms of the architectural setting. Apart from its scale, von Hadeln's scheme shows many important improvements over that of Cordenons. The frontal elevation is based on two works which in all probability reflect the direct influence of the Donatello altar, i.e., the altar by Nicolò Pizzolo in the Ovetari Chapel of the Eremitani and Mantegna's altar in S. Zeno, Verona: a segmental pediment with terminal volutes screens the *chua*, a shallow dome or vault which rises above an unbroken architrave extending the full width of the retable and resting on four columns. In the rear, the columns are replaced by pilasters. This structure forms a hall of considerable depth, so that the statues, lined up at a distance of 120 cm from the front edge, have to be placed on heavy plinths in order to raise them sufficiently for a full view at close range. The distribution of the statues between the supports follows that of Cordenons, although the sequence of the Saints is different. As for the reliefs, von Hadeln has realized that none of them could have been intended for the *mensa*, which had a painted frontal (doc. April 2, 4, 1449); in placing them on the retable, he follows the remarks of Michiel, so that the relief zone above the *mensa* shows two miracles and two evangelist panels each in the front and rear. The bronze relief of the Dead Christ forms the center of the frontal grouping (it has a perforated background, indicating a hollow space behind it, as suggested by Kauffmann, *D.*, p. 114). To the corresponding place in the rear, von Hadeln assigns the "iron grating for the back of the altar" (doc. June 23, 1449). This part of von Hadeln's reconstruction is quite unexceptionable. It gains especial support from the fact (which he duly emphasizes) that all the bronze panels are of practically the same height, indicating that they were meant to form one continuous horizontal sequence. Curiously enough, he does not acknowledge this rule for the angel reliefs,

although it applies to them with equal force; he places them on the ill-fated *cavaletti* of the columns and pilasters, instead of aligning them with the miracle panels as proposed by Cordenons.

The von Hadeln reconstruction carried such authority that it remained unchallenged for twenty years. Schubring's only objection (*HB*, pp. 53f) concerned the sequence of the statues, and Fiocco used it to fortify his identification of the two limestone volutes in the Santo as fragments of the Donatello altar (see above, p. 162). Meanwhile, Kauffmann had begun to question the soundness of von Hadeln's scheme because of its extravagant scale (see the summary of his lecture in *Sitzungsberichte der Berliner Kunstgeschichtlichen Gesellschaft*, 1928-1929, i, pp. 1ff); after reexamining the entire problem (*D.*, pp. 109ff) he arrived at a radically different reconstruction of his own (Fig. 4). On the basis of the Cinquecento ground plan of S. Antonio (see above, p. 171) and of the two Uffizi drawings related to the competition of 1579 (see above, p. 171) Kauffmann was able to prove that the *mensa* of the Donatello Altar must have been no more than c. 4.25 m in length, and that the entire structure could not have been much wider than c. 5 m, as against the 7.20 m postulated by von Hadeln. He also made short shrift of the *cavaletti*, having surmised the correct reading independently of Guidaldi. After this promising start Kauffmann, unfortunately, succumbs once again to his *idée fixe* of Donatello as an artist of basically mediaeval temper; his further deductions are designed to prove that the statues of the altar were housed, not in a columned hall but in a simple, old-fashioned shrine shaped like a shallow box, so that the effect of the whole must have been comparable to a large relief panel such as the Pizzolo Altar in the Ovetari Chapel. In defense of this notion Kauffmann cites the fact that in the documents the altar is never referred to as a *sacellum* or *tabernacolo* but as a *pala* or *ancona*, terms usually denoting an altar panel or shrine and, in his view, difficult to reconcile with the spacious framework visualized by von Hadeln. He further points to the monotonous recurrence of the term *cornice* (frame, molding) as indicating a compact, rather than a highly articulated architectural structure. Even the early demolition of the altar yields grist for his mill; does it not suggest that Donatello's design was of a modest, archaic type incompatible with the more lavish tastes of the later Cinquecento? On the other hand, Kauffmann neglects to discuss the documents dealing with the provisional wooden altar of 1448 and thus circumvents the necessity of explaining why such an elaborate preview should have been found desirable if the structure was no more than a simple shrine. Nor is he at all disturbed by the Adam and Eve relief on the back of the

Madonna's throne, which he proposes to hide from view completely (cf. the objections of Middeldorf, *AB*, p. 581). As for the columns and pilasters mentioned in the records, he reverts to Boito's arbitrary interpretation of these pieces as small-scale *colonete* intended for the *mensa*, disregarding the fact (already noted by Guidaldi, p. 265) that the documents refer to them more frequently as *colone*. The *chua grande*, another obstacle to his theory, Kauffmann interprets as a separate entity, a domed or vaulted canopy resting on four columns and large enough to enclose the entire altar, analogous to Michelozzo's tabernacle in the SS. Annunziata. He surmises that the two volutes published by Fiocco may have come from this structure, but fails to explain why an architectural feature of such size and importance, if it actually existed, should be mentioned in the account books only once (and not as a *tabernacolo* but as a *chua*) or how it can be reconciled with the location of the altar as indicated by the Cinquecento ground plan of S. Antonio (which shows no trace of a separate tabernacle and provides no room for one).

Kauffmann's only agreement with von Hadeln concerns the reliefs of the predella zone; he reduces the width of the intervening spaces and eliminates the projections but retains the same distribution otherwise. The twelve angel panels he places, in vertical strips of three, on the pilasters framing the front and rear of the shrine, an arrangement indicated to him by the circumstance that some of the angels seem to be looking down while others are glancing upward, suggesting an orientation towards a common center. By way of analogy he cites the angels on the painted frame of Fra Angelico's Madonna of the Linaiuoli, as well as the fact that the Uffizi sketch of c. 1579, showing the elevation of a new high altar for the Santo, has the Donatello angels mounted in vertical sequence. Still, one cannot help wondering why the master found it necessary to put each angel in a separate frame if he intended to use the panels in this fashion, or why his original plan called for only ten angels when twelve was obviously the number he needed to fill the four pilasters. The location Kauffmann assigns to the Entombment is, if anything, even more questionable. His predecessors had all placed it below the predella zone on the back of the altar, in accordance with the explicit testimony of Michiel (*sotto il scabello*). In Kauffmann's scheme, however, this space is subdivided by four small applied pilasters, the counterparts of the four *colonete* decorating the front of the *mensa*. As a consequence, he has to shift the Entombment to the area above the predella zone, i.e., to the back of the hypothetical shrine (*D.*, p. 223, n. 378).

The Kauffmann reconstruction was subjected to detailed analysis by Rolf Band (*op.cit.*), who accepted Kauffmann's findings concerning the possible maximum width of the altar but rejected the idea of the shrine as incompatible with the documentary evidence. Band's careful study of the Paduan account books demonstrates that the descriptive terms used in these records are too imprecise to yield the exact meanings imputed to them by Kauffmann: *colone, colonelle*, and *colonette* may all occur interchangeably in the same entry (the diminutive, it seems, could be applied to any column or pilaster smaller than those ordinarily employed in monumental architecture). In connection with the Donatello altar, *colone* is definitely the preferred term, both for the wooden *apparecchio* of 1448 and for the permanent structure. The relative size and importance of these supports can be judged more accurately from the number of work days it took to make them; the comparative material cited by Band (from account book entries dealing with *colonete* for the choir screen) indicates that they were a good deal taller than four feet. Band also proves, by means of several previously unpublished excerpts from the Santo records (doc. 27a-f), that Kauffmann's argument concerning the term *tabernacolo* is utterly baseless; in fifteenth century Padua, the word was used only for reliquaries and hence could not very well be applied to the superstructure of an altar. On the basis of all these considerations Band advocates the reinstatement, at least in principle, of the von Hadeln scheme, but of course without the *cavaletti* and on a scale sufficiently reduced to conform to Kauffmann's calculations. Finally, he examines the problem of the choir screen pilasters which Venturi had proclaimed as architectural remains of the Donatello altar, and proves that they must have been intended for the choir screen from the very start. (Some of his conclusions are confirmed independently by A. Prosdocimi in *Rivista d'arte*, XXI, 1939, pp. 156ff.) While Band does not offer a drawing embodying his conception of the altar, he provides detailed specifications for such a sketch (Fig. 1). The result is more satisfactory by far than any of the previous reconstructions, even if it still leaves a number of questions unanswered.

Band begins by restoring the angel panels to the predella zone. He believes, with Cordenons, that they are to be placed directly below the columns and pilasters, i.e., four each on the long sides, plus two on either flank. But since he retains the sequence proposed by Kauffmann for the other bronze reliefs, he concludes that the angels on the front and back of the predella must have flanked the four symbols of the evangelists, rather than the miracles as in the Cordenons scheme. In order to reconcile this arrangement with the fact that Donatello's original plan called for only ten angels, Band further conjectures that in

the provisional altar of 1448 the ninth and tenth angels had marked the front and back of the predella; when their places were taken by the Dead Christ and the iron grating, respectively, they were moved to the flanks, and two more panels were added for reasons of symmetry. On the premise that the spacing of the eight *colone* can be deduced from that of the angels, Band postulates a distance of no more than 60 cm between the pilasters, which he places at the corners of the superstructure, and the columns, which he regards as supports for the *chua*. He visualizes the latter as a groined vault measuring c. 3 m x 1.5 m and enclosed by four segmental pediments with scrolls. The large area beneath the *chua*, he believes, held a central group of five statues, separated by the columns from the two other figures in the narrow flanking compartments. He also suggests that this arrangement may help to account for the fact that Michiel's description of the altar mentions only five statues, even though he fails to explain how Michiel could have noted the symbols of the evangelists while ignoring the two statues directly above these panels. Band's analysis of the sequence of the statues is perhaps the most completely successful aspect of his reconstruction. Like von Hadeln and Kauffmann, he places the two monks nearest the Madonna, but his arrangement of the other figures is far more satisfactory than any of the schemes proposed before. Band draws attention to the hitherto neglected differences in height among the three pairs of saints, and argues that Donatello must have planned these differences so as to enhance and unify the effect of the ensemble; since the two shortest figures, SS. Francis and Anthony, undoubtedly occupied the places of honor next to the Madonna, the most harmonious solution for the rest of the statues would be an arrangement in ascending order, with the two bishops, the tallest of them, in third place on either side. In this connection Band points out that Michiel describes the statues as grouped around the Madonna (*attorno la nostra donna*) and suggests that they were probably not placed along a straight line but in the pattern of a shallow inverted V, so that the outermost pair was closest to the beholder. The diminishing size of the saints, he believes, lent special emphasis to this formation in space by creating an illusion of greater depth than Donatello actually had at his command. Band also makes the very perceptive observation that the two bishops must have been turning towards the beholder, rather than towards the center of the altar, since the acts they perform (i.e., blessing and baptizing) are meaningless when addressed to the Madonna. Similarly, the gestures of SS. Daniel and Justina are to be understood, not as indicative but as commendatory; instead of pointing to the Madonna they appeal to the faithful below.

Thus Band arrives at the following sequence:

Madonna
St. Francis St. Anthony
St. Justina St. Daniel
St. Prosdocimus St. Louis

The most recent reconstruction of the altar, by Planiscig (*D.*, pp. 85ff), is far less well considered than that of Band, although it, too, represents a modification of the von Hadeln scheme (Fig. 6). Planiscig rejects Kauffmann's work so completely that he does not even acknowledge its one positive feature, i.e., the calculations limiting the over-all width of the structure. His point of departure is the text of Michiel, especially the statement that there were five, rather than seven statues, which he tries to reconcile with the documentary data. In order to do this, he assumes that the *chua* had in fact accommodated five figures only; the other two (the bishops) he places on a lower level, at the ends of a pair of wings jutting out from the flanks of the altar. The resulting design not only bears an unfortunate resemblance to Boito's "recomposition" of the altar but has the additional disadvantage of even greater width (almost 10 m). Since a predella intended for five statues would not be long enough for all the bronze reliefs, Planiscig has to transfer the evangelist panels to the pedestals of the two "outriders." Strangely enough, he places them on the sides and the backs of the pedestals, so that they do not appear in the front view of the altar at all, despite the fact that their location is defined by Michiel in the same terms as that of the miracle panels, "two in front and two in back." That Michiel should have recorded the presence of the evangelists while forgetting the two statues directly above them, does not strike Planiscig as in the least absurd. With respect to the Entombment, as well as the four miracles, he follows the directions of Michiel; the Dead Christ occupies the center position on the front of the predella; and the angels are distributed over the four faces of the predella in accordance with the same principle that had guided Band, except that they now flank the miracles instead of the evangelists. This, however, necessitates a novel spacing of the supports of the *chua*, with the four columns forming a narrow center compartment just large enough for the Madonna, so that the latter is separated from the flanking figures on either side. Artistically, such an arrangement agrees well enough with the impassive and hieratic character of the Virgin and Child, but in the context of this particular design it looks awkward indeed, especially since all the statues under the *chua* are placed on a straight line. As for the sequence of the six saints, Planiscig accepts Band's proposal concerning the two bishops but makes St. Justina change

places with St. Daniel. Altogether, his is a curiously retrogressive solution to our problem.

The Planiscig reconstruction, then, in no way upsets the validity of Band's conclusions about the general appearance and dimensions of the altar. Still, even the latter scheme cannot claim to be definitive. While most of its specifications are fully compatible with the visual and written evidence, several others seem more than doubtful. Perhaps the most obvious difficulty concerns the angel panels; if the proposed distribution is correct, one wonders how Donatello could ever have thought that ten panels would be sufficient (cf. the contract of April 29, 1447), since it so clearly demands twelve. Band's hypothesis that the original plan called for single angels to mark the center of the front and back of the predella, in addition to the four pairs at the corners, is too awkward for serious consideration. Also, his arrangement of the twelve panels postulates a more or less uniform series, whereas in actual fact there are considerable differences among the reliefs, indicating several distinct groupings; some are definitely meant to be companion pieces, and two of them contain a pair of angels each. Nor does Band take account of the curious variations in height among the several categories of predella reliefs; why should the angel panels and the Deal Christ be 58 cm tall, as against 57 cm for the four miracles and 60 cm for the symbols of the evangelists? These differences, while slight, are certainly not a matter of chance (as assumed by von Hadeln, *loc.cit.*, the only scholar to comment upon them). Whatever their exact purpose, they argue against Band's contention that the reliefs were placed next to each other without intervening stone moldings, since they would have been embarrassingly evident in such an arrangement. Furthermore, Band takes certain liberties with Michiel's account of the altar; he places the evangelist panels not "at the corners" but near the corners of the predella, and he shares the general assumption that Michiel must have overlooked two of the statues. His attempt to explain this omission seems far more plausible than that of Planiscig, but the proposed grouping of the figures in 1-5-1 sequence is not wholly convincing aesthetically and has no analogies among other altars of the period.

It is curious indeed that neither Band nor Planiscig (let alone their predecessors) should have been willing to give full credence to Michiel's text, especially since all of them accepted it as the result of firsthand observation. The description of the altar is admittedly incomplete, but to attribute this to forgetfulness or

lack of accuracy seems hardly justified unless we can prove the same deficiencies to be a general characteristic of the author's work. If we give Michiel the benefit of the doubt in this respect (which he well deserves, considering the quality of his notes as a whole), there are three other possible reasons why he omitted some of the components of the altar from his account: he may not have thought them important or conspicuous enough to mention; he may have believed them to be the work of an artist other than Donatello; or perhaps they were no longer part of the ensemble at the time he saw it. So far as his omission of some of the bronze panels is concerned (i.e., of the twelve angels and the Dead Christ), only the first of these explanations need be considered. The reliefs could have been removed only at the cost of grievously damaging the appearance of the altar as a whole, nor is there the slightest evidence that these particular pieces were linked with the names of any lesser sculptors before the late nineteenth century, when Donatello's Paduan assistants emerged from the account books of the Arca. The two omitted statues present a different, and more intricate, problem. Whatever their exact place in the ensemble (assuming that they still belonged to it in Michiel's day), they could not very well have been overlooked. It is possible, however, that Michiel excluded them from the work of Donatello on the basis of what he was told on the spot. As Guidaldi has pointed out (p. 263), a local tradition to this effect can be traced in later times; the Paduan guidebooks of the eighteenth century attribute the SS. Louis and Prosdocimus (which at that time were physically divorced from the Donatello statues) to Tiziano Minio. Guidaldi also mentions an unpublished document of 1573 in the Archives of the Santo, according to which Francesco Segalla regarded all the statues of the high altar as the work of the Paduan sculptor Minello. Since the two bishops in all probability occupied the outermost positions in the sequence of statues (indicated by the fact that they are oriented towards the beholder rather than the Madonna), there has long been general agreement among Donatello scholars that they were the ones whom Michiel neglected to mention. The Tiziano Minio tradition (or its equivalent, if one existed as early as c. 1520) would seem to lend further weight to this opinion. On the other hand it is most unlikely that such a notion could have arisen so long as the two figures were still an integral part of the Donatellian structure.[4]

Thus the Tiziano Minio tradition, whatever its date of origin, does not argue against our accepting

[4] Even in the overextended reconstruction of Planiscig, who draws upon the Tiziano Minio tradition to justify his method of placing the bishops on separate pedestals, the two figures definitely remain within the ensemble. If it were possible to prove that the Tiziano Minio theory antedates the new altar

of 1579, Planiscig's scheme would hardly offer an adequate explanation for the origin of the idea. Instead, we should be tempted to conclude that the statues in question must have been removed from the altar at some time prior to the dismemberment of the structure as a whole.

Michiel's statement about the number of statues at face value.[5] Our assumption that two statues had been removed from the altar before c. 1520 is perhaps less revolutionary than it may seem at first sight. Inasmuch as the authorities of the Santo were willing to have the entire structure demolished in 1579, there is no particular reason to believe that they regarded Donatello's work as sacrosanct before that time. Nor do we have any positive assurance that the altar retained its pristine state in every respect until Girolamo Campagna and Cesare Franco replaced it with their own design. In fact, the contract between these two masters and the Arca del Santo (excerpted in Boito, *L'altare*, p. 13) provides a bit of corroborative evidence for our thesis. It enumerates the sculptural parts of the earlier altar to be incorporated into the new framework, including all the bronze panels and the Madonna but only four, rather than six, other statues. The list also mentions an *Ecce Homo*, i.e., the bronze *sportello* which today occupies the center of the predella in Boito's "reintegrated" altar. There can be no doubt that this piece was made for the high altar in the late years of the Quattrocento; it probably took the place of the iron grating in the back of the predella, as suggested by Guidaldi (pp. 243ff). Perhaps the addition of the *sportello* indicates that the original ensemble of the altar could have been modified in other ways as well during the years between 1450 and the time of Michiel's notes. The Uffizi drawing connected with the competition of 1579 (see above, p. 171) yields another indirect argument in favor of Michiel. It shows seven statues within the arch that forms the central feature of the projected altar, but they bear so little resemblance to those of Donatello that we cannot be sure of their identity. The Madonna is seated, with the Child embracing his mother; the positions of the two Franciscans are reversed (the Madonna turns towards St. Anthony, who appears at her right); and the rest of the group includes an unidentifiable female saint and a bearded bishop without attributes, in addition to the SS. Justina and Daniel. Did the author of the sketch intend all of these figures to be newly commissioned, along with the eleven other statues that appear in his design? He would have been entirely at liberty to do so, since the terms of the competition (recorded in the document published by Guidaldi, pp. 285f) do not specify the re-employment of the earlier sculptures. Or did he plan to use the statues from the Donatello Altar as the core of a greatly enlarged program? Significantly enough, his drawing

shows all the Donatellian bronze panels, but with various additions (there are sixteen standing angels, and two reliefs of the Dead Christ). In either case, it is not without significance for our present problem that only five of the seven statues correspond to those of the original set. The bearded bishop without the attributes of St. Prosdocimus, and the female saint replacing the St. Louis, must have been intended as new figures, unless we are willing to charge our unknown draughtsman with a truly unconscionable lack of exactitude.

The testimony of Michiel, then, finds support in the Campagna-Franco contract of 1579 and in the Uffizi drawing of approximately the same date. The latter source also indicates that the two statues removed from the Donatello altar between 1450 and c. 1520 were the SS. Louis and Prosdocimus. Apparently they did not become part of the altar of 1579 because they had been detached from their companions a long time before, so that Girolamo Campagna and Cesare Franco no longer thought of them as belonging to the Donatellian ensemble. Their continued separation from the other five figures eventually gave rise to the notion that they were the work of a different master.

What purpose could the SS. Louis and Prosdocimus have served outside their original context? Gonzati (1, pp. 67ff) states that they flanked Donatello's bronze Crucifix, which surmounted the arched central opening of the choir screen until the destruction of the latter in the seventeenth century. This claim was accepted at face value by some of the older Donatello scholars, even though Gonzati had failed to give a source for it; Semper (*D.* '87, p. 87) went so far as to assume that the two statues had never belonged to the high altar at all. Now it is true that the Crucifix stood above the center arch of the choir screen for at least a century from 1487 on. In 1590 it still occupied the same place, according to the *Religiose memorie* of the Padre Polidoro, the main source of Gonzati's reconstruction of the original choir enclosure (see above, p. 149). Polidoro, however, does not mention the two bishops; as Guidaldi has pointed out (p. 262), Gonzati probably relied on a later authority (Portenari, *Delle felicità . . .*, 1623) which refers to two life-size bronze statues flanking the main entrance to the choir. Guidaldi was able to prove (p. 286) that these figures were actually of stucco painted to resemble bronze, and that they were commissioned of Francesco Segalla in 1591, when the tall arch above the center of the screen was removed because it ob-

[5] We might note in this connection that there is no possibility of a clerical error here. The manuscript text, carefully transcribed by Frimmel, shows the word *quattro* (in the phrase, "the four statues . . . around the Madonna") written over a crossed-out *cinq*, indicating that Michiel had originally in-

cluded the Madonna in his count; he then decided to mention the center figure separately and made the necessary correction in the first part of his sentence. Obviously, the author had given some thought to the matter and felt no uncertainty about it.

structed the view of the new high altar. Thus, in the light of present-day knowledge, Gonzati's statement proves to be utterly without substance. Nevertheless, it is tempting to speculate on the possibility that the removal of the two figures from the altar might have had something to do with the choir screen after all. If we consider the similar Quattrocento screen in S. Maria dei Frari, Venice, with its rich complement of statues, it seems reasonable to assume that the Paduan authorities, too, aspired to a monumental sculptural program for their choir screen. Perhaps they originally expected Donatello, who had participated in the work on the new choir enclosure in 1449 (see above, p. 149), to carry out such a scheme, but this hope never materialized, since the master did not even live up to all of his contractual obligations with respect to the statues of the high altar (see below, p. 183). When the screen was finally completed, the Arca del Santo apparently lacked the financial means for another ambitious sculptural campaign; they contented themselves with the bronze reliefs of Bellano (1484-1488) and the transplanting of the Donatello Crucifix. Might they not also have decided at this time to transfer the SS. Prosdocimus and Louis from the altar to the choir screen? If so, they probably did not combine them with the Crucifix directly, since the two bishops could hardly take the place of the Virgin and St. John in such a grouping. Still, our statues could have enriched the appearance of the screen in a less conspicuous spot comparable to that of the two stucco figures by Francesco Segalla. In that event, they would have become available for relocation when the screen was demolished. This may explain their peculiar place in the Baroque *altarone* of 1651 (Guidaldi, figs. 5, 15). Unlike the other five Donatello statues, our bishops did not form part of the enormous retable behind the altar proper; instead, they occupied separate, low pedestals of their own on either side of the *mensa*. An analogous fate befell the Crucifix, which was also absorbed into the *altarone* after the razing of the choir screen.

The information at our disposal is admittedly too fragmentary to establish the premature removal of the two statues as certain beyond doubt. Yet the balance of the argument would seem to favor our acceptance of Michiel's testimony as prima facie evidence. At the very least, it provides us with a new working hypothesis whose implications demand to be explored. These implications are of considerable importance for the problem of reconstruction: If the SS. Louis and Prosdocimus could be detached from the ensemble, the design of the altar must have permitted such a reduction in the number of statues without irreparable damage to the harmonious effect of the whole. On the basis of this test, we must reject the arrangement advocated by Band, since the removal of two figures

from a 1-5-1 sequence could have resulted only in groupings of 0-5-0 or 1-3-1, both of which would look more than awkward in Band's system of intercolumniations. The 2-3-2 sequence proposed by Cordenons and von Hadeln, and the 1-2-1-2-1 scheme of Planiscig, are equally unsatisfactory. There is, in fact, only one possible arrangement that fits our condition: the sequence of 3-1-3, which can be reduced to a grouping of 2-1-2 without too much difficulty (in order to close the gap resulting from the removal of one of the statues on either side, we need only adjust the spacing of the remaining pair). Let us, then, begin our own reconstruction (Figs. 2, 7) by borrowing the central feature of Planiscig's scheme—a narrow compartment defined by the four *colonne a canaletti* and containing only the Madonna, but with the intervals on either side wide enough to hold three figures each. Next, we put the four symbols of the evangelists at the corners of the predella, "two in front and two in back" as specified by Michiel. We thus restore their true purpose, which only von Hadeln and Kauffmann had been willing to recognize before, i.e., to embellish the bases of the pilasters. The miracles of St. Anthony, again placed in accordance with Michiel's text, fill the areas beneath the flanking groups of statues; and the Dead Christ with mourning angels retains its position in the center of the predella, directly beneath the Virgin and Child.

The twelve angels present a more difficult problem. Obviously they, too, belong on the predella. Cordenons, Band, and Planiscig had correlated them with the columns and pilasters of the superstructure in such a way that each panel marked the position of one of these supports. As a result, they allotted four angels each to the long sides of the predella, and two each to the flanks. This distribution, however, is not very satisfactory, as we have pointed out in our critique of Band. While the angels undoubtedly did mark the bases of the eight supports in some fashion, this function was not theirs alone; Michiel clearly suggests that the symbols of the evangelists had the same purpose. We should keep in mind, moreover, that the angels and evangelists are classed together in the account books of the Arca. The two groups of reliefs were commissioned in the same contract (April 29, 1447), and their execution was in large measure entrusted to the master's assistants, who were parties to this agreement, while the miracle panels and the statues demanded a separate contract with Donatello alone (June 23, 1447). This certainly indicates that both the angels and the evangelists were regarded as lesser pieces, essentially decorative in character. Another complicating factor is the curious circumstance that only ten angels were ordered originally. Of the other two panels we only learn two years later (June 23,

1449), when Donatello received payment for them and for the Dead Christ. Is it possible to identify these latecomers? The question has attracted little attention so far. Schubring (*Urbano da Cortona*, Strasbourg, 1903, p. 63, and *KdK*, p. xlv) claims that they are the two *diaulos* players, on the ground that this is the only instrument in the group not derived from Psalm 150; and Band (p. 323) suggests that they might be the ones holding a harp and a tambourine, since these are the only panels with plastic garlands in the background. There is, however, a much more obvious way of tracking down our quarry. The fact that the two panels were paid for together with the Dead Christ permits us to assume a close connection between these three reliefs; they were the only bronzes added to the altar after the "dress rehearsal" of mid-1448, and Donatello appears to have worked on them simultaneously. This relationship is confirmed by the unusual measurements of the Dead Christ. Donatello would in all probability have preferred to make it a square of the size of the evangelist panels, but was unable to do so because he had to fit it into a space no more than 56 cm wide. Under the circumstances, we might expect him to have chosen a height of either 56 cm (to match its width), 60 cm (to match the height of the evangelists), or 57 cm (to match that of the miracles). Instead, he made it 58 cm, the exact height of the angel panels. Furthermore, as pointed out by Boito (*L'altare*, p. 21), the frames of the angels and of the Dead Christ show the same ornamental pattern, which is distinctly different from those employed in the other panels. All this can only mean that the three bronze reliefs of 1449 were intended to form a unit, with the two angel panels flanking the Dead Christ. Now it is certainly true that, as a group, these winged musicians are far too gay to accompany so solemn a theme. Among the twelve panels, we find only two that would be at all suited to such a purpose, i.e., those of the singing angels, differentiated from the others not only by the fact that they contain two figures each but also by their serious, meditative air. These, then, must be the latecomers we have been looking for. One might wonder at this point why Donatello found it necessary to cast them in the role of musicians at all, and why he placed them and the Dead Christ in separate frames instead of uniting them into a single, large relief, with four or six angels grieving for the Savior. The latter question can be answered simply enough: the area which the Dead Christ was intended to fill must have had the width of the central intercolumniation, so that the master needed separate flanking panels in order to mark the position of the columns.

Since he had already created ten angels with musical instruments for a similar purpose, he naturally designed the two additional panels in such a way that they became part of this series, at the same time adapting them to their own particular function as the immediate neighbors of the *Imago Pietatis*. Under these conditions, he could hardly have found a better solution than to fill the two reliefs with singers. It permitted him, first of all, to double the number of angels per panel, and thus to emphasize their privileged role, without disrupting the continuity of the series as a whole; mixed vocal and instrumental ensembles were common enough in the musical practice of the period, and so was the custom of two or more singers using the same part book (which contained several voices). On the other hand, the solemnly chanting foursome was set apart from its companions by the lingering belief that vocal music, because of its traditional association with the Church, held a higher rank than instrumental music.

The foregoing arguments leave little doubt that the singing angels did indeed flank the Dead Christ in the center of the predella.[6] In arriving at this conclusion we have, by an entirely different train of reasoning, fortified our previous thesis that the statues were arranged in 3-1-3 sequence. We have also completed the line-up of reliefs on the front face of the predella, which must have been subdivided into seven sections corresponding to the articulation of the superstructure. While some of these compartments might conceivably have held more than a single panel apiece, there is, for the present at least, no need to speculate on this possibility. The distribution here proposed is not only the most harmonious but has the further virtue of obeying the principle of "Occam's razor," i.e. that entities are not to be multiplied without necessity. Moreover, it accommodates all the statues without difficulty: the seven reliefs have a combined length of 4.62 m, which implies a predella of c. 5.25 m to 5.50 m, since we have to assume that the reliefs were framed by stone moldings. For the back of the predella we may postulate the same arrangement, except that the place of the Dead Christ was taken by the iron grating mentioned in the account books (June 23, 1449). The two angel panels flanking it were probably those with the plastic garlands (harp and tambourine).

Our only remaining task now is to find appropriate locations for the other eight angels. Here the documents offer no further clues, so that we shall have to depend on internal evidence entirely. Do the poses or instruments of the eight musicians suggest a grouping of some sort, or must we look upon each panel as a

[6] In Planiscig's reconstruction, oddly enough, one of the flanking panels in this group is the lute-playing angel, even though the author hints (p. 99) at the possibility of a special connection between the two pairs of singers and the Dead Savior.

self-sufficient entity? Schubring (see below, p. 182) had attempted to establish the sequence of the original ten angels on the basis of Psalm 150, which he regarded as the source for the entire set, but this theory rests on a series of false analogies between the instruments mentioned in the Vulgate and those chosen by Donatello: a *tuba* cannot be represented as a flute, a *psalterium* is not identical with a harp, nor a *cithara* with a lute. For the *organum* even Schubring could not find a counterpart among our reliefs, and the *tympanum* he was able to locate only by mistaking one of the two tambourines for a drum. If we take the Cantoria of Luca della Robbia, which is inscribed with the words of the same Psalm, as our standard of comparison, it turns out that Donatello has represented only three of the nine modes of praising the Lord as illustrated by Luca in accordance with the text: *chorda* (harp, lute, rebec), *cymbali benesonantes* (tambourines), and *cymbali jubilationis* (cymbals). We should like to propose a simpler and less problematic way of classifying the instruments in our eight panels. Half of them—the lute, the rebec, and the two flutes—are "modern" and "consonant," i.e., they are instruments of mediaeval origin designed for the playing of tunes and harmonies. The rest—cymbals, tambourine, and *diaulos*—are "ancient" and "dissonant"; they were invented long before the others, and their purpose, at least in the eyes of Donatello, was to produce dancing rhythms rather than musical sound patterns. Significantly enough, all three of them are to be found among the instruments that accompany the wild "Bacchanalian" dance of the angels on Donatello's Cantoria, while the other instruments are not (see Pls. 49a, c, d, 51d). Our eight panels, then, fall into two definite categories. That this was indeed the master's intention may be seen from the fact that one of the instruments occurs twice in either group. The two flutists, so obviously conceived as companion pieces that they are almost mirror images of each other, turn towards a common center; they must have flanked the lutenist and the fiddler. Their counterparts in the other ensemble, the pair of *diaulos* players, show a lesser degree of symmetry: one is raised on tiptoe, the other twists in a quick dancing movement. Yet they, too, were surely intended to face towards each other, with the cymbaleer and the tambourine player between them. The existence of two such cohesive groups suggests that the members of each foursome were meant to be placed fairly close together, so that they could be seen as distinct musical teams. For this reason it is difficult to imagine them tucked away among the larger panels on the long sides of the predella. We should prefer, instead, to place them on the two short sides, which so far have remained without sculptural *décor* of any kind in our scheme. Such an arrangement

is supported also by another consideration: The four pilasters at the corners of the altar must have been of sturdy size, since their bases were marked by the evangelist panels on the front and back of the predella. Their shape is defined by the term *quare* ($=$ *quadre*) in the account books (February 12, 1449), but this does not necessarily mean that they were square, for *quadro* may be used to designate a rectangle as well. In fact, the latter alternative seems far more plausible, since the predella itself was of rectangular shape. Thus, if the *risalti* beneath the pilasters on the main faces of the predella were wide enough to hold the evangelists, we may assume that the corresponding projections on the flanks provided a somewhat narrower field—perhaps c. 60 x 40 cm instead of c. 60 x 60 cm—for relief decoration. These areas, whatever their exact dimensions, must have been a good deal wider than the extraordinarily slender angel panels (21 cm), but they could well have accommodated the angels in pairs. We even have a clue for determining which of our two foursomes ought to be placed on the south face of the predella and which on the north. The contrasting types of musical instruments that distinguish the one from the other can be found again in the two angels with plastic garlands to whom we have assigned the positions on either side of the iron grating; the harp clearly belongs to the "concert" ensemble, the tambourine to the "Bacchanalian" group. Now the harpist turns towards the right, which means that we must put him to the left of the grating. The logical place for his musical confreres, therefore, would seem to be the flank nearest to him, i.e., the southern one, leaving the opposite side for the rest of the panels.

There is, of course, no assurance that Donatello planned to distribute the ten original angels in exactly this manner as early as 1447. Had he intended to mount eight of them in pairs from the very start, he might have combined them into four double panels instead of enclosing each figure in a separate frame. Perhaps he chose the latter alternative because in the beginning he was not yet entirely sure of their ultimate destination, in which case a uniform series of narrow panels would have had the advantage of greater flexibility. We know, after all, that the design of the altar underwent some changes in detail after the provisional installation of 1448, even though the location of the major reliefs and of the statues probably remained fixed throughout. It is possible, for instance, that the two angels with plastic garlands were originally earmarked for the positions later assigned to the singing angels, and that their purpose was to flank the coat of arms of Francesco Tergola, which had to be placed on the altar according to the terms of the donation (doc. April 13, 1446). The decision to prepare a niche for the Sacrament in the back of the predella does

not seem to have been made until after 1448. In order to comply with it, Donatello added the iron grating, the eleventh and twelfth angel panels, and the Dead Christ (all of these appear together in the same account book entry on June 23, 1449), simultaneously shifting the angels with the plastic garlands to the back of the altar and relegating the coat of arms to some less conspicuous spot (e.g., the flanks of the predella). Such a sequence of events would also help to explain how the altar came to be provided with both an *Imago Pietatis* and an *Entombment*. This near duplication could not have been part of the original scheme, but the *Entombment* undoubtedly was. (Why else should Donatello have placed the Fall of Man on the back of the Madonna's throne?) The stone slab for it was prepared early in 1449 (doc. February 22), as soon as the eight *colonne* were completed, and Donatello finished the carving two months later (doc. April 26). About this time, we may assume, the Arca del Santo decided that the Sacrament was to be kept inside the predella. As a consequence, it became desirable to introduce a reference to the Passion of Christ on the front of the altar too. Donatello, or his ecclesiastical patrons, chose the mystic-devotional *Imago Pietatis* because they were familiar with it from the Eucharistic wall tabernacles of the Venetian area, so that they associated it specifically with the keeping of the Sacrament (cf. the early fifteenth century wall tabernacle from Feltre reproduced in Guidaldi, p. 244). When Michiel saw the altar some seventy years later, he could no longer be expected to understand this particular significance of the *Imago Pietatis*; puzzled at finding two representations of the Dead Christ—or rather, three, if we count the *sportello*—he recorded only the "dead Christ . . . behind the altar," clearly the most important of the lot. The angel panels escaped his attention, we believe, for the simple reason that most of them were mounted on the inconspicuous small sides of the predella.

Surveying our reconstruction of the altar as a whole, we cannot but admit that it leaves a great many questions of detail open to doubt, even if its salient new features appear to be well anchored. The area where, on the basis of present-day knowledge, no conjecture is possible, includes all the rich ornamentation of the superstructure, the *mensa*, and the steps, reflected in the documentary references to colored marble, alabaster, bronze moldings, gilt cornices, and glazed tiles (January 1 to June 26, 1449). Some notion of its sumptuous and diverse character may be gained from the framework of the S. Croce Annunciation, which forms its only analogue among the master's other works, but the very unpredictability of this decorative scheme prevents us from attempting to

transfer any of its details to the corresponding places on the Padua Altar. The exact proportions of the architectural framework must remain equally subject to question; the measurements of the *chua*, of the eight supports, of the intercolumniations, and of the predella are known only to the extent that they are determined by the dimensions of the sculpture. Thus our drawing can offer no more than an abstract diagram of the structure. The full, sensuous reality of the original design is lost beyond recapture.

Nevertheless, our reconstruction may help to clarify the historic position of Donatello's design within the development of the *Sacra conversazione* altar, a type which it represents in uniquely majestic and monumental form. That its antecedents, as well as its successors, are to be found in painting rather than in sculpture, has been acknowledged by every student of the problem. Kauffmann (pp. 118ff), elaborating upon the implications of his own reconstruction, regarded the Padua Altar as a descendant of the unified Madonna-and-Saints panels introduced into the Florentine Quattrocento tradition by Fra Angelico and eventually translated into relief sculpture by Andrea della Robbia. He recognized only the Pizzolo Altar in the Eremitani Chapel as an echo of Donatello's scheme, which he looked upon as fundamentally different from the "illusionized triptych" of the S. Zeno Altar, the source of all subsequent Venetian *Sacre conversazioni*. This view of the Padua Altar as a retardataire type, which had to remain without issue because it was a Tuscan exile on Venetian, i.e., artistically foreign, soil, is tailored to fit Kauffmann's "mediaeval" interpretation of Donatello, needless to say. Von Hadeln (*loc.cit.*) had emphasized the influence of Donatello's design on the S. Zeno Altar, but the huge architectural framework of his reconstruction, which dwarfed and isolated the sculptural parts, made it difficult for him to define this relationship more exactly. He was unable, moreover, to point out any precedents from which such a structure might have been derived. Band, too, regarded the Donatello altar as a curiously anomalous affair. Having committed himself to the 1-5-1 sequence of statues, he could cite its resemblance to the S. Zeno Altar only in very general terms; nor did he attempt to explain the genesis of Donatello's design on the basis of earlier monuments. Here our own reconstruction offers at least the possibility of a more balanced perspective. The grouping of the statues in 3-1-3 sequence establishes a new and more specific connection with the S. Zeno Altar, since Mantegna likewise reserves the central intercolumniation for the Madonna and Child alone. Even the strange aloofness of Donatello's Virgin finds an echo in the later work: of the eight saints in the wings, only one actually looks at the Madonna, the others are

either reading, conversing with their neighbors, or glancing at the beholder. The composition of the Pizzolo Altar approaches that of the Florentine *Sacra conversazione* panels much more closely, but it can hardly be coincidence that here again the Madonna is set apart from the other figures by the tall back of the throne, with its flanking pilasters.

Our grouping of the statues also enables us to link the design of the Padua High Altar with Donatello's Florentine experiences before 1443. The unified Madonna-and-Saints groups cited by Kauffmann are of little relevance in this context; Donatello's main problem, after all, was how to integrate such a group with an architectural framework, and to do so in terms of the continuous, rational space concept of the Early Renaissance rather than by the mediaeval device of multiple compartments. Among the Florentine altars antedating the middle of the fifteenth century, we encounter only one attempt to accomplish this difficult task: the *Sacra conversazione* by Domenico Veneziano from S. Lucia de'Magnoli (now in the Uffizi). Its dominant compositional feature, a loggia of three groined vaults supported by eight slender columns, is obviously intended to achieve the monumental effect of a triptych without sacrificing the unity of perspective space. The Madonna occupies the central opening, while the two pairs of saints are placed on a slightly lower level in front of the lateral arches. Behind the loggia there rises a separate architectural backdrop of extraordinary shape; it might be described as a polygonal niche formed by a high wall, with small apses set in the three main faces and flanked by vaulted compartments of the same height. Beyond it we see the tops of three trees against the open sky. Could this daring and imaginative scheme have served as Donatello's source of inspiration? The loggia itself, and the grouping of the figures in relation to it, certainly suggest that such was the case, but an even stronger argument in favor of our thesis is provided by the peculiar backdrop of the scene. If we equate the loggia with the framework of the Padua Altar, then the arched polygonal niche assumes a role strikingly similar to that of the ambulatory arcade of the Santo, which formed the background of Donatello's structure. It must have been this feature that made our master recall the Domenico Veneziano panel when he first studied the setting of his own newly commissioned altar.

Unfortunately, no exact date can be assigned to the S. Lucia altarpiece. The only *terminus post quem* is

Domenico's famous letter to Piero de'Medici of 1438, and there appears to be general agreement among scholars that it must be placed in the 1440's, preferably in the middle or late years of the decade. We need feel no hesitation, however, in postulating a somewhat earlier date for the panel. The youthful development of Domenico, hitherto almost entirely unknown, has recently been illuminated by John Pope-Hennessy (*Burl. Mag.*, XCIII, 1951, pp. 216ff), who attributes the predella and some of the foreground figures of Fra Angelico's Coronation of the Virgin in the Louvre to the younger artist. On the basis of this important discovery, Pope-Hennessy concludes that "before 1440 [Domenico Veneziano] has already evolved a style similar in all essentials to that of the Santa Lucia painting" and that the latter, therefore, should be dated 1442.[7] There is good reason to assume, then, that the S. Lucia Altar was completed, or at least near completion, before Donatello left for Padua in 1443. Apparently he remembered it well, as the most exciting event in Florentine art at the time of his departure, when he had to face a similar task three years later.

Thus the Santo Altar forms the central link in a chain of architecturally framed *Sacre conversazioni* that reaches from Domenico Veneziano to Mantegna's S. Zeno Altar and to the Frari triptych of Giovanni Bellini. Its historic importance, we may rest assured, is fully commensurate with its greatness as a work of art.

THE SCULPTURE

The available documents permit us to date the sculptural parts of the altar with considerable exactitude. The earliest pieces to be cast, somewhat surprisingly, are the ten angel panels (i.e. those containing only one angel); they were cast in April 1447, and we may safely assume that they had been modeled during the previous two months. Then follow the four symbols of the evangelists, which were cast in May, and three of the miracles of St. Anthony (the Ass of Rimini, the Speaking Babe, and the Irascible Son), one of which was cast by May 10 while the other two were cast a few weeks later. The fourth miracle (the Heart of the Miser) was modeled in July and cast in August. Meanwhile, two of the statues, the SS. Francis and Louis, had been modeled; they were ready for casting on June 23. About the other five statues our information is less precise. They had all been cast by the end of May 1448, which leads us to assume that they were modeled late in 1447 and during the early months of 1448, or six to nine months after the first two figures.

[7] This is in no way incompatible with the earlier observation of Pudelko (*Mitteilungen Kunsthist. Inst. Florenz*, IV, 1934, pp. 45ff) that the Miracle of St. Zenobius in the Fitzwilliam Museum, Cambridge, one of the predella panels of the S. Lucia altarpiece, shows the influence of Ghiberti's *Arca*

di San Zanobi, completed in 1442. The relief of the same subject was probably modeled between 1439 and 1441, and Domenico could easily have seen it in Ghiberti's shop before the public emplacement of the *Arca*.

The Madonna appears to have been the last of the series; on May 25 she was carried directly from the foundry to the church (after the other statues and the reliefs, we may assume, had already been installed on the temporary altar in preparation for St. Anthony's Day, then only two and a half weeks away). The remaining bronze pieces, the Dead Christ and the flanking pairs of singing angels, were done during the first half of 1449 (the latter half of 1448 was presumably taken up by the chasing and "adorning" of the four miracles, a task Donatello had completed by the end of January 1449), as was the stone Entombment with its four flanking panels, and the God the Father.

For the short span of two and a half years—1447 to mid-1449—all this represents a truly astounding output. Bandinelli is quite right, in principle, when he states that Donatello could never have done this much without the aid of assistants. It is perhaps understandable, therefore, that older Donatello scholars should have attached great importance to the task of separating the master's own contribution from those of the various lesser men named in the records. Such efforts, which more recent students of the subject have been wise enough to abandon, are largely doomed to futility for a number of reasons; they have produced little besides some classic instances of connoisseurship-at-any-price, reflecting the utter inadequacy of the photographs hitherto available (the altar itself can be seen only under conditions that make detailed study practically impossible) and a fine disregard of what can be gleaned from the documents about the actual division of labor in Donatello's workshop. The twelve angel panels are a case in point: Schubring (*KdK*, pp. 102ff) acknowledges the master's own hand only in the two pairs of singing angels; of the other ten reliefs, he gives three to Giovanni da Pisa, two to Urbano da Cortona (whose personality he had tried to reconstruct in a monograph, Strasbourg, 1903), two to Antonio Chellini (with question mark), and one, tentatively, to Francesco del Valente; for the two *diaulos* players he has only question marks, representing assistants of uncertain identity. Now, the price of the angel panels was 12 ducats, or 68 lire 8 soldi, apiece (see the contract of April 29, 1447), and Donatello received the full amount for six panels (four on June 26, 1448, two on June 23, 1449); these six, then, including the two pairs of singing angels, must be substantially by his own hand, not only in the modeling but in the chasing. Another angel was "cast by his hand" but chased by Antonio Chellini (cf. the payment of December 19, 1447). The remaining five angels were modeled and chased by Donatello's four "disciples" and Nicolò Pizzolo, as evidenced by the accounting of September 1447: at that time Giovanni da Pisa, Antonio Chellini, Urbano da Cortona, and Francesco del Valente had each been paid a total of 159 lire 12 soldi, or 28 ducats, for "an angel and an evangelist" (i.e. 12 ducats for the one and 16 for the other, in accordance with the contract), while Nicolò Pizzolo had received 68 lire 8 soldi, or exactly 12 ducats; the purpose of the latter payment is not stated, but from the context it seems more than likely that it was for an angel panel (the previous payments to the same five artists in June 1447 are subsumed in the totals of the September accounting). On the basis of the documents, then, we should expect five of the original ten angels to show five distinct individual styles, each of them different from the comparatively homogeneous group of seven panels modeled by Donatello himself. Moreover, four of the five "subcontracted" angels ought to match the symbols of the evangelists; the fifth angel would thus be identifiable as the work of Nicolò Pizzolo. In practice, however, such a five-to-seven division is impossible to establish with any degree of finality (Kauffmann, *D.*, p. 236, n. 407, approximates it by distributing five of the angel panels among the four "Evangelist Masters"). Even if it could be done, we still would not know which angel-plus-evangelist was the work of which of the four masters named in the documents. The difficulty we meet here seems to be twofold: on the one hand, the work of the five "subcontractors" is less distinctive than we might hope; on the other, Donatello apparently made use of assistants in the chasing, perhaps even in the modeling, of the panels that ought to be entirely his according to the records. How else are we to explain the surprisingly uniform level of quality in the twelve angel panels as a whole? There are, to be sure, variations in both style and execution, but their range is not very great and they are, as it were, evenly distributed throughout the series. Thus we cannot find a single panel that deserves to be acclaimed unhesitatingly as by Donatello's own hand from start to finish, yet all of them are his in conception. He must have sketched out every panel, in accordance with his plan for the whole altar, and then left the execution largely to members of his shop. The "subcontracting" of five of the panels, we suspect, does not indicate a basic difference in working procedure; it merely reflects the higher standing of the "disciples" (and of Nicolò Pizzolo, who might be called an "associate") as against the *garzoni* and *lavoranti*. They were entitled to be paid directly by the Arca, rather than via Donatello's account, like the *garzoni*.

What is true of the angel panels applies *a fortiori* to the symbols of the evangelists—splendid creatures directly descended from the evangelist *tondi* of the Old Sacristy (see above, p. 135), where Donatello had developed the concept of the symbols as "animated lec-

terns."[8] The individual styles of the four "disciples" seem even more completely submerged here than in the angels. They surely merit the high praise bestowed upon them by Reymond (*Sc. Fl.*, II, p. 131) in opposition to Tschudi (*D.*, pp. 25f), who had deprecated them as shop pieces and had assigned the St. John and St. Matthew panels (plus several of the angels) to Antonio Chellini. Semrau (*D.*, pp. 81ff) had gone further still; he insisted, on the basis of entirely nebulous criteria, on crediting the St. Matthew symbol (plus two angels) to Giovanni da Pisa, the St. Luke symbol (plus one angel) to Urbano, the St. Mark symbol (plus two angels) to Antonio Chellini, and the St. John symbol (plus one angel) to Francesco del Valente. This scheme has deservedly remained without partisans among later scholars. Even Schubring (*KdK*, p. 199) regarded the evangelist symbols as in the main by Donatello himself, although he suggested that Giovanni da Pisa might have helped to execute the panel devoted to the evangelist who bore his name (!). Wilhelm Bode (*Denkmäler der Renaissance-Skulptur Toscanas*, Munich, 1892-1905, p. 35) likewise singled out Giovanni da Pisa as the only creative talent among Donatello's Paduan assistants and attributed to him not only the St. John symbol but the Dead Christ and the singing angels facing right. The arbitrariness of all these views need hardly be pointed out.

The seven statues, harder to see properly in their present setting than any of the reliefs, have until recent times fared worst of all at the hands of Donatello scholars. The literature of fifty years ago bristles with contradictory estimates of them. Tschudi (*loc.cit.*) neglects them entirely, as does Semper (*D.* '87, pp. 87f), except for the statement, based on Gonzati (see above, p. 176), that the two Bishops were intended to flank the bronze Crucifix above the central arch of the choir screen, rather than for the altar. The latter misconception was corrected by Semrau (*D.*, pp. 95f, note), who had read Gonzati with greater care. However, Semrau pronounced all the statues mediocre school pieces, singling out the Madonna for special criticism as "a most clumsy work" done in part by Urbano da Cortona; the best of the lot, according to him, are the two Bishops, which he attributes in their entirety to Niccolò Baroncelli (Ludwig Goldscheider, *Donatello*, London, 1941, still echoes this curious opinion). Boito, too, felt apologetic about the Madonna (*L'altare*, p. 20); it bears, he said, "obvi-

ous and unpleasant traces" of the great haste with which it was cast just before the erection of the temporary altar in May 1448. Bode, on the other hand, attributed its "empty expression" to overly elaborate chasing. In those years Reymond (*Sc. Fl.*, II, p. 133) was the only one perceptive enough to observe that the Madonna "recaptures the style of the great masters of the Middle Ages." His opinion could not sway Schottmüller, who again called the Madonna, along with the St. Justina, the weakest figures of the group (*D.*, pp. 68, 101). All of them, she claimed, were executed by assistants, though designed by Donatello; the St. Francis shows the greatest share of the master's own handiwork. Cruttwell (*D.*, p. 106) held similar views: she, too, regarded the two female figures as the feeblest and stressed the predominance of the workshop in the other statues. Only the SS. Louis and Daniel, she insisted, are by Donatello, in contrast to the "crabbed figures" of the other three male saints. Schubring (*KdK*, p. xliv and *HB*, p. 53) preferred to follow Semrau, but for the opposite reason; to him the two Bishops seemed weaker than the rest of the statues, hence he regarded them as later additions to the ensemble, possibly by Baroncelli, notwithstanding the fact that the St. Louis is mentioned in the documents as ready to be cast in June 1447.[9] More recent scholars—Colasanti, Kauffmann, Planiscig—have had no qualms about accepting all seven statues as Donatello's own work in every important respect. That indeed is what the documents would lead us to assume, and the visual evidence, it seems to me, fully confirms the written record. Kauffmann (*D.*, p. 124) wisely emphasizes that these figures are not meant to be seen individually but together; it is this "group character" that accounts for their unaccustomed quiescence, the emphasis on continuity of outline rather than on bold articulation, the lyric subtlety of gesture and expression—qualities which an earlier generation had misread as a lack of artistic power. Such differences as there are among the statues are due almost entirely to their varying degree of surface finish. A detailed inspection of them from this point of view may be instructive. Let us first recall the constant emphasis in the contracts on the cleaning and chasing of the raw casts of all the bronze pieces; Donatello and his coworkers had to obligate themselves to finish the surfaces to the point where they would be acceptable to goldsmiths. This "old-fashioned" standard of meticulous craftsmanship is complied with in

[8] Hence I find it difficult to accept the meaning imputed by Kauffmann (*D.*, p. 131) to the phrase *ut pinguntur* in the contract of April 29, 1447; it is not a reference to "specific North Italian models" that had to be followed—after all, the four panels were ready for casting by then—but should be read together with the preceding words, which define the subject of the reliefs as "the evangelists in the shape of

animals, as [customarily] depicted."

[9] Schubring also introduced some minor bits of misinformation by claiming that the St. Francis lacks the stigmata (cf. Pl. 78b) and by referring to the St. Daniel as the Prophet Daniel without, however, trying to explain why an Old Testament figure should be shown in the vestments of a deacon.

all the reliefs, and the records show that they were officially accepted as finished and paid for according to the terms of the contracts. Characteristically enough, however, we do not have a single entry explicitly referring to any of the statues as finished and paid for. They were, so to speak, never stricken from the account books. And the reason why they were not becomes evident as soon as we measure them by the same technical standard of surface treatment that we find in the reliefs: only two of them are actually "finished" in that sense—the SS. Francis and Louis, the earliest of the lot. Here alone every square inch of surface is fully controlled, here alone the elaborate ornamental detail and the differentiation of textures has been completed by engraving, chasing, and hammering. That Donatello did not carry out this technical labor all by himself must be taken for granted; there is, in fact, some evidence of "over-finishing" in the face of the St. Louis, which looks curiously expressionless in the frontal view because of the rather mechanical smoothing and polishing; only the profile reveals the impressive qualities of human character we would expect to find here. In contrast, the other five statues are all technically "unfinished" to some extent, although none of them can be described as a raw cast. Even in the St. Daniel, who comes closest to that state (as noted by Bertaux, *D.,* p. 157), the rough edges and protuberances have been chiseled off, holes repaired (note the plug in the chin), and skin surfaces smoothed, although his garment does not yet have the characteristic texture that appears in the other figures. The St. Anthony, of the same broad-featured, somewhat rustic type we encounter in the four miracle panels, shows consistent chasing except in the face and hands, which have been gone over only in the most cursory fashion. With the SS. Justina and Prosdocimus, the ornamental detail of the crown and miter has not yet been carried out. The Madonna is further advanced in this respect; her garments, her crown, and the elaborate decoration of the throne have been carefully finished, but some of the most important areas have not, such as her hair, the heads, hands, and feet of the Adam and Eve on the back of throne (in contrast to their bodies), and especially the Christ Child, whose left eye and right hand are badly mutilated. One cannot escape the impression that Donatello employed a number of chasing specialists to whom he entrusted the less critical portions of each statue while reserving for himself the hands and (except for the St. Louis, it seems) the faces. To finish

even these limited areas may have seemed a form of drudgery to him; in any event, he fell behind with his share of the work. The documents indicate that the architectural framework of the altar was practically complete by mid-1449, while the statues remained in the master's shop until the very last moment before St. Anthony's Day of 1450. Their removal to the church may well have been carried out against his protests, and his subsequent conflict with the Arca about the money still due him—according to the last account book entry, of July 1450, he had yet to receive almost 300 ducats—probably arose in large measure out of the technical incompleteness of most of the statues.[10] Could the Arca have insisted on penalizing Donatello for his failure to "finish" the statues by St. Anthony's Day 1450, which we may assume was the deadline for completion of the entire project?

Formally and iconographically, the Madonna is surely the most interesting of the seven statues. Her hieratic solemnity, her motionless and timeless grandeur, so thoroughly misunderstood fifty years ago, is now recognized as deriving from a Byzantine Madonna type (cf. Kauffmann, *D.,* pp. 122f).[11] It seems more than doubtful, however, that Donatello chose to follow such a model on his own initiative, and that the specific prototype he had in mind was the "Madonna del Carmine," attributed to Coppo di Marcovaldo, in S. Maria Maggiore, Florence, as suggested by Kauffmann. If the master had developed a sudden interest in Italo-Byzantine art during the later 1440's, we would presumably find further evidence of it elsewhere among the sculptures of the high altar; so far as I know, this is not the case. Moreover, he has thoroughly reinterpreted the Byzantine type according to his own functional view of the human body: the seated figure has become a standing one, and its rigid symmetry has been broken by the differentation between the free and the engaged leg. Is it not more plausible to assume, therefore, that Donatello had been requested by the Arca to conform to an older Madonna image—probably an icon similar to the "Madonna del Carmine"— owned by the Santo? It may even have been attached to the altar which Donatello's was meant to replace. In any event, icons of this sort must have been plentiful in the Venetian area, so that there is no need to fall back on a Florentine specimen. The throne with its sphinxes is clearly inspired by classical furniture, even though it is a free variant that cannot be linked to any one of the many known specimens (such as that in the Museo Archeologico, Florence, cited by Kauffmann,

[10] The term used in the document of 1456, *pro figuris et ornamentis,* does not compel such an interpretation but is certainly compatible with it.

[11] François Gébelin (*Donatello,* Collection Alpina, Paris, 1943) links the Paduan Madonna with ancient images of the seated Cybele and sees her as reflecting the influence of the

Platonic Academy under the leadership of Gemistos Pletho, with its merging of Christian and pagan concepts. This notion, cited with apparent approval by Charles Picard (*Revue archéologique,* 6e sér., xxviii, 1947, pp. 77f) is too fanciful to merit further discussion.

D., p. 235, n. 291; others are in the Glyptothek, Copenhagen, and in the Louvre; cf. Gisela Richter, *Ancient Furniture*, Oxford, 1926, fig. 281). Donatello had used similarly elaborate classical thrones in the evangelist *tondi* of the Old Sacristy in S. Lorenzo; that of the St. Matthew even has a sphinxlike creature for an arm rest. The Madonna's throne is surely meant to characterize the Virgin as the *Sedes Sapientiae* (Kauffmann, *loc.cit.*), and the sphinxes thus refer to the mysteries of Divine wisdom. That this interpretation was known to the Quattrocento is shown by the following passage from the Commentary of Pico della Mirandola on Benivieni's *Canzona d'amore* (ed. E. Garin, Florence, 1942, pp. 580f): "It was the opinion of the ancient theologians that the divine subjects and the secret mysteries must not be rashly divulged. . . . For this reason the Egyptians represented sphinxes in all of their temples, to indicate that divine things, if written at all, must be covered by enigmatic veils and poetic dissimulation. . . ."[12] The Fall of Man on the back of the throne is claimed by Kauffmann (*D.*, p. 236, n. 406) as a North Italian tradition, but without citing any examples. I see no reason to regard this as a regional custom; the earliest precedents appear to belong to the Sienese Trecento (Lippo Vanni, Paolo di Giovanni Fei: Eve reclining before the Madonna's throne), while the Fall of Man in Mantegna's Madonna della Vittoria in the Louvre is clearly derived from Donatello. In our instance, the scene not only serves to characterize the Virgin as *Eva secunda*; it is linked even more strongly with Christ the Redeemer, since it appears directly above the grating behind which the Sacrament was kept and above the large Entombment relief.[13]

In Vasari's day, the most admired parts of the high altar were the four miracles of St. Anthony. They must have been considered especially important from the very start, as suggested by their high price—85 ducats apiece, as against 16 for the symbols of the evangelists and 40 for the statues of saints (60 for the Madonna). In modern scholarly literature, too, these reliefs have attracted far greater attention than all the rest of the high altar sculptures, although here again, until recently, much of the discussion has centered on the exact share to be assigned to the master's assistants and on the chronological sequence of the panels. The latter question would seem to be of small importance in view of the fact that three of the miracles were modeled in the spring of 1447 and the fourth, the Heart of the Miser, was done not more

than two to three months later. Nor do the documents give any indication that Donatello made use of his "disciples" in this instance. Even so, Semrau (*D.*, pp. 102f) thought the Irascible Son markedly inferior to the rest in everything except the main group—he speaks of the "confusing conglomeration of buildings of every sort" in the background and of the "childlike" attempt to represent the sun—and assumed the participation of Bertoldo in the "compiling" of the classical motifs on the left. He also deduced from the "hasty" and "disjointed" character of the setting that this must be the earliest of the four reliefs, followed by the Heart of the Miser, the Ass of Rimini, and the Speaking Babe (which he believed to have been modeled in part by Giovanni da Pisa). Samuel Fechheimer (*Donatello und die Reliefkunst*, Strasbourg, 1904, p. 62) even claimed the Speaking Babe in its entirety for Antonio del Pollaiuolo, a proposal immediately rejected by Schottmüller (*D.*, p. 27, n. 4) and passed over in silence by most authors ever since. Characteristically, neither Semrau nor Fechheimer felt it necessary to explain how Bertoldo or Pollaiuolo could have been entrusted with such important tasks as members of Donatello's workshop in Padua without ever being mentioned in the account books of the Arca, which bristle with the names of men of far lesser importance. Semrau's chronology of the miracles had been worked out before the publication, by Lazzarini, of the contract of June 23, 1447; the chronologies of subsequent scholars, however, are equally arbitrary. Thus Cruttwell (*D.*, pp. 109f) places the Ass of Rimini first and the Speaking Babe last, while Schubring (*KdK*, pp. xlvii, 109ff; *HB*, pp. 53ff) simply reverses the order proposed by Semrau. In none of these schemes does the Heart of the Miser appear at the end, where the documentary evidence puts it. Today the main puzzle is not how to determine which sequence is most nearly correct but how to explain this preoccupation with what seems to us an essentially fruitless question. Part of the answer, we may be sure, lies in the very diversity of the four panels. Each is a work of such individuality, each contains so many elements not present in the others, that one hesitates to regard them as a continuous series, conceived and executed within the brief span of a few months. Still, we must be careful not to underestimate the range of Donatello's inventive power at any given point of his career. Are not the four scenes from the Legend of St. John in the Old Sacristy just as varied among themselves as our miracle panels? Is the contrast between the architectural settings of the

[12] The same meaning does not, however, attach to all sphinx thrones in Early Renaissance art; the sphinxes may also stand for stupidity, in accordance with the view of Dio Chrysostom, *Tenth Discourse*, xxxii, or for vicious paganism, as do those on the throne of Herod in Matteo di Giovanni's Massacre of the

Innocents in S. Agostino, Siena.

[13] Schottmüller (*D.*, p. 88) assumes that Donatello was influenced by Jacopo della Quercia's Fall of Man panel at S. Petronio. So far as I can determine, there is no connection between the two designs.

Raising of Drusiana and the Apotheosis of St. John any less great than that between the background of the Irascible Son and the Ass of Rimini? The Irascible Son, to be sure, is unique among the four reliefs in that it alone has the kind of sweeping perspective view familiar from the St. John *tondi*, with the figures distributed throughout the deep "arena" in which the scene is placed (Schubring, *loc.cit.*, defines it more precisely as a *teatro di pallone*, an elongated court for a ball game), while in the other panels the figure composition is confined to a fairly narrow foreground zone. But is that sufficient reason to date the Irascible Son earlier than the rest (as does Kauffmann, *D.*, pp. 125ff)? The Heart of the Miser, the last of the series, also has a setting of great complexity and considerable depth, crammed with fascinating but fantastic detail of the sort we know from the Lille Feast of Herod (note especially the architectural background structures on the right). It, too, is an outdoor scene; the dissection of the miser takes place in the middle of a street leading towards the façade of a church. The porch and doorway on the extreme left are probably meant to represent the house of the miser, whose money chest has been dragged into the street so that the people may witness the discovery of his heart inside the chest, as predicted by St. Anthony.[14] The intricacy of the *mise-en-scène* that links the Irascible Son and the Heart of the Miser is best explained, it seems to me, not by chronological considerations but by the circumstance that these panels were designed for the front of the high altar, where the beholder could approach them closely enough to "read" the details of the perspective background (the horizon of both reliefs is equidistant from the top and bottom of the frame). The Ass of Rimini and the Speaking Babe, in contrast, are meant to be seen from a somewhat greater distance and from below. The horizon here is slightly lower than the bottom of the frame.[15] The compositional scheme, too, is intended to "carry" farther: the architectural framework defines the stage-like foreground space, divided into three compartments, and on this stage of clearly limited depth the figures move as in a frieze, parallel to the plane of the relief. What all four panels have in common, however, is the dynamic intensity of the surging crowds, so utterly different from the sparse narrative of earlier miracle scenes. (For the traditional iconography of

the same subjects, cf. George Kaftal, *Iconography of the Saints in Tuscan Painting*, Florence, 1952, pp. 78ff and the bibliography cited there.) The central event of each scene is presented in calm, matter-of-fact fashion; the Saint acts with simple directness, shunning all dramatic flourishes, whether he displays the Sacred Host to the worshipful animal, receives the babe from the arms of its mother, or directs the opening up of the rich man's cadaver (the latter scene suggests a dissection before the medical faculty at Padua University, where Vesalius was to teach a century later while preparing his *De humani corporis fabrica*). Only the irascible son, who has cut off his own foot in remorse for kicking his mother (probably the mourning woman in the lower left-hand corner, as pointed out by Schubring, *KdK*, p. xlviii), has been given an agitated pose.[16] It is the electrifying impact of these miracles on the populace that has been Donatello's first concern. The sheer number of figures is unprecedented, even in his own earlier works: there are about 35 in the Speaking Babe, about 45 in the Ass of Rimini, and more than 70 each in the other two panels. Our master has, of course, drawn upon his previous experience with similar subjects; the spectators fleeing from the scene towards the right in the Speaking Babe and the Heart of the Miser have their counterpart in the Siena Feast of Herod, the frantic gestures are anticipated to some extent in the St. John *tondi* in the Old Sacristy, and the massed grouping of figures recalls the composition of the London Delivery of the Keys (which, however, is essentially static, as against the passionate movement of the Paduan crowds). But none of this really prepares us for the fluid, wavelike rhythm that binds together the agitated spectators in the St. Anthony panels. To attribute it to the influence of a specifically Paduan *genius loci*, as various authors have done (Semrau, *loc.cit.*; Schubring, *KdK*, p. xlvif; Kauffmann, *D.*, pp. 125ff; Middeldorf, *AB*, p. 574), is hardly sufficient. That Donatello was aware of his North Italian environment can be seen from his use of local costumes; he may also have been impressed with the colorful crowds in the frescoes of Altichiero and Avanzo in the Cappella Belludi and the Oratorio di S. Giorgio. Yet neither there nor in the sketchbooks of Jacopo Bellini or the frescoes of Pisanello do we find the tension, the dramatic sweep of our miracles,

[14] Behind it are two inscriptions which Gonzati (*op.cit.*, p. 149) interpreted as referring to the names of Donatello's assistants (similarly Cornel v. Fabriczy, *Repertorium f. Kw.*, XII, 1889, pp. 103f), even though their form is that of funeral tablets (cf. Semrau, *loc.cit.*, who also points out that the setting of the scene is not the narthex of a church, as previously suggested).

[15] Semrau, *loc.cit.*, regards this as due to the influence of Squarcione, from whom Mantegna a few years later took over the same device—an entirely implausible assumption in view

of the fact that such worm's-eye perspectives had been explored in Florence long before; cf. the Masaccio Trinity fresco and Donatello's London Delivery of the Keys.

[16] Its source, discovered by Fritz Saxl, is an ancient Pentheus torn limb from limb by the maenads (*Bericht über den XII. Kongress der Deutschen Gesellschaft f. Psychologie in Hamburg*, ed. Gustav Kafka, Jena, 1932, p. 20); Donatello has reversed the direction of the act, since the Saint is re-attaching the severed foot.

and it is this quality, rather than the episodic detail, that gives them their distinctive flavor. Nor can the new sense of continuity in Donatello's narrative art be accounted for in terms of the classical influence, whether we think of the Column of Trajan (Semrau, Kauffmann) or of the plentiful borrowings of individual motifs from sarcophagi (noted in detail by Kauffmann, *D.*, p. 235, n. 399). Entirely unverifiable is Kauffmann's reference to the great Franciscan preachers of the time, especially St. Bernardino of Siena, whose impact on the masses Donatello may have studied. Without denying the relevance of any of these partial explanations, we still marvel at the revolutionary compositional principles of the St. Anthony panels. What has happened here seems so utterly beyond the ordinary scope of the Quattrocento, so prophetic of the High Renaissance, that it can be described only as a "mutation," no less mysterious in origin than the St. Mark at Or San Michele or the St. George relief and equally incalculable in its consequences. The influence of these compositions on the Cinquecento, directly and indirectly, has indeed been fundamental (cf. Semrau, *D.*, p. 104, n. 1; Schott-müller, *D.*, p. 48; Schubring, *KdK*, pp. xlviif). What Wilhelm Vöge (*Raphael und Donatello*, Strasbourg, 1896) had to say about their reflection in the *Stanze*, although incorrect in detail remains true in principle:

[17] Several authors, misled by the ugly layer of brown paint covering the figures, have mistaken the material for terracotta

the Miracles of St. Anthony are the ultimate progenitors of the Mass of Bolsena, the Expulsion of Heliodorus, and the Fire in the Borgo.

The limestone Entombment, carved early in 1449, is the only piece of sculpture on the high altar that has always been acknowledged as entirely by Donatello's own hand.[17] Its style continues that of the most agitated groups in the miracle panels. The influence of Roman Meleager sarcophagi has often been noted (cf. C. Robert, *Die antiken Sarkophag-Reliefs*, Berlin, 1904, III, 2, No. 275, pp. 334ff, with particular reference to the specimen formerly in the Palazzo Montalvo, Florence) and is certainly evident in the violent gestures of the women. Four of them are present, but their raging grief is of such uniformly high pitch that we cannot tell which one is meant to be the Virgin Mary (unless she has actually been omitted, as suggested by Bertaux, *D.*, p. 161—an incredible though not altogether impossible thought). The classical source, however, does not account for the rhythmic interweaving of the figures, which is very different from the Entombment of the St. Peter's Tabernacle. Here again we encounter the new compositional principle of the miracle panels, and again we think of the High Renaissance. How much would Raphael's labor have been eased had he known this composition when he designed the Borghese Entombment!

(as did Semper, *D.* '87, p. 96 and Milanesi, *Cat.*, p. 16) or stucco (Semrau, *D.*, p. 97).

ST. JOHN THE BAPTIST, S. MARIA DEI FRARI, VENICE

PLATE 89 Wood, polychrome; H. 141 cm; W. (at elbow level) 42 cm; D. 27 cm *(1452-1453)*

DOCUMENTS: none (but see below)

SOURCES

1550 Vasari-Ricci, p. 55 (Milanesi, p. 413): "Having thus left Padua, [Donatello] returned to Venice and donated to the chapel of the Florentines in the church of the Friars Minor, as a memento of his generosity, a St. John the Baptist of wood, which he had carved with the greatest of care." (A shortened paraphrase in Borghini, *Riposo*, pp. 320f.)

While the statue itself is undocumented, Donatello is linked indirectly with work in the Frari through some court records of 1450 in the Municipal Archives of Padua (published by Erice Rigoni, *Archivio veneto*, 5. serie, VI, 1929, pp. 133ff, Nos. ix-xi, February 9, April 10 and 11). They relate to a lawsuit of the artist against one Petruzzo, a rag dealer from Florence resident in Padua, who in August 1447 had met Donatello in the Franciscan monastery of Bovolenta near Padua and had asked him to execute a model of wood and wax for a chapel or altar (the term *capella* could

be used for either, as noted by Kauffmann, *D.*, p. 238, n. 452) which a certain confraternity wished to erect in Venice. Donatello had finished the model long ago, but Petruzzo had neither claimed it nor paid for it, and the artist was now suing for the 25 ducats he had been promised, supported by the testimony of two of his assistants who had been present at the meeting with Petruzzo. Rigoni (*op.cit.*, p. 127) infers from the Florentine origin of Petruzzo that the confraternity in question probably was that of the Florentines, which in 1436 had been granted space for a chapel in the

Frari (according to Kauffmann, *D.*, p. 150, it was the first bay of the north aisle, next to the façade), but the thread of evidence here is a slender one indeed: there must have been numerous Florentines, exiled and otherwise, in Padua and Venice, and Petruzzo seems to have been among the less distinguished. That a rag dealer in Padua should have been in a position to approach Donatello as the official representative of the Florentine confraternity in Venice, is quite unlikely. From the circumstances described in the court records one rather has the impression that Petruzzo commissioned the model on speculation, as it were; he may have hoped to peddle it to the confraternity concerned (which need not have been the Florentine one), gaining some sort of profit for himself in the process. Evidently, however, the group he had in mind was either not interested in a *capella* after all or would have nothing to do with him, for the model never left Donatello's hands. (At one point Petruzzo had urged the artist to send it to Venice but Donatello had refused to do so *ne alii magistri . . . eam [formam] viderent*, i.e. he suspected that Petruzzo might want to have the design copied by some local masters without paying him his fee.) It seems, in fact, that the artist did not know for which confraternity the model was intended, otherwise either he or one of his witnesses would have mentioned it by name instead of speaking vaguely of "certain persons" and omitting any reference to the prospective location of the *capella*. And since the entire scheme came to naught, the "Petruzzo case" provides at best, even if we grant Rigoni's conjecture, no more than the most remote hint at a connection between Donatello and the chapel of his compatriots in the Frari.

Regardless of the peculiar episode summarized above, there is no reason to doubt that the St. John was made for the chapel of the Florentines, which must have been dedicated to the Baptist (according to Milanesi, *Cat.*, p. 17, the confraternity was known as the Compagnia di S. Giovanni Batista de'Fiorentini). Apparently the statue remained there until about a century ago, when it had to make way for the Titian monument (Milanesi, *loc.cit.*; the monument was decreed in 1839 and completed in 1852). It then stood for several decades in the second chapel to the left of the choir, where it was seen by Cornel v. Fabriczy (*Jahrbuch Kgl. Preuss. Kunstslgn.*, xxx, 1905, Beiheft, p. 53). Its present location is in the first chapel to the right. In 1947, it was exhibited in the Scuola di S. Rocco as part of the Mostra delle tre Scuole.

The naturalistic and garish polychromy of the statue is certainly no longer the original one (as claimed by Kauffmann, *loc.cit.*); it must have been renewed more than once. The most recent layer covers certain repairs such as the strips of metal attached to the backs of the legs (see Pl. 89a). The index finger of the right hand and the lower two thirds of the scroll are crude restorations. There is also a poorly patched area of damage along the belt. The wrongly latinized name of the artist on the gilt wooden pedestal has no claim to authenticity, even though the figure may at one point have carried a genuine signature of the customary form, OPVS DONATELLI FLOR.; the pedestal itself seems to be of the eighteenth century. Schubring (*KdK*, p. 200) has correctly observed that the right hand, like that of the bronze St. John in Siena, originally held a small reed cross. (Kauffmann, *loc.cit.*, who denies this, fails to note the opening for the stem of the cross between the index and middle fingers and the imprint of the cross on the folds of the mantle directly above; see Pl. 89b.)

Milanesi, *loc.cit.*, lists the St. John among the dated works of Donatello and places it in the year 1451, but without mentioning the documentary evidence on which he may have based this statement. Since 1451 seems plausible enough from the point of view of style as well, subsequent authors have refrained from offering alternative dates. The statue clearly belongs in the interval between 1449, when Donatello made his final sculptural contributions to the Padua High Altar, and the artist's return to Tuscany after November 1453; or, in terms of style, between the Padua Entombment and the Magdalen in the Baptistery of Florence. The latter, however, shows a far closer relationship to the St. John than does the Entombment. I should prefer, therefore, to date our statue at the very end of Donatello's "Paduan decade," in 1452-1453. Vasari may well be substantially correct when he claims that the master carved the St. John after he had left Padua, during a stopover in Venice. While there is no reason to assume that Donatello gave up his Paduan residence before the end of 1453 (in September he mounted the Gattamelata Monument on its pedestal; see above, p. 155), he probably visited Venice more often during that year than before: the arbitration agreement concerning the price of the Gattamelata was negotiated in Venice, and the four arbiters appointed by Donatello were Venetian masters. This, then, was the most opportune time for him to receive and carry out a commission from the Compagnia di S. Giovanni Batista, as against 1450-1452, when he was preoccupied with projects in Mantua, Modena, and Ferrara. By 1453, all of these had been abandoned.[1]

[1] For the documents relating to Donatello and the Arca di S. Anselmo in Mantua see Wilhelmo Braghirolli, *Giornale di erudizione artistica*, ii, Perugia, 1873, pp. 4ff, and G. B. Intra, *Archivio storico lombardo*, 2. serie, iii, 1886, p. 667; for the equestrian monument of Borso d'Este in Modena, see G. Campori, *Gli artisti italiani . . . negli Stati Estensi*, Modena, 1855,

How much work Donatello actually did on the various projects of 1450-1452 is difficult to say. The documents tell us of long drawn-out negotiations, of some preliminary labors, and above all of the artist's extraordinary procrastination. Donatello seems to have accomplished very little indeed during those years. This strangely negative record can hardly be accounted for in terms of external circumstances; Donatello must have passed through some sort of inner crisis, a crisis induced, according to Vasari, by lack of effective criticism: "Even though he was considered a miracle [in Padua] and praised by every intelligent man, he decided to return to Florence, saying that if he had stayed there any longer he would have forgotten all he ever knew, because everyone praised him so much, and that he was glad to return to his homeland, where the people were always criticizing him and thereby made him work harder and accomplish more" (Vasari-Ricci, p. 55; Milanesi, p. 413). Donatello certainly felt embittered about his Paduan experiences; Leonardo Benvoglienti, in a letter from Rome of April 14, 1458, to Cristofano Felici, the head of the Siena Cathedral workshop, quotes him as having said four years earlier that he "would dearly love to come to Siena, so as not to die among those Paduan frogs, which he almost did."[2] His frustration, however, would be quite understandable as a consequence of his wearisome disputes with the Santo, which still owed him money in 1456, and with the heirs of Gattamelata. Vasari's explanation (accepted by Kauffmann, *D.*, p. 108) betrays so strong a prejudice in favor of Florence that it cannot be taken at face value, especially since similar instances of *campanilismo* are far from rare in the *Vite*. Surely neither the state of art nor that of art patronage in northeastern Italy was as hopelessly provincial in the 1450's as Vasari implies. The true nature of Donatello's "crisis of confidence" is more deeply personal, one suspects, and thus hidden from direct view. Only the results are clearly apparent. If we compare the Padua High Altar with the St. John in the Frari, the artistic differences between the two are amazing for so short a span of time. The altar constantly recalls the master's Florentine works of the 1430's, while the St. John has no such precedents; it belongs with the post-Paduan phase of Donatello as exemplified by the Magdalen, the Giovannino Martelli, and the St. John in Siena.[3] Judged by the standard of the artist's previous statues,

the Frari St. John appears disappointingly "retrogressive":[4] Even the statues of the Padua High Altar, subdued as they are, look poised and robust beside this wraithlike figure, with its spidery limbs and desiccated flesh. The physical and spiritual being are no longer in harmony here—the spirit has overpowered the body, so that physical structure and function no longer have their old importance. Yet this "mediaeval" quality is not simply a return to traditional forms. The source of inspiration of the Frari statue is not the Italian Trecento but the St. John type of Byzantine art; we see it reflected in the extreme elongation of the figure as a whole, in the skeletal slimness of the arms and legs, in the gesture, the facial type, and even in the curiously abstract, sharp-angled folds of the cloak. Some years before, Donatello had utilized a Byzantine —or Italo-Byzantine—model for the Madonna of the Padua High Altar, but the two cases are far from analogous; the Virgin and Child has been completely translated into the language of Early Renaissance art (see above, p. 184) while the Frari St. John retains many of the essential qualities of its prototype, so that there is not merely a formal relationship here but an inner sympathy with Byzantine art such as we do not find in the Paduan Madonna. Must this inner sympathy not be interpreted as evidence of a new and intense religious faith? And was it perhaps the struggle for this faith that constituted Donatello's "crisis of the early 1450's"? The conclusion is difficult to escape, for the new attitude revealed by the Frari St. John can be felt in all of the master's subsequent works. Yet, here as well as later, Donatello does not repudiate his own past; his vocabulary remains realistic, and his individual self-awareness is undiminished. Instead of reverting to the supra-personal piety of the Middle Ages, he conveys the metaphysical reality of faith through a deepened insight into the nature of religious experience on the psychological plane. The facial expressions of his late statues mirror a manic state so acutely observed that it almost demands description in terms of modern psychopathology. Only the warmth and power of the artist's human understanding separates these heads from the realm of the clinical. The Frari St. John, where this salient feature appears for the first time, is the earliest "late work" of Donatello and thus holds a place of pivotal importance in the master's development.

pp. 185ff, and Giulio Bertoni and Emilio P. Vicini, *Rassegna d'arte*, v, 1905, pp. 69ff; for Ferrara see Michelangelo Gualandi, *Memorie . . . risguardanti le belle arti*, iv, Bologna, 1843, pp. 35, 137, Corrado Ricci, *L'Arte*, xx, 1917, pp. 40ff, and Arduino Colasanti, *Bolletino d'arte*, xi, 1917, pp. 93ff.

[2] Published in Gaetano Milanesi, *Documenti per la storia dell'arte senese*, ii, Siena, 1854, pp. 299f; Benvoglienti regrets that the *Opera* had not acted upon his proposal to call Donatello to Siena four years ago.

[3] The bronze statuette of the Baptist in the Berlin Museum, cited as the predecessor of our figure by Alfred Gotthold Meyer (*Donatello*, Leipzig, 1903, p. 104) and Planiscig (*D.*, p. 105) has nothing in common with it except the subject; see below, p. 246.

[4] That may be the reason why several critics thought it unworthy of Donatello's own hand and blamed its supposed shortcomings on the aid of assistants; see Tschudi, *D.*, p. 30, Schottmüller, *D.*, p. 68, Venturi, *Storia*, vi, p. 338.

ST. MARY MAGDALEN, BAPTISTERY, FLORENCE

PLATES 90-91 Wood, polychrome; H. 188 cm *(1454-1455)*

DOCUMENTS: none

SOURCES

1510 Albertini, p. 8: "In the Baptistery there is a St. Mary Magdalen by the hand of Donatello. . . ."

(Before 1530) Billi, pp. 32f, *s.v.* "Brunelleschi": "He did a St. Mary Magdalen for the church of S. Spirito, which was destroyed by fire, . . . a most excellent work, beyond comparison with those of Donatello in the Baptistery." (The latter part of the sentence is omitted in the Codice Petrei.)

pp. 40f, *s.v.* "Donatello" (repeated in Cod. Magl., p. 77): "He did the figure of St. Mary Magdalen which is now in the Baptistery."

(c. 1550) Gelli, p. 59: "Donatello did the St. Mary Magdalen which is in the Baptistery, a marvelous work."

1550 Vasari-Ricci, pp. 48f (Milanesi, p. 400, with additions, here indicated by italics): "In the Baptistery, opposite the tomb of Pope Giovanni Coscia, there is a St. Mary Magdalen in Penitence, of wood, by Donatello, very beautiful and well executed. *She is consumed by fasting and abstinence, and every part of her body shows a perfect knowledge of anatomy.*" (A shortened paraphrase in Borghini, *Riposo*, p. 318.)

1591 Bocchi, p. 13 (Cinelli, p. 33): "Among all [the many noteworthy statues in the Baptistery] the outstanding one is a St. Mary Magdalen in Penitence, consumed by abstinence and fasting; she was carved in wood by Donatello, and is so beautifully designed that she resembles nature in every way and seems alive."

The earliest dated reference to the statue is a notice of October 30, 1500, recorded among the *Spogli Strozziani* and published by Karl Frey (*Le Vite . . . di Giorgio Vasari*, I, Munich, 1911, p. 347): "The image of St. Mary Magdalen that used to be in the Baptistery and was then removed and put in the workshop, is being put back in the church." Another document of the same year was published in Giuseppe Richa, *Notizie istoriche delle chiese fiorentine*, V, Florence, 1757, p. xxxiii (reproduced in Semper, *D.* '75, p. 262, n. 119, and Cruttwell, *D.*, p. 53, n. 2); it records a decision of the Arte de'mercatanti to pay the goldsmith Jacopo Sogliani for a *diadema* (= halo?) he had made for the figure of St. Mary Magdalen newly placed in the Baptistery. According to Ferdinando del Migliore (*Firenze . . . illustrata*, Florence, 1684, p. 98) who relied on an older, unnamed source, Charles VIII of France [in 1498] so admired the statue that he tried to buy it at a high price, and the Council considered presenting it to him as a gift. The original

location of the figure in the Baptistery is not known for certain; in 1500 the statue was presumably returned to its old place, i.e. the southwest wall, where Vasari and Del Migliore (*loc.cit.*) saw it.[1] In 1688 the statue was again put in storage and its place given over to the baptismal font.[2] It remained there until 1735, when it was installed against the southeast wall of the church, with a commemorative inscription (reproduced in Semper, *loc.cit.*, and Cruttwell, *D.*, p. 53, n. 3). Finally, about 1912, the Magdalen was returned to its old place against the southwest wall, where it remains to this day.[3] The original polychromy of the figure is hidden under one or more heavy coats of paint which also blur some details of the carving. A careful cleaning, patterned on the procedure that was applied so successfully to the Faenza St. Jerome, is urgently desired.

Semper (*D.* '75, pp. 146, 260, n. 117) believed that Donatello's Magdalen had been made in competition with that of Brunelleschi for S. Spirito (on the basis

[1] Paatz, *Kirchen*, II, p. 263, n. 175, cites Albertini as saying that the marble decoration for the Magdalen had been executed by disciples of Donatello; however, Albertini's remark refers to the Tomb of John XXIII, not to the Magdalen.

[2] Filippo Baldinucci, *Notizie . . .*, III, Florence, 1728, *s.v.* "Donatello," note, states that "today the statue is in the workshop . . . , having been removed in 1688. . . ." See also Paatz, *loc.cit.*

[3] The previous installation is shown in Schubring, *KdK*, p. 137; the bronze halo by Jacopo Sogliani, visible in photographs taken prior to 1912, has since been removed.

of the Libro of Antonio Billi; cf. our discussion of the "competition motif" above, pp. 10f), and thus dated it in the early 1420's. Milanesi (*Cat.*, pp. 9f) thought it contemporary with the Tomb of John XXIII. A similar dating was proposed by Tschudi (*D.*, p. 21) in opposition to Schmarsow (*D.*, p. 48) who had been the first to recognize the statue as post-Paduan. The latter view has since been universally acknowledged. Because of the close kinship of the Magdalen with the Frari St. John (see above, p. 188), the date usually given for it is about 1455 (thus also Kauffmann, *D.*, p. 152). Planiscig (*D.*, pp. 107f) has pointed out that the figure must have been carved very soon after Donatello's return to Florence, because its influence is clearly reflected in the wooden Magdalen by an unknown master in the Museum at Empoli, which bears the name of the donor and the date 1455.[4] This *terminus ante* disproves the contention of Bertaux (*D.*, p. 173) and Paatz (*op.cit.*, p. 206) that our statue must be placed after the Siena St. John, or about 1460.

The date of the statue, then, is well established by stylistic evidence. Nor has its execution by the master's own hand ever been questioned.[5] Only Donatello himself could have created a work of such shocking impact; the Magdalen has been both praised and damned—sometimes, paradoxically, in the same breath —but never treated with indifference (cf. the negative opinions cited in Reymond, *Sc. Fl.*, ɪɪ, p. 153n; Cruttwell, *D.*, p. 52, calls the statue "repulsive in its ugliness" and marvels at its popularity, even though she grants its expressive power). Here all the qualities

that distinguish the Frari St. John so sharply from the artist's previous works (see above, p. 189) appear further intensified. If the former figure reflects the influence of a Byzantine St. John, the Magdalen suggests the solemn simplicity of the well-known Dugento panel of the same subject in the Accademia (as observed by Middeldorf, *AB*, p. 574; Kauffmann, *D.*, pp. 152, 239, n. 454, cites the same tradition exemplified by somewhat later Magdalen images). Its harsh grandeur, so different from anything created in Florence during Donatello's absence, must have jolted both artists and public like a thunderclap: one could hardly imagine a more dramatic way for our master to reassert his artistic authority in his native city. The deep impression he made is attested not only by such direct echoes of our statue as the Empoli Magdalen and that of Desiderio in S. Trinità (see below, p. 193) but by numerous reflections of it throughout the later Quattrocento (cf. Cruttwell, *loc.cit.*). Yet this popularity was due only in part to the greatness of the Magdalen as a work of art. The overpowering religious fervor expressed in the statue would have met a less ready response had it not coincided with a broader devotional trend which can be felt in Florence from the 1450's on—the same trend that helps to account for the popular success of the Giovannino Martelli (see below, p. 195; also cf. Kauffmann, *D.*, pp. 144f). Its climax was to come forty years later, under Savonarola. Donatello's Magdalen is strangely prophetic of the mood of that cataclysmic *fin de siècle*.

[4] For the Empoli statue see Cornel v. Fabriczy (*Jahrbuch Kgl. Preuss. Kunstslgn.*, xxx, 1909, Beiheft, p. 29, No. 84) who recognizes its dependence on the Baptistery Magdalen; the piece came to the Collegiata of Empoli from the church of S. Croce in Vinci.

[5] Lányi (*Probl.*, p. 23) lists it among the canonic works but adds that its state of preservation does not permit a definitive judgment.

ST. JOHN THE BAPTIST AS A YOUTH ("GIOVANNINO MARTELLI") MUSEO NAZIONALE, FLORENCE

| *PLATES 92-93* | Marble statue; H. 173 cm; W. 47 cm; D. 39 cm | *(c. 1455)* |

DOCUMENTS: none

SOURCES

(Before 1530) Billi, pp. 42f: "[Donatello] did a statue of St. John which is now in the house of the heirs of Ruberto Martelli."

1537-1542 Cod. Magl., p. 77: "By [Donatello's] hand is a marble statue of St. John which is now in the house of the heirs of Ruberto Martelli."

(c. 1550) Gelli, p. 59: "[Donatello] did a young St. John of marble in the house of the Martelli, which seems to be made of real flesh. . . ."

1550 Vasari-Ricci, p. 53 (Milanesi, pp. 408f, slightly rephrased): "In the houses of the Martelli there are many scenes of marble and bronze, among them a David three braccia tall, as well as a great

many things (Vasari-Milanesi has: many other things) generously given by Donatello to betoken the obligation and love he felt towards this family; and particularly a marble statue of St. John three braccia tall, a most precious work, now in the house of the heirs of Ruberto Martelli who had received it as a present (Vasari-Milanesi omits the last clause). This figure the heirs received in trust, with the proviso that it must never be pledged, sold, or given away, under severe penalty, in testimony of their affection for Donatello and of his gratitude to them for their protection and favors." (A much shortened paraphrase in Borghini, *Riposo*, p. 320.)

1568 Vasari-Milanesi, VI, pp. 90f, *s.v.* "Tribolo": "After the birth of Don Francesco, the duke's oldest son, Tribolo was charged with the decoration of S. Giovanni in Florence for the christening. . . . Under the lantern [of the dome] he made a large octagonal wooden vessel . . . also . . . a wooden pedestal in its center . . . surmounted by the marble St. John the Baptist of Donatello, three braccia tall, from the house of Gismondo Martelli."

1591 Bocchi, pp. 10f (Cinelli, p. 23): "In the house of Francesco Martelli there is a young St. John of marble by Donatello, that sculptor beyond compare who is valued as highly as the ancient artists. This statue is famous for its masterly and wonderful vividness. But it has become especially noteworthy through the circumstance that Ruberto Martelli, who understood the talent of Donatello and the exceptional beauty of the St. John better than anyone else, obliged his heirs not to give it away, sell it, or pledge it, on pain of losing land of great value, in order that so precious a work might forever remain in the house of his family."

The statue remained in the hands of the Martelli family until 1912, when it was acquired for the Museo Nazionale at a price of 400,000 lire.[1] In 1935, the figure was shown at the Exposition de l'art italien au Petit Palais, Paris (*Catalogue*, p. 309, No. 1029).

According to Balcarres (*D.*, p. 56) and Cruttwell (*D.*, p. 48), the Giovannino stood in the courtyard of the Palazzo Martelli until 1755. This claim is surely mistaken (as observed by Giacomo de Nicola, *Bolletino d'arte*, VII, 1913, pp. 277ff) since the marble surface is far too well preserved to have been exposed out-of-doors for any length of time. Apparently Balcarres relied on the inscription on the base of the statue (dating from 1794), which refers to the fact that in 1755, after the death of the last descendant of Ruberto Martelli, the ownership of the figure passed to Niccolò Martelli, the head of another branch of the family. The text, reproduced by De Nicola, *loc.cit.*, implies a relocation of the statue but not a change from the courtyard to the interior of the palace. De Nicola adds that the Giovannino was probably meant for a niche and would not have looked well in the center of an open space; maybe so, but the Cinquecento thought otherwise, according to Vasari's account of the Tribolo decoration of the Baptistery in 1541 (the passage, first mentioned by Kauffmann, *D.*, p. 210, n. 132, seems to have been unknown to De Nicola). In examining the statue, De Nicola found traces

of gilt in some areas. This agrees with the curiously mottled appearance of the marble, indicating that the entire figure was coated with color at one time. It may indeed have been intended that way from the start (cf. the coloring of the tomb of John XXIII, above, p. 61). The upper part of the slender metal cross is lost; there is a fine break in the marble of the right hand, along the inner edge of the ribbon. The crack, now sealed with lead, may have happened in the carving or, more probably, when the upper part of the cross was broken off.[2]

Until twenty years ago the Giovannino was regarded as an unquestionable work of Donatello, on the strength of the testimony of Vasari and his predecessors. Most scholars believed the statue to be a companion-piece of the David Martelli, whether or not they gave full credence to Vasari's story about the close relations between the young artist and Ruberto Martelli (Balcarres, *D.*, p. 52, points out that Donatello could not very well have been reared from childhood in the house of Ruberto Martelli, as Vasari claims, since the elder Ruberto was 73 years of age at the time of Donatello's birth and the younger Ruberto was born 22 years after Donatello). As a consequence, they felt it necessary to assign a common date to both figures, thus doing justice to neither (see the literature cited above, pp. 21ff). Kauffmann (*D.*, pp. 43ff), the most recent author to pursue this hypothesis,

[1] Cf. Emile Bertaux, *Revue de l'art ancien et moderne*, XXXIV, 1913, pp. 187ff, who states that this low price gained permission for the Martelli to sell the rest of their collection without restrictions; they had reportedly turned down an offer of three million [lire?] from Pierpont Morgan for the Giovannino.

[2] I am indebted to Dr. Clarence Kennedy for drawing my attention to this detail.

views them as a binomial "cycle" of elaborate symbolic meaning and recalls, by way of analogy, the constant pairing of figures in the Old Sacristy of S. Lorenzo. The obvious differences of style between the two statues he tries to explain as differences of characterization without chronological significance; here, he states, are Donatello's last marble statues, done in the late 1430's (Middeldorf, *AB*, p. 579, endorses this dating; Bertaux, *loc.cit.*, had made the same claim for the Giovannino alone).

Since then, the Giovannino has been placed in grave jeopardy. According to Lányi (*Pragm.*, pp. 129f, note), it is the work of Desiderio da Settignano, reflecting the influence of Donatello's late style (i.e. it must have been carved after 1453). This conclusion, which Lányi presented without supporting arguments but which, he says, was arrived at independently by M. Marangoni and shared by Adolfo Venturi, found another supporter in Leo Planiscig, who omitted the piece from his Donatello monograph of 1947 and gave his reasons for assigning it to Desiderio in an article two years later (*Phoebus*, II, 1949, pp. 55ff). The fact that the Giovannino was considered to be by Donatello in the Cinquecento, Planiscig maintains, has no evidential value; after all, the same is true of a number of other pieces that have been eliminated from the master's *œuvre* by common consent in modern times. Stylistically, the statue shows the closest kinship not with the post-Paduan statues of Donatello but with the early works of Desiderio such as the Arconati-Visconti *tondo* in the Louvre and the Mary Magdalen in S. Trinità, Florence (the latter work Planiscig regards as directly inspired by Donatello's Magdalen in the Baptistery and dating from about 1455; cf. his essay in *Arte mediterranea*, III, March-April, 1949, pp. 5ff). The case of the Giovannino, then, resembles that of the *pietra serena* panel in the Museo Nazionale showing the bust of the Infant St. John, which used to be regarded as an incontestable Donatello until the hand of Desiderio was recognized in it some decades ago.

This is certainly a serious challenge to the traditional view. That the Giovannino is a work of the mid-1450's seems to me beyond question; nor can there be any doubt of its close relationship to the post-Paduan statues of Donatello (Tschudi, *D.*, p. 21, was sagacious enough to note how closely our figure resembles the Magdalen in the Baptistery, although he dated both before Padua). And the highly finished marble surface, as well as the fact that we know of no other youthful St. Johns in the established *œuvre* of Donatello while there are several in Desiderio's (see below, pp. 228ff, for the so-called "St. John" from the Campanile), would seem to favor the younger master. Granting the great originality and expressive power

of the statue, which excludes attribution to an artist of lesser rank, we are faced with two alternatives: the Giovannino is either the work of Desiderio, directly inspired by the late statues of Donatello, or it was done by Donatello himself soon after his return from Padua, possibly with the aid of an assistant in the finishing process. A reasoned decision here is far from simple, for Desiderio, who had received his sculptural training during Donatello's absence, must have been tremendously impressed, at least temporarily, with the new style the older master brought back from his ten years' sojourn in Northeastern Italy. Thus it seems entirely plausible to place the most Donatellian pieces near the beginning of Desiderio's known *œuvre* (which, unhappily, does not include a single work to which we can attach a secure and precise date), as Planiscig has done in his *Phoebus* article. The Giovannino is a good deal more Donatellian than any of these, both in spirit and in detail, but could not Desiderio, on this one occasion, have emulated the older master more fully than at other times? Whether he did or not can be determined only by a careful comparison of our statue with its closest relatives in Desiderio's *œuvre* on the one hand, and with the post-Paduan figures of Donatello on the other. Before we embark on this task, it may be useful to emphasize that the often-repeated statement that Donatello never worked in marble after his departure from Florence about 1443, carries no authority whatever. It is based on nothing but the fortuitous circumstance that we do not happen to know of any documented marble pieces by the master after the 1430's—hardly a valid reason for such a generalization. Why indeed should Donatello have refused to handle marble in his later years? Surely not because of the physical labor involved (he did, after all, carve the large Entombment of *pietra di Nanto* behind the Padua High Altar as late as 1449). Even granting his personal preference for wood and bronze from 1450 on, we have no right to assume that he would have turned down a commission in marble after his return to Florence. The material of our statue, therefore, does not in itself discourage an attribution to Donatello, although it renders our problem more difficult. But then we have no marble statues of Desiderio, either, that would be useful for our purpose (the two youths on top of the Marsuppini Tomb are so different from the Giovannino that we must leave them out of account). We shall have to rely, instead, on the Magdalen in S. Trinità, which forms a particularly suitable starting-point for our inquiry since it is a direct "translation" into Desiderio's idiom of the Magdalen in the Baptistery. If Lányi and Planiscig are right, the Giovannino should have more in common with the S. Trinità statue than with the St. John in the Frari, the Baptistery Magdalen, and the St. John

in Siena. But does he? So far as I can see, the opposite is the case. There is, to be sure, a certain general resemblance between the Desiderio Magdalen and our figure, yet the tell-tale signs of common authorship—similarities of body details, facial expression, etc.—are missing. On the other hand, it is exactly these elements that link the Giovannino, despite the difference of material, with the three Donatello statues named above. Of particular interest is the fact that some features of the Giovannino can be explained only on the basis of the St. John in Venice, a figure almost certainly unknown to Desiderio. Whoever carved the left hand and scroll of our statue must have been thoroughly familiar with the corresponding details of the Frari St. John (cf. Pl. 89). Equally close are the drapery patterns of the two cloaks, with their straight ridges of folds meeting at a sharp angle, separated by deeply cut concave "troughs." The texture of the fur tunic in the Giovannino differs from that of the Frari St. John and the Baptistery Magdalen, but it does not match that of Desiderio's Magdalen any better. Here the contrasting properties of marble and wood seem to have been a major factor. Still, certain details of our statue, such as the knot of long strands of hair (below the right hand, visible from the side), are found again in the Baptistery Magdalen below the left elbow) and especially in the Siena St. John, where the hair shows the greatest tendency towards such entanglements. Since the two St. Johns and the Magdalen of Donatello are represented as aged ascetics, their limbs and faces show a degree of emaciation far beyond the still youthful Giovannino. Yet his is not the tender, swelling flesh of Desiderio; the suppression of arm and leg muscles makes the limbs look straight as sticks, and at the joints the bones are beginning to show through the skin. Desiderio's Magdalen, although clearly characterized as an aging woman, lacks this rigid, angular quality. In her stance, as well as in her facial expression, the frightening intensity of Donatello's Magdalen has been transmuted into lyrical pathos—a pathos with that touch of sweetness we feel in all of Desiderio's work. The head of the Giovannino, in contrast, has the acerbity characteristic of the late statues of Donatello. The youth is already in the throes of what Bertaux, *loc.cit.*, has fittingly called the *délire prophetique*, the same mania that we find mirrored in the faces of the Venice and Siena St. Johns and of the Baptistery Magdalen, where it reaches an overpowering climax. All the key symptoms are present: the strangely unfocused glance, the half-open mouth, no longer under conscious control, that seems quite incapable of articulating intelligible words but conveys an almost unbearable state of inner tension, like that of a medium in a trance. This is indeed, as Marilyn Aronberg Lavin has pointed

out, the young St. John after his meeting with Jesus, when the meaning of the life and passion of Christ had been revealed to him; having climbed the Mount of Penitence, he is now consciously becoming the Precursor through his life of violent penitence, as described in Fra Domenico Cavalca's *Vite de'Santi Padri* (see *Art Bulletin*, xxxvii, 1955, p. 91). Could Desiderio have created a type of such psychological complexity and expressive force? Not if we are to judge on the basis of his Magdalen or of the Arconati-Visconti *tondo* and the *pietra serena* panel, which show St. John as a delicate and charmingly serious child rather than a tortured adolescent. In all these cases, Desiderio has taken over the device of the half-open mouth, but its meaning is entirely different now: it gives the features an open, animated quality, without any hint of *délire prophetique*. The face of our figure also bears a marked resemblance to that of Donatello's Judith (compare Pls. 93b, 97c), another point in favor of the older master. She has much the same formation of nose and mouth, and above all a similarly tense, "abnormal" expression.

Finally, we must consider the testimony of the sources. The visual criteria adduced above for differentiating between Desiderio at his most Donatellesque and Donatello himself, are of a fairly subtle kind and thus subject to varying interpretation. Under such circumstances the sources, although not a decisive factor in themselves, do carry some weight—enough, perhaps, to tip the balance. Mere mention by Vasari has little evidential value, it is true, for the works referred to in his *Vita* of Donatello include a number that are surely not by our master. Yet, except in matters of chronology, Vasari is far more often right than he is wrong concerning Donatello, so that if we want to convict him of a mistake we should at least try to explain his error (or that of his predecessors; cf. above, pp. 10f, 19ff, and below, pp. 224, 232f) rather than accuse him of arbitrary invention. He was as conscientious in gathering and sifting information as it was possible to be at that time, and our debt to him is so enormous that everything he has to say deserves a respectful (though not uncritical) hearing. He will report traditional attributions on faith, however mistaken they might be, but so far as we know he never attached the names of great masters to anonymous works or changed established attributions on his own initiative. Thus we may be sure that his elaborate account of the Giovannino as a family heirloom handed down from Ruberto Martelli corresponds essentially to what he had been told by members of the family, who obviously held the statue in great respect. (The life span of Ruberto Martelli the Younger is fully compatible with the new, late dating of the Giovannino.) If a mistake had crept into this family

tradition concerning the authorship of the figure, it must have happened several decades before Vasari's time or even earlier, since the Giovannino is mentioned as a work of Donatello in the Libro of Antonio Billi, compiled within seventy-five years after the date of the statue. While the substitution of a great name for a lesser one would not be implausible in itself (even though Desiderio enjoyed considerable fame in his own right), I find it difficult to accept such a possibility in conjunction with the story of the Giovannino as a family heirloom (which we would then also have to regard as completely fictitious, unless we are willing to postulate that it was Desiderio who grew up in the house of Ruberto Martelli—as he could have, chronologically speaking—and gave him the statue as a token of his gratitude). By far the most likely assumption, it seems to me, is that the Giovannino was indeed given or sold to Ruberto Martelli by Donatello; that Ruberto valued the figure highly and did make some sort of stipulation about it in his will; and that the rest of the story as reported in Vasari was gradually invented by younger members of the family in an effort to explain how the statue had acquired its special status. That the Giovannino was linked with the name of Ruberto as early as the beginning of the Cinquecento may be inferred from the Libro of Antonio Billi, which describes it as "in the house of the heirs of Ruberto Martelli" instead of giving the name of whoever was the head of the family at that time. This peculiar phrasing would seem to be a highly elliptical reference to the heirloom status of the figure; it also suggests that the words were written not long after the death of Ruberto the Younger, who had lived to a ripe old age and whose name, because of his distinguished position and character, continued to dominate the family for another generation. At the time the Giovannino was created, about 1455, Ruberto the Younger was in his upper forties; thus at the beginning of the next century there must have been younger members of the family who had either witnessed the acquisition of the statue or heard about it from Ruberto directly. All of which makes it hard to believe that the true identity of the artist could have been forgotten during the short interval between Ruberto's death and the notice in the Libro. We should also take into consideration the general trustworthiness of the Libro regarding our master. Of the more than thirty works of Donatello mentioned in it, twelve are today secured by documentary evidence; nine have been accepted as part of his established *œuvre* on the basis of style; a few are lost or unidentifiable; and in only five instances can we convict the Libro of being wrong. Two of these—the horse's head in Naples and the Bellano reliefs in the choir of the Santo in Padua—concern monuments in cities far from Florence, where

the chances of local traditions becoming garbled or fanciful were greater than in Donatello's home territory. The remaining three cases are works in Florentine churches: the "Daniel" on the Cathedral façade (presumably the figure now recognized as Nanni di Banco's Isaiah of 1408; see above, p. 4), the St. Peter at Or San Michele (attributed to Ciuffagni; see below, p. 222), and the Lavabo in the Old Sacristy of S. Lorenzo (supposedly in part by Donatello, with additions by Verrocchio, but now regarded as wholly by the latter). The first two belong to the early years of the Quattrocento, and all three are in the immediate vicinity of famous major works of Donatello, i.e. they are what might be called "attributions by spill-over." If the Libro were mistaken about the authorship of the Giovannino, such an error would be far more serious than those uncovered so far and we should be hard put to find a reasonable explanation for it.

On the basis of all the foregoing, it seems wisest to accept the new dating of the statue proposed by Lányi and Planiscig but to retain the traditional designation, even if we have to stretch our conception of Donatello's post-Paduan style a bit in order to accommodate the Giovannino. Attributing the work to Desiderio entails many more difficulties than it resolves, especially in view of the great iconographic importance of the figure. The young St. John makes its first appearance on Italian soil in the thirteenth century and occurs with increasing frequency throughout the Trecento and the "International Style" (cf. Lavin, *op.cit.*). In all these instances, however, the Saint is shown as a child, and in a narrative context rather than as an isolated image. Curiously enough, this tradition seems to have come to an end with the advent of the Early Renaissance. Not a single example is known between the early years of the Quattrocento and the 1450's, when the subject was suddenly revived. The Giovannino Martelli may not have been the exclusive cause of this revival, but it is the earliest specimen of the young St. John in Renaissance art, the first adolescent St. John, and the first young St. John outside a narrative setting. Its impact can be felt immediately, in both sculpture (Desiderio, Antonio Rossellino) and painting (Baldovinetti, Filippo Lippi), even though the expressive intensity of the original is lost immediately in the process (see Lavin, *op.cit.*, pp. 92ff). An iconographic invention of such boldness and far-reaching importance has no parallel in Desiderio's *œuvre*, so far as I can see. If we assign it to Donatello, on the other hand, the Giovannino falls into place logically enough as one of many equally daring innovations, in direct line of succession to the St. George at Or San Michele and the three David statues. The reasons for the renewed popularity of the young St. John

from the 1450's on until about 1500 in Florentine art are as yet little understood. The sudden interest in the subject, with its emphasis on the mystic and devotional aspects, undoubtedly forms part of a general trend in the development of religious thought and feeling, especially among educated laymen.[3] That our Giovannino should have been the artistic vanguard of this movement is entirely in keeping with the new directness and intensely personal quality of religious experience reflected in the late work of Donatello.

[3] Symptomatic is the poem by Lucrezia Tornabuoni on the life of St. John, based on Cavalca, published in Lavin (*op.cit.*, pp. 100f) and its relation to the iconography of the Fra Filippo Lippi panel for the chapel of the Medici Palace; cf. Lavin, *op.cit.*, pp. 92ff.

ST. JOHN THE BAPTIST, CATHEDRAL, SIENA

PLATES 94-95 Bronze statue; H. 185 cm; max. W. 51 cm *1457*

DOCUMENTS

Two entries in the records of the chamberlain of the Cathedral workshop, in the archives of the Opera del Duomo, Siena, published by Gaetano Milanesi, *Documenti per la storia dell'arte senese*, II, Siena, 1854, p. 297:

1457, September 28: 5 lire 14 soldi have been paid to Florence as duty (*per chabella*) on a "half-figure" (*mezza figura*) of St. John, by Donatello.

October 24: Donatello delivers a St. John of bronze, with one arm missing; it consists of three pieces, to wit: the head [and upper body], weighing 224 lbs.; the middle part, down to the knees, weighing 221 lbs.; and the base with the legs up to the knees, weighing 143 lbs.

1467, Inventory of the Opera del Duomo, excerpted by Pèleo Bacci, *Jacopo della Quercia . . .* , Siena, 1929, p. 348n: A bronze St. John, a very beautiful figure, is in the basement of the Cathedral workshop.

SOURCES

(Before 1530) Billi, p. 42 (Cod. Strozz.; repeated in Cod. Magl., p. 78): "Donatello did a bronze figure of St. John the Baptist in the portal of Siena Cathedral, a beautiful work but with the right arm missing from the elbow down. He said he did not finish it because he had not received the rest of his pay. And when he left Siena he said that if they wanted him to finish the statue they would have to pay him as much as they had paid for the rest of the figure. Thus he left it incomplete." (The Cod. Petrei has a much shorter version of this passage, without reference to the doubling of the price but giving the location of the statue as the Opera del Duomo; the "porta del duomo" in the Cod. Strozz. is obviously a copyist's error, unless we choose to regard it as the residue of a reference to the Siena Cathedral Doors in the text from which both codices were derived.)

(c. 1550) Gelli, p. 60: "[Donatello] then did a bronze figure of St. John the Baptist in the Opera del Duomo in Siena, but not having been paid to his liking he left it incomplete, with a faulty arm."

1550, Vasari-Ricci, p. 56: "Similarly [i.e., like the ruined wax forms for the Cathedral doors] there remained in the workshop of Siena Cathedral a St. John the Baptist of bronze, whose right arm [Donatello] left incomplete from the elbow down; since he had not been paid in full, he said, he would not finish the figure unless he were to be paid twice the amount he already had received."

1568, Vasari-Milanesi, p. 415: "All that remained in the Siena Cathedral workshop by Donatello's hand was a bronze St. John the Baptist, which lacks the right arm from the elbow down; Donatello is said to have left it that way because he had not been paid in full."

The location for which the statue was intended is uncertain. Paul Schubring (*Die Plastik Sienas . . .* , Berlin, 1907, p. 85, n. 1) suggests that it may have been the high altar of the Baptistery, since the Cap-

pella S. Giovanni in the Cathedral, where the statue is at present, was not built until about 1480. Nor do we know when the figure was first put on public display; in 1467 it was still in storage, apparently because of the missing arm, but the three separate pieces had probably been joined together by then (otherwise the inventory might be expected to list them). They have been fitted to each other with such skill that Donatello himself must have supervised the task, even though he failed to supply the missing arm (Kauffmann, *D.*, p. 239, n. 456, infers from the latter circumstance that the master could not have attended to the joining of the pieces). According to the sources, the St. John was still in the Opera del Duomo during the first half of the Cinquecento. Their testimony, however, is not entirely clear, since they speak of Donatello having done, or left, the statue in the *Opera*, without insisting that it was there now. The same wavering between past and present can be found in the comments on the right arm; Vasari, in the second edition of the *Vite*, is the only one to state that the arm was still missing, and one wonders whether he based this claim on direct observation or on inference from his written sources. So far as the place where the figure was made is concerned, the sources are certainly mistaken; the document of September 28, 1457, implies that the St. John was cast in Florence. The only element of uncertainty here is the rather puzzling reference to a "half-figure of St. John," which led Schottmüller (*D.*, p. 138) to assume that the document does not relate to our statue but to another, untraceable commission for a half-length figure of the same saint. Actually, the meaning of the term *mezza figura* becomes clear if we keep in mind that those 5 lire 14 soldi were not part of the artist's fee but an impost of some sort—apparently export duty—paid to the Florentine authorities, and that the statue arrived in Siena in three pieces: the "half-figure" here should be translated, not as a half-length figure but quite literally as "half of a statue"—i.e., one of the three pieces of the St. John. These, it seems, were sent to Siena one by one, rather than together, and the impost was paid separately for each piece.

The story of the missing arm was questioned by Guglielmo della Valle (Vasari, *Le Vite . . .*, III, Siena, 1791, p. 197), who believed the entire statue to be by Donatello but noted that "it resembles a savage hunter rather than the Baptist." Recently Planiscig (*D.*, p. 114) has again claimed the right arm as part of the original statue; it is referred to as missing in the document of October 24, 1457, he suggests, because it was broken off in transit. However, there can be no doubt that the arm is indeed a later addition. Its style, quite alien to that of the late Donatello and in strong contrast with the left arm of the statue, shows some affinity to the bronze works of Vecchietta (see also above, p. 67). Donatello, in all likelihood, intended to have the right arm cast separately for technical reasons and therefore omitted it from the wax form for the upper third of the figure (he did the same with the top part of the reed cross), but once he settled down in Siena his energies were so completely absorbed by the project for the Cathedral doors that he neglected to finish the St. John. His reported refusal to do the arm because of inadequate payment must be viewed as a fictional embellishment of the factual core of the story, added so as to explain why the statue remained incomplete and reflecting the acrimonious spirit of Donatello's break with his Sienese patrons (see below, p. 207).

The style of the St. John has been well characterized by Kauffmann (*D.*, p. 153). The pose, the narrow rectangle of the contours, the omission of the cloak usually worn by the Baptist, recall the Magdalen, which is slightly earlier in date. So does the texture of the fur, with its twisted and knotted strands of hair, although the greater fluidity of treatment reflects the technical ease of modeling in wax as against wood-carving. On the other hand, the proportions of the statue are notably less elongated than those of the Frari St. John and of the Magdalen, and the body has recovered a good deal of the physical power of Donatello's earlier figures. Yet the expressive quality of the St. John—his "madness," as Cruttwell calls it (*D.*, pp. 51f)—is as great, and of the same kind, as that of the master's other post-Paduan statues.

JUDITH AND HOLOFERNES, PALAZZO VECCHIO, FLORENCE

Bronze group, with traces of partial gilding *(1456-1457; c. 1460)*
H. 236 cm (from bottom of base to top of Judith's head)
H. of base 55 cm; W. of each side 85.5 cm
H. of base reliefs 43.5 cm; W. 57 cm
Inscription on cushion between hands of Holofernes, · OPVS · DONATELLI · FLO ·
around top of pedestal, · EXEMPLVM · SAL · PVB · CIVES · POS · MCCCCXCV ·

DOCUMENTS

None relating to the commission or original location of the group (but see below). The following two entries in the record of deliberations of the Signoria, in the State Archives of Florence, were transcribed by Gaetano Milanesi and published by Eugène Müntz, *Les collections des Médicis . . .* , Paris, 1888, p. 103:

1495, October 9: Two bronze statues, a David in the courtyard of the palace of Piero de'Medici and a Judith in the garden of the same palace, are to be turned over to the *operai* of the Palazzo Vecchio, together with their pedestals (*cum omnibus eorum pertinentiis*); the *operai* are to install them there in whatever places they deem suitable.

October 14: Marco Cappello, the macebearer of the Signoria, reports that all the above objects (which included several other items beside the two bronze statues) have been duly consigned to the *operai*.

SOURCES

1464-1495 Bartolommeo della Fonte (Fontio), *Zibaldone*, Riccardiana Library, Florence, Cod. Ricc. 907, fols. 141ff, copy of a letter of condolence, dated August 5, 1464, on the death of Cosimo de'Medici to Piero il Gottoso by one *F. Francischus cognomento paduanus*, which includes the following passage (fol. 143r): "How many men laden with honors and riches do we not recall that were cast down from that pinnacle of power without warning . . . as you yourself have taught me. Kingdoms fall through luxury, cities rise through virtues; behold the neck of pride severed by the hand of humility (*Regna cadunt luxu surgent virtutibus urbes caesa vides humili colla superba manu*)." On the margin opposite the latter phrase Fontio has noted: "On the column below the Judith in the Medici Palace (*In columna sub iudith in aula medicea*)." The inscription was cited by Kauffmann (*D.*, p. 170) after one of the *Notizie* added by Luigi Passerini to the second edition of Agostino Ademollo, *Marietta de'Ricci. . . .* (Florence, 1845, I, p. 758, No. 39). Passerini states that "a small fifteenth century codex in my possession gives the inscription that was below the statue when it stood in the Medici Gardens at S. Marco; on one side of the column was written *Regna cadunt . . .* and on the other *Salus Publica. Petrus Medices Cos. Fi. libertati simul et fortitudini hanc mulieris statuam quo cives invicto constantique animo ad rem pub. redderent dedicavit.*" (Piero Son of Cosimo Medici has dedicated the statue of this woman to that liberty and fortitude bestowed on the republic by the invincible and constant spirit of the citizens.) This codex, which is our only source for the second inscription and for the alleged location of the Judith in the Medici Gardens, has either disappeared or remains untraceable. The passage from the *Zibaldone* quoted above was found by Ernst Gombrich, who drew attention to it in the *Art Bulletin* (xxxv, 1953, p. 83, n. 4). Since the *Zibaldone* is undated and must in any event have been compiled over a number of years, there is no way of telling when Bartolommeo copied the letter and added the marginal note; he probably did not do so until the 1470's, since he was only nineteen years old at the time of Cosimo's death.

1495 Luca Landucci, *Diario . . .* , ed. Iodoco del Badia, Florence, 1883, p. 121: "On December 21, 1495, the bronze Judith from the house of Piero de'Medici was placed on the *ringhiera* of the Palazzo Vecchio, next to the portal."

1504 Record of the meeting, on January 25, of a commission to advise on the best location of Michel-

angelo's marble David, published in Giovanni Gaye, *Carteggio* . . . , ii, Florence, 1840, pp. 455ff; Francesco di Lorenzo Filarete, the herald of the Signoria, proposes to substitute the David for the Judith [on the *ringhiera*] because "the Judith is a deadly symbol (*segno mortifero*) and does not befit us whose insignia are the cross and the lily, nor is it good to have a woman kill a man; moreover, the stars did not favor the erection of the Judith, for ever since then things have been going from bad to worse." Cosimo Rosselli prefers to have the David placed on the steps in front of the Cathedral, to the right, and Botticelli agrees but suggests that a Judith should be placed on the other side of the steps (not Donatello's Judith, as claimed by Kauffmann, *D.*, p. 168).

Landucci, *op.cit.*, p. 268 (cf. also Agostino Lapini, *Diario fiorentino* . . . , ed. Corazzini, Florence, 1900, pp. 61, 65): "On June 8, [the David of Michelangelo] was erected on the *ringhiera* in place of the Judith, which had to be removed and placed on the ground inside the Palace."

1506 Landucci, *op.cit.*, p. 276 (cf. Lapini, *op.cit.*, p. 117): "On May 10, the Judith was placed in the Loggia dei Lanzi, under the first arch towards Vacchereccia."

1510 Landucci, *op.cit.*, p. 301 (cf. Lapini, *op.cit.*, p. 73): "On June 18, they started to clear out the vault beneath the Loggia dei Lanzi. It had been built when the Loggia was erected, but no one had known about it until they rediscovered it while building a foundation for the bronze Judith. . . ."

Albertini, p. 17: ". . . and the Judith is in the Loggia."

(Before 1530) Billi, pp. 38f: "[Donatello made] the bronze Judith which is now in the Loggia dei Lanzi (*loggia de nostri Signorj*)."

1537-1542 Cod. Magl., p. 77: "[By Donatello] is the bronze Judith which is now in the Loggia dei Lanzi (*loggia del duca*)."

(c. 1550) Gelli, p. 59: "Donatello made the bronze Judith cutting off the head of Holofernes, which is now in the Loggia dei Lanzi."

1550 Vasari-Ricci, p. 51 (Milanesi, pp. 405f, slightly rephrased): "For the Signoria of the city he did a metal cast which was placed in an arch of their loggia on the piazza; it shows Judith cutting off the head of Holofernes and is a work of great excellence and mastery, which reveals to anyone who will consider the outward simplicity of the Judith in dress and appearance, the great spirit of that lady and the aid of God, while the appearance of the Holofernes exhibits the effect of wine and sleep, with death in his cold and drooping limbs. This cast Donatello did with such delicacy, patience, and love, and afterwards he chased it so well, that it is a great marvel to behold. Similarly the granite pedestal of simple design is most graceful and pleasing to the eye. He was so delighted with this work that it seemed to demand his signature above all others (the 1568 edition has: "that he wanted to put his name on it, which he had not done in his other works") and he inscribed it, *Donatelli opus.*"

1571 Francesco Bocchi, *Eccellenza della statua di San Giorgio di Donatello* . . . (first printed Florence, 1584; most recently reprinted in Bottari-Ticozzi, *Lettere pittoriche* . . . , Milan, 1822-1825, iv, pp. 255ff; German translation, with notes, in Semper, *D.* '75, pp. 175ff, 249ff): "However, our artist is to be admired not only in rendering the expression of the St. George but also in other works. Thus his bronze Judith, aside from other fine qualities, exhibits unusual boldness and force, as well as the strength granted her by God, for women do not ordinarily accomplish such deeds; she is frightened neither by what she has done nor by the savage head in her hand, but on the contrary displays the joyous confidence of youth." (Bottari-Ticozzi, pp. 287f; Semper, pp. 193f.)

1582 Lapini, *op.cit.*, p. 217: "[On August 4 . . .] the bronze Judith was installed beneath the arch of the great loggia which faces the new street of the magistrates; there, maybe, she will remain forever, since she has been moved around so many times, as related before."

1584 Borghini, *Riposo*, p. 319: "Donatello did the bronze Judith who has cut off the head of Holofernes; it is to be seen to this day in the arch of the Loggia dei Lanzi which faces the new Uffizi."

Bocchi, dedicatory letter to the Accademia del disegno for the first edition of *Eccellenza della statua di S. Giorgio* (Semper, *D*. '75, p. 180): "I am also convinced that [Donatello] knew his own great worth and wanted it founded on durability. For this reason he placed the arms and hands of his figures close to their bodies wherever possible, preserving the strength of the block, so that they might escape damage by time or chance. . . . With his bronze statues he did not observe this precaution, as we see in the Judith, whose arm stretches away from the body; for here . . . he relied on the strength of the material for protection."

1591 Bocchi, *Bellezze*, pp. 31f (Cinelli, pp. 72f; his additions in brackets here): "[But turning to the Loggia we see three beautiful statues there, the Judith, the Perseus, and the Sabines. . . .] The statues of the Piazza make this memorable beyond all others because of their beauty and artifice; they are so perfect that, like an incomparable treasure, they can only be envied but not imitated. The Judith of Donatello made her appearance earlier than the rest, at the hands of a most complete artist. And the later masters so admired her very great beauty that their own work became more subtle and praiseworthy. Thus each of them is in some respect superior to the others, and has for that reason achieved a great reputation. The Judith is marvelous and graceful to behold. Artists admire her vividness and the expression of saintly outrage on her face as she kills Holofernes, as well as the grand and natural design that brings out the difference between what is alive and what is dead; the way the drapery fits the body; and the languid, somnolent quality of the Holofernes. The limbs are conjoined to the body in a natural and lively manner, flesh and bone being rendered so gently and delicately that they seem alive in the bronze, and the very deception conveys the truth. . . . [And even though at first glance the drapery appears too confused, on further consideration one comes to realize the grace of the woman. . . .]"

The earliest known location of the Judith, but not necessarily her original one, is the garden of the Palazzo Medici. Passerini's statement that the statue had previously been in the Medici gardens at S. Marco cannot be accepted without reservation as long as the actual text on which it is based remains unknown. Did the manuscript specifically mention the gardens at S. Marco, or did Passerini merely infer that this was the place in question? The two inscriptions he cites demand no such caution, since one of them is confirmed by Bartolommeo della Fonte. They do not, however, justify the conclusion that Piero il Gottoso commissioned the statue; it may have been made for his father or for an unidentified patron. All we really know is that Piero attached a dedicatory inscription to it—presumably after his father's death, i.e. between 1464 and 1469, when he was the head of the family—and that by August 1464 the statue already had the other inscription (*Regna cadent . . .*), which according to the letter of condolence may also have been chosen by Piero.[1] That the two inscriptions were not conceived at the same time is further suggested by their different *ethos*; the first one is couched in terms of moral theology (see below), the second in those

of civic virtue. One wonders, therefore, what prompted Piero to add the second inscription. Could it have been a particular political event? According to a popular tradition recorded in Andrea Francioni (*Elogio di Donatello . . .*, Florence, 1837, pp. 34f) the statue commemorates the expulsion of the Duke of Athens. Passerini, *loc.cit.*, still believed this, but without explaining why Piero should have chosen to celebrate an event that occurred in 1343 (not to mention the embarrassing parallel between the expulsion of the Duke of Athens and that of Cosimo de'Medici ninety years later). It is possible, however, that the second inscription was occasioned by Piero's victory in 1466 over the conspirators led by Luca Pitti; to turn a personal triumph into a triumph of the citizenry at large would certainly have been a clever political gesture. This may also explain the odd notion of a public monument to liberty and fortitude in the garden of what was, after all, a private residence. About the setting of the Judith in that garden we have no direct information, apart from Bartolommeo della Fonte's note (and the statement cited by Passerini) referring to the columnar pedestal of the statue. The present pedestal may have been brought over to the Palazzo Vecchio

[1] The "post-revolutionary" inscription of 1495 that appears on the present pedestal of the Judith was surely composed with reference to Piero's dedication, of which it is a sort of ironic

echo: the *cives* now erect a monument of their own to the *salus publica*.

from the Medici Palace, as claimed by Giacomo de Nicola.[2] If so, it must have been reworked to remove the two earlier inscriptions.[3] That the statue and its base were intended as the center of a fountain, visible from all sides, is shown by the water spouts at the corners of the pillow and in the center of each of the three base reliefs.

The further history of the statue is well recorded. Its tenure inside the Palazzo Vecchio, after it had yielded its place on the *ringhiera* to Michelangelo's David in May 1504, was a brief one (Lensi, *op.cit.*, p. 105, claims it stood in the niche to the left of the doorway near the stairs, but without citing his source). Exactly two years later the Judith was moved to the westernmost of the three arches of the Loggia dei Lanzi facing the Piazza, where it remained until, in 1582, it again had to make way for the work of a living master, the Sabines of Giovanni da Bologna. It then stood under the arch of the Loggia facing the Uffizi until the First World War, when for safety's sake it was temporarily placed in the Museo Nazionale, affording an opportunity for inspection at close range. The traces of gilt were noted at that time (De Nicola, *loc.cit.*), although the extent of the gilding is difficult to determine.[4] In 1919, the statue regained the place it had occupied in 1495-1504: to the left of the portal, in front of the Palazzo Vecchio (cf. Lensi, *op.cit.*, pp. 352f). It has remained there to this day, except for removal for safekeeping during the Second World War. Before it was returned to its pedestal, the figure underwent a close technical inspection by Bruno Bearzi, who determined that it had been cast in eleven separate pieces (*Donatello, San Ludovico*, New York, Wildenstein, n.d. [1948], p. 27). Bearzi also pointed out that the drapery of the Judith was modeled with the aid of actual cloth, which served as a base for the wax—a daring procedure, both artistically and technically, since in the casting the heat of the molten bronze had to consume the fiber of the cloth along with the wax. How successfully this could be done is shown by the strip of ornament on Judith's forehead; here the wax covering became detached from its cloth support before or during the casting, and the bronze faithfully reproduces the warp and woof of the canvas (see *Bolletino d'arte*, XXXVI, 1951, pp. 119ff, fig. 2, and the same detail in our Pl. 97c). More problematic is Bearzi's claim that Donatello used casts from nature

for the legs of Holofernes, which are cast separately; while the possibility that this is true cannot be denied categorically, the "realism without stylization" of which Bearzi complains seems to me very much the same as that in the legs of the Siena St. John. Realism as emphatic as this is itself a style; no cast could render veins and sinews with such plastic clarity. Even from a purely practical point of view, it would seem far simpler and quicker for a sculptor of Donatello's facility to model the legs freely than to make them from casts. If we try to visualize the various steps involved in the latter method, apart from the difficulty of finding the owner of a pair of legs of the right size and shape, there is the problem of how to pose the model for the plaster cast so that the legs will "look right"—a task complicated by the fact that Holofernes is shown sitting on a cushion—and how to make the cast itself (the legs must dangle freely during this process). Then the female plaster mold will have to be converted into a male wax mold with armature and earthen core, another tedious procedure. Such "working from the outside in" not only seems contrary to Donatello's strong structural sense but holds little promise of success in getting the legs to fit properly, while the usual method (starting with the armature and working "from the inside out") permits all the necessary adjustments of shape and angle to be made long before the final stage.

The date of the Judith used to be regarded as pre-Paduan by older scholars, largely because of its connection with the Palazzo Medici, which was then still believed to be a work of the 1430's (Semper, *D.* '87, p. 69, thought it a monument to commemorate Cosimo's return from exile; Schmarsow, *D.*, p. 36, placed it in the years 1435-1440, mainly because he thought the base similar to the Cantoria balustrade; Wilhelm Bode, *Denkmäler der Renaissance-Skulptur Toscanas*, Munich, 1892-1905, p. 33, dated it towards 1440). The late character of the work was first recognized by Tschudi (*D.*, pp. 30f), who pointed out the resemblance of the Holofernes to the Siena St. John of 1457 and of the Judith to the Virgin Mary in the Deposition of the St. Lorenzo Pulpits. His view has come to be accepted throughout the more recent literature (Cruttwell, *D.*, p. 85, and De Nicola, *loc.cit.*, are the last to give the traditional dating), not only for reasons of style but on circumstantial evidence as well. Aby War-

[2] *Rassegna d'arte*, XVII, 1917, pp. 154ff. Wilhelm Bode (*Jahrbuch Kgl. Preuss. Kunstslgn.*, XXII, p. 38, n. 1) had suggested that the pedestal had been made for the bronze David and was not switched to the Judith until 1495.

[3] Kauffmann (*D.*, p. 244, n. 514) lists various analogies to the shape of the pedestal from the 1450's on but wonders if it has been drilled through for a water conduit, as it ought to be if it was part of the previous installation of the Judith; apparently no one thought of noting this when the statue was moved during the two world wars. Bode, *loc.cit.*, assumes that the Judith stood above the "granite basin spouting water,

with marble ornaments" mentioned by Billi and subsequent sources as a work of Donatello in the second court of the Medici Palace—a plausible if unverifiable hypothesis, since the basin is lost.

[4] The well-known picture of the Burning of Savonarola, in the Museo di S. Marco, Florence, shows the Judith on the *ringhiera*, fully gilt, but according to Colasanti (*D.*, p. 82) the painter has exaggerated here; the remaining traces of gold are to be found only on the base, the sword, the belt of Holofernes and some decorative details of Judith's costume.

burg had proved that the Medici Palace was not started until 1444, which meant that the Judith must have been commissioned after, rather than before, Donatello's Paduan sojourn of 1443-1453 (assuming, of course, that the statue was actually made for the Palace). The date most frequently given is about 1455 (Schottmüller, *D.*, pp. 51, 129; Schubring, *KdK*, pp. 132ff; Planiscig, *D.*, pp. 110, 145); Colasanti (*D.*, pp. 80f) prefers the immediate vicinity of the Siena Baptist of 1457, and Venturi (*Storia*, vi, pp. 343f) speaks of the Judith as one of Donatello's very last works and even postulates the aid of Bellano and Bertoldo in the modeling of the drapery. For me, too, the comparison with the Siena Baptist is the decisive argument. The rich plastic *décor* of Judith's gown recalls the saddle and armor of the Gattamelata, but as an echo rather than a prophecy. And the fact that the Bacchanalian *putti* on the base recur in the S. Lorenzo Pulpits further helps to establish the late date of the work.[5]

One of the arguments adduced by Tschudi for placing the Judith after 1453 is the form of the signature. Donatello, according to Tschudi, did not use the FLORENTINUS after his name until Padua; we find it only on the Gattamelata, the Judith, and the South Pulpit of S. Lorenzo. This, of course, is incorrect, since the FLORENTINUS also occurs in the signature of the Crivelli Tomb. Nevertheless, the signature of the Judith poses a problem; for it is the only authentic example in Florence to include the FLORENTINUS (the inscription on the South Pulpit is so poor epigraphically that I regard it as posthumous, in which case it would simply be a copy of the formula used on the Judith, since that was the only signature of the master readily accessible in Florence). We can well understand that Donatello wanted to proclaim himself a Florentine when he signed his work in Siena, Rome, or Padua, but why should he have wanted to do so at home? One might be tempted to assume that he felt it necessary to reassert his claim to Florentine citizenship after his ten years' absence. This hypothesis, however, would have a semblance of plausibility only if we accept the legend of Donatello finding himself forgotten and neglected upon his return and being sustained only by the loyalty of his old patrons, Cosimo and Piero de'Medici. The ultimate source of the story is Vespasiano da Bisticci, who in his Life of Cosimo tells us that the latter commissioned Donatello to make the S. Lorenzo Pulpits and the bronze doors of the Old Sacristy "in order that the master's chisel might not be idle, because in Cosimo's time the sculptors found scanty employment." The only purpose of the passage, I suspect, was to emphasize Cosimo's generosity as a patron of art; hence the ab-

surd claim concerning the scarcity of sculptural commissions in general. Yet the image of the poor and lonesome old age of a great master has a pathos that appeals almost irresistibly to our romantic heritage, so that the legend continues to reverberate in modern scholarly literature (e.g. Kauffmann, *D.*, p. 143; Planiscig, *D.*, p. 110). Donatello's *Catasto* Declaration of 1457, it is true, lists no commissions and hardly any other assets, but the conclusions to be drawn from this are highly debatable (cf. Rufus Graves Mather, "Donatello debitore oltre la tomba," *Rivista d'arte*, XIX, 1937, pp. 181ff, and the *caveat* of the editors). On the other hand, we have not only the impressive group of works actually carried out by our master between 1454 and 1466 but the commissions he either abandoned or never started: the Siena Cathedral doors (see below, p. 206), the statue of S. Bernardino for the Loggia di S. Paolo, commissioned on July 8, 1458 (Gaetano Milanesi, *Documenti per la storia dell'arte senese*, II, Siena, 1854, pp. 310f), and the Arca di S. Anselmo for Mantua, which he had begun while still in Padua and which Ludovico Gonzaga was anxious to have him complete as late as 1458 (cf. the correspondence in Willielmo Bragghirolli, *Giornale di erudizione artistica*, II, Perugia, 1873, pp. 6ff). Nor can this list be regarded as complete. In any event, there seems to be no basis for a psychological interpretation of the FLORENTINUS in the Judith signature. The only other explanation—if an explanation is needed—would be that the Judith was destined for a patron outside of Florence. Unlikely as this sounds, the possibility is not to be dismissed out of hand. After all, the unchallenged belief that the statue was commissioned by either Cosimo or Piero de'Medici is no more than an inference based on the location of the Judith on Medici property, and our earliest hint of that dates from 1464 (the letter of condolence to Piero). Could not the Medici have taken over a project started under different auspices, or bought the finished statue? For all we know, the bronze David may not have been made for them, either (it surely was not made for the Medici Palace; see above, pp. 77ff). And since the Judith was cast in eleven pieces, Donatello could have made it in Florence with the intention of sending the various parts to their destination separately, just as he did in the case of the Siena St. John (see above, p. 197). Perhaps, then, the hint contained in the form of the signature is worth exploring a little further. Do we know of any commissions or projects for patrons outside Florence which Donatello had undertaken at this time, which are otherwise unaccounted for, and which might possibly be identical with the Judith? There is only one such case among the records so far discovered: in September 1457 Urbano da Cortona received

[5] Cf. Colasanti, p. 94. De Nicola, *loc.cit.*, has pointed out that one of the scenes, the crushing of the grapes in a vat, derives

from a Roman sarcophagus in the Camposanto, Pisa.

202

25 ducats from the chamberlain of the Siena Cathedral workshop, on behalf of Donatello in Florence, to buy bronze for a "half-figure of Goliath" (*mezza fighura di Guliatte*; Milanesi, *op.cit.*, p. 297). What could this have been? To judge from the rather large amount of money involved, it was quite a monumental "half-figure." But who would want a statue—let alone half a statue—of Goliath? Not even the Philistines, I dare say. In all mediaeval and Renaissance art there is, I believe, not a single instance of such a figure. Milanesi (*Cat.*, p. 19) thought the *mezza figura* might be the head of Goliath only, and tentatively linked the document with Donatello's bronze David. That, however, is clearly not an acceptable answer to our problem. As for the *mezza figura*, it does not mean a half-length figure but "half a statue" or "part of a statue," i.e. the particular piece to be cast with the 25 ducats' worth of bronze (cf. our discussion of the same term in one of the documents relating to the Siena St. John, above, p. 197). In other words, we here have a reference to a major bronze statue, part of which was ready to be cast in September 1457—a bronze statue supposedly of Goliath! Obviously there must be something wrong with this. The solution to the puzzle was suggested to me some years ago by Dr. Clarence Kennedy, who wondered whether *Guliatte* might not be a misspelling (or a misreading on Milanesi's part) for *Giuditta*. Even without imputing a downright mistake to Milanesi—I have not seen the original document—this idea seems to have a good deal of plausibility. The orthography of Quattrocento documents is often highly individualistic, especially in the case of proper names. And *Giuditta* frequently turns into *Giulitta* or *Giuletta* (Albertini, for instance, latinizes it to *Iulecta*). *Guliatte* seems at least as close to these variants of *Giuditta* as to *Golia*, the usual Italian version of Goliath. I have not explored the variants of *Golia*; the addition of an extra syllable, *te*, strikes me as entirely possible, but the stress would still be on the *i*, so that the doubling of the *t*, which tends to shift it (to *Guliàtte*) seems improbable. Perhaps the matter is incapable of exact proof or disproof. With this caution, Dr. Kennedy's idea can certainly be accepted as a working hypothesis, since it disposes of two problems at once: the FLORENTINUS of the Judith signature and the "Goliath" document, which had been a thorn in the flesh of Donatello scholars ever since its publication a hundred years ago.

Unfortunately, the *Guliatte-Giulitta* document contains no clue to the intended location of the statue; we cannot venture to guess, therefore, whether or not it was planned as a fountain figure from the very start. Could it have been destined for the Loggia di S. Paolo,

or perhaps the Fonte degli Ebrei? The symbolic implications of the subject admit a great variety of possible purposes. Certainly there is nothing about the statue itself that indicates a specifically Medicean origin. What Kauffmann (*D.*, pp. 167ff) has to say about the compositional and iconographic relationship of the Judith to the *psychomachia* tradition is true enough; the medallion with the rearing horse on the back of Holofernes does indeed brand him as the *Superbus* who is being cut down by the hand of Humility, in accordance with the second line of the inscription, *caesa vides humili*. . . . That the first line, juxtaposing *luxus* and *virtutes*, is equally important for the symbolic meaning of the statue, has been pointed out in a brilliant note by Edgar Wind (*Journal of the Warburg Institute*, I, 1937-1938, pp. 62f), who cites the *Rationale Divinorum officiorum* of Durandus (Lib. VI, cap. 128, No. 1). There the exploit of Judith is interpreted as the victory of *sanctimonia sive continentia* over the Devil, who weakens the *lascives mundi*; Holofernes' head is cut off because it represents *luxuria* or *superbia*, the start of all vices. This triumph of Continence over the Appetites of the Body, Wind notes, is conveyed by Donatello through the contrast between the almost nude Holofernes and the very fully clothed Judith. It also accounts for the cushion (not a wineskin, as maintained by Bertha Harris Wiles, *The Fountains of Florentine Sculptors* . . . , Cambridge, Mass., 1933, pp. 12f), which is the *pluma Sardanapalis*, a well-known attribute of *luxuria* representations, as well as for the Bacchanalian revels of the *putti* on the base, which stress Holofernes' own drunkenness.[6] However, the very fact that the symbolism of the two figures has such a well-established tradition behind it, means that our Judith could have been assigned the role of *sanctimonia-continentia-humilitas*, and the Holofernes of *luxuria-superbia*, as easily in Siena as in Florence. The Medici would then simply have utilized this symbolic import of the statue for their own purposes by associating *luxus* with monarchies and *virtutes* with city republics, just as they took advantage of the traditional pairing of Judith and David when they placed both the bronze David and the Judith of Donatello in their newly completed palace (see above, p. 83).

The degree to which the Judith reflects a mediaeval heritage may help to explain the extraordinary variety of opinions the figure has evoked since the Cinquecento. Vasari and Bocchi (*Eccellenza, loc.cit.*) saw her as the divinely inspired heroine, strong and confident of her purpose, while Schmarsow and Semper (*D.* '87), described her as hesitating before the first blow, horrified by the thought of what she is about

[6] Kauffmann's strained interpretation of these panels, which imputes a Eucharistic meaning to them, converts what is clearly meant as a statue of Bacchus (see our Pl. 98b) into a *Caritas*,

and views the small decorative figures in the frames as prophets and sibyls, has been rightly protested by Middeldorf, *AB*, p. 576, n. 9.

to do. Schottmüller (*D.*, p. 53), in contrast, thought the action was in full progress; she had observed a big jagged gash on Holofernes' neck and took this to mean that Judith had already struck the first blow and was about to strike the second, as described in the Apocrypha (*Judith* 13:10, "Et percussit bis . . ."). The choice of this particular moment, Schottmüller observed, seems almost brutal to the modern beholder. Karl Justi went even further; he is said to have compared the Judith to a butcher's wife.[7] Kauffmann, who rightly objected to this naturalistic interpretation, maintained that the gash in Holofernes' neck was a casting fault. Actually, it is part of the seam where the head (which has been cast separately, together with the left hand of Judith) meets the body; Donatello may have decided not to close the gap here because he thought it could not be seen, or because he liked the suggestion of a partly severed neck. Either view could be defended. But the question as Schottmüller posed it is an idle one; Donatello did not conceive the statue in terms of a specific phase of action. Judith is not glancing at her victim, and the sword is not aimed at Holofernes' neck but raised in a kind of ritual gesture. (Cf. the penetrating observations of Dagobert Frey, *Gotik und Renaissance . . .*, Augsburg, 1929, p. 143, who was the first to point out the mediaeval antecedents of the figure.) What makes her, nevertheless, a thoroughly "modern" creation for her time is her complete physical poise and, most of all, the intense inner life mirrored in her features. She has the same faraway look, the same trembling, half-open mouth we know from the St. John statues in Venice and Siena and the Giovannino Martelli, and her face, like theirs, expresses with penetrating insight a psychological state that skirts the borders of delirium.

The aesthetic effect of the statue has often been criticized. Reymond (*Sc. Fl.*, II, p. 120) felt that this was due to its "deplorable location" in the Loggia dei Lanzi, which prevents the beholder from enjoying at close range the wonderfully rich detail that constitutes the main charm of the work; the Judith, he asserts, is "faite pour décorer un boudoir." Dvořák, *loc.cit.*, also thought the overlapping of the two bodies awkward, but stressed the wealth of naturalistic observation as compensating for the lack of monumentality ("grosse statuarische Konzeption"). To Schottmüller, *loc.cit.*, the way the figures are combined seemed "surprisingly unskillful," an effect she attributed to the inherent limitations of Early Renaissance art; not until the Cinquecento could a compositional problem such as this be solved successfully. The most recent—and most intense—critique of the Judith is

that voiced by Ottavio Morisani (*Studi su Donatello*, Venice, 1952, pp. 161ff), who compares it most unfavorably to the Abraham and Isaac group from the Campanile and calls it "the triumph of literature over poetry." He seems to regard the shortcomings of the work as the result of a momentary lapse in Donatello's creative powers ("Per la prima e forse per l'ultima volta sentiamo il grande artista indeciso"). There is indeed something paradoxical about the group. The commission itself—a free-standing statue of the victorious Judith—does not account for this; had Donatello been given the same task twenty years earlier, he would surely have found a different, and more "normal," solution: a single figure analogous to the triumphant David (i.e. showing only the head of Holofernes) and similar in general appearance to the lost Dovizia of the Mercato Vecchio.[8] Instead, he chose to follow the mediaeval *psychomachia* tradition, with the victor standing on the vanquished, and to monumentalize it into a group that would force the beholder to look at it from all sides. In order to accomplish this aim, he had to relate the two bodies to each other in a manner radically different from that of his Abraham and Isaac group, where the boy, being so much smaller than his father, could be united with him in a single "column," as it were: he had to "interlock" them as closely as possible without sacrificing the dramatic contrast essential to his theme. His solution may be strained, but it is an extraordinary and impressive one for all that. The triangle of the base has become an integral part of the design; on it he superimposes the rectangular cushion as a kind of secondary base, and another, inverted, triangle formed by the thighs of Holofernes. The axis of Judith's body marks the exact center of this star-shaped "plan." This rational, geometric scheme, it seems to me, is highly characteristic of Florentine Early Renaissance art and demands to be judged on its own terms rather than those of Giambologna. Compared to the ideal of the *figura serpentinata* (of which the spiral twist of the Abraham and Isaac group is curiously prophetic) it appears rigid and static, but it also has its own unique virtues: the awesome solemnity of the Judith could not have been achieved in any other way. Perhaps the sixteenth century, which bestowed such lavish praise upon the statue, was better able to do justice to these qualities than we are.

The likelihood that the Judith was originally destined for Siena raises the intriguing problem of when and how it came into the possession of the Medici. The commission—if we accept the Kennedy hypothesis—must have come to Donatello not later than the

[7] The dictum is attributed to him, without citing a source, in Max Dvořák, *Geschichte der Italienischen Kunst*, Munich, 1927, p. 121.

[8] The latter is fully discussed by Kauffmann (*D.*, pp. 41f). Cf. also Werner Haftmann, *Das italienische Säulenmonument*, Leipzig, 1939, pp. 139ff.

beginning of 1457 (1456 seems a more probable date, considering the amount of work involved), for a part of the statue was ready to be cast in September. Since we may assume that the figure never left Florence, it is not unreasonable to conjecture that the project came to a halt before it was completed, for within the next two months Donatello took up residence in Siena and became completely absorbed in his work on the Cathedral doors. Then, some two years later, he broke with his Sienese patrons and returned to Florence, causing an amount of ill feeling in Siena that reverberated until the Cinquecento (see below, p. 207). The causes of this break are unknown; Kauffmann (*D.*, pp. 144f) seeks them in the behavior of the Sienese authorities, who may have taken on more commitments than they could carry through financially. This is entirely possible, but the legendary account of the matter in Vasari and his predecessors suggests a different explanation: that Donatello was enticed to abandon his Sienese projects by emissaries from Florence. Perhaps both factors were involved: Donatello was disappointed because things in Siena were not going as well as he had anticipated—he had felt the same way in Padua, and probably during his earlier Florentine years as well; his environment hardly ever matched his ambition—and at the same time there was mounting pressure on him from Florence. We know, as a matter of fact, that he did not stay in Siena during 1458-1459 for lack of opportunities to work elsewhere. Throughout the fall of 1458, and presumably before and after, too, Ludovico Gonzaga made strenuous efforts to entice him back to Mantua, to resume the project of the Arca di S. Anselmo. On August 18, Gianfrancesco Suardi, whom the Duke had asked to plead with Donatello, wrote to Ludovico from Siena that "Donatello has given me his firm promise to come [to Mantua] the end of this month, but I do not know if he will keep his promise, since he is *molto intricato*" (Braghirolli, *loc.cit.*). The exact meaning of *intricato* here is not easy to render; perhaps "tricky, difficult" comes closest to what the writer had in mind. In any case, it is the opposite of "straightforward," and may thus serve as a useful corrective to the image of Donatello's personality conveyed by his friend Matteo degli Organi in 1434 for the benefit of the Prato Cathedral authorities ("a man whose demands are modest and easily satisfied"; see above, p. 110) and to the simple-mindedness that Vasari claims for our artist. In his reply of August 25, Ludovico, with surprising forbearance, comments on Donatello's stubbornness (*ha un cervello facto a questo modo che se non viene de lì non li bisogna sperare*), asks Gianfrancesco to continue his efforts, and instructs him to give Donatello eight ducats if he should decide to come but not to bother him about the two ducats he already has, in the event that the master should remain obdurate. Finally, on November 7, the Duke sent a courier to Siena who was to try to bring Donatello back with him; the courier brought a letter from Ludovico asking the help of Cosimo de'Medici in this mission. Such a request from one head of state to another ought to have carried some weight. We do not know how Cosimo responded to it—presumably he had to make at least a gesture even if he did not favor the Duke's purpose—but Donatello was not to be swayed. The Arca di S. Anselmo and whatever else he was expected to do in Mantua (the Duke speaks of "some labors already started by Donatello") must have seemed less attractive to him than the Siena Cathedral doors. Yet a year or so later he did leave Siena, not for Mantua but for Florence. His difficulties with the Sienese may have developed during that interval. At the same time, however, it is likely that he was offered commissions in Florence of greater appeal to him than either the Arca di S. Anselmo or the Cathedral doors; and such offers could only have come from the Medici, since there is no hint of Donatello's having had any connection with the Opera del Duomo or any of the other public bodies in Florence during the final years of his life. But why, one wonders, were the Medici so eager to have him back at this point? The S. Lorenzo Pulpits may well have been the chief reason; the construction of the church was far enough advanced in 1461 for the high altar to be consecrated (the bays of the nave nearest the crossing were completed and in use by then), and the commission for the pulpits must be connected with this event. The Medici Palace, too, was approaching completion. It is tempting to think that Cosimo or Piero knew about the Judith Donatello had left behind unfinished—perhaps as a raw cast—when he moved to Siena in the fall of 1457; that they were anxious to acquire the statue as a fitting companion to the bronze David; and that, in order to make sure that Donatello would finish the Judith for them, rather than for the Sienese, they may have induced him by a bit of intrigue to "burn his bridges" by his precipitate departure from Siena. If I be permitted one final hypothesis, I should like to suggest the possibility that the triangular base, although contemplated from the start, was not actually modeled and cast until the master's return to Florence about 1460—hence the recurrence of the same or closely related motifs on the friezes of the S. Lorenzo Pulpits.

LAMENTATION, VICTORIA AND ALBERT MUSEUM, LONDON

PLATE 101 Bronze relief; H. 33.5 cm; W. 41.5 cm *(1458-1459)*

D O C U M E N T S : none (but see below)

S O U R C E S : none

The relief was acquired 1863 in London; its previous history is unknown (Eric Maclagan and Margaret Longhurst, *Catalogue of Italian Sculpture* . . . , 1932, No. 8552-1863, p. 38). It is clearly not an "untouched bronze casting," as claimed by Maclagan-Longhurst, *loc.cit.*, but shows evidence of considerable chasing, although the original quality of the wax model is still preserved to a remarkable degree. The peculiar silhouetting of the figures could not have been intended from the start (as observed by Middeldorf, *AB*, p. 579); apparently the cast, otherwise of good quality, turned out too thin, so that some of the more deeply recessed areas, as well as the entire background, were full of holes, thus obscuring the design of the relief. For that reason the background has been cut away, except for some small remnants (e.g. the "bridge" between the left elbow of the maenadlike woman and the halo of the St. John, and the "membranes" connecting the left elbow of Christ with the right knee of the St. John and linking the legs of the St. John from the top of the boots to the knee). The lower right-hand corner of the panel has also been cut off in the process.

Since its first appearance in the literature on Donatello—a brief mention in Semper (*D. '87*, p. 98) seems to be the earliest reference to it—the Lamentation has been accepted without dissent as a late work of Donatello. Most authors stress its relation to the Entombment on the Padua High Altar and date it about 1450 (Semper, *loc.cit.*; Schottmüller, *D.*, p. 106, n. 1; Schubring, *KdK*, p. 123; Cruttwell, *D.*, p. 111; Colasanti, *D.*, pl. cxcix). Maclagan-Longhurst place it "after 1450," Wilhelm Bode (*Denkmäler der Renaissance-Skulptur Toscanas*, Munich, 1892-1905, p. 38) and Kauffmann (*D.*, p. 184) at the end of the 1450's. The latter also suggests that the relief may in some way be related to the ill-fated commission for the bronze doors of Siena Cathedral, on which Donatello worked in 1458-1459 but which he then abandoned rather suddenly. What we know of his labors for this project is little enough. The commission seems to have originated in the fall of 1457, while the artist was at work on the bronze St. John. When the Balìa was petitioned, on October 17, to let him settle in Siena, where he wanted "to live and die," the purpose of his stay was defined as the embellishment of the Cathedral—probably an indirect reference to the doors, since the St. John was almost finished then (Gaetano

Milanesi, *Documenti per la storia dell'arte senese*, II, Siena, 1854, pp. 295f). On December 10 Donatello received 22 pounds of wax "per fare la storia de la porta," i.e. he was about to model one relief panel for the doors (Milanesi, *op.cit.*, p. 297). Further deliveries of wax continued through the next three months, and on March 20, 1458, the master received wire and iron for armatures in connection with his work on the doors (Milanesi, *loc.cit.*). The project must have been quite widely known by then, for on April 14 Leonardo Benvoglienti, writing to the *operaio* of the Cathedral from Rome, asked to have his regards conveyed to "Donatello, the master of the doors" (Milanesi, *op.cit.*, No. 210, p. 299). According to an entry in the account books of the Cathedral, on October 3 of the same year, the master had so far been paid a total of 304 lire 14 soldi through Urbano da Cortona in Florence (Milanesi, *loc.cit.*); since the purpose of the payments is not stated, we do not know whether this sum relates to the St. John, to the doors, or to both. Another entry, of 1459 (day and month not given) refers to payment for "a bed and pillow . . . in the possession of Donatello of Florence, who is doing the bronze doors"(Milanesi, *loc.cit.*). The last mention of Donatello in Siena dates from March 6, 1461 (Milanesi, *loc.cit.*, without citing the text of the notice). Pèleo Bacci (*Jacopo della Quercia* . . . , Siena, 1929, pp. 347f) has added some further items of documentary information to those unearthed by Milanesi. On October 20, 1458, Donatello was staying in the house previously inhabited by Jacopo della Quercia, on the Piazza Manetti, while at work on the bronze doors of the Cathedral; and an inventory of the Cathedral workshop, in 1467, describes "two panels . . . for the Cathedral doors, by Donatello, with figures of wax; one [panel] covered with wax, the other not" (*Duo quadri per disengno delle porti . . . con figure suvi di ciera, una cierata et una no*). The same two panels still appear in the inventory of 1480 and in some later ones not specified by Bacci (who notes that the artist's name gradually became corrupted to "Daniello"). He also cites an inventory of August 1, 1639, listing "a bronze demonstration panel for the Cathedral doors, with double molding, three quarters of a braccio in size" (*Un pezzo di bronzo a cornice doppia, fatta fare per mostra delle parti* [sic; = porte?] *del Duomo, di tre quarri di braccio*). Apparently this panel was not

sculptured but served merely as a sample of the size and format of the reliefs for the doors. Nor can we be certain that it was a relic of the Donatello doors—there might, after all, have been later efforts to revive the project.

Donatello, then, worked on the doors from late 1457 to 1459 (or perhaps even 1461), and produced at least two relief panels in wax. It seems not at all unlikely that during this period he also had one or more of the reliefs cast in bronze. What led him to abandon the commission and to return to Florence remains one of the most intriguing mysteries of his entire career. The event itself caused such a stir that it was remembered for a hundred years. The Anonimo Magliabechiano (ed. Frey, p. 78) records it as follows: "He also undertook to do a bronze door for the Sienese, and made a very beautiful design as well as the forms for the casting. But it so happened that a certain Benedetto di Monna Papera, a clever Florentine goldsmith who was a familiar of Donatello, came to visit him on his way back from Rome. On seeing this beautiful work in progress, he reproached Donatello for letting the Sienese pride themselves on so worthy a project, and knew how to sway him so completely that on a certain holiday, when the apprentices were away, he and Donatello undid and spoiled everything and left for Florence. The apprentices then returned to find the entire work ruined and Donatello gone, nor did they receive word from him until he arrived in Florence." In the first edition of the *Vite* (ed. Ricci, pp. 56f), Vasari retells the same story at greater length and with many embellishments, stressing Benedetto's hatred of the Sienese and his malign spirit, which knew how to take advantage of the simple mind of Donatello. The second edition (ed. Milanesi, p. 415), oddly enough, omits any reference to the destruction of the wax forms and reduces the elaborate tale to the simple statement that Benedetto induced Donatello to go back to Florence, leaving the work on the doors unfinished as if it had never been begun. The significance of this account does not lie in its "plot," which hardly inspires confidence, but in its general tone. We can gather from it what we know through the documents as well, that the project was well advanced when Donatello dropped it. Beyond that, the story probably contains other elements of truth. The master's decision to abandon the commission and to return to Florence may well have been a sudden one; it could have involved an emissary from Florence, someone whose role was no more sinister than that of Pagno di Lapo in 1433 (see above, p. 110) but who in the course of time became the villain of the piece; and the circumstances of the whole event seem to have been such that the Sienese, whose pride was deeply hurt, could put the blame on the jealousy of the Florentines. If the root of the trouble was financial (as suspected by Kauffmann, *D.*, pp. 144f), it would have been only human for them to cover up so unpleasant a fact by a less humiliating explanation.

All this has no specific bearing on the London Lamentation. Yet there are several arguments that seem to favor Kauffmann's hypothesis concerning the origin of the piece. The style—as distinct from the figure types, some of which occur not only in the Padua Entombment but also in that of the St. Peter's Tabernacle—strikes me as closer to the S. Lorenzo Pulpits than to the Paduan reliefs; the treatment of hair and drapery of the two women on the left recalls the fluid movement of the strands of hair in the Siena St. John; the Virgin's head is swathed in cloth much like that of the Judith, and the articulation of Christ's torso show similarities with the body of Holofernes. Even the conspicuous use of haloes indicates the late date of the work; Donatello usually omits them, or employs them as sparingly as possible, in pictorial compositions of this sort except in the S. Lorenzo Pulpits. Thus the Lamentation can be assigned to the end of the 1450's without any difficulty. Its dimensions —½ braccio by ¾ braccio—fit the bronze panel mentioned in the inventory of 1639, as Kauffmann has pointed out (*D.*, p. 254, n. 635; presumably the "three quarters of a braccio" refers to the long side of a rectangle). And the cutting away of the background, too, is best explained if we assume that the Lamentation was made as a trial panel for the Siena Cathedral doors. In view of the fact that Donatello was engaged in work on the doors for at least a year and a half and probably longer, it would be strange indeed if his labors had been confined entirely to modeling in wax. Surely the Cathedral authorities were anxious to see a sample of the reliefs actually cast in bronze, and the artist himself must have wanted to explore the local facilities for casting (presumably he intended to utilize the services of a bell founder or of a similar specialized craftsman, as he had done before). While we do not know the program of the doors, we may safely assume that it consisted of narrative scenes (*storie*) in rectangular frames comparable to the ensemble effect of Ghiberti's East Doors; for it was the "Gates of Paradise," we may be sure, that had fired the ambition of the Sienese to achieve an equally splendid set of doors, and Donatello's willingness to carry out the task inevitably placed him in the position of competing with Ghiberti's masterpiece, which had been unveiled during his absence and could not have failed to impress him when he first saw it *in situ* upon his return to Florence. His sense of rivalry with Ghiberti, of which we find evidence in earlier years (see above, pp. 69ff, 138), may well have made him regret his decision of 1443 to go to Padua instead of doing the sacristy doors

of Florence Cathedral (see above, p. 150), so that he welcomed the chance to recapture this lost opportunity under Sienese auspices. It is not impossible, as a matter of fact, that the Sienese decided to order a pair of bronze doors for their Cathedral very soon after the ceremonial installation of the Ghiberti doors in 1452, and that they approached Donatello with their plan while he was still in Padua, although without arriving at a formal commitment:[1] However that may be, Donatello's desire to become a permanent resident of Siena, as evidenced by the petition to the Balìa of October 1457, was surely motivated by the commission for the doors, which he may well have thought of as the crowning achievement of his career. The Life and Passion of Christ would have been a most suitable program, the Life of the Virgin even more so (the site was dedicated to S. Maria Assunta); in either case, the Lamentation would have formed part of the cycle. And if—as is likely—the choice of subject for the sample panel was left to the artist, Donatello would quite naturally have picked the Lamentation, as the only Passion scene that was part of his "repertory."[2] The emphasis on the women in our relief suggests that it was indeed conceived as part of a Life of the Virgin.

Another notable aspect of the work that supports our hypothesis is the physical shallowness of the modeling and the lack of an explicit spatial setting. The master's earlier *storie* in bronze—the Siena Feast of Herod, the Miracles of St. Anthony—show foreground figures so fully modeled that they can almost be detached from the panel; and while this is less true of the S. Lorenzo Pulpits, they, too, like their predecessors, have clearly defined exterior or interior settings. In the Lamentation, on the contrary, the background must have been blank; the composition consists entirely of the compact group of figures in the plane nearest the beholder. This treatment of bronze relief recurs only twice in Donatello's *œuvre*: in the doors of the Old Sacristy of S. Lorenzo—where the actual modeling is as shallow as in our piece—and on the base of the Judith. Apparently the master reserved it for the few occasions when he had to apply bronze reliefs to the surface of what he regarded as "solid objects," such as doors or bases, whose material reality

should not be challenged by vistas of illusionistic depth. If the Lamentation was not made as a door panel, we should be at a loss to explain why Donatello treated it as if it were.

The shallow modeling in itself does not help us to account for the casting holes that necessitated the cutting away of the background. There are, however, some further considerations to be kept in mind: Donatello's previous bronzes for Siena had been cast in Florence, even the St. John, but after taking up permanent residence in Siena late in 1457 he was obliged to have his casting done locally; if the Lamentation was a sample panel for the Cathedral doors, it was the artist's first Sienese cast, done by a founder with whom Donatello had not worked before, so that the chances of a mishap were greater than usual. It is also possible that Donatello had failed to make the body of the panel behind the figures as deep as he should have. In modeling the reliefs for the S. Lorenzo Pulpits, he placed the figures on a base consisting of heavy cloth soaked in wax (see below, p. 217); he may have tried the same technique in the Lamentation, without backing the cloth with enough layers of wax. In any event, the cast turned out to be full of holes. Ordinarily, such a piece would surely have been discarded as useless, since without a solid background it could not be mounted in the place for which it was intended. The fact that Donatello went to the trouble of cutting away the damaged background, strongly indicates that he needed the Lamentation as a demonstration object. By placing the silhouetted figures against a smooth bronze panel of the proper size, he could still give the Cathedral authorities a preview of the general effect of the doors. (Perhaps the panel listed in the inventory of 1637 was the one he used for this purpose.)[3]

The historical framework outlined above for the London Lamentation inevitably contains a good deal of speculation. On the other hand, it is not unworthy of the great aesthetic importance of the work. The quality of the modeling is so superior that this must be acknowledged as the only post-Paduan relief of which we may be sure that it was executed entirely by Donatello's own hand.

[1] Leonardo Benvoglienti, in his letter of April 1458, regrets that the previous *operaio* did not bring the "master of the doors" to Siena four years earlier, and quotes Donatello as having said that he would dearly love to come to Siena, so as not to die among those Paduan frogs, which he almost did.

[2] Strangely enough, his *œuvre* does not include any others, so far as we know, prior to the S. Lorenzo Pulpits; I am dis-

regarding here the Berlin Flagellation and the Medici Crucifixion, for which see below, pp. 240, 242.

[3] The original appearance of the Lamentation, before the faulty casting, is approximated by a stucco replica of uncertain date in which the background has been added (Florence, Museo Bardini; see *Dedalo*, IV, 1924, pp. 500, 506).

BRONZE TWIN PULPITS, S. LORENZO, FLORENCE

PLATES 102-120 *(c. 1460-1470)*

PLATES 102-110 NORTH PULPIT
 H. 137 cm; L. 280 cm

PLATES 111-120 SOUTH PULPIT
 H. 123 cm; L. 292 cm

DOCUMENTS

None relating to the commission or execution of the pulpits. The following entry in the account books of S. Lorenzo, concerning the decoration of the church for the visit of Leo X, was published by Domenico Moreni, *Continuazione delle memorie istoriche . . . di S. Lorenzo*, Florence, 1817, II, p. 447 (No. xxxvi) and reprinted in Semrau, *D.*, p. 5, n. 2 (excerpts also in Semper, *D.* '75, p. 315):

1515 (day and month not given): In order to adorn the church with every possible decoration, the bronze pulpits have been brought into the church. It has cost 4 lire 4 soldi to fetch the lesser one (*el Pergamo minore*), which was in separate pieces; and 4 florins to fetch the large bronze pulpit, to put it in order (*assettarlo*) and place it on a wooden platform (*palco*). Also 2 lire 4 soldi for making three sets of holes in the pilasters to support (*fermare*) the pulpits, and 14 lire for cleaning and washing the pulpits. A wooden support has been built for the pulpit of the singers (*Pergamo de'cantori*), as well as a wooden railing or screen (*spagliere*), so that it will hold the singers (*in modo fusse capace de cantori*). The lesser pulpit, too, has been given a wooden support—it is resting on pillars of wood—and stairs have been built for one of the pulpits.

SOURCES

(c. 1485) Vespasiano da Bisticci, *Vite di uomini illustri del secolo XV*, s.v. "Cosimo de'Medici" (Semper, *D.* '75, p. 313; translation, by William George and Emily Waters, London, 1926, p. 224): "He had a particular understanding for sculpture, being a generous patron of sculptors and of all worthy artists. He was a good friend of Donatello and of all painters and sculptors; and because in his time the sculptors found scanty employment, Cosimo, in order not to have Donatello be idle, commissioned him to do some bronze pulpits for S. Lorenzo and some doors which are in the sacristy. He ordered the bank to pay every week enough money for the master and his four assistants, and in this way supported him."

1510 Albertini, p. 11: "[In S. Lorenzo Donatello] made the two bronze pulpits for the Gospels and Epistles."

(Before 1530) Billi, pp. 40f (repeated in Cod. Magl., p. 76): "[In S. Lorenzo Donatello did] two bronze pulpits, which he did not finish."

1547, December 7, Baccio Bandinelli, letter to Cosimo I (Semper, *D.* '75, p. 315; Giovanni Bottari and Stefano Ticozzi, *Raccolta di lettere . . .*, I, Milan, 1822, pp. 71f): "When he did the pulpits and doors of bronze in S. Lorenzo for Cosimo il Vecchio, Donatello was so old that his eyesight no longer permitted him to judge them properly and to give them a beautiful finish; and although their conception is good, Donatello never did coarser work."

1549, August 17, Antonio Francesco Doni, letter to Alberto Lollio (Giovanni Bottari, *Raccolta di lettere . . .*, III, Rome, 1759, p. 236) mapping out a sight-seeing tour of Florence: ". . . Then spend a whole day viewing the wonderful things in the Medici church . . . and after you have seen the bronze pulpits go to have supper. . . ."

(c. 1550) Gelli, p. 58: "[Donatello] also did two bronze pulpits in [S. Lorenzo]."

1550 Vasari-Ricci, ɪ, pp. 60f (Milanesi, ɪ, p. 150), *De la scultura*: "The second kind of relief is called low relief, and the forms are modeled only half as high as in half-relief. In these one can legitimately show the floor, buildings, perspectives, stairs, and landscapes, as we see in the bronze pulpits of S. Lorenzo, and in all other low reliefs of Donatello."

Vasari-Ricci, p. 57 (Milanesi, p. 416): "[Donatello] also laid out (*ordinò*) the bronze pulpits in S. Lorenzo, showing the Passion of Christ. These have design, force, invention, and an abundance of figures and buildings. As he could no longer work on them because of his age, his pupil Bertoldo finished them and added the final touches."

ibid., p. 62 (Milanesi, p. 425): "To his pupil Bertoldo he left all his work, and especially the bronze pulpits of S. Lorenzo, which Bertoldo then chased and brought to their present state; they are to be seen in that church."

Vasari-Ricci, ɪᴠ, p. 393 (Milanesi, ᴠɪɪ, pp. 141f), *Vita* of Michelangelo: "At that time Lorenzo the Magnificent kept the sculptor Bertoldo in his garden on the Piazza di San Marco, not so much as a custodian of the many beautiful antiquities assembled there at great expense, but because he wanted most of all to create a school of excellent painters and sculptors, under the tutelage of Bertoldo, who had been a pupil of Donatello. Although Bertoldo was now so old that he could no longer work, he nonetheless was a master of great skill and reputation; he had not only chased the casts of the bronze pulpits by his master Donatello but had done a great many other things in bronze. . . ."

1558, 1565 Agostino Lapini, *Diario fiorentino* . . . , ed. Corazzini, Florence, 1900, p. 123 (Semper, *D.* '75, p. 314): "On Wednesday, March 15, 1558, the bronze pulpit with the Passion of Christ by Donatello was placed on the four porphyry columns towards the cloisters, in the church of S. Lorenzo; and in December 1565 the other one, which is across from it, was [also] raised."

1568 Vasari-Milanesi, ᴠɪɪ, pp. 313f, *Vita* of Michelangelo: "The pulpit from which Varchi delivered his funeral oration, which was later printed, had no decorations at all. Since it was of bronze and its scenes in half- and low-relief had been done by the excellent Donatello, any ornament in addition would have been far less beautiful. But the other pulpit, on the opposite side, which had not yet been raised on its columns, fittingly supported a painting 4 braccia tall . . . by Vincenzo Danti. . . ."

1591 Bocchi, pp. 250ff (Cinelli, pp. 508ff): "As we advance through the nave [of S. Lorenzo] towards the high altar, we find two rectangular pulpits against the piers of the crossing, each resting on four beautiful columns of varicolored marble. Their sides are bronze panels in low relief by Donatello, representing the Passion of Christ and other subjects, which are held by all to be extraordinary works, both for their design and their workmanship. At the head of the one to the right are the Apostles receiving the Holy Spirit; their draperies are marvelously arranged. The Virgin, with a cloth on her head, is the most beautiful figure of all, because of her expression; also highly praised is another figure, which turns its face towards the ground, as if blinded by the Divine radiance. It shows truly stupendous artistic power. Then, on the back, there follows the Martyrdom of St. Lawrence, done in a fitting and grand style. The very beautiful saint has another figure by his side, whose back is aflame; it could not be bolder or more beautiful, and experts have recognized its extreme greatness. In the center of the front side Donatello has represented the Savior in Limbo, liberating the Holy Fathers. Their faces clearly reflect their longing for Divine help; there is a woman who advances towards Him who has come to free her, with a movement full of the greatest imaginable eagerness. The St. John also faces Christ, and is splendidly posed. The adjoining panel shows Christ rising from his grave. It has a fine design and wonderful invention, as does the third scene, where the draperies and the gestures are equally extraordinary. In the next

panel we see the Marys at the Tomb; their bearing is sad, and yet they are graceful in their sorrow. One of them, who buries her face in her draperies to show her grief, is magnificently conceived.

"The left-hand pulpit contains scenes that ought to precede these according to the sequence of events. We shall nevertheless recount them here in this order. On the back, which faces the place where the Sacrament used to be kept, and is likewise by Donatello, there is the Savior praying in the Garden, with some disciples asleep near by. They are done with great care. Below, other disciples are sleeping, and the relaxation of their bodies is most admirable. The very beautiful draperies, and the supreme understanding with which they have been modeled, testify to the greatness of this noble artist. On the adjoining side we see Christ brought before Pilate. The Savior is a majestic figure, and Pilate's costume and boots are excellent and beautiful. In the foreground are the soldiers who have brought Christ before the judge and are eagerly awaiting the verdict. Next to this scene, under an arch, there is the Savior before Caiphas. He looks down in silence, and these figures are done with such art that they skillfully convey the Biblical story. Very fine is a group that clamors for Christ to be crucified, betraying wrath and fury as much as Christ exhibits gentleness and humility. One figure, half naked, is so agitated that he seems completely alive. There follows, on the main face of the pulpit, the story of Christ on the cross between the two thieves. Here the artist displays his great knowledge of the human body, not only in the Christ but also in the thieves, although all three are done extremely well. St. John, whose hair is streaming down over his eyes in delicate strands, presses his right hand to his face in a gesture of extreme anguish. His drapery is arranged over the nude body with rare skill. The expert particularly admires one of the Marys, who sits on the ground and tears her hair in desperate grief; she has been done with great insight. The other scene on the same side shows Christ taken from the cross. The Virgin, who mourns with great emotion as she holds the body of her son, is admirable throughout for design and understanding. One of the Marys, wringing her hands in grief, is much praised, as well as Nicodemus, supporting the body of Christ, an equally fine figure. On the side towards the choir we see the Entombment of Christ. One figure, holding the knees of Christ, is exceptionally lifelike and shows great skill. Many other figures are of admirable design and most harmonious proportion. But especially praised is one of the Marys, who sits on the ground with one hand on her knee, and with her hair disheveled. She expresses the great inner grief that has seized her. Another figure, in tight-fitting drapery, vividly displays her extreme disconsolation."

The early history of the pulpits remains uncertain. Semper (D. '87, p. 103) and Semrau (D., pp. 5f) assumed that the individual pieces were put together for the first time in 1515, and even then only in a provisional manner, so that the final installation did not take place until 1558 for the North Pulpit and 1565 for the South Pulpit.[1] Kauffmann (D., pp. 177ff) and Paatz (op.cit., pp. 555f, n. 156), on the other hand, believe that the pulpits must have been assembled and on public view before 1510—and perhaps a good deal earlier—because of Albertini's reference to them,

which implies definite locations. (In describing them as "for the Gospels and Epistles," Albertini means either that they were actually being used for such readings or that they could be so used; whichever interpretation we prefer, his use of those two terms indicates that the pulpits stood on opposite sides of the church.) But what of the document of 1515? Paatz, loc.cit., has suggested that it probably concerns two different, otherwise unknown pulpits, since it speaks of a lesser and a large pulpit while Donatello's are of the same size.[2] Their length, to be sure, is practically

[1] The terms used in the literature for differentiating the two pulpits vary a good deal; Semrau, D., refers to them as "R" and "L," right and left as seen from the altar, while Cruttwell (D., pp. 122ff) and Paatz (Kirchen, II, p. 494) use the same terms in relation to a beholder entering the church and walking towards the altar. Schubring (KdK, pp. 141ff) identifies them as the pulpit on the south and north side of the nave, respectively, south being to our right as we face the altar. I am continuing the same practice here, even though S. Lorenzo

is a "disoriented" building, with its façade towards the east, so that what would ordinarily be the south aisle is the north aisle in this instance. Since, however, the temptation to think of the interior of S. Lorenzo as if it were properly oriented is almost overwhelming, it seems simplest to retain Schubring's "theological" north-south terminology. Surely the liturgy as practiced in disoriented churches is not revised with reference to the North Pole!

[2] Amusingly enough, Middeldorf, whom Paatz credits with

identical, but the difference in height is noticeable enough to justify the language of the document, quite aside from the extreme improbability that there ever were two other bronze pulpits in S. Lorenzo of which we learn only through this single reference. We may take it for granted, then, that the two pulpits that were "brought into the church" in 1515 are indeed ours. Nor can there be much doubt that the installation to which the document refers was a makeshift one for this particular occasion. Exactly where the pulpits were erected at that time cannot be inferred from the document; perhaps they occupied the same places where they had stood when Albertini saw them five to ten years earlier. Why had they been removed about 1510? The history of the church, so far as we know it today, does not relate any activities, structural or decorative, at that time, so that we are left without a possible clue. It may not be unreasonable, however, to assume that the installation witnessed by Albertini was the original one, dating from the 1470's; that this installation had been made rather hastily, inasmuch as the pulpits themselves give the impression of having been completed in something of a hurry after Donatello's death (see below); and that they were dismantled about 1510 in order to permit the construction of more permanent supports for them. Under those circumstances it would not be surprising that they were temporarily "called back into service" for the visit of Leo X. They belonged to the permanent stock of interior furnishings, seen and admired by many in previous years, and the Pontiff might well be expected to note their absence unfavorably. If, on the contrary, we assume that the pulpits had never been assembled before, it is difficult to understand why the canons of S. Lorenzo took the risk of having them put together at a time when everybody was working against the deadline of the impending arrival of Leo X. After all, how could they be sure that all the pieces were still there, after lying neglected in some musty storeroom for almost half a century, and would fit together properly? And how were they able to decide in advance that one of the pulpits was to be used for singers? This, too, indicates that they had seen the pulpits assembled before and could visualize their size and appearance beforehand.

After the Papal visit of 1515, the problem of the permanent installation of the pulpits appears to have been overshadowed, for several decades, by all the new, ambitious projects for the embellishment of S. Lorenzo. Nevertheless, as Kauffmann has pointed out (*loc.cit.*), they must have remained on public view,

to judge from the way Vasari speaks of them in the first edition of the *Vite* (see also the Doni letter of 1549 cited above). Finally, in 1558, the "large" or North Pulpit was placed on the marble platform and colored marble columns (Lapini loosely refers to them as "porphyry") that support it today. At the time of Michelangelo's funeral—July 14, 1564—the other pulpit, according to Vasari, was either resting temporarily on the floor of the church or on some sort of wooden base. In any case, it was fully assembled, rather than in pieces, since it supported a large painting. At the end of the following year it, too, was lifted onto a marble platform and columns.[3] Yet the location of the two pulpits at that time was not the present one. Kauffmann has observed that the rear side of both marble platforms shows an indentation—now filled in—90 cm wide and 30 cm deep, which exactly fits the width and depth of the pilasters attached to the crossing piers, proving that in the installation of 1558-1565 the two pulpits were, so to speak, wrapped around these pilasters. Kauffmann also found visual representations of them in this position—they were attached to the pilasters facing the nave—in Buontalenti's plan of the church, 1574, and in two Callot etchings showing the interior, of 1610 and 1619, respectively, while a print by Stefano della Bella of 1637 shows the pulpits as they are today, standing detached in the openings of the nave arcade next to the crossing. It was not until 1619-1637, then, that they were moved to their present places, and the openings in back closed with wooden relief panels of inferior workmanship. These had long been recognized as later additions, but nineteenth century scholars generally had believed them to be replacements for Donatello panels that had either been lost or never executed. (Thus still Wilhelm Bode, *Denkmäler der Renaissance-Skulptur Toscanas*, Munich, 1892-1905, p. 39.) Semrau (*D.*, pp. 9ff) was the first to claim, and to prove in cogent fashion, that the pulpits as we see them today are substantially complete. That the rear side was intended to have only one relief—the Agony in the Garden in the North Pulpit, the Martyrdom of St. Lawrence in the South Pulpit—is evident from the technical and aesthetic treatment of the free edge of these panels, as well as from the iconographic context: the Agony in the Garden is the logical starting point of the Passion cycle, which ends in the Pentecost, with the Martyrdom of St. Lawrence added as a tribute to the titular saint of the church. (The Passion scenes among the wooden panels added in the early seventeenth century —the Flagellation and the Crowning of Thorns—are

this observation, had himself spoken of "the large pulpit"— i.e., the North Pulpit—in his review of Kauffmann's book, *AB*, p. 574.

[3] Semrau, *D.*, p. 7, notes slight differences in the material

of the two sets of columns; Kauffmann, *D.*, p. 251, n. 599, cites stylistic parallels to the capitals in mid-sixteenth century Florentine architecture.

completely out of place and illustrate the difficulty of "completing" the program of the pulpits.) The discoveries of Kauffmann fully bear out Semrau's claim: The free edge of the Agony and St. Lawrence panels coincides exactly with the start of the indentation on the back of the marble platform, a clear indication that the pulpits were meant to be attached to the pilasters of the crossing piers from the very start. The space now occupied by the Flagellation and the Crowning of Thorns had been left open as the entrance to the pulpits.[4]

About the intended function of the pulpits Semrau has little to say. Albertini's testimony that they were "for the Gospels and Epistles" he dismisses as a "gelehrte Reminiscenz" without real meaning; after all, he argues, the pulpits had not even been put together when Albertini wrote about them. Semrau then compares the S. Lorenzo Pulpits with the mediaeval *ambones* of Roman churches (S. Clemente, S. Lorenzo fuori le mura, S. Maria in Aracoeli) and concludes that there is no possible connection; the Roman twin pulpits differ from ours not only in shape and in the character of the decoration (which is purely ornamental), but the *ambo* for the reading of the Gospels is always larger and more elaborate, while the S. Lorenzo Pulpits show no such differentiation. Moreover, Semrau adds, the true *ambones* are placed parallel to the axis of the nave, whereas the Donatello pulpits were probably meant to be attached to the choir screen, along the axis of the transept. He then links the S. Lorenzo Pulpits with the sculptured pulpits of the Tuscan Romanesque. These, however, are all individual pulpits, rather than *ambones*, and Semrau makes no attempt to explain why Donatello was asked to do two pulpits instead of one. The latter question was raised for the first time by Kauffmann, who arrives at the rather astounding answer that they must have been planned, not as pulpits but as *cantorie* like those of Luca della Robbia and Donatello in Florence Cathedral. Such galleries for singers and musicians are usually paired, while regular pulpits rarely are (he dismisses most *ambones* as too small to serve as precedents for the S. Lorenzo Pulpits). And does not the document of 1515 speak of the "large" pulpit as being for the singers? True enough—there can be no question that the "large" pulpit was used to hold singers in 1515, but the language of the document also suggests that this was not its original purpose, as pointed out by Semrau, *D.*, p. 6 (a railing or screen of wooden slats had to be built in order to make the pulpit fit for singers). Kauffmann admits, furthermore, that a true

cantoria was built in S. Lorenzo before 1465,[5] a circumstance that hardly strengthens his case. Neither does the iconographic program of our pulpits. Here Kauffmann resorts to the very weak argument that the Passion cycle is fully compatible with *cantorie* because it occurs on choir screens and the latter could serve as singers' galleries. At the same time, he feels that the function of the pulpits as *cantorie* is reflected in the dancing and music-making *putti* of the friezes above the Passion scenes. There are indeed a few dancing and music-making *putti* on the friezes, but they are clearly incidental to the Bacchanalian scenes enacted here (see below, p. 216) and in no way justify Kauffmann's claim that they are "late descendants of Donatello's Cantoria."

It seems strange that Kauffmann should have followed Semrau in attaching so little significance to Albertini's characterization of the pulpits, for his important findings concerning their physical history had removed one of Semrau's main arguments against them as true *ambones*, i.e. their intended location within the church. If Kauffmann is correct in this respect—and to me his arguments are most persuasive—he has established beyond reasonable doubt that the pulpits were meant from the very start to be placed parallel to the axis of the nave. Why, then, does he find it so difficult to believe that they were indeed "for the Gospels and the Epistles"? True, there are no twin pulpits of any sort among the surviving monuments of Tuscan mediaeval art (nor, so far as I can determine, were there any in Donatello's day), and the *ambones* of Roman churches are smaller than our pulpits and have no sculptural *décor*. Yet richly sculptured mediaeval *ambones* did exist in Italy, even though the only preserved specimen, that of the Cathedral at Cagliari in Sardinia, is not likely to have inspired the S. Lorenzo Pulpits. And should one not assume that Albertini, as a canon of S. Lorenzo, wrote with particular authority about the purpose of our pulpits? What prevented Kauffmann from accepting Albertini's word at face value was, I suspect, the "promediaeval" bias that had tripped him before (cf. especially above, p. 172); he wanted to see our pulpits as survivals of the Middle Ages, backed by a continuous tradition, and this tradition did not exist, *ambones* having gone out of style with the advent of the Gothic era in Italy. Apparently it never occurred to him that the S. Lorenzo Pulpits might be a Renaissance revival of an Early Christian tradition, although this, it seems to me, would be the natural way to approach them, considering their time and place. It is

[4] This also disposes of Semrau's speculations about the place for which the pulpits were originally intended (*D.*, pp. 18ff; he thought they were meant to be attached to the choir enclosure that Brunelleschi had planned for the crossing but abandoned in 1442; cf. Paatz, *loc.cit.*, p. 466).

[5] This is situated above the door leading from the left aisle to the cloister. Reflecting the design of Donatello's Cantoria in the Cathedral, it was therefore often claimed for the master by older scholars; cf. above, p. 126.

also exactly what Albertini's testimony suggests. Semrau was not entirely wrong when he characterized the words of Albertini as a "learned reminiscence"; they do, after all, presuppose a familiarity with the function of twin pulpits. Such knowledge was easily available, since Early Christian and mediaeval liturgical writings contain abundant references to the reading of the Gospels and Epistles, with precise instructions for the right method to follow. Once we recall the widely shared interest among Early Renaissance humanists in the editing and translating of patristic literature, it can hardly surprise us if occasional attempts were made to revive "old-fashioned" liturgical practices such as the reading of the Gospels and Epistles from twin pulpits. In fact, S. Lorenzo, the architectural embodiment of the new era, would seem to be the ideal setting for an experiment of this sort. If our hypothesis is right (it needs to be tested against the voluminous but largely neglected theological writings of the Florentine humanists of the time), the commission for the S. Lorenzo *ambones* was inspired, not by direct visual precedents but by literary sources. Donatello, who had to translate the idea into concrete physical reality, may well have recalled the Roman *ambones*, which he had surely seen in earlier years, but they could serve him as a prototype only in a very general sense; the shape and size, the iconographic program, and the manner of installation, necessarily had to be determined *at hoc*.

Although the large panels of the pulpits form a self-sufficient cycle, the choice and distribution of the scenes is not self-explanatory. Neither Semrau nor Kauffmann have dealt with this problem, even though a study of the program of the pulpits might be expected to have an important bearing on the question of their function: whether they were made for sermons, for singers and musicians, or "for the Gospels and Epistles." One of my former students, Irving Lavin, undertook to analyze the iconography of the Passion cycle on the S. Lorenzo Pulpits on the basis of Albertini's statement as part of his thesis for the degree of Master of Arts some years ago (*The Sources of Donatello's Bronze Pulpits in S. Lorenzo*, New York University, October 1951, typescript, pp. 74-89). The striking results of this study will be published independently, I hope, and can be summarized here only in briefest outline. Lavin begins by asking which side of the nave—and consequently, which pulpit—was used for reading the Gospels and Epistles, respectively, and shows that the North Pulpit must have been intended for the Gospels, the South Pulpit for the Epistles. The choice of scenes in the first represents what might be called the Passion proper, from the Agony in the Garden to the Entombment, and thus conveys to the beholder Christ's sacrifice and its promise of Salvation,

while the second shows the fulfillment of the promise in Christ's actions after his death. The dominant Eucharistic theme, according to Lavin, relates both pulpits to the altar as the symbolic center that unites the two parts of the program. In this context Lavin also explains the omission of those Passion scenes that would ordinarily belong to the cycle, as well as the resemblance of the two pulpits as a whole to sarcophagi. (The program of the South Pulpit, he points out, is closely analogous to that of such Trecento tombs as those of Cardinal Petroni in Siena Cathedral and of Gastone della Torre in S. Croce, by Tino di Camaino, which show the Resurrection in the center of the sarcophagus, between the *Noli me tangere* and the Doubting Thomas, with the Three Marys at the Tomb on the left flank and the Meeting at Emmaus on the right. In the South Pulpit, too, the Three Marys appear on the left flank and the Resurrection in the center of the main side; the other scenes have been changed so as to stress the Salvation of all mankind, rather than of the individual.)

When were the S. Lorenzo Pulpits commissioned? The sources contain no information on this point. (Vespasiano da Bisticci, who mentions the pulpits and the bronze doors of the Old Sacristy in the same breath, need not have meant to imply that they were all commissioned at the same time.) C. J. Cavallucci (*Vita ed opere di Donatello*, Milan, 1886, pp. 28ff) believed the pulpits to have been conceived together with the sculptural decoration of the Old Sacristy, about 1442, because of certain architectural details in the South Pulpit. Semrau (*D.*, p. 24) rightly rejected this argument but not the conclusion; he, too, assumed that the pulpits must have been planned prior to 1442 (since they supposedly were part of the choir enclosure as designed by Brunelleschi before the modification of 1442), although no actual work was done on them until after Donatello's return from Padua. Now that we know—thanks to Kauffmann—that the pulpits were intended from the outset to be attached to the crossing piers in the nave, we can dismiss the possibility of their having been planned at so early a date. For the construction of the church had been halted in 1425, before the walls of the choir chapel had reached their full height, and was not resumed until the latter half of 1442. The transept and the crossing—but not the dome—were largely completed at the time of Brunelleschi's death in 1446 (see Paatz, *op.cit.*, p. 466). Thus Donatello witnessed only the first year of this renewed building activity before his departure for Padua, and during that phase, from all indications, the energies of Cosimo de'Medici and his fellow patrons were concentrated on financing the construction of the church. It is almost inconceivable, therefore, that they gave any thought to the interior en-

richment of a nave, then still nonexistent. The first two bays of the nave arcade (on the north side) were erected between 1447 and 1449 (Paatz, *op.cit.*, pp. 524f, n. 24). Donatello thus could have been given the commission for the pulpits at any time after his return to Tuscany in 1454. Certainly by 1457 construction of the church had advanced to a point where it became possible to anticipate the completion of the western half of the interior within a few years. Yet at that very time Donatello became a resident of Siena, a clear indication that he had no major commission such as the pulpits to keep him in Florence (cf. above, pp. 205ff). There is thus every reason to believe that he did not receive the order for the pulpits until his return from Siena about 1460 (indeed, the commission may have been one of the reasons why he broke with the Sienese). This is the view shared by every Donatello scholar of the past fifty years.

That the master did not live to complete the pulpits is attested by the Libro of Antonio Billi and subsequent sources. In addition to Bertoldo, named by Vasari, Semrau credited Bellano and, possibly, two unknown masters with significant shares in executing—and to some extent even designing—the portions of the work left unfinished at Donatello's death (Vespasiano da Bisticci had mentioned four assistants). To determine how much was done by these lesser men in relation to Donatello's own contribution, has turned out to be an extremely thorny problem, and the variety of scholarly opinion on the subject is correspondingly great. Tschudi (*D.*, pp. 27f) and Semper (*D. '87*, pp. 105ff) praised both pulpits highly and minimized the weaknesses of detail, which they thought did not really interfere with the magnificent impact of the work as a whole. Schmarsow (*D.*, pp. 48f), on the other hand, believed it possible to distinguish Bertoldo's share in the design of the pulpits, and credited him with the friezes and with the Martyrdom of St. Lawrence. Reymond (*Sc. Fl.*, II, pp. 145ff) agreed with the view of Tschudi and Semper, although Donatello's own modeling, he felt, could be seen better in the North Pulpit. Cruttwell (*D.*, p. 124), too, saw Bertoldo's share largely confined to the South Pulpit. Bode (*Denkmäler, loc.cit.*), in contrast, emphasized the poor quality of the execution throughout; he believed that Donatello himself had designed every

panel as well as the *putto* friezes but had taken no part in the actual modeling anywhere, thus permitting his inept assistants to do grave damage to his sketches, which must have looked like the "Forzori Altar" in London (cf. below, pp. 244ff). Among the executants, according to Bode, the hand of Bellano stands out most clearly—he did the Agony in the Garden, the Crucifixion, and the Pentecost. To Bertoldo Bode assigns part of the friezes, the Martyrdom of St. Lawrence, and (together with Bellano) the double scene of Christ before Pilate and Caiphas. A third master executed the Lamentation and Entombment, and perhaps the Resurrection and Ascension, while the Marys at the Tomb betray yet another hand, of particular clumsiness.

Semrau begins his elaborate and discursive analysis of the pulpits with a technical examination (pp. 26ff), which leads him to conclude that the South Pulpit is the more fully integrated of the two, technically as well as artistically. The *putto* frieze of its main face was clearly the model for that of the North Pulpit, where the horse tamers at the corners have been replaced by paired vases plus one additional *putto* on the left and two on the right. This means that only the South Pulpit has the full length originally intended for both pulpits (292 cm, or almost exactly 5 braccia, as against 280 cm). The three scenes of its main face with their architectural divisions are cast as a single piece; they are also the only area to show traces of gilt. On the North Pulpit, in contrast, not all the pilasters dividing the scenes are cast together with the panels they frame; the pilasters on either side of the Lamentation and of the Entombment are cast individually. The latter panels, Semrau infers, must have been cast before the architectural framework of the North Pulpit as a whole was definitely fixed; and Donatello himself cannot be held responsible for this framework, which is far too strict for him (p. 54). Moreover, the elaborate ornament on the cornice is clearly a device of the late Quattrocento.[6] Thus the South Pulpit as a whole, Semrau maintains, is definitely closer to Donatello's original intention than its companion, a fact also conveyed by the signature on the frieze, which may be posthumous but was surely meant for the pulpit as a whole, rather than specifically for the frieze.[7] The picture that finally emerges, after

[6] This is not correct; Lavin (*op.cit.*, p. 70) points out that the same motif, in somewhat richer form, occurs on the building in the middle ground of Mantegna's Martyrdom of St. Christopher in the Eremitani. It must have originated there, for the motif—a very distinctive one—fits perfectly into the Mantegnesque repertory of similar forms but is decidedly alien to Donatello's ornamental tastes. What conclusions are to be drawn from Lavin's discovery remains debatable. I find it difficult to believe that Donatello himself came back from Padua with a drawing after Mantegna's motif and put it to work, as it were, some ten years later. More likely, the cornice is a posthumous

addition to the North Pulpit by an artisan thoroughly conversant with Mantegnesque ornament.

[7] That the inscription is indeed posthumous is suggested by its poor epigraphic quality in comparison with the signature on the Judith and by the fact that it includes the designation FLO[RENTINI], which in the case of the Judith may be explained by the probable Sienese destination of the work as pointed out above, pp. 202f; since not only the formula of the inscription but the Bacchanalian *putto* motifs seem inspired by the Judith, I am inclined to believe that the entire frieze was designed after Donatello's death by an assistant—not neces-

some 200 pages, from Semrau's discussion of the style of the pulpits, may be summarized as follows: the three scenes on the front of the South Pulpit were designed and executed by Donatello directly, with only a few minor passages by Bertoldo. The same is true of the Lamentation on the North Pulpit, except that here Bertoldo's share is larger, especially in the background. Bertoldo then independently designed and executed the *putto* frieze above the front of the South Pulpit (which became the model for the other parts of the friezes on both pulpits) and the Entombment. The Martyrdom of St. Lawrence is in part by Bertoldo. A number of years later Bellano took over the unfinished project and completed it as best he could by designing and executing the entire framework of the North Pulpit as well as the missing Passion scenes for it, i.e. the Crucifixion, the Agony in the Garden, and Christ before Pilate and Caiphas (the latter with the aid of some sort of sketch by Donatello). He also did the lateral panels for the South Pulpit: the Pentecost independently, the Marys at the Tomb based on a Donatello design.[8] Donatello scholars, handicapped by inadequate photographs (the pulpits are too high above the floor and too poorly lit for detailed inspection), could not challenge Semrau point by point. While acknowledging the participation of Bellano, as well as of Bertoldo and perhaps others, they have tended to see the underlying conception of Donatello in both pulpits as a whole, and in every

one of the large panels, although to a greatly varying degree. (Thus Bode, *loc.cit.*; Meyer, *D.*, p. 111; Schottmüller, *D.*, p. 32, n. 1; Schubring, *KdK*, p. lii; Bertaux, *D.*, p. 180ff; Colasanti, *D.*, pp. 74ff; Kauffmann, *loc.cit.*; Planiscig, *D.*, p. 128.) To assign any of the balustrade reliefs independently to Bertoldo or Bellano does indeed seem impossible; neither master, in his other known works, gives evidence of the inventive power that would be necessary to sustain Semrau's claims. Nor, it seems to me, can one pulpit be clearly ranked above the other in terms of closeness to Donatello's intentions; the unexampled boldness of the South Pulpit in the relation of the figures to their architectural framework does not mean that the organization of the North Pulpit, which recalls the St. Anthony panels in Padua, was not also conceived by Donatello (cf. Kauffmann, *D.*, p. 191). Every one of the balustrade panels has both its splendors and its miseries: details of extraordinary clumsiness (e.g. the Christ and the trees in the Agony in the Garden, or the angel entering from the right in the Martyrdom of St. Lawrence) and mechanically neat, "blank" surfaces, stand beside figures of unforgettable expressive force. Whether it will ever be possible to gain a precise understanding of the relationship between conception and execution in every panel, I shall not presume to say. The full photographic record of the pulpits now available, thanks to the devoted labor of Jenö Lányi, will in any event open up the way for such a study.

sarily, or even probably, Bertoldo—who added the horse tamers and centaurs as further classical details. The various *putto* groups are static, symmetrical, and repetitious compared to those on the base of the Judith, so that from the point of view of style there is no reason at all to assume that Donatello invented them; they are far too "tame" and classicizing for him. One need only compare the *putti* sarcophagus in the Camposanto, Pisa, which served as the source of the scenes on the Judith base (see above, p. 202), with the corresponding subjects on the pulpit friezes, in order to realize how much more literally the latter imitate their classical model. The *putto* scenes to the right of the centaurs—adoration of a *putto* on pedestal and raising of a herm—are equally close to their model, a sarcophagus of the type represented by a specimen in the Princeton University Art Museum (published by Ludwig Curtius, *Jahreshefte des Oesterreichischen Archäologischen Instituts*, XXXVI, 1946, pp. 76f); and the same, one suspects, holds true of the two scenes on the left—*putti* sailing on a raft and reclining under a palm tree—although their classical prototype remains to be discovered. Cf. the ancient material for all the frieze subjects cited by Semrau (*D.*, pp. 182ff), correcting the earlier analysis of Franz Wickhoff (*Mittheilungen des Instituts für östreichische Geschichtsforschung*, III, pp. 417ff). Semrau also discovered that one of the scenes, the adoration of the *putto* on a pedestal, is repeated twice on the frieze below the sarcophagus on the tomb of Francesco Sassetti (cf. Aby Warburg, *Gesammelte Schriften*, Leipzig-Berlin, 1932, I, pp. 152ff), in the midst of all sorts of other pagan subjects that seem to bear no relation to the Christian decoration above. That, it seems to me, is the spirit of the pulpit friezes as well. To charge these *putto* scenes with a profound Eucharistic symbolism (Kauffmann, *D.*, p. 185) is no more justified than in the case of the Judith base. Still, the latter does have a meaning

in relation to the main theme of the work (see above, p. 203), while the *putto* friezes have none unless we are willing to find a measure of significance in the circumstance that they seem to be composed entirely of motifs taken from ancient sarcophagi (for the centaurs and horse tamers, cf. the specimens in Solomon Reinach, *Repertoire de reliefs* . . . , III, Paris, 1912, pp. 108, no. 4; 118, no. 1; and 123, no. 2; all of them in the Camposanto, Pisa). If these subjects were regarded as having a sort of generic funerary flavor during the later Quattrocento (as suggested by their recurrence on the Sassetti Tomb), they might have been chosen as appropriate both to the sarcophagus-like shape of our pulpits and to the theme of the death and resurrection of Christ. More probably, the friezes betray nothing more profound than a taste for decorative motifs "quoted" from the antique which first arose in Northeastern Italy with Pisanello, Jacopo Bellini and Mantegna but did not become widespread in Florence until about 1470. In the œuvre of Donatello the only details at all comparable to the pulpit friezes are the nude, winged genii decorating the "classical" furniture of the Evangelist *tondi* in the Old Sacristy, but these, like the Judith base, have all the dynamic, imaginative qualities so conspicuously lacking in the pulpit friezes. The only motif on the pulpit friezes that has a direct counterpart in the master's previous work are the vases, which recall those on the cornice of the Cantoria—hardly a sufficient basis for insisting that he designed, or planned, the entire scheme.

[8] The subsequent Bellano literature has placed considerable reliance in Semrau's findings. Alessandro Scrinzi, (*L'Arte*, XXIX, 1926, pp. 248ff) claims the Crucifixion, the Pentecost, and the Marys at the Tomb for Bellano; Sergio Bettini (*Rivista d'arte*, XIII, 1931, pp. 45ff) credits him with the Crucifixion, the Pentecost, and the Agony in the Garden.

How are we to visualize the kind of sketch Donatello turned over—or left—to his assistants? Did they work from drawings? The fact that persistent search over the past seventy-five years has failed to turn up a single drawing that can be convincingly attributed to our master, makes us wonder whether drawings really played a significant part in the preparation of his statues and reliefs. He undoubtedly was called upon on occasion to submit formal drawings of such projects as the Padua High Altar to his patrons, but their function was not a creative one; they served merely to fix and record, for contractual purposes, a design already well worked out. About Donatello drawings of a more direct and spontaneous kind we have no documented information at all; the anecdote in Pomponio Gaurico's *De sculptura* of how Donatello, with incredible speed, filled a sheet with sketches of figures for a visitor who had asked to see the master's *abacus* (canon of ideal proportions), must be regarded as paradigmatic rather than as historically accurate, and the claims of Vasari and Vincenzo Borghini to have owned drawings by Donatello may very well be mistaken. Did Donatello then make plastic sketches in clay or wax instead of drawings? Here again no authentic examples have come down to us,[9] but in the case of large-scale commissions it seems to me almost inevitable that such small models should have preceded the actual execution. This is probably true of our pulpits as well. Yet I suspect that most, and possibly all, of the balustrade panels existed not merely in the form of small-scale sketches at the time of the master's death; what his assistants inherited were the actual wax reliefs intended for the foundry, in varying stages of completion. Bertoldo, Bellano, *et al.*, thus faced the task of "filling in," of elaborating and articulating those portions which Donatello had only roughed out or, in some instances, left entirely blank. There was no panel, I believe, that did not need some further work of this sort, but for several of them the necessary "editing" amounted to very little; in this group I should place the Lamentation, the Descent into Limbo, and the Resurrection. The least fully developed scenes were the Ascension and the Pentecost. The others range somewhere in between these two extremes. For purposes of analysis, the panels belonging to this intermediate group are perhaps the most instructive; it is here that *les extrèmes se touchent*. In some spots we can still see the texture of the canvas that served as the background of the relief, e.g. between the two trees above the sleeping St. Peter in the Agony in the Garden (Pl. 103), or in the background of the Christ before Caiphas (Pl. 105b). The group of Christ and his captors in the latter scene represents, I think, the state of the panel as it was when Donatello's assistants took it over, and before they started "articulating" the details. The same is true of the wonderful groups of onlookers in the two lunettes (Pl. 105), of the reliefs on the spiral column, and of the pagan deity above it (Pl. 105). But such instances are comparatively rare; most of the surfaces in these panels are of "mixed ancestry," as it were. To determine in any given instance how much of the epidermis we see is due to Donatello and to what extent it has been modified by lesser hands through modeling or chasing, is a fascinating but practically limitless task which cannot be attempted here.

One reason why Donatello scholars have refused to concede Semrau's claim that some panels were independently invented by Bertoldo and Bellano, is the extraordinary iconography evident in all the balustrade reliefs. Semrau showed little interest in this field, and Kauffmann was the first to betray an awareness of the range of problems it involves. Merely to draw attention to the unorthodox aspects of the Passion scenes is hardly sufficient; what we need are exact studies of every composition to determine its formal sources and its relation to iconographic precedent. Only then shall we be in a position to define the factor of personal inventiveness in these scenes, and this, in turn, may help to clarify the problem of their execution. Kauffmann is surely right in emphasizing the rarity of Passion cycles in Italian Early Renaissance art, which would have made it impossible for Donatello (even if he had wanted to do so) to follow an established tradition. But how far did he actually range in his search for prototypes? Is there, for instance, another Martyrdom of St. Lawrence in which the Saint has a companion on the grill (a feature already noted by Bocchi)? The iconographic sources cited by Kauffmann (*D.*, p. 256, n. 649) show nothing of the sort. And how did Donatello come to represent the Christ of the Ascension bodily carried aloft by a group of angels? The idea itself is not entirely unprecedented, but the known examples are so rare, and visually so different from ours, that Donatello could hardly have profited from them.[10] Did he, then, re-invent the motif independently, perhaps by combining the traditional frontal image of the Risen Christ with the Lord of Ghiberti's East Doors, surrounded by similar tiny angels clinging to his mantle? Another astonishing

[9] I am rejecting the "Forzori Altar," on which Bode relied so heavily in his estimate of the pulpit reliefs; see below, pp. 244ff.

[10] Helena Gutberlet, *Die Himmelfahrt Christi* . . . , Strasbourg, 1934, pp. 84ff, 224ff, lists only three specimens: the wooden doors of S. Sabina, Rome, the tympanum of the Porte Miégeville of St. Sernin, Toulouse, and an echo of the latter at S. Isidro de Leon. There are, needless to say, innumerable examples in Early Christian, Byzantine, and Romanesque art of angels carrying aloft a *mandorla* framing the Christ of the Ascension; this type, however, does not concern us here.

detail is the Janus-headed servant to the right of Pilate (Pl. 105a). The meaning of this figure, which had puzzled Kauffmann, seems clear enough: it symbolizes the conflict within Pilate, torn between the pleas of his wife and the demands of expediency. Donatello here casts the Roman governor in a role that can be likened only to that of the hero of a Shakespearean tragedy.[11] But what is the formal source of the image? The traditional iconography of the scene contains nothing that could have suggested the Janus-faced servant; and even Donatello, we may suppose, is not likely to have hit upon an idea as extraordinary as this without some visual stimulus. Actually, the answer to our problem is bafflingly simple: the two-facedness of our figure derives from that of Janus, or rather from the personification of January, as represented in certain calendarial cycles of Romanesque art. Some of them (notably the reliefs in the Museo del Duomo, Ferrara, and on the façade of the Pieve in Arezzo) show January as a Janus-headed man holding a large jug in one hand and a cup or bowl in the other, to suggest feasting. To Donatello, unfamiliar with this tradition, these implements suggested instead the water pitcher and basin brought by Pilate's servant for the symbolic washing of hands. By a bold stroke of the imagination, he seized upon the element of Janus-headedness as well, and endowed it with entirely new meaning. The procedure involved here can only be described

as "iconography in a new key," no longer bound by the rules we are wont to acknowledge for mediaeval art. The S. Lorenzo Pulpits still present a vast number of unsolved problems of a similar sort arising from Donatello's "non-Euclidean" way of coining new images. In this context I must refer again to the forthcoming study of Irving Lavin, which contains a good many contributions to the iconographic study of the various panels. One of his most striking discoveries concerns the Christ of the Resurrection, that unforgettable figure filled with the torpor of death (Pl. 116); its formal source is not to be found among earlier Resurrections,[12] but in a classical composition of Meleager on his deathbed as seen in sarcophagi in the Villa Albani, Rome, and in the Louvre, which includes an old man in profile view (facing right, his left foot resting on a stool) who leans on a heavy staff. Donatello has transformed this figure, with the fewest possible changes, into his incredibly weary Christ.

The few questions touched upon above, chosen more or less at random, are intended merely as samples of the multifarious problems confronting us in the S. Lorenzo Pulpits. Donatello's last work is also his most complex and challenging. To reach an adequate understanding of it—its genesis, physical and spiritual, as well as its impact (since it ranks among the climactic achievements of its century)—must be the long-range goal of all future studies of the master.

[11] For the background of this interpretation, and the concept of "two-facedness," cf. the Excursus of Lavin's thesis.

[12] Hence the perplexity of Hubert Schrade, *Ikonographie*

der Christlichen Kunst, I: Die Auferstehung Christi, Berlin-Leipzig, 1932, p. 235.

8. South Pulpit, S. Lorenzo, Florence, Martyrdom of St. Lawrence, detail showing the inscription discovered by Previtali, 1961

REJECTED ATTRIBUTIONS

TWO PROPHETS
PORTA DELLA MANDORLA, FLORENCE CATHEDRAL

PLATE 121 Marble; H. 128 cm (left) and 131 cm (right)[1] *(1405-1410; 1417-1418)*

DOCUMENTS: none

SOURCES: none

Semper (*D.* '75, pp. 53f) acclaimed these two figures as documented works of Donatello, on the basis of two entries in the records of the Cathedral workshop which he published in slightly incomplete form (p. 273). Poggi (*Duomo*, pp. 66f) gave a fuller transcription but accepted Semper's thesis, as did almost all subsequent authors until recent years, including Kauffmann (*D.*, pp. 3f, 196, n. 16) and Paatz (*Kirchen*, III, pp. 367, 488f, n. 225). A few small but important mistakes in Poggi's reading have since been corrected by Paolo Vaccarino (*Nanni*, Florence, 1950, pp. 21f) and Giulia Brunetti (in *Belle Arti*, 1951, p. 102). The entries in question are as follows:

1406, November 23 (Poggi, doc. *362*): Donatello, who has made (*fecit*) marble prophets to be placed on or above the Porta della Mandorla, receives 10 florins in part payment for the aforementioned work.

1408, February (Poggi, doc. *366* as amended by Vaccarino and Brunetti): The *operai* authorize payment of 16 florins to Donatello for a marble figure, 1⅓ braccia tall, for the Porta della Mandorla; he has received 10 florins and is to receive the remaining sum of 6 florins.

Under the same date, the record of disbursements lists 16 florins as paid to Donatello for a marble figure, 1⅓ braccia tall, for the Porta della Mandorla.

Albert Jansen, in his review of Semper, *D.* '75 (*Zeitschrift f. bild Kunst*, XI, 1876, p. 318), was the first to object to the attribution of both statues to Donatello, on documentary as well as stylistic grounds. He pointed out that a strict reading of the documents proved only that the master had been paid for one of the prophets; for the other, Jansen tentatively suggested an attribution to Ciuffagni. Lányi (*Pragm.*, p. 129) came to the same conclusion, and proclaimed Ciuffagni as the author of the more conservative of the two figures, that on the left. Planiscig (*Rivista*

d'arte, XXIV, 1942, pp. 125ff; *Nanni di Banco*, Florence, 1946, pp. 10ff; and *D.*, p. 15) followed the Jansen-Lányi interpretation of the document of 1408 but attributed the more conservative statue to Donatello; to him, the prophet on the left was the immediate predecessor of the marble David of 1408-1409, while the other seemed just as closely related to the Isaiah of Nanni di Banco. Meanwhile W. R. Valentiner had, quite independently, come to reject the left-hand statue as a work of Donatello for reasons of style alone (*Art Quarterly*, III, 1940, pp. 182ff; reprinted in his *Studies of Italian Renaissance Sculpture*, New York, 1950, pp. 25ff). He still assumed that Donatello had made two prophets; the one on the left, he believed, had been replaced for reasons unknown. Valentiner thought he had found it in a figure in the Musée Jacquemart-André, Paris, that had been attributed to Donatello by Balcarres (*D.*, p. 7). The left-hand prophet now *in situ* he ascribed to a conservative master of about 1390 and pointed out that it was, in reality, not a prophet at all, since it lacked the generic attribute of the scroll. Certain features—the laurel wreath, the gesture of the left hand, and the unfinished left leg, indicating that the figure was originally meant to be viewed mainly from the side—persuaded Valentiner that it had been designed as the angel of an Annunciation group. He also noted that the statue could not have been intended for its present location, since part of the molding behind it had to be chipped away in order to make room for the shoulders. Perhaps, he suggested, the figure belonged to an Annunciation group for which Jacopo di Piero Guidi received an order in 1388 and which might subsequently have been transferred to the Porta della Mandorla.[2]

Strangely enough, neither Valentiner nor any of his predecessors had bothered to find out the actual height of the Porta della Mandorla prophets. This was finally done by Vaccarino (*loc.cit.*), who measured the one on the right and found it to be 123 cm tall, i.e. slightly more than 2 braccia. Clearly, our two prophets are

[1] I owe these measurements to the kindness of Dr. Giulia Brunetti.

[2] Dr. Giulia Brunetti, who was able recently to inspect the figure at close range, has been kind enough to inform me that the back shows no dowel holes for wings. This in itself,

however, does not defeat Valentiner's suggestion, since the wings need not have been carved separately and could have been cut off without leaving a visible trace when the figure was converted into a prophet. In any event, the statue surely was not intended to be a prophet at the outset.

much too tall to fit the document of 1408. And since the figure referred to in that final accounting was, in all probability, one of the marble prophets Donatello had made, or was making, in 1406 (*fecit* might be a clerical error for *facit*), the earlier document does not apply to our statues either, quite apart from the fact that the one on the left was meant to be an angel (as convincingly shown by Valentiner, *loc.cit.*). Vaccarino acknowledged all this, but failed to offer any new conclusions about the date and authorship of the two figures. He dated both of them around 1406 and followed Planiscig in attributing the one on the right to Nanni, that on the left to Donatello.

This view has not remained uncontested. Valentiner, who had defended his previous opinions against those of Planiscig (*La Critica d'arte*, VIII, 1949, pp. 25ff), upheld them again in the face of Vaccarino's discoveries (*Art Quarterly*, XIV, 1951, pp. 307ff). He now proposed to identify the Jacquemart-André statue with the single prophet referred to in the document of 1408. This figure, he thought, was discarded, since it turned out to be too small for its intended location; the authorities thereupon ordered a pair of prophets 2 braccia tall from Donatello, but the master executed only one of these, that on the right. For its date Valentiner suggested 1409-1410, since late in 1409 Donatello had received 50 florins in part payment for "several marble figures" (Poggi, docs. *177, 178*) which might have included the prophet for the Porta della Mandorla. After that, according to Valentiner, the master was so busy that he never got around to doing the other prophet, and the authorities finally decided to utilize the angel from the Annunciation group of 1388-1389 by Jacopo di Piero Guidi as a substitute. Valentiner also tried to buttress his attribution of this angel-prophet to Jacopo di Piero by a comparison with that master's reliefs on the Loggia dei Lanzi. Brunetti (*loc.cit.*) found the statue too Ghibertesque for so early a dating, and proposed instead to ascribe it to Ciuffagni, as suggested by Lányi. Concerning the right-hand prophet, she sided with Planiscig and Vaccarino, placing it immediately before Nanni's Isaiah. Ottavio Morisani (*Studi su Donatello*, Venice, 1952, pp. 13ff) accepted Vaccarino's opinion on both statues.

The conspicuous place the two prophets have held in the Donatello literature of the past seventy-five years can hardly be justified by their inherent artistic importance, nor even by their status as documented works of a great master. It was due, rather, to their supposed early date, which conferred upon them a key role in the evolution of Early Renaissance sculpture as a whole. Curiously enough, the discoveries of Vac-

carino seem to have made little difference in this respect; the link with the documents is broken, yet most authors persist in dating the figures before 1408 (only Valentiner is willing to concede that one of them might have been done as late. as 1409-1410). It is worth emphasizing, therefore, that the available documents tell us absolutely nothing about the two statues; that we must determine not only the authorship but, first of all, the date and the evolutionary position of each figure on the basis of its style alone.

So far as the latter problem is concerned, the prophet on the left offers far less difficulty—and less interest—than the one on the right. Its generally Ghibertesque character has long been acknowledged. The peculiar "sagging" elegance of the drapery style has its closest analogues among the reliefs of the North Door of the Baptistery, rather than in Florentine stone sculpture of the late Trecento, so that Valentiner's attempt to ascribe the figure to Jacopo di Piero Guido carries little conviction.[3] Nor can I find a sufficient basis for assigning the prophet to Ciuffagni, whose earliest known work, the St. Matthew of 1410-1415, already betrays the impact of Donatello, although this suggestion seems to me the most plausible alternative so far. In any event, we need not hesitate to date the figure approximately in the years 1405-1410. That it shows certain similarities with Donatello's marble David of 1408-1409 cannot very well be denied, but these are, to my mind, of a quite impersonal sort. They indicate no more than a common Ghibertesque heritage. Of the individuality of Donatello, already very pronounced in the David, our angel-prophet shows not the slightest trace. Even if we assume an interval of as much as four years between the two statues—and we could hardly go beyond that—we might reasonably expect to find some hint of future greatness here; yet I, for one, completely fail to perceive it.

The right-hand prophet, in contrast, appears not only qualitatively superior but conspicuously un-Ghibertesque. That it is the work of Nanni di Banco or his workshop has been well established by the comparisons contained in Planiscig's article. However, I cannot conceive of its having been done prior to the Isaiah, a statue far more Gothic in every way. The little prophet, in fact, displays a stance more assured and better balanced than that of any other statue by Nanni. It is also, in this respect, further advanced than Donatello's marble David and approaches the so-called St. John the Baptist on the east face of the Campanile (see below, p. 228), as noted by Schottmüller many years ago (*D.*, p. 58). There can be little question that our prophet reflects the pose of the marble David, especially the exposed left leg; and since this leg, as we

[3] Wilhelm Vöge, while still accepting the authorship of Donatello, has recently observed the kinship of our statue with

some of the late Trecento apostles from Siena Cathedral; see *Festschrift für Hans Jantzen*, Berlin, 1951, p. 119.

have demonstrated (see above, p. 5), was freed from its sheath of drapery only in 1416, the latter date provides a *terminus post quem* for our prophet. Moreover, the drapery style and the head type of our figure are closer to the Assumption relief of the Porta than to any of Nanni's statues.[4] Thus the prophet ought to be dated, not in 1406-1407 but a decade later; it is, I believe, the last free-standing figure of Nanni, rather than his first, done at a time when the master was fully occupied with the large relief, so that he left the execution, in part, to a lesser hand. If this view is correct, we need not be surprised at the lack of any specific reference to our statue in the documents. Nanni probably carried it out as part of his total assignment on the Porta, in which case there would have been no need to mention the prophet separately. (The numerous payments to him between 1415 and 1420—Poggi, docs. *376-385*—refer, for the most part, simply to "marble figures," a term that might mean both statues and reliefs.)

But how did Nanni's youthful prophet come to be paired with a converted Annunciation angel? A combination as odd as this can be explained only as the result of special circumstances about which the documented history of the Porta della Mandorla tells us little indeed. Still, it does contain a few clues—enough for us to venture a hypothesis, however tentative. Let us start with the marble prophets that Donatello had been commissioned to do about 1406 and of which he finished only one, so far as we know. The documents fail to mention where on the Porta these figures were to be placed, but it seems plausible enough to assume that they were destined for the positions now occupied by the angel-prophet and the boy-prophet; the statue for which Donatello was paid in 1408 measured 1⅓ braccia, a height that corresponds almost exactly to the distance from the tops of the two pilasters to the lowest profile of the molding above. The *operai* probably tried out the Donatello prophet *in situ* and found it too small to be effective (just as, a year later, they set aside the marble David for the same reason; see above, p. 4). Its further history is unknown—if it still exists, it remains unidentified.[5] Having discarded the Donatello figure, the *operai* may well have decided

to let matters rest until the work on the upper part of the Porta was farther advanced. In 1409 (Poggi, doc. *371*) they requested the transfer of a marble Annunciation group from the Altar of the Trinity to the Porta, and five years later (Poggi, doc. *372*) they again asked for the transfer of such a group from "the newly established altar near the entrance to the Cathedral," adding that it had been made for the Porta. About this Annunciation we have no further knowledge; there certainly is no reason, documentary or stylistic, to identify it with an Annunciation group commissioned of Jacopo di Piero Guidi, as Valentiner has proposed.[6] On the other hand, we are tempted to follow Valentiner in regarding the angel-prophet as having belonged to the transferred Annunciation group; under the circumstances, this seems the simplest and most obvious assumption, even though the Annunciation was destined for the lunette rather than for the two flanking pilasters. The latter fact emerges from a document of April 2, 1414 (Poggi, doc. *374*), three months after the second request for the transfer of the group, when a painter was paid for putting a blue ground with gold stars on "the arch above the Porta, where the Annunciation is." Poggi (*op.cit.*, p. lxxii) takes it for granted that the Annunciation group remained in the lunette until, seventy-five years later, it was replaced by the mosaic Annunciation designed by Ghirlandaio, which is there still. Yet the document from which we learn of the latter commission (Poggi, doc. *399*; July 10, 1489), makes no mention of any sculptured group. In fact, it explicitly refers to the "empty spot" (*vacuum*) above the door. If the marble Annunciation had remained in the lunette until replaced by the mosaic, we might reasonably expect to find some provision in the documents for disposing of it in some way.

Clearly, the lunette had been unoccupied for quite a while when the *operai* commissioned the mosaic for it. Thus there is nothing to prevent us from assuming that the Annunciation group was removed soon after its installation in 1414. Nor is it difficult to think of a plausible reason for such a procedure: two standing figures of the size of our angel-prophet would simply be dwarfed by a field as large as that of the lunette.

[4] It may be relevant to note, in this context, that the Assumption relief itself contains additional proof of Nanni's interest in the marble David; the musician angel on the left wears a wreath clearly derived from the "amaranthine crown" of Donatello's statue, which we have analyzed above, pp. 6f.

[5] In any event, it cannot be the prophet statue in the Musée Jacquemart-André, which according to Valentiner (*La Critica d'arte, loc.cit.*) is 85 cm tall and thus must have been carved from a block of 1½ braccia (= 87.6 cm); in order to match the size of Donatello's prophet, it would have to be at least 16 cm smaller.

[6] Giovanni Poggi, *Catalogo del museo dell'opera del Duomo*, Florence, 1904, pp. 42f, suggests that the Annunciation group

from the lunette may be identical with the two statues Nos. 95 and 96 in that museum. Planiscig, *Nanni di Banco*, Florence, 1946, pp. 17ff, and Brunetti, in *Belle Arti*, 1951, pp. 3, 11f, assume this as certain, the former claiming the statues for Nanni, the latter for Jacopo della Quercia. The problem of the authorship of these beautiful and puzzling figures need not detain us here, but it is worth emphasizing that their connection with the lunette of the Porta della Mandorla remains purely hypothetical, unsupported by positive evidence of any kind. All we can safely say is that their measurements (given in Brunetti, *loc.cit.*, as 132 cm for the Angel, 140 cm for the Virgin) do not preclude such a possibility.

It would seem, then, that the *operai* had again misjudged the scale, just as in the case of the Donatello prophet of 1406-1408 and in that of the marble David. Still, it is odd that the Annunciation angel should have been reused as a prophet. If Nanni di Banco furnished the prophet on the right as part of his commission (on June 19, 1414, the *operai* had entrusted him with "all the work around said tympanum"; see Poggi, doc. 375) why did he fail to provide the one on the left? The most plausible explanation is the master's unexpected death early in 1421, when he had almost completed the commission (Poggi, doc. 386). During the rest of that year, Nanni's work was being appraised, and the *operai* did not order the tympanum to be installed above the portal until January 14, 1422 (Poggi, doc. 388). At that time, the Annunciation group in the lunette was still intact, for on February 10 a payment of 2 soldi was made for "brightening up the lily of Our Lady of the Annunziata portal" (Poggi, doc. 389; cf. also Brunetti, *loc.cit.*); but it did not remain there for long, I suspect. While the installation of the tympanum was in progress, the missing parts of the ensemble were being procured: in the spring, Donatello carved the relief busts of a prophet and a sibyl (see above, p. 43); in August, Nanni's Virgin was provided with a *cintola* (Poggi, doc. 392); and in September, Ciuffagni received the commission for a marble figure of St. Stephen, to occupy the pinnacle above the tympanum. This work, too, would have been Nanni's responsibility

had he lived to carry it out. A year later, in September 1423 (Poggi, doc. 395), the commission was withdrawn from Ciuffagni, and the *operai* decided to install in its place an older statue of a prophet. Evidently Ciuffagni had failed to deliver, and the *operai* were anxious to have the ensemble completed. Under these circumstances we need not be unduly surprised if they converted the angel of the Annunciation group from the lunette into a prophet for the pinnacle on the left of the tympanum. At such a height, they may have reasoned, the unfinished left leg and the absence of a scroll were not likely to be noticed, so that the only adjustments necessary were minor ones—to cut off the wings, to eliminate the blessing gesture by replacing the second, third, and fourth fingers of the right hand (see Pl. 473a) and to remove the lily from the left hand (unless the lily referred to in the document of February 1422 was placed in a vase between the two statues). There is, I believe, one further argument in favor of this hypothesis: ordinarily, the notion of changing an Annunciation angel into a prophet would be difficult to credit, since prophets were traditionally conceived of as scroll-bearing figures of patriarchal mien. But in our case Nanni, under the influence of Donatello's youthful marble David, had produced a prophet so boy-like in appearance that a converted angel made a better match for it than a conventional prophet statue from the store rooms of the Cathedral workshop.

ST. PETER
OR SAN MICHELE, FLORENCE

PLATE 122b Marble; H. 237 cm (including the plinth); W. (at the base) 72.5 cm. *(1415-1425)*

DOCUMENTS: none

SOURCES

Identical with those for Donatello's St. Mark; see above, pp. 16f.

Until some sixty years ago, the unanimous testimony of the sources, coupling the St. Peter with the St. Mark, was believed to furnish unassailable proof of Donatello's authorship. Semper (*D.* '75, pp. 85ff; *D.* '87, pp. 15f), Schmarsow (*D.*, p. 12), Reymond (*Sc. Fl.*, II, p. 89), Balcarres (*D.*, p. 36), and Venturi (*Storia*, VI, p. 242) treated the figure as the oldest of Donatello's contributions to the exterior decoration of Or San Michele, immediately preceding the St. Mark of 1411-1412. Bertaux (*D.*, pp. 22f) and very recently Paatz (*Kirchen*, IV, pp. 494, 536, n. 108) have echoed the same opinion, while Kauffmann (*D.*, pp. 29ff) dates the statue about 1420 and relates it to the Campanile prophets and the two Virtues of the Siena Font. Pastor

(*D.*, pp. 30f), on the other hand, claimed the St. Peter for Nanni di Banco, noting that its style seems incompatible with that of the St. Mark. This attribution was accepted by Bode (*Denkmäler der Renaissance-Skulptur Toscanas*, Munich, 1892-1905, pp. 14f), Schottmüller (*D.*, p. 63, n. 4), Schubring (*KdK*, p. 193), and others, so that the St. Peter even found a place among the assured works of Nanni in Thieme-Becker (*Allgemeines Lexikon . . .*, II, 1908, p. 436). A third group of scholars has rejected both these alternatives. Cruttwell (*D.*, p. 30) defined the statue as the work of "some Donatellesque follower or assistant, of the same artistic calibre as Il Rosso"; Middeldorf (*AB*, p. 579) and Planiscig (*Nanni di Banco*, Florence, 1946, p. 27)

were content to call it a thing of utter mediocrity, unworthy of any master of consequence. The latter author also dismissed Lányi's claim, advanced without supporting arguments (*Pragm.*, p. 129), that the St. Peter must be ascribed to Bernardo Ciuffagni.

The statue does indeed pose a dilemma unique in the field of Donatello scholarship. According to the sources, it was firmly established among the canonical works of the master before the end of the Quattrocento; such evidence, though far from absolute, cannot be lightly brushed aside. Yet the shortcomings of the figure are so obvious, especially in comparison with the St. Mark, that even the most wholehearted defenders of the attribution to Donatello have been embarrassed by them to some extent. The stance is weak and unstable; the drapery, despite its "clinging" effect, seems overelaborate, indecisive, and far from organic; the entire work fails to convey the inner strength, the commanding presence so strongly felt in the St. John the Evangelist and the St. Mark. This very lack of a clear-cut individual character removes our statue equally far from Donatello and from Nanni, even though in detail it is often reminiscent of both masters. Planiscig (*loc.cit.*) found it so devoid of any personal style that he thought several artists of unequal merit must have worked on it in succession. Does the St. Peter really deserve such utter condemnation? I believe not. As a work of art, it is far from negligible, whatever its faults; and the level of execution seems consistent enough to rule out the possibility of more than one artist being involved here. Its author, then, must be a sculptor of the second rank, who worked in the shadow of the great masters, always eager to absorb their influence, since he had no direction of his own, and yet incapable of fully comprehending their aims. At the same time, our artist was certainly much more than a routine craftsman; his St. Peter may be a failure, but it is an ambitious failure that demands to be judged by the standards of a Donatello or Nanni di Banco rather than of the International Style (of which it shows hardly a trace). These considerations eliminate the older men, such as Niccolò di Pietro Lamberti and Lorenzo di Giovanni d'Ambrogio, who could never have shed the Gothic tradition of their youth so completely. And the strong Nanni de Banco element in the St. Peter does not fit Il Rosso (Nanni di Bartolo), who began his career as a strict epigonus of Donatello (see below, p. 231). Our most likely candidate would be a man of about the same age as Donatello and Nanni, and here the choice, for all practical purposes, narrows down to the name already proposed by Lányi—Bernardo Ciuffagni (born 1385), a sculptor much inferior to them in talent who nevertheless, for a quarter of a century (1409-1434), carried out commissions comparable to

theirs in size and importance for the Cathedral workshop. Considering this close association with Donatello and Nanni at the center of sculptural patronage in Florence, it would be downright surprising if Ciuffagni had been passed over completely by the numerous guilds that ordered statues for their niches at Or San Michele during the second and third decades of the century, after a resolution of the Signoria in 1406 had urged them to do so (cf. Paatz, *op.cit.*, pp. 492, 519, n. 83).

Thus the external circumstances all seem to favor Ciuffagni as the author of the St. Peter. There are, I believe, equally plausible arguments for the attribution on stylistic grounds. Our knowledge of Ciuffagni's development as a sculptor begins with the seated St. Matthew for the Cathedral façade, commissioned in 1410 and completed within the next five years (cf. Poggi, *Duomo*, pp. xxxvi ff; now in the Museo dell' Opera del Duomo); it ends with the King David which he delivered in 1434 (cf. Poggi, *op.cit.*, p. liv; on the Cathedral façade until 1587, then transferred to the interior). These provide the fixed points on which our discussion must rest, since the intervening works—i.e., the Joshua and the Isaiah, both inside the Cathedral—raise problems of identity, date, and collaboration with other masters that have not yet been wholly resolved (cf. Lányi, *Statue, passim*, and Paatz, *Kirchen*, III, pp. 372, 385, 504f, n. 263; 547f, n. 435). The St. Matthew is a strangely incongruous figure: its drapery shows a variant of the International Style that recalls Ciuffagni's apprenticeship with Ghiberti (compare the evangelists and church fathers on the North Doors); the head type and the pose of the left hand resting on the book are derived from the St. Mark of Niccolò Lamberti, while the right hand is copied almost exactly from that of Donatello's St. John. The face and hands display a surprising amount of realistic detail —knuckles and cheekbones are emphasized, veins stand out clearly, and the eyes, otherwise still of conventional shape, have crow's-feet at the corners. Yet these features remain curiously isolated, so that they give the appearance of having been grafted onto the smooth and tightly stretched skin. In the face, Ciuffagni has attempted to match the new severity of expression of Donatello's St. John, but his success is marred by a sort of hairdresser's neatness in rendering the tightly curled beard and moustache.

If we now turn to the head of the St. Peter, we recognize it as the direct descendant of the St. Matthew: the Gothic element has receded, the realistic touches have multiplied, yet the basic structure of the head remains very much the same, as does the handling of the beard. Certain telltale details, such as the shape of the nose, are practically identical, and the skin areas are finished in the same unpleasantly

smooth fashion. Novel features are the departure from strict frontality and the attempt to give an animated expression to the face, but the turning of the head looks forced and slightly supercilious, and the expression might be described as a vaguely benevolent simper. These last two characteristics persist in the head of the David statue, where they have become exaggerated almost to the point of grotesqueness. The drapery style of the St. Peter has nothing in common with the St. Matthew. It is quite obviously patterned after the "Roman" drapery of Nanni di Banco's Quattro Coronati, especially that of the third figure from the left, which also provides the model for the right arm and hand of our statue. However, the rhythmic flow of Nanni's folds has lost its continuity; it is constantly disrupted by small eddies and cross-currents, which betray an effort to imitate the realistic "feel" of the cloth, so convincingly rendered in Donatello's St. Mark. Thus the peculiar clumsiness and timidity of the drapery style in the St. Peter must be understood as the result of superimposing two basically incompatible systems, neither of which has been properly understood. The same overcrowding of every shape with an excess of realistic detail appears in the hands and feet, with all their wrinkles and veins, in the neck and (to a slightly lesser degree) in the face of our statue. The King David shows the ultimate stage of this fatal tendency; here the flesh parts are of an almost unbelievable flabbiness, and the drapery has the rumpled look of an unmade bed. Ciuffagni's poverty of invention may be seen in the way certain motifs from the St. Peter recur in the later figure—the position of the feet on the plinth, the fringed undergarment over the left leg, the folds of the mantle covering all but the toes of the right foot, etc.

The visual evidence, then, clearly places the St. Peter at the midway point of Ciuffagni's development, as the hitherto missing link between the St. Matthew and the King David. As for its probable date, one primary fact must be kept in mind: according to the account books of the Cathedral workshop, Ciuffagni was away from Florence in March 1417 and did not return until four or five years later. (In 1420 he is still mentioned as absent; he resumed his work for the Cathedral in 1422. See Poggi, *Duomo*, docs. *225, 241, 428.*) If we consider how strongly our statue as a whole reflects the impact of the Quattro Coronati, while the head still recalls that of the St. Matthew in many ways, it seems far more plausible to assign the work to the years immediately before Ciuffagni's departure rather than to the period after his return. The St.

Matthew, it is true, was not finished until 1415 (Poggi, *Duomo*, doc. *217*), but we may assume that the basic design of the figure was fixed soon after the date of the commission, so that the statue in most respects represents Ciuffagni's style of c. 1411-1412. Its delayed completion, which caused the *operai* to threaten the artist with a penalty, might have been brought about by the new commission for the St. Peter in 1414 or 1415. One wonders, on the other hand, whether Ciuffagni actually delivered the St. Peter before 1417. His departure from Florence appears to have been rather sudden, since he left behind an unfinished Joshua, commissioned in October 1415 and destined for the Campanile (Poggi, *Duomo*, docs. *221, 223-226*). Did the St. Peter suffer a similar fate? Apart from the resemblances to the King David pointed out above, there is one other bit of evidence pointing to the possibility that our statue was not installed until the early 1420's. As Kauffmann has observed (*D.*, pp. 30, 205, nn. 89, 90), the perspective designs in marble inlay inside the tabernacle are a very advanced feature for which the earliest known parallel is the decoration framing the Assumption relief on the Porta della Mandorla, of 1422. Presumably, these panels were installed before the statue was put in the niche. Be that as it may, the perspective inlays also suggest a possible answer to the question of how the St. Peter came to be regarded as a joint commission of Brunelleschi and Donatello. Whatever the origin of these designs,[1] in the eyes of the late Quattrocento the mere fact that they are "illusionistic" would have been sufficient to claim them for Brunelleschi, whose fame as the originator of scientific perspective had been so well established by Alberti and Manetti. And once Brunelleschi had been credited with the niche, it was easy to conclude that he must have been commissioned to do the statue as well, even though Donatello actually carried it out. By analogy, this claim might then have been extended to the St. Mark, another bearded, patriarchal figure known as the work of Donatello, in a niche with inlaid marble paneling.[2]

But how did the St. Peter come to be attributed to Donatello in the first place? According to the available sources, this notion, which is found both in the *XIV uomini singhularj* and in Albertini, seems to have been well established by the time the story of the Brunelleschi-Donatello partnership made its appearance in the early Cinquecento (our oldest source for it is Billi's *Libro*). Here we must keep in mind that Ciuffagni was a minor figure, likely to be soon forgotten. After 1435, he fades from the scene so completely that for

[1] Mario Salmi, *P. Uccello, A. del Castagno, D. Veneziano*, 2d ed., Milan, 1938, pp. 10f, links them with Ghiberti rather than Brunelleschi.

[2] The St. George lent itself less easily to the same hypothesis

—it was too different in type from the other two statues, and the interior of the niche had no decoration of any kind. For a fuller discussion of the "growth pattern" of Brunelleschi-Donatello legends, see above, pp. 10f, 138ff.

the last twenty years of his life—he died in 1456—we know nothing of his activities or whereabouts. Vasari refers to him only once, in the Life of Filarete, but the name meant nothing to him; he could not link it with any Florentine monuments, and his statement that Ciuffagni worked in Rimini, Lucca, and Mantua has been invalidated by Milanesi (II, p. 463, n. 1) as due to a case of mistaken identity. The other sources, both pre- and post-Vasarian, omit the master altogether, and his works, if they are mentioned at all, appear either as nameless or under the label of Donatello. What we know of Ciuffagni's career today rests entirely on the archival researches of more recent times. Thus there is good reason to believe that the memory of the true author of the St. Peter did not survive for long among the members of the butchers' guild. The temptation to claim the figure for Donatello must have been as strong (and as understandable, given the circumstances) as it was in the case of Ciuffagni's statues for the Cathedral.

JOSHUA ("POGGIO BRACCIOLINI"), FLORENCE CATHEDRAL

PLATES 122c, 124a Marble; H. (including plinth) 182 cm; W. of plinth 63 cm; *1415-1416; 1420-1421*
D. of plinth 36 cm

DOCUMENTS

A number of entries among the records of deliberations and disbursements by the *operai* of the Florence Cathedral workshop, in the archives of the Opera del Duomo, from Poggi, *Duomo*, pp. 37ff, whose numbering we reproduce:

1415, October 9-19 (*221*): Bernardo di Piero Ciuffagni is commissioned to do a white marble statue of Joshua for the *opera*, to be placed on the Campanile, but the master-in-charge of the workshop must first judge the block to be of the right size for this purpose. The master-in-charge so certifies.

December 23 (*223*): Ciuffagni receives 12 florins in part payment for a Joshua of white marble which he is to do for the Campanile.

1416, March 11 (*224*): Ciuffagni receives 30 florins in part payment for the Joshua he is doing for the Campanile.

1417, March 6 (*225*): Ciuffagni has left Florence and has not been working on the marble statue for which the *opera* had advanced him certain sums [the amount is illegible]; the *operai* decide, therefore, to attach the artist's property.

1418, April 29 (*226*): The marble statue left unfinished by Ciuffagni is to be appraised and turned over to Donatello, who is to finish it.

1420, April 30 (*241*): Ciuffagni, having received an advance of 42 florins for the marble statue he did not finish, is still away; the figure is to be turned over to Nanni di Bartolo called Rosso, who shall finish it, substituting a different head.

May 14 (*242*): The value of the work done by Ciuffagni on the unfinished statue has been appraised at 22⅔ florins.

December 10 (*244*): Nanni is advanced 20 florins for a statue he is working on for the Campanile.

1421, April 26 (*247*): Nanni has completed the unfinished statue that had been turned over to him. The value of the entire figure has been appraised at 95 florins, and Nanni is to receive 52 florins 1 lira 7 soldi as the amount still due him for his share of the work.

October 31 (*250*): About five years ago Ciuffagni had been commissioned to do the marble statue of a certain prophet, which he left unfinished when he departed from Florence, even though he had been advanced 42 florins on it. About one year ago, this figure had been turned over to Donatello and Nanni. The *operai* now acknowledge that too low a value has been placed on Ciuffagni's

share of the work, and that his indebtedness to them, which stands at 42 florins less 22⅔ florins, is excessive. They decide to credit him with another 15 florins, thus reducing his debt to 5 florins, which he must make good within a year.

SOURCES

1510 Albertini, p. 9: "On the façade [of S. Maria del Fiore] there is . . . at the corner the statue of an old man, by Donatello. . . ."

1537-1542 Cod. Magl., p. 75: "On the façade of S. Maria del Fiore [Donatello did] . . . a bald old man (*un vecchio Zucchone*) at the corner. . . ."

1550 Vasari-Ricci, p. 49 (Milanesi, pp. 400f): "On the façade of S. Maria del Fiore Donatello in his youth did . . . at the corner towards the Via del Cocomero, an old man between two columns. It approaches the style of the ancients more closely than does any other work of his, the head revealing the thoughts brought on by age and care. . . ."

The present location of the statue, in the first bay of the north aisle of the Cathedral, is not the original one. The figure was presumably moved there after the destruction of the façade in 1587; its identification with the "old man by Donatello" at the north corner of the façade, first proposed by Schmarsow (*D.*, p. 9), seems entirely plausible and has not been challenged.[1] Nor is there any reason to doubt that our statue is the one referred to as the portrait of Poggio Bracciolini in the fourth bay of the north aisle by Giuseppe Richa (*Notizie istoriche*, VI, Florence, 1757, p. 121). Whether it was intended for the façade from the very start is less easy to decide; if the "Poggio" can be identified with the Joshua of the documents cited above, it was meant for the Campanile, where it may or may not have stood for some years before its reassignment to the façade.

How and when the statue came to be regarded as a portrait of Poggio, remains unexplained. The tradition is surely post-Vasarian, and probably somewhat older than Richa, the first author to mention it. We may assume that it was *ben trovato*, together with the notion that the Daniel, the other façade statue ascribed to Donatello by Vasari and his predecessors, represents Gianozzo Manetti, as an extension of the claim concerning the portrait identities of the Zuccone and its neighbor on the west side of the Campanile (see above, p. 41). Semper, accepting the "Poggio" label as historic fact, dated the statue about 1460, on the basis of the age of the sitter and the combined biographical data of Poggio and Donatello (*D.* '75, pp. 132, 268); later he suggested that the statue had been started as early as 1408-1415, because of the conservative drapery style, but retained the date of about 1460 for the head. Since then, the spuriousness of the "Poggio" designation has been universally recognized

(the name survives purely as a matter of convenience), and the entire figure, including the head, has been acknowledged as a work of the second or third decade of the Quattrocento. Schmarsow (*loc.cit.*) was the first to question whether the statue as a whole is worthy of Donatello; he felt particular misgivings about the lower half of the work, which led him to believe that the figure had been started by some lesser and more tradition-bound sculptor such as Ciuffagni. These doubts, although protested by Pastor (*D.*, p. 37), were echoed by Wilhelm Bode (*Denkmäler der Renaissance-Skulptur Toscanas*, Munich, 1892-1905, p. 16) and Schottmüller (*D.*, p. 63, n. 4). Poggi (*Duomo*, p. liv) even proposed to remove the statue from Donatello's œuvre entirely, and tentatively identified it with the prophet carved by Giuliano da Poggibonsi in 1410-1412, according to the documents (cf. Nos. *191, 193, 201, 203*). His hypothesis, impossible to verify on stylistic grounds, has been generally discarded (Kauffmann, *D.*, p. 207, n. 103, points out that the Giuliano prophet must have been of much smaller size than the "Poggio"). Another and equally ill-founded identification was launched by Schmarsow (*loc.cit.*), who equated the "Poggio" with Donatello's Joshua of 1412. This notion won the support of Venturi (*Storia*, VI, p. 243) and, more recently, of Colasanti (*D.*, pp. 15f), even though after the publication of the relevant documents (Poggi, *Duomo*, docs. *414-420*) there could be no doubt that the Joshua was the brick-and-terracotta "giant" made for one of the buttresses of the Cathedral (see above, p. 14). Kauffmann, fully aware of this, proposed an entirely new and very much sounder solution (*D.*, pp. 34f): for reasons of style, he rejected the figure as a work of Donatello except for the head, which, he noted, was carved from a separate piece of marble. In the rest,

[1] The large pen drawing of the façade in the Museo dell'Opera del Duomo shows a statue at that corner which may very well be ours, although the rendering is not precise enough to be unmistakable.

he saw the hand of Nanni di Bartolo. On the basis of these clues, he identified the "Poggio" with a prophet done by Nanni for the façade of the Cathedral in 1419-1420, since the records explicitly state that Nanni was permitted to carve the head separately and to utilize the services of another master (Poggi, *Duomo*, docs. *233-237, 239, 240*, cited below, p. 228). This other master, according to Kauffmann, was Donatello, with whom Nanni had the closest relations at that time. On the face of it, Kauffmann's hypothesis seems eminently persuasive; its only shortcoming is that it fails to account for the participation of Ciuffagni, whose peculiarly unpleasant but nonetheless distinctive style can be seen in much of the drapery and in the hands of the statue. By a strange coincidence, Lányi at this very time tackled the "Poggio" problem in much the same way as Kauffmann, although he reached a different conclusion (*Statue*, pp. 128f, 258ff). He, too, had observed that the head was carved separately, but he found that the documents mention two statues of which this is true: the Nanni prophet of 1419-1420, and a Joshua that had been started by Ciuffagni in 1416-1417 and subsequently turned over to Donatello and Nanni, who completed it in April 1421 (see the documents cited above).[2] Moreover, Lányi noted, the "St. John" on the east side of the Campanile likewise has a separately carved head. In deciding which statue corresponds to which set of documents, Lányi argued that the "Poggio" must be identical with Ciuffagni's Joshua, since the other figure in question is labeled as a St. John by the words on its scroll. Here, however, his reasoning is questionable; he takes for granted that the "St. John" was conceived as a St. John simply because it is inscribed as such, without considering the doubts expressed by Balcarres (*D.*, p. 19) and Schubring (*KdK*, p. 194). My own belief is that the figure was not meant to be a St. John at the time it was carved, and that the words on the scroll are a later addition (see below, p. 229). Even so, Lányi's proposal seems to me preferable to Kauffmann's.[3] After all, Ciuffagni, according to the documents, had a sizeable share in carving the Joshua —the accounting of 1421 indicates that he must have done about one third of the work—and the "St. John" shows no trace of his style, while the "Poggio" certainly does. Unlike Kauffmann, Lányi never specified which parts of the statue he regarded as by Donatello (his canon of the master's works, in *Probl.*, p. 23, lists our figure as "in part by Donatello"; Planiscig, *D.*, p. 33, accepts Lányi's identification of the statue as Ciuffagni's Joshua but shares Kauffmann's convic-

tion that only the head is by Donatello). A closer study of the documents might have convinced him that in all likelihood Donatello had no share at all in completing the statue. In April 1418, it is true, the Joshua was turned over to our master, but the fact that two years later the figure was transferred to Nanni suggests that Donatello had not done any work on it in the interval. Furthermore, the decision to substitute a different head was made not by the artists but by the *operai*, who directed Nanni to do this when they turned the statue over to him, so that the head, surely the most impressive part of the "Poggio," must have been carved after Donatello had relinquished the figure. The accounting of April 26, 1421, confirms our suspicion; here we learn that the completed statue had been appraised at 95 florins, and that Nanni was to receive 52⅓ florins as the sum still due him for his share of the work. Since the value of Ciuffagni's share had been appraised at 22⅔ florins in May 1420, we know that the total amount paid to artists other than Ciuffagni was 72⅓ florins. And this is exactly what Nanni received, for in December 1420 he had been advanced 20 florins "for a statue for the Campanile" which must have been the Joshua (no other payments are recorded under his name for the period April 1420-April 1421). In the face of such clear-cut evidence, we need not worry unduly about the fact that the document of October 31, 1421, refers to our figure as having been turned over to Donatello and Nanni about a year ago. This is plainly inaccurate—Donatello had been given the assignment three and a half years before the date of the entry, Nanni one and a half years—but since these events are only mentioned in passing, as part of the background for the financial settlement with Ciuffagni, which is the real subject of the entry, there was no necessity for the scribe to dig into the records and verify the details of his summary statement of the manner in which the statue was finished. Thus, if we insist on crediting Donatello with a share in the completion of the Joshua, we can do so only by assuming that he collaborated with Nanni on the project between May 1420 and April 1421 in clandestine fashion, without getting paid for his services by the *opera*. Had he been the lesser of the two masters, such an arrangement would be conceivable, since he might have worked on the statue as Nanni's employee; since he was not, we shall, I believe, have to discard this possibility.

The elimination of the head—or any other part— of the statue from Donatello's *œuvre* is not a loss to

[2] According to Schmarsow (*D.*, p. 19) this Joshua is the bearded prophet in the northernmost niche on the east side of the Campanile, a clearly erroneous opinion still repeated by Kauffmann (*D.*, pp. 23ff) and Alfred Nicholson (*Art in America*, xxx, 1942, p. 91).

[3] A third alternative, advocated by Nicholson, *op.cit.*, pp. 80n and 96, hardly deserves serious consideration; Nicholson equates the "Poggio" with Donatello's Habakkuk of 1435-1436, for which see above, p. 40.

be mourned, it seems to me. The weaknesses of the hands and drapery are too glaringly apparent to demand further comment, but the head, too, is disappointing upon detailed scrutiny. Its close relation to the beardless prophet from the east side of the Campanile (see Pl. 15b) was first recognized by Tschudi (*D.*, p. 8) and has been commented upon many times since. Yet the head of the Joshua does not represent the next evolutionary step beyond the beardless prophet in the direction of the Zuccone but a sort of caricature of it, overloaded with realistic detail and shallow dramatics of expression. In place of the quiet strength of its model, it offers a histrionic display of "character" that may have looked impressive enough to Vasari, who saw the figure only at a considerable distance, but which cannot survive inspection at close range. It is, in other words, a specimen of Donatello *maniera*—exactly what might be expected of an ambitious and superficial follower of the master such as the youthful

Nanni, whose lack of modesty is amply attested by his signature on the *Abdia*. If I am correct in assuming that Nanni assisted Donatello with the two prophet statues on the east side of the Campanile in 1416-1420 (see above, p. 38) before he emerged as an independent master, then he must have been very familiar indeed with the head of the beardless prophet, and we need not be surprised at his having taken it as the model which he wanted to surpass. He may have felt the task too difficult, for in his *Abdia* he reverted to the youthful type he had employed in the "St. John," so that the head of our statue has no counterpart in Nanni's Florentine phase. This is the reason why it could not be attributed to him on the basis of comparison with his other works of 1419-1422 (he left Florence in 1423; see Poggi, *Duomo*, doc. 268). It has taken the testimony of the documents to restore to him what by his standards must be adjudged one of his most ambitious artistic efforts.

"ST. JOHN THE BAPTIST," MUSEO DELL'OPERA DEL DUOMO, FLORENCE

PLATES 122a, 124b, c, d Marble; H. 207 cm (including plinth); W. of plinth 65 cm; D. of plinth 44 cm *1419-1420*
Inscriptions: on the scroll, ECCE AGNVS DEI; on the plinth, DONATELLO

DOCUMENTS

A number of entries among the records of deliberations and disbursements by the *operai* of the Florence Cathedral workshop, in the archives of the Opera del Duomo, from Poggi (*Duomo*, pp. 39f, 59), whose numbering we reproduce:

1419, July 12 (233): Nanni di Bartolo, called Rosso, is to be commissioned to do a marble statue, even though he is away; he must guarantee to indemnify the *opera* for the marble in case he should not finish the statue or should fail to do acceptable work.

July 31 (234): Nanni furnishes the guarantee requested above.

August 2 (235): Nanni is given permission to use two pieces of marble in carving the statue allocated to him—one for the head and neck, the other for the rest of the figure.

August 21 (236): Nanni receives permission to utilize the services of another sculptor (literally: to borrow, *mutuari*), who will have the right to work on the premises of the *opera*.

October 7 (237): Nanni is given an advance of 20 florins for the marble figure he is carving for the façade.

1420, January 9 (239): Nanni receives 15 florins in part payment for the marble statue he has made for the façade of the church.

March 19 (240): Nanni's statue has been appraised at 78⅓ florins, and he is to receive 43⅓ florins as the amount still due him.

1464, August 8 (331): The very beautiful four statues on the side of the Campanile facing the church are to change places with those on the side facing the Baptistery, which are very crude in comparison.

SOURCES

Identical with those for the Campanile statues; see above, pp. 35f.

Until its removal for safekeeping in 1940, and the subsequent decision to place it in the Museo dell' Opera, the statue occupied the northernmost niche on the west side of the Campanile. Presumably it was one of the four figures that were transferred there from the north side of the Campanile in 1464. Since its original destination was the façade of the Cathedral, we cannot be sure whether our statue ever stood in its appointed place before the *operai* decided to use it for the Campanile instead. It seems likely, however, that the "St. John" was one of the three statues which were in the workshop of the *opera* on February 4, 1431, when their installation "in certain vacant places on the Campanile" was decided upon (see Poggi, *Duomo*, doc. 307).

Until twenty years ago, the "St. John" was universally regarded as an unquestionable, signed work of Donatello. Semper (*D*. '75, p. 106) thought it one of the two statues for the Campanile for which our master received an advance of 10 florins on March 11, 1416 (see above, p. 38), because of its strong kinship with the St. George. This dating of the statue was adopted by the vast majority of subsequent scholars and is still followed by Kauffmann (*D*., p. 26), who identifies it with the figure completed in 1418 (see above, p. 38). Only Poggi (*Duomo*, pp. lix f), followed by Colasanti (*D*., pp. 17f), equated it with the Campanile prophet for which Donatello received payments in 1423-1426 (see above, p. 39). It was Lányi (*Statue*, pp. 254ff) who first pointed out that the "St. John" does not carry a bona fide signature (which ought to read, OPVS DONATELLI, like those of the Zuccone and the "Jeremiah") but merely a "label," epigraphically inferior and of uncertain date. He also made an observation that enabled him to match the statue with a set of documents relating to Nanni di Bartolo, thus removing it from Donatello's *œuvre* in what seems to me a strikingly persuasive argument: the head, he noted, is carved from a separate piece of marble. One need not share Lányi's belief in an almost mathematically precise correspondence of the available documents and statues in order to be struck by the fact that the long series of entries published by Poggi for the period 1415-1436 mentions only two statues with separately carved heads, and that among all the figures which can be linked to either the façade or the Campanile there are only two exhibiting this peculiar feature—the "St. John" and the "Poggio." According to the documents, one such figure was the Joshua begun by Ciuffagni in 1415-1417 and completed by Nanni di Bartolo in 1420-1421 (see the documents above, p. 225); the other was a "figure for the façade" commissioned of Nanni in 1419 and finished in 1420 (the documents relating to it are cited at the head of this entry). The latter must be the "St. John," Lányi maintains, since the Ciuffagni statue is clearly described as a Joshua. He has, I believe, made the right choice (see the stylistic comparison of the two figures above, pp. 227f), even though his primary argument is faulty, for the "St. John" could not have been intended as a St. John the Baptist. Schubring, the first to observe this (*KdK*, p. 194), pointed out that a Baptist without the tunic of fur would be an impossible anomaly (he suggests, for no apparent reason, that the statue might be a Jonah). In our case, the absence of the fur tunic is especially important, inasmuch as this would be by far the earliest known specimen of the "Young St. John," or Giovannino, in statuary form if we were to believe the words on the scroll. All the other examples date from the 1450's or later (cf. the various statues, busts, and reliefs by Desiderio da Settignano, Antonio Rossellino, and others). Their prototype is the Giovannino Martelli (see above, p. 195), rather than the Campanile figure, and they invariably show the fur tunic, as do the Trecento representations of the Young St. John in a narrative context (e.g., on the Baptistery doors of Andrea Pisano; see the thorough iconographic study of the subject by Marilyn Aronberg Lavin, *Art Bulletin*, XXXVII, 1955, pp. 85ff). Thus, if we accept the Campanile figure as a bona fide St. John, we should have to assume that the type was coined before 1420—surely neither Nanni di Bartolo nor Ciuffagni was capable of inventing it—but did not become popular until more than thirty years later; and that the earliest known example omits the one telltale feature that would have enabled the beholder to recognize it from a distance as a St. John (the words on the scroll could not be read from the street level any more than the signature of Nanni di Bartolo on the scroll of the Obadiah, which was noticed only in modern times; cf. the sources cited above, pp. 35f). But if our statue was not meant to be a Baptist, how are we to account for the inscription? There can be no doubt that the lettering is of the fifteenth century, yet its characters are most peculiar; some of them—the N, V, and I—have curved lines running through them that have no purpose at all except to give an "old-fashioned" look to the inscription (which, apart from the "d" in DEI, consists of Roman capital letters). None of these odd features is to be found on the scroll of the Obadiah, whose lettering matches that of the signatures of Donatello on the Zuccone and "Jeremiah" as well as the funerary inscription on the tomb of John XXIII.

The inscription on the scroll of the "St. John," then, has a purposely, though not very successfully, archaizing touch to it. Could it have been added in 1464, when the statue was moved to its present place?[1] Middeldorf (*AB*, p. 585) has suggested that the "Donatello" label on the base of our figure dates from the time of the reinstallation; the same, I believe, is true of the words on the scroll, as well as of the inscription on the scroll of the "Jeremiah" (see above, p. 39). The rationale of these epigraphic postscripts is not easy to fathom, but one might imagine the process somewhat as follows: in 1464, the *operai* of Florence Cathedral could well have been under the impression that all four of the statues to be transferred were by Donatello. The author of the *XIV uomini singhularj*, writing only a few years later, must have thought so since he speaks of "many" works by our master on the west side of the Campanile, and by 1510 the tradition was firmly established, as evidenced by Albertini (for both sources, see above, p. 35). There is nothing extraordinary about this tendency to claim too much; it simply illustrates what might be called the art historical counterpart of the law of the survival of the fittest, i.e. the general rule that in the course of time "the big names swallow the little names," especially if their works happen to be placed side by side. Assuming, then, that at the time of the transfer all four of the figures on the north side of the Campanile were credited to Donatello, the master-in-charge may have been rather surprised to discover that the Obadiah was signed IOHANNES ROSSVS. Since two figures carried the signature of Donatello, while the fourth did not, he decided, on the strength of what he had been told about the authorship of the entire group, that the nameless statue must be the work of Donatello, and engraved the master's name on its plinth just to keep the record straight. He also wondered about the identity of this youthful figure; ought it not to have an inscription on its scroll, like its companion the Obadiah? At this point, he recalled the Giovannino Martelli, Donatello's most recent statue of the same general type, and made up his mind that the nameless young prophet, too, was probably meant to be a Giovannino, so he added the appropriate words on the scroll. Finally, the master-in-charge began to speculate on the subject of the two signed Donatello figures, to whom he had assigned the places of honor. He had decided to put them on the bases of their Trecento predecessors, in order to compensate for their short stature (their height is about 10 cm less than that of the Obadiah and the "St. John"); and these bases, inscribed DAVID REX and SALOMON REX, may have led

him to think about the true significance of the two statues. The Zuccone had no scroll (in actual fact there is one but it is so well hidden that it might easily have escaped notice) but the other figure must be a prophet. Why the master-in-charge dubbed it Jeremiah is difficult to say (cf. above, p. 39); his reasons, whatever they may have been, need not concern us here. There is, however, another question that arises in this context: if our three "postscripts" date from the time of the transfer of the four statues to the west side of the Campanile—and we know of no suitable occasion after that when they might have been added—do we not have to concede them a certain evidential value, since Donatello was still alive then? Middeldorf (*loc.cit.*) uses this argument in defending the traditional attribution of the "St. John" to Donatello against Lányi's hypothesis. The document of August 8, 1464, which informs us of the relocation of the figures, does indeed precede the master's death by two years and four months. On the other hand, this entry only tells us when the transfer was decided upon, not when it was actually accomplished. There may well have been some delay; after all, the matter was not pressing, no other work was being done on the Campanile *décor* at the time, and the necessary scaffolding on two sides of the tower must have involved considerable labor. Still, let us assume that the transfer was carried out while Donatello was alive; does it necessarily follow that he was consulted as to the authorship of the "St. John," and if so, that he remembered exactly who did what in those busy days of half a century ago? Would he, in his late seventies and probably beset by the ills of old age, "have protested against the interference of meddlers," as Middeldorf puts it? Maybe so. I must confess, however, that I find it less difficult to believe that Donatello countenanced the mislabeling of Nanni's work as his own, under these particular circumstances, than to resolve the difficulties that would ensue if the "St. John" were to be retained in his *œuvre*. Disregarding, for the moment, all questions of style, Lányi's proposal to identify our statue with Nanni's "figure for the façade" is the only one that accounts for the physical peculiarities of the "St. John." From the documents in question, we gather that the *operai*, for reasons unknown, were anxious to have the figure at their disposal as quickly as possible (only nine months elapsed between the commission and the final payment, and Nanni's working time was a mere five months, from early August 1419 to early January 1420). The separately carved head evidently had something to do with this urgent schedule; unlike that of the Joshua, it was decided upon at the very

[1] Dario Covi, who is completing his doctoral dissertation for the Institute of Fine Arts at New York University on inscriptions in Florentine Quattrocento painting, was good enough to inform

me that archaizing tendencies of the kind mentioned here are not unknown in the second half of the century.

start as a matter of technical convenience, rather than as a substitute for the original, unsatisfactory head. And the head of the "St. John" does indeed seem far more completely integrated with the rest of the figure than the head of the "Poggio." Here it may be significant to note that the "St. John" is 17 cm taller than the statues on the east side of the Campanile (whose height averages 190 cm). Its larger size indicates that it was not destined for the Campanile but for the façade, another point in favor of Lányi's thesis. Apparently the *operai* did not have a block of exactly the right height at their disposal in July 1419 and were unwilling to wait for one to arrive from Carrara, so they set Nanni to work on a smaller block intended for one of the Campanile statues, permitting him to carve the head from another piece in order to make the figure tall enough for its purpose (i.e. 3½ braccia as against 3¼ braccia). The desire for speed also explains why Nanni received permission, three weeks later, to utilize the services of another sculptor. Who was he, and what did he do? Lányi does not enter into this question, but those who find his identification convincing and yet do not want to detach the "St. John" from Donatello's *œuvre* completely, could insist that Nanni's unknown collaborator must have been Donatello. Appealing as this alternative may seem, I regard it as unlikely: what Nanni needed after only three weeks of work on the block, I suspect, was a technically competent stonecarver to help with the roughing out of the statue, rather than an artistically superior associate. Moreover, the second master he wanted to bring in had to be given specific authorization to work on the premises of the *opera*; he was, in other words, an "outsider" who had no previous connection with the Cathedral workshop, and not Donatello, for whom such a permit would have been absurd.

Needless to say, the documentary and physical evidence discussed above would have to yield to the evidence of style if Donatello's authorship could be established convincingly on that basis. This is the attitude of Alfred Nicholson (*Art in America*, xxx, 1942, pp. 83n, and 84), who dismisses all of Lányi's arguments without bothering to refute them. I myself find it neither necessary nor desirable to credit Donatello with any part of the "St. John." There can be no question that the statue is in many ways closer to Donatello than the Obadiah, but this need not surprise

us, since the "St. John" was done almost two years earlier.[2] It represents, so far as we know, Nanni's first independent commission, after several years as a member of Donatello's workshop (see above, pp. 36ff). Yet, if our statue brings to mind the St. George and the marble David, its relation to these works is one of simple dependency; its design, instead of showing a development beyond the St. George, as we would expect of a Donatello statue, is a retrogressive *pastiche* of motifs taken from those two sources. The position of the legs, the turn of the head, and the arms are weakened reflections of the St. George, while the drapery of the lower half of the figure derives from the marble David as reshaped in 1416 (see above, pp. 4ff). Assuming that Nanni had to carve a youthful prophet, his dependence on the only two youthful figures in Donatello's work up to that point is plausible enough; however, the decision to make his prophet young and beardless seems to have been his own, rather than that of the *opera*. One is tempted to wonder, therefore, whether he chose this type because he was particularly well acquainted with the marble David and the St. George. Could it be that Nanni had entered Donatello's shop in 1416 when the master was working on both of those statues (i.e., carving the St. George and "adapting" the David), and that they were so vividly present in Nanni's mind for that reason? The Obadiah, executed between March and November 1422, no longer shows the same obvious relationship to Donatello; such residual strength as may be found in the stance, the hands, and the head of the "St. John" has been dissipated here. Yet the Obadiah is clearly the younger brother of our statue, both in expressive content and in terms of Morellian criteria (cf. the remarks of Ottavio Morisani, *Studi su Donatello*, Venice, 1952, p. 137). Even the plinths have the same shape; they are the only ones among all the Campanile statues to show profiled edges (the plinth of the "St. John" has been cut down on the left side; cf. Lányi, *Statue*, pp. 260f, n. 1). From the point of view of style, then, the "St. John" fits Lányi's hypothesis without the slightest difficulty. As a work of Nanni di Bartolo, it is a valuable addition to our knowledge of that artist's development, while in the context of Donatello's *œuvre* it is no more than a piece of unnecessary ballast which we can well afford to discard.

[2] The Abdia must be the figure whose name, according to Poggi, appears in the documents as Ulia and for which Nanni

received final payment on November 6, 1422; cf. Lányi, *Statue*, pp. 263f.

TOMB SLAB OF POPE MARTIN V
S. GIOVANNI IN LATERANO, ROME

PLATE 123a Bronze relief; L. 286 cm; W. 124 cm *1431 or later*
(c. 1435-1440?)

DOCUMENTS: none

SOURCES

1568 Vasari-Milanesi, p. 419: "It is said that Donatello's brother Simone, having made the model for the tomb of Pope Martin V, sent for him so that he might see it before the casting. Thus Donatello found himself in Rome just when the Emperor Sigismund was about to be crowned by Pope Eugene IV; he was constrained therefore, together with Simone, to take part in preparing the decorations for this festive event, and these brought him great fame and honor."

pp. 458f (*s.v.* "Antonio Filarete e Simone"): ". . . Simone, the brother of Donatello . . . having worked on the portal [the bronze doors of St. Peter's] did the bronze tomb of Pope Martin."

The identity of the Simone whom Vasari names here remains obscure. No such brother of Donatello is known from documents or other sources (we only hear of a sister), nor do we find a Simone among the assistants of Filarete (six of whom are named and represented on the back of the St. Peter's doors). Vasari has evidently confounded several individuals here; his statements, however, seem to fit none of the various artists of that far from uncommon name that are known from Quattrocento records. There is only one reference to a Simone in connection with Donatello: he is mentioned in 1467 as a former disciple of our master in an account book of the Florentine Compagnia di Sant'Agnese, for which he had made some decorations for St. Agnes' Day (see Milanesi-Vasari, p. 459n). Milanesi proposed to identify this Simone with Simone di Nanni Ferrucci of Fiesole, the father of the sculptor Francesco Ferrucci, and wanted to attribute to him most of the marble sculpture listed by Vasari as the work of "Donatello's brother Simone"; the bronzes, including the tomb of Martin V, Milanesi gave to Simone di Giovanni Ghini, a Florentine goldsmith born in 1407 who lived in Rome from 1427 until near the end of his life and died in Florence in 1491. Venturi (*Storia*, VI, p. 372, n. 4) pointed out, however, that according to the documents Simone Ghini seems to have been a goldsmith pure and simple, rather than a sculptor capable of large-scale commissions in bronze; he regarded the tomb of Martin V as the only known work of "Simone Fiorentino," a follower of Donatello of whom we have no record other than Vasari's account. While this did not prevent the Ghini hypothesis from finding general acceptance, Simone Ghini remains a nebulous figure of whose personal style we can form no conception for lack

of even one documented work.[1] The other Simone of Milanesi's theory, Simone di Nanni Ferrucci, is known to us mainly as a member of Ghiberti's workshop (the documents relating to him have been collected by Cornel v. Fabriczy, *Jahrbuch Kgl. Preuss. Kunstslgn.*, XXIX, 1908, Beiheft, pp. 2ff). The marble frame for Fra Angelico's *Madonna dei Linaiuoli*, the only work to which his name can be securely attached, was made after a design by Ghiberti and shows him to have been a craftsman without recognizable stylistic traits of his own, so that he hardly deserves to be credited with any of the marble pieces mentioned in Vasari's account of Simone (cf. Frida Schottmüller, "Zur Donatello-Forschung," *Monatshefte f. Kunstwiss.*, II, 1909, pp. 38ff).

Vasari himself seems to have felt rather uncertain about the Roman activities of "Donatello's brother Simone." In the first edition of the *Vite*, he mentions him only in the Life of Filarete (Vasari-Ricci, II, pp. 68f) and without reference to the tomb of Martin V; instead, he credits Filarete with "many bronze reliefs for papal tombs in St. Peter's which have now mostly disappeared," and informs us that Filarete and Simone collaborated on a marble tomb in S. Clemente. In the second edition, Filarete's sepulchral reliefs in bronze are omitted, and the marble tomb in S. Clemente has turned into "some marble tombs in St. Peter's which have now been dismantled." The reason for the change is clear enough—Vasari had learned in the meantime that Simone was the author of the tomb of Martin V, and had concluded that the tradition associating Filarete with bronze reliefs for papal tombs must be spurious. He was not quite sure, though, whether the "Simone of the tomb" was the same as the "brother of Donatello" whom he had introduced in the first

[1] His works in precious metals have all either disappeared or remain unidentified; for the documents concerning him see Eugène Müntz, *Les arts à la cour des papes*, I, Paris, 1878, pp. 166ff, and *Mélanges d'archéologie et d'histoire*, 1884, pp. 290ff.

edition as Filarete's associate on the doors of St. Peter's, and he resolved this doubt in his own characteristic fashion, by stressing that Simone did the tomb of Martin V *after* his work on the doors (even though he thereby contradicted his own chronology, since in the Donatello *Vita* of 1568 he had linked the tomb with the coronation of Emperor Sigismund in 1433, while the doors, according to his Filarete *Vita* of 1568, were commissioned not long after 1431 and took twelve years of labor). Moreover, in the second edition he claimed, contrary to fact, that Filarete had represented himself, Simone, and his disciples on the doors, whereas the first edition simply states that Filarete had represented himself and his disciples (without Simone, who is defined as his partner and artistic superior, rather than as a disciple). Thus one cannot but suspect that the story of Simone summoning Donatello to Rome to inspect the model of the tomb, may be just another fanciful elaboration of Vasari for the purpose of assuring us that the "Simone of the tomb" was identical with the "Simone of the doors." Interestingly enough, the relation of the latter Simone to Filarete has also undergone a change between the two editions of the *Vite*. In the first, we are told that when Filarete, a good bronze caster but an incompetent sculptor, had been commissioned to do the doors, he took Donatello's brother Simone as a partner because he was not equal to the task alone; that this Simone strove with all his might to imitate the style of Donatello although it was not given to him to reach such perfection; and that Simone did the two panels representing the martyrdom of Peter and Paul on the doors. According to the second edition, Filarete and Simone received the commission jointly; both of them had curried favor with the ministers of Eugene IV to whom the Pope, inexperienced in such matters, had left the choice of artists for the doors. Simone's share in the execution of the doors is not specified, and nothing is said about his ambition to imitate the style of his great brother. The first edition also tells us how Filarete grieved upon learning of the death of Simone, his most faithful friend, while the second omits any reference to the friendship of the two men. This curious shift of emphasis must, I think, be viewed in terms of Vasari's low opinion of Filarete; in both versions of the Filarete *Vita*, he calls the doors "shameful" and holds them up to scorn as a prime instance of irresponsible art patronage: whoever gives commissions of importance to "vile and inept" masters such as this, damages not only his own reputation but does grave injury to the public at large. In the first edition, he reinforces his point by telling us that Filarete was so inadequately equipped for the job that he had to seek the help of a better man, someone who at least tried to work like

Donatello and who actually carried out the most difficult parts of the commission (i.e. the two large narrative reliefs). Between 1550 and 1568, Vasari had come to concede a more independent career to the "Simone of the doors," whom he had by now compounded with the "Simone of the tomb," so he decided to demonstrate the moral of his homily on art patronage in a slightly different way: he made both artists into opportunists who gained the commission for the doors through favor rather than on merit. Within this new framework, it was no longer necessary, or even desirable, to proclaim Simone the better of the two and to stress his emulation of Donatello. Another reason for the change of "story pattern" was Vasari's *campanilismo*. In 1550, he was not yet aware that Filarete came from Florence; he says nothing about his origins while emphasizing the Florentine background of the artistically superior Simone. In the second edition, both artists are acknowledged as Florentines and have thereby achieved parity of talent—or rather of ineptitude—as well. All this suggests that when Vasari first heard of him, "Donatello's brother Simone" was a purely Florentine character whom he then injected into the making of the St. Peter's doors in order to minimize the artistic merits of Filarete, and still later equated with the "Simone of the tomb," inventing as a final touch the story of Donatello's being called to Rome to inspect the model of the tomb.

Thus there remains only one tangible element in Vasari's account of the tomb of Martin V—that according to a Roman tradition the author of the tomb was a certain Simone. It may be that this name perpetuates the memory of Simone Ghini, who through his long association with the papal court had probably become something of a local celebrity; but whether Ghini actually did the tomb, or what connection, if any, he had with Donatello, we cannot tell on the basis of what Vasari has to say about it. Any claim, therefore, that Donatello himself had anything to do with the tomb must rest entirely on stylistic evidence.

Such a claim was first advanced by Max Semrau (*Repertorium f. Kw.*, XIII, 1890, pp. 193f) and developed at greater length by Wilhelm v. Bode ("Donatello als Architekt . . . ," *Jahrbuch Kgl. Preuss. Kunstslgn.*, XXII, 1901, pp. 29f; reprinted in the various editions of *Florentiner Bildhauer der Renaissance*). Accepting Vasari's account at considerably more than face value, Bode assumes that Donatello went to Rome in order to pass judgment on a model for the tomb of Martin V made by his disciple Simone Ghini; then he notes the Donatellesque features of the slab, especially in the head, the drapery style, and the ornamental framework, and concludes that our master must in fact have furnished the design for the tomb, although the execution in detail remained in Ghini's

hands. That Donatello should have been asked to intervene he finds plausible enough in view of the fact that Ghini was still in his twenties at the time. He even suggests that Ghini may have been the *compagno* whom Pagno di Lapo had been sent to fetch from Rome, along with Donatello himself, in April 1433.[2] This view was supported by Schottmüller (*loc.cit.*, also *D.*, p. 124), Schubring (*KdK*, pp. 45, 196), and Bertaux (*D.*, pp. 97f); other scholars either rejected it or remained noncommittal, even though they were quite willing to equate the "Simone of the tomb" with Simone Ghini (Cruttwell, *D.*, pp. 13f; Colasanti, *D.*, pp. 27f, 98f, note). Kauffmann (*D.*, pp. 91f, 227, n. 301) regards the slab as "perhaps not entirely by Donatello" but credits our master with a major share in its design, which was then modified in detail by Ghini. The figure of the Pope, he claims, with its rigid solemnity and formalized drapery treatment, shows the deep impact upon Donatello of Romanesque sculpture. For those who are less prone than Kauffmann to discover mediaeval qualities in Donatello's art at every step, it is exactly this "Romanesque" flavor that argues against Donatello; to me, it represents a survival of conventional traits rather than, as Kauffmann believes, their deliberate revival. And where in Donatello's work do we find such strict frontality, such symmetry down to small details, such dry, lifeless drapery patterns? Neither the Crivelli effigy, with its clear differentiation between the free and the engaged leg, nor those of the Pecci or Coscia Tombs show any tendencies of this sort. Equally incompatible with Donatello's style is the strangely limp, flattened-out quality of all the forms that prevails not only in the effigy of Martin V but in the framework as well. It is particularly striking in the hands, which are little more than empty gloves, and can be felt even in the face, artistically the most impressive part of the work, which seems detachable like a mask—again a "glove" without a solid structural core underneath. Even so, the realism of these features certainly suggests the influence of Donatello (compare the head of the Coscia effigy, Pl. 27c). The drapery style, too, derives from such sources as the Pecci and Crivelli effigies. Even more specifically Donatellesque are the visible parts of the small Crucifixion embroidered in relief on the Pope's chasuble; the head of Mary that emerges above the right hand of the effigy seems inspired directly by a similar head in the *schiacciato* Lamentation on the St. Peter's Tabernacle (Pl. 42a).

The effigy rests in a sarcophagus whose tublike interior has strongly foreshortened sides, with the orthogonals converging upon a spot about 20 cm below the foot end of the slab. This perspective scheme has frequently been cited as an argument for attributing the design of the whole to Donatello, and there can indeed be little question that it echoes the Pecci Tomb. In contrast to the latter work, however, the illusionistic effect of our slab is vitiated by inconsistency: the receding orthogonals tell us that the effigy has been placed in a cavity of considerable depth, yet the feet and the head are in the plane nearest the beholder. As a result, the body gives the impression not of resting at the bottom of the sarcophagus but of hovering above it. The plaque with the two angels holding the papal coat of arms produces a similar conflict—its sides converge towards the same spot as the orthogonals of the sarcophagus, as if it were a strongly foreshortened rectangle, while in every other respect it looks like a trapezoid placed parallel to the main plane of the slab. What we have here, then, is an unsuccessful attempt to imitate the illusionism of the Pecci Tomb. Much the same might be said of the ornament; the repertory of motifs is almost identical with that on the S. Croce Annunciation and the Cantoria, yet without the density, the inventive richness, the rhythmic contrasts of Donatello's ensembles. In the S. Croce Tabernacle and the Cantoria, the ornament is deeply embedded in the architectural members; in the tomb of Martin V, it remains on the surface, ready to be scraped off, as it were. Highly characteristic is the design of the capitals at either end of the narrow pilasterlike panels that flank the effigy— a mask above an inverted Ionic volute, on a flat square field. This curious combination appears to be a faint echo of the pilasters of the S. Croce Tabernacle (with capitals made of twin masks and bases consisting of linked double volutes and claw feet) or of the masks above linked volutes below the main frieze of the Cantoria (Pls. 46a, c, e, 50). These latter may also be reflected in the masks and volutes flanking the plaque at the head end of the tomb. The tendrils and flowers on the pilasters and on the pillow are strikingly similar to those on the paneling behind the S. Croce Annunciation but at the same time more arid and geometric.

The foregoing observations permit us to define the author of the tomb of Martin V—whatever his name— as an artist of modest stature who must have had prolonged contact with Donatello between c. 1425 and 1435, since he displays thorough familiarity with a number of the master's works during this decade. (It could hardly have been Simone Ghini, who is documented in Rome since 1427.) When he did our slab, these impressions were still fresh in his mind. Thus the monument is most probably a work of the late 1430's, rather than of 1432-1433 as hitherto assumed on the basis of Vasari's anecdote linking it to the Roman sojourn of Donatello. Apart from this more

[2] The "partner" referred to here was surely Michelozzo; see above, p. 110.

than dubious testimony, there is no reason whatever to assume that the tomb was ready to be cast within two years after the Pope's death.[3] Nor do we have a *terminus ante* for the slab, although we know that the inscription at the feet of the effigy was composed by the humanist Antonio Loschi, Papal Secretary since 1418, who died in 1441. It is not impossible, of course, that our monument was carried out with the utmost promptness, but judging by the leisurely pace of similar commissions at that time, a delay of some years would seem entirely normal. The identity of the "Master of the Tomb of Martin V" must for the time

being remain open. He will have to be found among the numerous lesser artists who during the later 1420's and the 1430's helped to produce the tabernacles, tombs, and pulpits undertaken by the "firm" of Donatello and Michelozzo or by Donatello alone. The names of several of these men are known to us from the documents, and a few, thanks to diligent research, have begun to emerge as recognizable artistic personalities. Further persistence may well unearth the author of our slab, too, among this group, whether or not his name be Simone.[4]

[3] The inscription added to the tomb in 1853 to commemorate its transfer to the present setting, refers to it as "Simonis Florentini arte caelatum, MCCCCXXXIII"; this information is obviously derived from Vasari and therefore has no evidential value.

[4] Giuseppe Marchini, "Di Maso di Bartolommeo e d'altri," *Commentari*, III, 1952, p. 121, defines the master of the tomb

of Martin V in much the same way as I have done above, and suggests as possible attributions to the same hand the doorway leading from the first to the second cloister at S. Croce, Florence, and the silver reliquary dated 1457 in the Museo Diocesano, Cortona; the latter piece had already been linked with the "Simone of the tomb" by Girolamo Mancini, *L'Arte*, II, 1899, pp. 493ff.

ST. PROSDOCIMUS AND UNKNOWN SAINT, FONDAZIONE SALVATORE ROMANO, FLORENCE

PLATE 123b, c Limestone reliefs (fragmentary); H. 200 and 187 cm; W. 31 and 30 cm *(About 1450)*

DOCUMENTS: none

SOURCES: none

According to the Catalogue of the Fondazione Romano (Florence, 1946, No. 21, pp. 29f), these two pieces and several lesser ones were recovered in the demolition of a house in Padua, where they had served as steps (cf. *Gazetta antiquaria*, November, 1931). After their acquisition by Salvatore Romano, who believed them to be by Donatello, they were published by Giuseppe Fiocco in the monthly, *Padova* (VI, 1932, pp. 5ff). A translation of his article appeared soon after in *Burl. Mag.* (LX, 1932, pp. 198ff). Fiocco linked them, for unstated reasons, with the destroyed church of S. Bartolommeo and conjectured that they were given to S. Bartolommeo after the dismemberment of Donatello's high altar in the Santo (cf. above, pp. 169ff). The two fragments, he pointed out, are of *pietra di Nanto*, the same material as the Entombment on the back of the high altar; they also have ornamental mosaic inlays similar to those of the Entombment and match the style of the Entombment as well. Since it is known from documents and from the testimony of Michiel (see above, pp. 166, 167) that the Entombment on the back of the high altar was flanked on either side by two panels, each containing a single figure, Fiocco concluded that the two fragments in question must be part of this set. The unidentified saint, he thought, probably represents St. Maximus, a protector of Padua like St. Prosdocimus;

for the two lost panels he suggested SS. Daniel and Justina.

There are, however, a number of serious objections to Fiocco's hypothesis, as pointed out by Luigi Guidaldi (*Il Santo*, IV, 1932, pp. 241f, n. 1). First of all, their height (which must have been more than 200 cm in their original state) exceeds that of the Entombment slab by more than 60 cm, and it seems most unlikely that the flanking panels should have been taller than the one in the center. Guidaldi suggests that the difference might conceivably be explained by assuming that the steps in back of the altar extended only across the width of the Entombment, thus permitting the lateral panels to reach all the way down to the floor of the choir, but such a gap is hardly plausible. Moreover, the fragments are too narrow to fit the dimensions of the high altar, which had a total width of between 500 and 550 cm (see above, p. 172). Since the five panels together must have had approximately the same width, we can calculate the width of each of the four lateral ones as between 75 and 85 cm. Yet the two fragments in their present state measure only about 30 cm across, and even if we add what has been cut off we find that they could not have been much wider than 45 cm originally. Guidaldi also raises some iconographic problems in connection with Fiocco's thesis. Inasmuch as St. Prosdocimus is

represented among the bronze statues of the altar, why should he be shown a second time? And why should the Entombment be witnessed by four local saints, contrary to general practice? Guidaldi is surely correct in claiming that the four figures in question are much more likely to have been the four major prophets, the four evangelists, the four doctors of the Church, or the four cardinal virtues. All these arguments practically exclude the possibility that our two fragments ever formed part of the high altar. The alternative proposed by Kauffmann (*D.*, p. 233, n. 378) seems far more plausible at first glance, since it fits the scale of the pieces: are they not the remains of Donatello's work on the choir screen of the Santo? But the screen, as we know both from the documents and from surviving pieces, was made of white and red Veronese marble, rather than of *pietra di Nanto*, and Donatello's contribution to it involved an *antipeto . . . de marmoro* (see above, pp. 149ff). This solution, too, then, proves incorrect, although the fragments may well have belonged to some other choir screen

in Padua. (Guidaldi's suggestion that they formed part of a tomb carries little conviction.)

The style of the two pieces, while obviously Donatellesque, is difficult to assess in detail, due partly to their poor state of preservation. Even so, the quality of the carving hardly sustains an attribution to the master's own hand (cf. Planiscig, *D.*, p. 85). The grim-faced St. Prosdocimus doubtless reflects the bearded heads of the Entombment, but the undifferentiated, rigid treatment of the surfaces is on a far lower level than the rippling, pulsing forms molded by Donatello himself. So long as the precise local origin of the fragments remains undetermined, they had best be considered in general terms as evidence of some fairly ambitious decorative project in the wake of Donatello's Paduan activities, carried out by a sculptor who appears to have been part of the master's shop organization during the final phase of the work on the high altar. In the context of local Paduan sculpture, the pieces are not without interest and would repay further study.

BUST OF ST. LEONARD (OR ST. LAWRENCE), OLD SACRISTY, S. LORENZO, FLORENCE

PLATE 125a, b Terracotta; H. 50 cm; W. 52 cm (c. 1460)

DOCUMENTS: none

SOURCES: none

The earliest mention of the bust in the Old Sacristy is in Giuseppe Richa, *Notizie istoriche delle chiese Fiorentine . . .*, v, Florence, 1757, p. 39. At that time it was in a tabernacle above the door. (Milanesi, *Cat.*, p. 22, still saw it there, as did Semper, *D.* '87, p. 75, who observed remnants of a coat of stucco and paint on the bust.) Its present location, on a huge press against the entrance wall, dates from the time of the festivities in honor of the five hundredth anniversary of the master's birth (cf. Tschudi, *D.*, p. 22; Reymond, *Sc. Fl.*, II, p. 115).[1] The piece has often been regarded as part of Donatello's sculptural program in the Old Sacristy, hence the older literature usually identifies the subject as a St. Lawrence. However, according to Domenico Moreni (*Delle tre sontuose cappelle Medicee*, Florence, 1813, p. 256 and *Continuazione delle memorie . . . di S. Lorenzo*, II, Florence, 1817, p. 276) the bust represents St. Leonard and was made for the Neroni Chapel, dedicated to that saint (the fourth chapel off the left aisle of the church). If Moreni is correct—we do not know from what source he

derived his knowledge—the bust must have been modeled after 1457, for it was not until then that the Neroni Chapel and its neighbors were built (Walter Paatz, *Mitteilungen d. Kunsthistorischen Instituts Florenz*, IV, 1933, p. 140). Kauffmann, *D.*, pp. 158, 241, nn. 476-478, accepts this conclusion and places the St. Leonard in Donatello's post-Paduan years (all previous scholars had dated it in the decade before 1443, with Cruttwell, *loc.cit.*, advocating an even earlier date; Ludwig Goldscheider, *Donatello*, London, 1941, pl. 88, assigns it to the years "1447-1457?", thus neatly splitting the difference between the old and the new approach).

The attribution of the bust to Donatello has never been questioned explicitly, even though Lányi (*Pragm., Probl.*) and Planiscig (*D.*) may be said to have done so by omission. It is indeed a work of striking beauty, unrivaled by any other terracotta bust of the period, so that from the point of view of quality it well deserves such a distinction. Its style, however, seems to me clearly incompatible with Donatello's, whether before or after Padua.[2] The date of close to 1460 pro-

[1] Not the early 1900's as conjectured by Paatz, *Kirchen*, II, p. 567, n. 212 (perhaps on the basis of Cruttwell, *D.*, p. 100, who still refers to the bust as over the door).

[2] Kauffmann's attempt to relate it to the head of the bronze

David is no more than an extension of the same "blind spot" that made him claim similarities between the David and the Judith group.

posed by Paatz, while perhaps not established beyond cavil inasmuch as there is no final proof that the bust was made for the Neroni Chapel, corresponds to the "period flavor" of the piece, but this flavor has nothing in common with the late work of Donatello. A comparison with the heads of the Judith and the Giovannino Martelli—or that of the St. Daniel in Padua, to cite a somewhat earlier example—reveals the difference immediately (see Pls. 80c, 93b, 97c as against 125a). In such austere and introspective company the St. Leonard, with his softly rounded features, his cupid's-bow mouth ready to smile, appears almost coquettish. The relaxed yet animated expression, the subtle air of sensuousness, the caressing treatment of every surface that seems to convey texture differences without conscious effort—all these qualities are very remote from Donatello. On the other hand, they im-

mediately evoke the art of Desiderio da Settignano. Characteristic of Desiderio, too, is the design of the bust as a whole; the slight leaning backward, the combined tilting and turning of the head to the right, can be found in numerous busts associated with his name.[3] The physical type and the expression of the St. Leonard recall those of the two youths and the escutcheon-holding *putti* on the Marsuppini Tomb, a work begun in 1455 or soon after and completed, in all probability, during the very years proposed by Paatz as the date of our bust. There can be little question, then, that this, rather than the late style of Donatello, is the artistic *ambiente* where the St. Leonard must be placed. And since the superb quality of execution eliminates any thought of assistants or followers, we can only assign it to Desiderio's own hand.

[3] E.g., the Marietta Strozzi in the Berlin Museum and its many relatives and echoes; the difficult problem of separating those by the artist's own hand from the ones that are merely "Desideriesque" need not detain us here.

MALE BUST (NICCOLÒ DA UZZANO?), MUSEO NAZIONALE, FLORENCE

PLATES 124g, 125c, d Terracotta, polychrome; H. 46 cm; W. 44 cm *(c. 1460-1480)*

DOCUMENTS: none

SOURCES: none

The earliest reference to the bust uncovered so far (by Frida Schottmüller, *Monatshefte f. Kw.*, II, 1909, pp. 38ff) occurs in the fifth edition of Carlo Carlieri's *Ristretto delle cose più notabili della città di Firenze*, 1745, p. 125: "[In the Palazzo Capponi] there is the bust of Niccolò da Uzzano, a famous work of Donatello, with an inscription appropriate for so mighty a citizen." An engraving of our bust by Francesco Allegrini after Giuseppe Zocchi, 1763, discovered by Kauffmann (*D.*, p. 212, n. 145), does not show the inscription mentioned by Carlieri, which probably was on a bracket or pedestal that has since disappeared. However, Kauffmann, *loc.cit.*, found the text recorded in *L'osservatore fiorentino*, VIII, Florence, 1821, p. 43: "Magno et spectato viro/ Harum aedium primo conditori/ Nicolao de Uzano/ Ferrantes Capponius Maiori suo." He infers that Ferrante Capponi (1643-1714) added this inscription when the bust was moved to a new location within the Palazzo. Luigi Passerini, in a letter published by Semper (*D.* '75, p. 263, n. 120), refers to "two famous terracotta busts by Donatello" in the Palazzo Capponi, representing Niccolò da Uzzano and his brother Bernardo, "although the latter has recently been sold." Neither Semper nor any more recent scholar was able to trace this second bust. That of Niccolò was purchased by the Museo Nazionale in

1881 (Milanesi, *Cat.*, p. 26), after Bode had tried to secure it for Berlin (Wilhelm v. Bode, *Mein Leben*, 1930, I, pp. 130f).

The bust is disfigured by several coats of paint—the most recent one seems to be of the nineteenth century—which obscure some of the sculptural details. An exact duplicate, broken off at the base of the neck, was published by Robert Corwegh (*Der Kunstwanderer*, 1928, p. 67) as the original portrait head, modeled from life; Joseph Pohl (*Die Verwendung des Naturabgusses in der italienischen Portraitplastik . . .*, Würzburg, 1938, p. 50) describes it as a rather weak copy of the Florentine bust. Since I know the piece only from photographs—it belongs to the Estate of Frau Claire v. Abegg, Strüb near Berchtesgaden, which appears to be still under litigation—I am not in a position to define its relationship to the bust from the Palazzo Capponi. It is, however, far less heavily painted, and perhaps for that reason certain facial details, such as the lines on the forehead, the lower eyelids, and the wart on the right upper lip, show up more distinctly. A thorough cleaning of the Florentine bust is long overdue. Kauffmann, *loc.cit.*, has noted that when the bust was mounted on its present base of gilt wood (apparently at the behest of Ferrante Capponi, since the shape of the base is Baroque), it

was made 4 to 5 cm taller than it had been originally by the addition of a layer of material at the bottom. Actually, this material—which seems to be stucco—forms a wedge (clearly visible in Pls. 124g, 125c) that tilts the bust forward by about eight degrees. The change in angle, though small, is of considerable importance aesthetically, as evidenced by the contrasting photos on Pls. 124g and 125d, made under Lányi's direction. To restore the authentic bottom surface of the bust would be highly desirable.

The identity of the sitter has been a matter of dispute ever since Tschudi (*D.*, pp. 22f) raised the issue by pointing out that Niccolò da Uzzano died in 1432, while the bust seemed to be of a later date (he placed it about 1440, together with the St. Leonard, for which see above, p. 236). He was followed by Cornel v. Fabriczy (*L'Arte*, VI, 1903, p. 374), who suggested Piero Capponi, and Bertaux (*D.*, pp. 133f), who proposed Gino Capponi. Schubring (*Moderner Cicerone*, Florence, 1903, p. 10) noticed a hole in the back of the head which he thought suitable for fastening a halo, and concluded that the bust must be of a saint, but later returned, somewhat doubtfully, to the traditional view (*KdK*, pp. 42f, 196; *HB*, pp. 64f). An interesting if inconclusive thesis was proposed by Franz Studniczka, who interpreted the bust as a Renaissance portrait of Cicero (*Festschrift Heinrich Wölfflin*, Munich, 1924, pp. 135ff; first publication, in much shorter form, in *Winckelmannsfeier d. Archäol. Seminars*, Leipzig, 1911, paraphrased and endorsed by Lechat in *Revue de l'art ancien et moderne*, XXXI, 1912, pp. 367ff). Those who regarded the bust as a work of the sixteenth or seventeenth century likewise rejected its designation as Niccolò da Uzzano, needless to say (see below). Kauffmann, *loc.cit.*, on the other hand, vigorously defends the reliability of the traditional label (with the concurrence of Middeldorf, *AB*, p. 580), as does Pohl, *op.cit.*, pp. 48f. Ironically enough, they both rely on a piece of evidence contributed by Studniczka, *loc.cit.* (and anticipated, unknown to him, by Cruttwell, *D.*, p. 45): the portrait of Niccolò da Uzzano painted by Cristofano del Altissimo for the portrait gallery of Cosimo I in the later Cinquecento. This, Studniczka claims, is based on the bust, so that the latter must have been known as a portrait of Niccolò more than a century before Ferrante Capponi's inscription. In addition, Kauffmann, Middeldorf, and Pohl cite the portrait medal by Niccolò Fiorentino of c. 1480, for which they claim a striking physiognomic resemblance to the bust (denied by Studniczka and Fabriczy), and Kauffmann introduces a head from the mural of 1424-1428 on the façade of S. Egidio in Florence, by Bicci di Lorenzo, which he correctly identifies as the only contemporary portrait we have of Niccolò da Uzzano (Vasari had

mistaken it for a self-portrait of the painter, as noted by Middeldorf). The head in question does indeed agree remarkably well with the medal, but neither of them shows more than the most general kind of similarity with the bust. Nor am I persuaded that the Altissimo portrait reflects the bust; its nose, which is distinctly different from that of the bust, resembles those of the medal and of the head by Bicci di Lorenzo, while the upper lip agrees neither with the bust nor with the two earlier portrait heads. The same upper lip, however, along with the characteristic "Uzzano nose," occurs in a head, traditionally identified as that of Niccolò da Uzzano, in Benozzo Gozzoli's Journey of the Magi in the Chapel of the Medici Palace. Thus, if our bust is a portrait of Niccolò, it must be a highly idealized one; but the bust, from the shoulders up at any rate, does not give the impression of being idealized at all, what with the conspicuous Adam's apple and the two warts. It has, in fact, often been described as based on a death mask. Under these circumstances, the visual evidence for the identity of the sitter loses its force completely, and we are forced to fall back on Ferrante Capponi. That the bust had been in the Palazzo Capponi long before Ferrante labeled it as Niccolò da Uzzano, seems highly probable; but can we infer that the bust was known by that name all along? Is it not equally likely that the identification with Niccolò was thought up by a seventeenth century antiquarian who noticed a resemblance between the bust and the Altissimo portrait in the Uffizi corridor? Such a hypothesis, moreover, would explain why the bust received a new mounting and the inscription at the time of Ferrante Capponi, and why the work is not mentioned in the Florentine *guide* until the eighteenth century. Had the bust been known as a portrait of Niccolò da Uzzano before then—or as a work of Donatello, for that matter—we might reasonably expect to find some reference to it in Vasari, Bocchi, or Bocchi-Cinelli. The fact that they omitted it tends to suggest that the tradition ascribing the bust to our master does not go back beyond Ferrante Capponi's day, and perhaps not even as far as that. If we grant the seventeenth century origin of the notion that the bust represents Niccolò da Uzzano, it does not seem at all implausible to assume that the newly acquired iconographic importance of the work raised its artistic standing as well. Ferrante Capponi, or one of his descendants, may very well have concluded that their illustrious forebear must have been portrayed by the greatest sculptor of his time; and since Donatello, according to tradition, had represented other well-known contemporaries such as Gianozzo Manetti, Poggio Bracciolini, Francesco Soderini, and Giovanni di Barduccio Chierichini in his statues for Florence Cathedral (see above, pp. 40f, 226), he was a doubly

logical choice as the putative author of the bust.

The attribution of the "Niccolò da Uzzano" to Donatello has been attacked as often and as vigorously as the identity of the sitter. The first to protest it was Milanesi, *loc.cit.*, who listed the bust among the "doubtful or wrongly attributed works." Reymond (*Sc. Fl.*, II, pp. 116f) pronounced it "unworthy of Donatello" and placed it at the end of the Quattrocento, "closer to the Brutus of Michelangelo than to the St. Lawrence of Donatello." Bertaux, *loc.cit.*, also felt a kinship with the Brutus but believed that Michelangelo had been influenced by Donatello's bust.[1] Alfred Gotthold Meyer (*Donatello*, Leipzig, 1903, pp. 40f) and Schottmüller (*D.*, pp. 99f) agreed with Tschudi's view; both defended the bust as a masterpiece such as no one but Donatello could have created. So did Cruttwell, *loc.cit.*, who reported that some scholars—whose names she omits—regarded the work as Spanish (cf. Schubring, *KdK*, p. 196) or as a comparatively recent forgery. These opinions, so far as I have been able to determine, were never expressed in print, although Max Dvořák had ascribed our bust to an imitator of Michelangelo, apparently because of its supposed resemblance to the Brutus (*Kunstgeschichtliche Anzeigen*, Innsbruck, 1904, p. 77). Colasanti (*D.*, pp. 64f) treated the iconographic problem with indifference but acclaimed the bust as "one of the most powerful portraits of all time" and undoubtedly by Donatello (probably after 1433). To Kauffmann (*D.*, pp. 48ff), a date of 1426-1430 seemed indicated by a comparison of the bust with the Zuccone. He also insisted that the "Niccolò da Uzzano" was the earliest independent portrait of the Italian Renaissance and thus a truly epochal achievement. These far-reaching claims have been effectively deflated by Middeldorf, *loc.cit.*, who speaks of the "quite inartistic realism" and "the complete lack of style in the modeling of the face," and who wonders to what extent the bust deserves the status of a work of art rather than a modified facial cast. He classes it with a great many other Quattrocento busts similarly based on life or death masks and for that very reason impossible to attribute to known masters on grounds of style. The "Niccolò da Uzzano," he concludes, may or may not be by Donatello; it makes little difference, since we would in any event be unable to learn much about the master's style from this work. Middeldorf's opinion has since been cited with complete approval by Lányi (*Probl.*, p. 16, n. 11) and Planiscig, who had omitted the bust in both his Donatello monographs but rejected it explicitly in a separate article (*Firenze e il*

mondo, I, 1-2, 1948, pp. 35ff). After reviewing the iconographic evidence and pointing out the late origin of both the "Niccolò da Uzzano" and the "Donatello" traditions, Planiscig cites the comparison with Michelangelo's Brutus as evidence of the Cinquecento date of the bust, and the wart (in accordance with Studniczka, *loc.cit.*) as proof of its Ciceronian significance.[2] Finally, Planiscig draws attention to a marble bust that was erected in 1547 in the Salone of Padua as an ancient portrait of Livy but is actually a Renaissance forgery based on the death mask of an unidentified individual (Leo Planiscig, *Venezianische Bildhauer der Renaissance*, Vienna, 1921, pp. 315ff). The "Niccolò da Uzzano," he suggests, is another Cinquecento "reconstruction" of a famous Roman, and quite possibly North Italian or even Paduan; only this time the subject was Cicero, so whoever made the bust picked a death mask with the requisite wart.

That the face of the "Niccolò da Uzzano" is based on a death mask was first asserted by the German sculptor Adolf von Hildebrand (as reported in Wilhelm Bode, *Italienische Portraitskulpturen des XV. Jh. in den klg. Museen zu Berlin*, Berlin, 1883, p. 20). Meyer and Bertaux also emphasized it, with particular reference to the "caved-in" quality of the features and "hippocratic" eyes, while Studniczka and Kauffmann denied it. Pohl, *loc.cit.*, whose experience as a sculptor gives particular weight to his opinion in this matter, has confirmed the use of a death mask with arguments that seem entirely conclusive. Of special interest is his observation that the features are somewhat less than lifesize, corresponding to the shrinkage of a lifesize clay face in the kiln (he has found the same to be true of other terracotta death masks made directly from the female gesso molds). For the rest, Pohl claims to see the hand of Donatello in the "retouched" parts of the face, i.e. the eyes and mouth, but without entering into comparisons with the master's documented works. The harsh verdict of Middeldorf must, I am afraid, be acknowledged as essentially correct, even though the bust is not quite as devoid of style as he would have us think. We do not, of course, know the precise boundary line of the mask; it seems to have included part of the neck, as Pohl suggests. Yet such a cast could not have been converted into a bust without a good deal of additional free modeling, and the truly disconcerting thing about the "Niccolò da Uzzano" is that this modeling is of such poor quality. Especially the eyes, whose fishlike stare was noted by Cruttwell, are both badly placed in relation to their sockets and vacuous in expression. The same lack of organic feel-

[1] If such were really the case, it would be a powerful argument for the claim that the bust was known as a work of Donatello in the Cinquecento, but the only element of similarity is the turn of the head.

[2] The wart, as Studniczka has shown, was indeed regarded as a sort of facial emblem of Cicero in the Renaissance; his case, however, is weakened by the fact that our bust has two warts—why double an attribute such as this?—and by the circumstance that the supposed Niccolò da Uzzano head in the Gozzoli mural also has a wart.

ing appears in the way the skull has been added to the face; it seems unpleasantly small, and no allowance has been made for the physical bulk of the hair, which is indicated very perfunctorily by short curving strokes impressed in the clay surface. Even these occur mostly around the edges of the hairline; the back of the skull, around the hole commented upon by Schubring, shows no hair texture at all.[3] The ears, in contrast, are so naturalistic that one is tempted to think of them as part of the facial cast (there is a crudely patched damaged area at the right temple which also affects that ear). The treatment of the neck, too, shows this naturalism in the emphasis on anatomical details such as the neck muscles, the folds and creases of the skin, and the ugly, bulging Adam's apple (the back part is handled rather summarily), yet the result is structurally weak. The drapery arrangement vaguely suggests a toga, and its style has often been defined as classicizing. So far as I can see, it has no style at all. Pohl, *loc.cit.*, claims that it consists of real cloth saturated with gesso, as in the case of the stucco bust of the Young St. John in Berlin.[4] Whether this is true —and whether the impregnating material is actually gesso, rather than clay—I have been unable to verify; if it is not, the artist must have copied such an arrangement in the most painstaking manner, for the effect is exactly like that of the stucco-dipped linen of the Berlin Giovannino. Pohl regards the use of real cloth here as a "short-cut" due to the pressure of time (he assumes that the bust was made immediately after the death of Niccolò da Uzzano and may have been needed in time for the funeral); a "short-cut" it certainly is, but it also reflects the same taste for hyper-realism that led to the direct use of facial casts in busts such as ours. This taste seems characteristic of the second half of the Quattrocento. Among all the examples discussed by Pohl, the "Niccolò da Uzzano" is the only one for which he claims a date earlier than that (death masks as such, needless to say, were already known to the Trecento). It is in the later

fifteenth century, rather than in the sixteenth, that our bust must be placed, I believe. Planiscig's argument for a North Italian Cinquecento origin rests on far too slender a basis (a wart, to be exact), since the only analogy between our bust and the Livy portrait in Padua is that both supposedly show the use of death masks in representations of classical authors. His more general claim concerning the "Michelangelesque" turn of the head fails to take account of the wedge that was added to our bust about 1700 in order to tilt it forward. The resemblance to the Brutus really depends on this forward tilt (and may very well have been the reason why the wedge was thought desirable). As soon as we view the bust as it was intended to be seen, the head no longer shows the forward-craning movement that is mainly responsible for the analogy with the Brutus. Instead, we now find that the chin is raised and the entire head thrown back, as if the sitter were looking upward. Such a backward tilt of the head, and sometimes of the entire bust, occurs in less drastic form among busts of the 1460's and 1470's by Desiderio and his school (see above, p. 236). Thus Tschudi was guided by the right instinct when he felt that the "Niccolò da Uzzano" must be of about the same date as the St. Leonard in the Old Sacristy. This still leaves the possibility that our bust might be a late work of Donatello, around 1460; and here the drapery becomes of decisive importance. For at that time Donatello, too, was affected by the taste for hyper-realism, as evidenced by his use of real fabric for the costume of the Judith (see above, p. 201), which permits an exact comparison with the drapery of the "Niccolò da Uzzano." Nothing, it seems to me, could bring out the difference between the two works as strikingly as this particular test: it shows that when a great master avails himself of the "short-cut" method, he knows how to bend the material to his own will, so that the cloth, encrusted with ornament, loses its deadness and turns into a responsive vehicle of expression.

[3] Could this hole have served to anchor some sort of head-covering? It is difficult to imagine what shape it could have had, but the undifferentiated treatment of the skull does suggest such a possibility. The hole does not look like a later

addition.
[4] No. 28; attributed to Donatello by Bode but clearly Desideriesque; Kauffmann, *D.*, p. 241, n. 478, gives it to Desiderio outright.

THE FLAGELLATION OF CHRIST, FORMERLY STAATLICHE MUSEEN, BERLIN[1]

PLATE 127b Marble relief; H. 46.5 cm; W. 57.5 cm (*c. 1460-1470?*)

DOCUMENTS: none

SOURCES: none

The panel, said to have been owned by the Peruzzi family, was acquired in Florence in 1892 (*Beschrei-*

[1] Unaccounted for since May 1945 and presumably destroyed at that time in the fire that consumed the interior of the anti-

bung der Bildwerke der Christlichen Epochen, Kgl. Museen, Berlin, 2d ed., v, ed. Frida Schottmüller, 1913,

aircraft tower at Friedrichshain; see *Berliner Museen*, N.F., III, 1953, p. 11.

p. 15, No. 27; revised ed., 1933, p. 8, No. 1979). According to Wilhelm Bode (*Denkmäler der Renaissance-Skulptur Toscanas*, Munich, 1892-1905, p. 21) it had previously been attributed to Michelangelo, and Bode himself believed that it must have been the model for a lost composition by Michelangelo, reflected in the Flagellation mural of Sebastiano del Piombo in S. Pietro in Montorio. Bode's enthusiastic estimate of our relief as a masterpiece by Donatello closely related to the Siena Feast of Herod has, until recently, been accepted by the great majority of scholars (Schottmüller, *D.*, pp. 18f, 84f; Schubring, *KdK*, pp. 33, 195; Bertaux, *D.*, p. 76n), although some thought it more closely related to the Lille panel than to that in Siena (Reymond, *Sc. Fl.*, II, p. 114; Alfred Meyer, *Donatello*, Leipzig, 1903, p. 83; Cruttwell, *D.*, p. 69) while others placed it between the St. George relief and the Siena panel (Venturi, *Storia*, VI, pp. 255f; Colasanti, *D.*, pp. 45f; Kauffmann, *D.*, pp. 59f, 215, n. 179, endorsed by Middeldorf, *AB*, p. 579). In the beginning, Balcarres was the only dissenter (*D.*, p. 177) who called the Flagellation "the work of a clever but halting plagiarist." H. Folnesics ascribed it to Niccolò Coccari, a Dalmatian who had briefly assisted Donatello in Padua, on the basis of a relief with the same composition in Spalato by Niccolò's teacher, Giorgio da Sebenico (*Monatshefte f. Kw.*, VIII, 1915, p. 190); the two panels, however, are utterly dissimilar in style, as pointed out by Schubring (*HB*, p. 210), so that this view did not upset the prevailing opinion. Yet Schottmüller, in the 1933 edition of the Berlin catalogue, claims the work for Donatello only with reservations (Max Semrau, in Thieme-Becker, *Allgemeines Lexikon . . .*, IX, 1913, had omitted it from his list of the master's *œuvre*); Lányi (*Pragm.*; *Probl.*) rejects it by implication, Planiscig does so explicitly (*Phoebus*, II, 1949, p. 58); Ludwig Goldscheider (*Donatello*, London, 1941, p. 17) has grave doubts about it; and Rezio Buscaroli (*L'arte di Donatello*, Florence, 1942, p. 148) suggests that it might be a copy of a lost original by Donatello, or even a forgery.

The relief does indeed give rise to misgivings of various sorts. Its attribution to Donatello, so far as published opinion is concerned, rests on a rather perfunctory argument: the resemblance of the female figure to the princess of the St. George relief and the Salome of the Siena Feast of Herod, and the similarity of the architectural setting to those of the Siena and Lille panels. Even Kauffmann, who has commented on

the Flagellation at greater length than any previous author, is content with these superficial observations; he simply takes it for granted that the panel was carved by Donatello about 1420-1422 without answering the questions that are raised by this assumption.[2] The female figure certainly reflects a classical prototype (Colasanti, *D.*, p. 93, thinks of a Barbarian woman such as the "Thusnelda"); that, however, is the only quality she has in common with the princess and the Salome, whose style seems utterly different to me. As for the architectural background, it may be said to derive from the Siena and Lille panels, rather than to prepare them; the fact that it is Donatellesque does not force us to conclude that it must have been designed by the master himself. What seems to me an insuperable difficulty in ascribing the Flagellation to Donatello is its strange inconsistency of style, which gives it the character of a *pastiche*; it appears to combine a number of separate motifs without integrating them into a truly coherent composition. The most obvious instance of these internal discrepancies is the arbitrary difference in scale between the main group and the two figures on the left (cited by Kauffmann as an indication of the early date of the relief), which corresponds to a difference in style as well: the maid and the soldier are curiously rigid and immobile as compared to the other three figures, who seem far more advanced in their freedom of movement. Especially striking is the spacious diagonal pose of Christ. At this point, however, we encounter another inconsistency: the blank wall is placed so close to the front plane of the relief that the figures appear to be embedded in it, rather than standing in front of it (note especially the position of Christ's feet in relation to the floor pattern and the bottom edge of the wall; also the column, which looks like a shallow pilaster and disappears completely behind Christ). This spatial awkwardness might be understandable as another "early" feature were it not for the elaborate display of linear perspective in the design of the panel, which is clearly patterned after the Lille Feast of Herod rather than the Siena relief, thus establishing the mid-1430's as a *terminus post quem* for the Flagellation.[3] Unfortunately, our artist did not know how to place the figures properly within this complicated network of converging lines; the central group is designed with reference to a much lower horizon than that used in our panel. This becomes clear as soon as we compare it with two related compositions often referred to as

[2] He does, to be sure, point to similarities between the Christ and the Isaac of the Abraham group on the Campanile, and the loincloth of Christ reminds him of the kerchief of the Pazzi Madonna, but neither of these items of corroborative evidence strikes me as persuasive.

[3] Charles Yriarte, *Un condottiere au XVe siècle*, Paris, 1882, p. 407, suggests a relationship that, if correct, would yield a

terminus ante of 1442 for our relief; the figure of the maid, he believes, inspired the attendant on the extreme right in the Exorcism scene of Agostino di Duccio's Modena panel. The resemblance here is so vague, however, that it can be fully accounted for by assuming that both figures reflect a common prototype.

echoes of ours, a bronze plaquette (Schubring, *KdK*, p. 95, Berlin; another specimen in the Louvre) and a drawing (Schubring, *KdK*, p. xxxix, Uffizi; Ferrarese?). In both of them the horizon coincides with the floor line. The plaquette has no perspective background at all, yet the illusion of depth is far more convincing than in our relief; and since the entire action is much more forceful and expressive, we have here, I believe, a more direct reflection of the original design—whoever may have been its inventor—than in the marble panel. (Interestingly enough, both the plaquette and the drawing show Christ tied to a pilaster; hence the flatness of the column in our relief.) The design of the plaquette, although certainly not by Donatello, presupposes the master's late style, so that the marble Flagellation, too, can hardly be dated earlier than the 1460's. It is the work of an artist of decidedly undramatic temper, who has discarded almost completely the tragic violence still visible in the plaquette. Had he retained the blank background of the original composition, he would have preserved at least its spatial unity; instead, he has changed the void behind the figures into a flat wall by superimposing on it an alien perspective setting. Moreover, he has misunderstood his source: in the Lille relief, the masonry visible through the arcade belongs to a building in the far background, while in our panel it forms a wall that closes off the two center arches and contrasts rather oddly with the completely smooth surface behind the figures. Such blank spots occur neither in the Lille relief nor in that in Siena, where the material texture of architectural surfaces is strongly set off against the figures. The Flagellation group proper, then, and the surrounding architecture are in effect "quotations" from different sources which our artist has been unable to bring under a common denominator. The soldier and the woman, too, look like "quotations" from still another source; the former repeats the pose of the escaping *putto* on the extreme left in the Siena relief, while the latter is difficult to account for, even iconographically; I know of no other female witnesses to the Flagellation. (Could she be the maid who figures in the Betrayal of St. Peter?) However that may be, the compilatory character of our panel is clear enough to exclude its attribution to Donatello or any other master of major stature. The late dating of the work suggested above may seem puzzling at first glance; for the 1460's, this would be a strongly archaizing style. Nevertheless, we can hardly arrive at a different conclusion if we consider the way the three main figures are modeled. Their somewhat "soapy," smoothly undulating surface has no parallel in Donatello's *schiacciati* but it does betray the new *morbidezza* of flesh texture introduced by Desiderio and Antonio Rossellino after the middle of the century.

The style of the "Master of the Berlin Flagellation" does not match that of any identifiable sculptor, so far as I know. We do, however, have another work by the same hand. The marble relief in an oval frame of the Madonna adored by four angels, in the collection of the late W. L. Hildburgh, shows the same characteristics (published by the owner, *Art Bulletin*, xxx, 1948, pp. 11ff; cf. also my own note on the piece, and Dr. Hildburgh's reply, *ibid.*, pp. 143ff and 244ff). Here again we find an elaborate perspective setting derived from that of the Lille relief, yet with a curiously flat over-all effect; the arches rest on piers as smooth and undifferentiated as the blank wall of the Berlin Flagellation. There is also a remarkable similarity of facial types and expressions, especially in the profiles, and of drapery treatment. The same vaguely classicizing air pervades both panels, although the one in Berlin appears to be the younger and more developed of the two. Their absolute chronology, on the other hand, remains a difficult matter, and the date I have suggested here for the Berlin Flagellation may well have to be revised in the light of future findings. Perhaps it will be possible some day to say with greater assurance than I command at present just when the peculiarly contradictory style of these reliefs became possible.

THE CRUCIFIXION, MUSEO NAZIONALE, FLORENCE

PLATE 127a Bronze relief; H. 93 cm; W. 70 cm (*c. 1470-1480*)

DOCUMENTS: none

SOURCES

1568, Vasari-Milanesi, p. 417: "In the same *guardaroba* [of Duke Cosimo] there is a bronze relief panel showing the Passion of Our Lord, with a great number of figures; and also another bronze panel, likewise of the Crucifixion."

1584, Borghini, *Riposo*, p. 321: "In the *guardaroba* of the Grand Duke Francesco one may see . . . a bronze relief panel showing the Passion of Our Lord, with many figures; and another bronze panel of Christ on the Cross, with other figures that belong to the subject. . . ."

While its history cannot be traced back in detail, the panel is almost certainly the one mentioned by Vasari and Borghini (in the absence of evidence to the contrary, we may assume that it was one of the Medicean *bronzi moderni* exhibited in the Uffizi since the eighteenth century and transferred to the Museo Nazionale in the 1870's). The identification, denied by Milanesi (*Cat.*, p. 28), has since been generally accepted. Donatello's authorship, however, has repeatedly been questioned. Milanesi, *loc.cit.*, was struck by the *maniera tedesca* of the composition, Schmarsow (*D.*, p. 49) ascribed it to Bertoldo, and Semrau (*D.*, pp. 78f) saw it as the work of an eclectic disciple of Donatello. Tschudi, on the other hand, regarded the relief as in every essential the master's own invention, although he granted that some of the details might have been done by the young Bertoldo (*D.*, p. 29); Schottmüller placed it among the products of the Donatello workshop (*D.*, p. 90); Cruttwell (*D.*, p. 130), Colasanti (*D.*, p. 83), and recently Planiscig (*D.*, p. 116) adopted Tschudi's view; and even Wilhelm Bode conceded that the freshness of Donatello's modeling had suffered through overly meticulous chasing by a lesser artist (*Denkmäler der Renaissance-Skulptur Toscanas*, Munich, 1892-1905, p. 32). Schubring (*KdK*, p. 139) and Kauffmann (*D.*, p. 188) claim the panel for Donatello without qualification. Lányi, in an unpublished note, rejects it as merely "Donatellesque."

The "Medici Crucifixion" is certainly an ambitious and, in some ways, impressive work, replete with Donatellian features. Yet it also displays important weaknesses that cannot be blamed on the chasing. Nor are they explainable by assuming that Donatello designed the composition but left the actual modeling in large measure to some assistant. The very conception of the panel strikes me as incompatible with the master's genius. There is, first of all, the curious inconsistency of style which led Semrau to call the relief "eclectic": the basic flavor is obviously "post-Paduan" (Bode, *loc.cit.*, is the only one to suggest a date before 1443) and approaches that of the S. Lorenzo Pulpits, but the landscape background reproduces—not very successfully—the kind of infinite atmospheric recession Donatello created in his *schiacciato* reliefs of the 1420's and 1430's. We can even identify the specific model that has been followed here, i.e. the landscape setting of the Delivery of the Keys in London, as evidenced by the peculiar shape of the trees (compare Pl. 39b; the same observation was made by Semrau, *loc.cit.*). The angels "swimming" among the clouds are another

feature derived from Donatello's marble *schiacciati*. Are we to believe that the master himself, on this single occasion, decided to revive in bronze what he had done in marble thirty years earlier? And where in Donatello's pictorial reliefs do we find the arbitrary scale of the figures so noticeable in the "Medici Crucifixion?" (Compare especially the size of the soldiers sitting or lying on the ground at the bottom of the panel with that of the standing figures immediately behind them; the angel next to the thief on the extreme left is far too large in relation to the soldier below him.) Equally disturbing to the spatial progression within the panel is the inconsistent treatment of the various degrees of relief: Christ, the two thieves, and the man on the ladder are far more fully modeled than any other figures except those in the immediate foreground. On closer scrutiny, we notice all sorts of other discrepancies as well. The cross of Christ, for instance, is surely intended to be a good deal closer to the beholder than that of the thief on the right, yet the ladder and the man on it link them in such a way that we must assume the two crosses to be in the same plane. The perspective of the ladder is very poorly handled, as are the feet of the man on it; the rest of that figure shows excellent modeling, but the pose is ill adapted to the action, thus making us suspect that the entire figure has been lifted from some other context. Among the distant trees on the left there are various straight lines that seem to be lances, without any soldiers to carry them, and one of the two soldiers near the foot of the cross on the same side of the panel is equipped with three lances and two shields. The compilatory character of the composition is also evident in the mass of figures in the foreground, which shows a great deal of movement but lacks the dramatic focus of the Crucifixion or Lamentation scenes on the S. Lorenzo Pulpits. The most impressive figures are the four women and St. John—the only ones to have a Donatellesque ancestry and yet clearly inferior to their counterparts in the London Lamentation and the S. Lorenzo Pulpits. The Virgin Mary, who sits and stares at the ground, appears to have been borrowed from the S. Lorenzo Lamentation (where, however, she is holding the body of Christ on her lap). Very different in character is the half-nude soldier rushing onto the scene from the left; why is he looking back, as if pursued by an enemy? He, too, has the quality of a "quotation," although from another source. The other soldiers are curiously reminiscent of Mantegna (hence, perhaps, Semrau's remark about the "Paduan" flavor

of the panel), while the two horses' heads recall those in the David and Goliath panel of Ghiberti's East Doors. Finally, as still another aspect of the "Medici Crucifixion" alien to Donatello, we must note the over-emphasis on surface decoration, which is not merely an effect superimposed on the composition by the rich gold and silver inlay but must have been intended from the very start, since so much of the ornament is modeled rather than engraved. Tschudi, *loc.cit.*, thought the raised embroidery on the garments similar to that in the S. Croce Annunciation. However, the comparison only emphasizes the repetitious, over-loaded quality of the ornament in our panel, which even extends to the frame. The latter consists not only of the plain rectangular molding customary for such panels but of a curved inner molding decorated with a leaf pattern. This leaf molding occurs repeatedly in Donatello's work: it frames the ornamental paneling behind the figures in the S. Croce Annunciation, as well as the reliefs of the bronze doors in the Old Sacristy, and we also find it at the top and bottom of the S. Lorenzo Pulpits. Donatello obviously thought of it as belonging to the realm of decorative architecture (tabernacles, doors, pulpits), so that he is most unlikely to have used it for framing a separate pictorial relief such as ours.

The foregoing observations are sufficient, I believe, to exclude the "Medici Crucifixion" from Donatello's *œuvre* altogether. The old attribution to Bertoldo is equally difficult to justify. For the time being, then, its author will have to remain anonymous, even though it ought to be possible to recognize his hand in other works reflecting the influence of the late Donatello. Perhaps he is the same master who did the Martyrdom of St. Sebastian in the Musée Jacquemart-André, Paris (Schubring, *KdK*, p. 125; once claimed for Donatello, now generally recognized as merely "Donatellesque"), the Crucifixion from the Camondo Collection in the Louvre (Schubring, *KdK*, p. 174 [inadvertently reversed], as "school"), and the roundel of the Madonna with two garland-holding angels formerly owned by the Archduke Franz Ferdinand v. Este, Vienna (stucco replica, Berlin Museum [No. 36], Schubring, p. 164). These three bronze reliefs, surely the work of one artist, show many affinities to our panel, despite their much more modest size (the Christ of the Camondo Crucifixion is a direct echo of ours). All of them must have been produced not long after Donatello's death, in the 1460's or 1470's. The same general date will have to be assigned to the "Medici Crucifixion," although the composition incorporates many earlier elements.[1]

¹ Cf. the stucco Crucifixion panel in the Berlin Museum, No. 29, and the one in gilt *cartapesta* in the Budapest Museum, reproduced by J. Balogh ("Études sur la collection des sculptures anciennes du Musée des Beaux-Arts," *Acta historiae artium*

academiae scientiarum hungaricae, ɪ, 1953, p. 105); an exact stucco replica of our relief, in the Birmingham Museum, is illustrated in *Burlington Fine Arts Club, Catalogue of a Collection of Italian Sculpture . . .*, London, 1913, pl. ɪɪ.

FLAGELLATION AND CRUCIFIXION (THE "FORZORI ALTAR") VICTORIA AND ALBERT MUSEUM, LONDON

PLATE 126b Terracotta relief; H. 53.5 cm; W. 57.5 cm *(c. 1470-1480?)*

DOCUMENTS: none

SOURCES: none

The panel (No. 7619-1861) was acquired in 1860 from the Gigli-Campana Collection, where it had been regarded as a work of Benvenuto Cellini (see A. M. Migliarini, *Museo di scultura del risorgimento raccolto . . . da Ottavio Gigli*, Florence, 1858, p. 79, pl. xciv; Eric Maclagan and Margaret H. Longhurst, *Catalogue of Italian Sculpture*, 1932, p. 24). Its previous history is unknown. The conjecture of Wilhelm Bode (*Denkmäler der Renaissance-Skulptur Toscanas*, Munich, 1892-1905, pp. 39f) who claimed that the relief was the sketch for an altar commissioned for the city of Florence by the Arte della Lana through a member of the Forzori family, has been decisively refuted by

Max Semrau (*Kunstwissenschaftliche Beiträge August Schmarsow gewidmet*, Leipzig, 1907, pp. 95ff); Bode relied on the coats of arms of the wooden frame and the predella relief, neither of which could have belonged to the main panel in its original state.[1] The two scenes are obviously not a self-sufficient whole but the left wing and the center of a triptych, as pointed out by Schottmüller (*D.*, pp. 32f). The missing right wing may have represented the Entombment or the Resurrection. Even the main panel, however, has been tampered with, presumably at the time the predella relief was made. These later additions certainly include the heavy molding that frames the panel on

¹ The wooden frame is modern, the predella by a later and inferior hand; cf. Maclagan-Longhurst, *loc.cit.*, who identify

the coat of arms on the predella as that of the Spinelli.

three sides; the frieze above the architrave; and—one suspects—the two Corinthian pilasters (why is there no pilaster on the right-hand side?) as well as a good many patched areas throughout both halves of the relief. It is not impossible, in fact, that the two scenes were originally separate and that there is a seam hidden behind the central pilaster. A precise technical examination is urgently needed to settle these questions. Until then, any conclusions based on the ensemble effect of the two scenes should be viewed with extreme caution.

The attribution of the piece to Donatello dates from the time of its acquisition by the Victoria and Albert Museum (John Charles Robinson, *South Kensington Museum, Italian Sculpture . . . , a Descriptive Catalogue*, 1862, p. 17). It was accepted almost unanimously—Venturi, the only dissenter (*Storia*, vɪ, p. 450), proposed Giovanni da Pisa instead—and has not been challenged in the literature even today, except by omission (Planiscig, *D.*; Lányi, *Probl.*). From the very start, the scholars who dealt with the panel have stressed its close connection with the S. Lorenzo Pulpits (Robinson, *loc.cit.*, Semper, *D.* '75, p. 268, Bode, *loc.cit.*, were the earliest to do so), especially the double scene of Christ before Pilate and Caiphas, which Semrau, *loc.cit.*, regards as an inferior echo of our composition. According to Bode, the "Forzori Altar" is of particular importance because it shows us what Donatello's sketches for the pulpits must have looked like, so that it provides an artistic standard by which we can assess the master's own share in the execution of the pulpit reliefs (similarly Schottmüller, *loc.cit.*). Semrau even tried to link the London panel directly with the pulpits. Donatello, he argued, could never have planned the front of the North Pulpit as it appears now (i.e., as a "diptych" made up of the Crucifixion and the Lamentation); the original arrangement must have been tripartite, and the "Forzori Altar" represents two-thirds of it, executed soon after the master's return from Padua.[2] The proportions of the London panel, Semrau concedes, cannot be made to fit the long side of the pulpits by adding the missing compartment, but to him this objection is outweighed by the fact that in both cases the scenes are separated by pilasters. The authenticity of the pilasters in our relief, however, is highly dubious. Kauffmann (*D.*, pp. 182, 185, 254, n. 640) dismisses Semrau's conjectures and places the "Forzori Altar" soon after the Paduan St. Anthony reliefs, of which, he believes, it is the direct descendant. Like his predecessors, he tacitly assumes that the authorship of the panel is beyond dispute.

There can indeed be no doubt that the architectural framework of the "Forzori Altar" is based on that of the Ass of Rimini panel in Padua (see Pl. 84a), as evidenced by such details as the angels in the spandrels and the scroll with standing angel decorating the keystone of the arches. It also recalls the setting of Christ before Pilate and Caiphas on the North Pulpit of S. Lorenzo, although the resemblance here is not quite so close. At the same time, however, the relationship between figures and architecture in the London panel strikes me as fundamentally different from anything in Donatello's *œuvre*, and the attribution to him ought to be rejected on this ground alone (there are, I believe, other objections equally serious). We notice, first of all, the placement of the horizon, which coincides with the base line of the arches and is thus clearly in the upper half of the panel, so that the beholder views the scene from a point high above the figures on the ground (his eye level, in fact, is exactly that of the Crucified Christ). Among the pictorial reliefs of Donatello, we find this high horizon only in the St. George panel, the Siena Feast of Herod, and in three of the four St. John *tondi* in the Old Sacristy. In the first two instances, the steeply rising ground is still an archaic feature; the size of the foreground figures is technically "wrong" in relation to it—they are far too large—but their eye level coincides with that of the beholder, and as a consequence their dramatic impact upon us remains unimpaired by the demands of scientific perspective. In the St. John *tondi*, the scale of the figures is "correct," and their size in relation to the size of the panel corresponds roughly to what we find in the "Forzori Altar" (cf. especially the Raising of Drusiana and the Liberation from the Cauldron of Oil, Pl. 60b, c); the effect, however, is difficult to compare, both because of the special compositional problems presented by the circular format and because of the location of the St. John *tondi*, which made it necessary for Donatello to adapt their perspective to a distant viewer. The Ass of Rimini, on the other hand, as well as the double scene of Christ before Pilate and Caiphas, afford a precise comparison with the London panel, and for that very reason the artistic differences emerge all the more clearly. In the Paduan relief the horizon lies below the floor line, in the scene from the North Pulpit it is just below the eye level of the main groups of figures; in both, the figures are significantly larger in relation to the height of the panel than they are in the "Forzori Altar." Also, they are brought forward as much as possible, so that they form a continuous frieze overlaying the architectural background, while in the London panel most of them are placed in the middle distance, with large areas of empty floor visible in the foreground; here the figures do not "spill" over the architectural boundaries as they do in the other

[2] Semrau postulates that Donatello interrupted his work on the pulpits when he was commissioned to do the Siena doors.

two reliefs. The result is a curious disproportion: the perspective keeps us at a distance while the emotional agitation of the figures invites us to come closer. The architecture tends to overwhelm the figures—surely a danger that exists neither in the Paduan reliefs nor in the pulpits. By the same token, the decorative sculpture in the London panel (the angels above the arches, the lunette of a horseman and foot soldier) is too conspicuous, so that it competes with the "live" figures below. Here again Donatello, in the comparatively few instances where he introduces such "sculpture of sculpture" into his pictorial reliefs, carefully avoids any possible confusion between the two levels of reality. But let us now consider the two scenes of the "Forzori Altar" without reference to their architectural framework. Do the figures, individually and collectively, merit the high praise so often bestowed on them? Compared to the Paduan reliefs and to the pulpits, it seems to me, their grouping is weak and scattered, without the rhythmic continuity and expressive force so characteristic of the mature and late style of Donatello. And their very sketchiness is distinctly "fussy" when we match it against the figures in the St. John *tondi* and the unchased, sketchy details of the Padua Altar (e.g. Pl. 81a) and the S. Lorenzo Pulpits (e.g. Pl. 105). The "Forzori Altar" simply is not the work of a great master but of

a much lesser man who undoubtedly knew Donatello's reliefs well (he drew upon the Padua Altar, the North Pulpit, and perhaps the St. John *tondi*, too—notice the railing in the Flagellation) without understanding more than their surface aspects. His identity will be difficult to establish. He may have been a Northeast Italian rather than a Tuscan; there is a certain relationship between the Flagellation of the London panel and a Flagellation drawing of Jacopo Bellini (Goloubev, II, pl. 3, as pointed out by Maclagan-Longhurst, *loc.cit.*). The closest artistic relative of the "Forzori Altar," however, though surely not by the same hand, is the Flagellation drawing once ascribed to Donatello in the Uffizi (Schubring, *KdK*, p. xxxix), which Maclagan-Longhurst regard as a reflection of both the relief itself and the predella. More likely they derive from a common source—a source that suggests Ferrara and Padua far more than it does Donatello.[3] No doubt the last word on the "Forzori Altar" has not yet been spoken, and once its uncertain physical condition has been tested and defined a more precise determination of its origin may become possible. Still, there is little likelihood that the panel will ever regain the status it had fifty years ago in the eyes of Semrau, who called it "the most mature and harmonious creation among all of Donatello's reliefs."

[3] According to Kauffmann, *D.*, p. 254, n. 641, there are echoes of the London Crucifixion in Bertoldo's Crucifixion relief

in the Museo Nazionale, Florence; I fail to perceive any connection here.

ST. JOHN THE BAPTIST, FORMERLY STAATLICHE MUSEEN, BERLIN[1]

PLATE 126a Bronze statuette; H. 84 cm (c. 1470)

DOCUMENTS: none (but see below)

SOURCES: none

The figure was purchased in 1878 from the Palazzo Strozzi, Florence (*Bildwerke des Kaiser-Friedrich-Museums—Die Italienischen Bildwerke der Renaissance . . .*, II: *Bronzestatuetten*, ed. Wilhelm v. Bode, 1930, No. 23, Inv. 50). Its previous history is unknown. Bode, the first to bring it to public notice, believed it to be the gilt bronze Baptist which Donatello had been commissioned to do for the font of Orvieto Cathedral in 1423 but which he never delivered (*Jahrbuch Kgl. Preuss. Kunstslgn.*, v, 1884, pp. 25ff). According to the documents, published in Filippo della Valle (*Storia del Duomo di Orvieto*, Rome, 1791, p. 299), L. Luzi (*Il Duomo d'Orvieto . . .*, Florence,

1866, I, pp. 406f) and L. Fumi (*Il Duomo di Orvieto . . .*, Rome, 1891, pp. 313, 331), the commission was decided upon on February 10, 1423,[2] and on April 29 Donatello received five pounds of wax for modeling the figure. That he failed to deliver the piece can be inferred from the fact that in 1461 a gesso figure was installed above the font. Milanesi has rightly pointed out (*Cat.*, pp. 8f) that on the basis of these data Bode's assumption is a rather daring one. It does indeed seem more likely that Donatello, overburdened with commissions as he was in 1423-1424, simply abandoned the commission. Why should he have failed to deliver the statuette after casting it? The only plausible reason

[1] Unaccounted for since May 1945 and presumably destroyed at that time in the fire that consumed the interior of the anti-aircraft tower at Friedrichshain; see *Berliner Museen*, N.F., III, 1953, p. 17.

[2] Venturi, *Storia*, VI, p. 256, and Kauffmann, *D.*, p. 206, n. 96, assume this date to be "Florentine style" and give the year as 1424.

would be that the cast had been badly spoiled. In that event, however, the figure would not have survived. It is significant, moreover, that the artist did not mention the St. John for Orvieto in his *Catasto* Declaration of 1427, as he should have done had the commission still been "alive" at that time. We can only conclude that the commission had lapsed by then, or that Donatello had delivered the figure and been paid in full before 1427. The latter alternative, however, is incompatible with the notice concerning the gesso figure of 1461. Finally, there is the further difficulty that the Orvieto authorities had ordered a St. John with a cross and a scroll inscribed ECCE AGNVS DEI, while the Berlin figure has a cup and a scroll too small for an inscription (noted by Balcarres, *D.*, p. 147). Among recent scholars, Kauffmann alone still supports the Bode hypothesis. He circumvents the obstacle posed by the absence of a cross and inscription by assuming that the arms of the statuette are not the original ones, but there is no evidence that such is the case, apart from the fact that they are separate casts. Their style, so far as I can judge, matches that of the rest of the figure perfectly.[3] Venturi, *loc.cit.*, places the statuette in the vicinity of the Siena virtues, which he regards as superior in quality; Colasanti, *D.*, p. 20, also dates it later than 1423; and Planiscig, *D.*, p. 76, links it with the realism of Donatello's later works and proposes a date of c. 1440.

Although the authenticity of the statuette as a work of Donatello has never been questioned so far, it seems to me impossible to fit into the master's *œuvre*. The resemblance to the Siena Virtues, claimed by Venturi,

as well as that to the St. Peter at Or San Michele (for which see above, p. 222) and the Zuccone, emphasized by Kauffmann, *loc.cit.*, is confined to the big diagonal drapery motif of the mantle. Otherwise, the figure recalls the extreme attenuation of Donatello's post-Paduan statues, yet the somewhat self-consciously graceful posture, with its exaggerated *contrapposto*, has nothing in common with the Frari St. John or the Magdalen. Entirely alien to Donatello is the broken silhouette, especially the free-hanging piece of drapery that extends from the left shoulder to the ground and serves as a counter-balance to the curvature of the body. The face with its pinched-in temples is based on that of the Siena St. John (compare Pls. 95, 126a), but the contrast in expression makes it clear that the two could not possibly have been modeled by the same master. At the same time, this dependence provides a *terminus post* of 1458 for the Berlin statuette. Since the Siena St. John remained in storage for some ten years after its delivery because of the missing right arm (see above, p. 196), the "Master of the Berlin Baptist" may not have had an opportunity to study the statue until about 1470, when the right arm was added by a local master. This, then, would appear to be the most likely date of our statuette. The identity of its author, unfortunately, has so far eluded me; he must have been an artist of considerable individuality, and quite possibly a Sienese, who has here combined Donatellesque impressions—the head type of the Baptist of 1457 and the drapery style of the two virtues on the Siena Font—with a mannered elegance of pose reminiscent of the Risen Christ of Vecchietta.[4]

[3] Cf. my discussion of the arms of the "Amor-Atys" [above, p. 143], which present an analogous problem.

[4] Siena, Ospedale della Scala; Paul Schubring, *Die Plastik Sienas . . .*, Berlin, 1907, p. 92, fig. 64.

BEARDED HEAD ("VECCHIO BARBUTO"), MUSEO NAZIONALE, FLORENCE

PLATE 127c, d Bronze; H. 37.5 cm (1470-1480)

DOCUMENTS: none

SOURCES: none

The history of this fragmentary piece cannot be traced back beyond the late nineteenth century. Its attribution to Donatello, proposed by Wilhelm Bode (*L'Arte*, III, 1900, p. 312), attracted little attention until recently; most subsequent authors disregarded it entirely, and the few who did not criticized it severely. (Schubring, *KdK.*, p. 202, calls the head a Goliath and suggests that it may be Venetian, since it has "the melancholy pathos of a marine deity"; Cruttwell, *D.*, pp. 145f, pronounces it "especially poor" and denies that it "shows even the influence of Donatello.") Lányi, in contrast, listed the piece among the canonical

works of the master, believing it to be one of the two bronze heads originally attached to the Cantoria (*Probl.*, p. 23). Goldscheider, too, accepted it (*Donatello*, London, 1941, p. 36, pl. 136) but dated it 1455-1457 and wondered whether it might be the head of that "half-length figure of Goliath" for which Donatello received a quantity of metal through Urbano da Cortona in Florence in 1457 (see above, pp. 202f). As proof of its authenticity he cited the resemblance to the heads of the S. Rossore and the Siena St. John. Planiscig, who had omitted the head from his monograph of 1939, adopted a similar view (*D.*, pp. 64f, 113); he placed it in the

late 1450's on the strength of a comparison with the heads of the Holofernes from the Judith Group and of the Risen Christ on the South Pulpit of S. Lorenzo. The same opinion is shared by Filippo Rossi (*Donatello*, Florence, 1950, pl. 115).

The Lányi hypothesis need not detain us for long. Despite its fragmentary condition, the *vecchio barbuto* shows a perfectly straight neck, and there is no hint of a backward tilt, so that the head is ill adapted to mounting on a vertical surface, while the two matching bronze heads which Corwegh identified as belonging to the Cantoria offer no such obstacle (see above, pp. 123ff). Nor does the *vecchio barbuto* match the style of any work of Donatello about 1440. The Goldscheider-Planiscig dating seems a good deal more plausible, yet the supposed resemblance of our head

to those of the Siena St. John and the Holofernes turns out, on closer scrutiny, to be a very superficial one. The treatment of hair and beard, with its neatly defined curls and strands, lacks the turbulent fluidity so characteristic of the late Donatello; the same is true of the rather "knobby" modeling of the face; and the pathetic upward glance has no analogies at all in our master's work. The *vecchio barbuto* does, I believe, reflect the influence of the late Donatello to some extent; it is surely Florentine rather than Venetian. But it was done at least a decade after our master's death, by a bronze sculptor in the vicinity of Bertoldo who shared the latter's antiquarian interests, for the type and expression of the head clearly emulate the captive Barbarians of Roman art.

ST. JEROME IN PENITENCE, PINACOTECA, FAENZA

PLATE 128 Wood, polychrome; H. 139 cm (including base); W. 36.5 cm *(1480-1500)*

DOCUMENTS: none

SOURCES

1550 Vasari-Ricci, p. 55 (Milanesi, p. 413): "In the town of Faenza [Donatello] made of wood a St. John and a St. Jerome, which are no less highly regarded than his other works."

Milanesi, who seems to have been the first to identify the statue as that mentioned by Vasari, still saw it in the monastery church of S. Girolamo degli Osservanti (i.e., the Franciscans of strict observance, or Spirituals), for which it was presumably made. He noted the restoration of the figure in 1845 (*loc.cit.*, n. 4). According to Balcarres (*D.*, p. 148) it stood in the Cappella Manfredi until the suppression of the monastery in 1866. Towards 1887, it was transferred to the Museum (Tschudi, *D.*, p. 30). In 1940-1941, the statue was carefully cleaned and the old polychromy uncovered by the restorers of the Soprintendenza in Florence, who removed the loincloth and the cross as recent additions.[1] The left hand must have been intended to hold a long-stemmed crucifix, as shown by the position of the fingers and the turn of the head. There does not seem to have been a loincloth originally.

The Faenza St. Jerome was until recently looked upon with grave suspicion; among older scholars Bode alone followed Milanesi in accepting the figure as an authentic part of Donatello's œuvre (*Denkmäler der Renaissance-Skulptur Toscanas*, Munich, 1892-1905, p. 37), while others omitted it entirely or declared it the work of a lesser hand. Tschudi, *loc.cit.*, believed

both the Frari St. John and the St. Jerome to have been carved by an assistant after sketches by Donatello; Schubring and Balcarres placed it among the school pieces; Schmarsow (*D.*, p. 48, n. 1) and Pastor (*D.*, p. 93) found various features of the statue alien to Donatello, as did Schottmüller (*D.*, p. 52, n. 2) who compared the pose to that of a bronze statuette in Berlin attributed to Bertoldo (Inv. No. 2338) and thought the figure "possibly connected with the Donatello workshop." Cruttwell, *D.*, p. 143, rejected it outright. The authenticity of the statue has been championed by Kauffmann (*D.*, pp. 150, 153ff) and, since its restoration, by Rezio Buscaroli (*L'arte di Donatello*, Florence, 1942, p. 149), Planiscig (*D.*, p. 106) and Filippo Rossi (*Donatello*, Florence, 1950, pl. 108).

If the St. Jerome is to be regarded as a work of our master, the proof must be its kinship with the Frari St. John and the Magdalen in the Baptistery. A detailed comparison with these two figures remained difficult as long as the statue was disfigured by the restoration of 1845; now that the original surface has been brought to light, a more confident opinion is possible. Actually, the result of the recent cleaning has proved to be something of a disappointment for

[1] For the previous state of the figure see Schubring (*KdK*, p. 175), Kauffmann (*D.*, p. 27), and Alinari photos 10896, 10897.

those who had expected it to reveal a work of markedly higher quality: in every essential, the statue remains unchanged, and even the boulder with its clumsily appliquéd plants, which Kauffmann had regarded as a nineteenth century addition, turns out to be part of the original base. This one detail, needless to say, is not of decisive importance for the problem of authorship; but the anatomical forms, the pose and expression seem to me equally incompatible with Donatello's style of the 1450's. The carving of the body is far too "correct" physiologically, without the strained, angular quality of the Frari St. John and the Magdalen. It is not a body ravaged by old age and the denial of the flesh but a standard male figure on which some telltale marks of old age, such as swollen veins, have been superimposed in a rather superficial and pedantic manner.[2] The pose, too, reproduces a commonplace formula of the late Quattrocento that could, and did, serve any number of other purposes equally well; hence the long list of supposed "echoes" of our statue cited by Kauffmann.[3] Completely foreign to Donatello is the sentimental pathos

of the head, which ought to be sufficient evidence in itself that the statue could not have been carved before the last quarter of the fifteenth century (the expression ultimately derives from such precedents as Botticelli's St. Augustine at Ognissanti). The identity of the master—certainly not an artist of major stature, in my opinion—is difficult to establish. His link with the Donatello tradition in Florence must have been a very indirect one, if indeed he was a Florentine and not (as I suspect) a provincial Tuscan master.

As for the testimony of Vasari, we need not attach too much weight to it in this instance. Apparently he knew the statue only through reports, and not very reliable ones at that, since he also speaks of a wooden St. John; the latter reference seems to concern the marble bust of the Young St. John, now likewise in the Pinacoteca of Faenza, which is clearly a work of the Antonio Rossellino shop. The blame here belongs not so much to Vasari but to the faulty local tradition he recorded. To inquire into the origin of this tradition is hardly a task that promises to repay the necessary effort.

[2] Significantly enough, Kauffmann compared the back of the St. Jerome to that of the bronze David.

[3] The origin of the pose is probably classical, which would explain its very general use; cf. the spear-holding Hippolytus on a sarcophagus in the Uffizi cited by Kauffmann [C. Robert, *Die antiken Sarkophag-Reliefs*, Berlin, 1904, III, 2, No. 171, pl. LV].

APPENDIX
Selected Donatello Bibliography, 1957-1962

V. Martinelli, "Donatello e Michelozzo a Roma," in: *Commentari*, VIII, 1957, pp. 167ff

Martin Gosebruch, *Das Reiterdenkmal des Gattamelata* (Werkmonographien zur bildenden Kunst in Reclams Universal-Bibliothek, No. 29), Stuttgart, 1958

G. Soranzo, "Due note intorno alla donatelliana statua equestre del Gattamelata," in: *Bolletino del Museo Civico di Padova*, XLVI-XLVII, 1957-1958, pp. 21ff

Margrit Lisner, "Die Büste des heiligen Laurentius in der alten Sakristei von S. Lorenzo, ein Beitrag zu Desiderio da Settignano," in: *Zeitschrift für Kunstwissenschaft*, XII, 1958, pp. 51ff

John Pope-Hennessy, *Italian Renaissance Sculpture*, London, 1958

Georg Kauffmann, "Zu Donatellos Sängerkanzel," in: *Mitteilungen des kunsthistorischen Instituts Florenz*, IX, 1959, pp. 56ff (see Plate 50)

Irving Lavin, "The Sources of Donatello's Pulpits in S. Lorenzo," in: *Art Bulletin*, XLI, 1959, pp. 19ff

Margrit Lisner, "Zur frühen Bildhauerarchitektur Donatellos," in: *Münchner Jahrbuch der bildenden Kunst*, IX/X, 1958-59, pp. 72ff

Aldo de Maddalena, "Les Archives Saminiati: de l'Économie à l'Histoire de l'Art," in: *Annales: Économies, Sociétés, Civilisations*, XIV, 1959, pp. 738ff (cites the *Libro debitori creditori e ricordanze* of Giovanni Chellini, according to which Giovanni gave medical treatment to Donatello and on August 27, 1456, received in return a bronze roundel of the Madonna and Child with two angels)

John Pope-Hennessy, "The Martelli David," in: *Burlington Magazine*, CI, 1959, pp. 134ff

John Pope-Hennessy, "Some Donatello Problems," in: *Studies in the History of Art Dedicated to William Suida on his Eightieth Birthday*, New York, 1959, pp. 47ff

Raghna and Nic. Stang, *Livet og kunsten i ungrenessansens Firenze, II: De store billedhuggere og borgerrepublikken*, Oslo, 1959

Guy de Tervarent, *Attributs et symboles dans l'art profane, 1450-1600*, II, Geneva, 1959, col. 393, s.v. "Vase" (Atys-Amorino)

Wilhelm R. Valentiner, "Towards a Chronology of Donatello's Early Works," in: *Festschrift Friedrich Winkler*, Berlin, 1959, pp. 71ff (argues that the "St. John the Baptist" from the Campanile [see p. 228 above] is the David for which Donatello received 50 florins in 1412 [see p. 13 above])

Manfred Wundram, "Donatello und Ciuffagni," in: *Zeitschrift für Kunstgeschichte*, XXII, 1959, pp. 85ff (attributes the head of the "Poggio" in Florence Cathedral to Ciuffagni)

M. Libman, *Donatello* (in Russian), Moscow, 1960 (enlarged edition, 1962)

Erwin Panofsky, *Renaissance and Renascences in Western Art*, Stockholm, 1960, pp. 169 (Atys-Amorino) and 189 (Bust of a Youth, Museo Nazionale)

Giuseppe Fiocco and Antonio Sartori, "L'Altare grande di Donatello al Santo," in: *Il Santo*, I, Padua, 1961, pp. 21ff

Frederick Hartt, "New Light on the Rossellino Family," in: *Burlington Magazine*, CIII, 1961, pp. 387ff (Martelli David)

Giovanni Previtali, "Una data per il problema dei pulpiti di San Lorenzo," in: *Paragone*, No. 133, January 1961, pp. 48ff (see Fig. 8, p. 220)

Catalogue, Mostra di arte sacra antica dalle diocesi di Firenze, Fiesole e Prato, Florence, Palazzo Strozzi, 1961, p. 41, no. 308, and pl. xxiii (Crucifix from S. Piero a Sieve, S. Francesco a Bosco ai Frati, attributed to D. by Alessandro Parronchi)

Frederick Hartt and Gino Corti, "New Documents concerning Donatello, Luca and Andrea Della Robbia, Desiderio, Mino, Uccello, Pollaiuolo, Filippo Lippi, Baldovinetti and Others," in: *Art Bulletin*, XLIV, 1962, pp. 155ff (new documents, according to which D. spent 100 florins for bronze, charcoal, etc., between October 14 and November 19, 1456)

R. W. Lightbown, "Giovanni Chellini, Donatello, and Antonio Rossellino," in: *Burlington Magazine*, CIV, 1962, pp. 102ff (cites, without knowing the original, a late sixteenth-century excerpt from the passage in Giovanni Chellini's *Libro* published by Aldo de Maddalena, and speculates on the appearance of the bronze roundel by Donatello)

Raghna and Nic. Stang, "Donatello e il Giosuè per il Campanile di S. Maria del Fiore alla luce dei documenti," in: *Institutum Romanum Norvegiae, Acta ad archaeologiam et artium historiam pertinentia*, I, Oslo, 1962, pp. 113ff (shows that the Joshua of 1415-21 [see p. 225 above] is identical with the "St. John the Baptist" from the Campanile, not with the "Poggio")

INDEX

Index

—, Accademia, David, Michelangelo, 6, 20, 27f, 41, 78, 198f, 201; St. Matthew, Michelangelo, 22; Madonna and Saints, Perugino, 26n; Annunciation, Agnolo Gaddi (attributed), 106; Annunciation, Master of the Accademia Annunciation, 106n; St. Mary Magdalen Altar, Magdalen Master, 191

—, Baptistery, architecture, 52; bronze doors, 49; South Doors, Andrea Pisano, 49, 229; North Doors, Ghiberti, 6n, 10ff, 29, 30n, 31, 84n, 91, 135, 138, 220, 223; East Doors, Ghiberti, 20, 70, 82, 84n, 130n, 207, 244; mosaics, 70f; tomb of John XXIII, Donatello and Michelozzo, 52, 56, 59-65, 72, 76, 108, 190, 192; effigy, see Donatello; Magdalen, see Donatello

—, Campanile, Horsemanship panel, Andrea Pisano, 30; Logic and Dialectic, Luca della Robbia, 134; niche statues, see Museo Nazionale

—, Casa Buonarroti, predella panel, 106; Madonna of the Stairs, Michelangelo, 129

—, Casa Martelli, 21, 191ff; Martelli Arms, 43

—, Casa Valori, 92

—, Cathedral, 13, 41, 59, 76, 89, 118n, 119ff, 140n, 150n, 205; façade, 13f, 27, 35f, 41, 228; dome, 55; Sagrestia dei Canonici, 122; Porta della Mandorla, Hercules reliefs, 7n; Assumption of the Virgin, Nanni di Banco, 7n, 43, 91, 114n, 224; two prophets on pinnacles, 20, 99, 219-22; Annunciation mosaic, Domenico Ghirlandaio, 221; busts of prophet and sibyl, see Donatello; Isaiah, Nanni di Banco, 4ff, 195, 219; Joshua ("Poggio"), Ciuffagni and Nanni di Bartolo, 36ff, 223, 225-28; sacristy doors, Luca della Robbia, Michelozzo, and Maso di Bartolommeo, 122, 150; holy-water basins, Buggiano, 128; equestrian statue of Piero Farnese (destroyed), 157f; John Hawkwood, Paolo Uccello, 158; Arca di S. Zanobi, Ghiberti, 181n; Isaiah, Ciuffagni, 223; King David, Ciuffagni, 223f; terracotta Joshua (destroyed), see Donatello; Coronation of the Virgin, window, see Donatello; "Daniel," see Nanni di Banco, Isaiah

—, Convento della Calza, stucco replica of the Pazzi Madonna, 44

—, Fondazione Salvatore Romano, St. Prosdocimus and Unknown Saint, 235f

—, Loggia dei Lanzi, 80, 199f, 201, 204, 220; "Thusnelda," 38, 241; Perseus, Benvenuto Cellini, 80; Sabines, Giovanni da Bologna, 201

—, Medici Gardens at S. Marco, 198, 200, 210

—, Mercato Nuovo, 46, 52; Mercato Vecchio, 8; Dovizia, see Donatello

—, Museo Archeologico, sphinx throne, 184

—, Museo Bardini, stucco replica of London Lamentation, Donatello, 208

—, Museo dell'Opera del Duomo, St. Luke, Nanni di Banco, 12, 14f; St. Mark, Niccolò di Pietro Lamberti, 12ff, 223; drawing of Cathedral façade, 13,

226n; St. Matthew, Ciuffagni, 13ff, 220, 223f; "St. John the Baptist" from Campanile, Nanni di Bartolo, 26, 36ff, 39, 193, 220, 227-31; silver altar from Baptistery, 30; Obadiah from Campanile, Nanni di Bartolo, 36f, 228ff; Cantoria, Luca della Robbia, 75, 118f, 121ff, 127, 179, 213; two bronze heads attached to Cantoria of Donatello, 123ff; Annunciation Group (Nos. 95, 96), 221n; Cantoria of Donatello, see Donatello; St. John the Evangelist, see Donatello; Campanile statues (beardless prophet, bearded prophet, Abraham and Isaac, "Zuccone," "Jeremiah"), see Donatello

—, Museo Nazionale, bronze putto, 73ff; bronze mask, 81; Medici Crucifixion, 83, 242ff; Carrand Triptych, 106; Bearded Head ("Vecchio barbuto"), 124, 247f; Byzantine ivory casket, 126n; Brutus, Michelangelo, 142, 239; Infant St. John, relief bust, Desiderio da Settignano, 193f; "Niccolò da Uzzano," 237-40; Crucifixion, Bertoldo, 246; "Atys," bronze Bust of a Youth, bronze David, marble David, Giovannino Martelli, Marzocco, St. George, see Donatello

—, Ognissanti, 56f; St. Augustine, Botticelli, 249

—, Opificio delle Pietre Dure, 80

—, Or San Michele, tabernacles, 32; St. Peter, Ciuffagni, 17f, 26, 93, 195, 222-25, 247; Quattro Coronati, Nanni di Banco, 20n, 224; tabernacle of the Madonna delle Rose, 25f; St. Eloy tabernacle, base relief, Nanni di Banco, 30; Christ and St. Thomas, Verrocchio, 46ff, 51f; St. Matthew, Ghiberti, 50, 52, 56, 58, 63; tabernacle of St. John, 52; Orcagna tabernacle, 91, 114n; tabernacle of St. George, reliefs, see Donatello; tabernacle of St. Louis, see Donatello; St. Mark, see Donatello

—, Ospedale degli Innocenti, façade, Brunelleschi, 30

—, Palazzo Capponi, 237

—, Palazzo Davanzati, stucco replica of the Pazzi Madonna, 44

—, Palazzo Medici-Riccardi, 41, 77ff, 81, 139, 198, 200f; courtyard, medallions, 83f; Journey of the Magi, Benozzo Gozzoli, 238f

—, Palazzo Montalvo (formerly), Meleager sarcophagus, 187

—, Palazzo di Parte Guelfa, 46; Trinity, 53n

—, Palazzo Pazzi, 44

—, Palazzo Quaratesi, 25

—, Palazzo Strozzi, 246

—, Palazzo Vecchio, 3-7, 42, 77ff, 198f, 200f; Hercules and Cacus, Bandinelli, 24; Samson and the Philistine, Pierino da Vinci, 80; Judith and Holofernes, see Donatello

—, SS. Annunziata, tabernacle, Michelozzo, 173

—, S. Caterina degli Abbandonati, 57

—, S. Croce, Baroncelli Chapel frescoes, 6, 70f; Cappella del Noviziato, portal, Michelozzo, 54, 139; Pazzi tomb, 90; Assumption of the Virgin, fresco, 91;

Cavalcanti Chapel, 103ff; Serristori Chapel, 105; chapels destroyed in 1566, 105; Cavalcanti tombs, 105; Pazzi Chapel, tondi, Brunelleschi, 135; Marsuppini tomb, Desiderio da Settignano, 193, 237; tomb of Gastone della Torre, Tino di Camaino, 214; doorway from first to second cloister, 235n; Crucifix, Annunciation, St. Louis, see Donatello

—, S. Egidio, façade fresco, Bicci di Lorenzo, 238

—, S. Felicità, Barbadori Chapel, 55n

—, S. Lorenzo, 36, 211n; tomb of Donatello, xvn; Cantoria, 126n, 213; Neroni Chapel, 236; bronze pulpits, Old Sacristy, stucco reliefs and bronze doors, see Donatello; Old Sacristy, porticoes, 10n, 138ff; St. Leonard, 50, 134n, 236f; sarcophagus of the parents of Cosimo de' Medici, marble railing, terracotta medallions, 134n; Lavabo, 134n, 195

—, S. Marco, cloisters and library, Michelozzo, 139; fresco, Bernardo Poccetti, 13; Linaiuoli Altar, Fra Angelico, 173; frame, Ghiberti and Simone di Nanni Ferrucci, 232; Burning of Savonarola, 201n

—, S. Maria del Carmine, Ascension play, 93; Brancacci Chapel frescoes, Masaccio, 94f

—, S. Maria Maggiore, Madonna del Carmine, 184

—, S. Maria Novella, 41f, 61; Crucifix, Brunelleschi, 7ff, 148; tomb of Leonardo Dati, Ghiberti, 26, 102; Trinity, Masaccio, 30, 51f, 55, 131, 186n; tomb of Tedice degli Aliotti, 90, 158n; Strozzi Altar, Orcagna, 93; Annunciation, fresco, 106

—, S. Miniato, pulpit, 126

—, S. Pier Gattolini, 92

—, S. Spirito, Magdalen, Brunelleschi (destroyed), 11

—, S. Trinità, Magdalen, Desiderio, 193f; tomb of Francesco Sassetti, 216n

—, Uffizi, drawing after Donatello's marble David, Michelangelo, 28; drawings after the tomb of John XXIII, 61; drawing after Shaw Madonna, 86; two altar wings, Fra Bartolommeo, 86ff; Ascension, drawing, Lorenzo di Bicci (attrib.) 93; ground plan of S. Antonio, Padua, 171ff; two drawings of proposed High Altar, S. Antonio, Padua, 171ff, 176; St. Lucy Altar, Domenico Veneziano, 181; Niccolò da Uzzano, Cristofano dell'Altissimo, 238; Flagellation, drawing, formerly attributed to Donatello, 242, 246; Hippolytus sarcophagus, 249n

fluted columns, 52

Fontainebleau, Achilles cycle, Rosso Fiorentino, 129

Fonte, Bartolommeo della, xivn, xvn, 198, 200

Fonte, Giovambatista della, 24

Fontio, Bartolommeo, see Fonte

fortitudo, 6n

Forzori Altar, see London, Victoria and Albert Museum

Forzori family, Florence, 244

256

PLATES

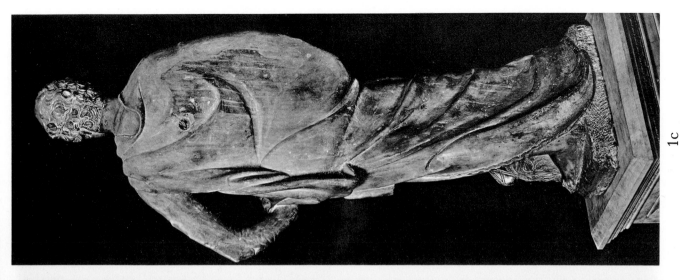

1c

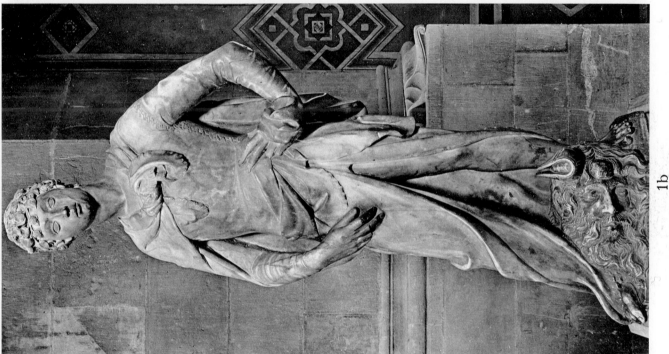

1b

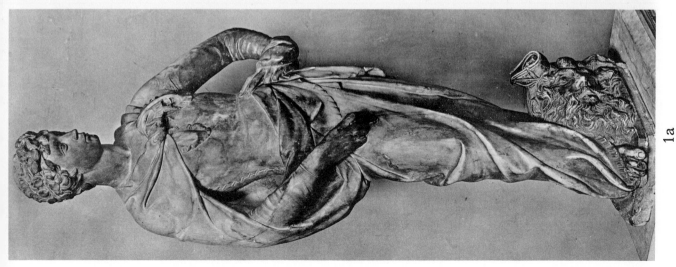

1a

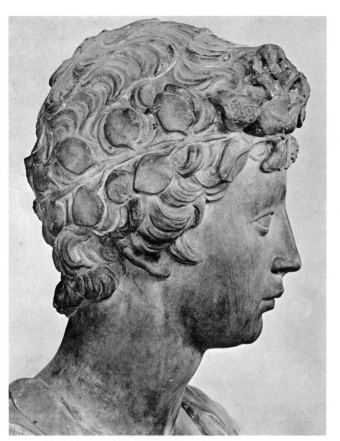

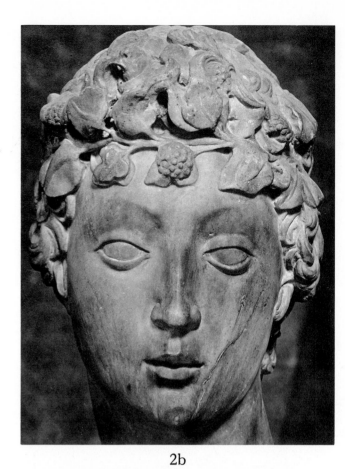

2a

2b

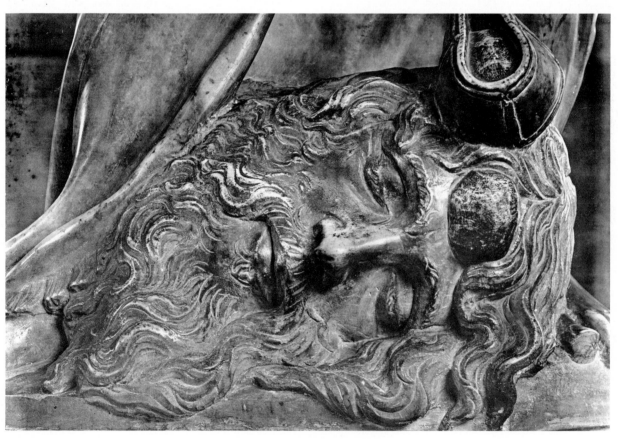

2c

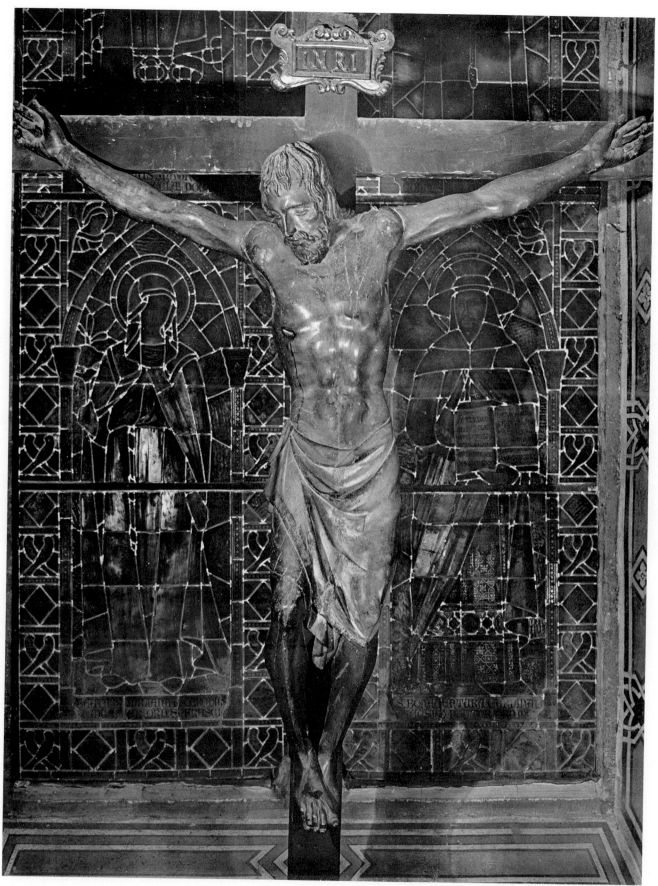

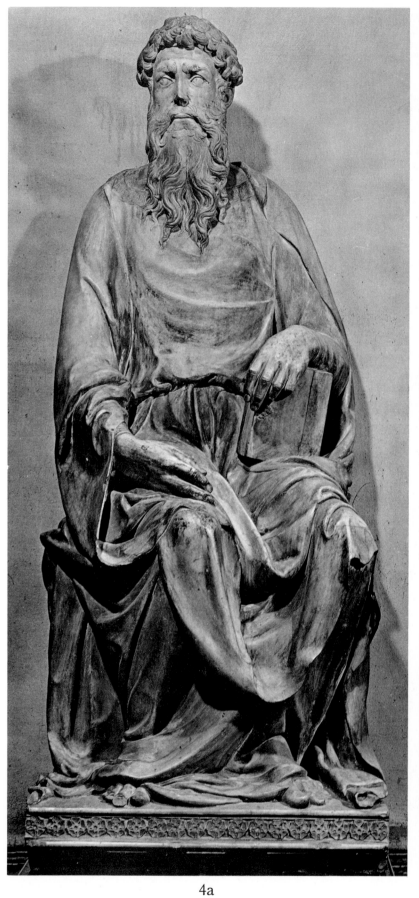

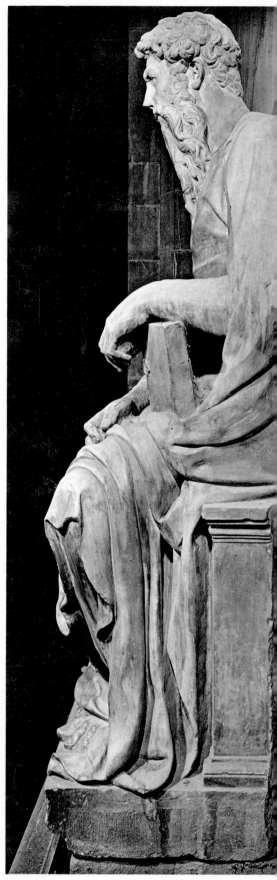

4a

4b

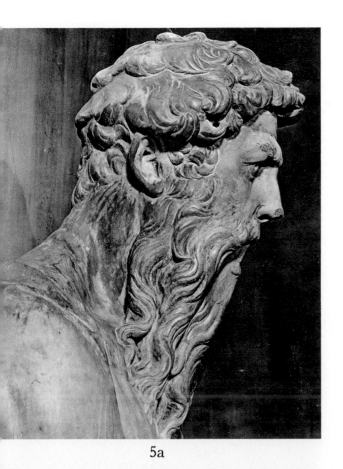

5a

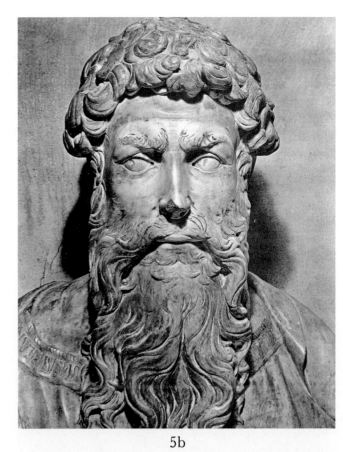

5b

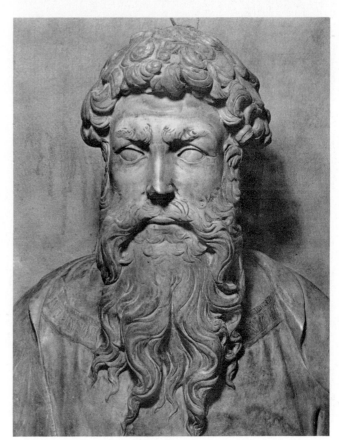

5c

5d

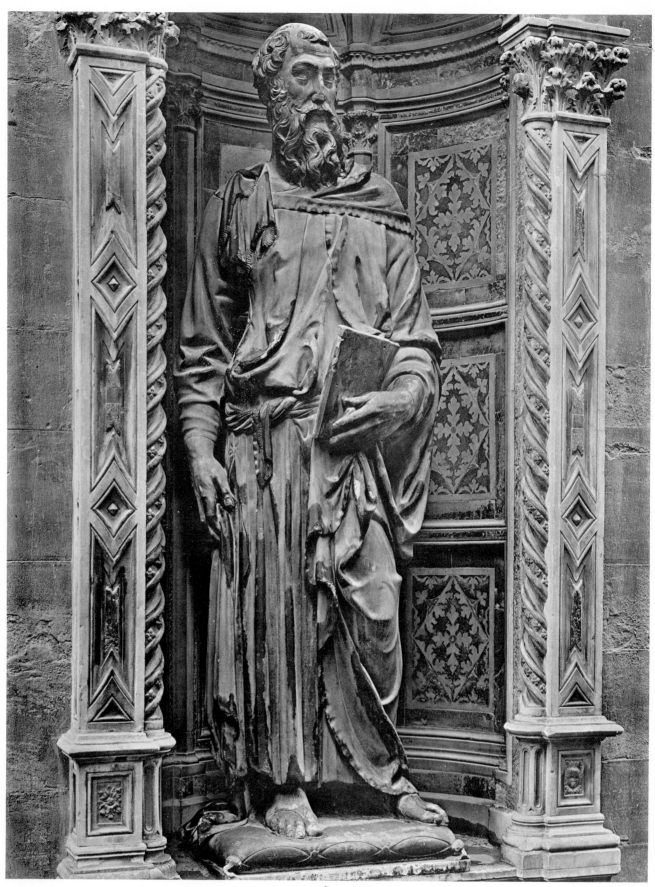

6

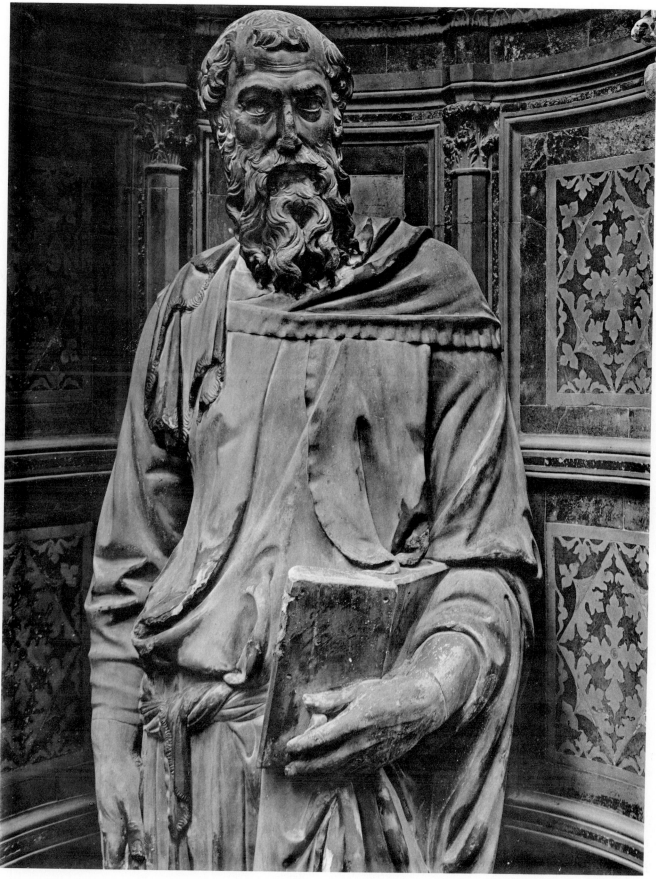

7

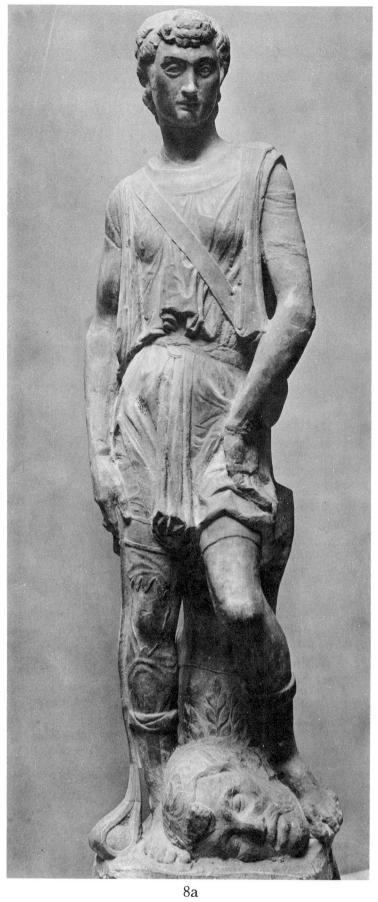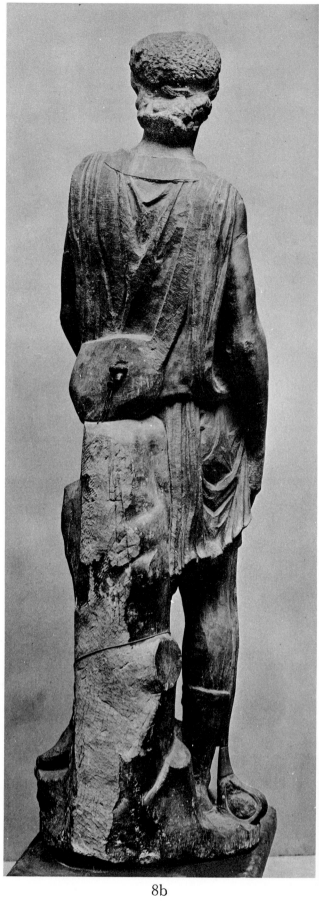

8a 8b

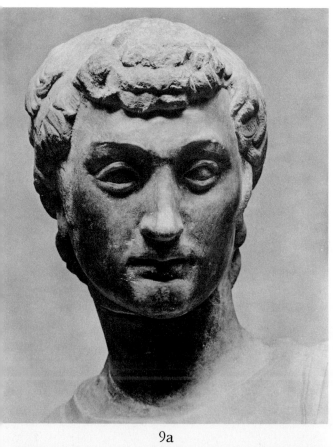

9a

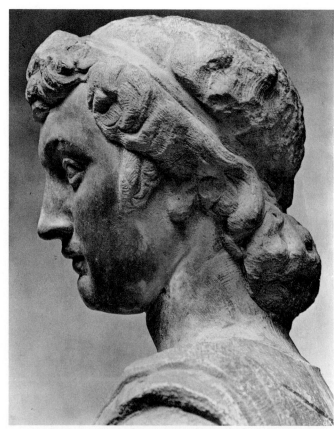

9b

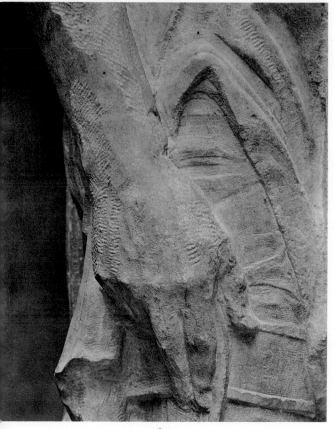

9c

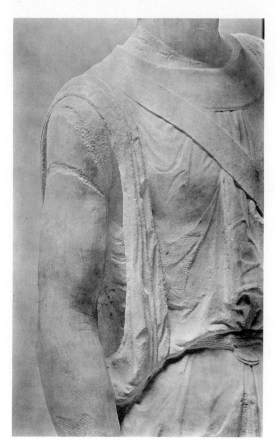

9d

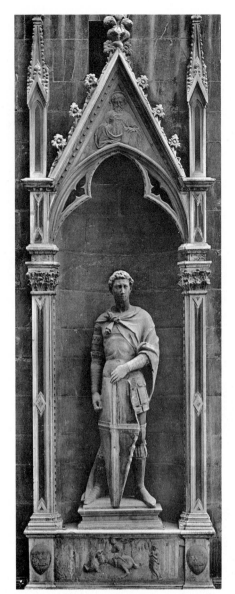

10a

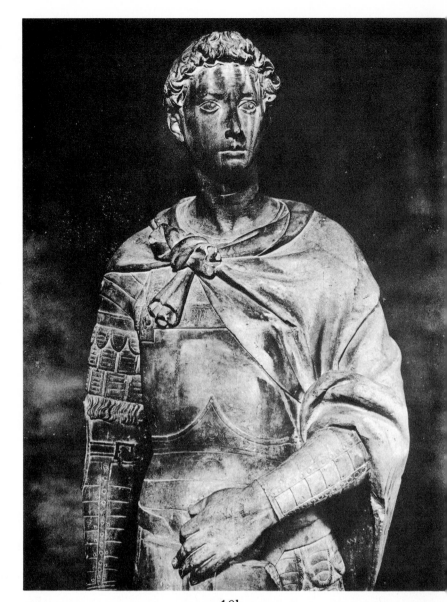

10b

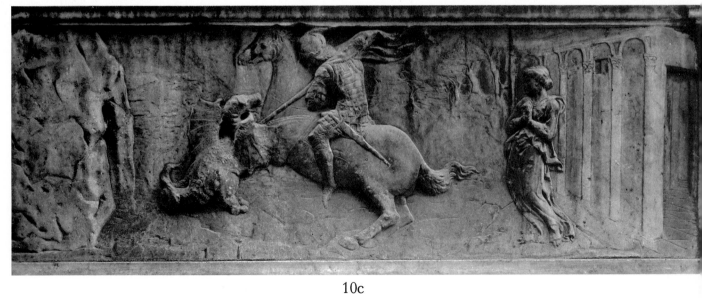

10c

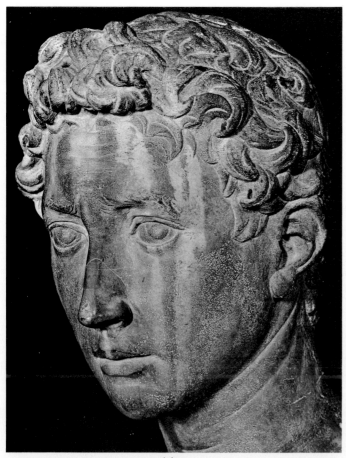

11a

11b

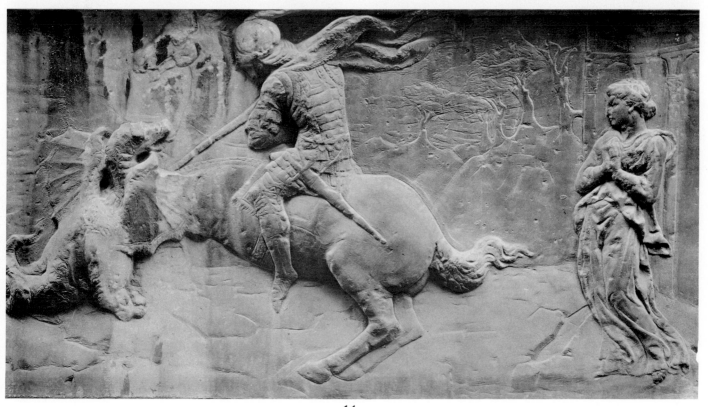

11c

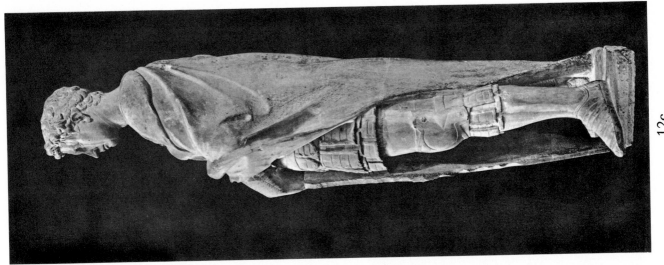

12a

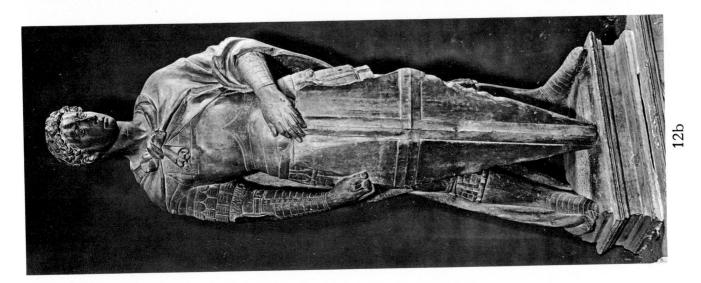

12b

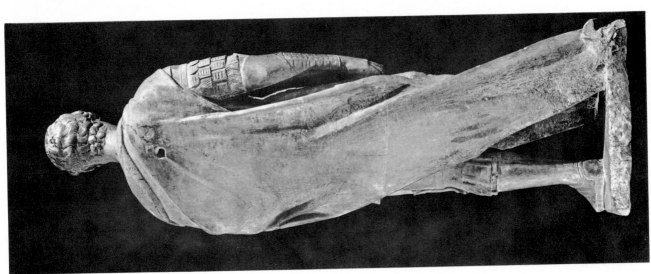

12c

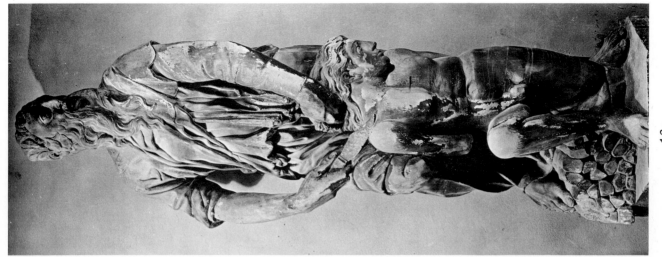

13c

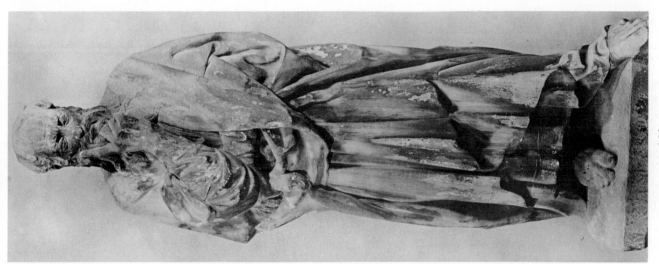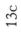

13b

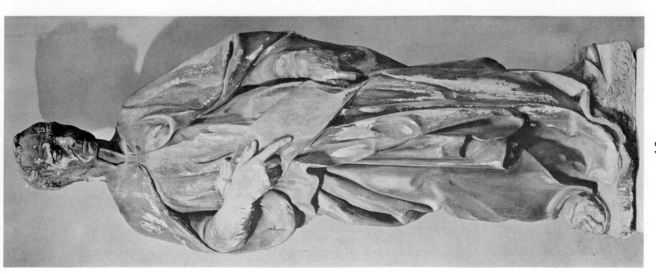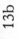

13a

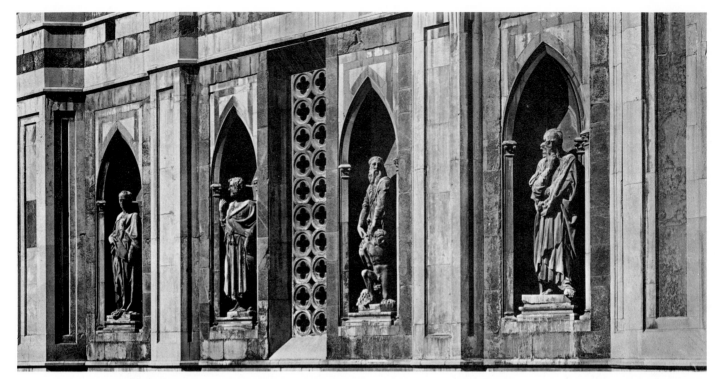

14a

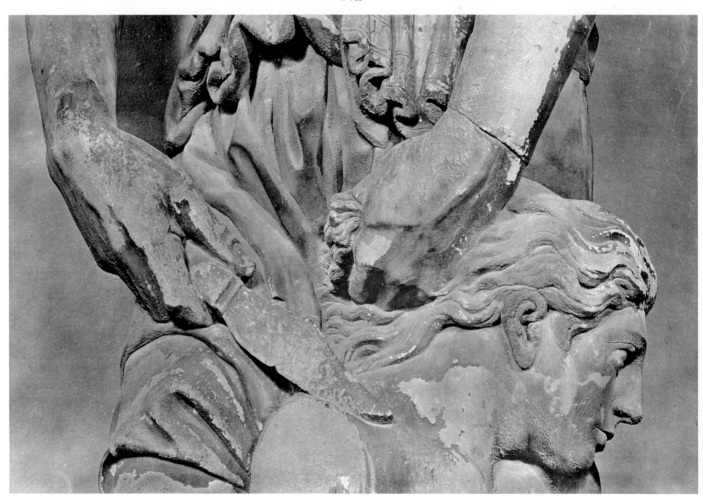

14b

15a

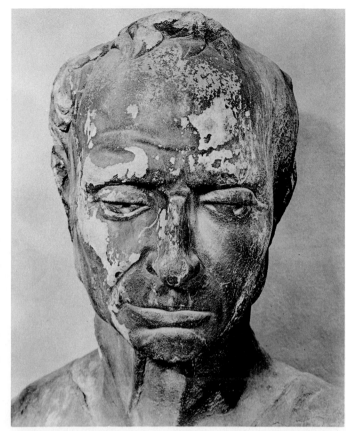

15b

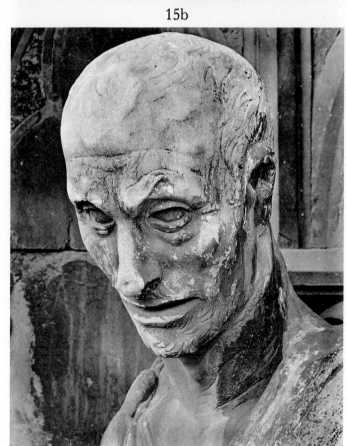

15c 15d

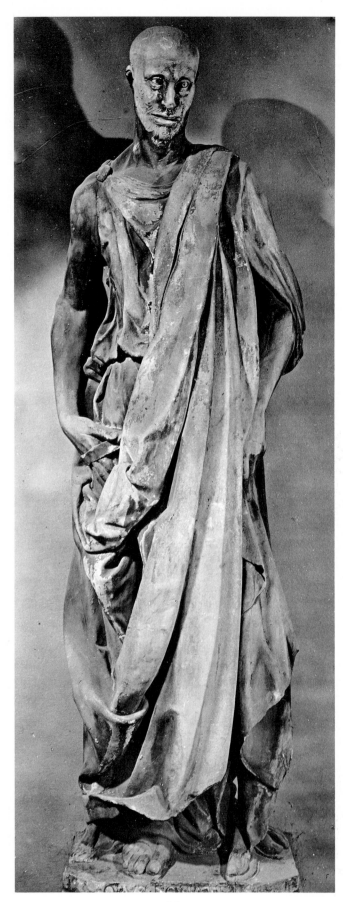

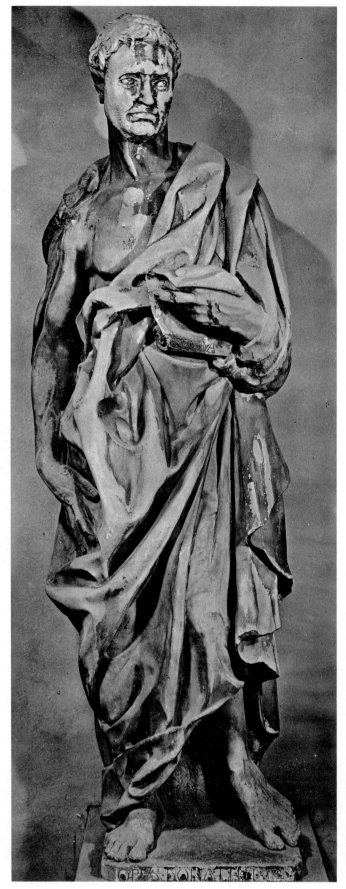

16a 16b

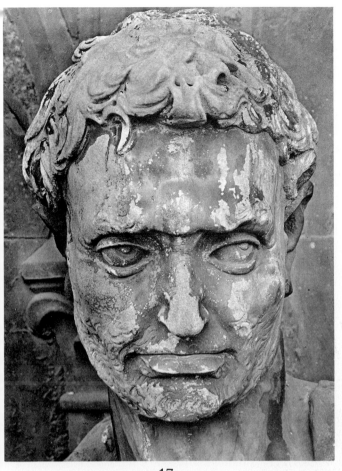

17a

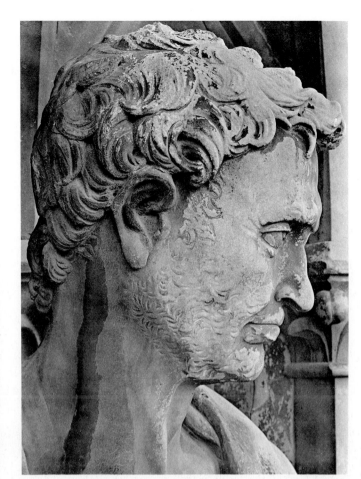

17b

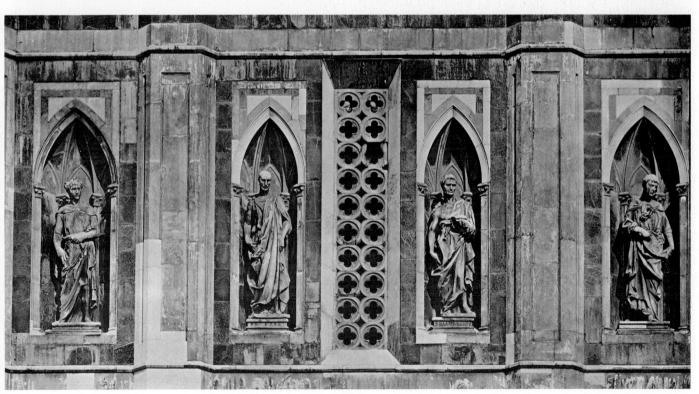

17c

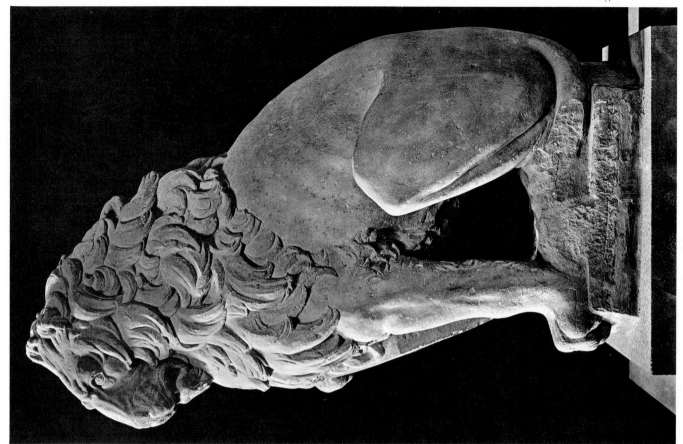

18a

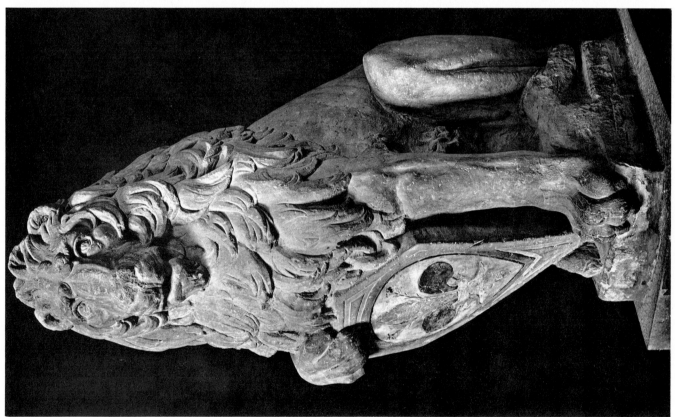

18b

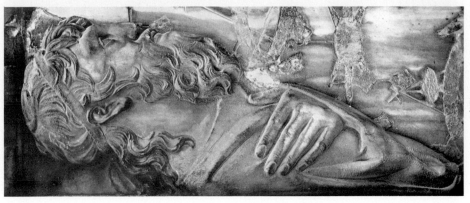

19a

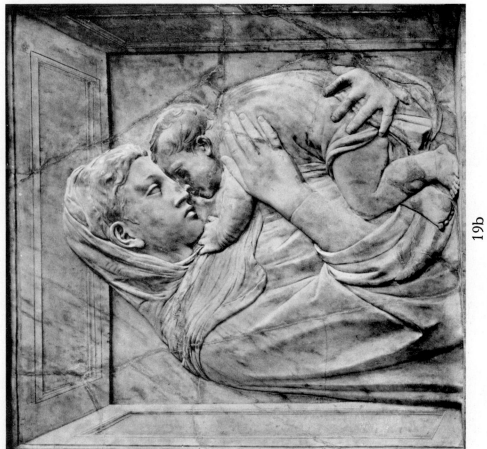

19b

19c

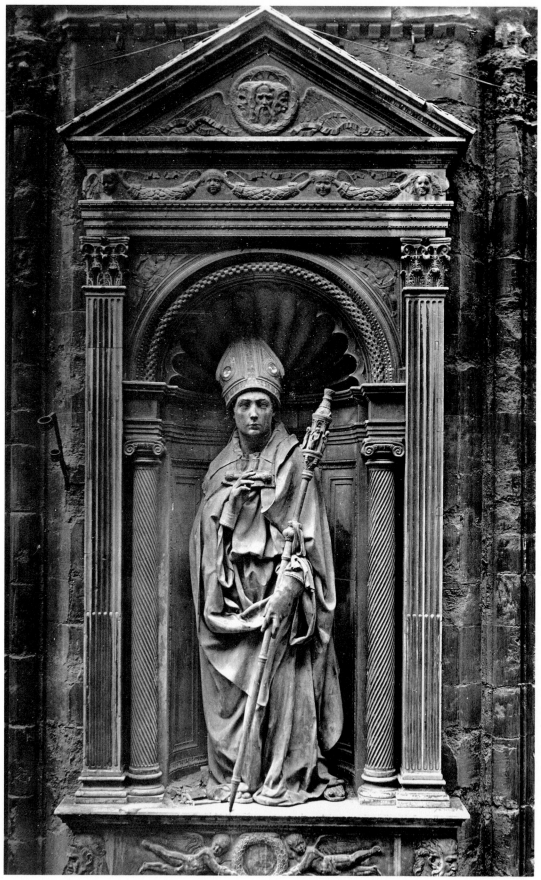

20

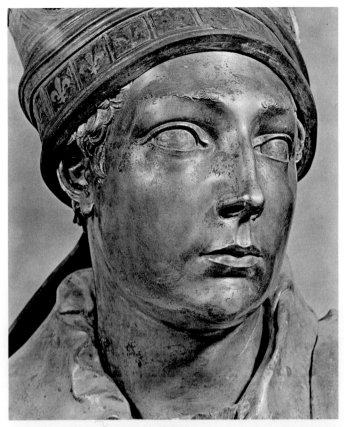

21a

21b

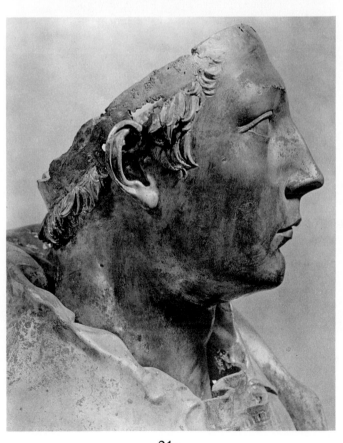

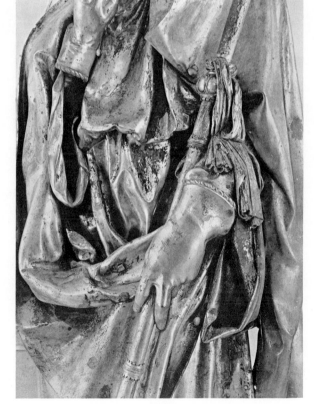

21c

21d

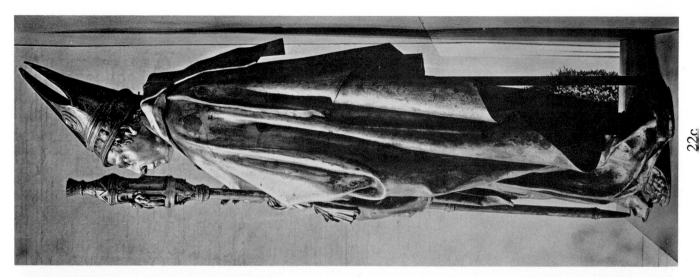

22a

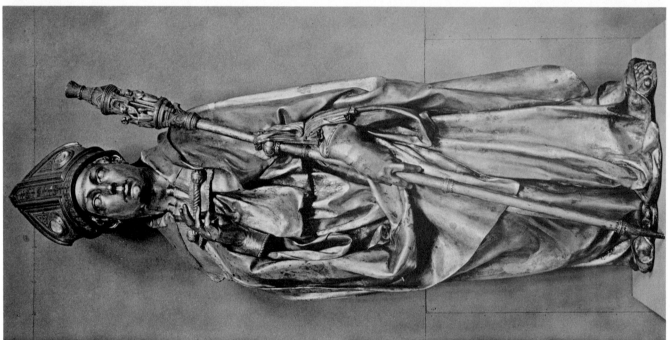

22b

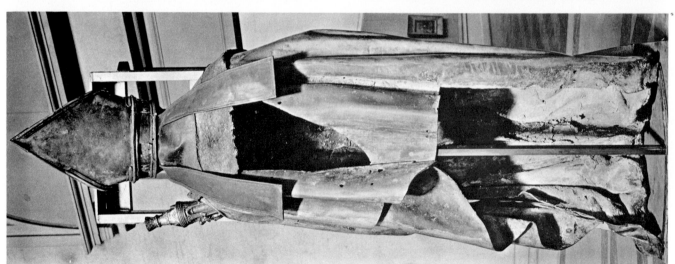

22c

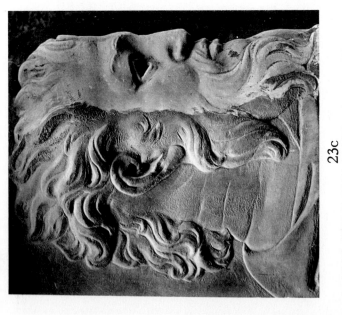

23c

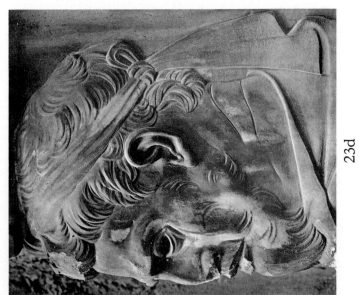

23d

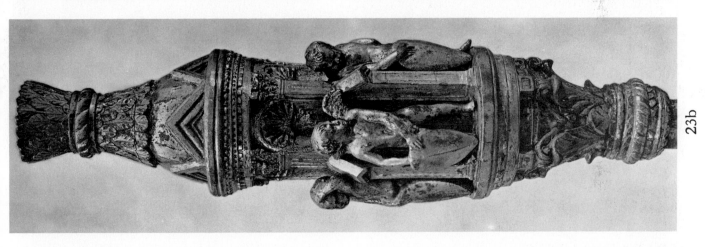

23b

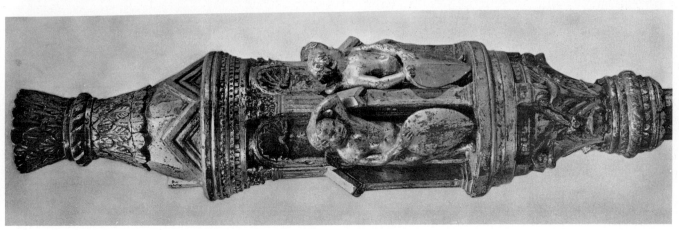

23a

24a

24b

24c

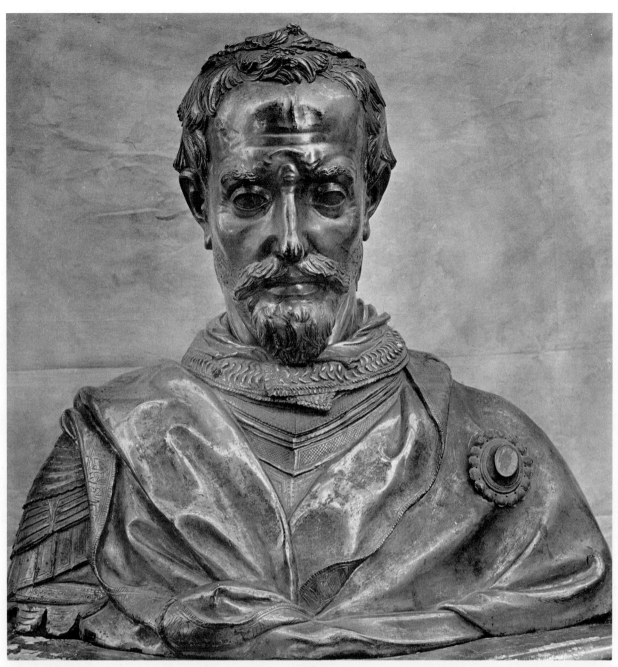

25a

25b

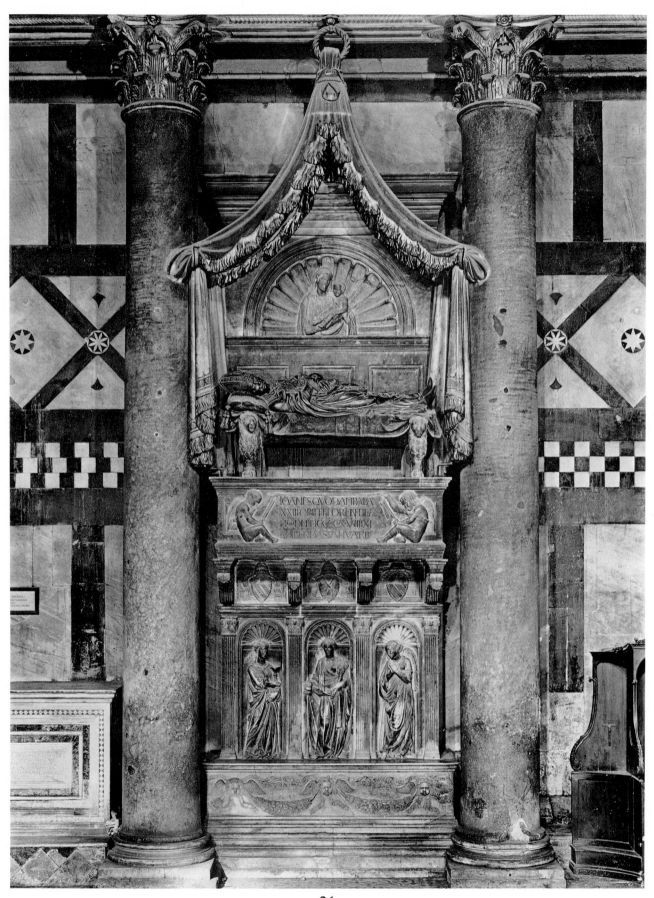

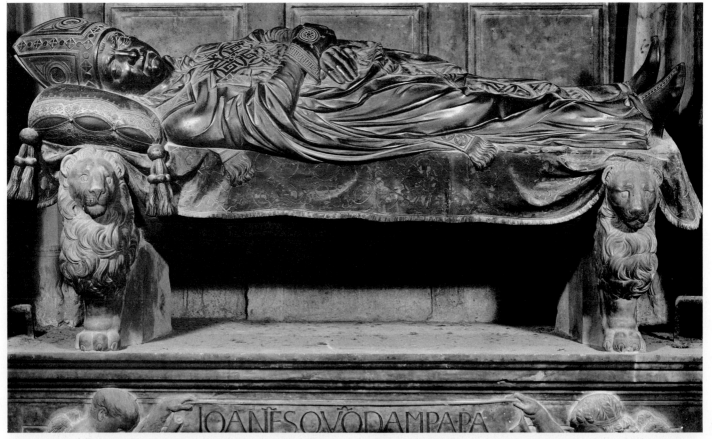

27a

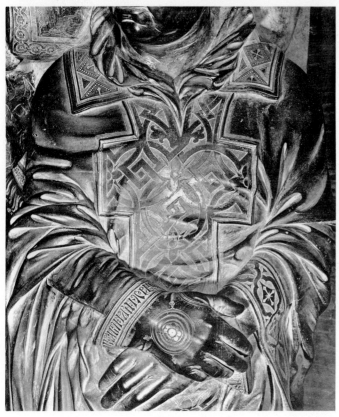

27b

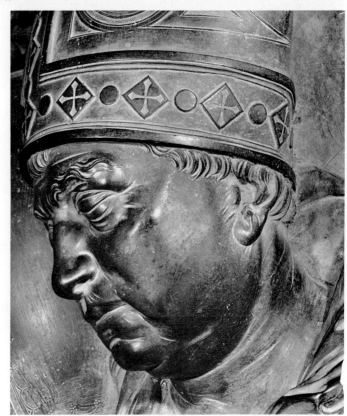

27c

29a

29b

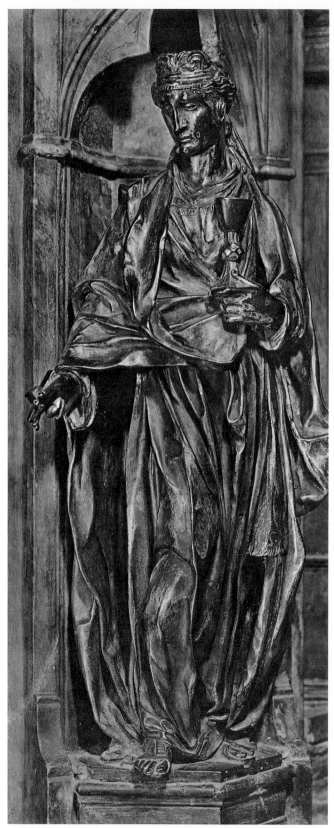 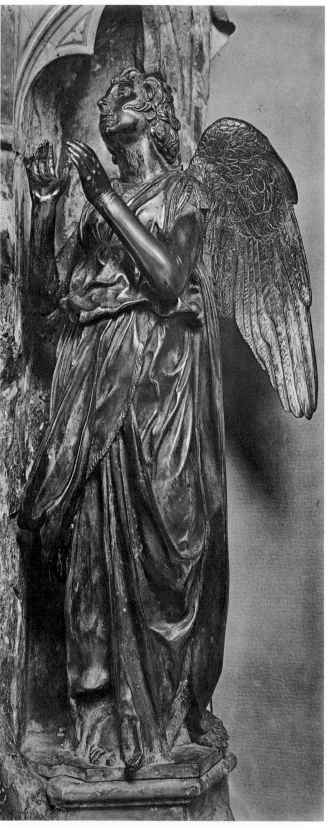

30a 30b

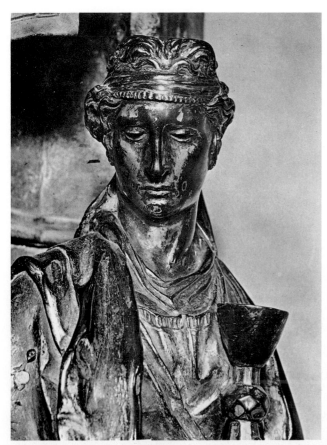

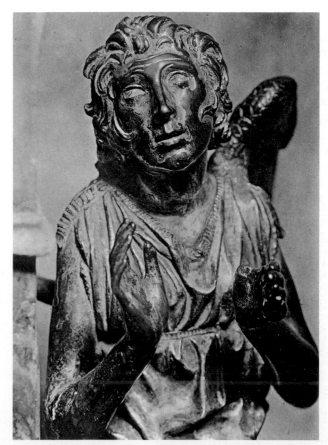

31a

31b

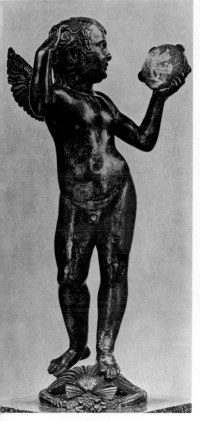

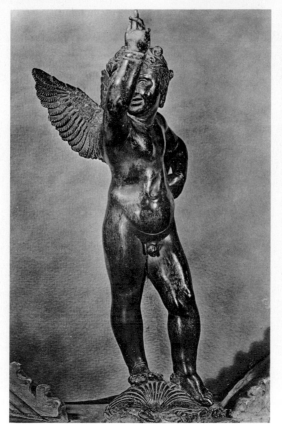

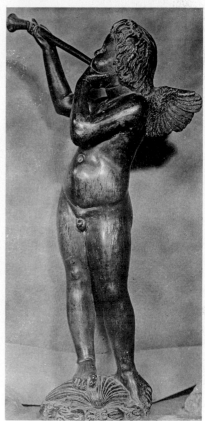

31c

31d

31e

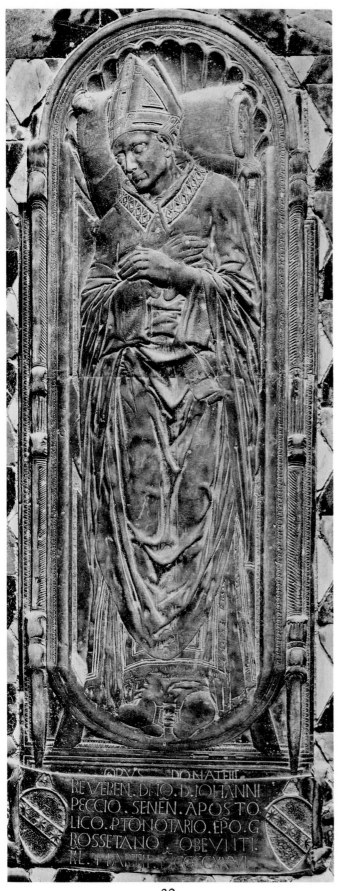

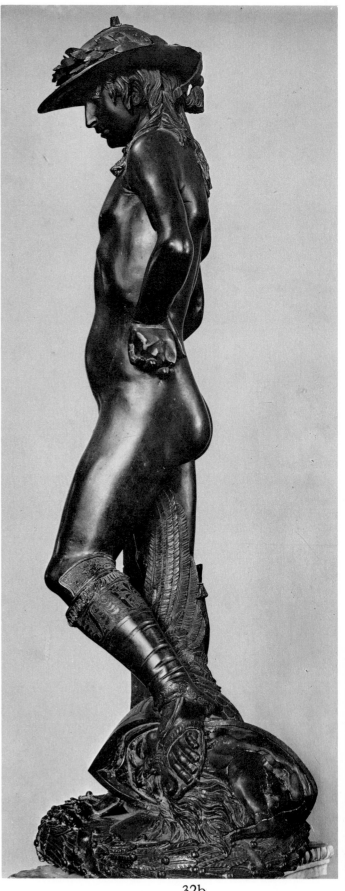

32a

32b

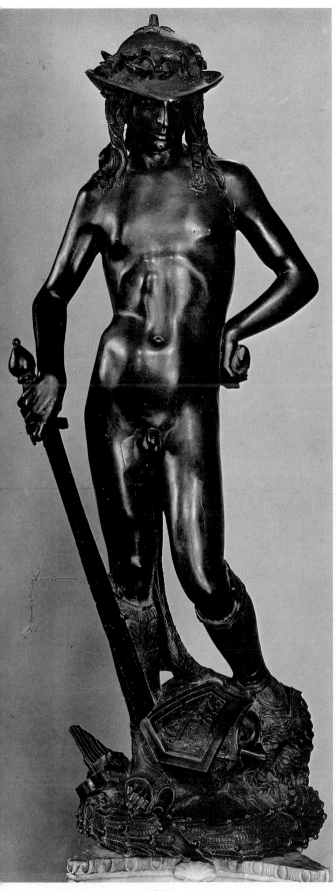

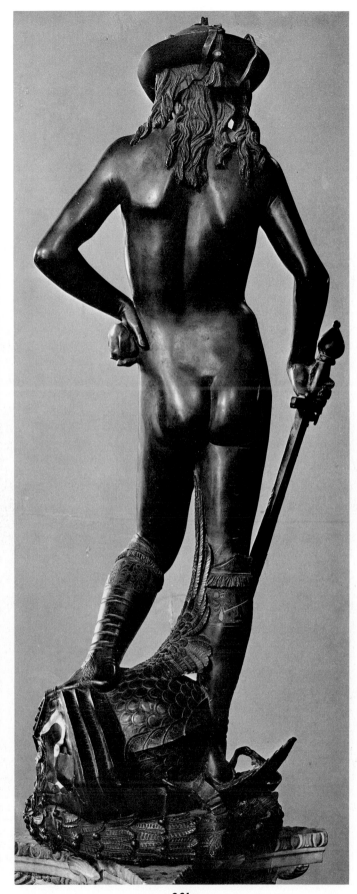

33a 33b

34b

34c

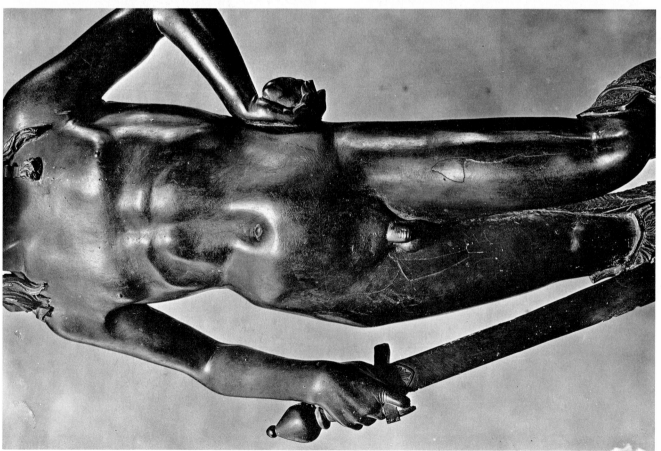

34a

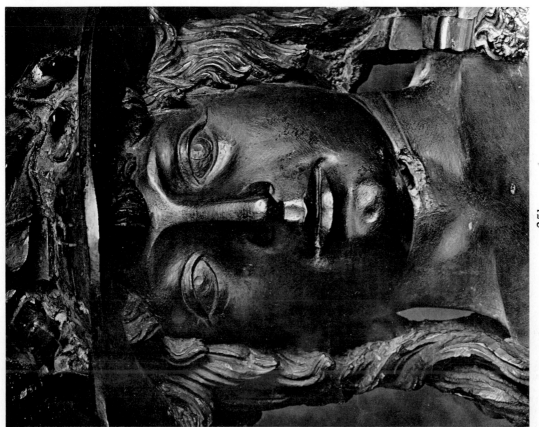

35b

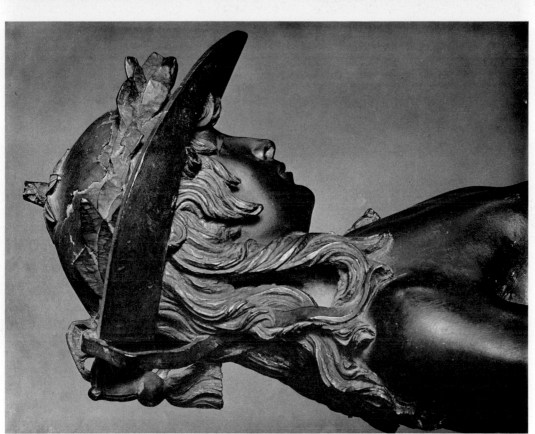

35a

36

37a

37b

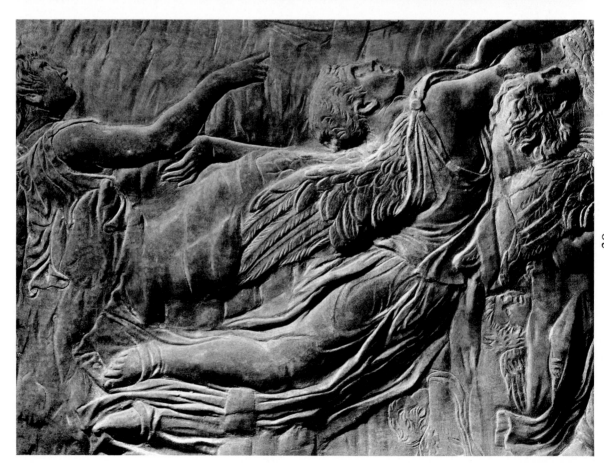

38a

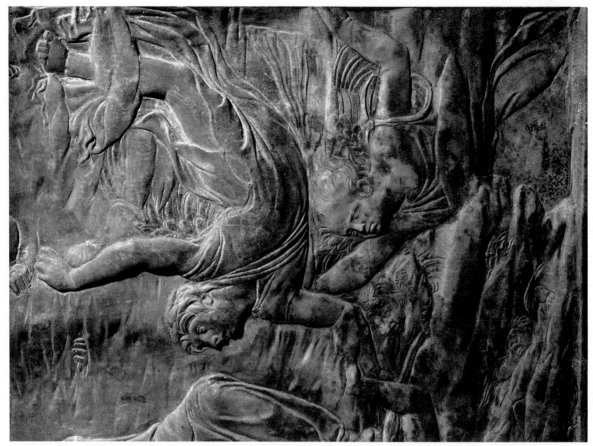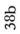

38b

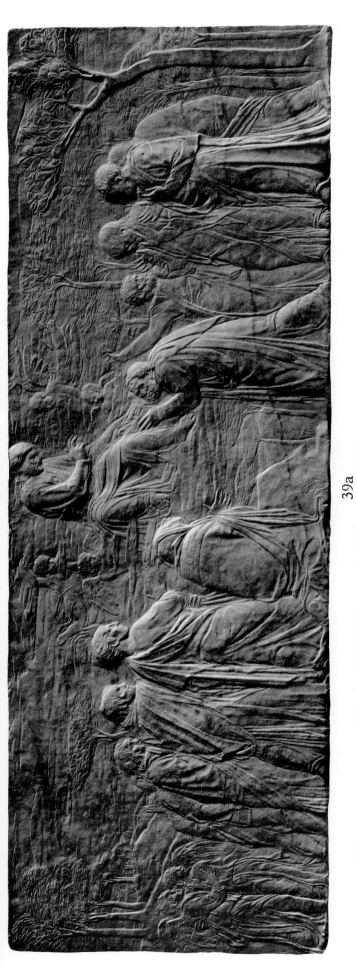

39a

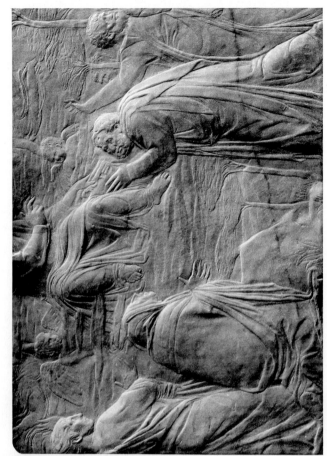

39c

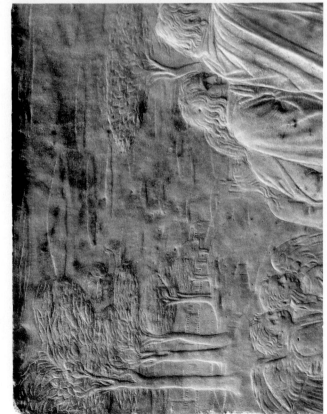

39b

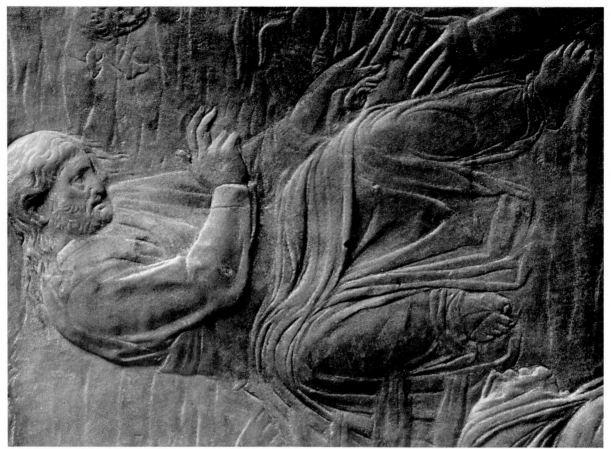

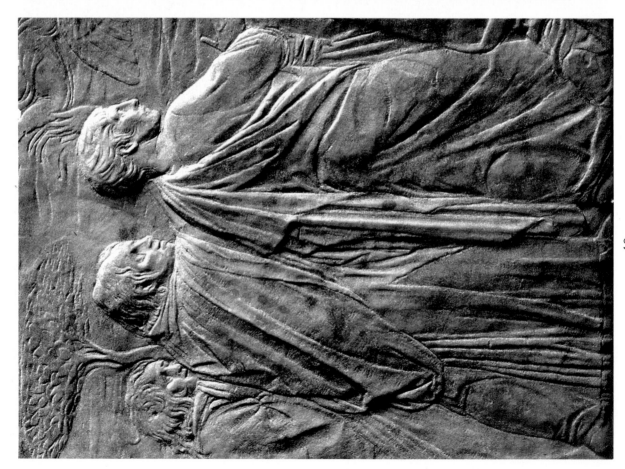

41a

41b

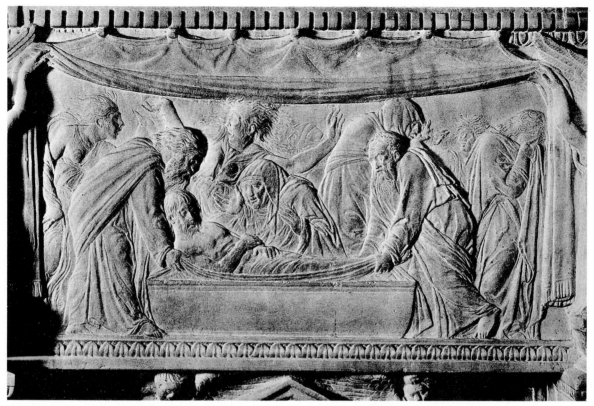

42a

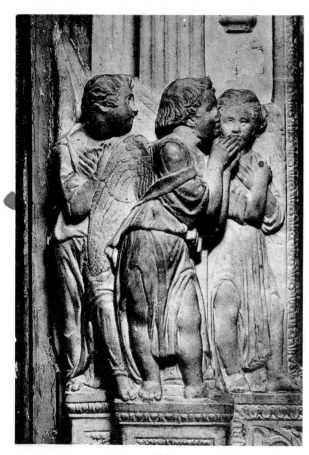

42b

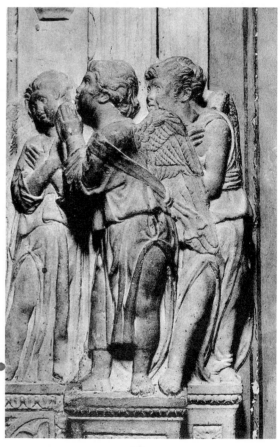

42c

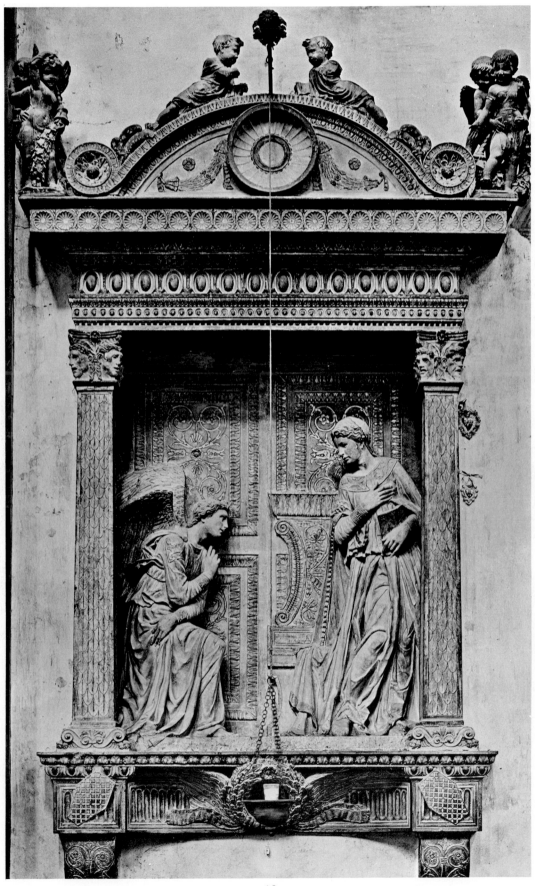

43

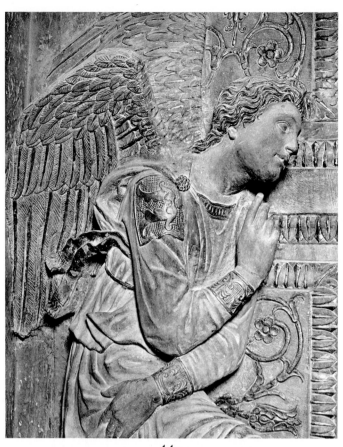

44a

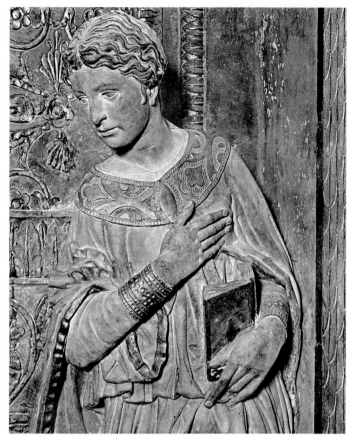

44b

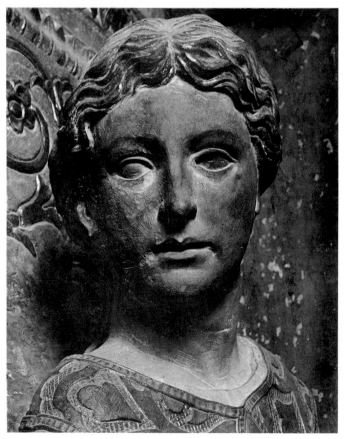

44c

44d

45a

45b

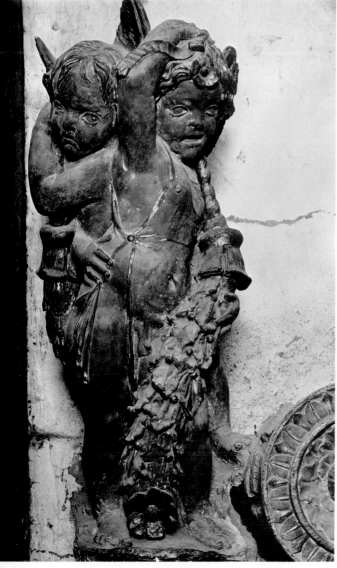

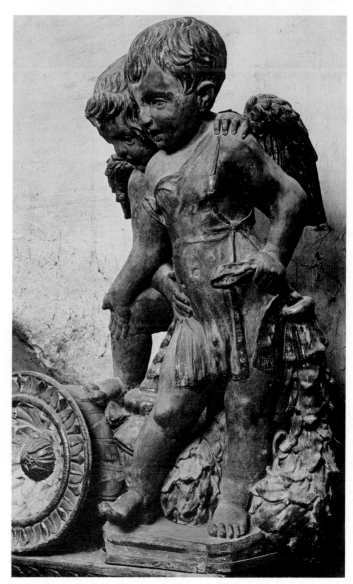

45c

45d

46a

46b

46c

46d

46e

46f

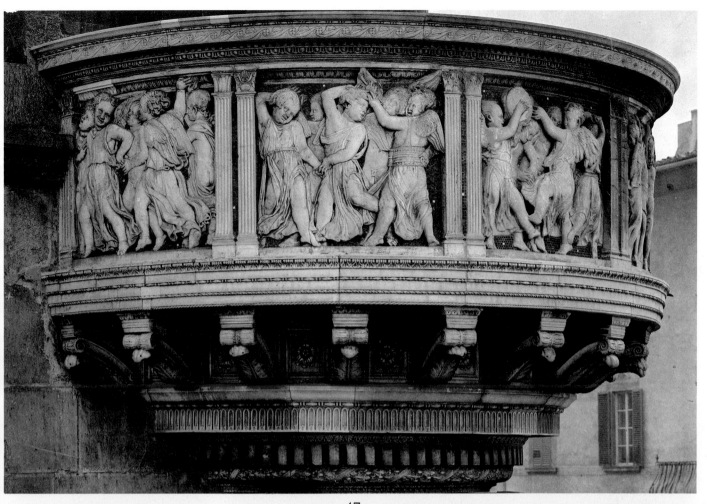

47a

47b

47c

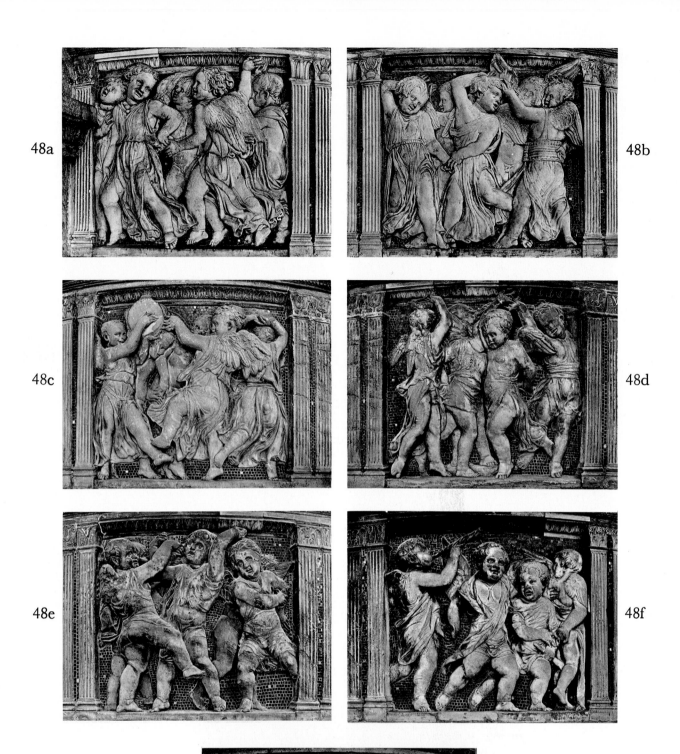

48a 48b

48c 48d

48e 48f

48g

49a

49b

49c

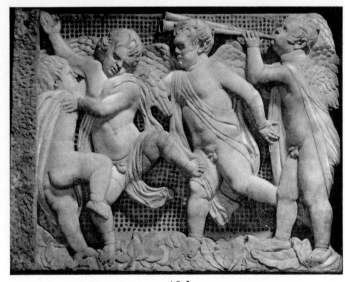

49d

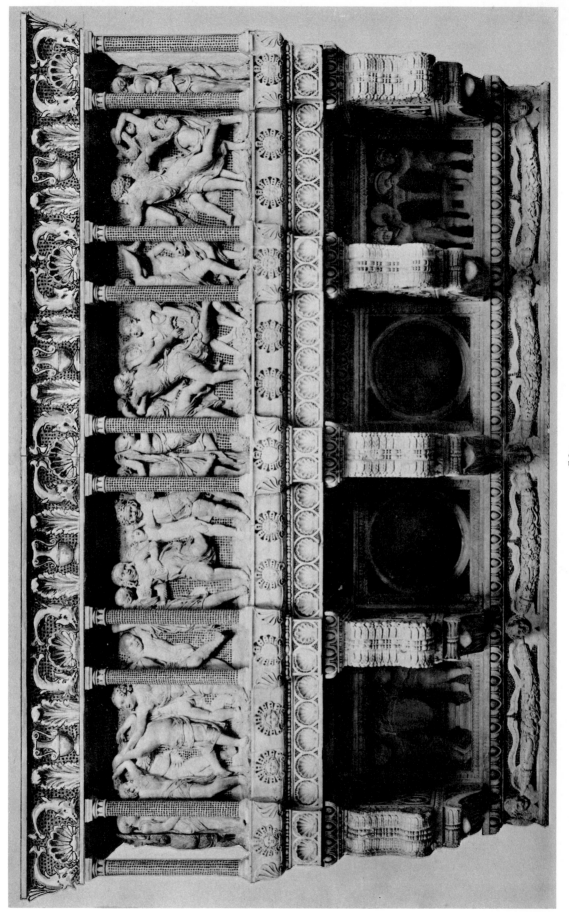

51a

51b

51c

51d

51e

51f

51g

51h

52a

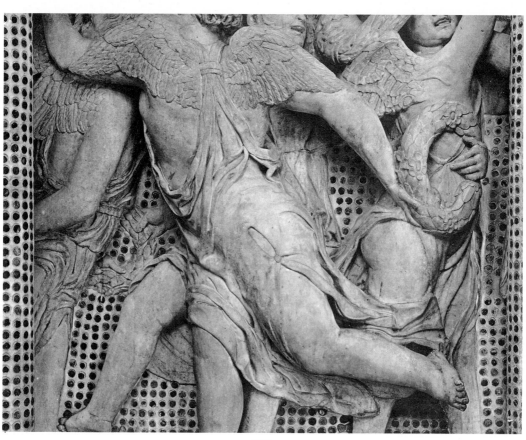

52b

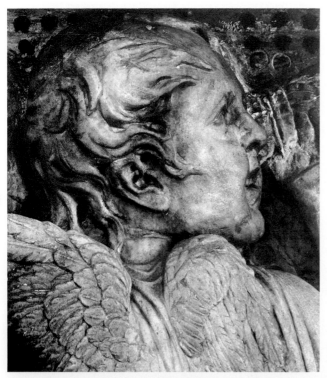

53a

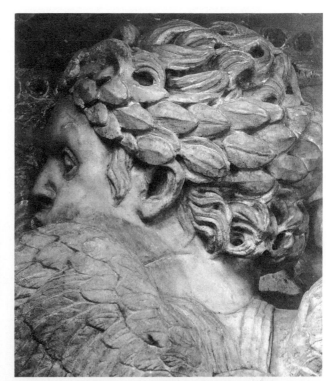

53b

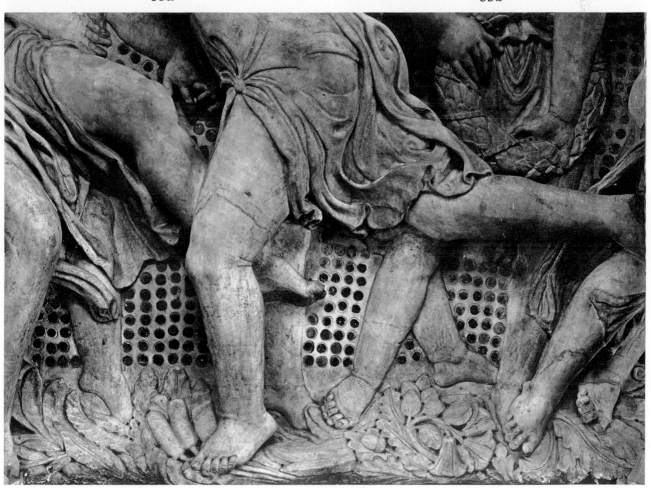

53c

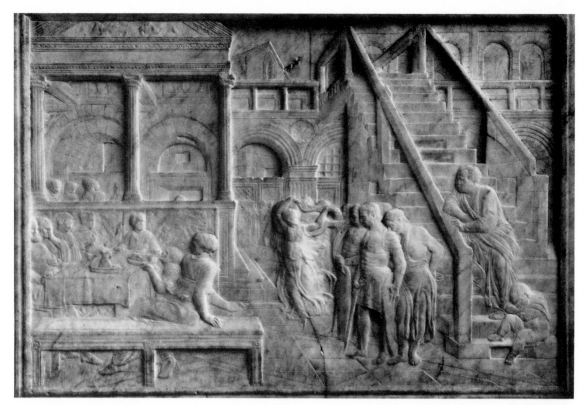

54a

54b

55a

55b

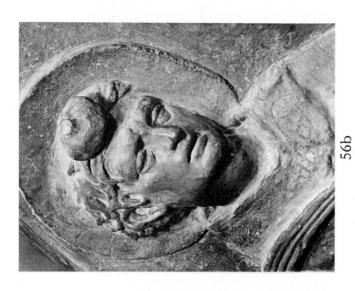

56b

56c

56a

57a

57b

58a

58b

58c

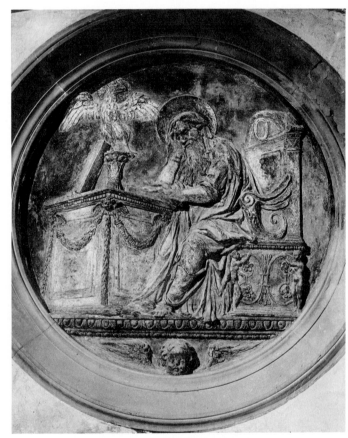

58d

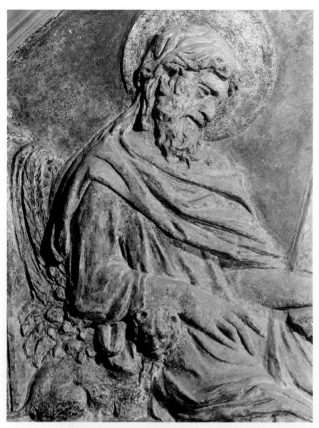

59a

59b

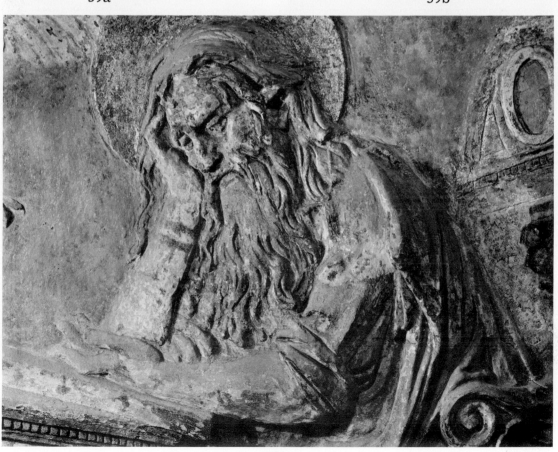

59c

60a

60b

60c

60d

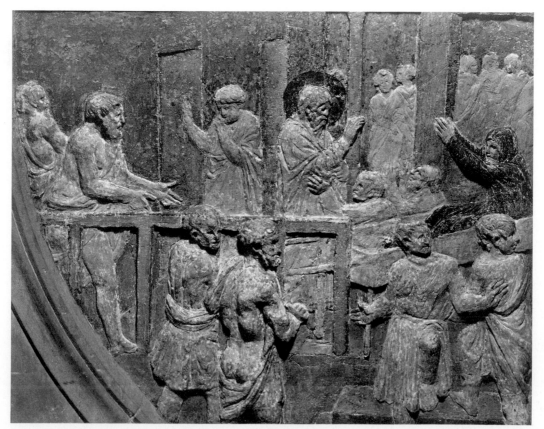

61a

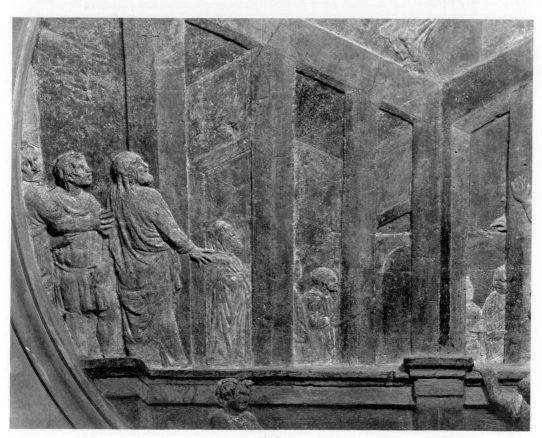

61b

62

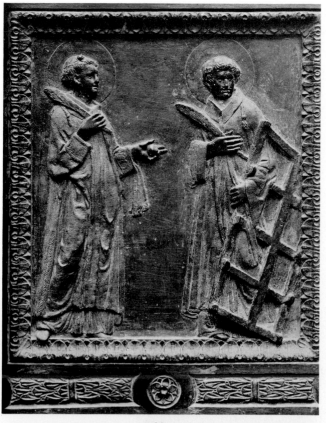

63a

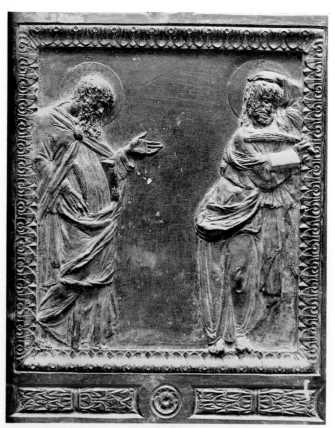
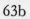

63b

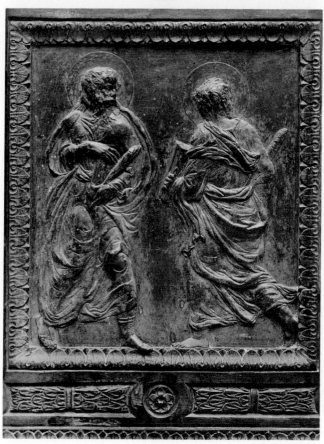

63c

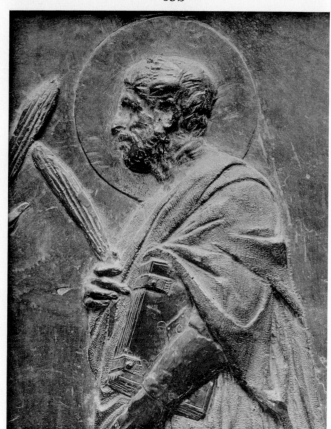

63d

64

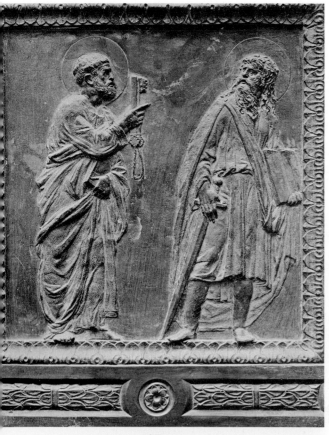

65a

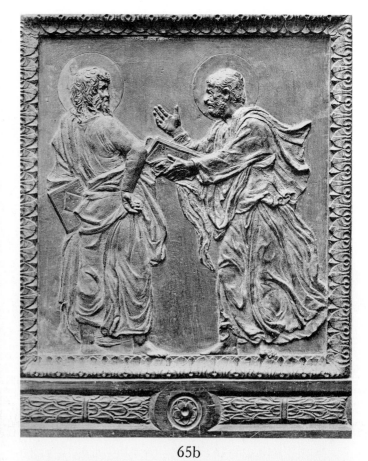

65b

65c

65d

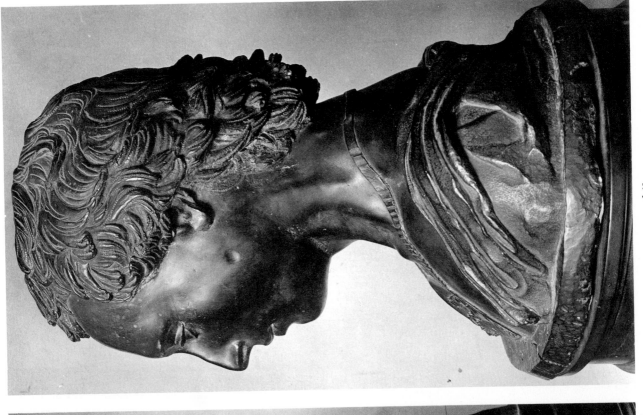

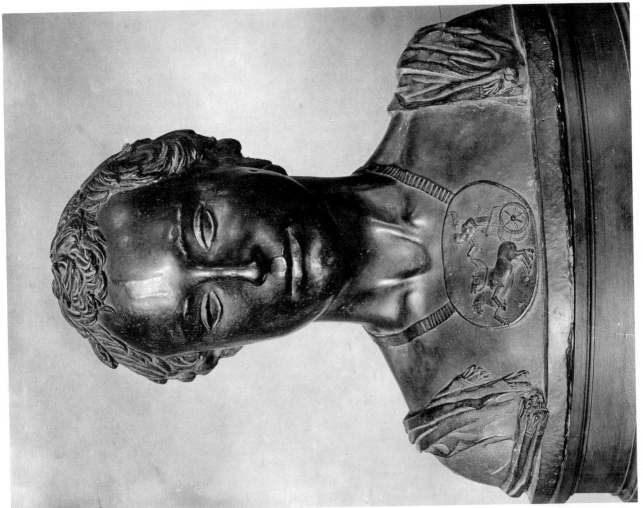

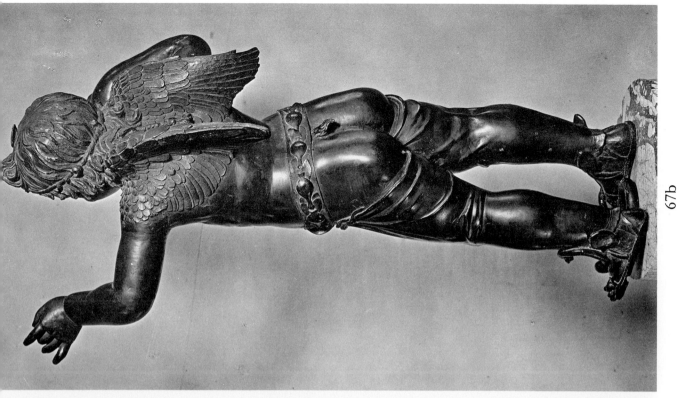

67b

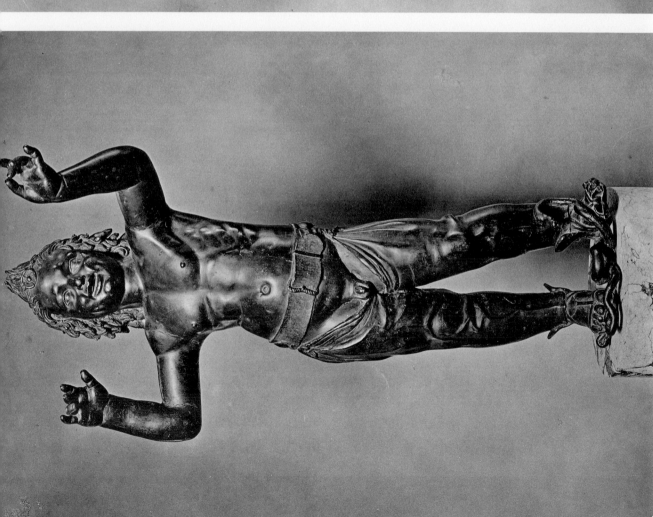

67a

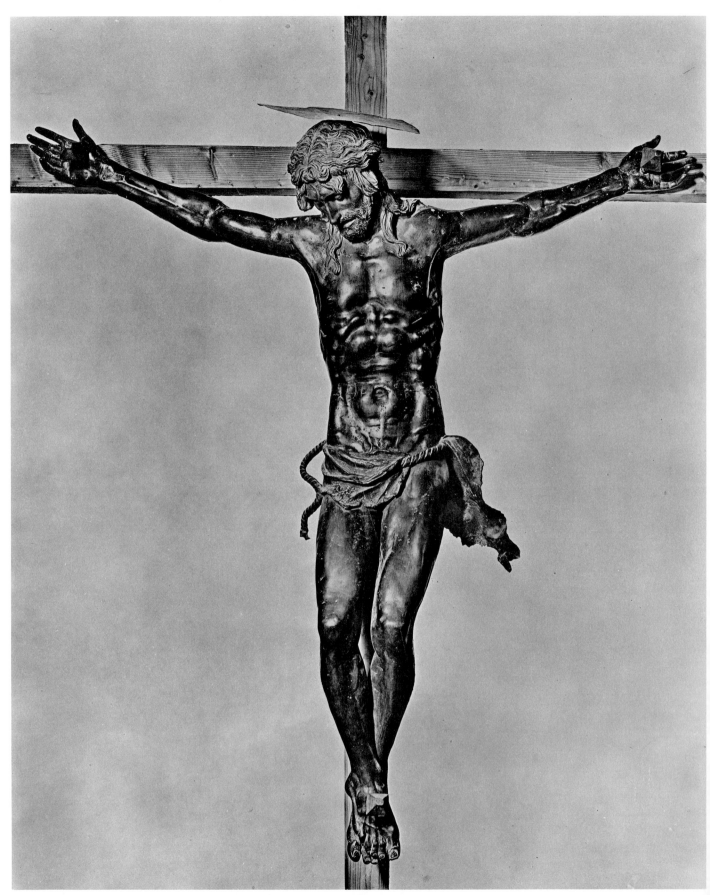

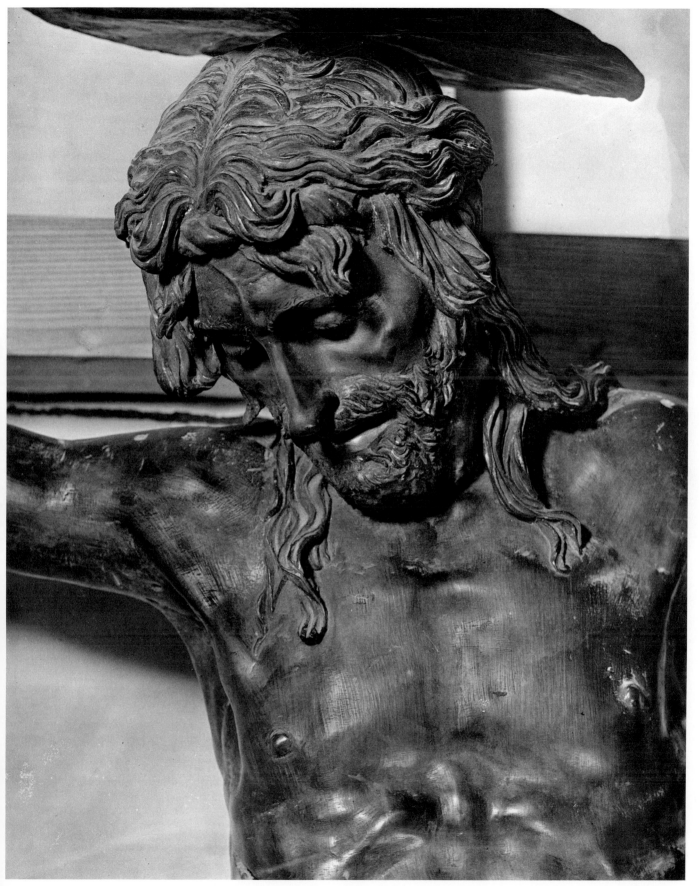

70a

70b

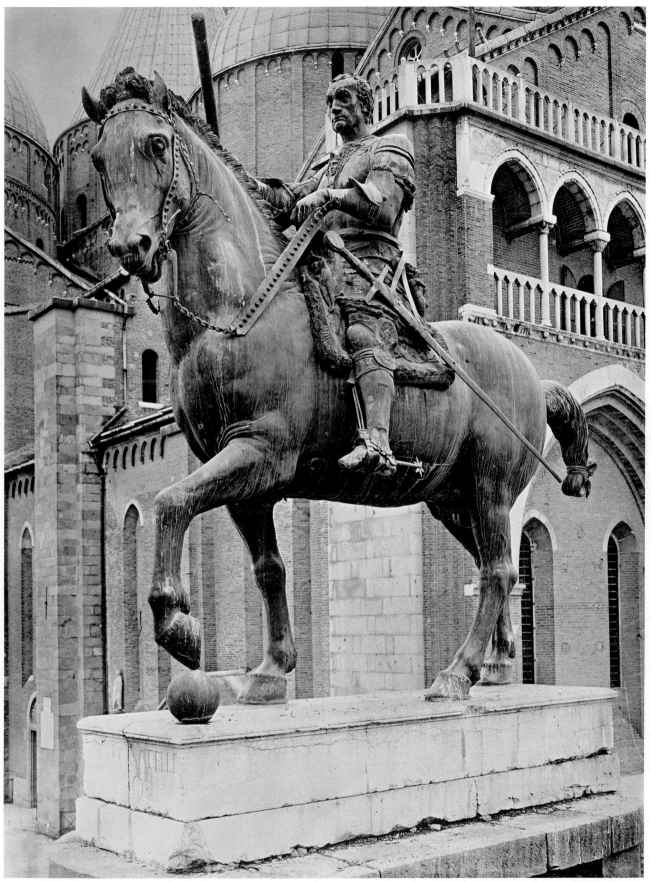

73a

73b

73c

73d

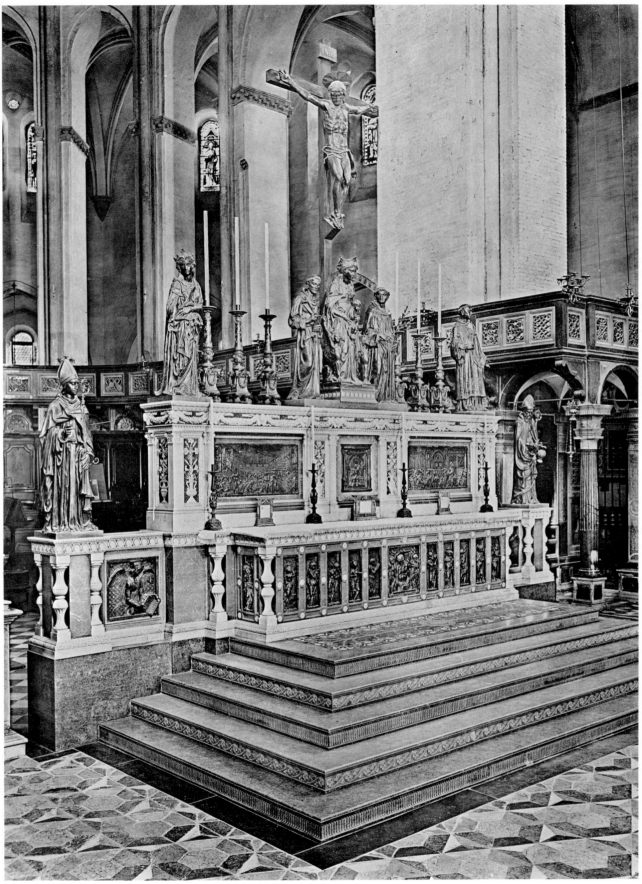

74

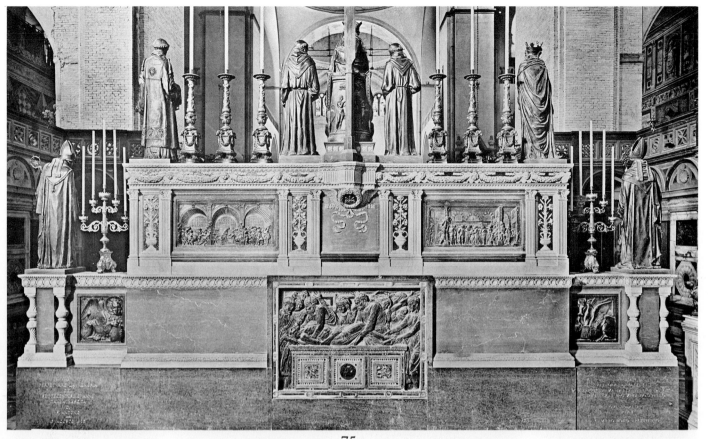

75a

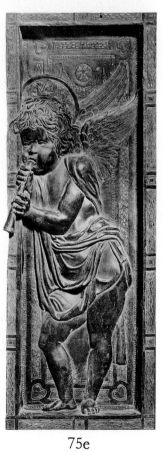

75b 75c 75d 75e

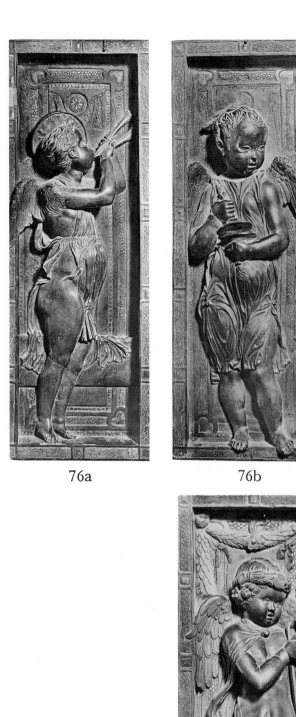

76a

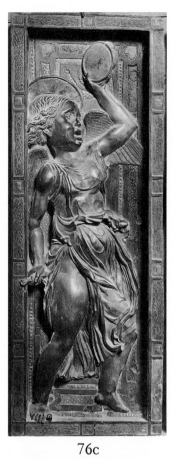

76c

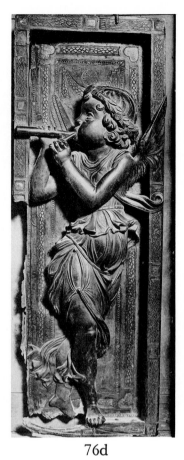

76d

76b

76e

76f

77a

77b

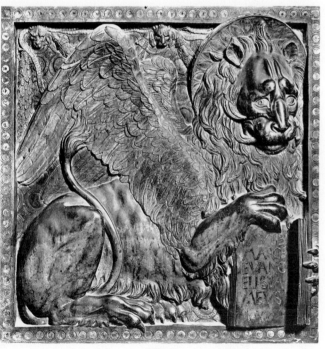

77c

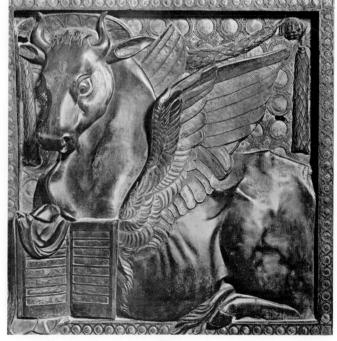

77d

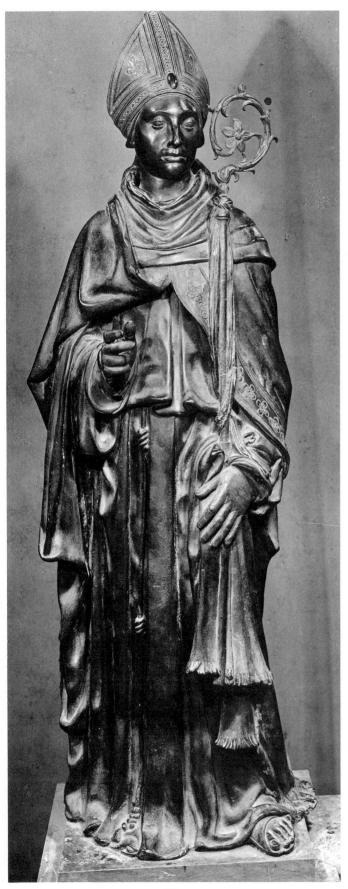

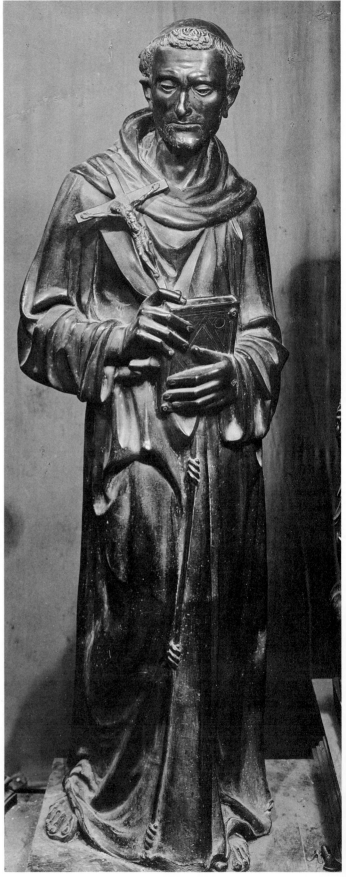

78a 78b

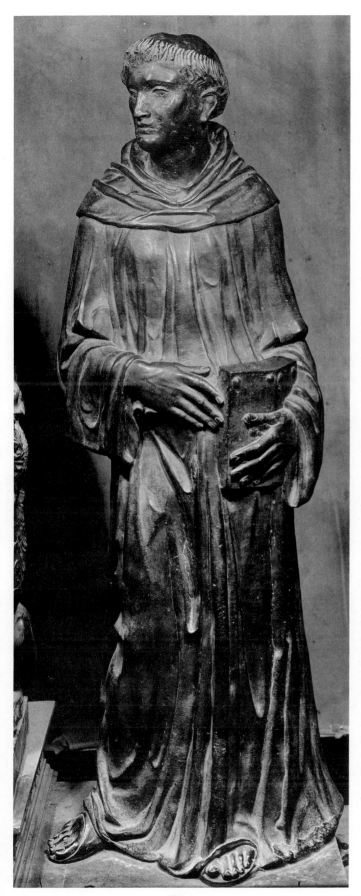

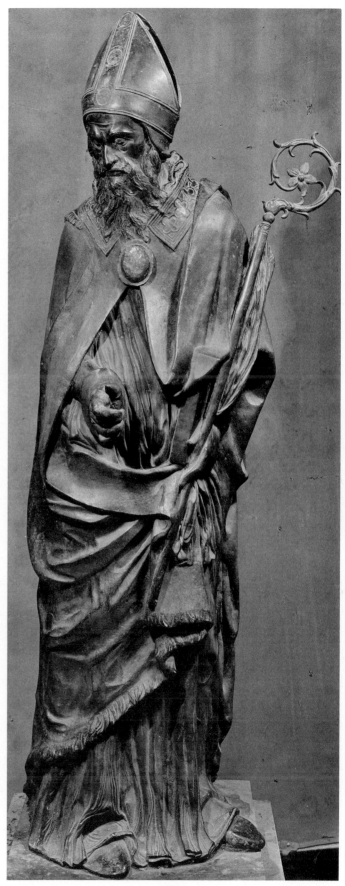

79a

79b

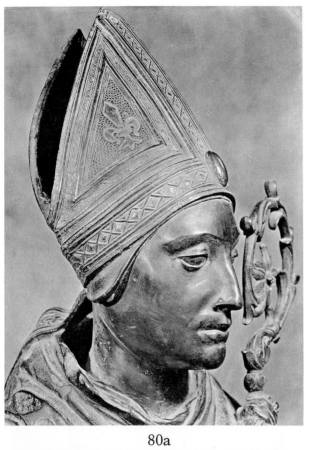

80a

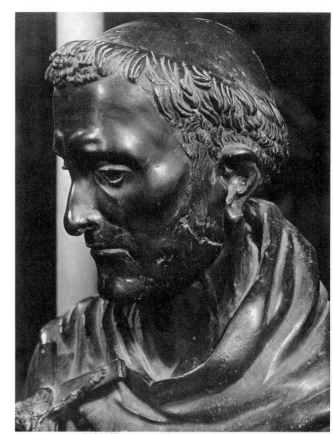

80b

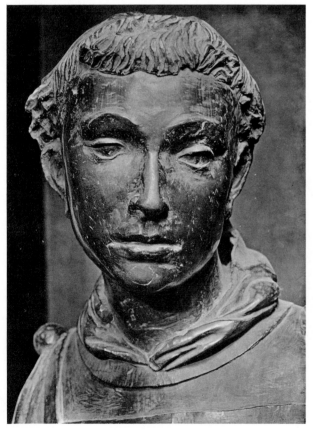

80c

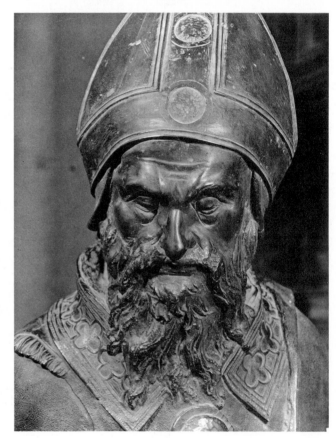

80d

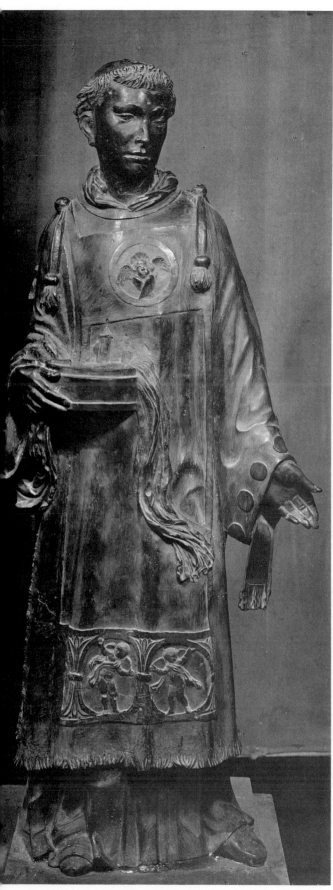

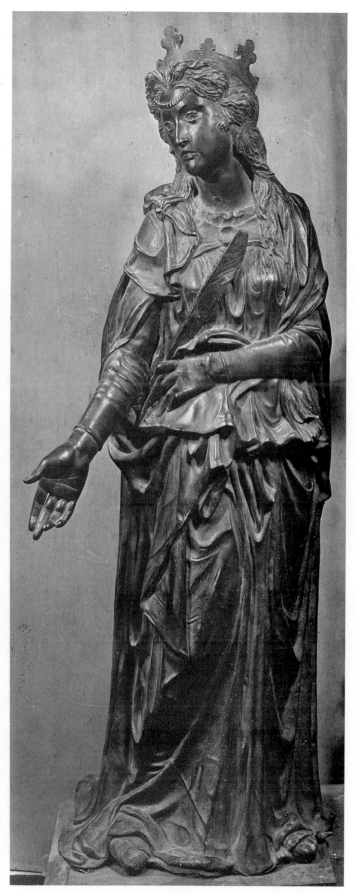

81a

81b

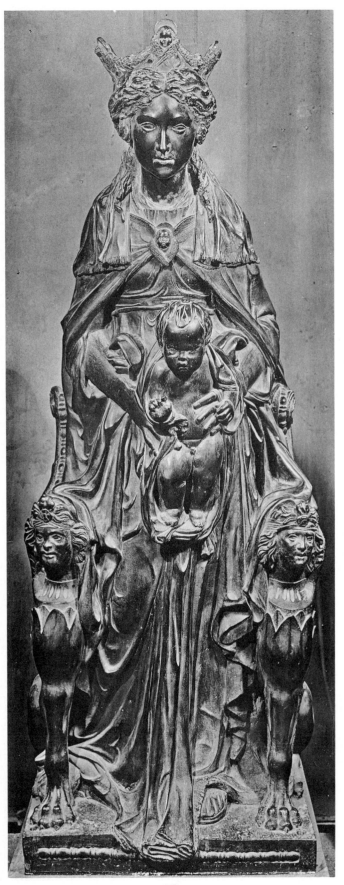

82a

82b

82c

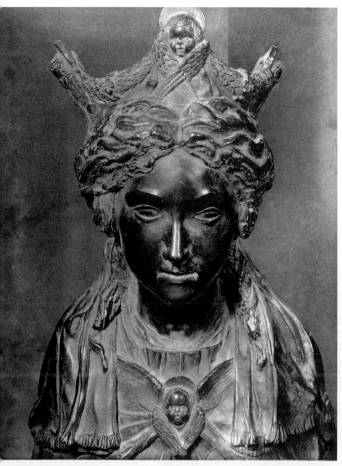

83a

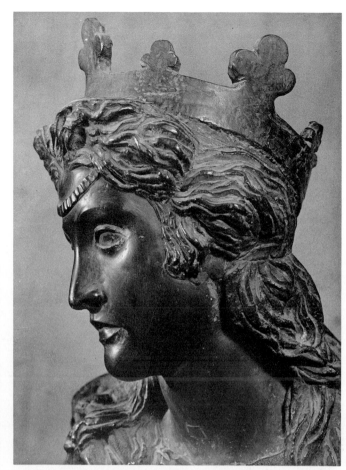

83b

83c

83d

83e

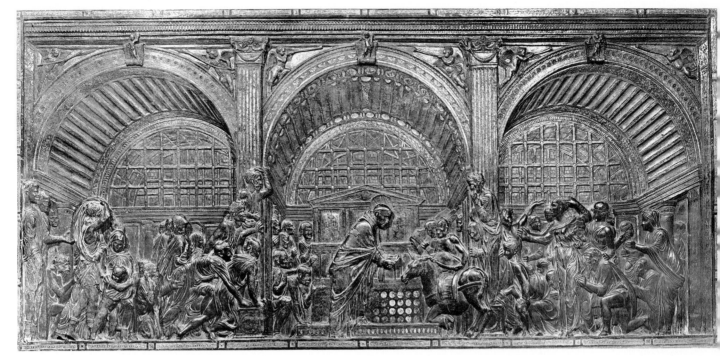

84a

84b

85a

85b

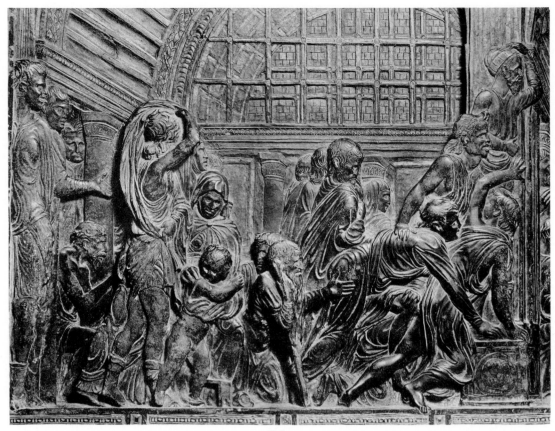

86a

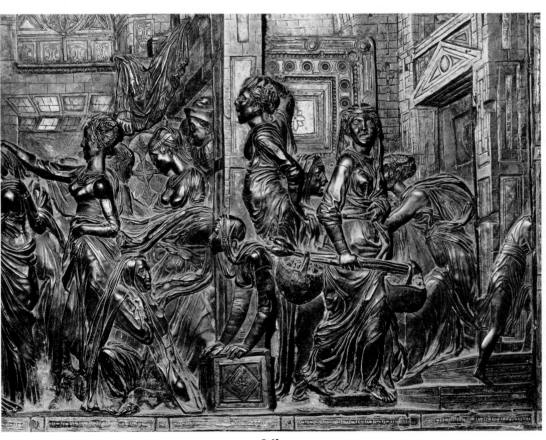

86b

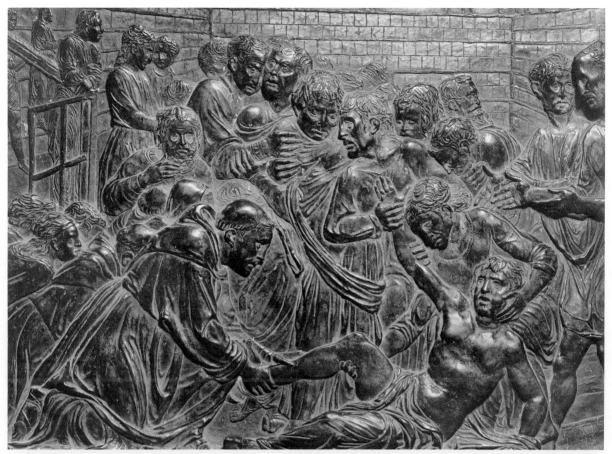

87a

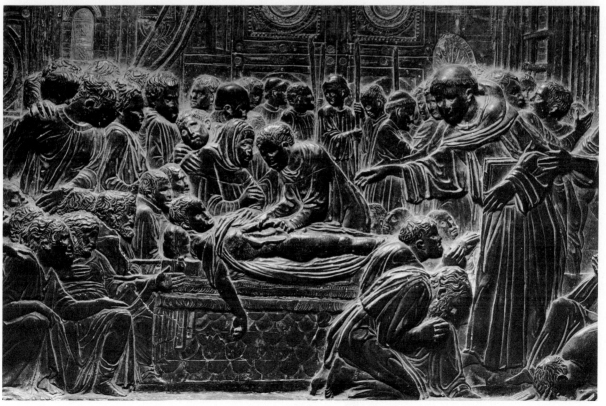

87b

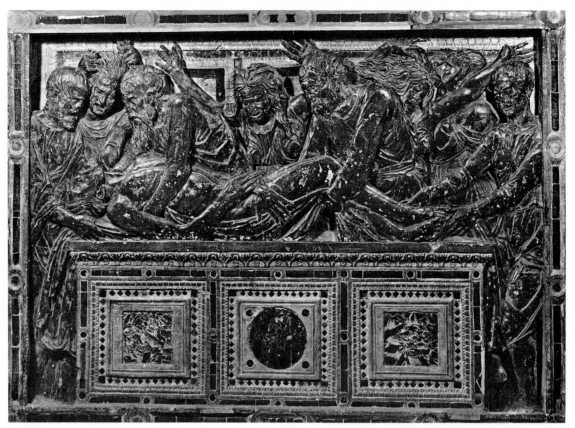

88a

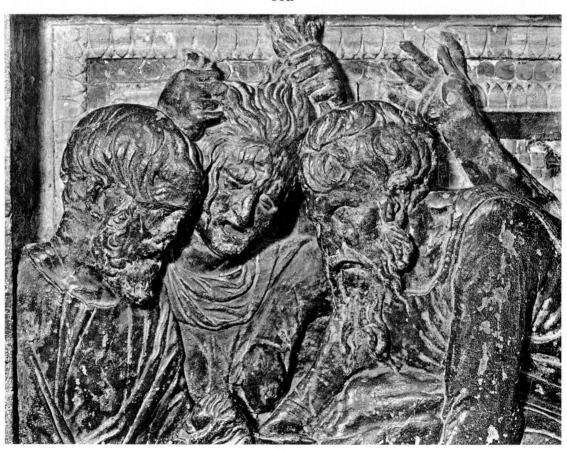

88b

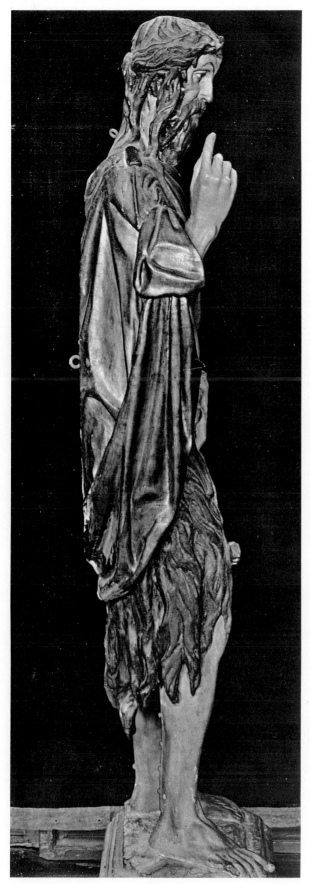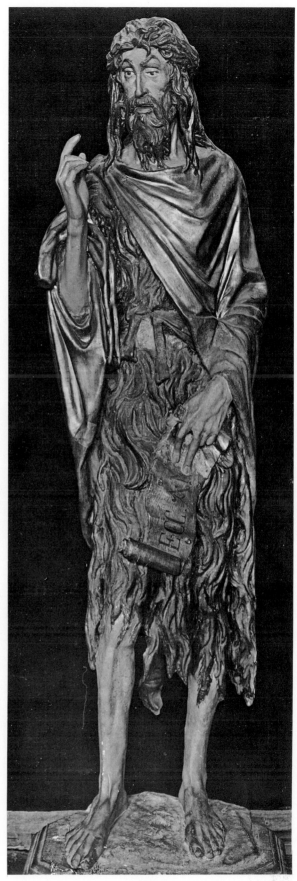

89a 89b

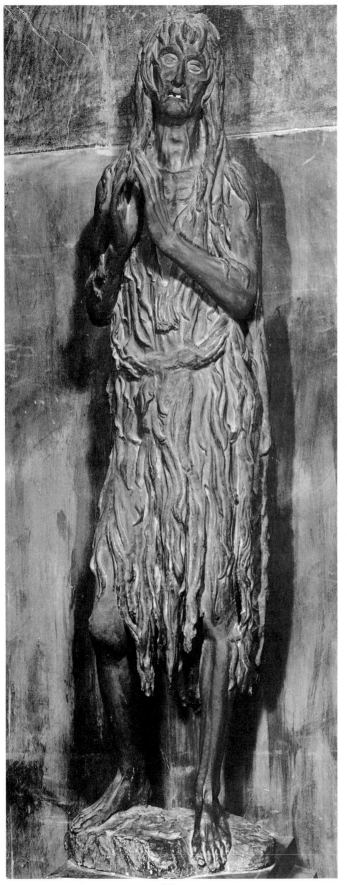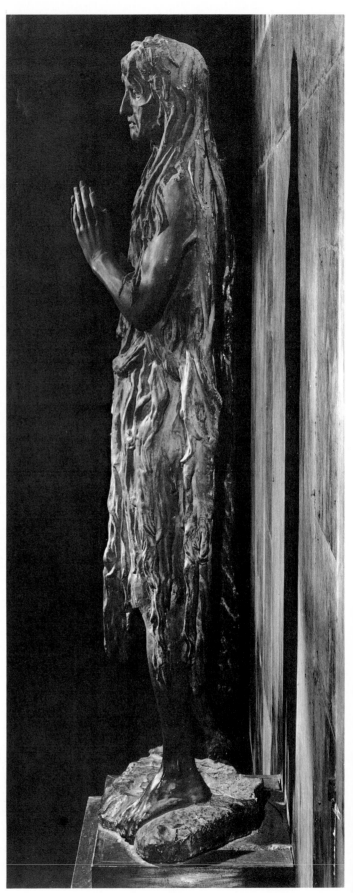

90a 90b

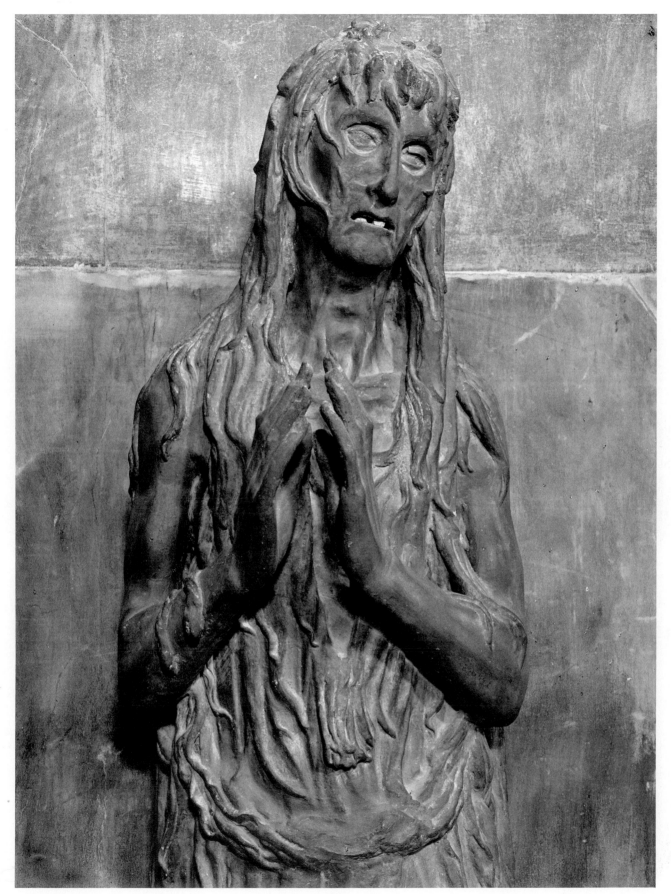

91

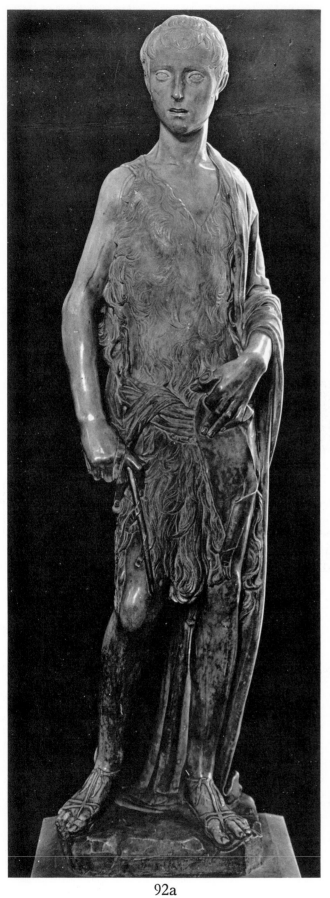

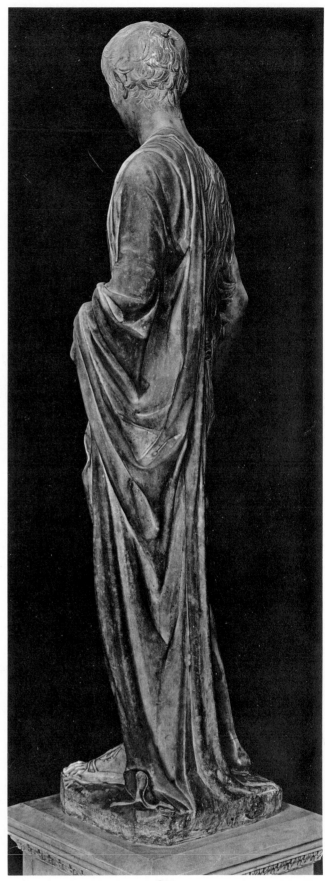

92a

92b

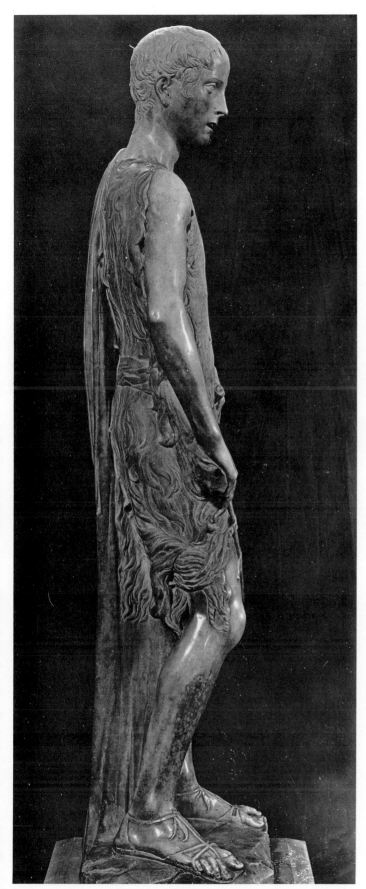

93a

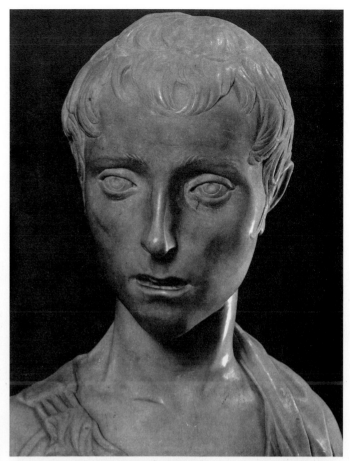

93b

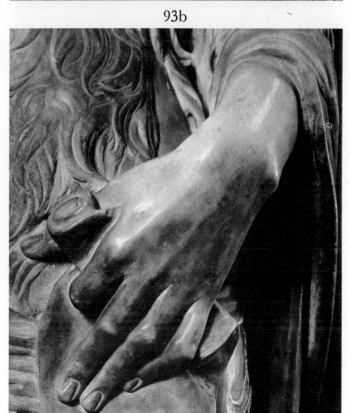

93c

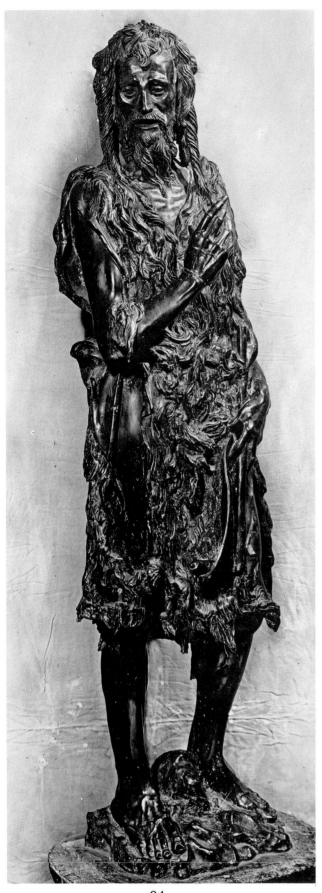

94a

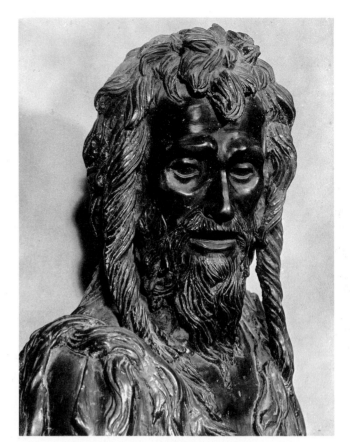

94b

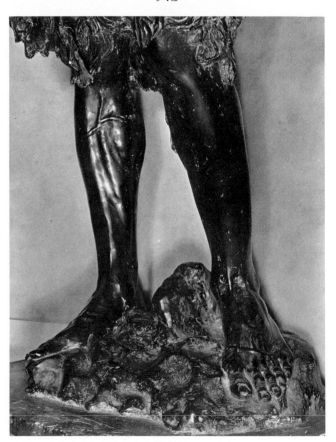

94c

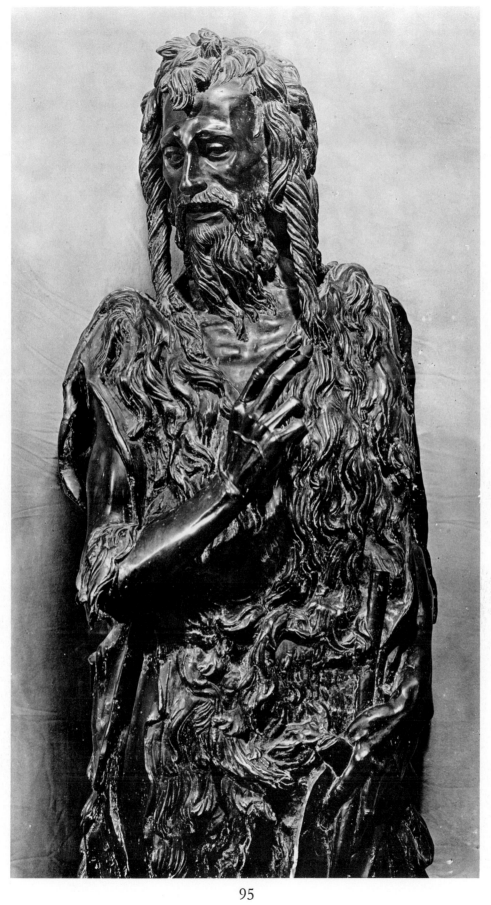

95

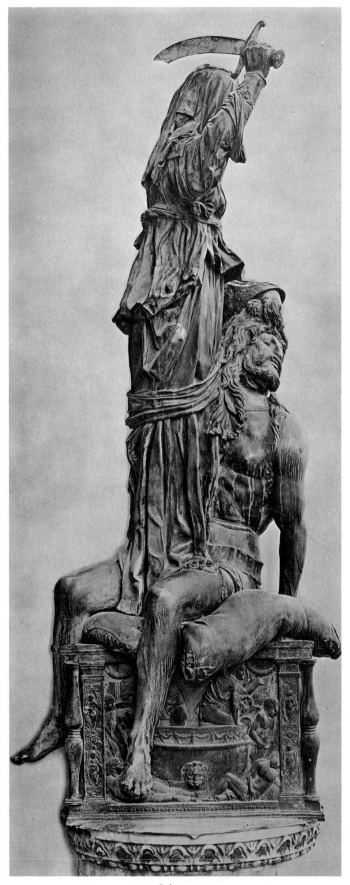

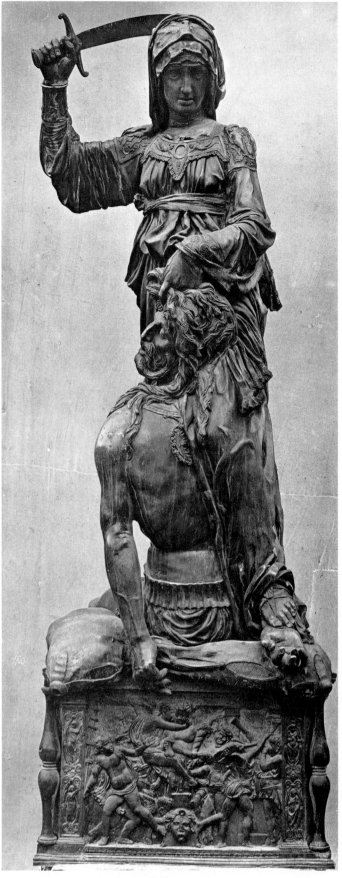

96a

96b

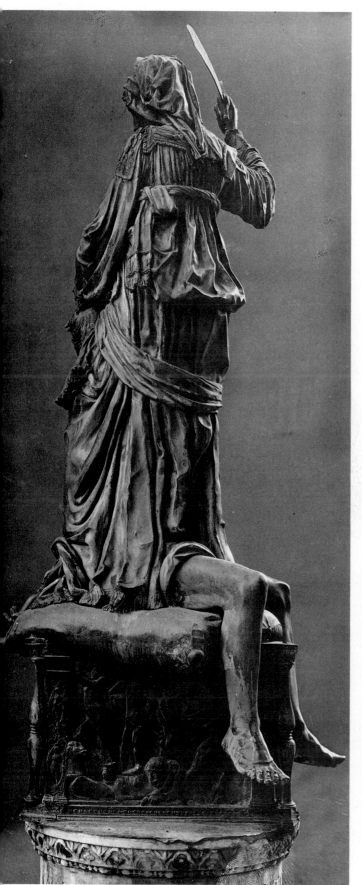

97a

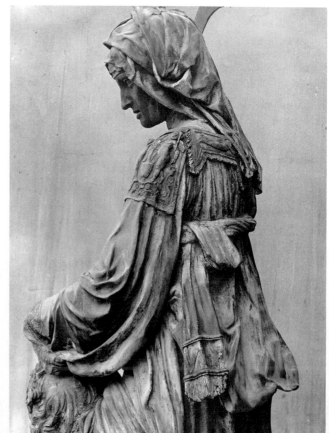

97b

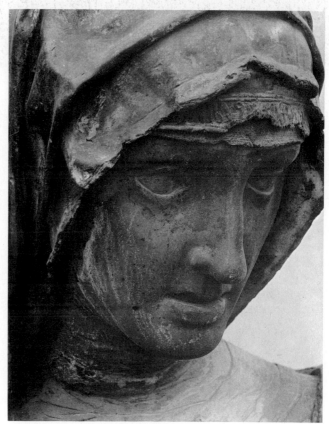

97c

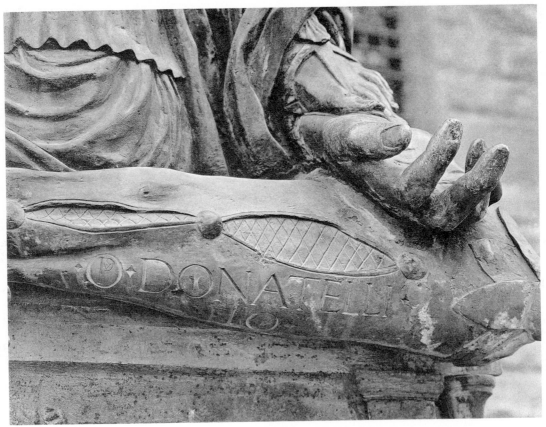

98a

98b

99a

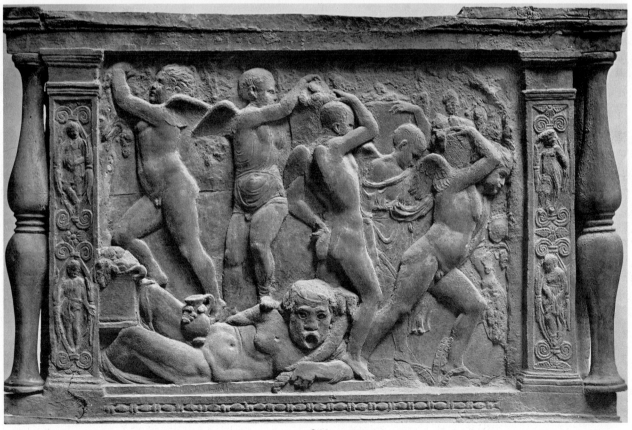

99b

100b

100a

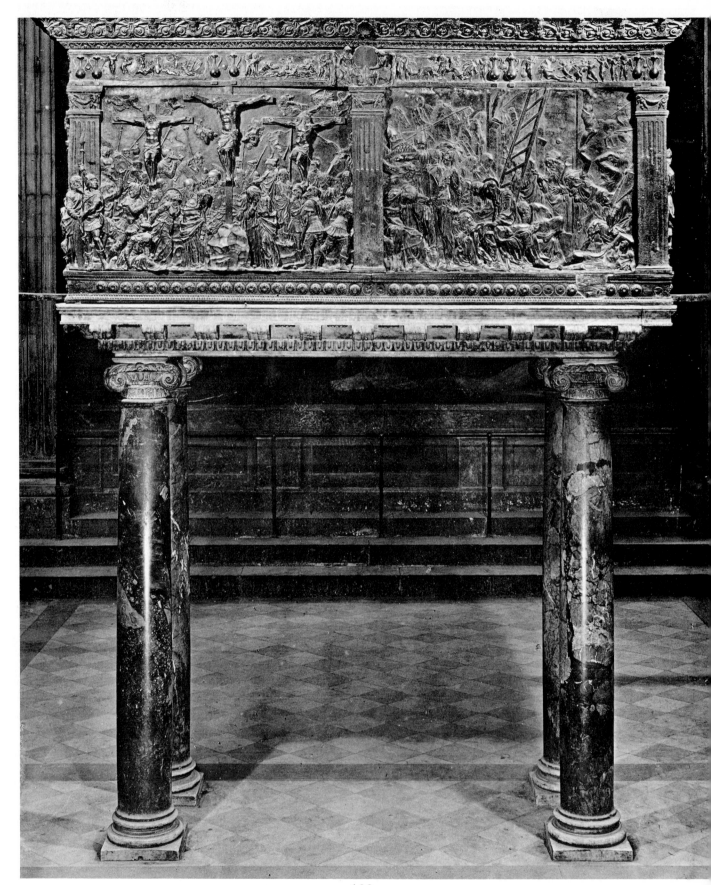

102

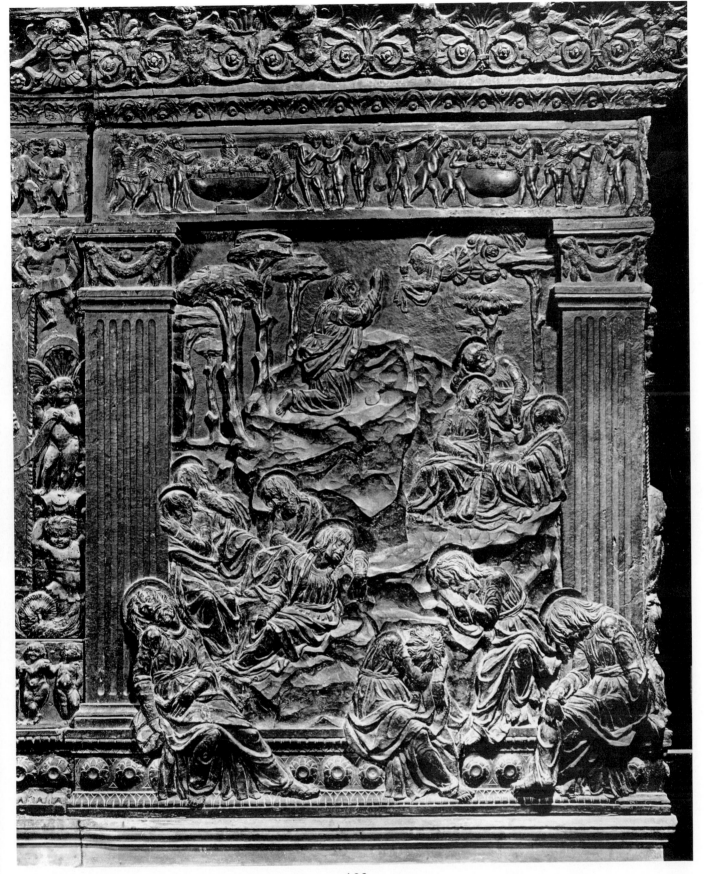

103

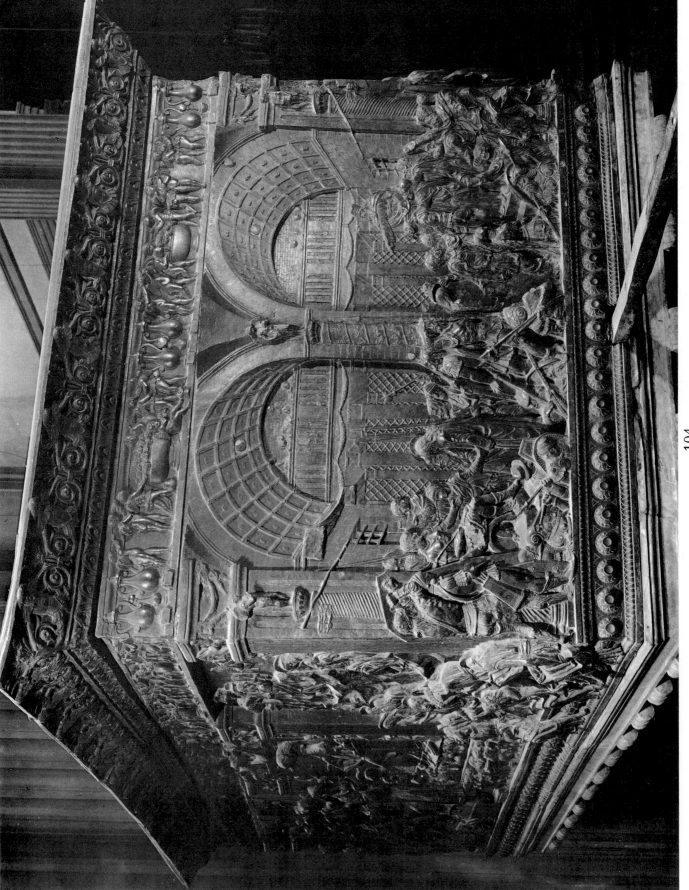

105b

105a

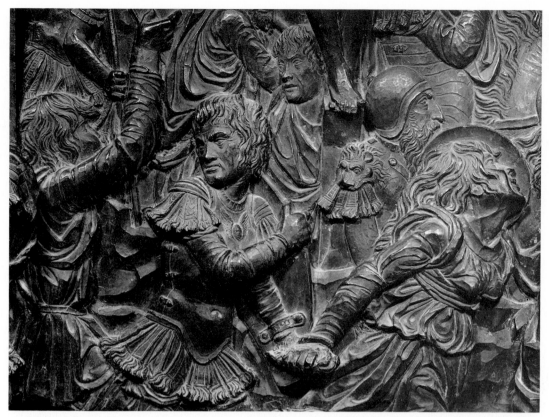

108a

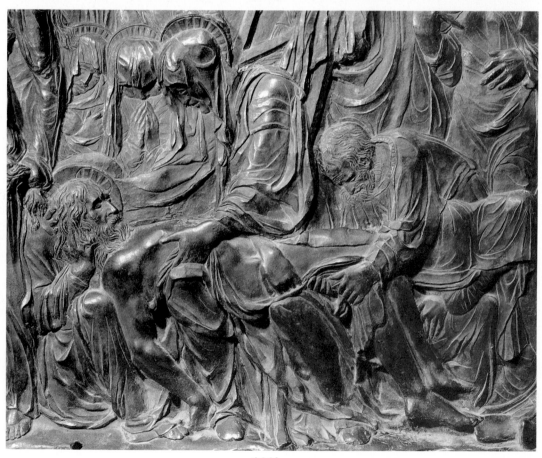

108b

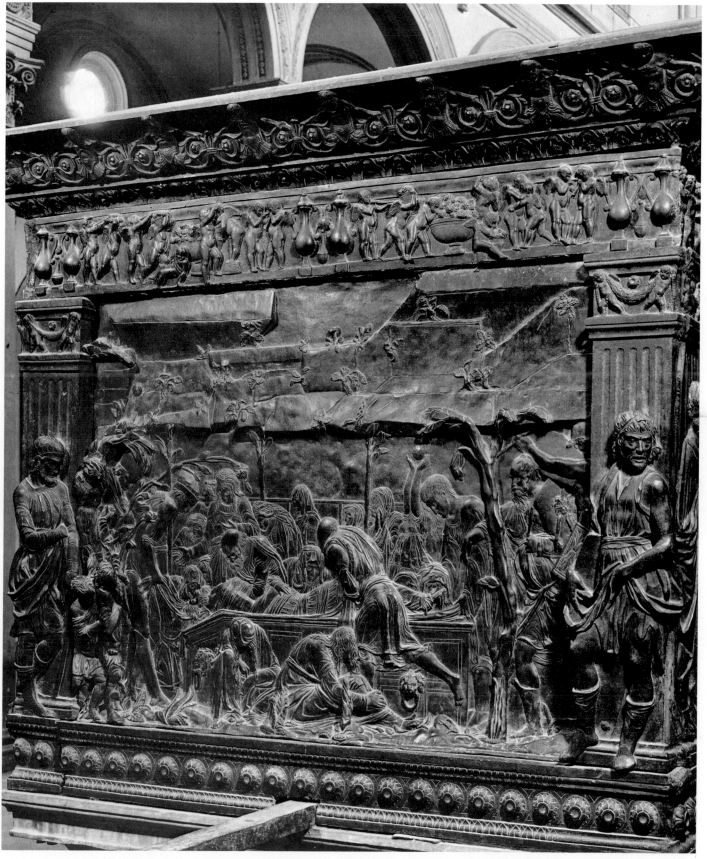

109

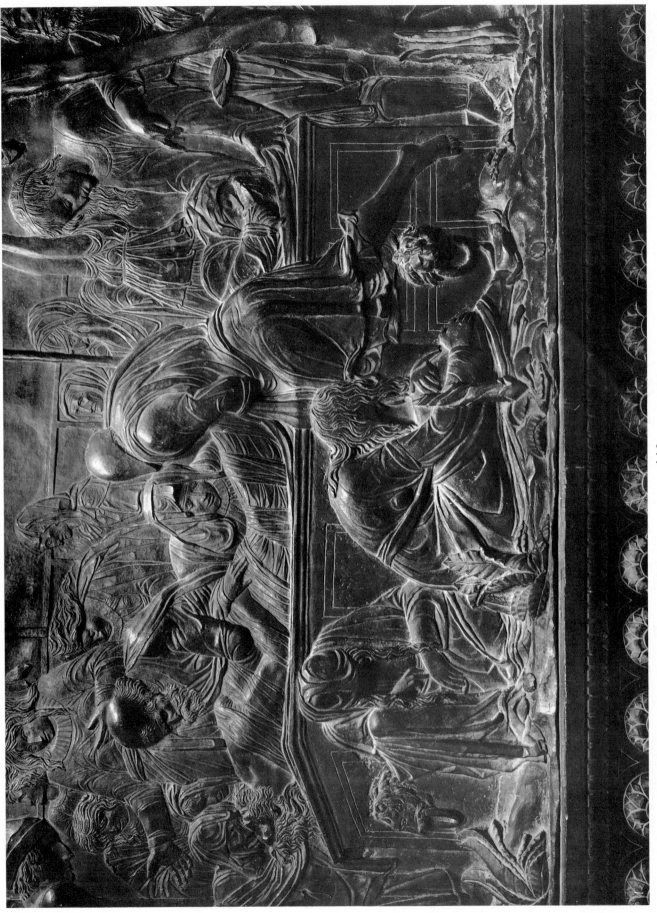

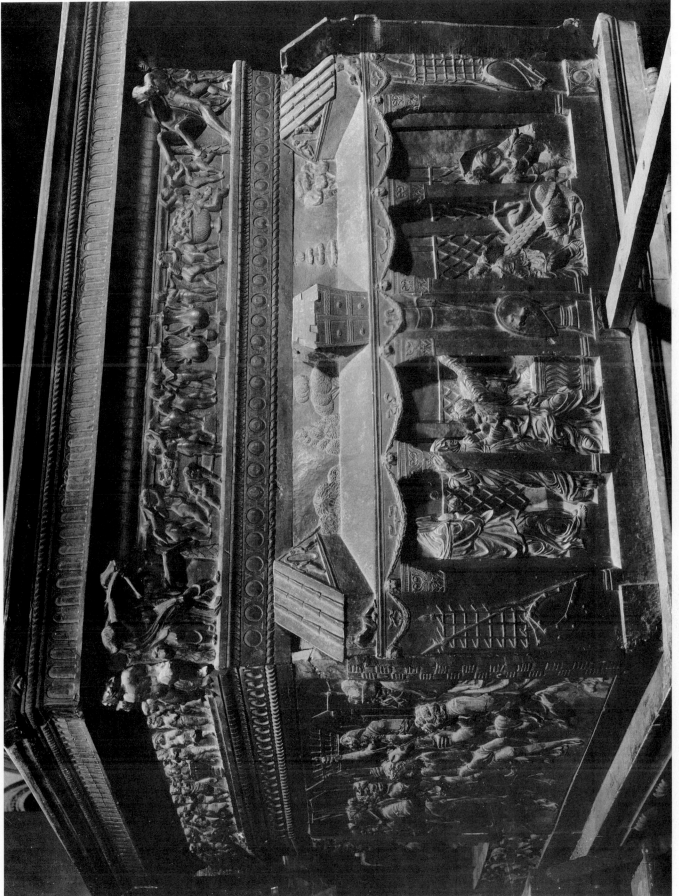

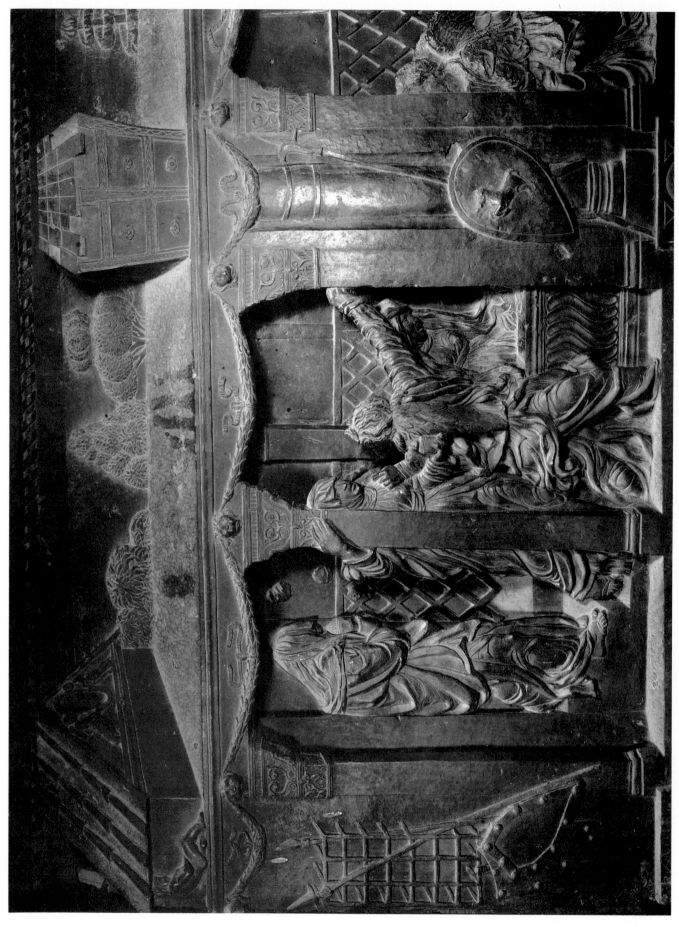

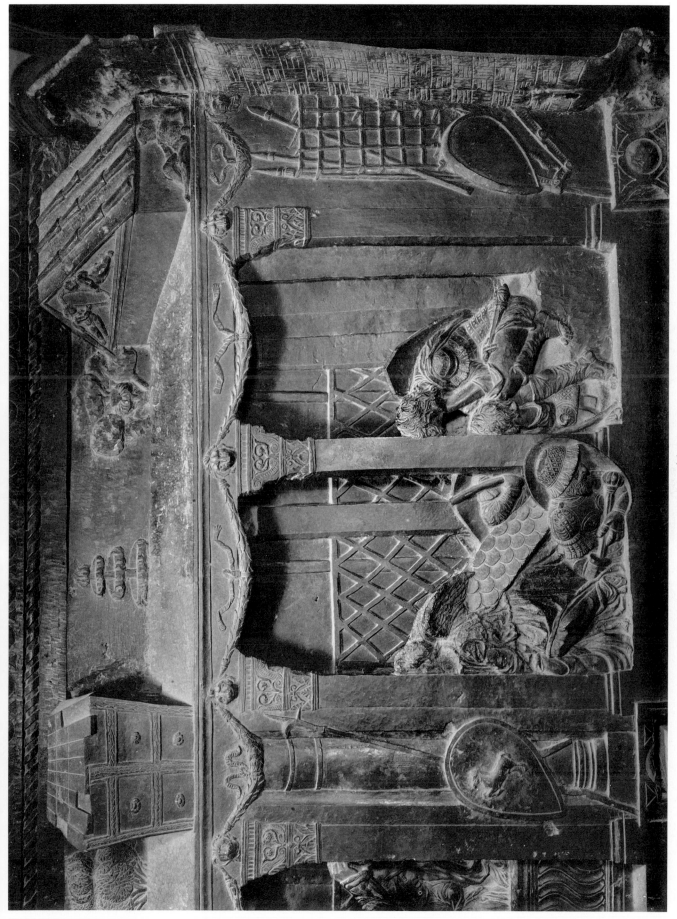

113

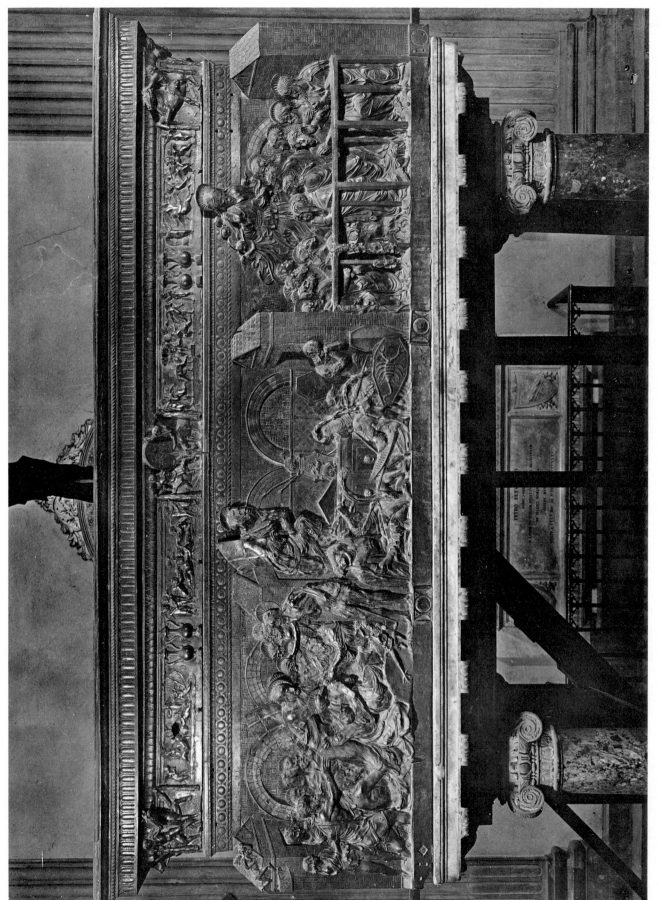

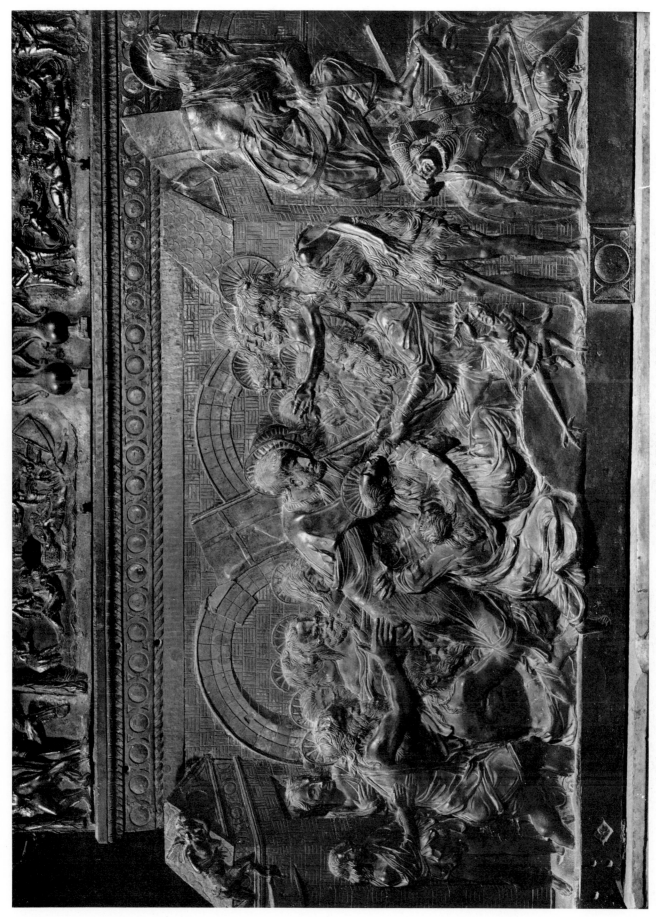

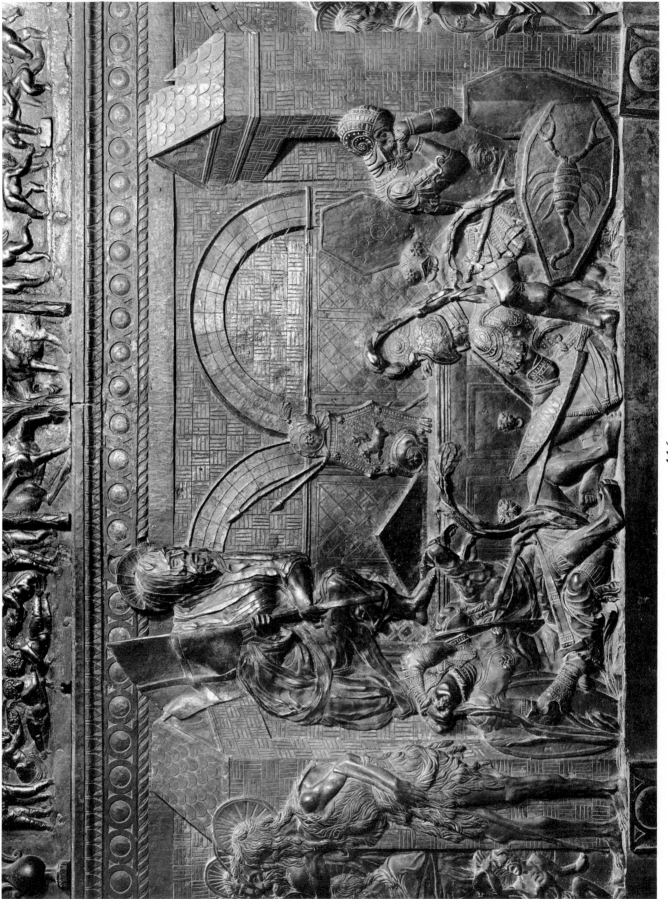

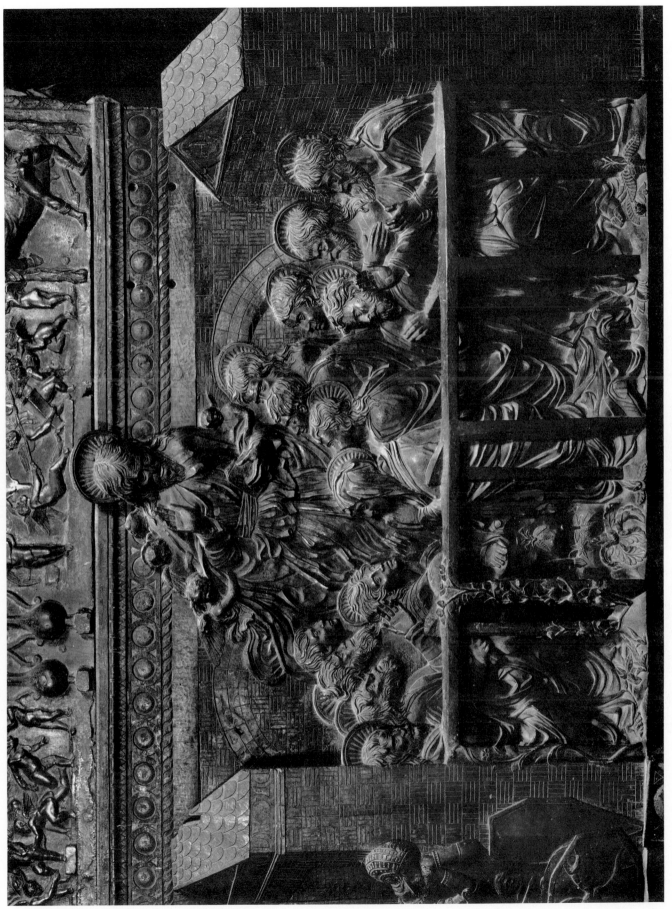

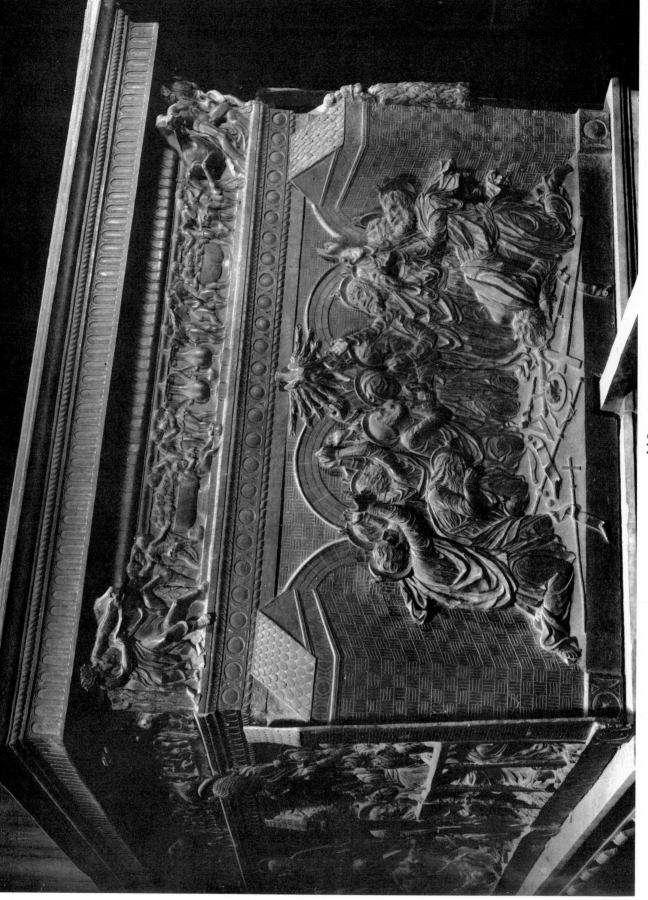

118

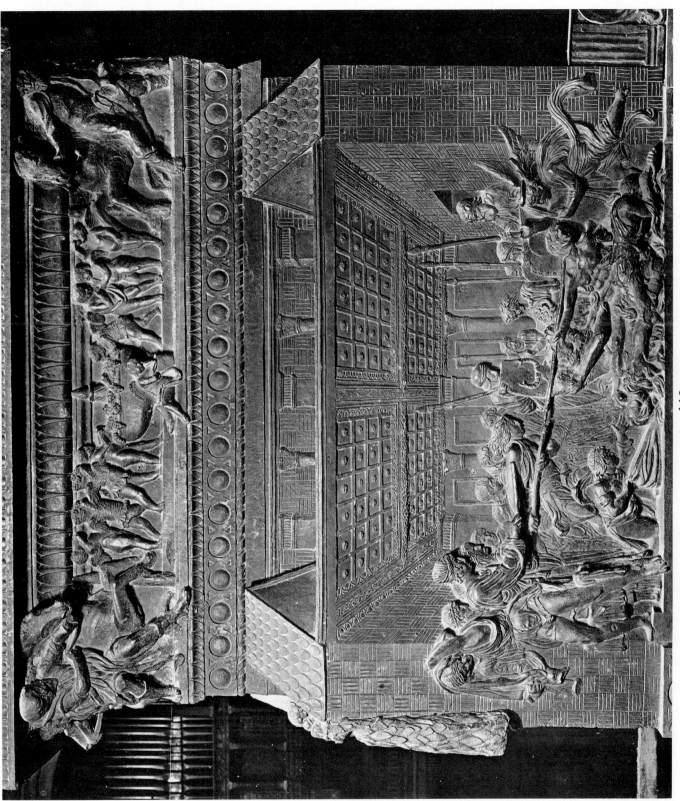

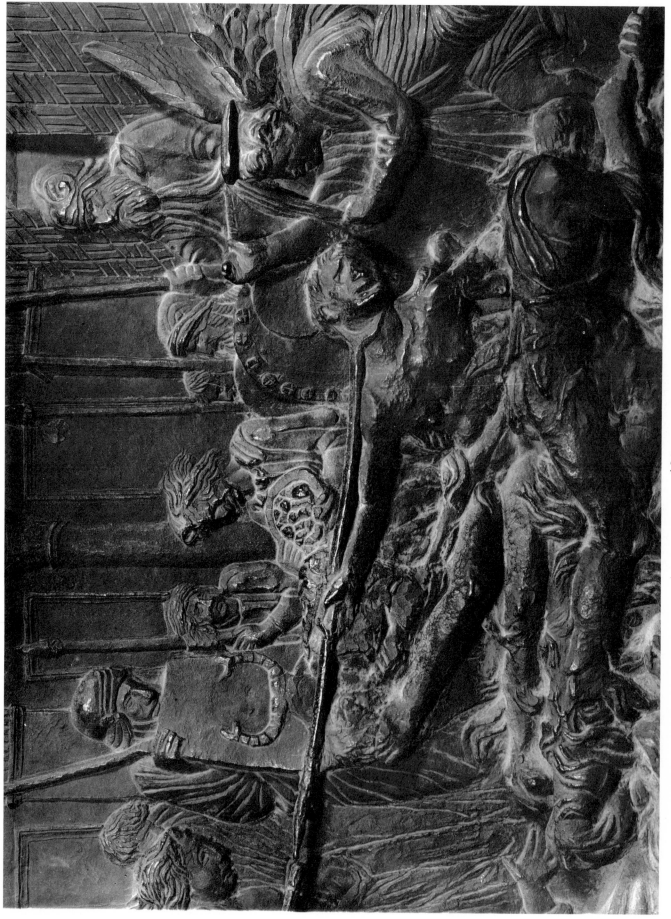

121d

121c

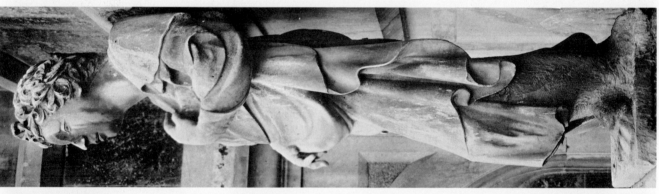

121b

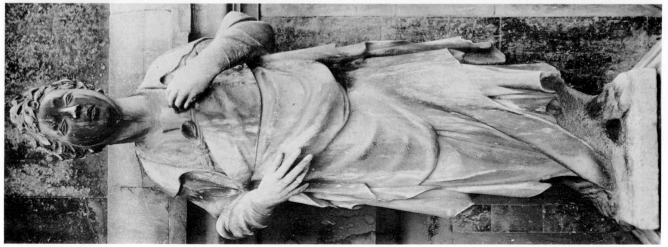

121a

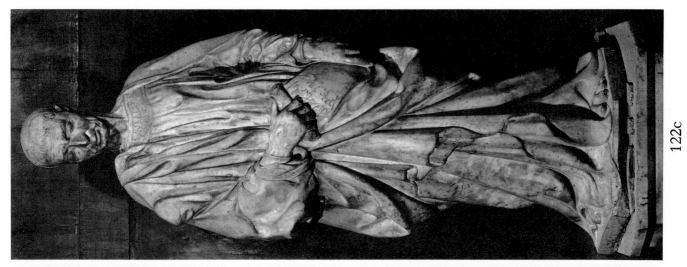

122c

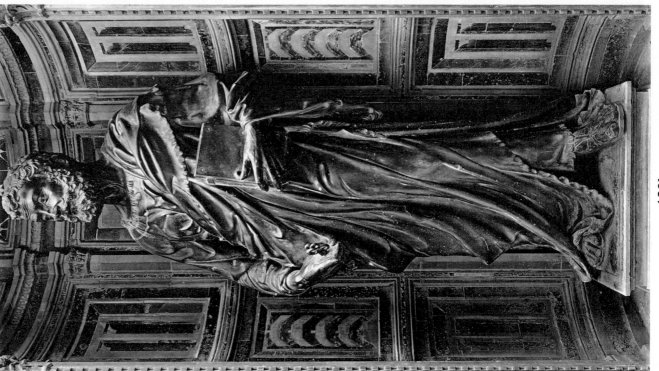

122b

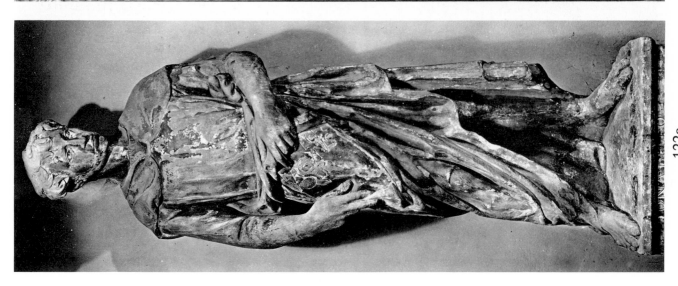

122a

123c

123b

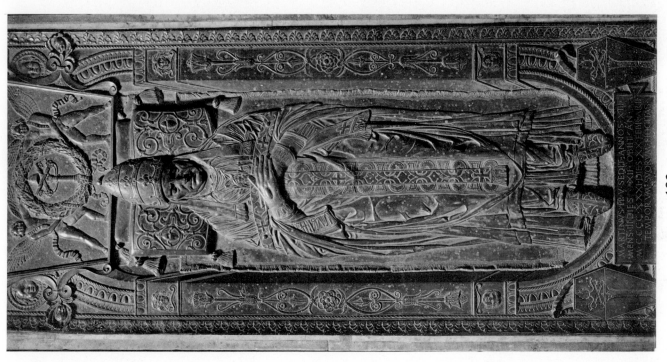

123a

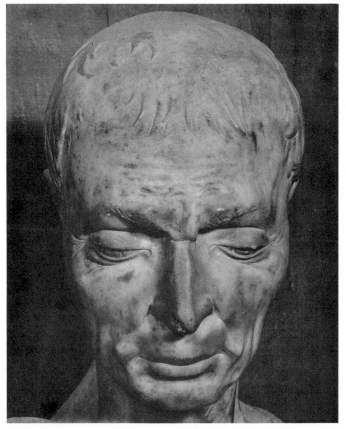

124a

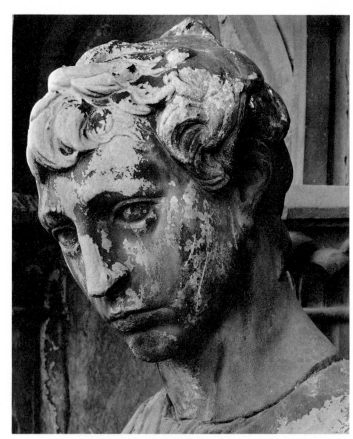

124b

124c

124d

124e

124f

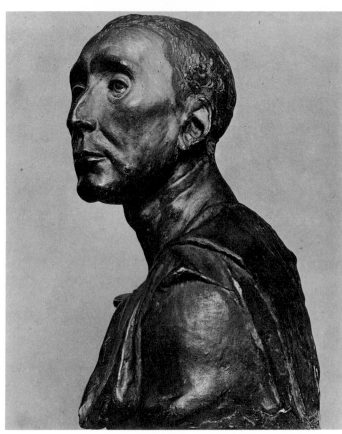

124g

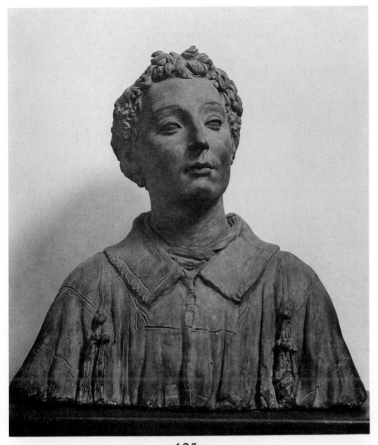

125a

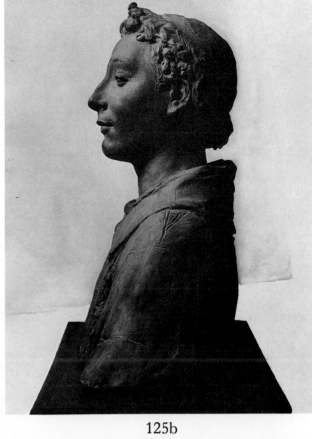

125b

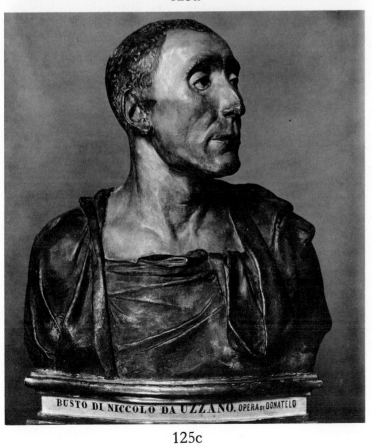

BUSTO DI NICCOLO DA UZZANO. OPERA DI DONATELO

125c

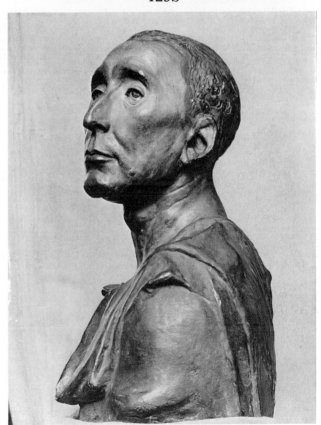

125d

126b

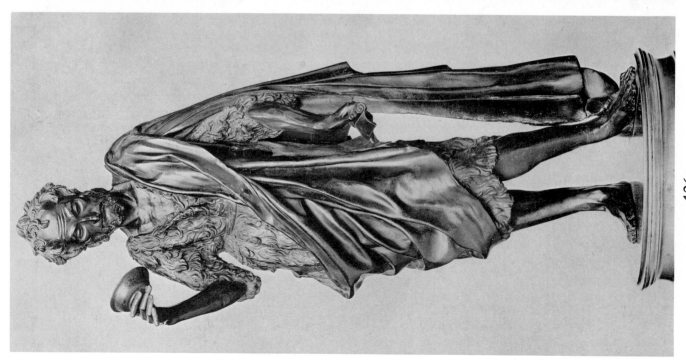

126a

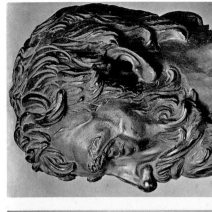

127d

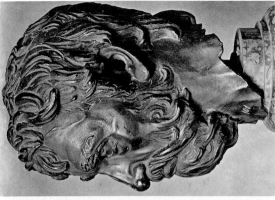

127b

127c

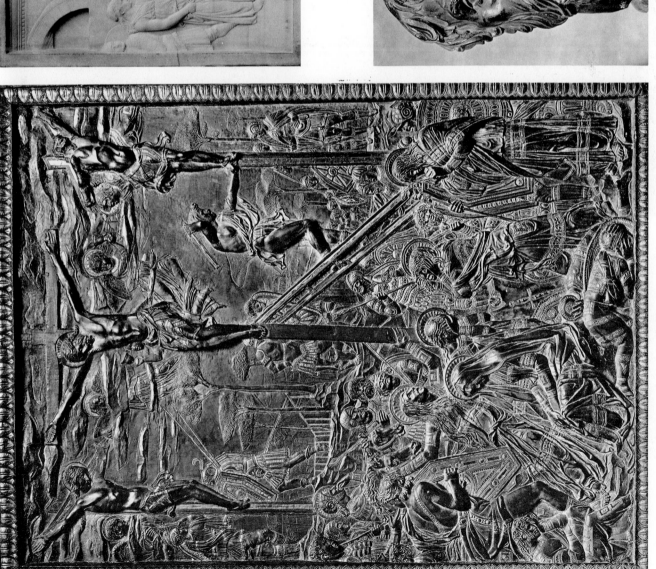

127a

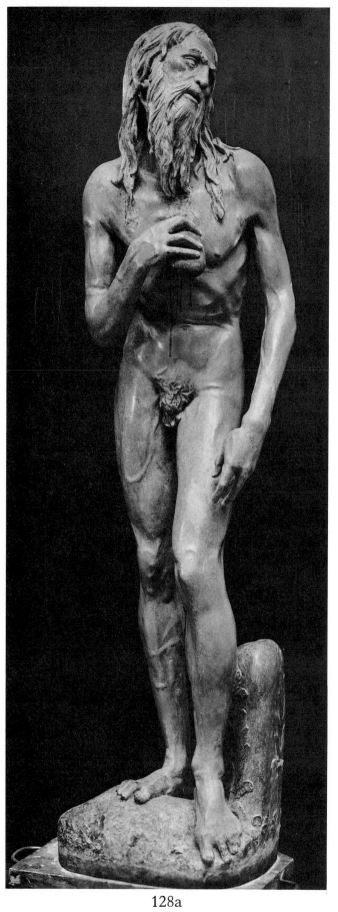

128a

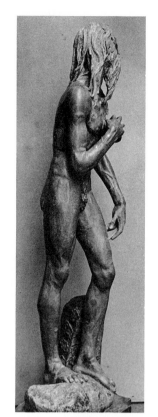

128b

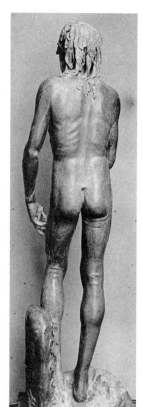

128c

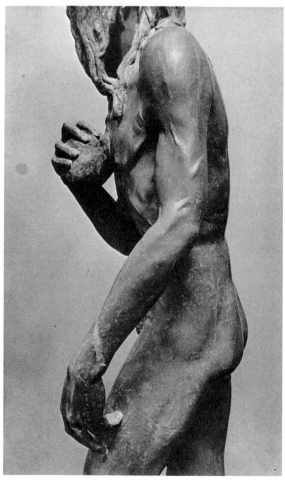

128d